Darrell Young

Mastering the
Nikon D7200

rockynook

NikoniansPress

Mastering the Nikon D7200
Darrell Young (a.k.a. Digital Darrell)
www.PictureandPen.com

Project editor: Maggie Yates
Project manager: Lisa Brazieal
Marketing: Jessica Tiernan and Mercedes Murray
Copyeditor: Maggie Yates
Layout and type: Petra Strauch
Cover design: Helmute Krause, www.exclam.de
Indexer: Darrell Young

ISBN: 978-1-937538-74-3
1st Edition (2nd printing, August 2017)
© 2016 Darrell Young
All images © Darrell Young unless otherwise noted

Rocky Nook Inc.
1010 B Street, Suite 350
San Rafael, CA 94901
USA

www.rockynook.com

Distributed in the U.S. by Ingram Publisher Services
Distributed in the UK and Europe by Publishers Group UK

Library of Congress Control Number: 2015948809

All rights reserved. No part of the material protected by this copyright notice may be reproduced or utilized in any form, electronic or mechanical, including photocopying, recording, or by any information storage and retrieval system, without written permission of the publisher.

Many of the designations in this book used by manufacturers and sellers to distinguish their products are claimed as trademarks of their respective companies. Where those designations appear in this book, and Rocky Nook was aware of a trademark claim, the designations have been printed in caps or initial caps. All product names and services identified throughout this book are used in editorial fashion only and for the benefit of such companies with no intention of infringement of the trademark. They are not intended to convey endorsement or other affiliation with this book.

While reasonable care has been exercised in the preparation of this book, the publisher and author assume no responsibility for errors or omissions, or for damages resulting from the use of the information contained herein or from the use of the discs or programs that may accompany it.

This book is printed on acid-free paper.
Printed in Korea

This book is dedicated to:

My wife of many years, Brenda; the love of my life and best friend …

*My children, Autumn, David, Emily, Hannah, and Ethan,
five priceless gifts …*

*My mother and father, Barbara and Vaughn, who brought me into this world and
guided my early life, teaching me sound principles to live by …*

*My Nikonians editor, Tom Boné,
without whose assistance I could not possibly write books …*

*My friends J. Ramon Palacios and Bo Stahlbrandt, who make it possible to belong to
Nikonians.org, the world's best Nikon Users' Community …*

*The wonderful staff of Rocky Nook, including Gerhard Rossbach, Scott Cowlin, Joan Dixon,
Ted Waitt, Jocelyn Howell, Maggie Yates, and Lisa Brazieal …*

And, finally, to Nikon, who makes the world's best cameras and lenses.

Special Thanks to:

Tony Trent of **www.atomos.com** (503-388-3236) for allowing me to use a powerful Atomos *Ninja Blade* external HDMI video recorder. The revolutionary Ninja Blade is the go-to "Smart Production Weapon" for Nikon HD-SLR camera owners who want to record the highest quality, uncompressed video their camera can output.

Brad Berger of **www.Berger-Bros.com** (800-542-8811) for helping me obtain a Nikon D7200 early in its production cycle so that I could write this book. I personally buy from and recommend Berger-Bros.com for Nikon cameras, lenses, and accessories. They offer old-time service and classes for your photographic educational needs!

Darrell Young (*DigitalDarrell*) is a full-time author and professional photographer, with a background in information technology engineering. He has been an avid photographer since 1968 when his mother gave him a Brownie Hawkeye camera.

Darrell has used Nikon cameras and Nikkor lenses since 1980. He has an incurable case of Nikon Acquisition Syndrome (NAS) and delights in working with Nikon's newest digital cameras.

Living near Great Smoky Mountains National Park and the Blue Ridge Parkway has given him a real concern for the natural environment and a deep interest in nature photography. You'll often find Darrell standing behind a tripod in the beautiful mountains of Tennessee and North Carolina, USA.

He loves to write, as you can see in the Resources area of the Nikonians Online community (**www.Nikonians.org**) and at his Master Your Nikon blog (**MasterYourNikon.com**). He joined the Nikonians community in the year 2000, and his literary contributions led to an invitation to become the founding member of the Nikonians Writers Guild.

Table of Contents

Foreword

Welcome to the 16th in the series of *Mastering the Nikon® DSLR* books authored by Nikonian Darrell Young (known to us as Digital Darrell). He is a Founding Member of the Nikonians Writers Guild, and his status as an accomplished and respected author is legendary in the world's largest Nikon enthusiast's online community: Nikonians.org.

This book is a perfect example of the "camera instruction" genre with an emphasis on friendly guidance from cover to cover as opposed to a complicated and often sleep-inducing technical diatribe. Darrell has the unique ability to entice his readers into a sense of discovery as he details the features of the Nikon D7200. He not only tells you what's new or different, he also explains how to take advantage of these features to improve yourself as a photographer. Quite often a new product is best reviewed, critiqued and explained by a person who literally wrote the book on its predecessor. Such is the case with *Mastering the Nikon D7200*.

The previous version, Nikon's D7100 (introduced February 2013), was a popular entry in the digital single-lens reflex (DSLR) market. It quickly took the title as the new flagship of Nikon's DX-sized sensor DSLR's. It's worth noting that when the camera was unveiled, there was strong sentiment and plenty of rumors that Nikon would soon be phasing out their smaller DX sensor DSLR's. Darrell Young's book on that camera carried his assessment, describing it as "the ultimate advanced-enthusiast DX camera." Photography consumers showed their enthusiasm for the D7100 by voting with their wallets, and Darrell's book on the camera has subsequently become one of the most popular in his *Mastering* series.

Darrell's amazing ability to understand the complexities of modern day digital single-lens reflex cameras is matched by his genuine passion for condensing and rewording intricate information to guide his readers through the technical maze. His progression in writing and layout talent has been just as amazing as Nikon's progression in introducing a host of new and extremely complex features in each new camera.

We are proud to include his impressive credentials and body of work in our ever growing and never-ending resources for our community, such as the forums, The Nikonian eZine, Nikonians Academy Workshops, Nikonians News Blog, Nikonians podcasts, our Wiki, and eBooks. Our community now has three language versions (English, German and French) and we continue to grow. We now surpass 500,000 members on record.

Nikonians, now entering its 16th year, has earned a reputation as a friendly, reliable, informative, and passionate Nikon® user's community thanks in great measure to members like our own Digital Darrell, who have taken the time to share the results of their experiences with Nikon imaging equipment.

Enjoy this book, the Nikonians community, and your Nikons.

J. Ramón Palacios (jrp) and Bo Stahlbrandt (bgs)
Nikonians Founders
www.nikonians.org

Camera Body Reference

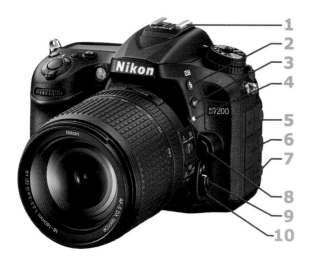

Front of Camera on Right Side (facing camera)

1. Accessory shoe (hot shoe)
2. Flash mode/compensation button (also raises flash #11)
3. Bracketing button (BKT)
4. Lens mounting mark
5. USB and External Microphone cover
6. HDMI connector cover
7. Accessory terminal connector (GPS, etc.) and Headphone cover
8. Lens release button
9. AF-mode button
10. Focus-mode selector

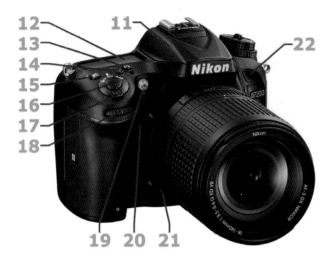

Front of Camera on Left Side (facing camera)

11. Built-in flash (pop-up Speedlight)
12. Control panel
13. Metering/Formatting button
14. Movie-record button
15. Exposure compensation/Reset button
16. Shutter-release button
17. Power switch
18. Sub-command dial
19. AF-assist illuminator
20. Depth-of-field preview (Pv) button
21. Fn (function) button
22. Infrared receiver (front)

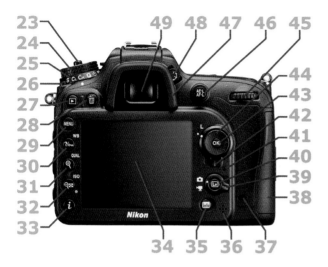

Back of Camera

23. Mode dial lock release
24. Mode dial
25. Release mode dial
26. Release mode dial lock release
27. Playback button
28. Delete/format button
29. MENU button
30. Help/Protect/WB button
31. Playback zoom in (QUAL) button
32. Playback zoom out/thumbnails (ISO) button and Reset
33. *i* button
34. Monitor
35. info button
36. Speaker
37. Infrared receiver (rear)
38. Memory card slot cover
39. Live view selector
40. Live view (Lv) button
41. Memory card access lamp
42. Focus selector lock
43. OK button
44. Multi selector
45. Main command dial
46. AE-L/AF-L button
47. Rubber eyecup
48. Diopter adjustment control
49. Viewfinder eyepiece

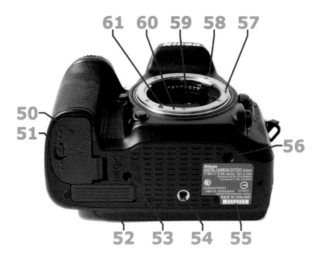

Bottom of Camera and Lens Mount (F-Mount)

50. Battery-chamber cover
51. Battery-chamber cover latch
52. MB-D15 contact cover
53. Battery pack mounting pin hole (1 of 2)
54. Tripod socket
55. Label for ID, battery voltage, compliance logos, and serial number
56. Battery pack mounting pin hole (2 of 2)
57. Lens lock pin (moved by Lens release button #8)
58. Meter coupling lever
59. CPU contacts (lens electronic communication)
60. Lens mount (Nikon F-mount)
61. AF coupling (screwdriver)

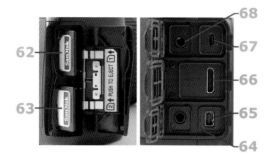

Under the Camera's Side Covers

62. Card Slot 1
63. Card Slot 2
64. Headphone connector
65. Accessory terminal for GPS and other accessories

66. HDMI mini-pin connector, type C
67. USB connector
68. External microphone (MIC) connector

Colors and Wording Legend

Throughout this book, you'll notice that in the numbered, step-by-step instructions there are colored terms as well as terms that are displayed in italic font.

1. Blue is used to refer to the camera's physical features.
2. Green is for functions and settings displayed on the camera's LCD screens.
3. *Italic* is for textual prompts seen on the camera's LCD screens.
4. *Italic* or ***bold italic*** is also used on select occasions for special emphasis.

Here is a sample paragraph with the colors and italic font in use:

Press the MENU button to reach the Setup Menu, and then scroll to the Format memory card option by pressing the down arrow on the Multi selector. You will see the following message: *All images on Memory card will be deleted. OK?* Select Yes and then press the OK button. **Please make sure you've transferred all your images first!**

Online Resources

Check the book's downloadable resources section from time to time because I may add additional material to supplement *Mastering the Nikon D7200*. The downloadable resources are found at these two web addresses:

http://www.nikonians.org/NikonD7200
http://rockynook.com/NikonD7200

Stay in touch with me by using the following points of contact:

– Website: **http://www.pictureandpen.com**
– Facebook: **https://www.facebook.com/groups/MasterYourNikon/**

01 Introduction and Initial Camera Setup

Everyone Loves a Baby © 2015 Brenda Young (DigitalBrenda)

Congratulations on your purchase of a Nikon D7200 camera, one of the most exciting new cameras in Nikon's product line! The D7200 is a hybrid-digital, single-lens reflex (HD-SLR) camera in Nikon's line of advanced-enthusiast digital cameras. It has a newly designed imaging sensor with more dynamic range and image quality than ever before for a camera in its class.

With a camera body design and internal operating system based on the mature and stable Nikon D7100 and many of the same internal hardware features as in the Nikon D750 and D810—including the new, very powerful EXPEED 4 microprocessor system—the Nikon D7200 is the ultimate DX advanced-enthusiast camera. Many professional photographers use the D7200 when weight is a factor because the camera's magnesium-alloy body is strong, yet light. It has an excellent APS-C (23.5mm×15.6mm), 24.2-megapixel (MP) DX imaging sensor—with its 1.5× crop factor—making the field of view for telephoto lenses even longer (narrower) than on an FX camera. This gives the D7200 a real edge in photography where maximum telephoto reach is desired.

The D7200 simply has everything an enthusiast photographer will need to bring home incredibly good images. With the D7200, digital photography has reached a level of maturity that will allow you to use your camera for a long time. The image quality is so high, the dynamic range so deep, the autofocus so exact, the 6 frames-per-second shooting rate so fast, and the file size so perfect that it may be years before you need another Nikon!

The high resolution of the sensor, for superb still images and clean, broadcast-quality video, make the D7200 one of the world's best HD-SLR cameras. The Nikon D7200 can deliver some of the highest-quality images out there for a DX camera. It has a robust camera body designed to last. With this camera we can return to the days when we seldom bought a new camera body and instead put our money into new Nikkor lenses. Wouldn't you like to have some new lenses?

Sure, new Nikon cameras will come out, and, like me, you'll be attracted to them. However, with the D7200 you won't have to buy a new camera unless you really want to. It will last for many years!

Now, let's learn how to configure and use your new D7200.

Learning about the Nikon D7200

The difficulty in writing a book about a powerful camera like the Nikon D7200 is balancing it for multiple types of users and their various levels of knowledge and interest. With too much technical detail, the book will read like a user's manual. With too little technical detail, advanced users will get no benefit from the book.

Some users of the Nikon D7200 HD-SLR camera have come over from the world of fully automated point-and-shoot cameras. On the other hand, many photographers have upgraded to the D7200 from cameras like the Nikon D3300, D5500, and D7100. Then, there are professionals who bought a D7200 to have a backup for their pro-level cameras. Others have come over from the film world, drawn by the siren call of lower cost, immediate image use, and extremely high quality.

In *Mastering the Nikon D7200* I've tried my best to balance the needs of new and experienced users. I remember my first DSLR and my confusion about how to configure the camera compared to my old film SLR: what's all this histogram, white balance, and color space stuff?

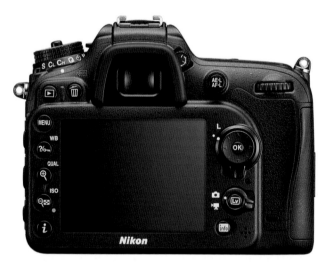

The bottom line is that the Nikon D7200 is a rather complex camera, and it requires a careful study of resources like this book to really get a grasp on the large range of features and functions. According to Nikon, it's an "advanced" camera, with features not found in lesser

"consumer" models. It's designed for people who really love photography and have a passion for image making that far exceeds just taking some nice pictures at a family event.

The D7200 has most of the features found in cameras like the D810 and D4S, which are cameras that professionals use to make a living. In fact, the Nikon D7200 is becoming the camera of choice for many pros who want a backup camera or a smaller, lighter camera for pleasure use and activities like hiking, skydiving, and underwater adventures. The camera body is robust enough—with its combination metal magnesium-alloy and carbon fiber reinforced thermoplastic frame—to take abuse and survive.

Following the publication of my books *Mastering the Nikon D7100, Mastering the Nikon D750,* and *Mastering the Nikon D810,* I compared the D7100, D750, D810, and D7200 side by side. I'm here to tell you that the Nikon D7200 has most of the functions found in the D750 and D810, and extends the feature set of the D7100.

The D7200 also has a full range of retouch functions that allow you to shoot images and postprocess them in the camera instead of on your computer. If you don't like computers but want to take digital photographs and videos, the Nikon D7200 is the camera for you!

Additionally, the Nikon D7200 has a very powerful video subsystem, allowing you to record H.264/MPEG-4 Advanced Video Coding (AVC) compressed HD (720p) or Full HD (1080p) video movies to the camera's memory cards, or stream overlay-free, uncompressed 8-bit 4:2:2 video to an external video recorder through its HDMI port.

I could rave for hours about all the cool features in the D7200. In fact, I do go on raving about this camera for the next 12 chapters. I hope you can sense my enthusiasm for this impressive new imaging machine as you read this book. There are few cameras in the world with this level of capability, and you own one!

First Use of the Camera

Surprisingly, quite a few brand-new DSLR users are buying a Nikon D7200 instead of a lower-cost, entry-level model. Even new users appreciate the robust high quality of the camera.

The upcoming sections and chapters are best read with your camera in hand, ready for configuration. There are literally hundreds of things to configure on this advanced DSLR. In this chapter, I'll give new D7200 users a place to start. Later, as you progress through this book, we'll look at all the buttons, switches, dials, and menu settings in detail. That will allow you to fully master the operation of your Nikon D7200.

Each menu in the camera has its own chapter or section. Plus, there is additional information on how to put it all together in chapters like **Metering, Exposure Modes, and Histogram; White Balance; Autofocus, AF-Area, and Release Modes;** and **Live View Photography**. Since the D7200 has a movie mode, we'll cover video capture in a separate chapter, **Movie Live View**.

First-Time HD-SLR Users

Although the D7200 is an advanced enthusiasts' camera, many brand-new HD-SLR users have purchased a D7200 as their first DSLR-type camera. New users may not know how to attach and remove a lens or change the battery, and they may need help with inserting and formatting memory cards.

The majority of this book's readers, however, already know how to perform these tasks. I do not want to ask a more experienced DSLR user to read over the basics of DSLR use, so I've created a document called **Initial Hardware Considerations** that you can download from either of these websites:

http://www.nikonians.org/NikonD7200
http://rockynook.com/NikonD7200

There are also several other articles of interest to new Nikon D7200 users on these webpages.

Now, let's start with the initial configuration of a brand-new Nikon D7200. There are five specific steps you must complete when you first turn on the camera.

Five Steps for First-Time Camera Configuration

This section is devoted to first-time configuration of the camera. There are certain settings that must be set up immediately (covered in this section) and others that should be configured before you use the camera extensively (covered in a later section [page 13], **Camera Functions for Initial Configuration**).

I won't go into detail on all possible settings in this chapter. Those details are reserved for the individual chapters that cover the various menus and functions. Instead, I'll walk you through five steps for first-time configuration of the camera. Then, in the **Camera Functions for Initial Configuration** section, I'll refer you to the page numbers that provide the screens and menus for each function that should be configured *before* you use your camera for the first time. The later chapters will cover virtually all camera settings.

When you first power on your camera it may display a screen informing you that the clock has been reset, and a small version of the clock-not-set symbol (seen in figure 1.1A) may be flashing on the rear Information display (Monitor). This happens when the camera's internal time clock has not been set, or has been reset. Therefore, if your camera's clock has not been previously set and you see a clock reset message, or a clock-not-set symbol is flashing on the Information display, be sure to set the clock before using the camera. We will review the procedure for setting the clock during the third step of our five-step initial setup.

Figure 1.1A –
Clock-not-set
symbol

Let's examine how to configure a new camera. You'll see the following five screens when you first turn the camera on, and they must be set up immediately.

Setting the Language: Step 1

The D7200 is multilingual and multinational. As partially shown in figure 1.1B, the menus can be displayed in one of 36 languages, as follows:

Arabic	German	Portuguese
Bengali	Greek	Romanian
Brazilian Portuguese	Hindi	Russian
Bulgarian	Hungarian	Serbian
Chinese (Simplified and	Indonesian	Spanish
Traditional)	Italian	Swedish
Czech	Japanese	Tamil
Danish	Korean	Telugu
Dutch	Marathi	Thai
English	Norwegian	Turkish
Finnish	Persian	Ukrainian
French	Polish	Vietnamese

Most likely the camera will already be configured to the language spoken in your area since various world distributors have the camera somewhat preconfigured.

Here are the steps to select your language:

1. Refer to figure 1.1B for the Language list the camera presents on startup.
2. Use the circular Multi selector on the back of the camera—with arrows pointing left, right, up, and down—to scroll up or down until your language is highlighted.
3. Press the OK button in the center of the Multi selector to select your language.

Figure 1.1B – Setup Menu Language screen

The camera will now switch to the second screen in the setup series, the Time zone screen.

Setting the Time Zone: Step 2

This is an easy screen to use as long as you can recognize the area of the world in which you live. Use the map shown in figure 1.1C to find your area, then select it.

Here are the steps to select the correct Time zone for your location:

1. Refer to figure 1.1C for the Time zone screen. You'll see yellow arrows pointing to the left and right on either side of the small black-and-gray world map.

Figure 1.1C – Setup Menu Time zone screen

2. With the Multi selector, scroll to the left or right until your world location is highlighted in yellow. You will see either a vertical yellow strip or a tiny yellow outline with a red dot. At the bottom of the screen you will see the currently selected Time zone. Mine is set to New York, Toronto, Lima (UTC-5), as shown in figure 1.1C.
3. Press the OK button to lock in your Time zone.

The camera will now present you with the next screen in the series, the Date and time screen.

Setting the Date and Time: Step 3

This screen allows you to enter the current date and time. It is in year, month, day (Y, M, D) and hour, minute, second (H, M, S) format.
 Here are the steps to set the Date and time:

1. Refer to figure 1.1D for the Date and time screen.
2. Use the Multi selector to scroll to the left or right and select the various date and time sections. Scroll up or down to set the values for each one. The time values use a 24-hour clock, or military time. Use the 12- to 24-Hour Time Conversion Chart on page 321 to convert the 12-hour time you are probably using (for example, 3:00 p.m. is 15:00:00).
3. Press the OK button when you have entered the Date and time.

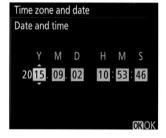

Figure 1.1D – Setup Menu Date and time screen

Next, the camera will switch to the Date format screen with settings for your area of the world.

Setting the Date Format: Step 4

The English-speaking world uses various date formats. The Nikon D7200 allows you to choose from the most common ones. There are three date formats you can select (figure 1.1E):

* Y/M/D – Year/Month/Day (2015/12/31)
* M/D/Y – Month/Day/Year (12/31/2015)
* D/M/Y – Day/Month/Year (31/12/2015)

U.S. residents usually select the M/D/Y format. However, you may prefer a different format.

Here are the steps to select the Date format you like best:

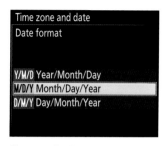

1. Refer to figure 1.1E for the Date format screen.
2. Using the Multi selector, scroll up or down to the position of the date format you prefer. M/D/Y is selected in figure 1.1E.
3. Press the OK button to select the format.

When you have selected a Date format, the camera will switch to the Daylight saving time screen.

Figure 1.1E – Setup Menu Date format screen

Setting Daylight Saving Time: Step 5

Many areas of the United States observe daylight saving time. In the springtime, most U.S. residents set their clocks forward by one hour on a specified day each year. Then in the fall they set their clocks back, leading to the clever saying, "spring forward; fall back."

You can use the Daylight saving time setting to adjust the time on your D7200's clock forward or back by one hour every six months, according to whether daylight saving time is currently in effect in your area.

To choose an initial Daylight saving time setting, follow these steps:

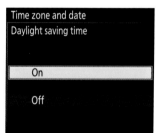

1. Refer to figure 1.1F for the Daylight saving time screen.
2. There are only two selections: On or Off. The default setting is Off. If daylight saving time is in effect in your area (spring and summer in most areas of the United States), select On. When daylight saving time ends, you will need to change this setting to Off (via the Setup Menu) to adjust the clock back by one hour.
3. Press the OK button to select your choice.

Figure 1.1F – Setup Menu Daylight saving time screen

Settings Recommendation: If you live in an area that observes daylight saving time, it's a good idea to adjust this setting whenever daylight saving time begins and ends. When you set the time forward or back on your wristwatch and clocks, you will need to adjust it on your camera as well. If you don't, your images will have metadata reflecting a time that is off by one hour for half the year. This setting allows you to adjust the camera's clock quickly by simply selecting On or Off.

This completes the initial camera setup, and you are now ready to start configuring other parts of the camera in whatever order you find convenient. You'll use the menu system, as described in the next section, to access individual configuration screens. Each configuration step described in this book is accompanied by all the screen graphics you'll need and step-by-step instructions on configuration choices.

Let's look at an overview of the menu system.

Accessing the Camera Menus

To access the various configurable menus in the D7200, you'll use the MENU button and the *i* button on the back of the camera (figure 1.2A). Please remember the locations of these two buttons since they will be mentioned often in this book.

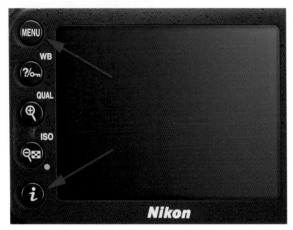

Figure 1.2A – Press the MENU button to open the main camera menus and the *i* button to open the shortcut menus

There are seven primary main menu systems in the camera, which work for both View-finder photography and Live view photography and videos. They are listed as follows:

• Playback Menu
• Photo Shooting Menu
• Movie Shooting Menu
• Custom Setting Menu
• Setup Menu
• Retouch Menu
• My Menu or Recent Settings

Additionally, there are three *i* button shortcut menus available for these types of photography and movies (along with the normal main menus listed previously):

• Viewfinder photography
• Live view photography
• Movie live view

This book has a chapter devoted to each of the main menus and fully discusses the *i* button shortcut menus in appropriate places.

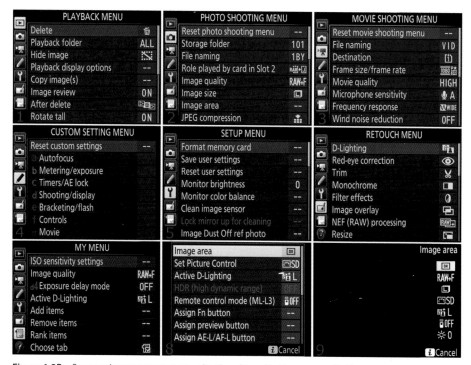

Figure 1.2B – Seven primary camera menus (1–7) and two *i* button menus (8–9)

Let's take a brief look at the opening screens of the seven main menus, shown in figure 1.2B, images 1–7. You get to these seven menus by pressing the MENU button and scrolling up or down with the Multi selector. A selector bar with tiny icons will appear on the left side of the Monitor when you press the MENU button. You can see the selector bar at the left of each menu in figure 1.2B, images 1–7.

As you scroll up or down in the selector bar, you'll see each menu appear on the Monitor, with its icon highlighted in yellow on the left side of the screen, and the menu on the right. The name of the menu you are currently using will be displayed at the top of the screen.

Additionally, there are three *i* button shortcut menus. Figure 1.2B, image 8 displays an example of the *i* button shortcut menu you will see when you are using Viewfinder photography. The screen shown in figure 1.2B, image 9, displays the *i* button menu shortcut screen used in the two Live view modes. The one actually shown is for Live view photography mode. The one for Movie live view mode (not shown) is very similar, with different menu choices.

Again, we will discuss each of these menus and their functions and settings in great detail as we go through this book.

Note: My Menu (figure 1.2B, image 7) can be toggled with an alternate menu called Recent Settings by using the Choose tab setting at the bottom of My Menu. These two menus— My Menu and Recent Settings—can't be active at the same time so only one of them is

shown in figure 1.2B (image 7). My Menu is much more functional for most people. The chapter titled **My Menu and Recent Settings** covers both of these options in detail so you can choose which one you want to appear most of the time on your camera. My Menu allows you to add the most-used menu items from any of the other menus to your own personal menu, and Recent Settings shows you the last 20 menu items you've changed.

Using the Camera's Help System

The D7200 is complex enough that it needs a help system. Fortunately, Nikon provides one. Whenever you have a function selected in one of the menus, you can press and hold the WB/help/protect button and a help screen will appear for that function.

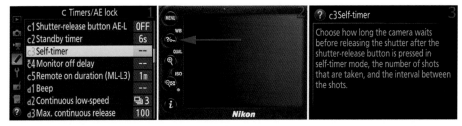

Figure 1.3 – Using the Help button to understand functions

Use the following steps to access the help system:

1. Highlight any function in any of the menus (figure 1.3, image 1).
2. Press the Help/protect (WB) button and hold it (figure 1.3, image 2).
3. A help screen will open that shows a brief description of what the function does (figure 1.3, image 3).

When you are trying to use the help system in the Custom Setting Menu, be sure that you are *not* looking at the heading menus; you should, instead, be inside the menu. For example, in figure 1.3, image 1, holding the help button won't work for the heading menu: c Timers/AE lock. You need to select one of the functions below the name of the menu, such as: c3 Self-timer or d1 Beep.

Check out the useful help screens. They are excellent for when you have forgotten exactly what a function does and could use a quick reminder. They are available for any of the menus.

Camera Functions for Initial Configuration

The following is a list of functions that you may want to configure before you take many pictures. These set up the basic parameters for camera usage. Each function is covered in great detail on the page number shown, so I did not repeat the information in this chapter. Please turn to the indicated page and fully configure the function, then return here and move on to the next function. When you are done, your camera will be ready for use.

Setup Menu
- Format memory card: Page 303
- Auto image rotation: Page 324
- Image comment: Page 327
- Copyright information: Page 328
- Wi-Fi: Page 351

Photo Shooting Menu
- File naming: Page 62
- Role played by card in Slot 2: Page 64
- Image quality: Page 65
- Image size: Page 73
- JPEG compression: Page 78
- NEF (RAW) recording: Page 80
- White balance: Page 85
- Set Picture Control: Page 87
- Active D-Lighting: Page 108
- Vignette control: Page 114
- Long exposure NR: Page 117
- High ISO NR: Page 120
- ISO sensitivity settings: Page 123

Movie Shooting Menu
- Destination: Page 151
- Frame size/frame rate: Page 151
- Movie quality: Page 153
- White balance: Page 159
- Set Picture Control: Page 161
- High ISO NR: Page 172
- Movie ISO sensitivity settings: Page 173

Playback Menu
- Playback folder: Page 25
- Playback display options: Page 30
- Image review: Page 42
- Rotate tall: Page 45

Custom Setting Menu
- a1 AF-C priority selection: Page 184
- a2 AF-S priority selection: Page 186
- a3 Focus tracking with lock-on: Page 188
- a8 Store points by orientation: Page 196
- c4 Monitor off delay: Page 215
- d1 Beep: Page 221
- d6 File number sequence: Page 228
- d7 Viewfinder grid display: Page 229
- e1 Flash sync speed: Page 238
- f2 Assign Fn button: Page 270
- f3 Assign preview button: Page 270
- f4 Assign AE-L/AF-L button: Page 270

Of course, there are hundreds more functions to configure, and you may find one function more important than another; however, these are the functions that you ought to at least give a once-over before you use the camera extensively.

Personal Camera Settings Recommendations

All through the book I offer my personal recommendations for settings and how to use them. Look for the **Settings Recommendation** paragraph at the end of most sections. These suggestions are based on my own personal shooting style and experience with Nikon cameras in various types of shooting situations. You may eventually decide to con-figure things differently, according to your own needs and style. However, these recom-mendations are good starting points while you become familiar with your camera.

Things to Know When Reading This Book

Here are a few things that you'll need to remember as you read this book. There are a lot of buttons and controls on the camera body. I have provided a **Camera Body Reference** section in the front of the book and a downloadable document titled **Camera Control Reference** that you can download from the website for this book. See the links to the downloadable resources in the next section.

What's the difference between these two resources? The **Camera Body Reference** is a place to go when you want to locate a control, including covers and doors, and the **Camera Control Reference** provides a deeper discussion of each button, dial, and switch on the camera.

I use Nikon-assigned names for the controls on the camera, as found in the Nikon D7200 User's Manual. For instance, I may say something like "press the Playback zoom out/

thumbnails (ISO) button" to show you how to execute some function, and you'll need to know where this button is located. Use the **Camera Body Reference** in the front of the book to memorize the locations of the camera controls.

I have provided page number references to the Nikon D7200 User's Manual at the beginning of most sections in case you want to refer to it for additional information about the camera settings. Using the Nikon manual is *entirely optional* and is not required to fully learn how to use your camera with this book. If you have no interest in using the Nikon manual, simply ignore the page number references.

Downloadable Resources Website

To keep this book small enough to carry as a reference in your camera bag, I have provided some less-used information in downloadable documents on these websites:
http://www.nikonians.org/NikonD7200
http://rockynook.com/NikonD7200
I will refer to these documents throughout the book when they apply to the material being discussed.

Author's Conclusion

Keep this book in your camera bag for reference, or acquire an electronic copy for use on your smartphone or tablet. You can acquire electronic copies of this book directly from the publisher as a bundle that includes three eBook formats (PDF, ePub, and Mobi). Use the following link to find the book:
http://bit.ly/1MUCa0o
If you use a Kindle reader, you can download a digital copy from Amazon.com at this link:
http://amzn.to/1CstehB
Let's get started on the camera's menu systems. There are a lot of individual functions and many settings within these functions. We will consider each of them so that you can use your camera to the fullest extent of its potential and improve your photography in the process.

The first menu we will consider is the Playback Menu, which is also the first menu listed by the camera. We will take each menu in order from that point forward.

Again, it is best if you have your camera in hand so that you can make adjustments and experiment with each setting as you go. Then, after you have read through the book, you will have discovered the functions that are most important to you, where they are located, and how to adjust them.

Are you ready? Let's master your new camera!

02 Playback Menu

This is My Best Side © 2015 Ray Heslewood (Hessy)

The Nikon D7200 has a big 3.2-inch high-resolution TFT-LCD Monitor, which you can use to examine in great detail the images you have taken. You can zoom in past the 100 percent pixel-peeping level to make sure an image is sharp enough. You can view, copy, delete, and hide images and examine detailed shooting information on each picture. You can even use the Monitor to view a slide show or use the HDMI port to output the slide show to a much larger device, such as a television (HDTV).

The Playback Menu has everything you need to control your camera's image playback and copying and printing functions. You'll be taking thousands of pictures and will view most of them on the Monitor; therefore, it is a good idea to learn to use the Playback Menu well.

In chapter 1 you configured the camera for picture-taking your way. This chapter, and the next several chapters, will consider the camera's menu systems. The D7200 has eight menus, with literally hundreds of configuration options. We'll examine each setting in each menu.

Remember, you will press the MENU button to enter the camera's menu system. The Playback Menu, which we'll consider in detail in this chapter, is first in the list of menus (figure 2.0). Since this menu controls how the Monitor displays images, you'll need to learn how to use it well.

By now you may have quite a few pictures on your memory card. The Playback Menu has everything you need to control image playback, copying, and printing. They are as follows:

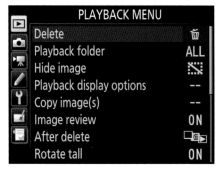

Figure 2.0 – The Playback Menu

- **Delete:** Allows you to delete all or selected images from your camera's memory card(s).
- **Playback folder:** Allows you to set which image folders your camera will display, if you have multiple folders on the camera's memory card(s).
- **Hide image:** Lets you conceal images so they won't display on the Monitor.
- **Playback display options:** Controls how many informational screens the camera will display for each image.
- **Copy image(s):** Gives you functions to copy images between the two memory cards.
- **Image review:** Turns the camera's post-shot automatic image review on or off.
- **After delete:** Determines which image is displayed next when you delete an image from a memory card.
- **Rotate tall:** Allows you to choose whether portrait-orientation images (vertical) display in an upright position or lying on their side on the horizontal Monitor.
- **Slide show:** Allows you to display all the images on your camera's memory card(s) in a sequential display, like the slide shows of olden days (pre-2002). No projector is required.

- **DPOF print order:** Lets you print your images directly from a PictBridge-compatible printer without using a computer—either by using digital print order format (DPOF) directly from a memory card or by connecting a USB cable to the camera.

Now, let's examine each of these settings in detail, with full explanations on how, why, and when to configure each item.

Auto FP High-Speed Sync Mode

The D7200 has an additional flash sync mode that lets it exceed the normal flash sync speed of 1/250 second. It is called Auto FP high-speed sync mode (*Custom Setting Menu > e Bracketing/flash > e1 Flash sync speed*). Normally, both the front and rear shutter curtains must be out of the way before the flash fires. Auto FP high-speed sync mode lets you use shutter speeds all the way up to 1/8000 second. At these speeds, the rear shutter curtain follows the front shutter curtain so closely that only a traveling narrow, horizontal slit exposes the sensor at any given time.

When you are using Auto FP high-speed sync mode and you select a sync speed faster than 1/250 second, the camera fires the flash in a series of short pulses instead of one big flash. The pulses fire as the narrow shutter curtain slit moves across the face of the sensor. The faster the shutter speed, the less power the flash can manage. You must be able to depend on ambient light in addition to flash when you use Auto FP high-speed sync mode, especially at higher shutter speeds. However, this lets you use faster lenses (e.g., f/1.4, f/2.8) wide open in bright light, due to the very fast shutter speed. You can expose properly with a very shallow depth of field, even though the light is very bright.

Technical TFT-LCD Monitor Information

As mentioned previously, the D7200 has a 3.2-inch, 170-degree wide-viewing angle, TFT-LCD Monitor with enough resolution, size, and viewing angle to allow you to really enjoy using it for previewing images. It has VGA resolution (640×480), based on a 1,228,800-dot (1.2M-dot) thin-film transistor (TFT), liquid-crystal display (LCD) panel. The bottom line is that this 3.2-inch screen has amazing clarity for your image previewing needs. You can zoom in for review up to 38× for Large (L) images, 28× for Medium (M) images, and 19× for Small (S) images. That's zooming in to pixel-peeping levels.

Now, if you want to get technical, here's the extra geek stuff:

If anything you read says the Monitor has 1,228,800 *pixels* of resolution the writer is uninformed. Nikon lists the resolution as 1.2M *dots,* not pixels. Technically, an individual pixel on your D7200's Monitor is a combination of four colored dots—red, green, blue, and white (RGBW). The four dots are blended together to provide shades of color and are equal to one pixel. This means the Monitor is limited to one-fourth of 1,228,800 dots, or 307,200 pixels of real image resolution. The VGA standard has 307,200 pixels (640×480), so the D7200's Monitor has VGA resolution.

The white dot color used on the D7200 Monitor is an added feature that many camera monitors do not have. This extra white dot color allows the Monitor to have better contrast and more accurate color. The D7200 Monitor isn't any higher in resolution than that of its predecessors, which also have VGA resolution but are limited to RGB colors, with no extra white dots (the W in RGBW). The older Nikon D700 has 920,000 RGB dots and the D7100 camera has 921,000 RGB dots, which when divided by three (one-third) equals approximately 307,000 pixels of actual resolution.

Delete

(User's Manual: Page 248, and Menu Guide: Page 18)

The *Delete* function allows you to selectively delete individual images from a group of images in a single folder or multiple folders on your camera's memory card. It also allows you to clear all images in the folders without deleting the folders. This is sort of like a card-formatting operation that affects only images, and not folders. However, if you have protected or hidden images, this function will not delete them.

There are three parts to the Delete menus:

- *Selected:* Deletes only selected images.
- *Select date:* Deletes all images taken on a certain date.
- *All:* Deletes all images in the folder you currently have selected with the Playback folder function (see the next main section). If a memory card is inserted in both slots, you can select the card from which to delete images.

Selected

Figure 2.1A shows the menu screens you'll use to control the Delete function for selected images.

Notice in image 3 of figure 2.1A that there is a list of images, each with a number in its lower-right corner. These numbers run in sequence from 1 to however many images you have in your current image folder or on the entire memory card. The number of images shown will vary according to how you have the Playback folder settings configured. (See the next section of this chapter, **Playback Folder**.)

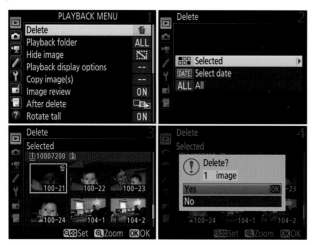

Figure 2.1A – Delete menu screens for the Selected option

If Playback folder is set to Current (factory default), the camera will show you only the images found in your current playback folder. If you have Playback folder set to All, the D7200 will display all the images it can find in all the folders on your camera's memory card.

Here are the steps to delete one or more images:

1. Select Delete from the Playback Menu and scroll to the right (figure 2.1A, image 1).
2. Choose Selected and scroll to the right (figure 2.1A, image 2).
3. Locate the images for deletion with the Multi selector and then press the checkered Playback zoom out/thumbnails button. This button will mark or unmark images for deletion. It toggles a small trash can symbol on and off on the top right of the selected image (red arrow in figure 2.1A, image 3).
4. Select the images you want to throw away, then press the OK button. A screen will appear and ask you to confirm the deletion of the images you have selected (figure 2.1A, image 4).
5. To finish deleting the images, select Yes and press the OK button. To cancel, select No and press the OK button (figure 2.1A, image 4).

Since the D7200 has multiple card slots, many functions can affect multiple memory cards when *Playback Menu > Playback folder > All* is selected. How can you tell which memory card is being affected by the current function?

Notice in figure 2.1B that there are two tiny SD card symbols in the top-left area of the screen (at the red arrows). Each card slot has a number: 1 or 2. If there is no memory card in one of the slots, the number for that slot will be grayed out.

Figure 2.1B – Active memory card slot configuration

As you use functions that affect displayed images, the memory card symbol will be underlined for the card that contains the image you are modifying. In figure 2.1B, it is apparent that there are two memory cards in the camera because the second card is not grayed out. The memory card in slot 1 contains the image that is currently selected, so the memory card symbol for slot 1 is underlined in yellow.

As you scroll through your images, notice that the yellow underline jumps to whichever card contains the currently highlighted image—if you have images on both memory cards. Be sure to pay attention to which memory card contains the picture you are working with.

Select Date

Using the Select date method is simple. When you preview your images for deletion, you won't be shown a list of all the images, as you will with the Delete option. Instead, the Select date screen (figure 2.1C, image 3) will give you a list of dates with a single representative image following each date.

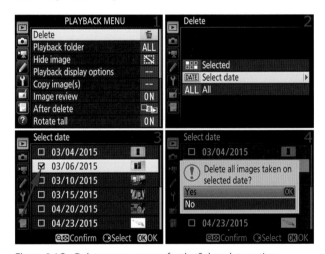

Figure 2.1C – Delete menu screens for the Select date option

Here are the steps to delete images by Select date:

1. Select Delete from the Playback Menu and scroll to the right (figure 2.1C, image 1).
2. Choose Select date and scroll to the right (figure 2.1C, image 2).
3. Notice that there's a check box to the left of each date (figure 2.1C, image 3). Check a box by scrolling up or down to the date of your choice with the Multi selector and then scroll to the right. This checks the box and tells the camera to delete all images that have the checked date. If the single tiny representative image next to the date is not sufficient to help you remember which images you took on that date, you can view them. Press the checkered Playback zoom out/thumbnails button, and the D7200 will switch to show the images for that date. If you want to examine an image more closely, you can hold in

the Playback zoom in button to temporarily zoom in on individual images. When you're satisfied that none of the images for that date are worth keeping, and while you are still examining images for that single date, press the OK button to select the date, or press the Playback zoom out/thumbnails button to return to the list of all dates.

4. Make sure the date you want to delete is checked as described in step 3, and press the OK button to start the image deletion process (figure 2.1C, image 3).
5. A final screen will ask you to confirm your deletion (figure 2.1C, image 4). This screen has a big red exclamation point and asks, *Delete all images taken on selected date?* If you scroll to Yes and press the OK button, the images will be deleted. Be careful! Select No and press the OK button to cancel the operation.

All

This option is like formatting a card, except that it will not delete folders. It will delete only images, except for protected or hidden images (figure 2.1D). Using this option is a quick way to format your card while maintaining your favorite folder structure.

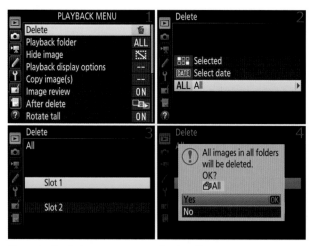

Figure 2.1D – Delete menu screens for the All option

Here are the steps to delete all images on the card (or in the current folder):

1. Select Delete from the Playback Menu and scroll to the right (figure 2.1D, image 1).
2. Choose All and scroll to the right (figure 2.1D, image 2).
3. Select the slot from which to delete images. Notice that both Slot 1 and Slot 2 are available (figure 2.1D, image 3). If there is a memory card missing from one of the slots, it will be grayed out and unavailable. Now scroll to the right.
4. Choose Yes from the next screen, which has the big red exclamation point and dire warning of imminent deletion (figure 2.1D, image 4). **Be very careful from this point forward!** If you have Playback folder set to D7200, the camera will delete all images in

every folder that was created by the D7200. The warning will say, *All images will be deleted. OK?,* followed by *D7200.* If you have Playback folder set to Current, the camera will delete only the images in the folder that is currently in use, and the warning will say, *All images will be deleted. OK?,* followed by *Current.* If you have Playback folder set to All, the camera will delete all images in all folders, and the warning will say, *All images in all folders will be deleted. OK?,* followed by *All.* The camera is prepared to delete every image in every folder (created by any camera) on the selected memory card if *Playback Menu > Playback folder > All* is selected. (See the next main section for information on the Playback folder option). When you select Yes and press the OK button, a final screen with the word *Done* will pop up briefly.

Being the paranoid type, I tested this thoroughly and found that the D7200 really will not delete protected and hidden images, and it will keep any folders you have created. However, if you are a worrier, maybe you should transfer the images off the card before deleting any images.

Settings Recommendation: I don't use the Delete All function often since I usually don't create special folders for each type of image. If you maintain a series of folders on your memory card(s), you may enjoy using the Delete All function. Most of the time, I just use Delete Selected and remove particular images. Any other time I want to clear the card, I use the Format memory card function on the Setup Menu or hold down the two buttons with the red Format label next to them. We'll discuss formatting the memory card in the chapter titled **Setup Menu,** under the heading **Format Memory Card** on page 303.

Simple Individual Image Deletion

Another way I get rid of individual images I don't want is by pressing the Playback button (▶) once, finding and viewing the image I want to delete on the Monitor, and then pressing the Delete (garbage can) button twice. This method is fast and deletes just one image at a time.

Protecting Images from Deletion

The Nikon D7200 will allow you to protect images from accidental deletion when you use the Delete function. Using this method will *not* protect images from deletion when you format the memory card.

To mark an image as protected from deletion, use the Help/protect button, as shown in figure 2.1E and the upcoming steps.

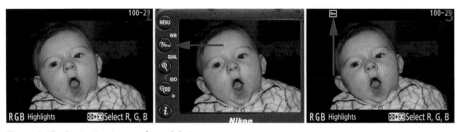

Figure 2.1E – Protecting images from deletion

Use the following steps to protect individual images from accidental deletion (figure 2.1E):

1. Display an image on the Monitor (figure 2.1E, image 1).
2. Press the Help/protect button (figure 2.1E, image 2, red arrow).
3. A small key symbol will appear in the upper left of the Monitor, signifying that this image is protected from the Delete function (figure 2.1E, image 3, red arrow).

If you have several images protected from deletion and you decide you want to remove the protection, you can follow the previous steps again. This will remove the key symbol and protected status.

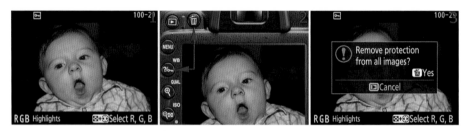

Figure 2.1F – Removing protection from all protected images at once

You can also remove protection from all protected images at once by following these steps:

1. Display any image on the Monitor (in Playback mode). It does not have to be a protected image (figure 2.1F, image 1).
2. Quickly press and hold down both the Help/protect button and the Delete button for about two seconds (figure 2.1F, image 2).
3. A screen will appear asking you, *Remove protection from all images?* (figure 2.1F, image 3). Press the Delete button, and after several seconds a screen will flash up briefly with the message, *Marking removed from all images*. At this point all deletion protection and key symbols have been removed from all images.

Recovering Deleted Images

If you accidentally delete an image or a group of images, or even if you format the entire memory card and then realize with great pain that you didn't really mean to, all is not lost. Immediately remove the card from your camera and do not use it until you can run image recovery software on the card. Deleting or formatting doesn't permanently remove the images from the card. It merely marks the images as deleted and removes the references to the images from the memory card's file allocation table (FAT). The images are still there and can usually be recovered as long as you don't write any new data to the card before you try to recover them.

It's wise to have a good image recovery program on your computer at all times. Sooner or later you'll have a problem with a card and will need to recover images. Many of the better brands of memory cards include recovery software, either on the card itself, or as a downloadable application.

To find the recovery software, do a Google search for your card's brand name followed by "image recovery software." For instance, to find my card's image recovery software, I searched Google with this sentence: "SanDisk image recovery software." I found SanDisk's Rescue Pro software right away. The Lexar brand has free software called Image Rescue. Search in a similar manner for whatever brand of card you use.

Playback Folder

(User's Manual: Page 266, and Menu Guide: Page 18)

The Playback folder setting allows your camera to display images during preview and slide shows. You can have the D7200 show you images created by the D7200 *only*, in all folders; images that were created by the D7200 and any other Nikon cameras, in all folders; or only the images in the current folder.

If you regularly use your memory card in multiple cameras, as I do, and sometimes forget to transfer images, adjusting the Playback folder setting is a good idea. I use a D810, D750, and D7200 on a regular basis. Often, I'll grab a 64-GB card out of one camera and stick it in another one for a few shots. If I'm not careful, I'll later transfer the images from one camera and forget that I have folders created by the other camera on the memory card. It's usually only after I have pressed the format buttons that I remember the other camera's images on my memory card. The D7200 comes to my rescue with its *Playback folder > All* function.

With All set, I can see all the images in all folders on both memory cards from all Nikon cameras.

Let's look at how the Playback folder function works by first looking at what each selection does and the steps needed to select the best function for you (figure 2.2).

The three selections (D7200, All, and Current) are described as follows:

- **D7200:** The camera will display images created by the D7200 only from all folders on both memory card slots. This is good to use if you are interested in seeing only D7200-created images, wherever they may reside.
- **All:** The D7200 will obligingly show you every image—created by any Nikon camera—it can find in all the folders on both memory cards. During playback, or before deletion, the D7200 will display images from other Nikon cameras you've used with the current memory card. Each camera usually creates its own unique folders, and normally the other folders are not visible. When you select All, the D7200 displays its own images and any other Nikon-created images in any folder on the two cards.
- **Current:** This is the most limited playback mode. Images in the image folder the camera is currently using will be displayed during playback, whether the images were created by the D7200 or another Nikon camera. No other images or folders will be displayed.

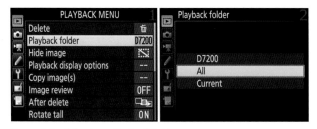

Figure 2.2 – Selecting a Playback folder source

Use the following steps to select the folder(s) from which your camera will display images:

1. Select Playback folder from the Playback Menu and scroll to the right (figure 2.2, image 1).
2. Choose D7200, All, or Current and press the OK button (figure 2.2, image 2).

Settings Recommendation: Using anything except All makes it possible for you to accidentally lose images. If you don't have any other Nikon cameras, this may not be a critical issue. However, if you have a series of older Nikon cameras around, you may switch memory cards between them. If there's an image on any of my memory cards, I want to see it and know it's there. Until I started using the All setting, I was sometimes formatting cards with forgotten images on them. From my pain comes a strong recommendation: Use All!

Hide Image

(User's Manual: Page 266, and Menu Guide: Page 19)

If you sometimes take images that would not be appropriate for others to view until you have a chance to transfer them to your computer, the *Hide image* setting is for you. You can hide one or many images, and when they are hidden, they cannot be viewed on the camera's Monitor in the normal way. After they are hidden, the only way the images can be viewed again in-camera is by using the Deselect all function shown in figure 2.3A, image 2.

There are three selections in the Hide image menu:

- **Select/set:** This allows you to hide individual images.
- **Select date:** This allows you to hide images by specific date(s).
- **Deselect all:** This allows you remove the hidden status from all images.

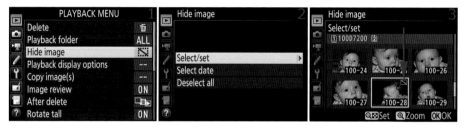

Figure 2.3A – Hide images with Select/set

Select/Set

This selection allows you to hide one or many images (figure 2.3A, image 3). Here's how to hide an image:

1. Select Hide image from the Playback Menu and then scroll to the right (figure 2.3A, image 1).
2. Choose Select/set from the list and then scroll to the right (figure 2.3A, image 2).
3. Scroll to the image you want to hide and press the Playback zoom out/thumbnails button to Set the image. You'll see a little dotted rectangle with a slash symbol appear in the top-right corner of the image you've selected (red arrow in figure 2.3A, image 3). You can do this same action on multiple images to hide more than one.
4. Press the OK button to hide the image(s). *Done* will appear on the Monitor when the hiding process is complete.

The number of images reported does not change when you hide images. If you have 50 images on the card and you hide 10, the camera still displays 50 as the number of images on the card. A clever person could figure out that there are hidden images by watching the number of images as they scroll through the viewable ones. If you hide all the images on the card and then try to view images, the D7200 will tersely inform you, *All images are hidden*.

You can also use these steps to unhide one or many images by reversing the process described earlier. As you scroll through the images, as shown in figure 2.3A, image 3, you can deselect them with the Playback zoom out/thumbnails button and then press the OK button to unhide them.

While you are selecting or deselecting images to hide, you can use the Playback zoom in button to see a larger version of the image you currently have selected. This lets you examine the image in more detail to see if you really want to hide it.

Select Date

This function allows you to hide a series of images according to the date they were taken. You might have been shooting a nature series in the Great Smoky Mountains one day and a glamour series for a national magazine the next day. You wouldn't mind your kids seeing the nature shots, but you might not want them to see the more glamorous ones. So you simply select the date(s) you took the glamour shots and hide them.

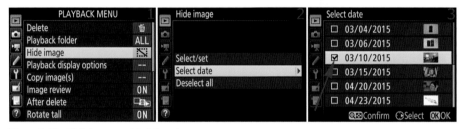

Figure 2.3B – Hide images with Select date

Use the screens shown in figure 2.3B and follow these steps:

1. Select Hide image from the Playback Menu and then scroll to the right (figure 2.3B, image 1).
2. Choose Select date from the list and then scroll to the right (figure 2.3B, image 2).
3. Now you can select the date of the images you want to hide from the list of available dates by scrolling up or down with the Multi selector (figure 2.3B, image 3). When your chosen date is highlighted, scroll to the right and a check mark will appear in the box to the left of the date (red arrow in figure 2.3B, image 3). If you'd like to review the images from a certain date before hiding them, simply select the date in question and press the Playback zoom out/thumbnails button. This will display only the images from the selected date on the Monitor. You can review individual images in detail by highlighting an image and pressing the Playback zoom in button. Or you can press the Playback zoom out/thumbnails button to return to the date screen.
4. The images taken on this date are now selected for hiding. If you press the OK button, all the images with the selected date will be hidden immediately, and the camera will return to the main Playback Menu after displaying *Done*.

Deselect All

This function provides a simple way to unhide the previously hidden images on the memory card all at once. When you execute Deselect All, every image on the card will be immediately revealed and viewable on the camera's Monitor.

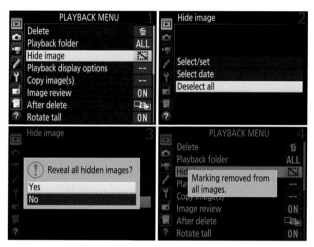

Figure 2.3C – Unhide images with Deselect all option

Here are the screens and steps used to unhide (deselect) all images marked as hidden:

1. Select Hide image from the Playback Menu and then scroll to the right (figure 2.3C, image 1).
2. Choose Deselect all from the list and then scroll to the right (figure 2.3C, image 2).
3. At the *Reveal all hidden images?* screen, select Yes and press the OK button. An hourglass will appear for several seconds, and all hidden images on the card will then be marked as viewable (figure 2.3C, image 3).
4. After the images are unhidden, the Monitor will display *Marking removed from all images* (figure 2.3C, image 4).

Losing Protection When You Deselect All Images (Unhide)

If you have images that are both hidden and protected from deletion and you unhide them, the deletion protection is removed at the same time.

Playback Display Options

(User's Manual: Page 266, and Menu Guide: Page 21)

The *Playback display options* selection allows you to customize how the D7200 displays several histogram and data screens for each image. You get to those screens by displaying an image on the camera's Monitor and scrolling up or down with the Multi selector.

When you want to see a lot of detailed information about each image, you can select it here. Or, if you would rather take a minimalist approach to viewing image information, simply turn off some of the screens.

If you turn off certain screens, the camera still records the information—such as lens used, shutter speed, and aperture—for each image. However, with no data screens selected, you'll see only one screen when you scroll up or down: the main file information screen.

With some or all of the Playback display option screens enabled, you can use the Multi selector to scroll up or down so you can examine detailed data on any image. In other words, you can scroll through your images by pressing left or right on the Multi selector and then scroll through the data screens for that image by pressing up or down on the Multi selector.

Here are the selections in this menu:

Basic photo info
• Focus point

Additional photo info
• None (image only)
• Highlights
• RGB histogram
• Shooting data
• Overview

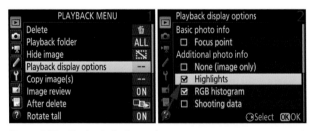

Figure 2.4A – Playback display options menu screens

Use the following steps to enable or disable any of the six playback display screens:

1. Select Playback display options from the Playback Menu and scroll to the right (figure 2.4A, image 1).
2. Choose any of the six available screens by highlighting a line in yellow with the Multi selector and scrolling to the right to put a check mark in the box for that item (red arrow

in figure 2.4A, image 2). You must scroll down to see the final selection, Overview, which does not show on the main screen. In figure 2.4A, image 2, only Highlights and RGB histogram are selected.

3. After you have put check marks in the boxes for all the screens you want to use, press the OK button.

Now, let's look at what each of these selections accomplishes (figures 2.4B to 2.4K).

Focus Point

If you are curious about which autofocus (AF) sensor was focused on your subject, and where it was focused during an exposure, use the Focus point mode to easily find out. If you are using Single-point AF or Dynamic-area AF, you'll see a single red AF indicator where the camera was focused when you took the picture (figure 2.4B, image 2).

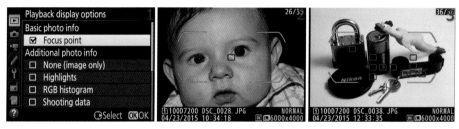

Figure 2.4B – Enabling the Focus point display

If you are using Auto-area AF, you'll see all the AF points that were providing autofocus in your image (figure 2.4B, image 3). This is a useful function for reviewing how the camera's AF system performs in different imaging situations.

None (Image Only)

This setting is designed to give you a somewhat larger view of the current image. It uses all of the available screen space to show the image (figure 2.4C, image 2). There are no text overlays, just the image by itself.

Figure 2.4C – Enabling the None (image only) display

This is a good selection for when you want to zoom in on the image to look at details. Since only the image itself is displayed, it's easier to scroll around within it for deep looks when using the camera's two zoom buttons (zoom in and out). You can zoom all the way in to 38× the normal image view. There is a tremendous level of detail buried inside each 24.3-megapixel image. You have an easy way to view it with None (image only).

Highlights

If you decide to use the Highlights selection, as shown in figure 2.4D, you will turn on what I call the "blink mode" of the camera. You'll see the words RGB Highlights at the bottom left of the screen. When any area of the image is overexposed, that area will blink white and black. A rectangle surrounding the word RGB will blink from black to yellow at the same time.

This is a warning. The blinking areas of the image are overexposed and have lost detail. You will need to use exposure compensation or manually control the camera to contain the exposure within the dynamic range of the camera's sensor.

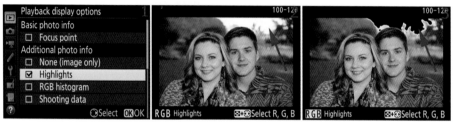

Figure 2.4D – Enabling the Highlights display

Look at the sky behind the young couple in figure 2.4D, screens 2 and 3. Notice how it is white (blown out) in image 2, and black in image 3. This means that area of the image has turned completely white from overexposure and has lost all detail. If you were looking at this image on your camera's Monitor, you would see the sky area repeatedly blinking white to black.

If you examine the histogram for an overexposed (blown-out) image, you'll see that it's cut off, or clipped, on the right side. Current software cannot recover much, if any, image data from the blown-out sections. The exposure has exceeded the range of the sensor and the image has become completely overexposed in the blinking area. We'll discuss how to deal with images that have light ranges exceeding the sensor's recording capacity in the chapter called **Metering, Exposure Modes, and Histogram** on page 425.

Highlights mode conveniently warns you when you have surpassed what the sensor can capture and lets you know that portions of the image will be overexposed.

RGB histogram

A histogram is a digital readout that shows the range of light and color in an image. If there is too much contrast, the histogram display will be cut off. We'll examine the histogram in more detail later. For now, let's see how to turn the display on and off.

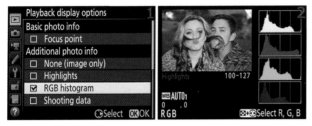

Figure 2.4E – Enabling the RGB histogram display

I like this feature because it allows me to view more than just a basic luminance (brightness) histogram. Enabling the RGB histogram display allows me to see all three color (chrominance) histograms—red, green, and blue—and a luminance histogram (white) on one screen (figure 2.4E, image 2). The D7200 stacks the four histograms on the right side of the screen, with luminance on top (white histogram) and the RGB color histograms below.

It is quite useful to see each color channel in its own histogram because it is possible to overexpose (blow out) only one color channel. The white luminance histogram usually looks similar to the green channel histogram because green is the most common color and the luminance histogram is weighted toward green. We'll discuss more about the luminance histogram and the three RGB channel histograms in the chapter titled **Metering, Exposure Modes, and Histogram** on page 442.

Shooting Data

This setting gives you four additional image-shooting data screens to scroll through (figure 2.4F).

Normally these shooting-data screens overlay a pale version of the image they represent, so you will see a faint image beneath the screens. However, to make the information on the screens more legible, I took pictures of a gray background. The data on these screens includes the following information.

Figure 2.4F – Enabling the Shooting data display

Shooting data, screen 1 (figure 2.4G)

- Light meter in use (Matrix, Spot, or Averaging), Shutter speed, and Aperture
- Exposure mode (P, S, A, M) and ISO sensitivity
- Exposure compensation value and optimal exposure tuning
- Lens focal length
- Lens overview data (e.g., 16–85mm/3.5–4.5)
- Focus mode and VR (vibration reduction)
- Flash type and commander mode (CMD)
- Flash sync mode
- Flash control and compensation
- Commander mode info (if used)

Shooting data, screen 2 (figure 2.4H)

- White balance (WB), color temperature, WB fine tuning, and Preset manual
- Color space (sRGB, AdobeRGB)
- Picture control detail (i.e., Standard, Neutral, Vivid, Monochrome, Portrait, Landscape, Flat) and adjustments: Quick adjust and Original Picture Control, Sharpening, Clarity, Contrast, Brightness, Saturation and filter effects, and Hue and toning.

Shooting data, screen 3 (figure 2.4I)

- High ISO noise reduction, Long exposure noise reduction
- Active D-Lighting (Off, Low, Normal, High)
- HDR exposure differential and smoothing
- Vignette control
- Retouch history
- Image comment

Shooting data, screen 4 (figure 2.4J)

- Artist
- Copyright

Overview

This screen provides an overview of the image detail for each picture (figure 2.4K). It is packed with approximately 30 items of information on each image, all in one convenient place.

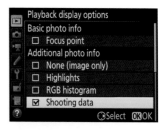

Figure 2.4G – Shooting data, screen 1

Figure 2.4H – Shooting data, screen 2

Figure 2.4I – Shooting data, screen 3

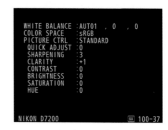

Figure 2.4J – Shooting data, screen 4

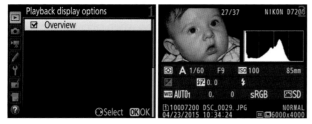

Figure 2.4K – Enabling the Overview screen

With this screen and the always-available file information screen (figure 2.4L), you will have enough information to determine the most important details about a particular image. Whether you select any other screens is entirely up to you and is determined by how much information you want for each image you have taken.

File information

This file information screen is not selectable under the Playback display options for the simple reason that it is always turned on and available for each image (figure 2.4L).

You cannot turn it off; although, if you have *Playback display options > Focus point* enabled, the Focus point and File information screens will combine into just one screen. File information includes a large, clear view of the picture with only basic image details.

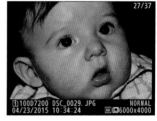

Figure 2.4L – File information screen

It provides information on the following items: image number in folder (2), total images in current folder (269), card slot where image is stored (1), folder name (100D7200), image filename (DSC-0029.jpg), JPEG compression level (Normal), date (04/23/2015), time (10:34:24), DX mode, image size (L), and image pixel count (6000×4000).

GPS Screen

If you take a picture with a GPS unit attached and active on your D7200, you'll have an additional screen available (figure 2.4M)—even if you don't have Shooting data selected.

It will not show up unless a GPS unit is attached to the camera when the picture is taken. We will consider the details of the GPS function and screen in the chapter titled **Shooting Menu** under the **GPS** heading.

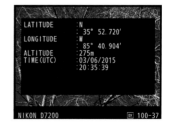

Figure 2.4M – GPS screen

Those are a lot of screens to scroll through, but they provide a great deal of information about the image. Look how far we've come since the days when cameras wrote date information on the lower-right portion of an image (permanently marking it) or between the frames on pro-level cameras.

Settings Recommendation: The screens I use frequently on my D7200 are as follows: None (image only) as seen in figure 2.4C, Highlights (figure 2.4D), RGB histogram (figure 2.4E), and Overview (figure 2.4K).

I like None (image only) because I love to drill down deep into these big 24-megapixel images to see what detail I've been able to capture. The D7200 gives me such deep, detailed images. I enjoy this setting because it lets me examine the image with no text overlay distractions.

The Highlights screen is very useful because at a glance I can see where I have overexposed an image and can take immediate corrective action. The black and white blinking action grabs my attention and I can change my settings for the better immediately.

The RGB histogram is also important to me because it allows me to see all the color channels, just in case one of them is being clipped off on the light or dark sides (no detail). It also allows me to see how well I am keeping my exposure balanced for light and dark.

The Overview screen gives me, at a glance, most of the important information I need to know about the image, along with a larger luminance histogram. If I only had one screen, I'd want it to be the Overview screen.

The Shooting data and Focus point screens are not very important to me personally. Also, if I have the Shooting data screens enabled, I'll have to scroll through four more screens to get to the screens I like to use. However, those are my preferences. If you want to examine a large amount of extra image data, then you should enable the other screens, too. Nikon gives us very thorough picture detail screens. Use what you like best.

Copy Image(s)

(User's Manual: Page 267, and Menu Guide: Page 21)

The D7200 provides a means to *Copy image(s)* between the camera's two card slots. I'll refer to the camera's two SD/SDHC/SDXC card slots as simply the SD cards slots (Slot 1 and Slot 2). If you've been shooting and decide you want a backup on the other card or want to give a card full of images to someone else, you can use this function to copy images between the two cards. If the Copy Image(s) function is grayed out and unavailable, you will need to insert two unlocked SD cards into the camera. You can't copy images unless you have two memory cards in the camera.

This convenient function has several steps: select a source card (if both cards have images) and the source folder; then select the images to copy; then select the folder on the destination card in which you want to place the images. Figure 2.5A shows the screens used to Copy image(s). First you'll need to select an image source. If Select source is grayed out, there are two potential reasons, which are explained after the following steps.

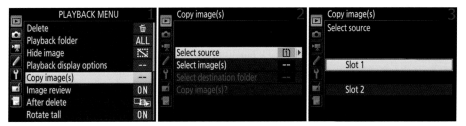

Figure 2.5A – Selecting a source for images to copy

Refer to figure 2.5A and follow these steps to select a source card:

1. Select Copy image(s) from the Playback Menu and scroll to the right (figure 2.5A, image 1).
2. Choose Select source from the list and scroll to the right (figure 2.5A, image 2).
3. Choose one of the card slots (Slot 1 or Slot 2), (figure 2.5A, image 3).
4. Press the OK button to lock in your choice.

Why is Select source grayed out? – When I first opened the menu shown in figure 2.5A, I found only one item available: Select image(s). The rest of the choices were grayed out. There are two reasons that Select image(s) may be the only option available. First, there might be images on only one of the cards. If only one card contains images, it has to be the source. This is the most likely scenario. Second, the SD card's write-lock switch might be in the locked (on) position. The switch is on the side of the card, and sometimes when you insert the card into a card reader or a camera at a slight angle the switch accidentally gets moved from the off position to the on position. Remove the card and unlock it. See the sidebar titled *Accidentally Inserting a Write-Locked Card* for more information about what happens when a write-locked card is inserted into one of the camera's memory card slots.

The following instructions assume that you have a card in each slot and images on both cards. If you have images on only one card, you can skip this process.

When you have chosen a source, it's time to select images to copy. It's a somewhat complex process to describe but fairly easy to use.

Accidentally Inserting a Write-Locked Card

The camera cannot write to an SD card with the write lock set to on. If the locked SD card is the only one inserted into the camera, you will see the word **CArd** blinking on the Control panel (yes, for some reason it has an uppercase A). If you press the info button, you will see the word **Card** (with no uppercase A), in large size, blinking on the monitor where the shutter speed is normally displayed. Just below, you will see the slot number blinking, next to a key symbol where the JPEG compression level is normally displayed (e.g., FINE). If only one of the cards in the two slots is write-locked, the slot number for that card will be blinking on the monitor, along with the small key symbol, but the camera will not display the blinking word **CArd** or **Card** because there is at least one available card it can write images to.

Why not lock one of your cards temporarily and then press the info button so that you will be familiar with what happens. This may save you some grief later. If you don't notice the blinking card icons, it may take a while to realize that you've accidentally moved the write-lock switch to the locked position on one of the cards. The camera is smart enough to write to the other SD card when it can't access one of them, so you may be happily snapping images, thinking they are being saved to the primary SD card (Slot 1) when they are actually being sent to the secondary card (Slot 2), or vice versa. The D7200 can still read the card and display images from a write-locked SD card if it contains images.

If you press the Shutter-release button with a single locked card in a card slot, a message will appear on the Monitor that says, *[1] Memory card is locked. Slide lock to "write" position.* The small 1 or 2 at the beginning of the warning sentence signifies which card slot has the locked card.

Figure 2.5B – Selecting a source folder for images to copy

First, follow these steps to choose a folder:

1. Choose Select image(s) from the list and scroll to the right (figure 2.5B, image 1).
2. Choose the folder that contains the images you want to copy (figure 2.5B, image 2). My camera happens to be using folders named 100D7200 and 101D7200. Your camera may have several folders available, or only one. After you have chosen a folder, scroll to the right.
3. There are three options for copying images: Deselect all, Select all images, and Select protected images (figure 2.5C). Each option has a slightly different way of doing things. Choose only one option for your copy operation, follow the directions for your chosen option, then continue with step 4.

Figure 2.5C – Deselecting all images to copy

- **Deselect all:** Choose Deselect all and then scroll to the right (figure 2.5C, image 1). Deselect all opens a list of images, none of which have been selected. It sounds a little weird to select images for copying with a function named Deselect all, but this function automatically deselects all the images so you can choose which new images to copy. You'll need to scroll around with the yellow rectangle and select images one at a time. Mark (Set) an image for copying by pressing the Playback zoom out/thumbnails button, and you'll see a small white check mark appear in the top-right corner of the image thumbnail. Figure 2.5C, image 2 (red arrow) shows only one picture selected: number 100–304. (It's the only one with a check mark.) By the way, the 100 in 100–304 is the first three characters of the folder number (100D7200), and the 304 in 100–304 is the image number (1–999) in that particular folder. Now move on to step 4.

Figure 2.5D – Selecting all images to copy

- **Select all images:** Choose Select all images and scroll to the right (figure 2.5D, image 1). The Select all images screen will appear, with all images selected (they all have check marks, as shown in figure 2.5D, image 2). If you want to copy all of the images, move on to step 4. If you want to deselect a few of them before copying, scroll to an image and press the Playback zoom out/thumbnails button. This action will remove the check mark from the image thumbnail. After you've unchecked the images you don't want to copy, move on to step 4.

Figure 2.5E – Selecting protected images to copy

- **Select protected images:** Choose Select protected images and scroll to the right (figure 2.5E, image 1). If you used the Help/protect (WB) button to mark images as protected, they will appear in the list of images with a key symbol and a check mark, indicating that they are already checked for copying (red arrows in figure 2.5E, image 2). If you have many images on the card and only a few are protected, it may

be hard to find the protected images. Rest assured that the camera knows which ones to copy. It will display all the images but only copy the protected ones. You can see the number of protected images that will be copied in the upper-right corner of the display (1/308). This figure shows that I will copy 1 protected image out of 308 images on the card in Slot 1 (from folder 100D7200). Now move on to step 4.

4. After you have selected all of the images you want to copy, press the OK button and the Monitor will display the Copy images(s) menu. Now it's time to select a destination folder into which you'll copy the images (figure 2.5F).

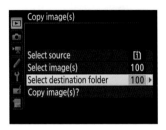

Figure 2.5F – Selecting a destination folder

5. Choose Select destination folder from the Copy image(s) menu and scroll to the right (figure 2.5F). You will have two options: Select folder by number or Select folder from list (figure 2.5G and figure 2.5H, respectively). Before we move on to step 6, let's investigate these two options. Pick an option, follow the instructions for that option, and then move on to step 6.

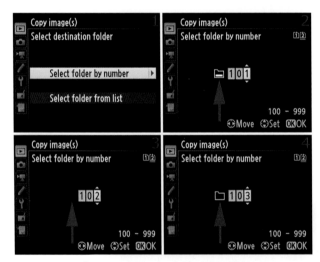

Figure 2.5G – Selecting a destination folder by number

- **Select folder by number:** Choose Select folder by number from the Select destination folder menu and scroll to the right (figure 2.5G, image 1). The next screen will display a folder number that can be changed to any number between 100 and 999 (figure 2.5G, screens 2–4). If you select a number for a folder that already exists on the destination card, the images will be copied into that folder. If you select a folder number that does not exist on the destination card, the folder will be created and the source images will be copied into the new folder on the destination card. Figure 2.5G, screens 2–4 represent just one Select folder by number screen, and show the different conditions you may see when selecting a folder. Image 2 (red arrow) shows that

folder 101 exists and has some images in it. The folder symbol is partially full. Image 3 (red arrow) shows that folder 102 does not exist (there is no folder symbol) and the camera will create one if selected. Image 4 shows that folder 103 does exist, but it is empty. Now move on to step 6.

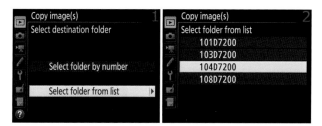

Figure 2.5H – Selecting a destination folder from a list of folders

- **Select folder from list:** If there are no existing folders on the destination card, this option will be grayed out. Obviously you can't copy images to a folder that doesn't exist, so use the Select folder by number option to create a new folder. If this option is not grayed out, choose Select folder from list and scroll to the right (figure 2.5H, image 1). The next screen will display a list of folders. My list in figure 2.5H, image 2 has four folders in it. I chose to use the folder named 104D7200. After you have selected the destination folder, move on to step 6.

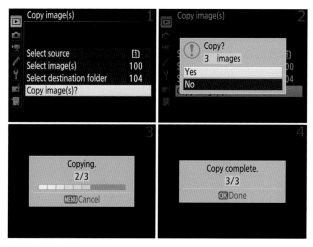

Figure 2.5I – Copying images

6. Now it's finally time to copy some images. We've selected a source card and folder, some images, and a destination folder. Notice that you don't have to select a destination memory card. Since we've already selected a source card, the other card automatically becomes the destination. The D7200 does not support copying images to the same memory card; you can copy only to the other card. All that's left is to select Copy image(s)? and press the OK button.

7. Figure 2.5I shows the screens for this step. After you have selected Copy image(s)?, you'll see a screen asking for verification. Mine says *Copy? 3 images* (figure 2.5I, image 2). Select Yes and press the OK button. Figure 2.5I, image 3 shows that the camera is *Copying 2/3* pictures from the source card to the destination card. Notice that the screen shows the progress of the copy action with a green progress bar. This will take several minutes to complete if you are copying a large number of images.

8. Figure 2.5I, image 4 shows the final screen in the series, signifying that the image copying process is complete. Press the OK button to return to the main menu.

There's one more screen to be aware of, in case you try to copy images into a folder where they already exist. If an identical file name already exists in the destination folder, you may or may not want to overwrite it.

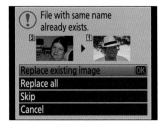

The camera will warn you about this with the screen shown in figure 2.5J, and it will display thumbnails of both images. You can choose Replace existing image, Replace all, Skip, or Cancel.

Figure 2.5J – Image overwrite warning

Image Review

(User's Manual: Page 267, and Menu Guide: Page 26)

Image review does exactly what it says; it displays an image you've just taken on your camera's Monitor. With this function set to On, you'll see each picture you take just after you take it. You can review the image for quality and usefulness.

With Image review set to Off, you won't see each picture unless you press the Playback button afterward. This saves battery life. However, the camera's battery is long lived because the D7200 does not use a lot of power. If you prefer to review each image after you take it, then you'll need to set this feature to On.

You can control how long each image is displayed on the Monitor before it shuts off by adjusting *Custom Setting Menu > c Timers/AE lock > c4 Monitor off delay > Image review*. This custom image review time can be adjusted to display pictures from 2 seconds to 10 minutes. We'll discuss this in more detail in the chapter titled **Custom Setting Menu** on page 215.

There are two Image review settings:

- **On:** Shows a picture on the Monitor after each shutter release.
- **Off:** The Monitor will stay off when you take pictures.

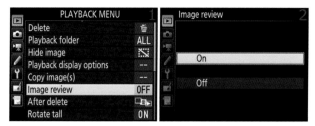

Figure 2.6 – Enabling Image review

Here are the steps to choose an Image review setting:

1. Choose Image review from the Playback Menu and scroll to the right (figure 2.6, image 1).
2. Select On or Off from the Image review screen (figure 2.6, image 2). Most of us will set this feature to On right away. Otherwise, the only way to view an image after taking it is to press the Playback button.
3. Press the OK button to lock in the setting.

Settings Recommendation: Because the camera's battery lasts a long time, I leave Image review set to On. I am an unashamed image chimper (see sidebar **Are You a Chimper, Too?**) and I always examine each image, if there's time. Photography is enjoyable, and one of the good things is the satisfaction you feel when you capture a really nice image. However, if you are shooting a sports event and blasting through hundreds of shots per hour, there's not much time to view each image. It all boils down to how you shoot. If you aren't inclined to view your images as you take them, then it may be a good idea to set Image review to Off—merely to save battery life.

Are You a Chimper, Too?

Chimping means reviewing images on the Monitor after each shot. I guess people think you look like a monkey if you review each image. Well, I do it anyway! Sometimes I even make monkey noises when I'm chimping my images. Try saying, "Oo, Oo, Oo, Ah, Ah, Ah" really fast when you're looking at an image and are happy with it. That's chimping with style.

After Delete

(User's Manual: Page 267, and Menu Guide: Page 26)

If you delete an image during playback, one of your other images will be displayed on the camera's Monitor. The After delete function lets you select which image is displayed after you delete an image. The camera can display the next image or the previous image, or it can detect which direction you were scrolling—forward or backward—and let that determine which image appears after you delete another.

The three selections on the After delete menu are, as follows:

- **Show next:** If you delete an image and it wasn't the last image on the memory card, the camera will display the next image on the Monitor. If you delete the last image on the card, the previous image will be displayed. Show next is the factory default behavior of the D7200.
- **Show previous:** If you delete the first image on the memory card, the camera will display the next image. If you delete an image somewhere in the middle or at the end of the memory card, the previous image will be displayed.
- **Continue as before:** This weird little setting shows the flexibility of computerized camera technology in all its glory. If you are scrolling to the right (the order in which the images were taken) and decide to delete an image, the camera uses the Show next method to display the next image. If you happen to be scrolling to the left (opposite from the order in which the images were taken) when you decide to delete a picture, the camera will use the Show previous method instead.

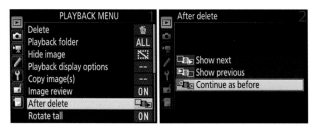

Figure 2.7 – Playback Menu – After delete

Use the following steps to choose an After delete setting (figure 2.7):

1. Choose After delete from the Playback Menu and scroll to the right (figure 2.7, image 1).
2. Select one of the settings from the After delete screen (figure 2.7, image 2).
3. Press the OK button to lock in the setting.

Settings Recommendation: When I delete an image, I'm not overly concerned about which image shows next—most of the time. However, this functionality is handy in certain styles of shooting and when I am deleting rejects.

For instance, some sports or wildlife shooters might like to move backward through a long sequence of images, starting with the last image taken. They can then delete the images that are not usable in the sequence, and the camera will immediately show the previous image for review. When they reach the first image in the sequence, the entire series is clean and ready to use.

I leave my camera set to Continue as before, as shown in figure 2.7, image 2, because it will use the direction I was scrolling to decide which image to display after deleting one.

Rotate Tall

(User's Manual: Page 267, and Menu Guide: Page 27)

When you shoot a portrait-oriented (vertical) image with the camera turned sideways, the image can later be viewed as a horizontal image lying on its side or as a smaller, upright (tall) image on the camera's horizontal (wide) Monitor.

If you view the image immediately after taking it, the camera's software assumes that you are still holding the camera in the rotated position and the image will be displayed correctly for that angle. Later, if you are reviewing the image with the camera's playback functionality and have Rotate tall set to On, the image will be displayed as an upright, vertical image that is smaller so it will fit on the horizontal Monitor. You can zoom in to see sharpness detail, if needed.

If you would rather have the camera leave the image lying on its side in a horizontal view, forcing you to turn the camera 90 degrees to view it, you'll need to choose Off. The following two settings are available:

- **On:** When you take a vertical image, the camera will rotate it so you don't have to turn your camera to view it naturally during playback. This resizes the view of the image so that a vertical image fits in the horizontal frame of the Monitor. The image will be a bit smaller than normal. When you first view the image after taking it, the camera does not rotate it because it assumes you are still holding the camera in a vertical orientation. It also senses which end of the camera is up—if the Shutter-release button is up or down—and displays the image accordingly.
- **Off:** Vertical images are left in a horizontal direction, lying on their side; you'll need to turn the camera to view the images in the same orientation as when they were taken. This provides a slightly larger view of a portrait-oriented image.

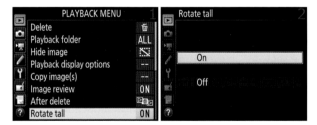

Figure 2.8 – Playback Menu – Rotate tall

Here are the three steps to choose a Rotate tall setting:

1. Choose Rotate tall from the Playback Menu and scroll to the right (figure 2.8, image 1).
2. Select On or Off from the Rotate tall screen (figure 2.8, image 2).
3. Press the OK button to finish.

There is another camera function that affects how this works. It's called Auto image rotation, under the Setup Menu. We'll discuss this function more deeply in the chapter titled **Setup Menu** on page 324. Auto image rotation causes the camera to record the angle at which you are holding it as part of the image's metadata. Auto image rotation should be set to On so that an image will report how it should be displayed on the camera's Monitor and on your computer.

In other words, Rotate tall and Auto image rotation work together to display your image in the correct orientation. Rotate tall gives you the choice of how the image is viewed based on the orientation information it finds in the image's metadata. *Setup Menu > Auto image rotation* causes the camera to store how the image was taken so it will know whether the image has a vertical or horizontal composition. It can then report this information to the Rotate tall function.

Settings Recommendation: I leave Rotate tall set to On. That way I can view a portrait-oriented image in its natural, vertical orientation without turning my camera. Be sure you understand the relationship between this function and Auto image rotation, which stores orientation data with the picture. I always set *Playback Menu > Rotate tall* and *Setup Menu > Auto image rotation* to On.

Slide Show

(User's Manual: Page 267, and Menu Guide: Page 27)

I used to do slide shows back in the old film days. I'd set up my screen, warm up my projector, load my slides, and watch everyone fall asleep by the hundredth slide. For that reason, I hadn't been using the *Slide show* functionality in my previous cameras very often. However, with the D7200's big 3.2-inch monitor and VGA resolution, it should be a satisfying viewing experience for one or two people.

If the monitor is not large enough, you can connect the camera to a high-definition television (HDTV) and do a slide show for an even larger group. Connecting to an HDTV requires the separate purchase of an HDMI (type A) to mini-HDMI (type C) cable.

When you are ready for your show, you can control how long each image is displayed with the Frame interval setting. First, let's see how to start a Slide show (following the D7200's menu order), and then we'll see how to change the Image type for display and Frame interval timing.

Starting a Slide Show

You can start the Slide show immediately, and it will commence with a default display time (Frame interval) of two seconds (2s) per image, displaying the images and movies it finds on your camera's memory card(s).

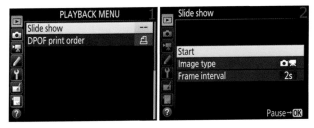

Figure 2.9A – Playback Menu – Slide show

Use the following steps to start a Slide show immediately:

1. Select Slide show from the Playback Menu and scroll to the right (figure 2.9A, image 1).
2. Select Start and the Slide show will begin immediately, using the default Image type (Still images and Movies) and Frame interval timing (2 s).

You can easily change the way the camera chooses what Image type to display during the Slide show. The next subsection shows how.

Selecting an Image Type for a Slide Show

As you will notice in figure 2.9B, image 2, you can set the camera to display any Still images and movies it finds, or Still images only, or Movies only.

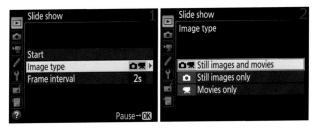

Figure 2.9B – Playback Menu – Slide show Image type

Use the following steps to change the Image type for display:

1. Select Image type from the Slide show screen (figure 2.9B, image 1).
2. Choose one of the three listed image types (figure 2.9B, image 2).
3. Press the OK button.

Note: If Movies only is grayed out and unavailable, it simply means you have no movies on the memory cards inserted into the camera.

Now let's consider how to change the amount of time before the camera changes to the next image or movie in the slide show.

Changing a Slide Show's Frame Interval

If you want to allow a little more time for each Still image to display or between each Movie, you'll need to change the Frame interval (display time). Your Frame interval choices are as follows.

- **2 s:** 2 seconds
- **3 s:** 3 seconds
- **5 s:** 5 seconds
- **10 s:** 10 seconds

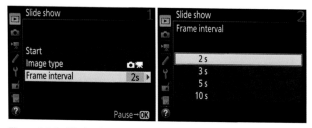

Figure 2.9C – Playback Menu – Slide show Frame interval

Use these steps to change the Slide show's Frame interval:

1. Choose Frame interval from the Slide show menu and scroll to the right (figure 2.9C, image 1).
2. Select one of the four choices between 2 s and 10 s.
3. Press the OK button to lock in a new Frame interval.

To start the Slide show after you change the Frame interval, repeat the steps shown in the previous subsection, **Starting a Slide Show**. The Slide show will now run at the speed you chose.

Settings Recommendation: I usually set the Frame interval to 3 s. If the images are especially beautiful, I might set it to 5 s. I've found that 2 s is not quite enough, and 5 s or 10 s may be too long. I wish there were a four-second setting, but 3 s seems to work well most of the time.

Slide Show Camera Control Options

There are several options that affect how the images are displayed during a slide show. None of these options are in the camera menus; they are available through the camera's controls. Your options are as follows:

- **Skip back/Skip ahead:** During the slide show you can go back to the previous image for another viewing by simply pressing left on the Multi selector. You can also see the next

image with no delay by pressing right on the Multi selector. This is a quick way to skip images or review previous images without stopping the slide show.

- **View additional photo information:** While the slide show is running, you can press up or down on the Multi selector to view the additional data screens. The screens you will see depends on how you have your camera's Playback display options configured for Highlights, Focus point, RGB histogram, and Shooting data (see the section called **Playback Display Options** earlier in this chapter). If any of these screens are available, they can be used during the slide show.

- **Pause slide show:** During the slide show you may want to Pause, change the Frame interval, or even Exit the show. If you press the OK button, the slide show will be suspended and you will see the Pause screen (figure 2.9D).

Figure 2.9D – Playback Menu – Slide show Pause and Restart

- **Restart:** Selecting OK or scrolling to the right with the Multi selector when this option is highlighted continues the slide show, starting with the image following the last one that was viewed.

- **Frame interval:** Selecting OK or scrolling to the right with the Multi selector when this option is highlighted takes you to the screen that allows you to change the display time to one of four values: 2 s, 3 s, 5 s, or 10 s. After you choose the new Frame interval, select Restart to continue the slide show where you left off.

- **Exit:** This option exits the slide show.
 - **Exit to the Playback Menu:** If you want to quickly exit the slide show, simply press the MENU button and you'll jump directly back to the Playback Menu.
 - **Exit to playback mode:** You can press the Playback button to stop the slide show and switch to a normal full-frame or thumbnail view of the last image seen in the slide show. This exits the show on the last image viewed.
 - **Exit to shooting mode:** If you press the Shutter-release button halfway down, the slide show will stop. The camera is now in shooting mode, meaning that it is ready to take some pictures.

DPOF Print Order

(User's Manual: Page 267, and Menu Guide: Page 179)

Why did Nikon choose to put image-printing functions in the Playback Menu? Well, printing is a permanent form of image playback, isn't it? You play (print) the images to your printer and then view them without a camera or a computer. What a concept!

DPOF print order allows you to create a print order on a memory card and plug that card into a compatible inkjet printer, or superstore kiosk printer, and print JPEG images. The function does not work with RAW images (see sidebar). Let's see how it works.

In-Camera Printing—Not for RAW Images

If you are a RAW shooter, the in-camera printing process won't benefit you, unless you use the Retouch Menu to create JPEGs on your memory card. Not all printers can handle printing from RAW files, so Nikon chose to limit DPOF and PictBridge printing from the D7200 to JPEG files.

DPOF Printing

This function is designed to create a print order on your camera's memory card. Later this print order can be used to print directly from the memory card by inserting it into a DPOF-compatible printer. You can print to any device that supports DPOF. All you have to do is insert the memory card, select print from the printer, and wait for your pictures to print out. This is not a difficult process, and it is quite fun and satisfying.

When using DPOF you do not have to connect the camera to anything. Simply inserting a memory card that contains a digital print order on it into a DPOF-compatible printer will cause the printer to detect the order and offer to fill it. Each DPOF printer's method of doing this varies, of course. However, the entire process is automated so that a new user won't have to do much more than select the number of prints and whether or not a border is required. The following steps will allow you to create and print a digital print order on your DPOF-compatible printer.

Use the following steps to create a new DPOF print order on your memory card.

1. Select DPOF print order from the Playback Menu and scroll to the right (figure 2.10A). You will see the screen in figure 2.10B, image 1.

Figure 2.10A – DPOF print order

Figure 2.10B – Removing the print marking from all images

2. If you don't have any existing digital print orders on the memory card, please skip this step and go directly to step 4. If you have an existing print order that you no longer want, you'll need to choose Deselect all and scroll to the right (figure 2.10B, image 1). The next screen will ask you, *Remove print marking from all images? Yes/No*. Choose Yes and press the OK button (figure 2.10B, image 2). If there are previously marked images,

a message that says, *Marking removed from all images* will flash on the screen (figure 2.10B, image 3), and then the Playback Menu will reappear. Otherwise, no message will appear and the camera will return to the Playback Menu.

Figure 2.10C – Choosing images and number of prints

3. Since you're going to create a new print order and save it to the memory card, choose Select/set from the DPOF print order screen and then scroll to the right (figure 2.10C, image 1).
4. Now you'll see the Select/set thumbnail list with all the JPEG images on your memory card (figure 2.10C, image 2). Select the images you want to print with the Multi selector. After you have highlighted an image, hold down the checkered Playback zoom out/thumbnails button and scroll up with the Multi selector. Each upward or downward press of the Multi selector changes the number of prints ordered for that particular image (figure 2.10C, image 2, red arrow). You can select from 1 to 99 prints for each image you highlight. I chose three (03) prints for the image with the red arrow, which is displayed beside a printer symbol. After you have selected which images to print and how many copies you want, press the OK button.
5. The next screen allows you to add shooting data or date imprints to each of the images in the print order (figure 2.10C, image 3):
 • Print shooting data: This prints the shutter speed and aperture on each print in the order.
 • Print date: This prints a date on each print in the order.
6. Put check marks in the boxes next to these selections by highlighting the option you want and scrolling to the right with the Multi selector. When you have completed your choices, press the OK button (figure 2.10C, image 3). Be careful with this setting because the data will be printed on the front of the image. I leave these two selections unchecked when I print.
7. Finally you will be presented with a screen telling you that the print order is complete (figure 2.10C, image 4).

At this point, your print order has been saved to the memory card. You'll need to remove it from the camera and insert it into the card slot of a DPOF-compatible printer or kiosk.

I have not found a way to create more than one print order on a single memory card. An existing order can be edited with the *DPOF print order > Select/set* function, or it can be removed with the *DPOF print order > Deselect all* function. If you look at a memory card containing a print order on your computer, you'll see a new folder named MISC. It will have a file in it named AUTPRINT.MRK. That file is the digital print order.

PictBridge Printing

Another way to print images without using a computer is to attach your camera's USB cable to a PictBridge-compatible printer to print JPEG files (not RAW files). Most advanced amateur and professional users of the D7200 will want to post-process their images in computer software (like Lightroom, Nikon Capture NX-D, Nikon View NX-i, or Photoshop) before printing, so this functionality is not used as often as other functions. However, it can be useful for someone who would rather simply take pictures and print them at home with little or no post-processing.

Since these seldom-used functions require multiple pages to describe, involve an external device connection, and many people do not use them, I have relegated the PictBridge printing information to a detailed document called **PictBridge Printing with the Nikon D7200** and included it in the downloadable resources at the following websites:
http://www.nikonians.org/NikonD7200
http://rockynook.com/NikonD7200

Author's Conclusion

Wow! The Nikon D7200 sure has a lot of playback screens and menus. I remember the old days when if you wanted to see your images, you'd have to find the old shoebox full of pictures or open an album and flip pages. Sometimes I miss photo albums. You know what? I'm going to run down to the superstore right now and buy several albums. Then I'll have some images printed and put them into the albums. Better yet, I think I'll go buy a DPOF-compatible printer so I can print my own images for the albums.

Now, let's move on to the next menu system in the camera, the Photo Shooting Menu. This is one of the most important menus because it affects how the camera is configured to shoot still pictures. Learn the Photo Shooting Menu's settings well!

03 Photo Shooting Menu

Wallaroo and Joey © 2015 Deborah Albert (debalbe)

The Photo Shooting Menu settings are the most-used functions in the camera. Spend time carefully learning about each of these selections because you'll use them often. They affect how your camera takes pictures in all sorts of ways.

The following is a list and overview of the 23 items found on the D7200 Photo Shooting Menu:

- **Reset photo shooting menu:** This function restores the factory default settings in the Photo Shooting Menu for the currently selected User setting.
- **Storage folder:** Allows you to select which folder subsequent images will be stored in on the memory card(s).
- **File naming:** Lets you change three characters of the image file name so it is personalized.
- **Role played by card in Slot 2:** Allows you to select how the camera divides image storage between Slot 1 and Slot 2.
- **Image quality:** Allows you to select from seven image quality types, such as JPEG fine or NEF (RAW).
- **Image size:** Allows you to choose whether to shoot Large (6016 × 4016, 24.2 M), Medium (4512 × 3008, 13.6 M), or Small (3008 × 2008, 6.0 M) images.
- **Image area:** Allows you to choose whether or not the camera automatically selects DX mode when a DX lens is mounted (Auto DX crop) and if it will shoot in FX (36 × 24), 1.2× (30 × 20), or DX (24 × 16) mode.
- **JPEG compression:** Allows you to select Size priority or Optimal quality for your best JPEG images.
- **NEF (RAW) recording:** Allows you to set the compression type and bit depth for NEF (RAW) files.
- **White balance:** Allows you to choose from nine different primary White balance types, including several subtypes, and includes the ability to measure the color temperature of the ambient light (Preset manual).
- **Set Picture Control:** Allows you to choose from six Picture Controls that modify how the pictures look.
- **Manage Picture Control:** With this function, you can save, load, rename, or delete custom Picture Controls on your camera's internal memory or card slots.
- **Color space:** Allows you to select the printing industry standard: Adobe RGB, or the Internet and home use standard, sRGB.
- **Active D-Lighting:** Allows you to select from several levels of automatic contrast correction for your images. The camera itself will protect your images from a certain degree of under- or overexposure while extending the camera's dynamic range.
- **HDR (high dynamic range):** Allows you to control the overall contrast in the image to provide a wider dynamic range by automatically combining—in the camera—two pictures taken at different exposures.
- **Vignette control:** Lets you automatically remove the darkening at the corners and edges of pictures taken with wide-open lens apertures.
- **Auto distortion control:** Causes the camera to look for barrel and pincushion distortion and attempt to automatically correct it. Recommended for G and D lenses only.

- **Long exposure NR:** This function uses the black-frame subtraction method to significantly reduce noise in long exposures.
- **High ISO NR:** This function uses a blurring method, with selectable levels, to remove noise from images shot with high ISO sensitivity values.
- **ISO sensitivity settings:** Allows you to select the camera's normal ISO sensitivity range, from ISO 100 to ISO 25,600, or use two special monochrome-only high-ISO settings, Hi 1BW (ISO 51,200) and Hi 2BW (ISO 102,400). You can also use Auto Mode to let the camera decide automatically.
- **Remote control mode** (ML-L3): Gives you remote control of your camera so you can use a Nikon ML-L3 wireless remote to control the camera in various ways, including mirror-up shooting. This control can be used to replace a standard release cable.
- **Multiple exposure:** Allows you to take more than one exposure in a single frame and then combine the exposures in interesting ways.
- **Interval timer shooting:** Allows you to put your camera on a tripod and set it to make one or several exposures at customizable time intervals.

Each of these items can be configured and saved for later recall by using the two available User settings on the D7200 Mode dial (U1 and U2).

User Settings U1 and U2

(User's Manual: Page 62)

User settings U1 and U2 are memory locations to which you can assign specific camera configurations that you would like to save for future use. Let's briefly discuss how U1 and U2 work (see **Save User Settings** in the chapter titled **Setup Menu** on page 306).

If you configure your camera's internal settings in a particular way and want to save that setup, simply go to the Setup Menu and select *Save user settings > Save to U1 [or U2] > Save settings*. This is optional, in case you don't want to use U1 and U2 on the Mode dial (figure 3.0). However, it is a very convenient way to configure your camera for specific shooting situations so you can change setups quickly.

Figure 3.0 – U1 and U2 user settings

For instance, with my D7200, I set user setting U1 as my high-quality setting. I shoot in NEF (RAW) Image quality with Lossless compressed and 14-bit depth in NEF (RAW) recording, Adobe RGB Color space, ISO 100, and Neutral Picture Control.

U2 is my party setting. I use JPEG fine Image quality with Size priority in JPEG compression, sRGB Color space, ISO 400 with Auto ISO sensitivity control set to On and Maximum sensitivity set to 1600, and SD Picture Control.

The two user settings on the Mode dial allow you to store a lot more than just Photo Shooting Menu items. They can also store a specific configuration for many other settings, such as the Custom settings in the Custom Setting Menu, exposure modes, flash, compensation, metering, AF-area modes, bracketing, and more. Nikon has given us a powerful and flexible way to configure our cameras for specific shooting needs.

We'll discuss the detailed configuration of these two settings in the chapter titled **Metering, Exposure Modes, and Histogram** under the subheading **U1 and U2 User Settings**. For now, just keep in mind that you can save the settings you make to the upcoming Photo Shooting Menu items in a cumulative way within user settings U1 and U2 on the Mode dial. After you configure many aspects of your camera, you can save the changes with *Setup Menu > Save user* settings *> U1 (or U2) > Save settings*.

You can make changes to the camera's settings at any time outside of the U1 and U2 Mode dial positions with no effect on the two user settings. When you select U1 or U2 on the Mode dial, those settings outside of U1 or U2 will be overridden—but not overwritten—by your chosen user setting. In other words, if your camera is configured in a certain way for general use outside of the two user settings, and then you select U1 or U2, the user settings do not overwrite the current configuration. Instead they toggle the settings you've saved in U1 or U2. When you exit U1 or U2, the camera reverts to however it was previously configured outside of the user setting.

Basically, you can configure the camera in up to three separate ways: U1 and U2, and however you have the camera configured outside of the two user settings.

There are several Photo Shooting Menu options that cannot be stored and saved in the user settings:

- Reset photo shooting menu
- Storage folder
- Image area
- Manage Picture Control
- Remote control mode (ML-L3)
- Multiple exposure
- Interval timer shooting

The listed Photo Shooting Menu functions are independent of the user settings that you can save. If you modify one of these five functions, it will function the same way no matter what user setting you have selected. We will discuss how to save user settings in the chapter titled **Setup Menu,** under the subheading called **Save User Settings** on page 306.

Now, let's examine how to configure the camera's Photo Shooting Menu settings.

Configuring the Photo Shooting Menu

(User's Manual: Page 268, Menu Guide: Page 30)

Press the MENU button on the back of your D7200 to locate the Photo Shooting Menu, which corresponds to a green camera icon in a yellow square on the toolbar at the left side of the Monitor (figure 3.1). The yellow square changes to green when you enter the menu by scrolling to the right with the Multi selector.

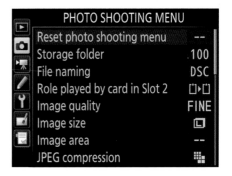

Figure 3.1 – The Photo Shooting Menu is the camera's most often-used menu

We'll now examine each of the settings on the Photo Shooting Menu. Have your camera in hand, and maybe even the Nikon User's Manual and Nikon Menu Guide if you are interested in what they say about certain settings (page numbers provided). Remember that it's *entirely optional* to use the User's Manual or Menu Guide. This book is a comprehensive reference, but sometimes it is good to get an alternate view for deeper understanding. The two Nikon manuals, although somewhat dense, are still good references.

If you take time to think about and configure each of these settings at least once, you'll learn a lot more about your new camera. There are a lot of settings to learn about, but don't feel overwhelmed. Some of these settings can be configured and then forgotten, and you'll use other settings more often. We'll look at each setting in detail to see which ones are most important to your style of shooting.

Reset Photo Shooting Menu

(User's Manual: Page 268, Menu Guide: Page 31)

Be careful with this selection. *Reset photo shooting menu* does what it says—it resets the Photo Shooting Menu, for the currently selected user setting only (U1, U2, or outside the user settings), back to the factory default configuration (figure 3.2). If you have U1 selected on the Mode dial, it resets only U1, and so forth.

This is a rather simple process. Here are the steps to reset the Photo Shooting Menu:

1. Select Reset photo shooting menu from the Photo Shooting Menu and scroll to the right (figure 3.2, image 1).
2. Choose Yes or No (figure 3.2, image 2).
3. Press the OK button.

Figure 3.2 – Reset the photo shooting menu

Note: This function resets all Photo Shooting Menu functions, including the settings that cannot be saved in a User setting: Reset photo shooting menu, Storage folder, Image area, Manage Picture Control, Remote mode (ML-L3), Multiple exposure, and Interval timer shooting. This may be a problem if you have carefully configured one of the listed settings and then you answer Yes to Reset Photo Shooting Menu because your settings will be lost.

Settings Recommendation: This is an easy way to start fresh with a particular User setting since it's a full reset of all the values, including the five special settings. I use this when I purchase a preowned camera and want to clear someone else's settings or if I simply want to start fresh. If you use any of the listed nonsaveable settings regularly, be aware that the Reset photo shooting menu function will reset them.

Storage Folder

(User's Manual: Page 268, Menu Guide: Page 31)

Storage folder allows you to either create a new folder for storing images or select an existing folder from a list of folders. The D7200 automatically creates a folder on its primary memory card named something similar to 100D7200. The folder can hold up to 999 images. You'll see the full name of the folder on some camera screens and when you examine the memory card in your computer—check in the digital camera images (DCIM) folder on the memory card.

When the camera senses that the current folder contains 999 images and you take another picture, the new image is written to a new folder that is a seamless continuation of the previous folder. The first three digits of the new folder name is increased by one. For example, if you are using a folder named 100D7200, the camera will automatically create a new folder called 101D7200 when you exceed 999 images in the original folder.

Manually Creating a New Storage Folder

If you want to store images in separate folders on the memory card, you might want to create a new folder, such as 200D7200. Each folder you create can hold 999 images, and you can select any folder as the default by choosing *Storage folder > Select folder from list* (discussed in the next subsection). This is a nice way to isolate certain types of images on

a photographic outing. Maybe you'll put landscape shots in folder 300D7200 and people shots in 400D7200. You can develop your own numbering system and implement it with this function.

When you manually create folder names, you may want to leave room for the camera's automatic folder creation and naming. If you try to create a folder name that already exists, the camera doesn't give you a warning; it simply switches to the existing folder.

Let's examine how to create a new folder with a number of your choice, from 100 to 999 (100D7200 to 999D7200).

Figure 3.3A – Select folder by number

Here are the steps to manually create a new folder:

1. Select Storage folder from the Photo Shooting Menu and scroll to the right (figure 3.3A, image 1).
2. Choose Select folder by number and scroll to the right (figure 3.3A, image 2).
3. You'll now see a screen that allows you to create a new folder number from 100 to 999 (figure 3.3A, image 3). Create your number using the Multi selector, then press the OK button.

Settings Recommendation: You cannot create a folder numbered 000 to 099; I tried! Remember that the three-digit number you select will have D7200 appended to it and it will look something like 101D7200 or 301D7200 when you have finished. After you have created a new folder, the camera will automatically switch to it.

Selecting an Existing Storage Folder

What if you want to simply start using an existing folder instead of making a new one? You may have already created a series of folders and want to switch among them to store different types of images. It's easy with the following screens and steps.

Use the following steps to select an existing folder:

1. Select Storage folder from the Photo Shooting Menu and scroll to the right (figure 3.3B, image 1).
2. Scroll down to Select folder from list and scroll to the right (figure 3.3B, image 2). If this selection is grayed out, there is only one folder on the memory card. You'll need to create a new folder with the instructions found in the previous section.

3. You'll see the available folders displayed in a list that looks like the one shown in figure 3.3B, image 3. Select one of the folders from the list. I happen to have six folders—100D7200 to 105D7200—on my current memory card.
4. Press the OK button. The camera will switch back to the Photo Shooting Menu main screen, with the new folder number displayed to the right of Storage folder.

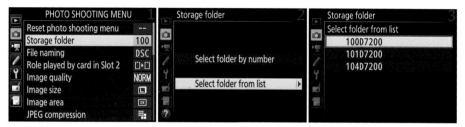

Figure 3.3B – Select folder from list

All new images will be saved to this folder until you exceed 999 images in the folder or manually change to another folder. One note of caution: If you are using folder 999D7200 and the camera records the 999th image, or if it records image number 9999—the Shutter-release button will be disabled until you change to a different folder. Nikon warns that the camera will be slower to start up if the memory card contains "a very large number of files or folders."

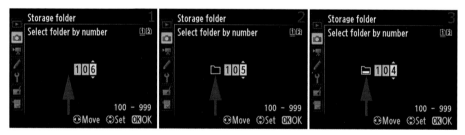

Figure 3.3C – Three folder conditions: Image 1, no images (no folder); Image 2, folder empty; Image 3, folder partially full

Note: There is also a fourth condition—not shown in figure 3.3C—that displays an icon of a full folder, which means there are 999 images in the folder or it contains an image numbered 9999. You cannot write any more images to a folder when it is full.

If you try to write to a folder containing an image ending with the number 9999, you could cause the camera to lock its Shutter-release button until another memory card is inserted or the current card is formatted.

Settings Recommendation: As memory cards get bigger and bigger, I can see a time when this functionality will become very important. Last year I shot around 325 GB of image files. With the newest memory cards now hitting 512 GB, I can foresee a time when the card(s) in my camera will become a months-long backup source. This is a good function to learn how to use.

File Naming

(User's Manual: Page 268, Menu Guide: Page 34)

File naming allows you to control the first three characters of the file name for each of your images. The default is DSC, but you can change it to any three alphanumeric characters.

The camera defaults to the following File naming for your images:

- When using sRGB Color space: DSC_1234
- When using Adobe RGB Color space: _DSC1234

You can see that depending on which Color space you are using, the camera adds an underscore to one side of the three characters (figure 3.4, image 2).

I use this feature in a special way. Since the camera can count images in a File number sequence from 0001 to 9999, I use File naming to help me personalize my images. The camera cannot count higher than 9,999. Instead, it rolls back to 0001 for the 10,000th image.

When I first got my D7200, I changed the three default characters from DSC to 1DY. The *1* tells me how many times my camera has passed 9,999 images, and *DY* is my initials, thereby helping me protect the copyright of my images in case they are ever stolen and misused.

Since the camera's image File number sequence counter rolls back to 0001 when you exceed 9,999 images, you need a way to keep from accidentally overwriting images from the first set of 9,999 images you took. I use this method:

- First 9,999 images: 1DY_0001 through 1DY_9999
- Second 9,999 images: 2DY_0001 through 2DY_9999
- Third 9,999 images: 3DY_0001 through 3DY_9999

See how simple it is? This naming method shows a range of nearly 30,000 images. Since the D7200's shutter is tested to a professional level of 150,000 cycles, you will surely need to use a counting system like this one. My system works up to only 89,991 images (9,999 × 9). If you use this counting system and start your camera at 0 (0DY_0001 through 0DY_9999), you can count up to 99,990 images.

If Nikon would give us just one extra digit in the image counter, we could count in sequences of just under 100,000 images instead of 10,000 images. I suppose that many of us will have traded up to the next Nikon DSLR before we reach enough images that this really becomes a constraint.

File Number Sequence Used with File Naming

Custom Setting Menu > d Shooting/display > d6 File number sequence controls the File number sequence setting. That function works along with File naming to let you control how your image files are named. If File number sequence is set to Off, the D7200 will reset the four-digit number—after the first three custom characters in File naming—to 0001 each

time you format your memory card. I set File number sequence to On as soon as I got my camera so it would remember the sequence all the way up to 9,999 images. I want to know exactly how many pictures I've taken over time. We'll talk more about File number sequence in the chapter titled **Custom Setting Menu** on page 228.

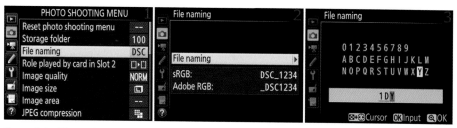

Figure 3.4 – File naming

Here are the steps to set up your custom File naming characters:

1. Select File naming from the Photo Shooting Menu and scroll to the right (figure 3.4, image 1).
2. Select File naming and scroll to the right (figure 3.4, image 2).
3. Use the Multi selector to scroll through the numbers and letters to find the characters you want to use (figure 3.4, image 3). Press the OK button on the D7200 to insert a selected character. To correct an error, hold down the Playback zoom out/thumbnails button and use the Multi selector to scroll to the character you want to remove. Press the Delete button to delete the bad character.
4. Press the Playback zoom in button to save your three new custom characters. They will now be the first three characters of each image file name.

Now you've customized your camera so the file names reflect your personal needs.

Note: Be careful about inserting a memory card that has existing images with an image sequence from a different camera. The D7200 will pick up the new sequence as soon as you take a picture and continue using that sequence. To return to your previous D7200 image sequence, simply insert your old memory card with the previous sequence on it and take a picture. This will restore your original image sequence.

Settings Recommendation: We discussed how I use the three custom characters in the beginning of this section. You may want to use all three of your initials or some other numbers or letters. Some people leave these three characters at their default. I recommend using your initials, at a minimum, so you can easily identify the images as yours. With my family of Nikon shooters it sure makes it easier! If you use my method, be sure to watch for the images to reach 9999 and rename the first character for the next sequence of 9,999 images.

Role Played by Card in Slot 2

(User's Manual: Page 268, Menu Guide: Page 35)

Role played by card in Slot 2 is designed to let you control the flow of images to the camera's memory cards. You can decide how and to which card(s) the camera writes image files. Slot 1 is the top card slot when you open the Memory card slot cover, and Slot 2 is on the bottom.

Here is a description of the three ways you can configure the Role played by card in Slot 2 setting:

- **Overflow:** Have you ever gotten the dreaded *Card full* message? If you select Overflow, it will take a lot longer to get this message. Overflow writes all images to the card you have selected under Primary slot selection. Then when the card in Slot 1 is full, the rest of the images are sent to the card in Slot 2. The image number shown on the Control panel and in the Viewfinder will count down as you take pictures and they are written to the card in Slot 1. When the image count nears zero, the camera will switch to the card in Slot 2, and the available image count number on the Control panel will increase to however many images will fit on the second card. It is not necessary to use the same size card when using this function. The camera will merely fill up all available space on both cards as you take pictures.
- **Backup:** This function is a backup for critical images. Every image you take is written to the memory cards in Slot 1 and Slot 2 at the same time. You have an automatic backup system when you use the Backup function. If you are a computer geek (like me), you'll recognize this as RAID 1 or drive mirroring. Since your camera is very much a computer, a function like this is great to have. Be sure that both cards are of equal capacity or that the card in Slot 2 is larger than the card in Slot 1 when you use this function. Otherwise the image capacity shown on the camera screen will be reduced. Since the camera will write a duplicate image to each card, the smallest card sets the camera's maximum storage capacity. When either card is full, the Shutter-release button becomes disabled.
- **RAW Slot 1–JPEG Slot 2:** If you like to shoot NEF (RAW) files, this function can save you some time. You'll have a JPEG for immediate use and a RAW file for post-processing later. When you take a picture, the camera will write the RAW file to the card in Slot 1 and a JPEG file to the card in Slot 2. There is no choice in this arrangement; RAW always goes to the primary card and JPEG always goes to the secondary card. This function works only when you have *Photo Shooting Menu > Image quality* set to some form of NEF (RAW) + JPEG. If you set Image quality to just NEF (RAW) or just JPEG fine—instead of NEF (RAW) + JPEG fine, for example—the camera will write a duplicate file to both cards, like the Backup function.

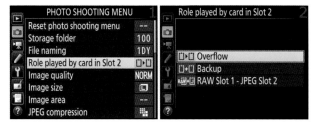

Figure 3.5 – Role played by card in Slot 2

The steps to choose the Role played by card in Slot 2 are as follows:

1. Select Role played by card in Slot 2 from the Photo Shooting Menu and scroll to the right (figure 3.5, image 1).
2. Choose one of the three selections discussed previously (figure 3.5, image 2).
3. Press the OK button.

Settings Recommendation: When I'm out shooting for fun or for any type of photography where maximum image capacity is of primary importance, I select Overflow. This causes the camera to fill up the primary card and then automatically switch to the secondary card for increased image storage. If I'm shooting images that I cannot afford to lose, such as at a unique event like a wedding or a baptism, I often use the Backup function for automatic backup of every image.

If I want both a RAW and JPEG file, I use the RAW Slot 1–JPEG Slot 2 function. This lets me have the best of both worlds when card capacity is not a concern, and it gives me redundancy, like Backup. In a sense, RAW Slot 1–JPEG Slot 2 backs up your images; they are just in different formats. I use each of these selections from time to time, but my favorite is Overflow.

Image Quality

(User's Manual: Page 268, Menu Guide: Page 36)

Image quality is simply the type of image your camera can create, along with the amount of image compression that modifies picture storage sizes.

You can shoot several distinct image formats with your D7200. We'll examine each format in detail and discuss the pros and cons of each as we go. When we're done, you'll have a better understanding of the formats, and you can choose an appropriate one for each of your shooting styles. The camera supports the following seven Image quality types:

- NEF (RAW) + JPEG fine
- NEF (RAW) + JPEG normal
- NEF (RAW) + JPEG basic
- NEF (RAW)

- JPEG fine
- JPEG normal
- JPEG basic

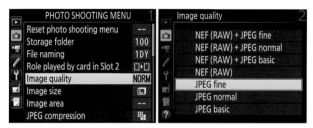

Figure 3.6A – Choosing an Image quality setting with menus

The steps to select an Image quality setting are as follows:

1. Select Image quality from the Photo Shooting Menu and scroll to the right (figure 3.6A, image 1).
2. Choose one of the seven Image quality types. Figure 3.6A, image 2, shows JPEG fine as the selected format.
3. Press the OK button to select the format.

The first three selections on the Image quality list (figure 3.6A, image 2) allow the camera to take a NEF (RAW) file and a JPEG fine, normal, or basic file at the same time. Fine, normal, and basic indicate three levels of compression that are available for the JPEG format. When you press the Shutter-release button with one of the three NEF (RAW) + JPEG Image quality modes selected, the camera creates a RAW file and a JPEG file and writes them to the memory card(s) as separate files.

Note: You can also use the QUAL button (Playback zoom in button) to set the Image quality (and size) on the Monitor.

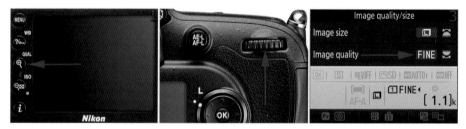

Figure 3.6B – Choosing an Image quality setting with external controls

The steps to change the Image quality are as follows:

1. Hold down the QUAL button (figure 3.6B, image 1).
2. Rotate the rear Main command dial to change the Image quality (figure 3.6B, image 2).
3. Look at the Monitor to see the Image quality value change. The red arrow in figure 3.6B, image 3, shows the quality (e.g., RAW, FINE, RAW+F). RAW+F means NEF (RAW) + JPEG fine, RAW+N means NEF (RAW) + JPEG normal, and RAW+B means NEF (RAW) + JPEG basic.
4. Release the QUAL button to lock the Image quality setting.

Let's examine each of these formats and see which ones you might want to use regularly. We'll go beyond how to turn the different formats on and off and discuss why and when you might want to use a particular format. Even though the Image quality list has seven different entries, the camera really shoots in only two formats: NEF (RAW) and JPEG. To understand how they work, we'll examine the NEF (RAW) and JPEG formats.

NEF (RAW) Image Quality Format

The Nikon NEF proprietary format stores raw image data directly onto the camera's memory card. Most of the time photographers refer to a NEF file simply as a RAW file. These RAW files can easily be recognized because the file name ends with NEF. This image format is not used in day-to-day graphics work (like the JPEG format), and it's not even an image yet. Instead, it's a base storage format used to hold images until they are converted to another file format ending in something like JPG, TIF, EPS, or PNG.

If you select Lossless compressed in *Photo Shooting Menu > NEF (RAW) recording,* the NEF format stores all available image data. If Compressed is selected instead, the camera makes a somewhat smaller RAW file by compressing the RAW image data in a visually lossless way to make a smaller file. Although it is virtually impossible to see any image degradation from using Compressed, most enthusiasts will leave the camera set to Lossless compressed. We will discuss this in more detail in this chapter under the **NEF (RAW) Recording** section on page 80.

NEF (RAW) Conversion Software

You must use RAW conversion software—such as Nikon View NX-D, Nikon ViewNX2, Nikon ViewNX-i, Adobe Lightroom, or Adobe Photoshop—to convert your NEF-format RAW files into other formats.

You can download a free copy of Nikon's latest RAW conversion software from the following website:
https://support.nikonusa.com/app/answers/detail/a-id/61/~/current-versions-of-nikon-software

There are also several aftermarket RAW conversion software packages available. Do a Google search of "Nikon RAW conversion software" for a listing. Before you shoot in NEF (RAW) format, it's a good idea to install your RAW conversion software of choice so you'll be able to view, adjust, and save the images to another format when you are done shooting. You will not be able to work with NEF files on your computer unless you have RAW conversion software installed.

Settings recommendation: Since Nikon CaptureNX2 is no longer available for the latest cameras, I will sometimes convert my NEF file to the 16-bit TIFF format with ViewNX2 or Capture NX-D and continue using CaptureNX2 for image manipulation—I have used CaptureNX2 for many years and it's hard to change. I use Adobe Lightroom as an alternate

conversion and post-processing software, along with Adobe Photoshop. Additionally, I have been experimenting with the Google NIK Collection found here:
https://www.google.com/nikcollection/

While I was writing this book, the new Nikon ViewNX-i and the Nikon ViewNX-Movie Editor software were announced. All versions of the new ViewNX-i software for still images are available at the previous Nikon link. Initially ViewNX-i did not start off with all the features found in ViewNX2. However, by September 2015, Nikon has promised to make ViewNX-i the equivalent of ViewNX2. Therefore, after that time, I assume ViewNX2 will gradually disappear from daily use.

Viewing RAW Files as Thumbnails on Your Computer

Some operating systems provide a downloadable patch or *codec* (coder-decoder) that lets you see NEF files as small thumbnails in the file manager software (e.g., Windows Explorer or Mac Finder).

Do a Google search on these specific words to start your search for available codecs: "download Nikon NEF RAW viewer." You will find free codecs for Windows 7 and 8, Vista, XP, and Mac. However, be careful that you don't go to a website that promises the moon and delivers malware instead.

Nikon lists a free codec for Windows 7 and 8.1 (32 and 64 bit) and Windows Vista (32 and 64 bit, Service Pack 2) at this website:
http://nikonimglib.com/nefcodec/

Unfortunately, there is a greater selection of codecs for Windows than for Mac. However, with so many software developers out there, things change constantly.

A RAW File Is Not an Image, Yet!

Now, let's talk about NEF, or RAW, quality. I use the NEF (RAW) format most of the time. I think of a RAW file like I thought of my slides and negatives a few years ago. It's my original image that must be saved and protected.

It's important that you understand something very different about NEF (RAW) files. They're not really images—yet. Basically, a RAW file is composed of black-and-white sensor data and camera setting information markers. The RAW file is saved in a form that must be converted to another file type to be used in print or on the web.

When you take a picture in RAW format, the camera records the image data from the sensor and stores markers within the NEF file for how the camera's color, sharpening, contrast, saturation, and so forth are set, but it does not apply the camera setting information to the image. In your computer post-processing software, the image will appear on-screen with the settings you initially configured in your D7200. However, these settings are applied temporarily for your computer viewing pleasure.

For example, if you don't like the white balance you selected at the time you took the picture, simply apply a new white balance and the image will appear as if you had used

that setting when you took the picture. If you initially shot the image using the Standard Picture Control and now want to use the Vivid Picture Control, all you have to do is apply it—with your Nikon RAW conversion software of choice—before the final conversion and it will be as if you used the Vivid Picture Control when you first took the picture.

This is quite powerful! Virtually no camera settings are applied to a RAW file in a permanent way. That means you can apply completely different settings to the image in your RAW conversion software and it will appear as if you had used those settings when you first took the picture. This allows a lot of flexibility later.

NEF (RAW) is generally used by individuals who are concerned with maximum image quality and who have time to convert the images. A conversion to JPEG sets the image markers permanently, and a conversion to the TIFF format sets the markers but allows you to modify the image later. Unfortunately, the TIFF format creates very large file sizes.

Here are the pros and cons of NEF (RAW) format:

NEF (RAW) positives

- Allows the manipulation of image data to achieve the highest-quality image available from the camera.
- All original details stay with the image for future processing needs.
- No conversions, sharpening, sizing, or color rebalancing will be performed by the camera. Your images are untouched and pure!
- You can convert NEF files to any other image format by using your computer's more powerful processor instead of your camera's processor.
- You have much more control over the final look of the image since you, not the camera, make the final decisions about the appearance of the image.
- A 12-bit or 14-bit format provides maximum color information.

NEF (RAW) negatives

- Not often compatible with the publishing industry, except after conversion to another format.
- Requires post-processing with proprietary Nikon software or third-party software.
- Larger file sizes are created, so you must have larger storage media.
- There is no industry-standard RAW format. Each camera manufacturer has its own proprietary format. Adobe offers a generic RAW format called digital negative (DNG) that has become an industry-standard RAW format. You can use various types of software, such as Adobe Lightroom, to convert your RAW images to DNG if you desire.
- The industry standard for home and commercial printing is 8 bits, not 12 bits or 14 bits.

Now, let's examine the most popular format on the planet: JPEG.

JPEG Image Quality Format

As shown in figure 3.6A, image 2, the D7200 has three JPEG modes. Each mode affects the final quality of the image. Let's look at each mode in detail:

- JPEG fine Compression approximately 1:4
- JPEG normal Compression approximately 1:8
- JPEG basic Compression approximately 1:16

Each JPEG mode provides a certain level of lossy image compression, which means that it permanently throws away image data as you select higher levels of compression (fine, normal, basic). The human eye compensates for small color changes quite well, so the JPEG compression algorithm works very well for viewing by humans. A useful thing about JPEG is that you can vary the file size of the image, via compression, without affecting the quality too much.

Here are details of the three JPEG modes:

- *JPEG fine* (or fine-quality JPEG) uses a 1:4 compression ratio. If you decide to shoot in JPEG, this mode will give you the best-quality JPEG your camera can produce.
- *JPEG normal* (or normal-quality JPEG) uses a 1:8 compression ratio. The image quality is still very acceptable in this mode. If you are shooting at a party for a 4×6-inch (10×15 cm) image size, this mode will allow you to make lots of images.
- *JPEG basic* (or basic-quality JPEG) uses a 1:16 compression ratio. These are still full-size files, so you can surely take a lot of pictures. If you are shooting for the web or just want to document something well, this mode provides sufficient quality.

Note: It's hard to specify an exact number of images that a particular card size will hold. My D7200 reports that 150 lossless compressed NEF (RAW) images will fit on an 8 GB memory card, yet when the card is full I often have more than 300 images. With the higher compression ratio of JPEG files, it's even harder to predict exactly. The complexity within a scene has a lot to do with the final compressed file size. It's easier to compress a low-detail image than a high-detail image. That's why the camera underreports the number of images it can hold. You'll find that your memory cards will usually hold many more images than the estimate presented by the camera.

The JPEG format is used by individuals who want excellent image quality but have little time for, or interest in, post-processing or converting images to another format. They want to use images immediately when they come out of the camera, with no major adjustments.

The JPEG format applies your chosen camera settings to the image when it is taken. The image comes out of the camera ready to use, as long as you have exposed it properly and have configured all the other settings appropriately.

Since JPEG is a lossy format, you cannot modify and save a JPEG file more than once or twice before compression losses begin degrading the image. A person who shoots a large number of images or doesn't have the time to convert RAW images will usually use JPEG. That encompasses a lot of photographers.

Nature photographers might want to use NEF (RAW) since they have more time for processing images and wringing the last drop of quality out of them, but event or journalist photographers on a deadline may not have the time for, or interest in, processing images, so they often use the JPEG format.

Here are the pros and cons of capturing JPEG images:

JPEG positives

* Allows for the maximum number of images on a memory card and computer hard drive.
* Allows for the fastest transfer from the camera memory buffer to a memory card.
* Compatible with everything and everybody in imaging.
* Uses the printing industry standard of 8 bits.
* Produces high-quality, first-use images.
* No special software is needed to use the image right out of the camera (no post-processing).
* Immediate use on websites with minimal processing.
* Easy transfer across the Internet and as email attachments.

JPEG negatives

* JPEG is a lossy format.
* You cannot manipulate and resave a JPEG image more than once or twice before it begins to degrade. Every time you modify and resave a JPEG image, it loses more data and quality because of data compression losses.

Combined NEF + JPEG Shooting (Two Images at Once)

Some shooters use the first three Image quality settings, shown in figure 3.6A, image 2, which save two images at the same time:

* NEF (RAW) + JPEG fine
* NEF (RAW) + JPEG normal
* NEF (RAW) + JPEG basic

These settings give you the best of both worlds because the camera saves a NEF file and a JPEG file each time you press the Shutter-release button. In NEF (RAW) + JPEG fine, my camera's 8 GB single-card storage drops to 114 images since it stores a NEF file and a JPEG file for each picture I take.

You can set *Photo Shooting Menu > Role played by card in Slot 2* to write the NEF (RAW) file to one card and the JPEG file to the other. You can use the NEF (RAW) file to store all the image data and later process it into a masterpiece, and you can use the JPEG file immediately with no adjustment.

The NEF (RAW) + JPEG modes have the same features as their stand-alone modes. In other words, a RAW file in NEF (RAW) + JPEG mode works like a RAW file in NEF (RAW)

mode, and a JPEG file in NEF (RAW) + JPEG mode works like a JPEG fine, normal, or basic file without the NEF (RAW) file.

Image Compression Information

The Image quality file formats of the D7200 can compress the image file into a smaller file size. We'll discuss several image compression types—like JPEG fine/normal/basic, JPEG Size priority or Optimal quality, and NEF (RAW) Lossless compressed or Compressed— in later sections of this chapter. However, for now I'll mention where you can find the compression functions in the Photo Shooting Menu.

JPEG compression is controlled by the **Photo Shooting Menu > JPEG compression** selection, along with the JPEG fine, normal, or basic compression on the **Photo Shooting Menu > Image quality** screen. JPEG is always a compressed format; you'll just select how much compression is applied. NEF (RAW) compression is controlled by the **Photo Shooting Menu > NEF (RAW) recording > Type** selection. These two compression selections allow you to control the size of your JPEG and RAW files.

Pay careful attention to the various compression levels offered for the images you shoot. After you set these compression levels, all images of that format will be affected. Also, remember that image compression is specific to User settings (U1 and U2), which means you can control it separately for each of your camera's two User settings and the third non-User setting.

Image Format Recommendations

Which format do I prefer? Why, RAW, of course! But it does require a bit of commitment to shoot in this format. NEF (RAW) files are not yet images and must be converted to another format for use. Once converted, they can provide the highest quality images your camera can possibly create.

When shooting in RAW, the camera is simply an image-capturing device, and you are the image manipulator. You decide the final format, compression ratio, size, color balance, and so forth. In NEF (RAW) mode, you have the absolute best image your camera can produce. It is not modified by the camera's software and is ready for your personal touch. No camera processing allowed!

If you get nothing else from this section, remember this: by letting your camera process images in *any* way, it modifies or throws away data. There is a finite amount of data for each image that can be stored in your camera, and later in your computer. With JPEG, your camera optimizes the image according to the assumptions recorded in its memory. Data is thrown away permanently, in varying amounts.

If you want to keep *all* the image data that was recorded with your images, you must store your originals in RAW format. Otherwise you'll never again be able to access that original data to change how it looks. A RAW file is the closest thing to a film negative or transparency that your digital camera can make. That's important if you would like to modify the

image later. If you are concerned with maximum quality, you should probably shoot and store your images in RAW format. Later, when you have the urge to make another master-piece out of the original RAW image file, you'll have *all* of your original data intact for the highest-quality image. (Compressed NEF loses a little data during initial compression, but Lossless compressed does not. I use Lossless compressed. These RAW compression types will be considered in an upcoming section called **NEF (RAW) Recording** under the sub-heading **Type,** on page 80.)

If you're concerned that the RAW format may change too much over time to be readable by future generations, you might want to convert your images to TIFF or JPEG files. TIFF is best if you want to modify your files later. I often save a TIFF version of my best images in case RAW changes too much in the future. Interestingly, I can still read the NEF (RAW) for-mat from my 2002-era Nikon D100 in the latest Nikon ViewNX2. Therefore, I think we are safe for a long time with our NEF (RAW) files.

Settings Recommendation: I shoot in NEF (RAW) format for my most important work and JPEG fine for the rest. Some people find that JPEG fine is sufficient for everything they shoot. Those individuals generally do not like working with files on a computer or do not have time for it. You'll use both RAW and JPEG, I'm sure. The format you use most often will be controlled by your time constraints and digital workflow.

Image Format Notes

If you have been shooting in NEF (RAW) + JPEG mode with a single memory card inserted in the camera, the D7200 will display only the JPEG image on the Monitor.

Also, NEF (RAW) images are always Large images. The next section will discuss Image size, which applies only to JPEG images. There are no Large, Medium, and Small NEF im-ages. All RAW files are the maximum size available (6000 × 4000; 24 MP) and contain all image data.

Finally, you may want to investigate the *Retouch menu > NEF (RAW) processing* function, which allows you to create a JPEG file from a NEF (RAW) file, in-camera, with no computer involved.

Image Size

(User's Manual: Page 269, Menu Guide: Page 37)

Image size lets you shoot with your camera set to various megapixel sizes. The default Im-age size setting for the D7200 is Large, or 24.0 M (M = megapixels, shown elsewhere as MP).

Image size applies only to images captured in JPEG fine, normal, or basic modes. If you're shooting with your camera in any of the NEF (RAW) + JPEG modes, it applies only to the JPEG image in the pair. Image size does not apply to a NEF (RAW) image. This setting is relatively simple since it affects just the megapixel size of the image.

The Image area function (next main section), controls which Image sizes are offered to you when using the Image size screens. Here are the three settings under Image size that are affected by the selected Image area, which will be discussed in the next section:

DX mode (Image area)

- Large (6000 × 4000; 24.0 M)
- Medium (4496 × 3000; 13.5 M)
- Small (2992 × 2000; 6.0 M)

1.3× Mode (Image area)

- Large (4800 × 3200; 15.4 M)
- Medium (3600 × 2400; 8.6 M)
- Small (2400 × 1600; 3.8 M)

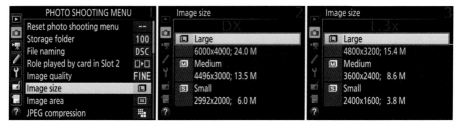

Figure 3.7A – Choosing an Image size based on the Image area setting

The steps to select an Image size are as follows:

1. Select Image size from the Photo Shooting Menu and scroll to the right (figure 3.7A, image 1).
2. Choose one of the three Image size settings. Figure 3.7A, images 2 and 3, show Large as the selected size. You will see only one of these two screens (images 2 or 3), according to how you have Image area configured (next section). Image 2 shows the Image sizes for DX Image area, and image 3 shows the Image sizes for the 1.3× Image area.
3. Use the Multi selector to select a size and press the OK button to choose the size.

You can also use the QUAL button (Playback zoom-in button) to set the Image size (and quality) on the Monitor.

Figure 3.7B – Choosing an Image size setting with external controls

The steps to change the Image size are as follows:

1. Hold down the QUAL button (figure 3.7B, image 1).
2. Rotate the front Sub-command dial to change the Image size (figure 3.7B, image 2).
3. Look at the Monitor to see the Image size value change. The red arrow in figure 3.6B, image 3, shows the size (e.g., L for Large, M for Medium, and S for Small).
4. Release the QUAL button to lock the Image size setting.

I'm not very interested in using my 24.2 MP camera to capture smaller images. However, there are reasons to shoot at lower megapixel sizes, such as when a smaller-resolution image is all that will ever be needed or if card space is at an absolute premium.

Setting the Image quality to JPEG basic, the Image size to Small, the Image area to DX mode, and the JPEG compression to Size priority allows the camera to capture 10,300 images on an 8 GB card. The images are 2.6 MP in size (1968×1312 = 2,582,016 pixels, or about 2.6 MP) and are compressed to the maximum level, but the card can hold a lot of them. If I were to journey completely around the earth and I had only one 8 GB memory card to take with me, I could use these settings to document my trip well.

Note: As previously mentioned, Image size applies only to JPEG images. If you see Image size grayed out on your camera Monitor, you have NEF (RAW) format selected.

Settings Recommendation: You'll get the best images with the Large (24.2 M) Image size. The smaller sizes won't affect the quality of a small print, but they will seriously limit your ability to enlarge your images. I recommend leaving your camera set to Large unless you have a specific reason to shoot smaller images.

Image Area

(User's Manual: Page 269, Menu Guide: Page 37)

Image area is a convenient built-in crop of the FX image to a smaller size. Where the FX (3:2) "area" is 36×24mm, the camera can provide two additional image areas: $1.2\times$–30×20mm, and DX ($1.5\times$)–24×16mm. If you need these particular image areas, you will be familiar with the industry-standard formats they provide.

There are two parts to the Image area function: Choose image area and Auto DX crop. Let's consider both of them.

Choose Image Area

The camera offers two Image area formats. The two images in figure 3.8A are of my 1963 Nikkormat Zoom 35, with its cool Nikkor 43–86mm f/3.5 lens, the first zoom lens on a production SLR camera. I did not vary the camera position at any point when taking these images, so you can see how the change in Image area affects the size (crop) of the subject.

DX 1.3x

Figure 3.8A – The two Image area formats

Following is a detailed list of specifications for the two available image areas, including sensor format crop (mm), Image size, pixel count, and megapixel (M) rating:

DX Image area (24 × 16mm):
- Large: 6000 × 4000 – 24.0M
- Medium: 4496 × 3000 – 13.5M
- Small: 2992 × 2000 – 6.0M

1.3× Image area (18 × 12mm):
- Large: 4800 × 3200 – 15.4M
- Medium: 3600 × 2400 – 8.6M
- Small: 2400 × 1600 – 3.8M

Now let's see how to select one of the Image area formats for those times you need to vary the Image area crop.

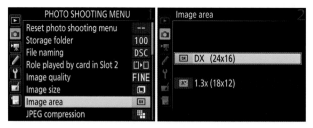

Figure 3.8B – Choosing an Image area format

Use the following steps to select one of the Image area formats:

1. Choose Image area from the Photo Shooting Menu and scroll to the right (figure 3.8B, image 1).
2. Select one of the two Image area crops, DX (24 × 16) or 1.3× (18 × 12). In figure 3.8B, image 2, DX (24 × 16) is selected.
3. Press the OK button to save the Image area setting.

Note: You can also assign Image area to a camera button, such as the Fn, Preview, or AE-L/AF-L button. Then you can adjust the area on the fly without using the Photo Shooting Menu. We will consider how to make the assignment in the chapter titled **Custom Setting Menu,** in the sections for Custom settings f2, f3, and f4 starting on page 270.

Micro Four Thirds from a Nikon?

The 1.3× image area (18 × 12mm) is very similar in size to the Micro Four Thirds industry-standard image format (18 × 13.5mm). It still has a reasonably Large image size of 15.4 MP, which allows room for some extra cropping, if needed.

The 1.3× image area is a 50% crop of a full-frame (FX) Nikon sensor (36 × 24). While using a telephoto lens in 1.3× mode, the *apparent* focal length will be doubled compared to FX (e.g., a 300mm lens provides a 600mm field of view), while still maintaining image quality equivalent to the Micro Four Thirds system.

If you've been wanting to photograph small objects from a distance, such as birds, this format may be quite useful to you.

Using the *i* Button Menu

There is an alternate way to access the Image area menu. When you press the *i* button on the back bottom left of the camera, the *i* button menu opens, with Image area as the first selection. Let's examine how to use it.

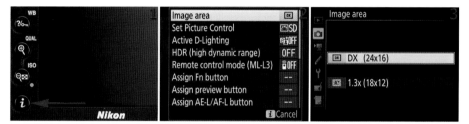

Figure 3.8C – Using the *i* button menu to select an Image area

Use the following steps to select one of the Image area formats from the *i* button menu:

1. Press the *i* button to open the *i* button menu (figure 3.8C, image 1).
2. Select Image area from the menu and scroll to the right (figure 3.8C, image 2).
3. Select one of the two Image area crops (figure 3.8C, image 3). My camera has DX (24 × 16) selected.
4. Press the OK button to save the Image area setting.

Viewfinder Image Area Frames

When you select the 1.3× image area mode, the camera will display a special frame in the DX viewfinder that marks off the area encompassed by that cropped Image area mode.

My camera's viewfinder has grid lines (see figure 3.8D). In image 1 you can see a normal DX viewfinder. However, in image 2, if you will notice, there is an additional frame shown in red on the 1.3× screen. The DX mode uses the entire viewfinder (image 1), while the 1.3× mode uses less of the Viewfinder, as shown by the red 1.3× frame (image 2). This frame normally appears in black, but is shown in red for ease of viewing in this book. The 1.3× frame

will appear only when you have the 1.3× mode selected. Also, the small 1.3× symbol will appear in the top-right corner of the screen (image 2).

Figure 3.8D – 1.2× (left) and DX (right) frames in the FX viewfinder

The normally black 1.3× frame will be briefly displayed in red when you press the Shutter-release button halfway down while the ambient light is low. (**Note:** You can control when the 1.3× frame line flashes red by adjusting the *Custom Setting Menu > a Autofocus > a5 Focus point illumination* setting, as described in the chapter titled **Custom Settings Menu** on page 191.)

When using the smaller 1.3× Image area, any parts of your subject that stray outside of the 1.3× frame when you are taking pictures will not be in the final image. While using the smaller 1.3× Image area in the Viewfinder, you must constantly be aware of your subject's location in relation to the 1.3× frame or you may lose some of the subject.

When you are using Live view mode, the camera will compensate for the varying frame sizes and will show you the Image area of the actual DX or 1.3× Image area only. Therefore, you can frame normally when using Live view on the camera's Monitor.

Settings Recommendation: Being a nature shooter, I normally leave my camera set to DX, its largest image area. If I need a little extra apparent reach for one of my telephoto lenses, I may switch the camera to 1.3× mode for convenience, although I could simply crop the image later in the computer. This extra 1.3× Image area format is merely to prevent you from having to manually crop the image later.

JPEG Compression

(User's Manual: Page 269, Menu Guide: Page 38)

JPEG compression allows you to fine-tune the level of compression in your JPEG images. The JPEG format is always a compressed format. The Image quality settings for JPEG images include fine, normal, and basic. Each of these settings provides a certain level of compression of the picture's file size, as we've discussed briefly in a previous section. In review, here are the compression specifications:

- **JPEG fine:** 1:4 compression ratio (25 percent of original size)
- **JPEG normal:** 1:8 compression ratio (12.5 percent of original size)
- **JPEG basic:** 1:16 compression ratio (6.25 percent of original size)

The compression ratios listed are best-case scenarios. JPEG files will normally vary in size when the subject of one image is more complex than that of another. For instance, if you take a picture of a tree with lots of leaves and bark against a cloudy blue sky, JPEG's compression formatting has a lot more work to do than if you take a picture of a red balloon on a plain white background. All those little details in the leaves of the tree cause lots of color contrast changes, so the JPEG file size will naturally be bigger for the complex image. In the balloon image, there is little detail in the balloon or the background, so the JPEG file size will normally be much smaller. The less detail in an image, the more efficient JPEG compression is.

What if you want all of your JPEG images to be the same relative size? Or, what if file size doesn't matter as much to you, while quality is very important? That's what the JPEG compression menu allows you to control, the final quality of your JPEG images, by varying the amount of compression. Let's examine the two settings:

- **Size priority:** This compression setting is designed to keep all your JPEG files at a certain uniform size. This size will vary according to whether you selected JPEG fine, normal, or basic in the Image quality menu. Image quality controls the regular, everyday compression level of the JPEG file, and Size priority tweaks it even more. How does it work? With Size priority enabled, the camera software has a target file size for all the JPEGs you shoot. Let's say the target size is 9.5 MB. The D7200 will do its best to keep all JPEGs set to that particular file size by altering the level of compression according to content. If a JPEG file has lots of fine detail, it will require more compression than a file with less detail to maintain the same file size. By enabling this function, you are telling the camera that it has permission to throw away however much image data it takes to get each file to the 9.5 MB target. This could lower the quality of a complex landscape image much more than an image of a person standing by a blank wall. Size priority instructs the camera to sacrifice image quality—if necessary—to keep the file size consistent. Use this function only for images that will not be used for fine art purposes. Otherwise your image may not look as good as it could.
- **Optimal quality:** This setting doesn't do anything extra to your images; the camera simply uses less compression on complex subjects. In effect, you are telling the camera to vary the file size so the image quality will be good for any subject—complex or plain. Instead of increasing compression to make an image of a complex nature scene fit a certain file size, the camera compresses the image only to the standard compression level based on the Image quality you selected (JPEG fine, normal, or basic) to preserve image quality. Less image data is thrown away, so the image quality is higher. However, the file sizes will vary depending on the complexity of the subject. Why not test this for yourself and see what file sizes you get between the two modes?

Now, let's examine how to select one of the JPEG compression types.

Figure 3.9 – Choosing a JPEG compression type

The steps to choose a JPEG compression type are as follows:

1. Select JPEG compression from the Photo Shooting Menu and scroll to the right (figure 3.9, image 1).
2. Choose Size priority or Optimal quality. Figure 3.9, image 2, shows Optimal quality as the selected compression type.
3. Press the OK button.

Settings Recommendation: I normally use Optimal quality when I shoot JPEGs since the whole JPEG concept is one of lossy image compression and I don't want the potentially heavier compression of Size priority to lower the image quality.

Size priority just adds more potential image quality loss, so I tend to avoid it. The only time I use Size priority is when I'm shooting snapshots. When I'm at a party taking pictures of friends having a good time, I'm not creating fine art and won't make an enlargement greater than an 8×10-inch (20×25 cm) size. In that case, I don't worry about extra compression. In fact, I might just welcome it to avoid storing larger-than-needed images on my computer's hard drive. Using Size priority lets the camera use fairly consistent files sizes. When consistent file size is not critical but maximum JPEG quality is, use Optimal quality.

NEF (RAW) Recording

(User's Manual: Page 269, Menu Guide: Page 38)

NEF (RAW) recording is composed of two menu choices: Type and NEF (RAW) bit depth. Type is concerned with image compression, and NEF (RAW) bit depth deals with color quality. We'll look at both of these choices and see how your photography can benefit from them.

Type

In previous sections we discussed how JPEG files have different levels of compression that vary the size of a finished image file. NEF (RAW) also has compression choices, though not as many. The nice thing about the RAW compression methods is they don't throw away

massive amounts of image data like JPEG compression does. NEF (RAW) is not considered a lossy format because the file stays complete, with virtually all of the image data your camera captured.

One of the NEF (RAW) compression methods, called Compressed, is very slightly lossy. The other, Lossless compressed, keeps *all* the image data intact. Let's discuss how each of the available compression methods works.

Although there are two NEF (RAW) formats available, you see a single NEF (RAW) selection on the Image quality menu. After you select NEF (RAW), you need to use *Photo Shooting Menu > NEF (RAW) recording > Type* to select one of the two NEF (RAW) compression types:

- **NEF (RAW) Lossless compressed** (20–40 percent file size reduction): The factory default for the NEF (RAW) format is Lossless compressed. According to Nikon, this compression will not affect image quality because it's a reversible compression algorithm. Since Lossless compressed shrinks the stored file size by 20 to 40 percent—with no image data loss—it's my favorite compression method. It works somewhat like a ZIP or RAR file on your computer; it compresses the file but allows you to use it later with all the data still available.
- **NEF (RAW) Compressed** (35–55 percent file size reduction): Before the newest generation of cameras, including the D7200, the Compressed mode was known as visually lossless. The image is compressed and the file size is reduced by 35 to 55 percent, depending on the amount of detail in the image. There is a small amount of data loss involved in this compression method. Most people can't see the loss since it doesn't affect the image visually. I've never seen any loss in my images with the Compressed mode. However, I've read that some people notice slightly less highlight detail. Nikon says the Compressed mode uses nonreversible compression, with "almost no effect on image quality." However, after you've taken an image using this mode, any small amount of data loss is permanent. If this concerns you, then use the Lossless compressed method. It won't compress the image quite as much (20 to 40 percent instead of 35 to 55 percent), but it is guaranteed by Nikon to be a reversible compression that does not affect the image. Evidently, most of the small compression loss occurs in the brightest parts (highlights) of the image, which contain most of the image data.

Figure 3.10A – Choosing a NEF (RAW) recording compression type

The steps to select a NEF (RAW) recording compression Type are as follows:

1. Select NEF (RAW) recording from the Photo Shooting Menu and scroll to the right (figure 3.10A, image 1).
2. Choose Type and scroll to the right (figure 3.10A, image 2).
3. Select a compression method from the Type menu (figure 3.10A, image 3). Lossless compressed is selected on my camera.
4. Press the OK button to save your selection.

An image with a large area of blank space, such as an expanse of sky, will compress a lot more efficiently than an image of, for example, a forest with lots of detail. The camera displays a certain amount of image storage capacity in NEF (RAW) modes—about 150 images on an 8 GB card.

In the two NEF (RAW) compressed modes, the D7200 does not decrease the image capacity counter by one for each picture taken. Instead, it decreases the counter approximately every two shots, depending on how well it compressed the images. When the card is full, it might contain nearly twice as many images as the camera initially reported it could hold. Your D7200 deliberately underreports storage capacity when you are shooting in either of the NEF (RAW) compressed modes because it can't anticipate how well the compression will work on each image.

Settings Recommendation: I'm concerned about maximum quality along with good storage capacity, so I shoot in Lossless compressed mode all the time. It makes the most sense to me since it produces a file size close to half the size of a normal uncompressed RAW file (if you could create one with the D7200, which you can't). More expensive Nikon cameras can create uncompressed RAW files, even though a Lossless compressed file retains all data and is stored on your computer hard drive at close to half the size.

I haven't used Compressed mode much since Lossless compressed became available in Nikon cameras a few years ago. Even though I can't see any image quality loss, it bothers me that it's there, if only slightly. The extra 10 or 15 percent compression is not worth the potential small data loss to me. If I were running out of card space but wanted to keep shooting RAW, I might consider changing to Compressed temporarily. Otherwise it's Lossless compressed for me!

NEF (RAW) Bit Depth

NEF (RAW) bit depth is a special feature for those of us concerned with capturing the best color in our images. The D7200 has three color channels, one for red, another for green, and the last one for blue (RGB). The camera combines those color channels to form all the colors you see in your images. Let's talk about how bit depth, or the number of colors per channel, can make your pictures even better.

With the D7200, you can select the bit depth stored in an image. More bit depth equals better color gradations. An image with 12 bits contains 4,096 colors per RGB channel, and an image with 14 bits contains 16,385 colors per RGB channel. In lesser cameras, the color information is limited to 12 bits. If you do not fully understand what this means, take a look at the **Channel and Bit Depth Tutorial** following this section.

Figure 3.10B – Choosing a NEF (RAW) bit depth

The steps to choose a NEF (RAW) bit depth are as follows:

1. Select NEF (RAW) recording from the Photo Shooting Menu and scroll to the right (figure 3.10B, image 1).
2. Select NEF (RAW) bit depth and scroll to the right (figure 3.10B, image 2).
3. Select 12-bit or 14-bit from the NEF (RAW) bit depth menu (figure 3.10B, image 3).
4. Press the OK button to save your selection.

Settings Recommendation: Which bit depth setting is best? I always use 14 bit because I want all the color my camera can capture for the best possible pictures. If you read my bit depth tutorial in the next subsection, you'll understand why I feel that way. My style of shooting is nature oriented, so I am concerned with capturing every last drop of color I can.

There is one small disadvantage to using the 14-bit mode. Your file sizes will be 1.3 times larger than they would have been in 12-bit mode. There is a lot more color information being stored, after all.

Channel and Bit Depth Tutorial

What does all this talk about bits mean? Why would I set my camera to use to 14-bit depth instead of 12-bit depth? This short tutorial explains bit depth and how it affects color storage in an image.

An image from your camera is an RGB image, where each of the three colors—red, green, and blue—have separate channels. If you're shooting in 12-bit mode, your camera will record up to 4,096 colors for each channel, so there will be up to 4,096 different reds, 4,096 different greens, and 4,096 different blues. Lots of color! In fact, almost *69 billion colors* ($4{,}096 \times 4{,}096 \times 4{,}096$). If you set your camera to 14-bit mode, the camera can store 16,384 different colors in each channel. Wow! That's quite a lot more color— almost *4.4 trillion shades* ($16{,}384 \times 16{,}384 \times 16{,}384$).

Is that important? Well, it can be, since the more color information you have, the better the color in the image—if it has a lot of color. I always use the 14-bit mode, which allows for smoother color changes when a large range of color is in the image. I like that!

Of course, if you save your image as an 8-bit JPEG or TIFF, most of those colors are compressed, or thrown away. Shooting a JPEG image in-camera (as opposed to a RAW image) means that the camera converts the image from a 12- or 14-bit RGB file to an 8-bit file. An 8-bit image file can hold 256 different colors per RGB channel—more than *16 million colors* ($256 \times 256 \times 256$).

There's a big difference between the number of colors a camera captures by demosaicing a RAW file and the number captured in a JPEG file (16 million versus 4.4 trillion). That's why I always shoot in RAW; later I can make full use of all those extra colors—if the subject contains that many shades—to create a different look for the same image.

If you shoot in RAW and later save your image as a 16-bit TIFF file, you can store all the colors you originally captured. A 16-bit file can contain 65,536 different colors in each of the RGB channels, which is significantly more than the camera actually captures.

Some people save their files as 16-bit TIFFs when they post-process RAW files, especially if they are worried about the long-term viability of the NEF (RAW) format. TIFF gives us a known and safe industry-standard format that will fully contain all image color information from a RAW file.

It's important that you learn to use your camera's histogram so you can examine the various RGB channels at a glance.

We'll discuss the histogram in an upcoming chapter titled **Metering, Exposure Modes, and Histogram**. In the meantime, please look at figure 3.10C, which shows the histogram screen on your camera and its RGB channels.

We talked about this screen in the chapter titled **Playback Menu**. However, I want to tie this in here to help you understand channels better. The histogram displays the amount and brightness of color for each of the RGB channels.

In figure 3.10C you can see four small histograms on the right side of the screen. The bottom three histograms represent the red, green, and blue color channels, as can easily be seen.

The white histogram on top is not an additional channel. It is called a luminance histogram, and it represents a combined, weighted histogram for the three color channels (green 59 percent, red 30 percent, and blue 11 percent). The luminance histogram closely reflects the way a human eye sees color. The luminance histogram is also

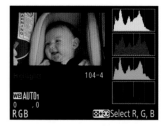

Figure 3.10C – RGB histogram screen

known as a brightness histogram. In reality, even though all the color channels influence the luminance histogram, over half of its information comes from the green channel. Notice that the luminance histogram and green channel histogram are very similar.

In digital photography we must use new technology and learn lots of new terms and acronyms. However, by investing a little time to understand these tools, we'll become better digital photographers.

White Balance

(User's Manual: Page 269, Menu Guide: Page 39)

White balance is designed to let you capture accurate colors in each of your camera's RGB color channels. Your images can reflect realistic colors if you understand how to use the White balance settings. This is an important thing to learn about digital photography. If you don't understand how White balance (WB) works, you'll have a hard time when you want consistent color across a number of images.

In this section we will look at White balance briefly and learn how to select the various White balance settings. This is such an important concept to understand that an entire chapter—titled **White Balance**—is devoted to this subject. Please read that chapter very carefully (see page 449). It is important that you learn to control the White balance settings thoroughly. A lot of what you'll do in computer post-processing requires a good understanding of White balance control.

Many people leave their cameras set to Auto White balance. This works fine most of the time because the camera is quite capable of rendering accurate color. However, it's hard to get exactly the same White balance in each consecutive picture when you are using Auto mode. The camera has to make a new White balance decision for each picture in Auto. This can cause the White balance to vary from picture to picture.

For many of us this isn't a problem. However, if you are shooting in a studio for a product shot, I'm sure your client will want the pictures to be the same color as the product and not vary among frames. White balance lets you control that carefully, when needed.

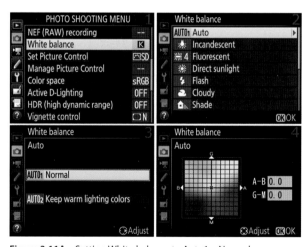

Figure 3.11A – Setting White balance to Auto1 – Normal

The steps to select a White balance setting are as follows:

1. Select White balance from the Photo Shooting Menu and scroll to the right (figure 3.11A, image 1).
2. Choose a White balance type, such as Auto or Flash, from the menu and scroll to the right (figure 3.11A, image 2).

3. If you choose Auto, Fluorescent, Choose color temp., or Preset manual you will need to select from an intermediate screen, similar to the one shown in figure 3.11A, image 3. Auto presents two settings: Auto1 – Normal and Auto2 – Keep warm lighting colors. Fluorescent presents seven different types of fluorescent lighting. Choose color temp. allows you to select a color temperature manually from a range of 2500 K (cool or bluish looking) to 10000 K (warm or reddish looking). Preset manual (PRE) provides stored White balance memory locations d-1 through d-6 and allows you to choose one of them to store or reuse a certain WB setting. If this seems a bit overwhelming, just choose Auto1 – Normal for now. The chapter titled **White Balance** will explain how to use all these settings (see page 449).

4. As shown in figure 3.11A, image 4, you'll now arrive at the White balance fine-tuning screen. You can make an adjustment to how you want this White balance to record color by introducing a color bias toward green, yellow, blue, or magenta. You do this by moving the little black square in the middle of the color box toward the edges of the box in any direction. If you make a mistake, simply move the black square to the middle of the color box. Most people do not change this setting.

5. After you have finished adjusting (or not adjusting) the colors, press the OK button to save your setting. Most people press the OK button as soon as they see the fine-tuning screen so they don't change the default settings for that particular White balance.

You'll also find it convenient to change the White balance settings by using external camera controls.

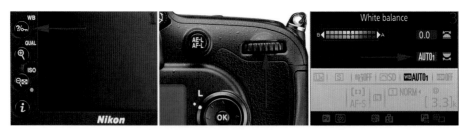

Figure 3.11B – Setting White balance with external controls

Use these steps to set the WB with external camera controls and the Monitor:

1. Hold down the WB button, which shares functionality with the Help/protect button (figure 3.11B, image 1).

2. Turn the rear Main command dial (figure 3.11B, image 2) as you watch the WB icons change on the Monitor (figure 3.11B, image 3). Select the WB value you want to use. My camera has Auto1 selected. If you want to fine tune the WB, you can do so on this screen (image 3) along the blue (B) and amber (A) axes only. Simply turn the front Subcommand dial and you will see characters appear where 0.0 is currently displayed. You will also see a small indicator move toward the B or A in the B/A color scale in the top left of the screen (image 3). For instance, to add blue, turn the Sub-command dial clockwise and numbers such as B0.5 or B1.0 will appear instead of 0.0. The larger the number

after the B, the more blue tint is added. To add amber (reddish) to the WB, turn the Sub-command dial counterclockwise. The indicator will move toward the A in the B/A scale and you will see characters such as A0.5 or A1.0 appear in place of 0.0. The adjustment range for B is from B0.5 to B6.0; the adjustment range for A is A0.5 to A6.0.

3. Release the WB button to lock in your choice.

Note: We will discuss what the WB fine-tuning numbers mean—along with WB in general—in much greater detail in the **White Balance** chapter on page 449.

Settings Recommendation: Until you've read the chapter titled **White Balance,** I suggest that you leave the camera's White balance set to Auto1 – Normal. However, please do take the time to understand this setting by reading the dedicated chapter carefully. Understanding White balance is especially important if you plan to shoot JPEGs regularly.

Set Picture Control

(User's Manual: Page 270, Menu Guide: Page 40)

Set Picture Control allows you to choose a Picture Control for a shooting session. Nikon's Picture Control system lets you control how your image appears in several ways. Each control has a specific effect on the image's appearance. If you shot film a few years ago, you will remember that each film type has a distinct look. No two films produce color that looks the same.

In today's digital photography world, Picture Controls give you the ability to impart a specific look to your images. You can use Picture Controls as they are provided from the factory, or you can fine-tune Sharpening, Clarity, Contrast, Brightness, Saturation, and Hue.

We'll discuss how to fine-tune a Nikon Picture Control later in this section. In the next section, Manage Picture Control, we'll discuss how to save a modified Picture Control under your own Custom Picture Control name. You can create up to nine Custom Picture Controls.

I'll refer to Picture Controls included in the camera as Nikon Picture Controls because that's how Nikon refers to them. You may also hear them called Original Picture Controls in some Nikon literature. If you modify and save a Nikon Picture Control under a new name, it becomes a Custom Picture Control. I'll also use the generic name of Picture Control when referring to any of them.

The cool thing about Picture Controls is that they are shareable. If you tweak a Nikon Picture Control and save it under a name of your choice, you can then share your control with others. Compatible cameras, software, and other devices can use these controls to maintain the look you want from the time you press the Shutter release button until you print the picture.

Now, let's look closer at the Picture Control system. As shown in figure 3.12A, image 2, there is a series of Picture Control selections that modify how your D7200 captures an image. They are as follows:

- SD: Standard
- NL: Neutral
- VI: Vivid
- MC: Monochrome
- PT: Portrait
- LS: Landscape
- FL: Flat

Each of these settings has a different and variable combination of the following settings:
- Sharpening
- Clarity
- Contrast
- Brightness
- Saturation
- Hue
- Filter Effects (applies only to MC – Monochrome)
- Toning (applies only to MC – Monochrome)

You can select one of the controls (SD, NL, VI, MC, PT, LS, or FL) and leave the settings at the factory default, or you can modify the settings (figure 3.12A, image 3) and completely change how the D7200 captures the image.

Note: If you are shooting in NEF (RAW) mode, the D7200 does not apply these settings directly to the image as it does with a JPEG or TIFF, but it stores the settings with the image, allowing you to change to a different Picture Control later on your computer using Nikon Capture NX-D or Nikon ViewNX2/NX-i, if you so desire.

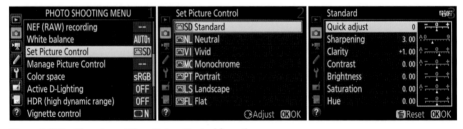

Figure 3.12A – Choosing a Nikon Picture Control from the menus

Here are the steps to choose a Picture Control from the Photo Shooting Menu:

1. Select Set Picture Control from the Photo Shooting Menu and scroll to the right (figure 3.12A, image 1).
2. Choose one of the Nikon Picture Controls from the Set Picture Control screen (figure 3.12A, image 2). At this point, you can simply press the OK button and the control you've highlighted will be available for immediate use. It will show up as a two-letter

name in the Photo Shooting Menu next to Set Picture Control. You can see this in figure 3.12A, image 1, where SD is shown next to Set Picture Control. You can also modify the currently highlighted control by scrolling to the right instead of pressing the OK button.

3. After choosing an option from the Set Picture Control menu (shown in shown in figure 3.12A, image 2), scroll to the right. Your camera will present the Picture Control fine-tuning screen, as shown in figure 3.12A, image 3. You can adjust the Sharpening, Clarity, Contrast, Brightness, Saturation, or Hue by scrolling up or down to select a line and then right or left (+/−) to fine-tune the value of that line item. Please notice the Quick adjust selection at the top of figure 3.12A, image 3. By highlighting Quick adjust and scrolling left or right, you can change Sharpening, Contrast, and Saturation all at once in +2/−2 steps. Clarity, Brightness, and Hue remain individual adjustments only. By using Quick adjust instead of adjusting the individual settings, such as Sharpening or Saturation, you may tend to keep the control more in balance while making the effect of the control stronger or weaker. If the Quick Adjust setting is sufficient for your needs, make the adjustment, press the OK button to set the values for that Picture Control, and skip the rest of these steps. However, if you want to fine-tune each setting individually, continue with step 4.

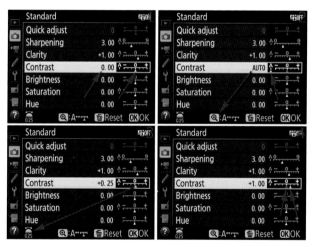

Figure 3.12B – Fine-tuning the Contrast setting for the SD Picture Control

4. Figure 3.12B starts where figure 3.12A leaves off. Please notice that Contrast is selected in figure 3.12B, image 1. We will use Contrast as our sample; however, you can use the information in this step for any of the individual settings (e.g., Clarity). As you can see, Contrast is currently set at 0.00 (image 1, red arrows). You can adjust Contrast in 0.25 increments up to +/− 2.0 steps. You can also select AUTO mode for an individual setting by pressing the Playback zoom in button. AUTO will appear after Contrast, and the tiny yellow pointer on the adjustment scale will point to A instead of 0, as shown in image 2. AUTO means the camera will decide how much contrast to add to the image. In image 3,

you can see that the pointer on the adjustment scale has been moved toward the + side (higher contrast). Fine adjustments can be made in 0.25 step increments by turning the front Sub-command dial (image 3, red arrow). Or you can adjust the contrast in larger, 1.0 step increments by pressing left or right on the Multi selector (image 4). Notice that there are two tiny indicators showing at the point of the two red arrows in image 4. The one that is bright yellow (right arrow) is the new adjustment position you have selected. The one that is a pale dim yellow (left arrow) is the current (old) setting for Contrast. Until you have made a new selection permanent, you will always be able to see where the current setting is in relation to the new setting based on the position of the dim pointer.

5. Repeat step 4 for any of the other individual settings you want to adjust for this Picture Control (e.g., Brightness, Saturation). Once you are finished, press the OK button to lock in the setting.

Now that you have adjusted a Picture Control away from its factory default settings, it would be good to know how to return the control its default settings. Let's consider how to do so (figure 3.12C).

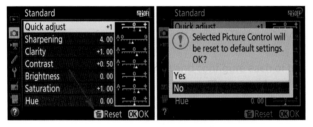

Figure 3.12C – Resetting a Nikon Picture Control

Use the following steps to reset a Picture Control:

1. Open the adjustment screen for the Picture Control you want to reset, and then press the Delete button (garbage can; figure 3.12C, image 1).
2. A box will appear that says, *Selected Picture Control will be reset to default settings. OK?* (figure 3.12C, image 2). Select Yes and press the OK button to return the Picture Control to its factory default settings.

Note: If you choose to modify a Picture Control using Quick adjust or with the individual line item settings (Sharpness, etc.), it is not yet a Custom Picture Control because you have not saved it under a new name. Instead, it is merely a modified Nikon Picture Control. We'll discuss how to name and save your own Custom Picture Controls in the upcoming section, **Manage Picture Control** on page 97.

Figure 3.12D shows an asterisk after the Vivid control (VI* – Vivid) in both Photo Shooting Menu screens (see red arrows). This asterisk appears after you have made a modification to any of the Picture Control's inner settings (Contrast, etc.). The asterisk will go away if you reset the Picture Control to its factory settings.

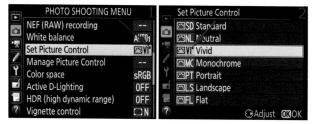

Figure 3.12D – An adjusted Nikon Picture Control (see asterisks)

Now let's examine each of the Picture Controls.

Examining Picture Controls

Now it's time to break out my red, green, and blue (RGB) Lego blocks as sample subjects for Picture Control Sharpening, Clarity, Contrast, Brightness, Saturation, and Hue variation comparisons.

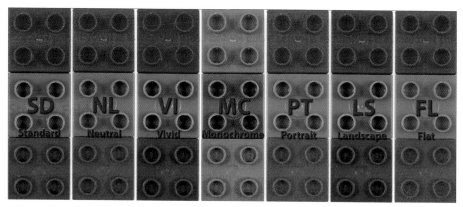

Figure 3.12E – Sample color variations among Nikon Picture Controls

Figure 3.12E provides a look at the differences in color saturation and shadow with the various controls. Due to limitations in printing, it may be hard to see the variations, but they are clearly visible in a picture. Saturation and Contrast depth increase within these Picture Control choices, in this order: FL (very low) > NL (low) > SD (medium) > VI (high). PT appears to be a modified form of the NL control, and LS seems to be a modified form of the VI control.

The following is an overview of what Nikon says about Picture Controls and what I see in my sample images taken with the various controls (figure 3.12E).

- **SD,** or **Standard,** is Nikon's recommendation for getting "balanced" results. Nikon recommends SD for most general situations. Use this if you want a balanced image and do not want to post-process it. It has what Nikon calls "standard image processing." The

SD control provides what I would call medium saturation, with darker shadows to add contrast. If I were shooting JPEG images in a studio or during an event, I would seriously consider using the SD control. I would compare this setting to Fuji Provia or Kodak Kodachrome 64 slide films.

- **NL,** or **Neutral,** is best for an image that will be extensively post-processed in a computer. It has the widest available dynamic range of any of the Picture Controls. It too is a balanced image setting, but it applies minimal camera processing, so you'll have room to do more with the image during post-processing. NL has less saturation and weaker shadows, so the image will be less contrasty (wider dynamic range). The effects of the NL and SD controls are harder to see in figure 3.12E because there's not a marked difference. However, the NL control will give you extra dynamic range in each image due to more open shadows and slightly less saturated colors. If you've ever shot with Fuji NPS film or Kodak Portra negative films and liked them, you'll like this control.

- **VI,** or **Vivid,** is for those of us who love Fuji Velvia slide film! This setting places emphasis on saturating primary colors for intense imagery. The contrast is higher for striking shadow contrast, and the sharpness is higher, too. If you are shooting JPEGs and want to imitate a saturated transparency film like Velvia, this mode is for you! If you look at the red block in the VI example in figure 3.12E, you'll see that it's pushed into deep saturation, almost to the point of oversaturation. Plus, the greens and blues are extra strong. That means your nature shots will look saturated and contrasty. Be careful when you are shooting on a high-contrast day, such as in direct sunshine in the summer. If you use the VI control under these conditions, you may find that your images are too high in contrast. It may be better to back off to the SD or NL control when shooting in bright sunshine. Of course, with the higher inherent dynamic range in the D7200, this is not as much of an issue as with previous Nikons. You will need to experiment with this to see what I mean. On a cloudy or foggy low-contrast day, when the shadows are weak, you may find that the VI control adds pleasing saturation and contrast to the image.

- **MC,** or **Monochrome,** allows the black-and-white lovers among us to shoot in toned black-and-white. The MC control basically removes the color by desaturation. It's still an RGB color image, but the colors have become levels of gray. It does not look the same as black-and-white film, in my opinion. The blacks are not as deep, and the whites are not as bright. To me, it seems that the MC control is fairly low contrast, and that's where the problem lies. Good black-and-white images should have bright whites and deep blacks. To get images like that from a digital camera, you'll have to manually work with the image in a graphics program like Photoshop, using the Channel Mixer (see the upcoming sidebar Note on Photoshop for D7200 Black-and-White Images). However, if you want to experiment with black-and-white photography, this gives you a good starting point. Additionally, there are two extra settings in the MC control that allow you to experiment with Filter effects and Toning. We'll look at these settings in the upcoming section called MC Picture Control Filter Effects and Toning. The MC control creates a look that is somewhat like Kodak Plus-X Pan negative film, with blacks that are not as deep.

- **PT,** or **Portrait,** is a control that "lends a natural texture and rounded feel to the skin of portrait subjects" (Nikon's description). I've taken numerous images with the PT control

and shot the same images with the NL control. The results are very similar. I'm sure that Nikon has included some software enhancements specifically for skin tones in this control, so I would definitely use this control for portraits of people. The results from the PT control look a bit like smooth Kodak Portra or Fuji NPS negative film.

- **LS,** or **Landscape,** is a control that "produces vibrant landscapes and cityscapes," according to Nikon. That sounds like the VI control to me. I shot a series of images using both the LS and VI controls and got similar results. Compared to the VI control, the LS control seemed to have slightly less saturation in the reds and a tiny bit more saturation in the greens. The blues stayed about the same. It seems that Nikon has created the LS control to be similar to, but not quite as drastic as, the VI control. In my test images, the LS control created smoother transitions in color. However, there was so little difference between the two controls that you'd have to compare the images side by side to notice. Maybe this control is meant to be more natural than the super-saturated VI control. It will certainly improve the look of your landscape images. The look of this control is somewhere between Fuji Provia and Velvia. You get great saturation and contrast, with emphasis on the greens and blues in natural settings.

- **FL,** or **Flat,** is a control that allows you to preserve details "over a wide tone range, from highlights to shadows." If you are a JPEG or TIFF shooter and need maximum dynamic range in your image but do not want to use HDR (high dynamic range) imaging (where you shoot several images at different exposures and then combine them), you may be able to use this Picture Control as a substitute. The D7200 has wide dynamic range already, with excellent detail in the shadow areas; therefore, a very low contrast Picture Control setting can help maintain maximum dynamic range in a single image. You may also use this Picture Control when you are shooting video and later want to professionally color grade the results. It is hard to compare this Picture Control to a certain film stock; I have never shot any film with contrast and saturation this low.

MC Picture Control Filter Effects and Toning

The Monochrome, or MC, Picture Control has some added features that are enjoyable for those who love black-and-white photography. Let's examine Filter effects and Toning more closely.

Filter Effects

As shown in figure 3.12F, there are Filter effects that simulate the effect of yellow (Y), orange (O), red (R), and green (G) filters on a monochrome image. Yellow, orange, and red (Y, O, R) change the contrast of the sky in black-and-white images. Green (G) is often used in black-and-white portrait work to change the appearance of skin tones. You do not have to go buy filters for your lenses; they are included in your D7200.

Figure 3.12F – Monochrome Filter effects screen

In figure 3.12G, you'll see an unretouched sample of a color SD Picture Control photo (for comparison) alongside the five flavors of Monochrome (MC) Filter effects. It is rather interesting how the yellow, orange, red, and green filters affect the RGB Lego blocks.

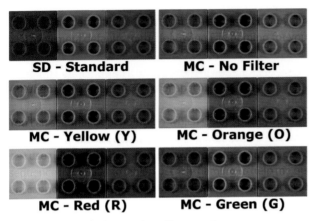

Figure 3.12G – Monochrome Filter effects samples

The Filter effects settings are more pronounced than those you would achieve using a glass filter attached to your lens. Now, let's examine the MC Toning effects.

Toning

Toning allows you to add special tints to your monochrome images. As shown in figure 3.12H, there are 10 variable Toning effects available—B&W (standard black-and-white), Sepia, Cyanotype, Red, Yellow, Green, Blue Green, Blue, Purple Blue, and Red Purple. Each of the Toning effects is variable within itself, and you can adjust the saturation of the individual tones. In figure 3.12H, I cranked them all the way up to the maximum setting, which tends to oversaturate the toning color. I wanted you to clearly see the maximum potential of the Toning settings.

Compare how the RGB blocks look under the various toning settings. The red block is on top, green in the middle, and blue on the bottom. Clearly, the toned blocks all look similar in brightness (with only minor variation) to the B&W blocks, showing that the underlying image for each of the color tones is simply black-and-white.

You can shoot a basic black-and-white image, use filters to change how colors appear, or tone the image in experimental ways. Can you see the potential for a lot of fun with these tones?

In the Monochrome menu screen at the top left of figure 3.12H, notice that to the right of the word Toning there is a row of tiny colored rectangles. The first rectangle is half black and half white; that is the normal black-and-white (B&W) selection, and it has no extra toning. Next to that you'll see a golden-brown rectangle; that is the Sepia toning effect (selected). To the right of that is the bluish Cyanotype effect. The smaller rectangles that follow the first three selections are the other available colors for toning.

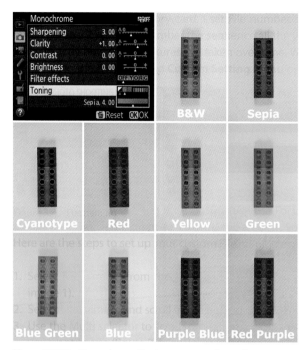

Figure 3.12H – Monochrome Toning screen and samples

Figure 3.12I shows how to adjust the depth of color saturation for each of the color tints (tones) shown in figure 3.12H. Each color has seven major saturation gradations available, as shown in the little bar tinted the same color as the one you have selected for toning—in this case, Sepia. This saturation adjustment bar allows you to select the depth of saturation for each of the colors. In figure 3.12I, the setting has been moved from 4.00 (default) to 5.00.

Figure 3.12I – Fine-tuning the Toning setting

Use these steps to adjust the depth of color saturation for toning an image (figure 3.12I):

1. Scroll to Toning on the Monochrome screen, and then press left or right on the Multi selector to select a color (e.g., B&W, Sepia, Cyanotype). My camera has Sepia selected.
2. To make adjustments to the saturation level of the Toning color, first press down on the Multi selector to select the saturation adjustment bar below the color selections, and then press right or left on the Multi selector to make one-step saturation adjustments. The available saturation adjustment range is from 1.00 to 7.00, with the default being level 4.00 saturation. For adjustments finer than one step, turn the front Sub-command dial in 0.25 increments to select more or less color saturation.
3. Make your Toning saturation-level selection and then press the OK button to lock in the new saturation level.

Using the *i* Button Menu to Set Picture Control

You may also use the *i* button menu to fine-tune and set a Picture Control for your camera. Here's how.

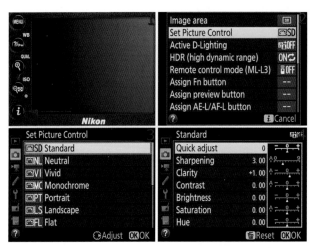

Figure 3.12J – Using the *i* button menu to Set Picture Control

Use these steps to Set Picture Control with the *i* button menu:

1. Simply press the *i* button (figure 3.12J, image 1) to open its special menu, select Set Picture Control (figure 3.12J, image 2), and scroll to the right.
2. Next, highlight the Picture Control you want to use (figure 3.12J, image 3) and press the OK button to choose it. Or, you can scroll to the right and fine-tune the internal settings of the Picture Control.
3. You can fine-tune the Picture Control using the screen controls seen in figure 3.12J, image 4 (e.g., Quick adjust, Sharpening, Clarity).
4. Press the OK button when you are finished.

This works very much like the Photo Shooting Menu step-by-step method described for figure 3.12A at the beginning of this section.

I'm sure you will agree that Nikon's Picture Control system is very powerful and flexible, especially for those who like to shoot mostly JPEG images. Now, let's see how to go about managing your own Custom Picture Controls in our next section, **Manage Picture Control**.

Note on Photoshop for D7200 Black-and-White Images

Since the RGB color channels are still intact in the camera's black-and-white image, you can use Photoshop's Channel Mixer *Image Menu > Adjustments > Channel Mixer*... to manipulate the color channels and improve the blacks and whites. If you use Photoshop to play with the channels, be sure to check the Monochrome box on the Channel Mixer window. If you don't, you'll simply add color back into your black-and-white image. The fact that you must check the Monochrome box proves that a D7200 black-and-white image is really just a color image with the colors desaturated to levels of gray. The good thing about this is that you now have room to play with the three color channels, similar to how you use filters when shooting black-and-white film. You can add or subtract contrast by moving the channel sliders until you are happy with the results. There is a lot of discussion of these techniques on the Internet. Why not join the Nikonians.org community to discuss how to best achieve beautiful black-and-white images? Look for the Nikonians Gold Membership 50% off coupon at the back of this book.

Manage Picture Control

(User's Manual: Page 270, Menu Guide: Page 41)

The *Manage Picture Control* function is designed to allow you to create and store Custom Picture Control settings for future use. You can take an existing Nikon Picture Control (SD, NL, VI, MC, PT, LS, or FL) that is included with the camera, make modifications to it, and then rename it.

If you modify a Picture Control using the Set Picture Control function discussed in the previous section, you simply create a one-off setting. If you'd like to go further and create your own named Custom Picture Controls, the D7200 is happy to oblige. There are four choices on the Manage Picture Control screen:

- Save/edit
- Rename
- Delete
- Load/save

Let's look at each of these settings and see how to manage Picture Controls effectively.

Save/Edit a Custom Picture Control

There are six screens used to save/edit a Nikon Picture Control (figure 3.13A)—storing the results for later use as a Custom Picture Control.

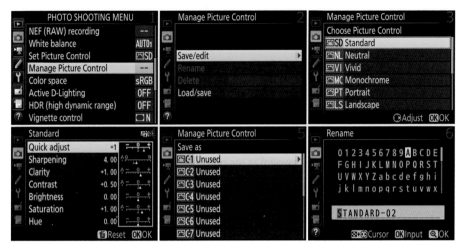

Figure 3.13A – Save/edit a Custom Picture Control

Here are the steps to edit and save a Picture Control with a modified setting:

1. Select Manage Picture Control from the Photo Shooting Menu and scroll to the right (figure 3.13A, image 1).
2. Highlight Save/edit and scroll to the right (figure 3.13A, image 2).
3. Choose a Picture Control that you want to use as a base for your new settings and then scroll to the right (figure 3.13A, image 3). I am modifying the SD – Standard Picture Control and will save it under a different name.
4. Make your adjustments to Sharpening, Contrast, and so forth. I simply used the Quick adjust setting and added +1 to it, increasing the overall effect of Standard by 1 (out of 2). When you have modified the control in a way that makes it yours, press the OK button (figure 3.13A, image 4). If you want to abandon your changes and start over, you can simply press the Delete button (garbage can) and it will reset the control to factory specs.
5. Select one of nine storage areas named C-1 to C-9 and scroll to the right (figure 3.13A, image 5). Only seven of the nine storage areas are viewable without scrolling down. In figure 3.13A, image 5, they are all currently marked as Unused. I can save as many as nine different Custom Picture Controls here for later selection with Set Picture Control.
6. You will now see the Rename screen, which works just like the other screens you have used to rename things. Type in a new name by selecting characters from the list at the top of the screen and pressing the Multi selector center button to choose the highlighted character (figure 3.13A, image 6). To correct an error, hold down the Thumbnail/Playback zoom out button and use the Multi selector to move back and forth along the field that contains the new name. The camera will create a default name for you by appending a dash and two numbers at the end of the current control name. I left it at the default of Standard–02.
7. Press the OK button when you have entered the name of your Custom Picture Control.

Once you have created and saved a Custom Picture Control, you can still tell which control was used as its base, just in case you name it in a way that does not suggest its origins. Notice the red arrow in the upper-right corner of the screen in figure 3.13B. This is the control we just created in the previous steps (Standard–02) and it is derived from an SD Nikon Picture Control, as shown by the SD label at which the arrow is pointing.

Figure 3.13B – Identifying the base of a Custom Picture Control

Your camera is now set to your Custom Picture Control. You switch between your Custom Picture Controls and the basic Nikon Picture Controls by using Set Picture Control (see previous section titled Set Picture Control). In other words, each of your newly named Custom Picture Controls will appear in the Set Picture Control menu for later selection.

Now, let's look at how to rename an existing Custom Picture Control.

Rename a Custom Picture Control

Now that you have created and saved a new Custom Picture Control or two, you may want to rename one of them. Here's how.

Figure 3.13C – Rename a Custom Picture Control

Use the following steps to rename an existing Custom Picture Control:

1. Select Manage Picture Control from the Photo Shooting Menu and scroll to the right (figure 3.13C, image 1).
2. Select Rename and scroll to the right (figure 3.13C, image 2).
3. Select one of your Custom Picture Controls from the list (C-1 to C-9) and scroll to the right (figure 3.13C, image 3). I selected to rename STANDARD-02. This is the Custom Picture Control we created in the preceding section.

4. You will now be presented with the Rename screen. To create a different name, hold down the Thumbnail/Playback zoom out button and use the Multi selector to scroll back and forth within the old name. When you have the small gray cursor positioned over a character, you can delete that character with the garbage can Delete button. To insert a new character, position the yellow cursor in the character list above and press the Multi selector center button. The character that is under the yellow cursor will appear on the name line below, at the position of the gray cursor. If there is already a character under the gray cursor, it will be pushed to the right. Please limit the name to a maximum of 19 characters (figure 3.13C, image 4). I renamed the STANDARD-02 Custom Picture Control STANDARD-EX2.

5. Press the OK button when you have entered the new name.

Note: You can have more than one control with exactly the same name in your list of Custom Picture Controls. The camera does not get confused because each control has a different location (C-1 to C-9) to keep it separate from the rest. However, I don't suggest that you give several custom controls the same name. How would you tell them apart?

When a Custom Picture Control is no longer needed, you can easily delete it.

Delete a Custom Picture Control

You cannot delete a Nikon Picture Control (SD, NL, VI, MC, PT, LS, FL). In fact, they don't even appear in any of the Manage Picture Control menu screens.

Figure 3.13D – Delete a Custom Picture Control

However, you can delete one or more of your Custom Picture Controls with the following screens and steps:

1. Select Manage Picture Control from the Photo Shooting Menu and scroll to the right (figure 3.13D, image 1).

2. Select Delete from the Manage Picture Control screen and scroll to the right (figure 3.13D, image 2).
3. Select one of your nine available Custom Picture Controls and scroll to the right (figure 3.13D, image 3). I selected VIVID-02 for deletion.
4. Choose Yes at the *Delete Picture Control?* prompt (figure 3.13D, image 4).
5. Press the OK button and the Custom Picture Control will be deleted from your camera.

Now, let's move to our last menu selection from the Manage Picture Control screen, Load/save.

Load/Save a Custom Picture Control

There are three parts to the Load/save function. They allow you to copy Custom Picture Controls to and from the memory card or delete them from the card.

If you have two memory cards in the camera, the D7200 will automatically choose the one assigned as the Primary card slot when you save a custom control. You cannot choose to write to the Secondary card slot. However, you could write to the Secondary slot by re-moving the Primary card, leaving the camera no choice but to write to the only card it can find. (Use *Photo Shooting Menu > Primary slot selection* to set one of the memory card slots to primary.)

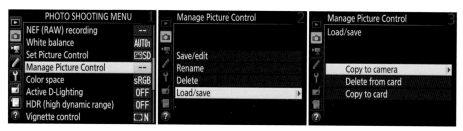

Figure 3.13E – Load/save a Custom Picture Control

Here are the three selections on the Load/save menu, as shown in figure 3.13E, image 3:

- **Copy to camera:** Loads Custom Picture Controls from the memory card into your camera. You can store up to nine controls in your camera's nine available memory locations (C1–C9).
- **Delete from card:** Displays a list of any Custom Picture Controls found on the memory card. You can selectively delete them.
- **Copy to card:** Allows you to copy your carefully crafted Custom Picture Controls (C1–C9) from your camera to a memory card. You can then share them with others. The camera will display up to 99 control locations (01–99) on any single memory card.

Let's examine each of these selections and see how best to use them.

Copy to Camera

You can use the Copy to camera function to copy Custom Picture Controls from your camera's memory card to the camera's Set Picture Control menu. Once you have transferred a Custom Picture Control from your memory card to your camera, it will show up in the *Photo Shooting Menu > Set Picture Control* menu.

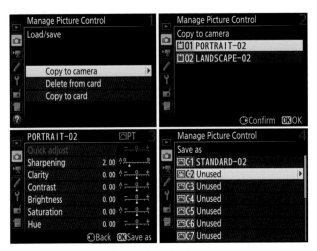

Figure 3.13F – Manage Picture Control – Copy to camera

Here are the steps to copy a Custom Picture Control from the memory card to the camera itself:

1. Figure 3.13F continues from the last screen shown in figure 3.13E (Load/save on the Manage Picture Control menu). Choose Copy to camera and scroll to the right (figure 3.13F, image 1).
2. You will be presented with the list of Custom Picture Controls that are currently on the memory card (figure 3.13F, image 2). If there are no controls on the memory card, the camera will display a screen that says, *No Picture Control file found on memory card.* My camera in Figure 3.13F, image 2, shows two controls—PORTRAIT-02 and LAND-SCAPE-02. Select a control from the list and press the OK button. (If you scroll to the right instead, you will be able to examine and adjust the control's settings before saving it to your camera [figure 3.13F, image 3]. If you don't want to modify it, simply press the OK button.)
3. You will now see the Manage Picture Control Save as menu, which lists any Custom Picture Controls already in your camera (figure 3.13F, image 4). Select one of the Unused memory locations and press the OK button.
4. You'll now be presented with the Rename screen, just in case you want to change the name of the Custom Picture Control (figure 3.13G). If you don't want to change the name, simply press the OK button and the custom control will be added to your

camera's Set Picture Control menu. It is okay to have multiple controls with exactly the same name. The camera keeps each control separate in its list of controls (C-1 to C-9). However, I always rename them to prevent future confusion. To create a different name, hold down the Thumbnail/Playback zoom out button and use the Multi selector to scroll back and forth within the old name. Once you have the small gray cursor positioned over a character, you can delete it with the garbage can Delete button. To insert a new character, position the yellow cursor in the character

Figure 3.13G – Manage Picture Control – Choose a new name (or Rename)

list above and press the Multi selector center button. The character that is under the yellow cursor will appear on the name line below, at the position of the gray cursor. If there is already a character under the gray cursor, it will be pushed to the right. Please limit the name to a maximum of 19 characters. Press the OK button when you have entered the new name.

You can also create Custom Picture Controls in programs like Nikon Capture NX 2, which uses its Picture Control Utility, and load them into your camera using the preceding four steps.

Delete from Card

Once you've finished loading Custom Picture Controls or optional Nikon Picture Controls to your camera, you may be ready to delete a control or two from the memory card. You could format the memory card, but that will blow away all images and Picture Controls on the card. A less drastic method that allows you to be more selective in removing Picture Controls is the Delete from card function.

Here are the steps used to remove Custom Picture Controls from your camera's memory card:

1. Figure 3.13H continues where figure 3.13E left off. Choose Delete from card from the Load/save menu and scroll to the right (figure 3.13H, image 1).
2. Choose one of the Custom Picture Controls that you want to delete (figure 3.13H, image 2). I chose Portrait-02. You can confirm that you are deleting the correct control by scrolling to the right, which gives you the fine-tuning screen with current adjustments for that control (figure 3.13H, image 3). If you are sure that this is the control you want to delete, move on to the next step by pressing the OK button.
3. You will be shown a screen that asks, *Delete Picture Control?*, with the control's name below (Portrait-02). Choose either Yes or No (figure 3.13H, image 4). If you choose Yes, the Picture Control will be deleted from the memory card. If you choose No, the camera will return to the previous screen.
4. Press the OK button to execute your choice.

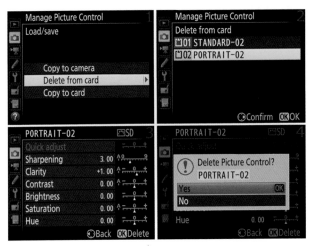

Figure 3.13H – Manage Picture Control – Delete from card

Copy to Card

After you create up to nine Custom Picture Controls using the instructions in the last few sections, you can use the Copy to card function to save them to a memory card. Once they are on a memory card, you can share your custom controls with friends who have compatible Nikon cameras.

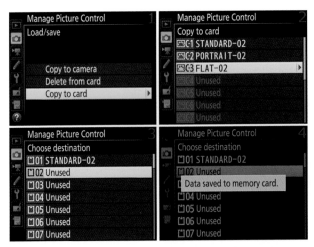

Figure 3.13I – Manage Picture Control – Copy to card

When your Custom Picture Controls are ready to go, use the following steps to copy them to a memory card:

1. Figure 3.13I continues where figure 3.13E left off. Choose Copy to card from the Load/ save menu and scroll to the right (figure 3.13I, image 1).
2. Select one of your current Custom Picture Controls from the Copy to card menu and scroll to the right (figure 3.13I, image 2). I chose FLAT-02 to copy to the memory card.
3. Now you'll use the Choose destination menu to select the location in which you want to save the custom control (figure 3.13I, image 3). You have 99 choices; select any Unused location by scrolling down.
4. Press the OK button and you'll briefly see a screen that says, *Data saved to memory card.* Your Custom Picture Control is now ready to distribute to the world or load onto another of your compatible Nikon cameras.

Color Space

(User's Manual: Page 270, Menu Guide: Page 41)

Color space is an interesting and important part of digital photography. It helps your camera fit into a much broader range of imaging devices. Software, printers, monitors, and other devices recognize which Color space is attached to your image and use it, along with other color profiles, to help balance the image to the correct output colors for the device in use.

The two Color spaces available on the Nikon D7200 have different gamuts, or ranges of color. They are called sRGB and Adobe RGB (figure 3.14A). You can see the actual range of color the Color space gives your images in figure 3.14B.

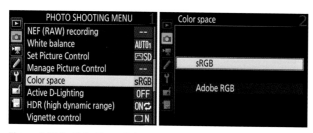

Figure 3.14A – Selecting a Color space

Here's how to select your favorite Color space:

1. Choose Color space from the Photo Shooting Menu and scroll to the right (figure 3.14A, image 1).
2. Select the Color space that you want to use (figure 3.14A, image 2), keeping in mind that Adobe RGB has a larger color gamut. We'll learn more about that in the next subsection.
3. Press the OK button to lock in your choice.

Which Color Space Should I Choose?

Adobe RGB uses colors from a broad selection of the total color range that approximates human vision (called CIELAB in the graphics industry), so it has a wider gamut than sRGB (figure 3.14B). If you are taking images that might be printed commercially, Adobe RGB is often the best Color space to use (see sidebar, **Which Color Space Is Best, Technically?**).

Figure 3.14B – CIELAB, Adobe RGB, and sRGB Color spaces

After a JPEG file is created, either in a camera or on a computer, both the Adobe RGB and sRGB color gamuts are compressed into the same number of color levels. A JPEG has only 256 levels for each of its red, green, and blue (RGB) channels. However, since the Adobe RGB Color space takes its colors from a wider spectrum, you will have a better representation of reality when there are lots of colors in your image.

If you shoot in RAW format a lot, you may want to consider using Adobe RGB to store the maximum number of colors in your image files for later use, even though, for reasons we'll discuss in a moment, it really doesn't matter in RAW mode. It still is a good idea to leave your camera set to Adobe RGB.

Remember that a NEF (RAW) image file can contain 4,096 levels of color per RGB channel in 12-bit mode and 16,385 levels in 14-bit mode—instead of the limited 256 levels in an 8-bit JPEG. Using Adobe RGB makes a lot of sense when shooting in NEF (RAW) mode because of its capacity to contain more colors as a base storage medium.

There are some drawbacks to using Adobe RGB, though. The sRGB Color space is widely used in printing and display devices. Many local labs print with sRGB because so many point-and-shoot cameras use that format. If you try to print directly to some inkjet printers using the Adobe RGB Color space, the colors may not be as brilliant as with sRGB. If you aren't going to modify your images in post-processing and plan to print them directly from your camera, you may want to use sRGB. If you shoot only JPEGs for computer display or Internet usage, it might be better to stay with sRGB for everyday shooting.

If you are a RAW shooter and regularly post-process your images, you should consider using Adobe RGB. You will have a wider gamut of colors to work with and can make your images the best they can be. Later, you can convert your carefully crafted images to print

with a good color profile and get great results from inkjet printers and other printing devices. Here is a rough way to look at it:

- Many people who regularly shoot in JPEG format use sRGB.
- Many people who regularly shoot in RAW format use Adobe RGB.

These are not hard-and-fast rules, but many people follow them. I shoot RAW a lot, so I often use Adobe RGB.

In reality, though, it makes *no difference* which Color space you choose when you shoot in NEF (RAW) because the Color space can be changed after the fact in your computer. However, most people are not in the habit of changing the Color space during a RAW to JPEG conversion. Therefore, if you need the extra color range, why not leave the camera set to Adobe RGB for later convenience? Why add an extra step to your digital darkroom workflow? If you are shooting for money—such as for stock image agencies—most places expect that you'll use Adobe RGB. It has a larger color range, so it's the quality standard for most commercial printing.

Settings Recommendation: I use Adobe RGB most of the time since I shoot a lot of nature pictures with a wide range of color. I want the most accurate color my camera can give me. Adobe RGB has a wider range of colors, so it can be more accurate when my subject has a lot of colors. However, if you are shooting JPEG snapshots, there's no need to worry about this. Leave the camera set to sRGB and have fun.

Which Color Space Is Best, Technically?

There is a large color space used by the graphics industry called CIELAB (figure 3.14B) or CIE L*a*b* . This color space is designed to approximate human vision. Adobe RGB covers about 50 percent of the CIELAB color space, and sRGB covers only about 35 percent. In other words, Adobe RGB has a wider gamut. That means Adobe RGB gives your images access to significantly higher levels of color, especially cyans (bluish tones) and greens. Another important consideration if you'll send your work to companies that use offset printing—such as book and magazine publishers—is that Adobe RGB maps very well to the four-color cyan, magenta, yellow, black (CMYK) printing process. If you are shooting commercial work, you may want to seriously consider Adobe RGB. Stock photo shooters are nearly always required to shoot in Adobe RGB.

Active D-Lighting

(User's Manual: Page 270, Menu Guide: Page 42)

Active D-Lighting (ADL) is used to help control contrast in your images. Basically, it helps preserve details in both the highlights and shadows that would otherwise be lost.

Sometimes the range of light around a subject is broader than a camera sensor can capture. DxO Labs rates the Nikon D7200 as able to capture 14.6 EV steps of light under controlled conditions, but in real life the range of light can sometimes exceed what the sensor can handle. The contrast is too high!

Because the camera sometimes cannot grab the full range of light—and most people use the histogram to expose for the highlights—some of the image detail will be lost in the shadows. The D7200 allows you to "D-Light" the image—bring out additional shadow detail, while protecting the highlights. In other words, you can lower the contrast in the picture. ADL has these settings:

- Auto
- Extra high
- High
- Normal
- Low
- Off

If you are familiar with Nikon CaptureNX2, you may know how ADL works. You can use it to bring up lost shadow detail at the expense of adding noise in those darker areas. We'll talk about noise in an upcoming section called **Long Exposure NR** on page 117.

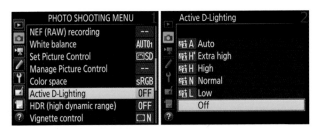

Figure 3.15A – Choosing an ADL level

Use the following steps to choose an ADL level (figures 3.15A):

1. Choose Active D-Lighting from the Photo Shooting Menu and scroll to the right (figure 3.15A, image 1).
2. Select one of the Active D-Lighting levels (figure 3.15A, image 2). Refer to figure 3.15C to see how the levels affect an image.
3. Press the OK button to save your setting.

As with some other important functions, the D7200 adds access to the ADL setting through the *i* button menu (figure 3.15B, image 2).

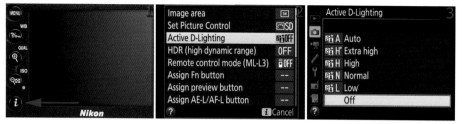

Figure 3.15B – Choosing an ADL level (alternate screens)

Here are the steps to use the *i* button menu to select an Active D-Lighting level:

1. Press the *i* button to open the special menu (figure 3.15B, image 1).
2. Highlight the Active D-Lighting setting and scroll to the right (figure 3.15B, image 2).
3. Select one of the five Active D-Lighting levels (e.g., Low, Normal, High), or choose Off for no ADL.
4. Press the OK button to lock in the setting (figure 3.15B, image 3).

Basically, ADL will bring out detail in areas of your image that are hidden in shadow due to excessive image contrast. It also tends to protect the highlights from blowing out or becoming pure white with no detail.

Figure 3.15C shows a series of six images with ADL set to its various levels, including Off. I took six pictures of my favorite RGB blocks, a Nikon lens cap, and a Nikon body cap. The six images start with ADL set to Off, and they progress through Low, Normal, High, Extra high, and Auto. I used the Vivid Picture Control to maximize contrast.

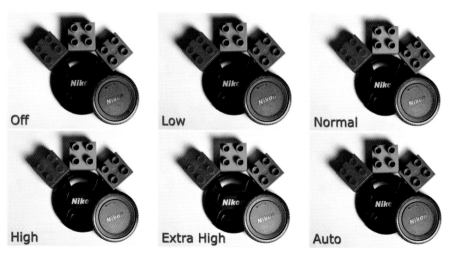

Figure 3.15C – ADL at all five levels and off

The images in figure 3.15C were taken with a point source light and deep shadows (high contrast) to show how ADL tries to pull detail out of the shadows and protect the

highlights. Notice the silver Nikon logo on the lens cap. You can begin to see detail in the last few letters as the ADL level increases. In the first image, with ADL set to Off, you can see no detail past the K in Nikon. Gradually, over the next few ADL levels, the final two letters begin to appear.

The detail shown in the Auto setting looks very similar to the High setting, which tells me that the camera chose a setting close to High ADL because of the excessive contrast. Also, notice that no highlights are blown out. ADL tends to protect highlights.

Settings Recommendation: You'll need to experiment with the ADL settings to see which ones you like best. It has the effect of lowering contrast, and some people do not like low-contrast images. Also, any time you recover lost detail from shadows, there will be extra noise in the recovered areas, so be careful!

ADL can be useful to JPEG shooters, in particular. Since you really shouldn't modify a JPEG file, it's important that the image is created exactly right in the first place. When you are shooting in a high-contrast setting, such as direct sunlight, some degree of ADL may help rein in the contrast.

If you set ADL much above Normal, the image will start to have an artificial look, in my opinion. Light skin tones can develop a pinkish look that seems unnatural to me. You can't see this in figure 3.15C because there are no skin tones. If you shoot some pictures of people with higher levels of ADL, you'll see what I mean.

Remember, your camera has multiple user settings, and you can set ADL for each setting (U1 and U2) in a different way and then select the most appropriate setting for a particular job. I leave it set to Off for the user setting that uses NEF (RAW) mode and On for the user setting that uses JPEG. Normally I don't go much above the Low setting, except for party JPEGs, which I set to Normal. My best JPEGs are set to Low because I worry about adding noise to the images with higher ADL levels.

Use Auto mode when you're shooting JPEGs and don't have time to fool with camera settings but you must get the shot, no matter what. Auto lets the camera decide the appropriate level of ADL according to the ambient light and contrast in the image.

Experiment with this by shooting images in high-contrast and low-contrast settings at all ADL levels. You'll see how the camera reacts, and then you can decide how you'll use this functionality.

HDR (High Dynamic Range)

(User's Manual: Page 270, Menu Guide: Page 42)

With the *HDR* feature, the camera combines two JPEG exposures into a single image. It is not available in NEF (RAW) mode or any mode that uses RAW. The camera uses HDR techniques to merge details from an underexposed shot and an overexposed shot into one picture with a much greater dynamic range than normal. In figure 3.16A you can see a series of HDR images. Each HDR image is made up of two images that are automatically combined.

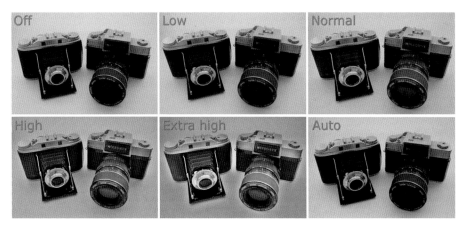

Figure 3.16A – HDR combination samples

Let's examine how to use the HDR mode for automatically combining images in the camera.

How Does HDR Work in the D7200?

HDR in the D7200 is a form of simple two-image bracketing that allows you to create an HDR image without setting up a normal bracketing series. There are two settings under HDR:

- **HDR mode:** This setting has three options: On (series), On (single photo), and Off. When On (series) is selected, the camera will keep shooting its two-image HDR brackets until you set HDR mode to Off. When you choose On (single photo), the camera will take a single two-image HDR bracket for one picture combination. Off means the camera does not create an HDR image.
- **HDR strength:** In a similar way to Active D-Lighting (ADL), in-camera HDR attempts to extend the dynamic range of the final image. Unlike ADL, which extends the range of a single image by manipulating the exposure, HDR takes two pictures with different exposures of varying strength; that is, the camera takes the first picture at close to a normal exposure, with maybe some underexposure to keep the highlights in check, then it overexposes the second picture to pull data out of the shadows. It then combines the two images into one. The strength setting simply tells the camera how much over- and underexposure to use in the two images to get more image data. It goes from slight amounts (Low) to outrageous amounts (Extra high).

First, let's examine how to configure the two settings and prepare for HDR shooting.

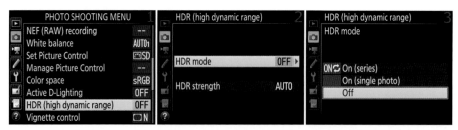

Figure 3.16B – Choosing an HDR mode

Use these steps to enable HDR mode for a single picture or a series:

1. Choose HDR (high dynamic range) from the Photo Shooting Menu and scroll to the right (figure 3.16B, image 1).
2. Select HDR mode and scroll to the right (figure 3.16B, image 2).
3. Decide if you want to make one or a series of HDR images and choose accordingly: On (series) for a series of combined images, or On (single photo) for a single combined picture (figure 3.16B, image 3). Choose Off to disable HDR.
4. Press the OK button to prepare the camera for shooting in HDR mode.

When the D7200 is set to HDR mode, you will see the abbreviation Hdr displayed in the lower-right area of the Viewfinder when you press the Shutter-release button halfway down. While using Live view mode, you will see HDR followed by an abbreviation for the level (L, N, H*, A) on the top-right area of the Monitor (e.g., HDR L). It will go away when the HDR mode is set to Off.

Now, let's examine how to configure the HDR strength setting.

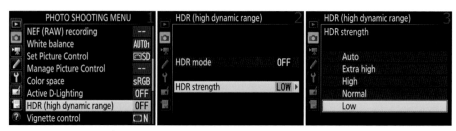

Figure 3.16C – Choosing an HDR strength

Use the following steps to choose an HDR strength setting:

1. Choose HDR (high dynamic range) from the Photo Shooting Menu and scroll to the right (figure 3.16C, image 1).
2. Select HDR strength and scroll to the right (figure 3.16C, image 2).
3. Choose one of the five settings, according to how much exposure variance you want between the two images that will be combined. Use Auto to let the camera decide, or choose from Extra high to Low (figure 3.16C, image 3). If you have a high-contrast

subject, you may want to try Normal or High first to see if it works okay. For low- to medium-contrast subjects, choose Low or Normal.

4. Press the OK Button to lock in your choice.

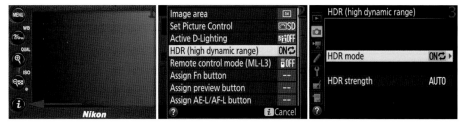

Figure 3.16D – Alternate screens to enable HDR

You can change the HDR settings more quickly by using the *i* button menu (figure 3.16D):

1. Press the *i* button to open the special menu (figure 3.16D, image 1).
2. Highlight HDR (high dynamic range) and scroll to the right (figure 3.16D, image 2).
3. Use the steps from figures 3.16B and 3.16C to set the HDR mode and HDR strength.

Now it's time to take an HDR picture. Here are some things you need to know during and after the HDR process:

- The camera will take two exposures when you press the Shutter-release button one time. It is a good idea to have the camera on a tripod, or you may end up with a blurry combined image. If you do choose to handhold in low light, brace yourself and do not allow camera movement. When the light is very bright, the HDR process can be quite fast. It is much slower in low light and takes several seconds to deliver a combined image.
- *Hdr* will be displayed in the lower-right area of the Viewfinder when you hold the Shutter-release button halfway down.
- *HDR* will display on the upper-right side of the Monitor during Live view HDR shooting.
- During HDR exposure and image combination, the Live view screen will not display anything.
- *Job* will flash briefly in the lower-left area of the Viewfinder during image combination.
- The edges of the image may be cropped, so do not allow important parts of the subject to touch the edges.
- You cannot select any form of NEF (RAW) when you're using HDR; you can use only JPEG. HDR is grayed out on the Photo Shooting Menu when you're using NEF (RAW).
- Matrix metering is the most effective meter type when you shoot HDR images. If you use Center-weighted or Spot metering, or a non-CPU lens, an HDR strength of Auto is the same as the Normal HDR strength setting. It may be best to stick with Matrix metering for HDR.

Settings Recommendation: I am a big fan of bracketed HDR. You can often find me on top of some Appalachian mountain shooting a five-bracket HDR image of the valley below. Beautiful things can be done with HDR. I do not like the shadowless HDR that some photographers shoot. To me it looks fake and seems faddish. However, HDR, when used correctly, can help create images that the camera could not normally take due to an excessive light range.

The D7200's HDR two-shot method is not quite up to the standards of a fully bracketed HDR shot. However, the D7200's HDR function makes it possible to capture an image you could not get otherwise due to excessive contrast.

Be careful not to use HDR with a rapidly moving subject. The subject will be in a different place on each of the two exposures and cause blurry combined images. Reserve HDR shots for static or very slow-moving subjects (e.g., clouds).

If you are really into HDR, or would like to be, check out the excellent second edition of *Practical HDRI,* by Jack Howard, published by Rocky Nook. Howard will show you everything you need to know about HDR.

Photoshop has built-in software for HDR, or you can buy less-costly dedicated software, such as Photomatix Pro by HDRsoft (my favorite). I've been using Photomatix Pro for several years to combine my bracketed images into carefully tone-mapped HDR images.

There are some limitations to in-camera HDR, which is why people who are really serious about it use the main bracketing system and combine their images in professional HDR software. However, using the HDR function in the D7200 is an easy way to knock off a few quick HDR images for those times when only HDR will do. Give it a try!

Vignette Control

(User's Manual: Page 271, Menu Guide: Page 43)

Vignette control allows you to reduce the amount of vignetting (slight darkening) that many lenses have in the corners at wide-open apertures. The angle at which light rays strike a sensor on its edges is greater than the angle at which rays go straight through the lens to the center of the sensor. Because of the increased angle, some light falloff occurs at the extreme edges of the frame, especially at wide apertures, because more of the lens element is in use.

In recognition of this fact, Nikon has provided the Vignette control setting. It can reduce the vignetting effect to a large degree. If more vignette control is required, you can use Photoshop or Nikon CaptureNX2 (or other software) to remove it.

Figure 3.17A shows a sample of what the Vignette control can accomplish on its own. I shot four pictures of the sky at a wide-open aperture. Each picture has more Vignette control applied, from Off to High.

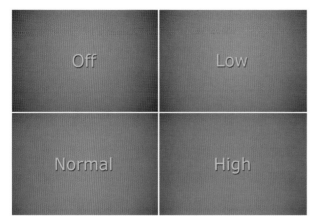

Figure 3.17A – Vignette control range

Let's see how to configure Vignette control for edge light falloff reduction with your lenses.

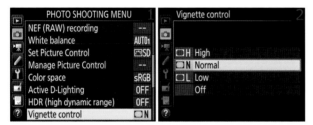

Figure 3.17B – Vignette control choices

Here are the steps to choose a Vignette control level:

1. Choose Vignette control from the Photo Shooting Menu and scroll to the right (figure 3.17B, image 1).
2. Select an edge-lightening level from the list. My camera has Normal selected in figure 3.17B, image 2.
3. Press the OK button to lock in the level.

Note: Vignette control will work only with G-, E-, and D-type lenses, with the exception of PC lenses. Nikon warns that you may see noise, fog, or variations in edge brightness while using "custom Picture Controls and preset Picture Controls that have been modified from default settings." It may be a good idea to test each of your lenses and pixel peep the edges to see if you notice any problems. Vignette control does not work when you shoot movies, multiple exposures, or when using a lens that supports the FX format.

Settings Recommendation: The camera default is Normal, so I have been shooting most of my images with that setting. I like this control. It does help remove vignetting in the corners when I shoot with the aperture wide open. I have not noticed any additional noise or image degradation in the corrected areas. I suggest leaving your camera set to Normal

at all times unless you are shooting with a lens that has a greater tendency to vignette, in which case you can increase it to High. Even High does not seem to fully remove the vignetting when a lens is wide open, so this is not an aggressive algorithm that will leave white spots in the corners of your images.

Why not shoot a few images with your lenses at wide aperture and see how the Vignette control works with your lens and camera combinations?

Remember, you can remove vignetting in the computer with post-processing software if the camera's Vignette control setting does not entirely remove the problem.

Auto Distortion Control

(User's Manual: Page 271, Menu Guide: Page 44)

Auto distortion control is a function designed to automatically detect and remove certain lens aberrations in Nikkor type G, E, and D lenses. Basically, if you leave this setting turned On, the camera will try to remove barrel distortion when you use a wide-angle lens and pincushion distortion when you use a telephoto lens (figure 3.18A).

Figure 3.18A – Extreme examples of barrel (left) and pincushion (right) distortion

Barrel distortion occurs when straight lines bow outward like a barrel. Imagine a door frame with the middle bowed outward. It looks strange! Also, when you are close to an object, things centered directly in front of the lens can seem closer to the camera than things on the edges of the picture. Shooting against a flat wall can make it seem to bulge toward the camera in an odd way.

Pincushion distortion is just the opposite; the edges of things seem to bow inward. If you see this problem in your images, Auto distortion control may help you overcome it. Unfortunately, this can cause the edges of your image to be removed (cropped) as the camera adjusts the distorted areas of the image.

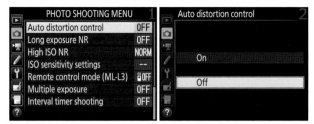

Figure 3.18B – Using Auto distortion control

Use the following steps to enable or disable Auto distortion control:

1. Select Auto distortion control from the Photo Shooting Menu and scroll to the right (figure 3.18B, image 1).
2. Choose On or Off from the menu (figure 3.18B, image 2).
3. Press the OK button to lock in the setting.

Settings Recommendation: I tend to shoot in RAW and want to adjust my images later in Photoshop so I can use its very powerful distortion tools. I therefore rarely leave this function enabled. However, if you are a JPEG shooter who is allergic to post-processing images, this function gives you another automatic choice to keep you off the computer. If you know your lens tends to have barrel or pincushion distortion, maybe you'll want to use this function.

Long Exposure NR

(User's Manual: Page 271, Menu Guide: Page 45)

Long exposure NR (noise reduction) is designed to combat visual noise in long exposures. Long-exposure noise is a little different from grainy-looking high-ISO sensitivity noise due to its cause. Nikon says long-exposure noise appears as: "bright spots, randomly-spaced bright pixels, or fog." Why does this happen? During longer exposures, the imaging sensor can start to warm up a little, especially in warm ambient temperatures. This causes a condition called amp noise, in which warmer sections of the imaging sensor start to display more foggy noise than other sections.

Additionally, when pixels are left turned on for a longer period of time, a few of them may become brighter than normal and record an improper color; often bright red. Those off-color, hot pixels should be removed by the camera. Long exposure NR does just that.

Long-exposure noise is best handled by this Long exposure NR function, while high-ISO noise is well handled by High ISO NR (next section). Sometimes, when you are shooting long exposures at higher ISO settings, both may be needed!

Nikon warns that images taken at shutter speeds longer than 1 second without Long Exposure NR may exhibit more long-exposure noise than is acceptable for normal images.

There are two settings for Long exposure NR, as shown in figure 3.19A.

- **On:** When you select On and the exposure goes over 1 second, the camera will take two exposures with the exact same time for each. The first exposure is the normal picture-taking exposure. The second is a dark-frame subtraction exposure, in which a second exposure is made for the same length of time as the first one, but with the shutter closed. The noise (hot pixels and fog) in the dark frame image is examined and then subtracted from the original image. It is really quite effective and beats having to blur the image to get rid of noise. I've taken exposures of around 30 seconds and had perfectly usable results. The only drawback is that the exposure time is doubled because two exposures are made. The dark frame exposure is not written to the memory card, so you'll have only one image, with much less noise, in the end. While the dark frame image is being processed, the words *Job nr* will blink on the camera display. During this second exposure, while *Job nr* is flashing, you cannot use the camera. If you turn it off while *Job nr* is flashing, the camera still keeps the first image; it just doesn't do any noise reduction on it. If Long exposure NR is set to On, the frame advance rate may slow down a little in Continuous release mode, and the capacity of the in-camera memory buffer will drop while the image is being processed.
- **Off:** If you select Off, then, of course, you will have no long exposure noise reduction with exposures longer than 1 second.

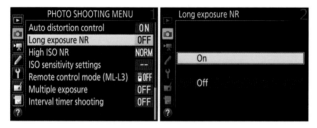

Figure 3.19A – Choosing a Long exposure NR setting

Here are the steps to choose a Long exposure NR setting:

1. Choose Long exposure NR from the Photo Shooting Menu and scroll to the right (figure 3.19A, image 1).
2. Select either On or Off (figure 3.19A, image 2).
3. Press the OK button to save your setting.

You can also open the Long exposure NR menu by pressing the *i* button and selecting Long Exposure NR from near the end of the menu (second page).

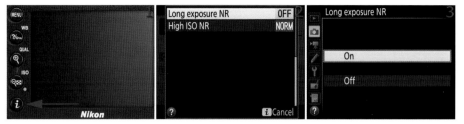

Figure 3.19B – Opening Long exposure NR from the *i* button menu

Use these steps to change Long exposure NR quickly with the *i* button menu:

1. Press the *i* button once (figure 3.19B, image 1). This will cause the *i* button menu screen to appear (figure 3.19B, image 2). Scroll to the Long exposure NR position and press the OK button.
2. The Long exposure NR screen will now appear, allowing you to turn it On or Off (figure 3.19B, image 3) by highlighting your choice and pressing the OK button.

Settings Recommendation: I like the benefits of Long exposure NR. I shoot a lot of waterfall and stream shots where I often need exposures of several seconds to really blur the water. Also, I like to take midnight shots of the sky and even shots of city scenes at night. Even though it may slow down the frame rate slightly and allow me fewer images in the in-camera memory buffer for burst shooting, I still use it most of the time.

If I were a sports or action shooter using Continuous release mode, I might leave Long exposure NR turned Off. It's unlikely I would be using exposures longer than 1 second, and I would want maximum frames per second as well as the ability to cram as many images into the camera buffer as possible. I wouldn't want my camera to slow down while writing images to the memory card.

Your style of shooting will govern whether this function is useful to you. Ask yourself one simple question: "Do I often shoot exposures longer than one second?" If so, you may want Long exposure NR set to On. Compare how the images look with and without it. I think you'll like Long exposure NR.

Pixel Problems

Pixel problems can damage an otherwise pristine image. Let's explore the difference between the three pixel problems: a stuck pixel, a hot pixel, and a dead pixel.

Stuck Pixel: This type of pixel is receiving power from the camera, so it is not a dead pixel. However, the pixel has lost its mind, in a sense, and ignores the actual shades it should be recording. The pixel will display in one color that does not change from picture to picture. The most common color seems to be red, although you might see another color. The key is that a stuck pixel is stuck on one color all the time, and that color does not match the surrounding pixels that are reporting correct color shades. It is always present in the image in the same spot and does not disappear.

Hot Pixel: This pixel problem is very common. Even the most expensive cameras suffer from them. Even brand-new cameras! They come and go from various places and can have almost any color, although, again, the ones I see are usually red (maybe because that's the most noticeable color). These off-color pixels are caused by heat in the sensor and sometimes even from high ISO settings (above ISO 800). Camera manufacturers try to map out pixels that tend to become hot pixels before the camera leaves the factory. However, due to the variability of where they are located at different levels of heat and ISO settings, it is impossible to map them out fully. This type of pixel is often removed by the camera's two noise reduction functions: Long exposure NR and High ISO NR, with Long Exposure NR being the most effective.

Dead Pixel: A dead pixel is a defective pixel on the camera's sensor. It is not receiving power, or it is no longer able to function when power is applied. It could appear as a tiny dark spot in your image that does not change position from picture to picture. Or, it could appear as an off-colored pixel due to Bayer-filter demosaicing. Generally, cameras come from the factory with all dead pixels mapped out. However, if a pixel dies over time, you will see evidence of the dead pixel once it is completely dead. Once a pixel dies, it usually stays nonfunctional.

High ISO NR

(User's Manual: Page 271, Menu Guide: Page 45)

High ISO NR (High ISO Noise Reduction) lessens the effects of digital noise in your images when you use high ISO sensitivity (exposure gain) settings by using a blurring and resharpening method.

Nikon doesn't specify the exact ISO level at which High ISO NR kicks in. I suspect that a small amount of noise reduction occurs at around ISO 400–800 and gradually increases as the ISO gets higher.

The D7200 has better noise control than most cameras, so it can shoot up to ISO 800 with little noise. However, no digital camera (that I know of) is completely without noise, so it's a good idea to use some noise reduction above a certain ISO sensitivity.

If High ISO NR is turned Off, the camera still does a small amount of noise reduction— less than the Low setting. Therefore, there will always be some noise reduction at higher ISO settings.

You can control the amount of noise reduction by choosing one of the four High ISO NR settings: High, Normal, Low, or Off. Shoot some high-ISO exposures and decide for yourself which settings you are comfortable with.

Figure 3.20A is a sample image of my 1963 Nikkorex Zoom 35 taken at ISO 25,600 with High ISO NR set to Off, Low, Normal, and High settings. The red rectangle in the little picture of the camera indicates the area that is shown in the four larger images. These images were shot with no flash of the dark subject at the camera's highest normal ISO sensitivity setting. It is a worst-case noise scenario.

Figure 3.20A – High ISO NR – Off to High correction samples

High ISO NR works by first blurring then resharpening the image more and more as you increase the setting from Low to High. By blurring the image, the camera blends the grainy noise into the surroundings to make it less visible. Some mild resharpening is applied to restore image sharpness. This whole process tends to make the image lose detail, which is worsened with higher noise reduction levels.

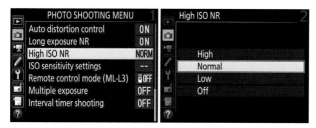

Figure 3.20B – Setting High ISO NR

Use the following steps to choose a High ISO NR setting:

1. Choose High ISO NR from the Photo Shooting Menu and scroll to the right (figure 3.20B, image 1).
2. Select one of the noise reduction levels: High, Normal, Low, or Off (figure 3.20B, image 2).
3. Press the OK button to save your setting.

The D7200 also allows you to control the High ISO NR function by using the *i* button menu.

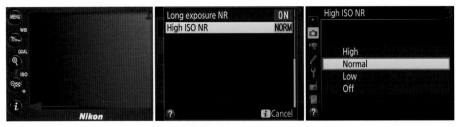

Figure 3.20C – Setting High ISO NR (alternate screens)

1. Press the *i* button (figure 3.20C, image 1).
2. Select High ISO NR from the end of the menu (last item), and press the OK button (figure 3.20C, image 2).
3. Select one of the noise reduction levels: High, Normal, Low, or Off (figure 3.20B, image 3).
4. Press the OK button to save your setting.

Settings Recommendation: I leave High ISO NR set to Low or Normal. I do want some noise reduction above ISO 800. However, since any form of noise reduction blurs the image, I don't go too far with it. I shoot RAW, so it really makes no difference because I can change everything later in the computer. If I were shooting JPEG, it would make a serious differ-ence. Why not test a few images at high ISO sensitivity settings with High ISO NR turned On to see which setting you like? Remember that you can use a different choice for each User setting (U1 and U2) to configure your camera for different shooting styles.

What Is Noise?

Have you ever tried to watch TV while children are playing in the same room? The louder you turn up the TV, the louder the kids get, it seems. However loud the volume of the TV, the children laughing and running around degrades the pure sound you desire. There is a high child-to-TV noise ratio that interferes with your enjoyment of the program. After a while, there is a point when you simply have to ask the kids to leave the room. Noise in a digital image is somewhat similar. You want pure, clean images when you take pictures, but digital noise interferes with the clarity. The higher you turn the camera's ISO sensitivity, the more digital noise degrades your image. The noise-to-signal ratio can damage the picture. How can you make the visual noise go away? Use High ISO NR, that's how!

ISO Sensitivity Settings

(User's Manual: Page 271, Menu Guide: Page 46)

ISO sensitivity settings give you control over the light sensitivity of the imaging sensor, including whether you manually control it or the camera sets it automatically.

An ISO sensitivity number, such as 200 or 3200, is an agreed-upon sensitivity level for the image-capturing sensor. Virtually everywhere one goes in the world, all camera ISO numbers will mean the same thing. With that fact established, camera bodies and lenses can be designed to take advantage of the ISO sensitivity ranges they will have to deal with.

In figure 3.21A we see the external camera controls used to change the ISO sensitivity on the D7200. This is a good way to adjust ISO sensitivity quickly. This is also the easiest method to change the camera's ISO sensitivity setting, although it doesn't involve the Photo Shooting Menu, which we are now examining.

Figure 3.21A – External controls to set ISO manually

Here are the steps you'll use to manually adjust the camera's ISO sensitivity:

1. Hold down the ISO button (figure 3.21A, image 1). The D7200 will display the current ISO sensitivity on all camera displays.
2. Rotate the rear Main command dial counterclockwise to increase the ISO sensitivity or clockwise to decrease sensitivity while watching the ISO value change on the Monitor (figure 3.21A, image 2).
3. The ISO sensitivity number will also show on the Control panel (Figure 3.21A, image 3), and at the bottom right of the Viewfinder and the Live view screen.
4. Release the ISO button when the value you desire appears on the camera's displays.

ISO Sensitivity

You can also use ISO sensitivity settings directly from the Photo Shooting Menu to change the camera's ISO sensitivity. Figure 3.21B shows the three screens used. Select your favorite ISO sensitivity for the circumstances in which you find yourself.

Notice in image 3 of figure 3.21B that you have a scrollable list of ISO sensitivity settings, from ISO 100 to Hi 2BW and Auto. The "normal" ISO range for the D7200 is ISO 100 to 25600.

Following is a list of the camera's ISO range:

- **Normal** ISO 100 to 25600 Color
- **Hi BW1** ISO 51200 equivalent Monochrome
- **Hi BW2** ISO 102400 equivalent Monochrome

As the list shows, the camera also offers two monochrome-only extended ISO modes: Hi BW1 (ISO 51200 equivalent) and Hi BW2 (ISO 102400 equivalent). The two monochrome, extended Hi ISO modes are available only when the camera's Mode dial is set to P, S, A, or M, and the modes use the current settings found under *Set Picture Control > MC Monochrome* in the Photo Shooting Menu (see page 93).

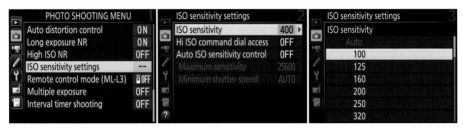

Figure 3.21B – Setting ISO sensitivity from the Photo Shooting Menu

Here are the steps to select an ISO sensitivity setting (figure 3.21B):

1. Choose ISO sensitivity settings from the Photo Shooting Menu and scroll to the right (figure 3.21B, image 1).
2. Select ISO sensitivity from the menu and scroll to the right (figure 3.21B, image 2).
3. Scroll up or down in the ISO sensitivity settings menu until you highlight the ISO value you want to use (figure 3.21B, image 3). ISO 100 is selected.
4. Press the OK button to save the ISO sensitivity setting.

The standard minimum ISO sensitivity for the D7200 is ISO 100. You may adjust the camera's ISO sensitivity in a range from ISO 100 to 25600, in 1/3 or 1/2 steps. The ISO step increment is controlled by *Custom Setting Menu > b Metering/exposure > b1 ISO sensitivity step value,* and can be set to 1/3 or 1/2 EV step. We'll look at this more carefully in the upcoming chapter titled **Custom Setting Menu** on page 201.

Select your favorite ISO sensitivity setting, using either the external camera controls or the Photo Shooting Menu's ISO sensitivity settings function. If you'd like, you can simply let your camera decide which ISO it would like to use. Let's consider this often-misunderstood feature in detail.

Hi ISO Command Dial Access

Normally, the camera limits your ISO sensitivity selection to a maximum of ISO 25600 when using the ISO button and rear Main command dial to make an ISO sensitivity selection. However, by setting High ISO command dial access to On, the extended, monochrome Hi BW1 and Hi BW2 are also available as ISO sensitivity selections.

Following are the screens to configure Hi ISO command dial access.

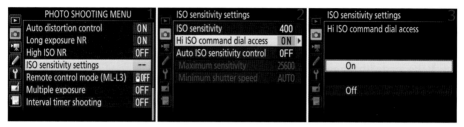

Figure 3.21C – Enabling Hi ISO command dial access

Use the following steps to enable or disable Hi ISO command dial access:

1. Choose ISO sensitivity settings from the Photo Shooting Menu and scroll to the right (figure 3.21C, image 1).
2. Select Hi ISO command dial access from the menu and scroll to the right (figure 3.21C, image 2).
3. Select On or Off from the Hi ISO command dial access menu (figure 3.21C, image 3). My camera has On selected.
4. Press the OK button to save the setting.

Figure 3.21D – Hi ISO sensitivity settings on the Information display

Once you have enabled Hi ISO command dial access, the Hi-BW1 (Hi1) and Hi-BW2 (Hi2) settings will show on the Monitor screen when you hold down the ISO button (figure 3.21D, image 1) and turn the rear Main command dial to the end of the ISO range (figure 3.21D, image 2). This works the same way as the screens shown in figure 3.21A, except the ISO range now extends to the two highest ISO settings.

Note: The same two extended, monochrome ISO settings will appear on various camera displays and menus with the following names:
- Hi BW1, Hi-BW1, Hi1, and H1 for the ISO 51,200 equivalent setting
- Hi BW2, Hi-BW2, Hi2, and H2 for the ISO 102,400 equivalent setting

ISO Sensitivity Auto Setting

You may have noticed that there's a grayed-out Auto setting at the top of the ISO sensitivity settings menu in figure 3.21B, image 3. The same setting is not grayed out in figure 3.21E.

This Auto setting is the default when you have the camera set to one of the Mode dial's automatic SCENE or EFFECTS modes or the AUTO mode, and it allows the camera to take full control of adjusting the ISO sensitivity to help you get the picture under difficult lighting.

Note: Don't confuse the ISO sensitivity Auto setting with the AUTO mode (the green camera on the Mode dial) or the *Auto ISO sensitivity control* (ISO-AUTO) that we'll discuss in the next subsection.

Figure 3.21E – ISO sensitivity Auto setting

A nice feature on the D7200 is that you can use the fully automatic AUTO, EFFECTS, or SCENE modes and still adjust the ISO sensitivity manually by taking the ISO out of Auto and selecting a specific ISO instead (figure 3.21E). Auto will stay grayed out until you enter one of the SCENE or AUTO modes.

This feature allows new users to gradually learn how to take more control of the camera settings.

Auto ISO Sensitivity Control (ISO-AUTO)

You may have noticed in figure 3.21C, image 2, that there is another setting available, the *Auto ISO sensitivity control,* which defaults to Off. This setting allows the D7200 camera to control the ISO sensitivity and shutter speed according to the light levels sensed by the camera's metering system. Figure 3.21F shows the Photo Shooting Menu screens used to enable Auto ISO sensitivity control.

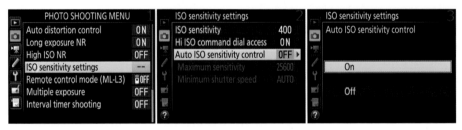

Figure 3.21F – Enabling Auto ISO sensitivity control

Use the following steps to enable or disable the Auto ISO sensitivity control:

1. Choose ISO sensitivity settings from the Photo Shooting Menu and scroll to the right (figure 3.21F, image 1).

2. Select Auto ISO sensitivity control from the menu and scroll to the right (figure 3.21F, image 2).
3. Select On or Off from the ISO sensitivity settings menu (figure 3.21F, image 3). My camera has On is selected.
4. Press the OK button to save the ISO sensitivity setting.

Once you've set Auto ISO sensitivity control to On, you should immediately set two values, according to how you shoot: Maximum sensitivity and Minimum shutter speed. Let's discuss each of them.

Maximum Sensitivity

The Maximum sensitivity setting is a safeguard for you (figure 3.21G, image 2). It allows the camera to adjust its own ISO sensitivity from the minimum value you have set in ISO sensitivity (figure 3.21B, image 2) to the value set in Maximum sensitivity (figure 3.21G, image 2), according to light conditions.

Think of the main *ISO sensitivity* setting as the ISO floor value (lowest ISO used) and the *Maximum sensitivity* setting as the ISO ceiling value (highest ISO used). When using the Auto ISO sensitivity control, the camera will not exceed the floor and ceiling ISO values.

The camera will try to maintain the lowest ISO sensitivity it can to get the picture. However, if needed, it can rapidly rise to the Maximum sensitivity level to "get the picture" no matter what.

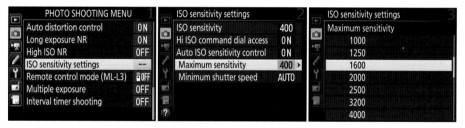

Figure 3.21G – Auto ISO sensitivity control – Maximum sensitivity

If you would prefer that the Maximum sensitivity setting not exceed a certain maximum ISO value, simply select a Maximum sensitivity from the list shown in figure 3.21G, image 3.

The factory default Maximum sensitivity value is ISO 25600. This default setting will let the camera take the ISO sensitivity all the way up to ISO 25600 in a low-light situation. However, if you think an ISO that high may cause too much noise in your images, you may want to reduce the ISO value. My camera is set to ISO 1600 (image 3). Maximum sensitivity is the maximum ISO value the camera will use to get a good exposure when the light drops.

What happens when the camera reaches the Maximum sensitivity setting and there still isn't enough light for a good exposure? Let's find out by examining the second part of the Auto ISO sensitivity control, Minimum shutter speed.

Minimum Shutter Speed

Because shutter speed helps control how sharp an image can be, depending on camera shake and subject movement, you will need some control over the minimum shutter speed allowed while the ISO sensitivity auto control is turned On (figure 3.21H).

The Minimum shutter speed setting allows you to select the minimum shutter speed that the camera will allow when the light diminishes. In exposure modes Programmed auto (P mode: camera controls shutter and aperture) and Aperture-priority (A mode – camera controls shutter and you control aperture), the camera will not go below the Minimum shutter speed unless the Maximum sensitivity setting still won't give you a good exposure.

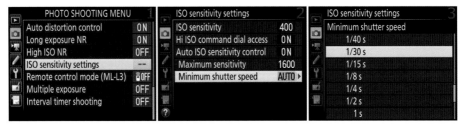

Figure 3.21H – Auto ISO sensitivity control – Minimum shutter speed

This is the answer to our question in the last section about what happens when there is not enough light and the camera has reached the Maximum sensitivity level. Even though you've selected a Minimum shutter speed, the camera will go below the Minimum shutter speed when the Maximum sensitivity ISO number has been reached and the light is still too low for a good exposure.

In other words, in Programmed auto (P) or Aperture-priority (A) exposure modes, if you get into low light and try to take pictures, the camera will try to keep the ISO sensitivity as low as possible until the shutter speed drops to your selected Minimum shutter speed. Once it hits the selected Minimum shutter speed value—like the 1/30s shown in figure 3.21H, image 3—the ISO sensitivity will begin to rise up to your selected Maximum sensitivity value, like the ISO 1600 shown in figure 3.21G, image 3.

Once the camera hits the Maximum sensitivity value, if there still isn't enough light for a good exposure, it won't keep raising the ISO sensitivity. Instead, the camera will now go below your selected Minimum shutter speed, dropping below the 1/30s shown in figure 3.21H, image 3. Be careful, because if the light gets that low, your camera can go all the way down to a shutter speed of 30 seconds to get a good exposure. You had better have your camera on a tripod and have a static subject with shutter speeds that low.

Look at the Minimum shutter speed value as the lowest "safe" speed, after which you'll put your camera on a tripod. Most people can handhold a camera down to about 1/60s if they are careful, and maybe 1/30s if they're extra careful and brace themselves. Below that, it's blur city for your images. It's even worse with telephoto lenses. Camera movement is greatly magnified with a long lens, and a Minimum shutter speed of 1/250s to 1/500s or more may be required.

The next section discusses an excellent solution the Nikon D7200 gives us for those times when we are using a longer lens requiring a faster shutter speed to maintain sharp images—the Auto Minimum shutter speed setting.

Auto Minimum Shutter Speed

There is an important principle in photography called the reciprocal of focal length shutter speed rule. You may know the rule; however, a short review won't hurt. This impressive-sounding rule simply means that you should use a tripod (no handholding) whenever the shutter speed in use is below the reciprocal of the lens's focal length. For example, if you are using a 50mm zoom position on your lens, you should not use a shutter speed below 1/50s without having the camera on a tripod.

With a 105mm focal length, the minimum handheld shutter speed is 1/100s or 1/125s. There is no 1/105s available, so you can use the closest one. If you are using a 300mm lens, you should not use a shutter speed below 1/300s.

The reason this rule exists is because a longer focal length tends to magnify the subject and any vibrations you introduce when you press the shutter-release button. With a shutter speed below the reciprocal of the lens focal length, you can introduce movement just from your heartbeat, the reflex mirror slap, or natural hand shakiness. If you are going to handhold the camera at slower shutter speeds, you need to learn how to brace yourself properly. The best thing is to use a tripod any time you have to shoot below the reciprocal of the lens's length. Otherwise, you will be known for your well-exposed, yet blurry images (from camera shake). While lenses with vibration reduction (VR) can help, they are not a cure-all for camera shake at slow shutter speeds.

When using the Auto ISO sensitivity control you have an opportunity to implement the reciprocal of focal length shutter speed rule in an *automatic* fashion. The Nikon D7200 has added an Auto setting for Minimum shutter speed, which allows the camera to sense what focal length is currently in use and prohibits the camera from using a minimum shutter speed that would cause camera shake—unless the Maximum sensitivity ISO has been exceeded. Let's examine how to use it.

Use these steps to enable Auto Minimum shutter speed:

1. Choose ISO sensitivity settings from the Photo Shooting Menu and scroll to the right (figure 3.21I, image 1).
2. Select Minimum shutter speed and scroll to the right (figure 3.21I, image 2).
3. Select Auto from the top of the Minimum shutter speed list and scroll to the right (figure 3.21I, image 3).
4. Adjust the Auto Minimum shutter speed fine-tuning scale (figure 3.21I, image 4). Each position on the scale is the equivalent of one stop (1 EV). The camera will use the reciprocal of the focal length of the mounted lens if the yellow pointer is left in the center as seen in figure 3.21I, image 4. If you move it one notch to the right of center the camera will switch to the reciprocal of the focal length plus one stop. If you are using a 50mm lens, the reciprocal of 50mm plus one stop is 1/100s (1/50s plus 1 EV) for the camera's

minimum shutter speed. If you move the scale one notch to the left of center, the camera will use 1/25s instead (1/50s less 1 EV). Here is a list matching what each position on the scale represents if you are using a 50mm lens: 1/13s, 1/25s, 1/50s, 1/100s, 1/200s. Of course, these numbers will vary with the focal length of the lens mounted on the camera.

5. Press the OK button to lock in the fine-tuned Auto Minimum shutter speed.

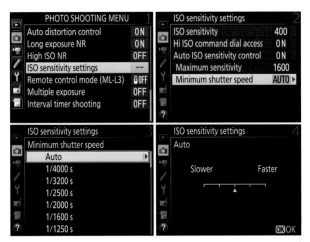

Figure 3.21I – Auto ISO sensitivity control – Auto Minimum shutter speed

Note: Shutter-priority (S) and Manual (M) modes allow you to control the camera in a way that overrides certain parts of the Auto ISO sensitivity control.

In Manual mode (M), the camera relinquishes all control of the shutter and aperture. It can adjust only the ISO sensitivity by itself, so it can obey the Maximum sensitivity but the Minimum shutter speed is overridden and does not apply.

In Shutter-priority mode (S), the camera can control the aperture but the shutter speed is controlled only by the camera user. So, the Auto ISO sensitivity control can still control the Maximum sensitivity but has lost control over the Minimum shutter speed.

Also, it may be a good idea to enable High ISO NR—as discussed a few pages back—when you use the Auto ISO sensitivity control. This is especially true if you leave the camera set to the default Maximum sensitivity value of 25600. Otherwise, you may have excessive noise when the light drops.

When a flash unit is used, the value in Minimum shutter speed is ignored. Instead, the camera uses the value found in Custom setting e1 Flash sync speed.

If Auto is selected for Minimum shutter speed, the camera will decide which shutter speed to use as a minimum based on the focal length of the lens in use, if the lens is a CPU type; otherwise, for a non-CPU lens, the camera selects 1/30s as a Minimum shutter speed.

Settings Recommendation: When I use the Auto ISO sensitivity control with my D7200 I set my camera to Auto Minimum shutter speed. Why worry about having to adjust a setting just because I changed lenses? The camera is smart enough to know what to do and tries to protect me from losing sharpness from camera shake.

Enabling ISO-AUTO with External Controls

If you like to use external controls to make adjustments when possible (don't we all?), be aware that you can conveniently turn the Auto ISO sensitivity control on and off with the ISO button, the front Sub-command dial, and the Monitor or Control panel.

Figure 3.21J shows the controls. You will need to configure ISO-AUTO before you use the external controls or the camera will use factory defaults.

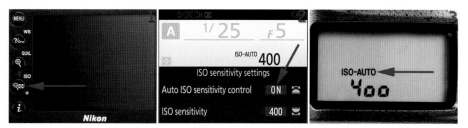

Figure 3.21J – Enabling Auto ISO sensitivity control with external camera controls

Here are the steps you'll use to manually enable or disable ISO-AUTO:

1. Hold down the ISO button (figure 3.21J, image 1).
2. Rotate the front Sub-command dial to enable or disable ISO-AUTO, the Auto ISO sensitivity control (figure 3.21J, image 2). On is enabled, Off is disabled.
3. The ISO-AUTO symbol will show on the Control panel (figure 3.21J, image 3).

When, Why, and How Should I Use ISO-AUTO?

How much automation do you need to produce consistently excellent images? Let's explore how and when automatic, self-adjusting ISO might improve or degrade your images. What is this feature all about? When and why should I use it? Are there any compromises in image quality when using this mode?

Normally, you set your camera to a particular ISO number, such as 200 or 400, and shoot your images. As the light gets darker, or in the deep shade, you might increase the ISO sensitivity to continue taking handheld images.

If you absolutely must get the shot, the Auto ISO sensitivity control will work nicely. Here are a few scenarios:

- **Scenario #1:** Let's say you are a photojournalist and you're shooting flash pictures of the president as he disembarks from his airplane, walks into the terminal, and is driven away in his limousine. Under these circumstances, you have little time to check your ISO settings or shutter speeds and are shooting in widely varying light conditions.
- **Scenario #2:** You are a wedding photographer in a church that doesn't allow the use of flash. As you follow the bride and groom from the dark inner rooms of the church out into the lobby and finally up to the altar, your light conditions vary constantly. You have

no time to deal with the fluctuations in light by changing your ISO because things are moving too quickly.

- *Scenario #3:* You are at a party, and you want some great pictures. You want to use flash, but the pop-up Speedlight may not be powerful enough to reach across the room at low ISO settings. You really don't want to be bothered with camera configuration at this time but still want some well-exposed images. Light will vary as you move around the room, talking, laughing, and snapping pictures.

These scenarios present excellent environments for the Auto ISO sensitivity control. The camera will use your normal settings, such as your normal ISO, shutter speed, and aperture, until the light will not allow those settings to provide an accurate exposure. Only then will the camera raise the ISO or lower the shutter speed to keep functioning within the shutter/aperture parameters you have set.

Look at Auto ISO as a fail-safe for times when you must get the shot but have little time to deal with camera settings or when you don't want to vary the shutter/aperture settings but still want to be assured of a well-exposed image.

Unless you are a private detective shooting handheld telephoto images from your car or a photojournalist or sports photographer who must get the shot every time regardless of maximum quality, I personally would not recommend leaving Auto ISO sensitivity control set to On all the time. Use it only when you really need to get the shot under any circumstances!

Of course, if you are unsure of how to use the correct ISO for the light level due to lack of experience, don't be afraid to experiment with this mode. At the very worst, you might get noisier-than-normal images. However, it may not be a good idea to depend on this mode over the long term because noisy images are not very nice.

Are There Any Drawbacks to Using ISO-AUTO?

Maybe! It really depends on how widely the light conditions vary when you are shooting. Most of the time, your camera will maintain the normal range of ISO settings in Auto ISO sensitivity control, so your images will be their normal low-noise, sharp masterpieces. However, at times the light may be so low that the ISO may exceed low-noise range and will start getting into the noisier ranges above ISO 1600.

Just be aware that the Auto ISO sensitivity control can and will push your camera's ISO sensitivity into a range that causes noisier images when light levels drop, if you have allowed it. Use it with this understanding and you'll be fine.

The Auto ISO sensitivity control is yet another feature of our powerful Nikon cameras. Maybe not everyone needs this fail-safe feature, but for those who do, it must be there. I will use it myself in circumstances where getting the shot is the most important thing and where light levels may get too low for normal ISO image-making.

Even if you think you might only use it from time to time, do learn how to use it for those times. Experiment with the Auto ISO sensitivity control. It's fun and can be useful!

Remote Control Mode (ML-L3)

(User's Manual: Page 272, Menu Guide: Pages 47, 73)

Remote control mode (ML-L3) allows you to use a Nikon ML-L3 wireless remote control to fire the shutter remotely. Its primary purpose is to give you a way to take hands-off images while the camera is on a tripod. This reduces camera shake and allows you to release the shutter either from a distance or up close without touching the camera.

I tested my D7200 with an ML-L3 remote controller outdoors on a bright, overcast day and was able to fire the camera from about 35 feet away. It is a rather effective little infrared unit for hands-off photography.

To use the Remote control mode you'll need to select one of the three modes in the Photo Shooting Menu; mount your camera on a tripod, beanbag, or other support device; and use the button on the ML-L3 remote to fire the shutter. There are three Remote control modes (and Off) available in the Photo Shooting Menu:

- **Delayed remote:** When you press the ML-L3 shutter-release button, the camera waits two seconds and then fires the shutter.
- **Quick-response remote:** When you press the ML-L3 shutter-release button, the camera fires the shutter immediately.
- **Remote mirror-up:** The first press of the ML-L3 shutter-release button raises the reflex mirror. You should wait for camera and tripod vibrations to subside, then press the ML-L3 shutter-release button again to fire the shutter. This is a two-step operation that can help you create sharper images by preventing mirror slap from causing blur in your images and allowing general vibrations to cease before taking the picture.
- **Off:** The camera will not respond to the ML-L3 remote controller.

You will use the screens shown in figure 3.22A to select one of the Remote control modes.

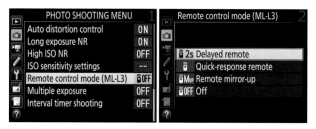

Figure 3.22A – Selecting a Remote control mode

Use the following steps to prepare the camera for Remote (hands-off) shooting with the ML-L3 infrared controller:

1. Place your camera on a tripod or other stationary supporting device.
2. Remove the rubber viewfinder eyepiece (DK-23 rubber eyecup) by sliding it upward.

3. Install the plastic DK-5 eyepiece cap where the rubber eyecup was. This prevents improper exposures by preventing light from entering the viewfinder eyepiece. The DK-5 eyepiece cover should be in the box that the camera came in, or you can buy one from a camera store. If you decide not to use the plastic eyepiece to cover the viewfinder, at least shield it with your hand or a hat during remote operations. Otherwise the exposures may not be correct, especially when there is strong light behind the camera.

4. Select Remote control mode (ML-L3) from the Photo Shooting Menu and scroll to the right (figure 3.22A, image 1).

5. Choose your favorite Remote control mode from the three choices. I chose Delayed remote for a 2-second (2s) delay (figure 3.22A, image 2).

6. Press the OK button to confirm your choice.

Using the Nikon ML-L3 Remote Controller

The camera enters Remote control mode as soon as you select any setting besides Off from the menu seen in Figure 3.22A, image 2. There is no special Remote control symbol or setting on the Release mode dial, such as was found on previous advanced-enthusiast Nikon cameras. Instead, just select any setting besides Off and you are ready to fire the camera remotely with the ML-L3 unit seen in figure 3.22B.

Figure 3.22B – The Nikon ML-L3 Remote Control unit (infrared)

Once you have selected one of the three active modes (not Off) from the menu seen in figure 3.22A, image 2, the camera enters Remote control mode and stays ready for you to fire it with the ML-L3 for a period of time. You may specify how long the camera will stay in Remote control mode by selecting a timeout from the *Custom Setting Menu > C Timers/AE Lock > c5 Remote on duration (ML-L3)* setting (page 219). You can choose from 1 to 15 minutes for the timeout. When the timeout expires, the camera will automatically select Off for

Remote Control Mode (ML-L3). The D7200 will then cease responding to the ML-L3 until you re-enable Remote control mode.

The camera body has two infrared sensors. One is a large one found just above the D7200 logo on the front of the camera. Another is found on the back of the camera, on the bottom right near the Memory card slot cover. Therefore, you can fire the camera with the ML-L3 from the back or the front.

Settings Recommendation: I am pleased to see the Remote mirror-up mode on the D7200. Most people consider this a professional feature. It allows you to take very sharp images by removing the chance of camera shake from the movement of the reflex mirror. I recommend that you learn to use this mode anytime you are shooting for maximum quality. All three of the Remote control modes have their place. Learn to use them all for maximum flexibility.

Multiple Exposure

(User's Manual: Page 272, Menu Guide: Page 48)

Multiple exposure is the process in which you take more than one exposure on a single frame, or picture. Most people do only double exposures, which is two exposures on one frame.

Multiple exposure requires you to figure the EVs carefully for each exposure segment so that in the final picture all the combined exposures equal one normal exposure. In other words, your subject's background will need two exposures at half the normal EV to equal one normal exposure. The D7200 allows you to figure out your own exposure settings and set the controls manually, or you can use Auto gain to help you with the exposure calculations.

There are really only four steps to set up a Multiple exposure session. However, there are several Shooting Menu screens to execute these four steps. The steps are as follows:

- Select the number of shots you want to take.
- Set Auto gain to On or Off, depending on how you want to control the exposure.
- Choose whether you are shooting one image or a series of images.
- Take the picture.

Next we will examine the screens and method used to execute the four steps.

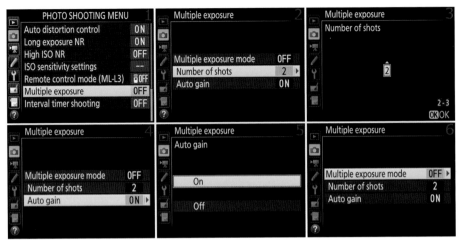

Figure 3.23A – Configuring the camera for Multiple exposures

Use the following steps to configure one or a series of multiple exposures:

1. Select Multiple exposure from the Photo Shooting Menu and scroll to the right (figure 3.23A, image 1).
2. Select Number of shots and scroll to the right (figure 3.23A, image 2).
3. Enter the number of shots you wish to take, either 2 or 3, and press the OK button (figure 3.23A, image 3).
4. Select Auto gain and scroll to the right (figure 3.23A, image 4).
5. Select On and press the OK button (figure 3.23A, image 5).
6. At this point you must select the Multiple exposure mode and choose whether you want one Multiple exposure or a series (figure 3.23A, image 6). Figure 3.23B takes up where figure 3.23A leaves off. It shows the final step of choosing how many multiple exposure images you want to take in this session.

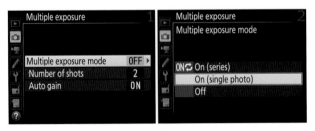

Figure 3.23B – Choosing one Multiple exposure or a series

7. Select Multiple exposure mode and scroll to the right (figure 3.23B, image 1).
8. Choose On (series) if you want to take more than one distinct Multiple exposure image or On (single photo) for just one Multiple exposure picture.
9. Press the OK button, and your camera is ready to take the multiple exposure.

After you've selected the Number of shots (step 2), the camera remembers the value and comes back to it for the next session. To repeat another Multiple exposure series with the same settings, you'll have to use the screens for figure 3.23B again and start over with step 7. That prepares the camera to do the Multiple exposure series (or single photo) in the same way as last time. The camera remembers the previous settings until you reset them by using the screens in figure 3.23A.

Understanding Auto Gain

Auto gain defaults to On, so you need to understand it. Auto gain applies only if you want to make a number of exposure segments with the exact same EV for each. If you want to make two exposures, the camera will meter for a normal exposure and then divide the exposure in half for the two shots. For three shots, it will divide the exposure by 1/3, four shots by 1/4, eight shots by 1/8, and so forth.

For example, if I want a two-shot Multiple exposure, I usually want the background to get 1/2 of a normal exposure in each shot so it will be properly exposed in the final image. If I need four shots, I want the background to get only 1/4 of a normal exposure for each shot so it will be exposed correctly after the four shots are taken. Auto gain divides the exposures automatically.

It took me a little while to wrap my brain around the confusing description in the User's Manual. Whoever heard of *gain* meaning dividing something into parts? I think Nikon means that each shot gains a portion of the normal exposure so that in the end the exposure is complete and correct.

You should use Auto gain only when you don't need to control the exposure differently for each frame and can instead use an exact division of similar exposures.

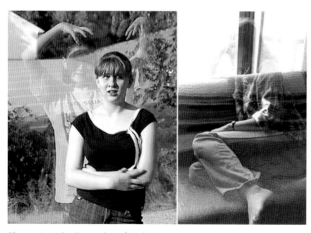

Figure 3.23C – Examples of Multiple exposures

Auto gain works fine if you're not using masks, where part of the image is initially blocked off and then exposed later. When you use a mask, you want a full normal exposure for

each of the uncovered (nonmasked) sections of the image, so Auto gain will not work. For masked exposures, you should use manual exposures, with Auto gain turned Off.

Settings Recommendation: Multiple exposure images can be a lot of fun to create (figure 3.23C). I often shoot Multiple exposure images with two people in the frame. One person leaves after the first half of the exposure is taken, and the other person stays still. When you're finished, you'll have a normal picture of one person and the background, but the person that left halfway through the Multiple exposure will be ghosted.

It's even more fun if you have the person who leaves touch the stationary person during the first half of the Multiple exposure. Maybe you could have the moving person put a hand on the stationary person's shoulder or embrace the stationary person. If the stationary person is very careful not to move, the image will remain sharp and raise eyebrows.

You can also do this with just one person, as the second picture in figure 3.23C shows. Just make sure your subject leaves halfway through the Multiple exposure. Finally, be sure to use a tripod when you create a Multiple exposure unless you mask part of the frame. Otherwise the background will be completely blurred by camera movement between shots.

Interval Timer Shooting

(User's Manual: Page 272, Menu Guide: Page 49)

Interval timer shooting allows you set up your camera to shoot a series of images over time. Make sure you have a full battery or are connected to a full-time power source, such as the Nikon EH-5b AC adapter, for shooting images over long periods.

Interval timer shooting is different than the setting covered in the next main section, *Time lapse photography,* in that it does not create a movie at the end of the image series. When the camera is done with the Interval timer shooting session, you simply have a series of images taken over a period of time.

There are four steps involved in configuring Interval timer shooting:

- Choose a start time
- Choose an interval
- Choose the number of intervals and the number of shots per interval
- Enable or disable Exposure smoothing

Let's carefully consider how to configure your Interval timer choices.

Configuring an Interval Timer Shooting Session

The screens in figure 3.24A look a little daunting; however, it might help you to realize that the bottom third of screens 2 through 6 are informational in nature. They display the choices you make in the top half of each screen.

Note: You can start the timer immediately by selecting the Start selection from the menu. However, we will save that step for last because we have configured nothing for the Interval timer. Therefore, we will skip Start at the top of the Interval timer shooting menu (figure 3.24A, image 2) and begin by setting up Start options (figure 3.24A, image 3).

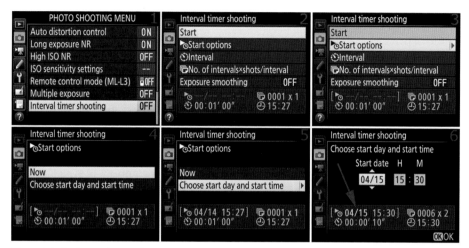

Figure 3.24A – Interval timer shooting configuration

Use the following steps to configure an Interval timer shooting session:

1. Select Interval timer shooting from the Photo Shooting Menu and scroll to the right (figure 3.24A, image 1).
2. Skip over the Start selection for now because we have not configured any of the Interval timer settings yet (figure 3.24A, image 2). Later, after you have configured the Interval timer, you can simply come back and select Start to begin the timer. The camera will remember the settings from your last configuration of the Interval timer and you can use them again by selecting Start and pressing the OK button.
3. Scroll down one place from Start and select Start options, then scroll to the right (figure 3.24A, image 3).
4. The Start options screen will display two choices, Now and Choose start day and start time (figure 3.24A, image 4). Choose Now if you want to start the timer three seconds after you select Start and press the OK button. If you would rather select a specific date and time to start the timer, simply select Choose start day and start time from the Start options menu and scroll to the right (figure 3.24A, image 5).
5. The Choose start day and start time screen will now appear (figure 3.24A, image 6). The Start date is always presented in the Month/Day (MM/DD) format, while the time is presented in a 24-hour (international time) format. If you are not using the Now selection from the previous step, move to the Start date field and enter the month and day, such as:
04/15

Please notice that the Start date (04/15) is highlighted in yellow in the informational section that appears on the lower third of image 6 (red arrow). As you set the Interval timer functions, you will see each of them appear in this informational area. After the timer is fully configured you can use this section to quickly see whether you want to use current settings or modify them in a future session.

Next, scroll over to the H field and enter an hour in international time format (e.g., 15 = 3 p.m.). Enter the time at which you want the intervals to begin. The selectable hour (H) range is from 00 (midnight) to 23 (11 p.m.). After you have entered an hour setting, enter a minute setting. The selectable minute (M) range is from 00 to 59. If you wanted to start at 3:30 p.m., you would insert the following:

15:30

Once you've entered the time, press the OK button to lock it in. Check the informational section below, which will show the entry. My camera reflects 04/15 15:30, or April 15th at 3:30 p.m. in figure 3.24A, image 6.

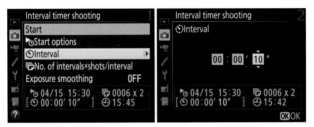

Figure 3.24B – Choosing an Interval

6. The camera will now return to the Interval timer shooting menu. Choose the Interval setting on the Interval timer shooting screen and scroll to the right (figure 3.24B, image 1).

7. You will now see the Interval selection fields with selections representing Hours: Minutes' Seconds" in the following format (figure 3.24B, image 2):

00: 00′ 00″

The first two zeros represent the hours, the second set represents minutes, and the third set seconds. Since we want to start out with an Interval of 10 seconds, let's set the screen to look like this:

00: 00′ 10″

Once you've entered the time, press the OK button to lock it in.

Figure 3.24C – Choosing the number of intervals and number of shots per interval

8. Now we'll choose the number of intervals and shots per interval by selecting No. of intervals×shots/interval and scrolling to the right (figure 3.24C, image 1).

9. You will be presented with a screen where you can select the number of intervals (No. of intervals) times the number of shots per interval (shots/interval), as seen in figure 3.24C, image 2. Number of intervals × number of shots = total shots. These values are gathered in this format:

$0000 \times 0 = 0000$

You can set the number of intervals (0000) anywhere between 0001 and 9999. You can set the number of shots taken per interval anywhere between 1 and 9. If, for example, you want to shoot over the course of six intervals, and take two pictures during each interval, set your camera so that it looks like this (figure 3.24C, image 2):

$0006 \times 2 = 00012$

This means that there will be six intervals (0006) of 10 seconds each (set in step 7) and that the camera will take two pictures for each interval (× 2), for a total of 12 pictures (00012). In other words, 2 pictures will be taken every 10 seconds over a period of 60 seconds, for a total of 12 images at the end of the series (0006 intervals × 10 seconds each = 60 seconds). The maximum number of images that can be taken in one Interval timer session is 89991.

10. Next, you may select Exposure smoothing (figure 3.24D, image 1), which allows the camera to adjust the exposure of an image so that it matches the exposure of the previous image, when using P, S, and A modes under the Mode button. If you use M mode, you must have *Photo Shooting Menu > ISO sensitivity settings > Auto ISO sensitivity control* set to On, or Exposure smoothing will not work. Choose Exposure smoothing from the Interval timer shooting screen and scroll to the right (figure 3.24D, image 1).

11. Select On or Off for Exposure smoothing and press the OK button to finish the configuration of the Interval timer shooting system (figure 3.24D, image 2).

Figure 3.24D – Choosing an Exposure smoothing setting

12. You are now ready to Start the Interval timer using the settings displayed in the informational section on the lower third of the Interval timer shooting screen (figure 3.24E). When you select Start, as shown in figure 3.24E, image 1, and press the OK button, a *Timer Active* message will briefly appear on your camera's Monitor (figure 3.24E, image 2).

Figure 3.24E – Starting the Interval timer shooting session.

If you look at the top Control panel, where the shutter speed and aperture listing normally appears, you will see a countdown of the number of intervals and shots per interval, just before the camera fires the pictures in the series. For instance, with a camera set to six intervals and two shots per interval (0006 × 2), the Control panel will display shutter speed and aperture, and just before the camera fires the two shots for the interval, it will display the interval number and shots per interval (briefly). Where you normally see the shutter speed, the camera will count down the number of intervals left over—the number 6, in our example. Where the aperture listing normally appears, the camera will present the number of frames, which is 2F for two shots per interval. The readout on the Control panel will look like this:

6 2F

As the camera works its way through the intervals, you will see the interval number (6) count down (reducing). As each interval period occurs, the camera will fire the number of shots you selected (2F) and that number will count down for each shot taken: (i.e., 2F, 1F). No other camera display besides the Viewfinder shows this 6 2F counter. The Viewfinder continues displaying the shutter speed and aperture.

You cannot use the Monitor while the camera is actually firing the Interval timer; it goes off during interval countdown. However, immediately after the camera fires, it will display the shots just taken, allowing you a period between intervals to use the Monitor and check progress or change camera settings. If you happen to press the Info button, which opens the Information screen, you will see the symbol INTVL flashing at the top of the Monitor.

What if you need to pause or cancel the interval countdown? Let's consider how that is done.

Pause, Cancel, or Restart an Interval Timer Shooting Session

You may need to pause or cancel the Interval timer while it is counting down to the start time you set in Shooting options, or when the timer is already active and taking pictures. The Interval timer will continue to function and count down even if you have switched the camera off. Therefore, once you have activated the timer you will need to use the screens shown in figure 3.24F to pause or cancel it. Let's see how to do it.

Figure 3.24F – Pausing or canceling an Interval timer shooting session

Use these steps to pause or cancel an Interval timer shooting session:

1. While awaiting an interval to expire, press the Menu button and select Interval timer shooting from the Shooting Menu and scroll to the right (figure 3.24F, image 1).
2. Choose Pause to temporarily stop the timer, or Off to cancel the session (figure 3.24F, image 2). If the intervals you selected are very close together (a few seconds for each interval), you will have only a very short period of time to Pause or cancel the session (select Off) immediately after the camera fires a shot.
3. Press the OK button to lock in your choice.

Figure 3.24G – Restarting or canceling an Interval timer shooting session

If you have previously paused the Interval timer and would like to restart or cancel it, use the following steps:

1. Select Interval timer shooting from the Photo Shooting Menu and scroll to the right (figure 3.24G, image 1).
2. Select Restart, which allows you to continue your Interval timer session, or Off, which lets you cancel the session.
3. Press the OK button to lock in your choice.

Note: If the memory card fills up during a shooting session and has no more room for images, the timer will remain active but the camera will stop taking pictures. You can resume shooting after you have either deleted some pictures or inserted another memory card.

Interval timer shooting will pause if you select the Self-timer position on the Release mode dial. You must turn the dial away from the Self-timer mode position before you can restart the timer.

During pauses, you can replace batteries and memory cards without ending the Interval timer session. To restart the session and continue where it left off, you must use the Shooting Menu screens shown in figure 3.24G.

Please remember that pausing the session does not affect Interval timer settings. If for any reason the camera cannot continue Interval timer photography, it will display a warning on the Monitor.

Skipping Intervals: The camera will skip an interval if any of the following occurs:

- Any photographs from the previous session are not yet taken
- The memory card is full
- Single-servo AF is active and the camera is unable to focus (the camera refocuses before each shot)

The camera will then try again at the next interval.

User Settings: Changes to Interval timer shooting apply to both of the User settings (U1 and U2). Therefore, changing to a different User setting during a session does not interrupt the Interval timer.

Bracketing Info: You can adjust bracketing for the exposure, flash, White balance, or Active D-Lighting (ADL) before you start Interval timer shooting or between intervals. Bracketing overrides the number of shots, so you may not get what you expected if any kind of bracketing is active. Also, according to Nikon, "If White balance bracketing is active during an Interval timer session, the camera will take one shot at each interval and process it to create the number of copies specified in the bracketing program."

Settings Recommendation: Please learn to use this function! It is complicated, but if you read this section carefully and practice using Interval timer shooting as you read, you'll learn it quickly. This type of photography allows you to shoot things like flowers gradually opening or the sun moving across the sky. Have some fun with it!

Author's Conclusion

Congratulations! If you save the current Photo Shooting Menu settings to one of the cameras two User settings (U1 and U2) with *Setup Menu > Save user settings,* you have configured one of the camera's User settings. Now, configure the camera a different way and save it to the other one.

Taking advantage of the camera's two User settings gives you a great deal of flexibility in how your camera operates. You can switch between two different camera configurations very quickly.

The upcoming information about the Custom Setting Menu will round out the major configuration of your camera for daily shooting.

04 Movie Shooting Menu

North Face of the Eiger © 2015 Dave Irwin, Blue Delta Photography (Delta5)

The Movie Shooting Menu is a new menu subsystem similar to the Photo Shooting Menu discussed in the previous chapter. The Movie Shooting Menu applies its settings to the creation of video instead of still pictures.

In previous Nikon cameras, as video capabilities increased, the video functions could be a little harder to locate because they were appended to some of the still picture menus. However, Nikon has wisely created a completely new menu for Movie functions only. These easy-to-locate functions will make it much easier to configure your camera for quality video capture.

Following is a list and overview of the 15 items found on the D7200 Movie Shooting Menu:

- *Reset movie shooting menu:* Restores the factory default settings in the Movie Shooting Menu for the currently selected User setting.
- *File naming:* Lets you change three characters of the image file name so it is personalized.
- *Destination:* Allows you to choose which of the two memory cards will be used to record videos.
- *Frame size/frame rate:* Use this function to choose the frame size (e.g., 1080p, 720p) and the frame rate (e.g., 60p, 30p, 24p).
- *Movie quality:* Lets you select the bit rate (Mbps) of the movie for controlling overall quality.
- *Microphone sensitivity:* Gives you control over the sensitivity of the built-in stereo mic and any external mic plugged into the audio-in (MIC) port under the rubber flap on the camera's side.
- *Frequency response:* Allows you to set one of two audio recording modes: Wide, which records a full range of sounds; and Voice, which asks the camera to narrow its audio frequency response to the human voice range.
- *Wind noise reduction:* Gives you a reduction filter to remove a portion of the rumbling noise made when wind blows on a microphone.
- *Image area:* Allows you to choose whether the camera uses DX (24×16) or 1.3× (18×12) mode when shooting videos.
- *White balance:* Chooses from eight different primary White balance types, including several subtypes, and includes the ability to measure the color temperature of the ambient light (Preset manual).
- *Set Picture Control:* Chooses from seven Picture Controls that modify how the video looks.
- *Manage Picture Control:* Saves, loads, renames, or deletes custom video Picture Controls on your camera's internal memory or card slots.
- *High ISO NR:* Uses a blurring method, with selectable levels, to remove noise from videos shot with high ISO sensitivity values.
- *Movie ISO sensitivity settings:* Allows you to select a large range of ISO sensitivity values, from ISO 100 to ISO 25600, or you can let the camera decide automatically with Auto ISO Mode.

- ***Time-lapse photography:*** The camera will take a numbered series of images over a timed interval and automatically assemble the images into a silent movie when the last image has been taken.

Many of these items can be configured and saved for later recall by using the two available User settings on the D7200 Mode dial (U1 and U2).

User Settings and the Movie Shooting Menu

Eleven of the fifteen settings on the Movie Shooting Menu can be saved under one of the User settings (U1 or U2 on the Mode dial). Similar to the Photo Shooting Menu we considered in the previous chapter, most of your movie settings choices can be saved for later recall. We will discuss how to save the Movie Setting Menu functions to one of the User settings in the chapter titled **Shooting Menu** under the heading **Save User Settings** on page 306.

Following is a list of the four movie functions that *cannot* be saved into one of the User settings:

- Reset movie shooting menu
- Image area
- Manage Picture Control
- Time-lapse photography

Movie Shooting Menu Location

Figure 4.1 shows the location of the Movie Shooting Menu—the third menu down on the left. Its symbol is a movie camera on a tripod.

Let's examine each Movie Shooting Menu function in detail.

Figure 4.1 – The Movie Shooting Menu

Reset Movie Shooting Menu

(User's Manual: Page 273, Menu Guide: Page 51, 11)

Reset movie shooting menu does what it says—it resets the Movie Shooting Menu back to factory defaults for the currently selected user setting (U1, U2, or outside the user settings). If you have U1 selected on the Mode dial, it resets only U1, and so forth. If you have neither of the User settings selected on the Mode dial, it resets the functions outside the User settings back to their default configuration, which won't affect either U1 or U2.

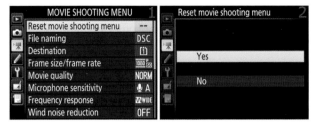

Figure 4.2 – Resetting the Movie shooting menu back to factory defaults

This is a rather simple process. Here are the steps to reset the Movie Shooting Menu:

1. Select Reset movie shooting menu and scroll to the right (figure 4.2, image 1).
2. Choose Yes or No (figure 4.2, image 2).
3. Press the OK button.

Note: This function resets all Movie Shooting Menu functions, including the four settings that cannot be saved in a User setting (see list in previous section). This may be a problem if you have carefully configured one of the four settings and then you choose Yes on the Reset movie shooting menu screen, because your settings will be lost.

Using this function *does not* reset the Photo Shooting Menu settings also saved under a particular User setting; only the Movie Shooting Menu settings. Therefore, after you have reconfigured the Movie Setting Menu function, you will need to resave the User setting again with the *Setup Menu > Save user settings* function, which will resave both the Current Movie Setting Menu and Photo Setting Menu under a single User setting. Changing the Movie Setting Menu and resaving will not affect previously saved Photo Shooting Menu settings. You can maintain both the Photo Shooting Menu and Movie Shooting Menu under U1 or U2, modifying and resaving each of the two menus' settings independently. When you reset and resave one menu (Movie), the settings in the other menu (Photo) are maintained without modification.

Settings Recommendation: This is an easy way to start fresh for video with a particular User setting since it's a full reset of all the Movie Setting Menu values. I use this when I purchase a pre-owned camera and want to clear someone else's settings or if I simply want to start fresh.

File Naming

(User's Manual: Page 273, Menu Guide: Page 51)

The *File naming* function allows you to change the first three characters (prefix) in the video's file name to three characters of your choice. The default is DSC. You could use your initials, a combination of letters and numbers, all letters, or all numbers.

This works identically to the File naming function in the Photo Shooting Menu. If you recall, there is a suggestion in the chapter on the Photo Shooting Menu for tracking the number of still image files your camera has created (see page 62) so that you can keep up with it when your camera rolls the filename's postfix over to 0001 after exceeding 9999 files (i.e., when you exceed DSC-9999, the camera rolls the filename over to DSC-0001).

However, unless you bought your D7200 to use primarily as a video maker, you will probably shoot less video compared to still images. In that case, you may not be concerned with exceeding 9999 videos. If you are concerned with tracking when your camera's videos roll over from 9999 to 0001, review both this section and the similar section in the **Photo Shooting Menu** chapter, under **File Naming,** on page 62.

Following is how to modify the first three characters (prefix) of the video filename.

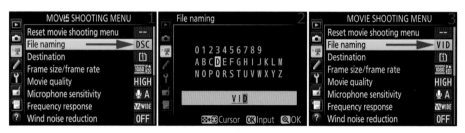

Figure 4.3 – Renaming the filename prefix

Here are the steps to set up your custom File naming characters:

1. Select File naming from the Movie Shooting Menu and scroll to the right (figure 4.3, image 1).

2. Use the Multi selector to scroll through the numbers and letters to find the characters you want to use (figure 4.3, image 2). Press the OK button to select and insert a character. To correct an error, hold down the Playback zoom out/thumbnails button and use the Multi selector to scroll to the character you want to remove. Press the Delete button to delete the bad character. My camera is now using the prefix VID for all video files. Notice how the red arrows in images 1 and 3 point to the previous (DSC) and new (VID) prefix.

3. Press the Playback zoom in button to save your three new custom characters. They will now be the first three characters of each image file name (figure 4.3, image 3).

Now you've customized your camera so the file names reflect your personal needs.

Settings Recommendation: Because I shoot only a moderate number of videos in comparison to the large number of still images I create, I am not concerned with tracking when a video filename exceeds 9999 and rolls back over to 0001. Therefore, I simply add the prefix VID to my video files.

However, if you think you will create more than 9999 videos with this camera, you may want to consider using the postfix-number tracking system I describe in the **File Naming** function under the **Photo Shooting Menu** chapter, on page 62.

Destination

(User's Manual: Page 273, Menu Guide: Page 51)

Destination lets you choose which memory card will receive and store your movies. Just below the card slot selections you will see something like this: 02h 18m 45s (h=hours, m=minutes, s=seconds). This is the total video recording time the particular card will hold. If you're serious about shooting movies with your camera, you'd better buy some high-capacity cards—you'll need them!

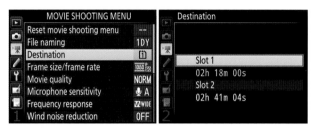

Figure 4.4 – Movie settings – Destination

Here are the steps to select a Destination for your movies:

1. Select Destination from the Movie Shooting Menu and scroll to the right (figure 4.4, image 1).
2. Select Slot 1 or Slot 2. Your movies will automatically flow to the card slot you have chosen (figure 4.4, image 2). Carefully note the hours, minutes, and seconds (e.g., 02h 18m 00s) available under the slot you select so the camera won't run out of card space at an inopportune moment. The video recording will stop automatically if the memory card is full.
3. Press the OK button to save your setting.

Settings Recommendation: I normally send all movies to Slot 2 when I am out shooting still images and videos. I do this merely for convenience. If you are a heavy video shooter, you may want to use Slot 1 as the primary slot for videos.

Frame Size/Frame Rate

(User's Manual: Page 273, Menu Guide: Page 52)

The Nikon D7200 provides seven *Frame size/frame rate* settings. Five of them are available only in the camera's default DX (24×16) Image area mode. Two are available only in 1.3× (18×12) Image area mode. We will discuss how to configure the Image area in the upcoming **Image Area** section (on page 158).

Following is a chart that shows the Frame size (pixels) and frame rate (e.g., 60p, 30p) available for each Image area.

Option	Frame size (pixels)	Frame Rate	Image area
1920 × 1080; 60p	1920 × 1080	60p	1.3× only
1920 × 1080; 50p	1920 × 1080	50p	1.3× only
1920 × 1080; 30p	1920 × 1080	30p	DX and 1.3×
1920 × 1080; 25p	1920 × 1080	25p	DX and 1.3×
1920 × 1080; 24p	1920 × 1080	24p	DX and 1.3×
1920 × 720; 60p	1280 × 720	60p	DX and 1.3×
1280 × 720; 50p	1280 × 720	50p	DX and 1.3×

Table 4.1 – Frame size/frame rate options (figure 4.5, image 2)

There will be additional information on this subject presented in the chapter titled **Movie Live View,** on page 519. Let's examine how to choose a Frame size/frame rate setting.

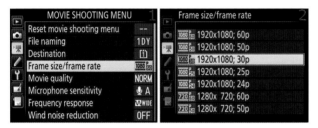

Figure 4.5 – Choosing a Frame size/frame rate setting for the video

The following steps allow you to select a Frame size/frame rate for your next movie:

1. Choose Frame size/frame rate from the Movie Shooting Menu and scroll to the right (figure 4.5, image 1).
2. Choose a size and rate for your movie from the list of seven Frame size/frame rate choices (figure 4.5, image 2). If the top two settings in figure 4.5, image 2, are grayed out and not available, and you need to use them, you will have to set the camera to 1.3× (18×12) Image area mode. Otherwise, in the default DX (24×16) Image area mode, you are limited to the last five selections on the Frame size/frame rate menu.
3. Press the OK button to lock in the setting.

Settings Recommendation: I tend to prefer the cinematic look provided by the 1920×1080; 24p mode. That's what we see when we go to the movies. However, if you want to use a somewhat faster frames-per-second rate for action, select 30p, which gives you 30 frames per second in progressive (p) mode for less motion blurring.

If you want to shoot some slow motion, you will need to set the camera to 1.3× (18×12) Image area mode and shoot the video at 1920×1080; 60p. Then you will have to play the video back at a slower frame rate. Unfortunately, the process for changing video rates after the fact is beyond the scope of this book. For more information on shooting slow motion video and the necessary software, I suggest discussing this subject in the **Nikon Video** forum at **www.Nikonians.org**.

Movie Quality

(User's Manual: Page 273, Menu Guide: Page 53)

Movie quality affects the "bit rate" (Mbps) at which the movie is shot. The bit rate decides the quality level of the movie, much like how the JPEG type (Fine, Normal, Basic) sets the quality of a JPEG still image. The higher the bit rate, the better the video quality. For video written to the memory card, there are two available bit rates: High quality and Normal. How these are applied is controlled by the Frame size/frame rate of the video.

Table 4.2 shows a list of Frame size/frame rates, Movie quality bit rates, and maximum video lengths controlled by the bit rate.

Frame size/ Frame rate	Bit Rate High Quality	Bit Rate Normal	Maximum Length High Quality/Normal
1920 × 1080; 60p	42 Mbps	24 Mbps	10 min/20 min
1920 × 1080; 50p	42 Mbps	24 Mbps	10 min/20 min
1920 × 1080; 30p	24 Mbps	12 Mbps	20 min/29 min 59 sec
1920 × 1080; 25p	24 Mbps	12 Mbps	20 min/29 min 59 sec
1920 × 1080; 24p	24 Mbps	12 Mbps	20 min/29 min 59 sec
1280 × 720; 60p	24 Mbps	12 Mbps	20 min/29 min 59 sec
1280 × 720; 50p	24 Mbps	12 Mbps	20 min/29 min 59 sec

Table 4.2 – Movie quality affects video recording length and quality

Now let's examine how to select one of the two Movie quality choices.

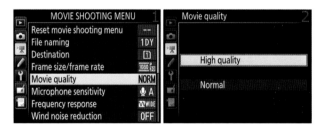

Figure 4.6 – Choosing a Movie quality (bit rate)

1. Select Movie quality from the Movie Shooting Menu and scroll to the right (figure 4.6, image 1).
2. Choose High quality or Normal (figure 4.6, image 2).
3. Press the OK button to lock in the Movie quality.

Note: The Movie quality setting is applied to compressed (H.264 MPEG-4 AVC) video written to the camera's memory cards only. Streaming uncompressed video through the HDMI port to an external video recorder—such as an Atomos Ninja Blade—is not affected by this setting. We will discuss this in more detail in the chapter titled **Movie Live View** on page 519.

Settings Recommendation: Because I am interested in maximum video quality, I leave my camera set to High quality. Any important video that will be displayed on a local computer or HDTV for friends and family to view deserves the High quality setting.

However, if you are shooting some fun video for uploading to a social media site, which will compress the video to the max, destroying its high quality in the process, you could select Normal. Or, if your camera is low on card space and you need to cram as much video onto the card as possible, use the Normal setting.

If you are really serious about shooting maximum quality video, download the supplementary document titled **Recording Uncompressed HDMI Video** from one of this book's downloadable resources sites and learn about using an external Atomos video recorder:
http://www.nikonians.org/NikonD7200
http://rockynook.com/NikonD7200

Microphone Sensitivity

(User's Manual: Page 273, Menu Guide: Page 53)

Microphone sensitivity allows you to choose how sensitive the camera's audio recording circuit is to sound. You can use your camera's internal stereo microphone, a hotshoe-mounted microphone such as the Nikon ME-1 stereo mic, or an external mic.

Microphones, other than the built-in stereo mic, are plugged into the audio-in port found on the side of the camera, under the rubber flap labeled MIC.

Let's examine how to use each of the three available Microphone sensitivity settings.

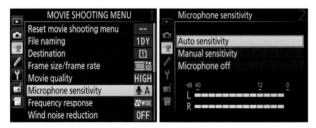

Figure 4.7A – Choosing a Microphone sensitivity setting

The following steps allow you to select a Microphone sensitivity setting for your next Movie:

1. Select Microphone sensitivity from the Movie Shooting Menu and scroll to the right (figure 4.7A, image 1).
2. Choose Auto sensitivity, Manual sensitivity, or Microphone Off (figure 4.7A, image 2). These settings are live, so you can test them immediately.
3. Press the OK button to lock in the Microphone sensitivity setting.

If you decide to use Manual sensitivity instead of Auto, such as in figure 4.7A, image 2, you will need to use the Manual sensitivity setting, which lets you choose a sound level manually, as seen in figure 4.7B.

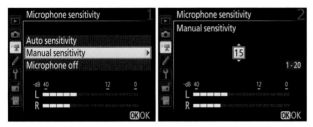

Figure 4.7B – Choosing a Microphone sensitivity setting manually

Use these steps to choose a sound level manually (figure 4.7B). Figure 4.7B continues where figure 4.7A leaves off:

1. Choose Manual sensitivity from the Movie Shooting Menu and scroll to the right (figure 4.7B, image 1).
2. Select a level for the microphone from the box by scrolling up or down with the Multi selector. You can choose from level 1 to level 20. The higher the number, the greater the mic sensitivity, and vice versa. The microphone is set to level 15 currently, which is the factory default (figure 4.7B, image 2). These settings are live, so you will be able to test them immediately.
3. Press the OK button to lock in your choice.

As displayed in figure 4.7C, image 1, you can also choose to disable the microphone completely and record a silent movie by selecting the Microphone off setting. Use this setting if you are using a clapperboard for synchronization and an external sound-recording device. This will separate sound recording from the camera body or attached mic, removing the little squeaks, clicks, and whines that all HD-SLR cameras make while autofocusing, zooming, and changing apertures.

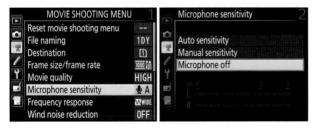

Figure 4.7C – Disabling the internal microphone and audio-in MIC port

Use these steps to turn the internal stereo microphone off and disable the MIC audio-in port on the camera:

1. Choose Microphone sensitivity from the Movie Shooting Menu and scroll to the right (figure 4.7C, image 1).
2. Select Microphone off from the menu to disable the internal stereo mic and the audio-in MIC port (figure 4.7C, image 2).
3. Press the OK button to lock in your choice.

Settings Recommendation: For basic video using the built-in stereo mic, or even with an external hotshoe-mounted mic, such as the Nikon ME-1, the Auto setting seems to perform well.

Experiment with this setting at Auto and Manual to see which works best for you. Auto sensitivity works for most of us, and Manual sensitivity is better for those with more critical needs.

If you are using an external video recorder and streaming uncompressed video from the HDMI port, you will generally set the camera's Microphone sensitivity setting to Microphone off and use an external audio recorder and a sound synchronization device.

Frequency Response

(User's Manual: Page 274, Menu Guide: Page 54)

The *Frequency response* function allows you to choose two different ranges of audio-frequency response to use while recording sound for a video. Sound is a very important part of quality video recording!

Maybe you want to record a video in the wilds of the jungle and would like to pick up the sound of every birdsong, leaf rustle, and buzzing insect. On the other hand, you could be recording a video of a famous lecturer and would rather not pick up the sounds of people walking by, a bird singing outside the window, and road traffic outside.

The Nikon D7200 gives you better control of sound quality than many Nikons before it. With a combination of the Microphone sensitivity and Frequency response functions you can capture some very high-quality sound. Microphone sensitivity affects how sensitive the microphone is, and Frequency response affects which sound frequencies the mic is most sensitive to. We've already considered Microphone sensitivity, so now let's see how Frequency response works.

Figure 4.8 – Choosing a microphone frequency response setting

Use the following steps to choose a Frequency response setting for your camera's microphone.

1. Select Frequency response from the Movie Shooting Menu and scroll to the right (figure 4.8, image 1).
2. Choose one of the two Frequency response settings (figure 4.8, image 2). Select Wide range for those times when you want to record every sound near your camera. This setting is best for nature, travel, and general family videos. Choose Vocal range when you are videoing a person or group of people talking. This setting helps eliminate spurious background noises.
3. Press the OK button to lock in your choice.

Settings Recommendation: Because I am a nature photographer, I often use the Wide range setting when shooting video in the Great Smoky Mountains. However, when recording a wedding ceremony, I often use the Vocal range setting so that I won't get so much spurious noise from the audience.

Test these two settings carefully for your style of photography to see which works best for you. Most people use Wide range for general video recording.

Wind Noise Reduction

(User's Manual: Page 274, Menu Guide: Page 54)

The *Wind noise* reduction setting helps remove that aggravating sound you hear when wind blows on a microphone. Have you ever recorded a video on a beautiful, breezy spring day, only to later find that you have recorded that distinctive rumbling sound of wind blowing across a microphone instead of the clear sound you desired?

While that sound may not be completely eliminated without using special microphones designed to deal with it, it can be significantly reduced with a selective low-cut filter, which removes or cuts low frequency noises like wind rumbles.

Fortunately for D7200 users, Nikon has included a low-cut filter setting for when you are recording video. If you turn this filter on, you can remove a portion of wind noise when recording outside.

However, if you are recording an orchestra, with deep cello and bass parts, a low-cut filter may take away some of the depth in the recording, so maybe it shouldn't be left on all the time. Let's see how to enable and disable the Wind noise reduction low-cut filter.

Use the following steps to choose a Wind noise reduction setting for your camera's microphone.

1. Select Wind noise reduction from the Movie Shooting Menu and scroll to the right (figure 4.9, image 1).
2. Choose On to enable the filter, or Off to disable it (figure 4.9, image 2).
3. Press the OK button to lock in your choice.

Figure 4.9 – Using the Wind noise reduction low-cut filter

Settings Recommendation: I use this wind noise filter selectively. Most of the time I am using an external Nikon ME-1 hotshoe microphone, which has a foam screen around the mic to reduce or eliminate most wind noise. I do use Wind noise reduction when I am outside using the built-in stereo mic to record family events, such as a cookout in Great Smoky Mountains National Park.

Image Area

(User's Manual: Page 274, Menu Guide: Page 54)

The *Image area* function is designed to allow you to take advantage of the extra apparent reach of the 1.3× crop mode, or use the uncropped view of the DX mode. The camera defaults to the normal DX mode and subsamples the 24×16mm sensor to use what it needs to make the video Frame size you selected under the Frame size/frame rate function.

However, you can have the camera use the 1.3× mode's 18×12mm cropped sensor area instead for subsampling the video Frame size. This mode creates the look of an increased lens length (narrower field of view).

Figure 4.10A shows two videos I created from exactly the same position. The DX mode is obviously wider in field of view for the video frame, where the 1.3× mode has a stronger apparent telephoto effect.

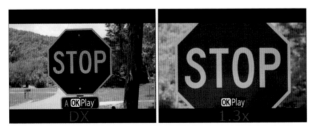

Figure 4.10A – DX and 1.3× video modes

You will also notice that the camera automatically adjusted the frame size to fit the Live view screen when using the two modes. In other words, you will see no lines on the Live view screen like you see in the Viewfinder when you select the 1.3× mode for still images. Instead, the camera simply presents the exact field of view you will see in your video.

This is much simpler to use when shooting a video because you don't have to worry about trying to keep the video within certain lines on the Monitor. The video simply fits the screen and shows only what the camera is actually recording.

Let's see how to switch between the two Image area modes.

Figure 4.10B – Choose an Image area mode

Use the following steps to choose one of the two Image area modes:

1. Select Image area from the Movie Shooting Menu and scroll to the right (figure 4.10B, image 1).
2. Choose either the DX (24×16) mode or the 1.3× (18×12) mode, according to whether you need a normal view or a slightly telephoto view (figure 4.10B, image 2).
3. Press the OK button to lock in your choice.

Settings Recommendation: For general video recording, I leave the camera in DX mode. However, when I am trying to video something smaller or farther away, such as birds in a tree or a bear across a meadow, I will switch to 1.3× mode to maximize the apparent tele-photo view of my subject. The 1.3× mode is convenient for those who need to video things at a distance and would like a larger subject in the Live view screen.

White Balance

(User's Manual: Page 274, Menu Guide: Page 55)

The *White balance* (WB) settings for video recording work basically the same way they do for making still images. You can select a specific WB type, such as Direct sunlight, Fluores-cent, or Cloudy, or you can let the camera decide which WB to use with the Auto WB mode.

If you prefer to be extremely accurate, you can choose a specific Kelvin color tempera-ture from 2500K to 10000K, or you can do an ambient light reading from a white or gray card for the best color temperature matching.

Virtually everything you know about WB for still images works the same way for video recording. To prevent this section from repeating material covered in the **Photo Shooting Menu,** and again in the chapter titled **White Balance,** we will consider only how to make a WB selection in this section.

For deeper information on how to use White balance, see the more detailed **White Balance** section found on page 85 under the chapter titled **Photo Shooting Menu**. Refer to the chapter titled **White Balance** on page 449.

Now, let's examine how to select a particular WB value for your video.

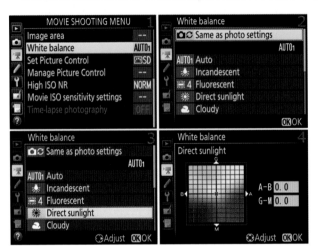

Figure 4.11A – Choosing a WB value for video recording

The steps to select a White balance setting for video recording are as follows:

1. Select White balance from the Movie Shooting Menu and scroll to the right (figure 4.11A, image 1).
2. If you prefer to use a carefully prepared WB value currently in use in the Photo Shooting Menu for still images, you can highlight the Same as photo settings selection and press the OK button to use the same settings you were using previously for your still images (figure 4.11A, image 2). This is a factory default setting for video recordings. If this setting is satisfactory, you can press the OK button to select it and skip the following steps. To use a different WB for video recordings than you use for still images, proceed with step 3.
3. Choose a White balance type, such as Auto or Cloudy, from the menu and scroll to the right (figure 4.11A, image 3).
4. If you choose Auto, Fluorescent, Choose color temp., or Preset manual you will need to select from an intermediate screen with additional choices, similar to the one shown for the Fluorescent WB in figure 4.11B. The Auto WB screen presents two settings: Auto1 – Normal and Auto2 – Keep warm lighting colors. Fluorescent presents seven different types of fluorescent lighting (as seen in figure 4.11B). Choose color temp. allows you to select a color temperature manually from a

Figure 4.11B – Sample intermediate screen for Fluorescent

range of 2500 K (cool or bluish looking) to 10000 K (warm or reddish looking). Preset manual (PRE) provides stored White balance memory locations d-1 through d-6 and allows you to choose one of them to store or reuse a certain WB setting. If this seems a bit overwhelming, just choose Auto1 – Normal for now. The chapter titled **White Balance** will explain how to use all these settings for both video and still images (see page 449). Once you have selected the WB value you want to use, either press the OK button to lock the WB value and skip step 5, or scroll to the right to fine-tune the value.

5. If you want to fine-tune the WB value, you will use the screen shown in figure 4.11A, image 4. You can make an adjustment to how you want this White balance to record color by introducing a color bias toward green, yellow, blue, or magenta. You do this by moving the little black square in the middle of the color box toward the edges of the box in any direction. If you make a mistake, simply move the black square to the middle of the color box. Most people do not change this setting. After you have finished adjusting (or not adjusting) the colors, press the OK button to save your setting. Most people press the OK button as soon as they see the fine-tuning screen so they don't change the default settings for that particular White balance.

Settings Recommendation: I generally leave my camera set to the *Same as photo settings* selection when I am shooting video (figure 4.11A, image 2). A nature photographer, such as myself, generally can shoot both still images and video with similar WB values. However, your style of video may require a WB setting completely different from the setting you use to shoot still images. The camera offers you the ability to have separate WB values for both photos and video.

Set Picture Control

(User's Manual: Page 275, Menu Guide: Page 40, 55)

The *Set Picture Control* function allows you to use Nikon Picture Controls to impart a certain look to your video. Set Picture Control works in a very similar way for both video and still images. In fact, the factory default for this function is the same as the settings that you last used when taking pictures (figure 4.12A).

Each Picture Control has settings for sharpening, contrast, brightness, saturation, and hue. Here is a list of each choice on the Set Picture Control menu and what each one does for your videos:

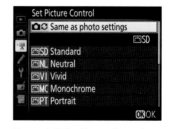

Figure 4.12A – Picture Control settings for video

- **Same as photo settings:** Uses the same Picture Control settings as when you were last taking still pictures (factory default).
- **SD Standard:** A Picture Control setting that gives a medium level of sharpening, contrast, brightness, saturation, and hue. This is a good general purpose Picture Control for video; it's not too saturated and not too weak colored.

- **NL Neutral:** A Picture Control setting that gives a low level of sharpening, contrast, brightness, saturation, and hue. Good for videos with subjects that require low saturation and contrast.
- **VI Vivid:** A Picture Control setting that gives a high level of sharpening, contrast, brightness, saturation, and hue. Use this Picture Control for nature videos where you want very saturated reds, blues, and greens. This is not a good Picture Control to use for videos where skin tones are important because the VI control uses very strong colors and high contrast.
- **Monochrome:** A Picture Control for those who like to shoot old-style, black-and-white videos. The standard settings within the control are medium, which means you may want to experiment with the contrast settings. This control also provides filter effects that allow you to use the equivalent of a yellow, orange, red, or green filter for special effects. Additionally, you can use toning to tint the video in interesting ways. Toning filter options include sepia, cyanotype, red, yellow, green, blue green, blue, purple blue, and red purple.
- **Portrait:** This Picture Control uses settings that make it good for videos featuring people, in which skin tones are important. It is a bit more saturated and contrasty than the NL Neutral control, but not quite as strong as the SD Standard control, and no where near as strong as the VI Vivid control.
- **Landscape:** This Picture Control is designed for those who want natural landscape videos without the extra saturation of the VI Vivid control. While this control does add some additional saturation to natural colors, they are not garish or oversaturated.
- **Flat:** This Picture Control is designed for professional videographers. It has very low sharpening, contrast, and saturation. A video shot with this control will have maximum dynamic range (low contrast) and weaker colors. It allows the videographer to grade the video in professional editing software, selectively adding the needed amounts of saturation, sharpening, and contrast in a computer software program.

If you leave this function set to *Same as photo settings,* the camera will use the same Picture Control settings for both still images and video. By selecting any of the listed Picture Controls instead of Same as photo settings, you are separating Picture Control Use for still image and video shooting. Each will use their own settings, instead of sharing Picture Control settings.

Now let's consider how to select one of the Picture Controls for shooting a video with a specific look.

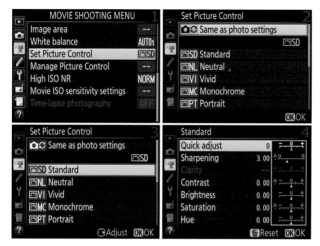

Figure 4.12B – Choosing a Picture Control

1. Select Set Picture Control from the Movie Shooting Menu and scroll to the right (figure 4.12B, image 1).

2. If you prefer to use the same Picture Control settings for still images and videos, simply leave the selection set to Same as photo settings (figure 4.12B, image 2). The camera will then use the settings you have configured for still images when you are shooting videos. Press the OK button to lock in the Same as photo settings selection (default) and skip the following steps.

3. However, if you prefer to use different settings for still images and videos, scroll down and select one of the seven Picture Controls (figure 4.12B, image 3). Press the OK button to choose that Picture Control, unless you would like to fine-tune its internal settings. If so, scroll to the right to open the adjustment screen.

4. You now have access to the Sharpening, Contrast, Brightness, Saturation, and Hue settings for any of the Picture Controls. Several of the Picture Controls have the Quick Adjust setting disabled for video. None of the Picture Controls allow use of the Clarity setting for video. Make your adjustments by scrolling up or down to select a setting and then scrolling left (–) or right (+) to adjust the setting. The name of each setting is self-explanatory. When you are done, press the OK button to lock in your settings. To reset a Picture Control's internal settings, press the Delete button (garbage can) and choose the Yes option when prompted with the screen that says: *Selected Picture Control will be reset to default settings OK?*

Note: As previously mentioned, this Set Picture Control function for videos is very similar to the Set Picture Control function for still images. To prevent duplication of material, we have only considered how to select the controls in this chapter. For a much more detailed discussion of how the Picture Controls work, including the internal adjustments within

each control, please read the section **Set Picture Control** in the chapter **Photo Shooting Menu** on page 87.

Settings Recommendation: I normally leave my camera set to the SD Standard Picture Control, unless I am shooting nature video. I like the idea of separating my use of Picture Controls for still images and video. When I am shooting nature videos on an overcast, low contrast day, I will often use the VI Vivid Picture Control to add a little snap to the video. If I am shooting nature in direct sunshine, I do not like the extra high contrast of the VI Vivid Picture Control and therefore use the LS Landscape Picture Control.

If I am shooting a high-school graduation or wedding, I will usually use the PT Portrait Picture Control to prevent odd skin coloration in my human subjects. If I plan to grade the video myself in my computer, I will use the FL Flat Picture Control to record as much dynamic range as I can in the video for later manipulation in software.

This is a very subjective setting. You will need to experiment with the various Picture Controls to see what they can add to your videos. Each of them has a certain look that can be useful at different times.

Manage Picture Control

(User's Manual: Page 275, Menu Guide: Page 41, 55)

The *Manage Picture Control* function is designed to allow you to create and store Custom Picture Control settings for future video use. You can take an existing Nikon Picture Control (SD, NL, VI, MC, PT, LS, or FL) that is included with the camera, make modifications to it, and then rename it.

If you modify a Picture Control using the Set Picture Control function discussed in the previous section, you simply create a one-off setting. If you'd like to go further and create your own named Custom Picture Controls, the D7200 is happy to oblige.

Any changes you make to a Nikon Picture Control within this function affect that particular control for video use only. The camera saves Custom Picture Controls separately for still images and video. You will not see custom controls for still images on the video menu and vice versa.

Let's look at each of these settings and examine how to manage Picture Controls effectively.

Save/Edit a Custom Picture Control

There are six screens used to save and edit a Nikon Picture Control (figure 4.13A)—storing the results for later use as a Custom Picture Control.

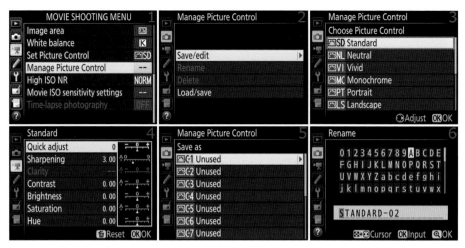

Figure 4.13A – Save/edit a Custom Picture Control

Here are the steps to edit and save a Picture Control with modified settings for use in your video productions:

1. Select Manage Picture Control from the Movie Shooting Menu and scroll to the right (figure 4.13A, image 1).
2. Highlight Save/edit and scroll to the right (figure 4.13A, image 2).
3. Choose a Picture Control that you want to use as a base for your new settings and then scroll to the right (figure 4.13A, image 3). I am modifying the SD – Standard Picture Control and will save it under a different name.
4. Make your adjustments to Sharpening, Contrast, and so forth. I simply used the Quick adjust setting and added +1 to it, increasing the overall effect of Standard by 1 (out of 2). Some Picture Controls do not allow you to use Quick Adjust, and none allow the use of the Clarity setting. It that case you will need to adjust the individual internal settings, according to what is available for adjustment. When you have modified the control in a way that makes it yours, press the OK button (figure 4.13A, image 4). If you want to abandon your changes and start over, you can simply press the Delete button (garbage can) and reset the control to factory specs.
5. Select one of nine storage areas named C-1 to C-9 and scroll to the right (figure 4.13A, image 5). Only seven of the nine storage areas are viewable without scrolling down. In figure 4.13A, image 5, they are all currently marked as Unused. I can save as many as nine different Custom Picture Controls here for later selection with Set Picture Control.
6. You will now see the Rename screen, which works just like the other screens you have used to rename things. Type in a new name by selecting characters from the list at the top of the screen and pressing the Multi selector center button to choose the highlighted character (figure 4.13A, image 6). To correct an error, hold down the Thumbnail/Playback zoom out button and use the Multi selector to move back and forth along the field that contains the new name. The camera will create a default name for you by

appending a dash and two numbers at the end of the current control name. I left it at the default of STANDARD–02.

7. Press the OK button when you have entered the name of your Custom Picture Control.

Once you have created and saved a Custom Picture Control, you can still tell which control was used as its base, just in case you name it in a way that does not suggest its origins. Notice the red arrow in the upper-right corner of the screen in figure 4.13B. This is the control we just created in the previous steps (STANDARD–02) and it is derived from an SD Nikon Picture Control, as shown by the SD label to which the arrow is pointing.

Figure 4.13B – Identifying the base of a Custom Picture Control

Your camera is now set to your Custom Picture Control. You switch between your Custom Picture Controls and the basic Nikon Picture Controls by using Set Picture Control (see previous section titled **Set Picture Control**). In other words, each of your newly named Custom Picture Controls will appear in the Set Picture Control menu for later selection.

Now, let's examine how to rename an existing Custom Picture Control.

Rename a Custom Picture Control

Now that you have created and saved a new Custom Picture Control or two, you may want to rename one of them. Here's how.

Use the following steps to rename an existing Custom Picture Control for video use:

1. Select Manage Picture Control from the Movie Shooting Menu and scroll to the right (figure 4.13C, image 1).
2. Select Rename and scroll to the right (figure 4.13C, image 2).
3. Select one of your Custom Picture Controls from the list (C-1 to C-9) and scroll to the right (figure 4.13C, image 3). I selected to rename STANDARD-02. This is the Custom Picture Control we created in the preceding subsection.
4. You will now be presented with the Rename screen. To create a different name, hold down the Thumbnail/Playback zoom out button and use the Multi selector to scroll back and forth within the old name. When you have the small gray cursor positioned over a character, you can delete that character with the garbage can Delete button. To insert a new character, position the yellow cursor in the character list above and press the Multi selector center button. The character that is under the yellow cursor will appear on the name line below, at the position of the gray cursor. If there is already a character under the gray cursor, it will be pushed to the right. Please limit the name to a maximum of 19 characters (figure 4.13C, image 4). I renamed the STANDARD-02 Custom Picture Control STANDARD-EX2.
5. Press the OK button when you have completed the new name.

Figure 4.13C – Rename a Custom Picture Control

Note: You can have more than one control with exactly the same name in your list of Custom Picture Controls. The camera does not get confused because each control has a different location (C-1 to C-9) to keep it separate from the rest. However, I don't suggest that you give several custom controls the same name. How would you tell them apart?

When a Custom Picture Control is no longer needed, you can easily delete it.

Delete a Custom Picture Control

You cannot delete a Nikon Picture Control (SD, NL, VI, MC, PT, LS, FL). In fact, they don't even appear in any of the Manage Picture Control menu screens.

Figure 4.13D – Delete a Custom Picture Control

However, you can delete one or more of your video Custom Picture Controls with the following screens and steps:

1. Select Manage Picture Control from the Movie Shooting Menu and scroll to the right (figure 4.13D, image 1).
2. Select Delete from the Manage Picture Control screen and scroll to the right (figure 4.13D, image 2).
3. Select one of your nine available Custom Picture Controls and scroll to the right (figure 4.13D, image 3). I selected VIVID-02 for deletion.
4. Choose Yes at the *Delete Picture Control?* prompt (figure 4.13D, image 4).
5. Press the OK button and the Custom Picture Control will be deleted from your camera.

Now, let's move to our last menu selection from the Manage Picture Control screen, Load/save.

Load/Save a Custom Picture Control

There are three parts to the Load/save function. They allow you to copy Custom Picture Controls to and from the memory card or delete them from the card.

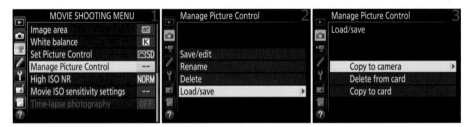

Figure 4.13E – Load/save a Custom Picture Control

Here are the three selections on the Load/save menu, as shown in figure 4.13E, image 3:

- **Copy to camera:** Loads Custom Picture Controls from the memory card into your camera. You can store up to nine controls in your camera's nine available memory locations (C1–C9).
- **Delete from card:** Displays a list of any Custom Picture Controls found on the memory card. You can selectively delete them.
- **Copy to card:** Allows you to copy your carefully crafted Custom Picture Controls (C1–C9) from your camera to a memory card. You can then share them with others. The camera will display up to 99 control locations (01–99) on any single memory card.

Let's examine each of these selections and see how best to use them.

Copy to Camera

You can use the Copy to camera function to copy Custom Picture Controls from your camera's memory card to the camera's Set Picture Control menu for video use. Once you have transferred a Custom Picture Control from your memory card to your camera, it will show up in the *Movie Shooting Menu > Set Picture Control* menu.

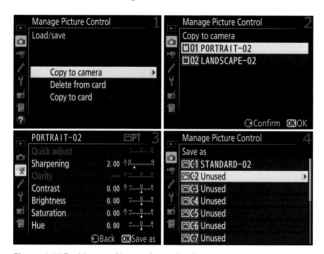

Figure 4.13F – Manage Picture Control – Copy to camera

Here are the steps to copy a Custom Picture Control from the memory card to the Set Picture Control menu:

1. Figure 4.13F continues from the last screen shown in figure 4.13E (Load/save on the Manage Picture Control menu). Choose Copy to camera and scroll to the right (figure 4.13F, image 1).
2. You will be presented with the list of Custom Picture Controls that are currently on the memory card (figure 4.13F, image 2). If there are no controls on the memory card, the camera will display a screen that says, *No Picture Control file found on memory card*. My camera in Figure 4.13F, image 2, shows two controls—PORTRAIT-02 and LAND-SCAPE-02. Select a control from the list and press the OK button. (If you scroll to the right instead, you will be able to examine and adjust the control's settings before saving it to your camera [figure 4.13F, image 3]. If you don't want to modify it, simply press the OK button.)
3. You will now see the Manage Picture Control Save as menu, which lists any Custom Picture Controls already in your camera (figure 4.13F, image 4). Select one of the Unused memory locations and press the OK button.
4. You'll now be presented with the Rename screen, just in case you want to change the name of the Custom Picture Control (figure 4.13G). If you don't want to change the name, simply press the OK button and the custom control will be added to your

camera's Set Picture Control menu. It is okay to have multiple controls with exactly the same name. The camera keeps each control separate in its list of controls (C-1 to C-9). However, I always rename them to prevent future confusion. To create a different name, hold down the Thumbnail/Playback zoom out button and use the Multi selector to scroll back and forth within the old name. Once you have the small gray cursor positioned over a character, you can delete it with the garbage can Delete button. To insert a new character, position the yellow cursor in the character list above and press the Multi selector center button. The character that is under the yellow cursor will appear on the name line below, at the position of the gray cursor. If there is already a character under the gray cursor, it will be pushed to the right. Please limit the name to a maximum of 19 characters. Press the OK button when you have completed the new name.

Figure 4.13G – Manage Picture Control – Choose a new name (or Rename)

Delete from Card

Once you've finished loading Custom Picture Controls for video to your camera, you may be ready to delete a control or two from the memory card. You could format the memory card, but that will blow away all images and Picture Controls on the card. A less drastic method that allows you to be more selective in removing Picture Controls is the Delete from card function.

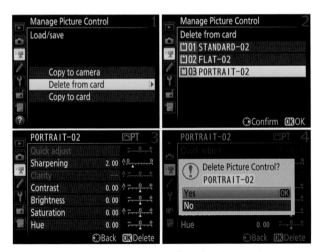

Figure 4.13H – Manage Picture Control – Delete from card

Here are the steps used to remove Custom Picture Controls for video from your camera's memory card:

1. Figure 4.13H continues where figure 4.13E left off. Choose Delete from card from the Load/save menu and scroll to the right (figure 4.13H, image 1).
2. Choose one of the Custom Picture Controls that you want to delete (figure 4.13H, image 2). I chose PORTRAIT-02. You can confirm that you are deleting the correct control by scrolling to the right, which gives you the fine-tuning screen with current adjustments for that control (figure 4.13H, image 3). If you are sure that this is the control you want to delete, move on to the next step by pressing the OK button.
3. You will be shown a screen that asks, *Delete Picture Control?,* with the control's name below (PORTRAIT-02). Choose either Yes or No (figure 4.13H, image 4). If you choose Yes, the Picture Control will be deleted from the memory card. If you choose No, the camera will return to the previous screen.
4. Press the OK button to execute your choice.

Copy to Card

After you create up to nine Custom Picture Controls for video using the instructions in the last few sections, you can use the Copy to card function to save them to a memory card. Once they are on a memory card, you can share your custom video controls with friends who have compatible Nikon cameras.

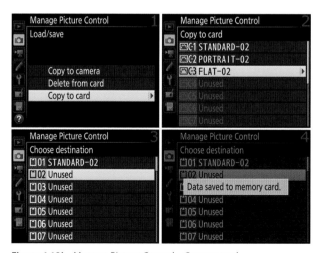

Figure 4.13I – Manage Picture Control – Copy to card

When your Custom Picture Controls for video are ready to go, use the following steps to copy them to a memory card:

1. Figure 4.13I continues where figure 4.13E left off. Choose Copy to card from the Load/save menu and scroll to the right (figure 4.13I, image 1).

2. Select one of your current Custom Picture Controls from the Copy to card menu and scroll to the right (figure 4.13I, image 2). I chose FLAT-02 to copy to the memory card.
3. Now you'll use the Choose destination menu to select the location in which you want to save the custom control (figure 4.13I, image 3). You have 99 choices; select any Unused location by scrolling down.
4. Press the OK button and you'll briefly see a screen that says, *Data saved to memory card.* Your Custom Picture Control is now ready to distribute to the world or load onto another of your compatible Nikon cameras.

High ISO NR

(User's Manual: Page 275, Menu Guide: Page 55, 45)

High ISO NR (High ISO Noise Reduction) lessens the effects of digital noise in your videos when you use high ISO sensitivity settings.

The D7200 has better noise control than most cameras, so it can video up to ISO 1600 with little noise. However, no HD-SLR camera (that I know of) is completely without noise, so it's a good idea to use some noise reduction above a certain ISO sensitivity.

If High ISO NR is turned Off, the camera still does a small amount of noise reduction—less than the Low setting. Therefore at higher ISO settings there will always be some noise reduction.

You can control the amount of noise reduction by choosing one of the four High ISO NR settings: High, Normal, Low, or Off.

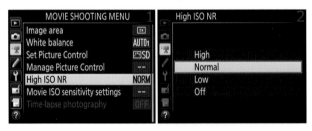

Figure 4.14 – Setting High ISO NR

Use the following steps to choose a High ISO NR setting for video:

1. Choose High ISO NR from the Movie Shooting Menu and scroll to the right (figure 4.14, image 1).
2. Select one of the noise reduction levels: High, Normal, Low, or Off (figure 4.14, image 2).
3. Press the OK button to save your setting.

Settings Recommendation: I leave High ISO NR set to Low or Normal. I do want some noise reduction above ISO 1600 for videos. However, since any form of noise reduction blurs the video slightly, I don't go too far with it. Shoot some high-ISO videos and decide for yourself which settings you are comfortable with.

Movie ISO Sensitivity Settings

(User's Manual: Page 275, Menu Guide: Page 56)

Movie ISO sensitivity settings give you control over the light sensitivity of the imaging sensor, including whether you manually control it, or the camera sets it automatically, while you are making a video.

Let's examine the various settings within the Movie ISO sensitivity settings function.

ISO Sensitivity

You can use Movie ISO sensitivity settings directly from the Movie Shooting Menu to change the camera's ISO sensitivity. Figure 4.15A shows the three screens used. Select your favorite ISO sensitivity for the circumstances in which you find yourself.

Notice in image 3 of figure 4.15A that you have a scrollable list of ISO sensitivity settings. It extends from ISO 100 to 25600.

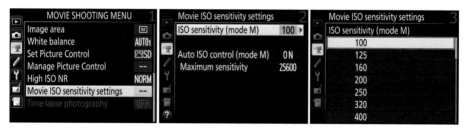

Figure 4.15A – Setting ISO sensitivity from the Movie Shooting Menu

Here are the steps to select an ISO sensitivity setting (figure 4.15A):

1. Choose Movie ISO sensitivity settings from the Movie Shooting Menu and scroll to the right (figure 4.15A, image 1).
2. Select ISO sensitivity (mode M) from the menu and scroll to the right (figure 4.15A, image 2).
3. Scroll up or down in the ISO sensitivity settings menu until you highlight the ISO value you want to use (figure 4.15A, image 3). ISO 100 is selected.
4. Press the OK button to save the ISO sensitivity setting.

Select your favorite ISO sensitivity setting, using the Shooting Menu's ISO sensitivity settings function. If you'd like, you can simply let your camera decide which ISO it would like to use. Let's consider this feature in detail.

Auto ISO Control (Mode M)

You may have noticed in figure 4.15A, image 2, that there is another setting available, the *Auto ISO control (mode M),* which defaults to Off. This setting allows the D7200 camera to control the ISO sensitivity according to the light levels sensed by the camera's metering system. Figure 4.15B shows the Movie Shooting Menu screens used to enable the Auto ISO control (mode M).

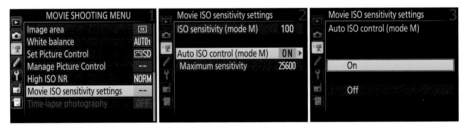

Figure 4.15B – Enabling Auto ISO control (mode M)

Use the following steps to enable or disable the Auto ISO control (mode M):

1. Choose Movie ISO sensitivity settings from the Movie Shooting Menu and scroll to the right (figure 4.15B, image 1).
2. Select Auto ISO control (mode M) from the menu and scroll to the right (figure 4.15B, image 2).
3. Select On or Off from the Auto ISO control (mode M) menu (figure 4.15B, image 3). My camera has On selected.
4. Press the OK button to save your choice.

Once you've set Auto ISO control (mode M) to On, you should immediately set the Maximum sensitivity (ISO) that you want to use while shooting a video. Let's discuss how.

Maximum Sensitivity

The Maximum sensitivity setting is a safeguard for you (figure 4.15C, image 2). It allows the camera to adjust its own ISO sensitivity from the minimum value you have set in ISO sensitivity (figure 4.15A, image 3) to the value set in Maximum sensitivity (figure 4.15B, image 2), according to light conditions.

Think of the main *ISO sensitivity* setting as the ISO floor value (lowest ISO used) and the *Maximum sensitivity* setting as the ISO ceiling value (highest ISO used). When using the Auto ISO sensitivity control, the camera will not exceed the floor and ceiling ISO values.

The camera will try to maintain the lowest ISO sensitivity it can to make a good video. However, if needed, it can rapidly rise to the Maximum sensitivity level.

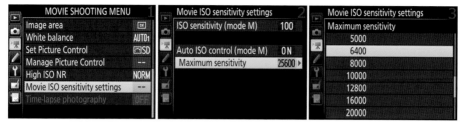

Figure 4.15C – Auto ISO sensitivity control – Maximum sensitivity

Use the following steps to choose a Maximum sensitivity (ISO) for your video when the Auto ISO control (mode M) is set to On:

1. Select Movie ISO sensitivity settings from the Movie Shooting Menu and scroll to the right (figure 4.15C, image 1).
2. Highlight Maximum sensitivity and scroll to the right (figure 4.15C, image 2).
3. Select an ISO value to be used as the automatic maximum ISO if the light drops below normal (figure 4.15C, image 3). My camera has ISO 6400 selected. The camera will attempt to use a lower ISO until it can no longer make good video without raising the ISO value.
4. Press the OK button to lock in the ISO value.

The factory default Maximum sensitivity value is ISO 25600. This default setting will let the camera take the ISO sensitivity all the way up to ISO 25600 in a low-light situation. However, if you think an ISO that high may cause too much noise to appear in your video, you may want to reduce the ISO value. Maximum sensitivity is the maximum ISO value the camera will use to get a good exposure for the video when the light drops.

Time-Lapse Photography

(User's Manual: Page 275, Menu Guide: Page 57)

Time-lapse photography is a cousin of Interval timer shooting (see previous chapter). The primary difference is that Time-lapse photography is designed to create a silent time-lapse movie obeying the Frame size/frame rate and Image area options configured earlier in this chapter.

During time-lapse photography, the camera automatically takes pictures at intervals you select during setup and later assembles them into a time-lapse movie.

Let's examine how to set up a short time-lapse sequence using Time-lapse photography.

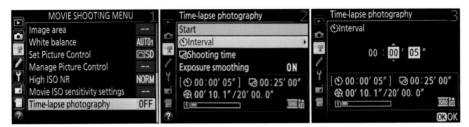

Figure 4.16A – Configuring a Time-lapse Interval

Here are the steps to set up a Time-lapse Interval, Shooting time, and Exposure smoothing:

1. Choose Time-lapse photography from the Movie Shooting Menu and scroll to the right (figure 4.16A, image 1).
2. We are skipping the Start selection at this time, until we have fully configured the Time-lapse settings. Select Interval from the Time-lapse photography screen and scroll to the right (figure 4.16A, image 2).
3. Set the picture Interval in minutes and seconds. You can choose from 00:01 second to 10:00 minutes (figure 4.16A, image 3). The hours column is not available to adjust from the Interval screen. I entered 00′05″ in image 3, which means I have selected a 5 second interval. The camera will take a picture every 5 seconds during the Shooting time period set in Step 4. Press the OK button to lock in your setting and return to the Time-lapse photography screen.
4. Select Shooting time from the Time-lapse photography screen and scroll to the right (figure 4.16B, image 1).

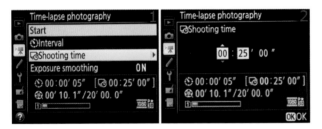

Figure 4.16B – Choosing a Shooting time

5. Choose a Shooting time over which the picture Interval will be executed (figure 4.16B, image 2). You can choose from 1 minute (00:01) to 7 hours 59 minutes (07:59). The seconds column is not available to adjust from the Shooting time screen. I entered 25 minutes (00: 25′00″) in image 2, which means the camera will take a picture every 5 seconds (the Interval set in step 3) over a 25-minute period (the Shooting time). Press the OK button to lock in your setting and return to the Time-lapse photography screen.

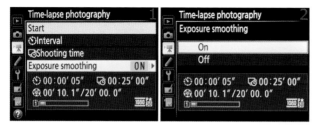

Figure 4.16C – Selecting Exposure smoothing

6. Next, you may select Exposure smoothing (figure 4.16C, image 1), which prevents abrupt exposure changes between images, when using P, S, and A modes on the Mode dial. If you use M mode, you must have *Photo Shooting Menu > ISO sensitivity settings > Auto ISO sensitivity control* set to On, or Exposure smoothing will not work. Choose Exposure smoothing from the Time-lapse photography screen and scroll to the right (figure 4.16C, image 1).

7. Select On or Off for Exposure smoothing and press the OK button to finish the configuration of the Time-lapse photography system (figure 4.16C, image 2).

8. Make sure your camera is on a tripod and ready for shooting the Time-lapse sequence, and then select Start from the Time-lapse photography menu (figure 4.16D, image 1).

Figure 4.16D – Starting a Time-lapse photography session

9. The camera will display a screen informing you: *Starting time-lapse photography. Press OK to end before shooting is complete.* This screen will be displayed for three seconds and the camera will begin shooting your sequence (figure 4.16D, image 2). During the Time-lapse sequence you will see a moving line symbol forming the sides of a rectangle on the upper Control panel, and the images will appear on the monitor briefly as they are captured. If you choose to end the sequence early, simply press the OK button and the camera will stop taking pictures. Other than the fact that the camera stops taking pictures and the line symbol stops moving on the Control panel, there is nothing externally visible that lets you know the Time-lapse photography sequence has stopped when you press the OK button. Nothing happens and several seconds later nothing continues to happen!

Note: Before you start a time-lapse sequence, check the framing and exposure by taking a picture from the position you will use to capture the time-lapse movie. It is often best to

shoot in Manual (M) exposure mode with everything preset to a particular aperture, shutter speed, and ISO sensitivity. When shooting in M mode, if you are worried about ambient light changes affecting the exposure during the time-lapse session, simply enable *Photo Shooting Menu > ISO sensitivity settings > Auto ISO sensitivity control*. Use the ISO-Auto setting from the Photo Shooting Menu because the Time-lapse photography function is just a series of still images joined together and is not a true video. ISO-Auto allows the camera to vary the ISO sensitivity within a range you can set, and will prevent inconsistencies in exposure during the sequence. Additionally, it is a good idea to choose a White balance setting other than Auto to keep the colors the same across all the images in the time-lapse movie.

If you have selected a long shooting time, you may want to consider connecting the camera to the optional Nikon EH-5b AC adapter for continuous power (you'll also need the Nikon EP-5B power supply connector if you do).

Time-lapse photography is not available (it's grayed out) if Shutter speed is set to Bulb, when you are in the middle of a bracket sequence, if the camera is connected via an HDMI cable to an external device for movie recording, or when HDR, Multiple exposure, or Interval timer shooting is enabled.

Time-sequence length calculation: The total number of frames in the movie can be calculated by dividing the shooting time by the interval. Then you calculate the movie length by dividing the number of frames by the frame rate (e.g., 30p, 24p) you've selected in *Movie Shooting Menu > Frame size/frame rate*. Remember, the Time-lapse photography system makes short movies based on Frame size/frame rate and Image area configured under the Movie Shooting Menu.

What you will see while shooting: While you're recording the time-lapse sequence, a moving line symbol outlining a rectangle will be active on the Control panel. The time remaining in hours and minutes will be displayed in the upper-left corner of the Control panel, just before each frame is recorded. The normal shutter speed and aperture will be displayed on the Control panel between frames (unless the frames are too closely spaced in time), allowing you to make adjustments if needed (according to the exposure mode you are using). No matter how you have *Custom Setting Menu > c2 Standby timer* configured, the exposure meter will not turn off during shooting. To stop the sequence outright, press the OK button or turn the camera off.

A movie is made: When the sequence is complete, the camera will automatically assemble a short, silent movie based on the frame rates you selected in in the Movie Shooting Menu. You can identify the time-lapse movie by the fact that it shows a Play button on the screen with the first frame of the movie sequence.

Settings Recommendation: Instead of having to manually assemble frames from Interval time shooting into a movie, Time-lapse photography does it for us, based on normal camera movie settings. It is quite convenient for those of us who would like to experiment

with or shoot interesting time-lapse sequences. Try shooting some short sequences of an event and see how easy it is!

Author's Conclusions

The Nikon D7200's Movie Shooting Menu brings virtually all the video functions for your powerful HD-SLR camera together into one convenient menu system. This means no more searching among the other menus for video functions.

This shows how much progress the video subsystems have made in the last few years in our HD-SLR cameras. They are indeed HD (hybrid digital) SLR cameras with both video and still image capability. With so many video functions all together in one menu, it is even easier than before to create excellent video movies with your camera.

The next chapter begins a discussion of the very large Custom Setting Menu, which is the core of the camera's configuration for various shooting styles. Be sure to have your camera in hand as we proceed through the deepest, most technical parts of D7200 custom function configuration.

Detroit Tigers First Baseman Miguel Cabrera © 2015 Steven King, Steve King Studios (steve_king)

Back in the early days of photography, such as pre-1999, cameras were relatively simple affairs. They were either manual or had a few semiautomatic modes.

The professional Nikon cameras had a few tricks up their sleeves with features controlled by what were called the CSM settings. The menu used a system of hard-to-remember CS numbers. CSM stood for Custom Setting Menu and CS stood for Custom Setting. Few people could easily remember what CS 3 or CS 7 meant, so they used the small, thin manuals for initial configuration or simply ignored the settings.

How things have changed! The camera you hold in your hand has a CSM, too. It turns out that the early seed planted by Nikon software engineers has grown from a few sparse CSM settings to a full-blown dictionary of Custom Setting Menu settings. Little did we know that our basic cameras would turn into computerized machines of photographic automation. Where the 50-page manuals of yesterday fully sufficed, today's cameras come with manuals more like encyclopedia volumes.

Fortunately, that massive amount of computer automation and inherent complexity provides a camera that—even in inexperienced hands—can produce excellent pictures consistently. When an advanced photographer wants to learn how to use the various features of the camera, it can take weeks of study to fully master. But then you can do things with the camera that less-experienced users can't. A book, like this one, can compress the time it takes to complete that study by providing the real-life experience of a person who has already taken time to fully research and explain each part of your camera.

Your Nikon D7200 is a truly powerful camera. It can be used as a fully automated point-and-shoot or as a master's brush for creative photography. As we progress through the literally hundreds of choices in the Custom Setting Menu, you may discover things that you never knew your camera could do. With a little effort, you can come away with a much greater understanding of how to use your new photographic tool.

The Custom Setting Menu is the core of the camera's configurability. Combined with the two Shooting Menus (Photo and Movie, chapters 3 and 4) and the Setup Menu (chapter 6), you have complete control over how the D7200 functions. Without further ado, let's look deeply into the 53 functions found in the Custom Setting Menu and continue our journey to mastering the Nikon D7200.

The User Settings and the Custom Setting Menu

Like the Shooting Menus, the Custom Setting Menu options are stored within the user settings (U1 and U2) on the Mode dial (figure 5.0). Although there is no direct connection between the two Shooting Menus (Photo and Movie) and the Custom Setting Menu, you can make a connection by configuring both menus under one user setting.

Figure 5.0 – User settings U1 and U2

Maybe setting U1 will be a repository for a certain style-paired Photo/Movie Shooting Menu and Custom Setting Menu configuration, and setting U2 will be for menus that are configured in a completely different style-based way. I did this with my D7200 by configuring the Shooting Menus and Custom Settings Menu for nature photography and video in U1, and storing events photography and video settings in U2.

When you think of the Shooting Menus and the Custom Setting Menu as a paired group of functions controlled by one of the user settings, you begin to see how powerful the Nikon D7200 can be.

Be absolutely sure that you save your settings in U1 before going to U2 to make changes. Otherwise you'll lose your carefully configured settings in either the Shooting Menus or the Custom Setting Menu for that particular user setting. Save the user settings in the Setup Menu with the following function:

Setup Menu > Save user settings > Save to U1 (or U2) > Save settings

Note: Remember that the Shooting Menus and Custom Setting Menu configurations outside of U1 and U2—what I call non-user settings—are completely different camera configurations than the configurations in U1 and U2. As a result, there are three ways to configure your camera's Shooting Menus and Custom Setting Menu: by using U1, U2, or non-user settings.

Now, let's see how to use and configure the 53 functions of the Custom Setting Menu. You should repeat the configuration of all these functions for each user setting. This allows you to configure the camera in two completely different ways, one for U1 and another for U2. The non-user settings outside of U1 and U2 can simply be used for general everyday shooting.

Using the Custom Setting Menu

(User's Manual: Page 276, Menu Guide: Page 58)

Figure 5.1 shows the location of the Custom Setting Menu. It's the fourth menu down on the left-side icon bar, and its symbol looks like a small pencil.

There are seven Custom Setting Menu headings in the D7200 (a through g). Each menu heading has several functions underneath it. We have a lot of ground to cover, and we will do so in great detail. But first there is an initial function on the menu that we need to consider before we get into the main Custom settings.

Figure 5.1 – Custom Setting Menu

Reset Custom Settings

(User's Manual: Page 276, Menu Guide: Page 62)

If you ever want to start fresh with the Custom settings under a particular user setting, you can return the camera to the factory default configuration with Reset custom settings. Make sure you have the Mode dial set to the correct user setting (U1, U2, or the non-user setting outside U1 and U2) before you use the Reset custom settings function.

Figure 5.2 – Reset custom settings

Here are the steps to Reset custom settings that are currently active:

1. Select Reset custom settings from the Custom Setting Menu and scroll to the right (figure 5.2, image 1).
2. Choose Yes from the menu (figure 5.2, image 2).
3. Press the OK button to reset the custom settings under the current user setting to factory default settings.

This chapter is divided into seven distinct sections, one for each major division of the Custom Setting Menu. This will make it easy for you to find a particular setting in the large number of available choices.

Now, let's look at each setting, starting with those found under Custom setting a Autofocus.

Section One: a Autofocus

Custom Settings a1 to a9

You'll find 9 distinct settings within the *a Autofocus* menu in the D7200.

- **a1:** AF-C priority selection
- **a2:** AF-S priority selection
- **a3:** Focus tracking with lock-on
- **a4:** AF activation
- **a5:** Focus point illumination
- **a6:** Focus point wrap-around
- **a7:** Number of focus points
- **a8:** Store points by orientation
- **a9:** Built-in AF assist illuminator

Custom Settings a1–a9 allow you to configure the autofocus system in various ways. The whole process is rather complex—yet important for good photography.

I felt that autofocus and the related functions were important enough to include an entire chapter dedicated to Autofocus (AF), AF-area modes, and Release modes in this book (on page 473). It covers autofocus and its supporting functions in much deeper detail. Please be sure to read that chapter well.

Custom Setting a1: AF-C Priority Selection

(User's Manual: Page 276, Menu Guide: Page 62)

AF-C priority selection is designed to let you choose how your autofocus works when using Continuous-servo autofocus mode (AF-C).

Make sure you understand how this function works. If you configure this setting incorrectly for your style of shooting, it's entirely possible that a number of your pictures will be out of focus. Why?

Well, if you'll notice in figure 5.3, image 3, there are two specific settings:

- **Release:** If the image must be taken, no matter what, you will need to set AF-C priority selection to Release. This allows the shutter to fire every time you press the Shutter-release button, even if the image is not in focus. Releasing the shutter has "priority" over autofocus. If you are well aware of the consequences of shooting without a focus guarantee, then use this setting to make your camera take a picture every time you press the Shutter-release button. Your camera will shoot at its maximum frames per second (FPS) rate because it is not hampered by the time it takes to validate that each picture is in correct focus. You'll need to decide whether taking the image is more important than the image being in focus. We'll discuss why the Release function exist in an upcoming section titled **Using Custom Settings a1 and a2**.
- **Focus:** This setting is designed to prevent your camera from taking a picture when the Viewfinder's green in-focus indicator dot is not displaying. In other words, if the picture is not in focus, the shutter will not release. It does not mean that the camera will always focus on the correct subject. It simply means that your camera must focus on something before it will allow the shutter to release. Nikon cameras do a very good job with autofocus, so you can usually depend on the AF module to perform well. The Focus setting will drastically increase the chances that your image is in correct focus.

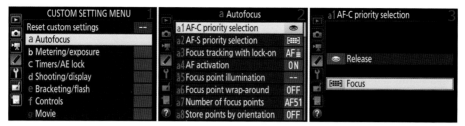

Figure 5.3 – Choosing a shutter-release priority for AF-C mode

Here are the steps to select a shutter-release priority when using AF-C mode:

1. Select a Autofocus from the Custom Setting Menu and scroll to the right (figure 5.3, image 1).
2. Highlight a1 AF-C priority selection and scroll to the right (figure 5.3, image 2).
3. Choose one of the two settings from the menu, with full understanding of what may happen if you don't choose Focus. If you have the experience to use depth of field to cover autofocus, in case of slight focusing errors, or if you set the AE-L/AF-L button to use AF-ON (back button focus) instead of the Shutter-release button for initiating autofocus, you may do well with AF-C priority selection set to Release. Test this carefully.
4. Press the OK button to select your shutter-release priority.

Settings Recommendation: Since I'm not a sports or action shooter, I choose Focus. Even if I were an action shooter, I would choose Focus. Read the subsection called **Using Custom Settings a1 and a2** under next section **(Custom Setting a2)** before making your final choice. The safe choice is Focus. However, if you are an action shooter and have enough experience to deal with a camera that will fire the shutter when you press the Shutter-release button, regardless of whether the image is in focus, the Release setting may work better for you.

Back Button Focusing

You can use the AE-L/AF-L button on the back of the camera to initiate autofocus (AF)—for viewfinder photography—by configuring *Custom Setting Menu > f Controls > f4 Assign AE-L/AF-L button > Press* to AF-ON. Afterward, you can use the AE-L/AF-L button instead of the Shutter-release button for autofocus. The Shutter-release button will not initiate AF when AF-ON is selected for the AE-L/AF-L button. You will focus the camera with the AE-L/AF-L button and then press the Shutter-release button to take the picture.

Custom Setting a2: AF-S Priority Selection

(User's Manual: Page 276, Menu Guide: Page 63)

AF-S priority selection is very similar to AF-C priority selection. It too allows you to choose whether the camera will take a picture without something in focus. With this function, you set a shutter-release priority for Single-servo autofocus mode (AF-S). Set it wrong and many of your pictures may be out of focus. I choose Focus when using AF-S.

There are two modes to choose from (figure 5.4, image 3):

- **Release:** A photo can be taken at any time, even if there is nothing in focus. This can lead to images that are out of focus, unless you manually focus each time you take a picture. The camera's priority is releasing the shutter when you press the Shutter-release button.
- **Focus** (default): The image must be in focus or the shutter will not release. This means that the shutter won't release unless the Viewfinder's green in-focus indicator dot is on. This is the closest thing to a guarantee that your image will be in focus when you press the Shutter-release button. However, if you are focused on the wrong part of your subject, the camera will still fire.

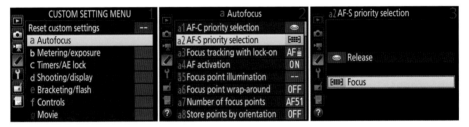

Figure 5.4 – Choosing a shutter-release priority for AF-S mode

Here are the steps to select a shutter-release priority when using AF-S mode:

1. Select a Autofocus from the Custom Setting Menu and scroll to the right (figure 5.4, image 1).
2. Highlight a2 AF-S priority selection and scroll to the right (figure 5.4, image 2).
3. Choose one of the two settings from the menu, with full understanding of what may occur if you don't choose Focus (figure 5.4, image 3).
4. Press the OK button to select your shutter-release priority.

Settings Recommendation: Once again, I choose Focus. I love pictures that are in focus, don't you? When I don't want the camera to care about autofocus over shutter release, I'll just flip the switch to manual on the camera or lens and focus where I want. Up next is the section called **Using Custom Settings a1 and a2**. Read it well!

Using Custom Settings a1 and a2

Before we proceed to the next Custom Setting, please consider the following special information:

Release priority vs. Focus priority: Two of the more important functions in this Custom Settings chapter are a1 and a2. I added this special section so you'll understand why you must pay very close attention to these two settings.

Focus priority simply means that your camera will refuse to take a picture until it can reasonably focus on something. Release priority means that the camera will take a picture when you decide to take it, whether anything is in focus or not!

Now, you might ask yourself, "Why is there such a setting as Release priority?" Well, many professional photographers shoot high-speed events at high frame rates—taking hundreds of images—and use depth of field (or experience and luck) to compensate for less-than-accurate focus. They are in complete control of their camera's systems and have a huge amount of practice in getting the focus right where they want it to be.

There are valid reasons for these photographers to not use Focus priority. However, most of those same photographers do not let pressing the Shutter-release button halfway down start autofocus either because the focus could change every time the Shutter-release button is pressed. They set a4 AF activation so that the autofocus doesn't even activate until a button assigned to AF-ON is pressed instead of the Shutter-release button. They then use the button that AF-ON is assigned to (usually the AE-L/AF-L button) exclusively for auto-focus and the Shutter-release button to take the picture. They separate the two functions instead of using the Shutter-release button for both. This is called *back button focusing.*

You need to ask yourself, "What type of a photographer am I?" If you are a pro shooting hundreds of pictures of fast race cars, Focus priority may not be for you. However, for the average photographer taking pictures of his kids running around the yard, deer jumping a fence, beautiful landscapes, flying birds, or portraits, Focus priority is usually the best choice. For most of us, it's better to have the camera refuse to take the picture unless it's able to focus on our subjects.

When you're shooting at a high frame rate, Focus priority may cause your camera to skip a series of out-of-focus images. It will slow your camera's frame rate so that it will not reach its maximum frames per second in some cases. But, I have to ask, what is the point of several out-of-focus images mixed with the in-focus pictures?

Why waste the card space, add shutter wear, and then have to weed through the slightly out-of-focus images?

Note: Pay special attention to these two settings. You will need to decide—based on your style of shooting—whether you want your camera to refuse to take an out-of-focus image. If you set a1 and a2 to Focus priority and you try to take an out-of-focus image, the Shutter-release button will simply not release the shutter. The green in-focus indicator in the Viewfinder will have to be on before the shutter will release.

Settings Recommendation: I set both a1 and a2 to Focus priority. I'm not a high-speed shooter, so I don't need my camera to take a picture "no matter what." What good are out-of-focus images? We'll discuss this even more in the chapter titled **Autofocus, AF-Area, and Release Modes**.

Custom Setting a3: Focus Tracking with Lock-On

(User's Manual: Page 276, Menu Guide: Page 64)

Focus tracking with lock-on allows you to select the length of time your camera will ignore an intruding object that blocks your subject.

In other words, let's say you are focused on a bird flying past you. As you pan the camera with the bird's movement, the autofocus system tracks it and keeps it in good focus. A road sign briefly interrupts the focus tracking as the bird moves behind it and then reemerges. How would you feel if the bright, high-contrast road sign grabbed the camera's attention and you lost tracking on the bird? That would be quite aggravating, wouldn't it?

The D7200 provides Focus tracking with lock-on to prevent this from happening. The "lock-on" portion of this function helps your camera keep its focus on your subject, even if something briefly comes between the camera and subject. The camera locks on to your subject doggedly if this function is enabled.

Without Focus tracking with lock-on, any bright object that gets between you and your subject may draw the camera's attention and cause you to lose focus on the subject.

The camera provides a variable timeout period for the lock-on functionality. Lock-on timeout allows an object that stays between the camera and your subject for a predetermined length of time to attract the camera's attention. You can adjust this time-out according to the delay time period that works best for you. Plan to experiment a bit so that you can determine what is best for your style of shooting. The factory default is Normal, which I've determined from my own testing is about a one-second delay.

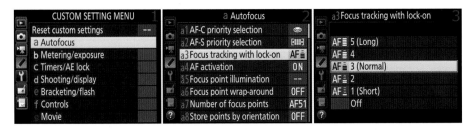

Figure 5.5 – Focus tracking with lock-on

Here are the steps to configure Focus tracking with lock-on:

1. Select a Autofocus from the Custom Setting Menu and scroll to the right (figure 5.5, image 1).
2. Highlight a3 Focus tracking with lock-on and scroll to the right (figure 5.5, image 2).
3. Choose one of the six choices from the menu. Figure 5.5, image 3, shows 3 (Normal), the factory default of about one second. The longest period, 5 (Long), seems to provide only about two seconds of delay in my experience. Time each of these for yourself and see what you think.
4. Press the OK button to select the time-out period.

With Single-point AF, the camera will start the lock-on timeout as soon as the single AF point is unable to detect the subject.

While using Focus tracking with lock-on with Dynamic-area AF, Auto-area AF, or 3D-tracking, I was amused at how adamant the camera was about staying with the current subject. I'd focus on a map on the wall and then cover most of the focusing points with the User's Manual. As long as I allowed at least one or two AF points to remain uncovered so the camera could see the map, the focus did not switch to the manual. I could just hear the D7200 muttering, *"Hah, you can't fool me, I can still see a little edge of that map there, so I'm not changing focus!"*

Only when I stuck the D7200 manual completely in front of the lens, covering all the AF points, did the camera decide to start timing the Focus tracking with lock-on timeout. After a second or two, the camera would give up on the map and focus on the manual instead.

Try this yourself! It's quite fun and will teach you something about the power of your camera's AF system.

Does Lock-On Cause Autofocus to Slow Down?

Some misunderstanding surrounds this technology. Because it is designed to cause the autofocus to hesitate for a variable time period before seeking a new subject, it may make the camera seem sluggish to some users.

But, this "sluggishness" is really a feature designed to keep you from losing your subject's tracked focus. Once the camera locks on to a subject's area of focus, it tries its best to stay with that subject even if it briefly loses the subject. This keeps the lens from racking in and out and searching for a new subject as soon as the previous subject is no longer under an AF point.

It also causes the camera to ignore other higher-contrast or closer subjects while it follows your original subject. You will have to judge the usefulness of this technology for yourself. I suggest that you go to some event or down to the lake and track moving objects with and without lock-on enabled. Your style of photography has a strong bearing on how you'll use—or whether you'll use—Focus tracking with lock-on.

Focus tracking with lock-on has little to do with how well the camera focuses. Instead, it is concerned with what it is focused on. There are some good reasons to leave Focus tracking with lock-on enabled in your camera.

If Focus tracking with lock-on is set to Off, Dynamic-area AF, 3D-tracking, and Auto-area AF will instantly react to something coming between your subject and the camera, even if it only appears in the frame for a moment. A good example of this is when you are tracking a moving subject and just as you are about to snap the picture, a closer or brighter object enters the edge of the frame and is picked up by an outside sensor. The camera may instantly switch focus to the intruding subject. When Focus tracking with lock-on is enabled, the camera will ignore anything that briefly gets between you and your subject.

When using Dynamic-area AF, 3D-tracking, or Auto-area AF mode, I call turning off Focus tracking with lock-on "focus roulette!"

Configuring Custom setting a3 is not difficult. However, you'll need to decide just how long you want your camera to stay locked on to a subject's area before it decides that the subject is no longer available when something intrudes.

Settings Recommendation: I leave Focus tracking with lock-on enabled at all times. When I'm tracking a moving subject, I don't want my camera to be distracted by every bright object that gets in between me and the subject. In fact, the camera defaults to 3 (Normal) from the factory. Nikon gives us variable focus lock timeouts so we can change how long the camera will keep seeking the old subject when we switch to a new one. I suggest you play around with this function until you fully understand how it works. Watch how long the camera stays locked on one subject's area before an intruding object grabs its attention.

This is one of those functions that people either love or hate. Personally, I find it quite useful for my type of photography. Try it and see what it does for you.

Custom Setting a4: AF Activation

(User's Manual: Page 277, Menu Guide: Page 65)

AF activation allows you to choose whether you want the Shutter-release button to cause the camera to autofocus. If you leave this setting at the factory default, the AF system will be activated when you press the Shutter-release button halfway down or when you press a button that was assigned the AF-ON function (see Custom Settings f2, f3, f4, f10, g1, g2, and g3 for AF-ON assignment). Alternatively, you can set the camera so that the button assigned to AF-ON is the only button that can initiate autofocus. In this case, the Shutter-release button will not activate autofocus.

The primary purpose of this function is to allow a very experienced photographer to separate shutter release and autofocus operations. A sports photographer may want to autofocus the camera only when she presses the AE-L/AF-L button and not when she presses the Shutter-release button.

Various styles of photography require the photographer to find a good autofocus point with the AE-L/AF-L button, and then fire many frames with the Shutter-release button with no danger of the camera changing the autofocus during shutter release.

Here's a description of the two selections:

- **Shutter/AF-ON:** Autofocus will be activated if you press the Shutter-release button halfway or if you press a button that was assigned the AF-ON function.
- **AF-ON Only:** Autofocus works only when you press a button that was assigned the AF-ON function. The Shutter-release button will not activate autofocus; it will only start metering and release the shutter.

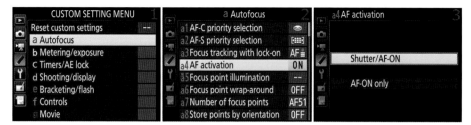

Figure 5.6 – AF activation

Here are the steps used to configure AF activation:

1. Select a Autofocus from the Custom Setting Menu and scroll to the right (figure 5.6, image 1).
2. Highlight a4 AF activation and scroll to the right (figure 5.6, image 2).
3. Choose one of the two choices from the menu. In figure 5.6, image 3, Shutter/AF-ON has been selected.
4. Press the OK button to lock in the setting.

Settings Recommendation: I use Shutter/AF-ON myself because I'm primarily a nature shooter and don't need to separate autofocus from shutter release. I don't have many fast-moving subjects, other than flying birds or leaping deer. And with those, it just feels more natural to me to autofocus and fire the shutter with one button.

However, if I were shooting a high-speed event and wanted to maximize my camera's firing speed (frame rate), I wouldn't hesitate to use the AF-ON functionality, and I would change Custom setting a1 – AF-C priority selection to Release priority. That would let me use my thumb to "back button focus" with the AE-L/AF-L button (having AF-ON assigned to it), while my index finger fires bursts of images with the Shutter-release button using the Continuous high (CH) frame rate. I would autofocus only when needed and would use depth of field to cover small focus variations. That way, I could get as many pictures into my camera as possible for later publication choices.

Custom Setting a5: Focus Point Illumination

(User's Manual: Page 277, Menu Guide: Page 65)

Focus point illumination allows you to change how the autofocus (AF) points appear in the Viewfinder when you use the various AF modes. The AF point illumination can be on or off according to the brightness of your subject and its contrast with the background. It can even be made to disappear while shooting in Manual focus mode.

Let's examine each of the settings inside the Focus point illumination function to see what they do, and then we will explore how to choose your favorite setting.

AF point illumination

When using this setting, you have three choices on how the AF points appear in the Viewfinder. Let's examine each of them.

- *Auto:* The selected AF point is automatically highlighted in red briefly during autofocus when the camera detects that the AF point may not contrast well with the subject, making it hard to see in the Viewfinder.
- *On:* The selected AF point is always highlighted in red briefly during autofocus.
- *Off:* The selected AF point is not highlighted in red during autofocus.

Let's see how to select your favorite AF point illumination setting.

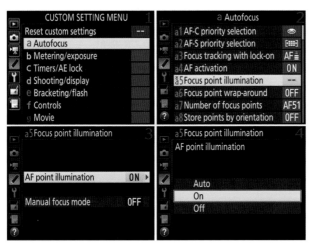

Figure 5.7A – AF point illumination choices

Use the following steps to choose one of the AD point illumination choices:

1. Select a Autofocus from the Custom Setting Menu and scroll to the right (figure 5.7A, image 1).
2. Highlight a5 Focus point illumination and scroll to the right (figure 5.7A, image 2).
3. Choose AF point illumination and scroll to the right (figure 5.7A, image 3).
4. Select Auto, On, or Off, referring to the previous list (figure 5.7A, image 4). On is currently selected.
5. Press the OK button to lock in your choice.

Next let's examine how to use AF point illumination with manual focus.

Manual focus mode

This setting allows you to change how the AF point appears in the viewfinder when the camera is used in a manual mode.

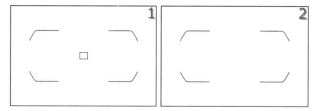

Figure 5.7B – Manual focus mode, On (1) and Off (2)

Here is a list of what the two selections do:

- **On:** If you choose On for this mode, the active focus point will be visible in the Viewfinder (figure 5.7B, image 1) as a small rectangle that can be moved around among the 51 AF points by pressing the Multi selector's directional sides.
- **Off:** If you choose Off and enter a Manual focus mode, there will be no AF points showing in the Viewfinder (figure 5.7B, image 2) until you decide to move the AF point(s) with the Multi selector, which will cause the AF point to appear only briefly.

Let's see how to choose one of these two settings.

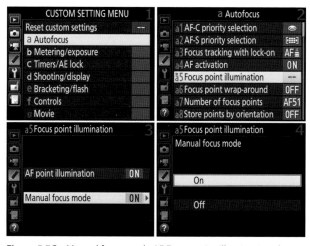

Figure 5.7C – Manual focus mode AF Focus point illumination choices

Use the following steps to choose a Manual focus AF point type:

1. Choose a Autofocus from the Custom Setting Menu and scroll to the right (figure 5.7C, image 1).
2. Select a5 Focus point illumination from the a Autofocus menu and scroll to the right (figure 5.7C, image 2).
3. Choose Manual focus mode from the a5 Focus point illumination menu and scroll to the right (figure 5.7C, image 3).

4. Referring to Figure 5.7C and the information on what On and Off does, select one of the two choices and press the OK button to lock in your choice.

Note: Auto-area AF is not affected by the Focus point illumination settings. You will not see any AF points in the Viewfinder until you have a subject in focus, at which point you will see a varying pattern of AF points displayed briefly. The AF points are always chosen by the camera in Auto-area AF mode.

Settings Recommendation: I tend to leave AF point illumination set to On so that the camera will always flash the selected AF point in red when using autofocus. However, when I am using manual focus, I leave Manual focus mode set to Off so that the AF point will not get in my way.

Custom Setting a6: Focus Point Wrap-Around

(User's Manual: Pages 277, Menu Guide: Page 66)

Focus point wrap-around allows you to control how AF point scrolling on the Viewfinder works. When you are scrolling your selected AF point to the right or left, or even up and down in the array of 51 points, it will eventually come to the edge of the Viewfinder area. What happens next is controlled by the settings in this function.
 Here is a description of the two settings:

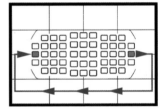

Figure 5.8A – Focus point wrap-around

- **Wrap:** This setting allows the selected AF point to scroll off of the Viewfinder screen and then reappear on the other side (figure 5.8A).
- **No wrap (default):** If you scroll the AF point to the edge of the screen, it stops there! You'll have to use the Multi selector to move the point in the opposite direction, back toward the middle.

Figure 5.8B – Focus point wrap-around

Here are the steps used to configure Focus point wrap-around:

1. Select a Autofocus from the Custom Setting Menu and scroll to the right (figure 5.8B, image 1).

2. Highlight a6 Focus point wrap-around and scroll to the right (figure 5.8B, image 2).
3. Choose one of the two choices from the menu. In figure 5.8B, image 3, No wrap has been selected.
4. Press the OK button to lock in the setting.

Settings Recommendation: Wrapping the AF point around from one side to the other drives me bonkers. I don't like it on my computer screen or in my camera's Viewfinder. When the AF point gets to the edge, I want it to stop so that I can scroll back the other way with the Multi selector. However, I humbly submit that some people will simply adore having their AF point wrap to the other side of the Viewfinder. If that describes you, simply set it to Wrap. It's always No wrap for me!

Custom Setting a7: Number of Focus Points

(User's Manual: Page 277, Menu Guide: Page 66)

Number of focus points allows you to adjust the distance the AF point moves when you scroll it around the screen with the Multi selector.

If you move your AF point often, it might get tiring to scroll through the full 51 focus points, one AF point jump at a time. In older Nikon cameras, we had a maximum of 11 or 39 points to scroll through, so it wasn't too bad. However, with 51 AF points, it could take longer than you want to scroll from one side of the viewfinder to the other. Or, you might just like the old way better!

Nikon has given you a choice. If you'd rather not scroll through the entire 51-point grid, you can set Number of focus points to 11 AF points instead (figure 5.9A).

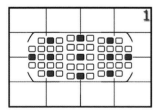 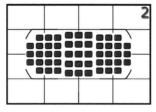

Figure 5.9A – 11 AF points (1) vs. 51 AF points (2)

In Figure 5.9A, image 1 shows the 11-point setting, while image 2 shows the 51-point setting. This does not change the fact that there are 51 points available in Dynamic-area AF or Auto-area AF modes. It just means that the Multi selector will make the selected AF point move farther with each press. It skips over AF points when you scroll in Single-area AF and Dynamic-area AF modes. This means that you cannot choose "in-between" sensors as selected AF points, so you have a smaller choice of points with which to start autofocus.

When using Auto-area AF, the camera does not allow you to move the AF points. So this function does not affect the camera when Auto-area AF is selected.

Here is a description of each Number of focus points selections:

- **51 points** (default): Choose from any of the 51 focus points (AF points) when you are scrolling through them.
- **11 points:** Choose from only 11 focus points (AF points) when you are scrolling through them. The other AF points are still available for autofocus; you just can't scroll directly to them—some are skipped. That means the Multi selector will move the selected AF point around more quickly.

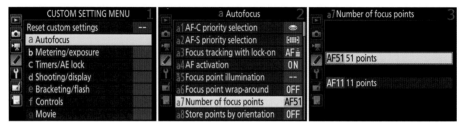

Figure 5.9B – Number of focus points

Here are the steps to select one of the Number of focus points settings:

1. Select a Autofocus from the Custom Setting Menu and scroll to the right (figure 5.9B, image 1).
2. Highlight a7 Number of focus points and scroll to the right (figure 5.9B, image 2).
3. Choose one of the two choices from the menu. In figure 5.9B, image 3, AF51 51 points has been selected.
4. Press the OK button to lock in the setting.

Settings Recommendation: I usually leave my camera set to 51 points for nature work because I have time to scroll among the AF points in an unhurried fashion. The only time I'll change that is when I need to shoot very quickly at an event that moves at a rapid pace, like a graduation ceremony or wedding. At these events I may not have time to scroll through all 51 points to select an AF point on the edge of the Viewfinder, so I'll set Number of focus points to 11 points.

Remember, setting it to 11 points does not change how many AF points are actually used by the camera. It only affects how fast you can move among the AF points when you use the Multi selector to scroll around. Some AF points are skipped during scrolling. You still get the benefit of the other 51 points, if they are set to be active.

Custom Setting a8: Store Points by Orientation

(User's Manual: Page 277, Menu Guide: Page 67)

Store points by orientation is a function that allows a photographer who changes the camera from horizontal (landscape) to vertical (portrait) orientation frequently to have

separate control over the AF point(s) in use for each orientation. You must use the same AF-area mode for each camera orientation (e.g., Dynamic-area AF, Single-point AF).

Figure 5.10A shows the three camera orientations related to the Store by orientation function. Let's examine two settings in the Store points by orientation function:

- ***Yes: You can select a separate AF point location for each of three camera orientations (figure 5.10A).***
- ***No:*** The camera does not store a separate AF point position for different camera orientations. It uses the same AF point for any camera angle.

How Does It Work?

Let's say you are shooting a horizontal wedding photo of a group. You moved the selected AF point to the top of the 51 points so that you can focus on faces with the camera in a horizontal orientation (figure 5.10A, left). Afterward, the group leaves, but the bride and groom stay, and you decide to shoot with the camera in a vertical orientation for a nice, full-length portrait (figure 5.10A, middle).

If you have the Store by orientation function enabled, the camera will remember the last AF point position for the vertical images you shot and automatically move the AF point(s) back there when you rotate the camera back to vertical. It can remember the previous AF point position for all three camera orientations, shown in figure 5.10A. Let's examine how to do it.

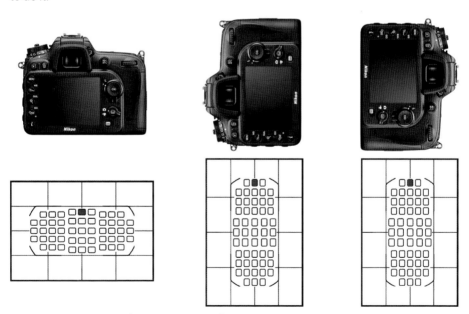

Figure 5.10A – Store points by orientation turned On

Storing an AF Point Position

First, you will enable Store points by orientation (set it to Yes). Next you must set the AF point position, by scrolling with the Multi selector, for all three available orientations, or the camera will not automatically move the AF point when you change the orientation of the D7200. With Store points by orientation set to No, the AF point(s) position will remain the same for all three orientations. You must set each AF point position you want to use for a particular orientation (horizontal or one of the two vertical orientations).

In other words, after enabling Store points by orientation, when you are shooting with the camera in the horizontal orientation, you will select the AF point position you want to use by simply scrolling there with the Multi selector. Afterward, you will switch to each of the vertical orientations and do the same thing—select the AF point position you want to use while holding the camera in that orientation. No other action is required to set the AF point position for each camera orientation. Once set, the camera will automatically move the AF point to the correct position for the current camera orientation as soon as you rotate the camera (figure 5.10A).

The camera will store the position of the AF point for one horizontal and two portrait orientations automatically, without you having to do anything other than select the AF point position for that orientation. You can have separate AF point positions for (1) horizontal (figure 5.10A, left); (2) vertical with hand grip up (figure 5.10A, middle); and (3) vertical with hand grip down (figure 5.10A, right). If you shoot with the camera upside down, it will use the AF point for the normal horizontal orientation; there is not a separate upside-down orientation.

This function could save you significant time by preventing you from having to scroll the AF point constantly as you change camera orientations and change AF-area modes for that orientation.

Now let's see how to choose one of the two settings found in the Store points by orientation function.

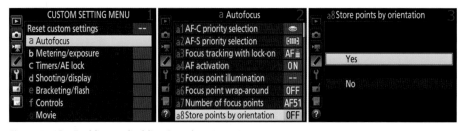

Figure 5.10B – Enabling or disabling Store by orientation

Here are the steps to choose one of the Store by orientation settings:

1. Select a Autofocus from the Custom Setting Menu and scroll to the right (figure 5.10B, image 1).
2. Highlight a8 Store points by orientation and scroll to the right (figure 5.10B, image 2).

3. Choose one of the two choices, Yes or No, from the menu. In figure 5.10B, image 3, Yes has been selected.
4. Press the OK button to lock in the setting.

Note: The camera's light meter must be active for the D7200 to automatically move the AF point to its saved location when you rotate the camera. Press the Shutter-release button halfway down to enable the light meter.

Settings Recommendation: I leave my camera set to the Yes setting because I often change the AF point location for different camera orientations. I like having the AF point(s) automatically pop to a certain position when I am creating vertical portraits or horizontal group shots. It saves me time!

Custom Setting a9: Built-In AF-Assist Illuminator

(User's Manual: Page 277, Menu Guide: Page 68)

You've seen the very bright little light on the front of the D7200, near the grip (figure 5.11A).

Nikon calls this very bright light the *Built-in AF-assist illuminator.* It lights up when the camera senses low-light conditions and when you're using certain AF-area modes (not all) to help with autofocus. Custom setting a9 allows you to control when that powerful little light comes on.

There are two settings for the Built-in AF-assist illuminator:

Figure 5.11A – Built-in AF-assist illuminator

- **On** (default): If the light level is low, the Built-in AF-assist illuminator lights up to help illuminate the subject enough for autofocus. This works with the following Autofocus and AF-area modes only:
 a. Auto-area AF-area mode, anytime it's needed.
 b. When Single-servo AF (AF-S) Autofocus mode is selected and Single-point AF, Dynamic-area AF (9, 21, 51 points), or 3D-tracking AF-area modes are in use, and *only* if you have selected the center AF point in the Viewfinder.
 c. When Continuous-servo AF (AF-C) Autofocus mode is selected the Built-in AF-assist illuminator becomes inactive.
- **Off:** The AF-assist illuminator does not light up to help you in low-light autofocus situations. The camera may not be able to autofocus in extremely low light.

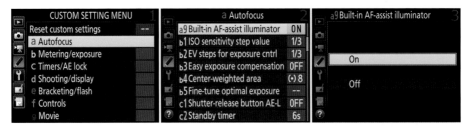

Figure 5.11B – Built-in AF-assist illuminator settings

Here are the steps to set the Built-in AF-assist illuminator to On or Off:

1. Select a Autofocus from the Custom Setting Menu and scroll to the right (figure 5.11B, image 1).
2. Highlight a9 Built-in AF-assist illuminator and scroll to the right (figure 5.11B, image 2).
3. Choose On or Off from the menu. In figure 5.11B, image 3, On has been selected.
4. Press the OK button to lock in the setting.

Settings Recommendation: I leave Built-in AF-assist illuminator set to On most of the time. It is activated only when the light is low enough to need it. However, let me qualify this for specific circumstances. If you are trying to take pictures without being noticed, such as from across the room with a zoom lens or while doing street photography, you certainly don't want this extremely bright little light drawing attention when you start autofocus.

Or, you may be shooting wildlife, such as a giant grizzly bear, and surely don't want to call attention to yourself by shining a bright light into the old bear's eyes. Use this feature when you don't mind others noticing you—especially if they are eight feet tall with claws—because it will draw attention immediately.

Section Two: b Metering/Exposure

Custom Settings b1 to b5

You'll find five settings within the *b Metering/exposure* menu in the D7200:

- **b1:** ISO sensitivity step value
- **b2:** EV steps for exposure cntrl
- **b3:** Easy exposure compensation
- **b4:** Center-weighted area
- **b5:** Fine-tune optimal exposure

The first two settings in the Metering/exposure menu (b1, b2) affect how your camera views steps in its EV range. Most people like to have their camera work very precisely, so they'll use the 1/3 step EV selection for b1 and b2. Others might not be as selective and would prefer to change sensitivity in 1/2 step EV. The last three functions all affect how exposure works (b3–b5).

Custom Setting b1: ISO Sensitivity Step Value

(User's Manual: Page 278, Menu Guide: Page 69)

ISO sensitivity step value allows you to change the way the camera handles its progression of exposure values for ISO. In other words, the camera's ISO "step" value is set with Custom setting b1. You can control the steps with the following values:

- 1/3 step EV (ISO steps: 200, 250, 320, 400, etc.)
- 1/2 step EV (ISO steps: 200, 280, 400, 560, etc.)

If you are concerned with maximum ISO control, use the 1/3 step setting. It takes longer to scroll through the ISO selections if you manually set your ISO value in 1/3 steps; however, it gives you greater exposure control. The 1/3 step setting is the factory default value for b1.

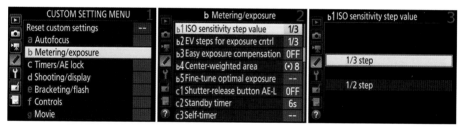

Figure 5.12 – ISO sensitivity step value

Here are the steps to change the ISO sensitivity step value:

1. Select b Metering/exposure from the Custom Setting Menu and scroll to the right (figure 5.12, image 1).
2. Highlight b1 ISO sensitivity step value and scroll to the right (figure 5.12, image 2).
3. Choose either 1/3 step or 1/2 step from the menu. In figure 5.12, image 3, 1/3 step has been selected.
4. Press the OK button to lock in the setting.

Now, let's talk more about how to use the ISO sensitivity step value setting. With ISO sensitivity step value set to 1/3 step, hold down the ISO button on the bottom left of the camera and turn the rear Main command dial to the right. If your camera was set to ISO 100 initially, you'll see that the ISO number shown on the camera's displays change with the following pattern:

- ISO sensitivity step value set to **1/3 step:**
 Lo 1, Lo 0.7, Lo 0.3, 100, 125, 160, 200, 250, 320, 400, 500, 640, 800, 1000, etc.

- ISO sensitivity step value set to **1/2 step:**
 Lo 1, Lo 0.5, 100, 140, 200, 280, 400, 560, 800, 1100, 1600, 2200, 3200, etc.

Settings Recommendation: I like the most control I can have over ISO sensitivity increments. I normally leave this set to the factory default of 1/3 step. This allows me to carefully fine-tune the ISO sensitivity value for precise exposures.

Custom Setting b2: EV Steps for Exposure Cntrl

(User's Manual: Page 278, Menu Guide: Page 69)

EV steps for exposure cntrl refers to the number of steps in the shutter speed and aperture because those are your main exposure controls. It also encompasses the exposure bracketing system. Just as with the ISO sensitivity covered in the previous section, you can control the number of steps in the full range of exposure values.

Here are the two settings available for exposure control:

- 1/3 step (EV is 1/3 step; bracketing is 1/3 EV)
- 1/2 step (EV is 1/2 step; bracketing is 1/2 EV)

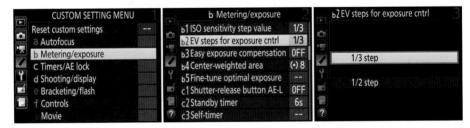

Figure 5.13 – EV steps for exposure cntrl

Here are the steps used to adjust EV steps for exposure cntrl:

1. Select b Metering/exposure from the Custom Setting Menu and scroll to the right (figure 5.13, image 1).
2. Highlight b2 EV steps for exposure cntrl and scroll to the right (figure 5.13, image 2).
3. Choose either 1/3 step or 1/2 step from the menu. In figure 5.13, image 3, 1/3 step has been selected.
4. Press the OK button to lock in the setting.

Now, let's examine the concept in more detail. All EV steps for exposure cntrl really means is that when you are adjusting the shutter speed or aperture manually, each will work incrementally in the following steps.

- **Shutter and Exposure** (starting at a random shutter speed or aperture)

- **1/3 step EV:**
 Shutter: 1/100, 1/125, 1/160, 1/200, 1/250, 1/320, etc.
 Aperture: f/5.6, f/6.3, f/7.1, f/8, f/9, f/10, etc.

- **1/2 step EV:**
 Shutter: 1/90, 1/125, 1/180, 1/250, 1/350, 1/500, etc.
 Aperture: f/5.6, f/6.7, f/8, f/9.5, f/11, f/13, etc.

- **Bracketing**
 1/3 step EV Bracket: 0.3, 0.7, 1.0 (or 1/3, 2/3, 1 EV steps)
 1/2 step EV Bracket: 0.5, 1.0 (or 1/2 and 1 EV steps)

Nikon chose to combine shutter speed, aperture, exposure, flash compensation, and bracketing all under Custom setting b2. The factory default value for EV steps for exposure cntrl is 1/3 step.

Settings Recommendation: Similar to ISO sensitivity step value, I keep *EV steps for exposure cntrl* set to 1/3 step. It's critical to control the EV steps with granularity, especially with exposure. It's best to increment the EV in small steps for use with the histogram.

What Is EV?

EV simply means exposure value, which is an agreed-upon value of exposure metering. It is spoken of in partial or full EV steps, like 1/3, 1/2, or 1 EV. It simply means different combinations of shutter speeds and apertures that give similar exposures. An EV step corresponds to a standard logarithmic "power-of-2" exposure step, commonly referred to as a stop. So, instead of saying 1 EV, you could substitute 1 stop. EV 0 (zero) corresponds to an exposure time of 1 second at an aperture of f/1.0 or 15 seconds at f/4. EV can be positive or negative. EV -6 equals 60 seconds at f/1.0. EV 10 equals 1/1000 seconds at f/1.0 or 1/60 seconds at f/4. The EV step system was invented in Germany back in the 1950s. Interesting, huh?

Custom Setting b3: Easy Exposure Compensation

(User's Manual: Page 278, Menu Guide: Page 70)

Easy exposure compensation lets you set the camera's exposure compensation without using the +/− Exposure compensation button. Instead, you can use the Command dial of your choice to dial in exposure compensation.

There are three settings in Easy exposure compensation: On (Auto reset), On, and Off. If you set the camera to On (Auto reset) or simply to On, you can use the Command dials to set exposure compensation instead of the +/− Exposure compensation button. Off means what it says; you will have to use the +/− Exposure compensation button.

Each exposure mode (P, S, A, M) reacts somewhat differently to Easy exposure compensation. Let's consider how the Program (P), Shutter-priority (S), and Aperture-priority

(A) modes act when you use the three settings. The Manual (M) mode is not affected by Custom setting b3, although it does allow compensation with the normal +/− Exposure compensation button. Here are the values and how they work:

- **On (Auto reset):** Using the Sub-command dial in Program (P) or Shutter-priority (S) mode or the Main command dial in Aperture-priority (A) mode, you can dial in exposure compensation without using the normal +/− Exposure compensation button. The other Command dial will control the aperture or shutter speed, as it normally would. Once you allow the meter to go off, or turn the camera off, the compensation value you dialed in is reset back to 0. That's why it's called Auto reset. If you have already set a compensation value using the normal +/− Exposure compensation button, then the process of dialing in compensation with the Command dial simply adds or subtracts compensation from the value you added with the normal +/− Exposure compensation button. When the meter resets, it returns back to the compensation value you added with the +/− Exposure compensation button and not to 0.
- **On:** This works the same way as On (Auto reset), except that the compensation you've dialed in does not reset but stays in place, even if the meter or camera is turned off.
- **Off:** Only the normal +/− Exposure compensation button applies exposure compensation.

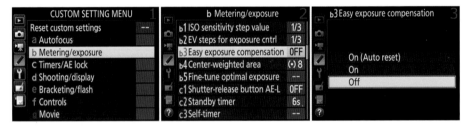

Figure 5.14 – Easy exposure compensation

Here are the steps used to configure Easy exposure compensation:

1. Select b Metering/exposure from the Custom Setting Menu and scroll to the right (figure 5.14, image 1).
2. Highlight b3 Easy exposure compensation and scroll to the right (figure 5.14, image 2).
3. Choose one of the three items on the menu. In figure 5.14, image 3, Off has been selected.
4. Press the OK button to lock in the setting.

Note: The granularity of Easy exposure compensation's EV step fine-tuning is affected by Custom setting b2 (EV steps for exposure cntrl, page 202), with 1/3 or 1/2 EV step settings. Also, the Command dials used to set compensation and change shutter speed and aperture can be swapped in Custom setting f5 (Customize command dials, page 227). Additionally, you cannot use Custom setting b3 at the same time as Custom setting d8 (Easy ISO,

page 230). Adjustments to either Custom setting b3 or d8 will result in a warning message and a reset of the opposite setting.

When you adjust exposure compensation with either the normal +/− Exposure compensation button or with Easy exposure compensation, a +/− symbol will appear on the camera's various displays.

Settings Recommendation: The normal +/− Exposure compensation button works fine for me. However, I have read in forums that some people really like this functionality because they can change the shutter speed and aperture with one Command dial, and dial in exposure compensation with the other.

I think I will keep on using what I am used to; however, why not experiment with this for a few minutes and see if you like dialing in compensation with the Command dials instead of the +/− Exposure compensation button? Nikon gives us a lot of choices!

Custom Setting b4: Center-Weighted Area

(User's Manual: Page 278, Menu Guide: Page 71)

Center-weighted area allows you to control the area on the Viewfinder that has the greatest weight in metering a subject when the camera is using Center-weighted metering mode. Years ago our cameras didn't have Matrix metering. Back in the good old days, we all had averaging meters, center-weighted meters, or none at all.

If you prefer not to use Nikon's built-in database of image scenes, otherwise known as Matrix metering, and you use Spot metering only as needed, you are most likely using the Center-weighted meter. It's cool that Nikon gives us a choice. You have four meter styles in your camera, adding to its flexibility.

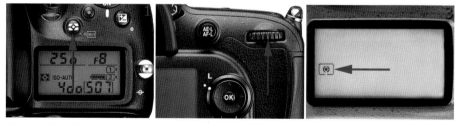

Figure 5.16A – Metering button, Main command dial, and Control panel

On top of the camera, just above the Control panel, you will find a button with a Matrix metering symbol on it (figure 5.16A, image 1). This is the Metering button, and it is used to select the type of meter you want to use. Hold the Metering button down and turn the rear Main command dial (figure 5.16A, image 2) while watching the Control panel on top of the camera. It will display one of the four metering symbols (figure 5.16A, image 3). In this case, we have the Center-weighted meter selected because this section considers how it works.

The Center-weighted meter can be configured to use a central area of the Viewfinder to do most of its metering, with less attention paid to subjects outside this area, or it can be set up to simply average the entire frame. Here are the five area-size settings used by the

Center-weighted metering mode:

- 6mm
- 8mm
- 10mm
- 13mm
- Average

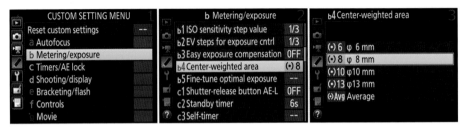

Figure 5.16B – Center-weighted metering mode area

Here are the steps used to choose a Center-weighted metering mode area:

1. Select b Metering/exposure from the Custom Setting Menu and scroll to the right (figure 5.16B, image 1).
2. Highlight b4 Center-weighted area and scroll to the right (figure 5.16B, image 2).
3. Choose one of the five items on the menu. In figure 5.16B, image 3, 8mm has been selected.
4. Press the OK button to lock in the setting.

Let's see how each setting works. Figure 5.16C shows the approximate size of the most sensitive area in the Viewfinder for each area size of the Center-weighted meter. The pink circle is the most sensitive area for metering, and it gets larger for each setting. In the final frame of figure 5.16C, all areas of the frame are equally sensitive and average the light values of everything seen in the Viewfinder.

Figure 5.16C – Center-weighted and Average-weighted areas shown in pink

When you are using the Center-weighted metering mode, the metering system uses an invisible circle in the center of the Viewfinder to meter the subject (figure 5.16C). When it's set down to 8mm, it's almost small enough to be a spot meter because the real Spot metering mode of the camera uses a 3.5mm circle (about 2.5 percent of the frame) surrounding the currently selected AF point.

The Center-weighted meter cannot be moved around with the currently selected AF point as the Spot meter can be. Instead, the camera assigns the greatest weight to the center of the Viewfinder frame, and everything outside the circle in the center is not as important.

Each size increase from 6, 8, 10, to 13mm will increase the sensitivity of the center of the Viewfinder so that more emphasis is given to a larger area in the middle.

If you select the Average (Avg) setting, the entire Viewfinder frame is used to meter the scene. The camera takes an average of the entire frame by including all light and dark areas mixed together for an averaged exposure.

Note: If you use a non-CPU lens with the Center-weighted meter, the camera selects the 8mm circle automatically and it does not change, regardless of which setting is chosen in the menu.

Also, if you are shooting with a filter that has a filter factor over 1×, you may want to consider using the Center-weighted meter because the Matrix meter may not be as accurate.

Settings Recommendation: When I use the Center-weighted meter, I generally use the 13mm setting to make the largest area of the center of the Viewfinder be the most sensitive section. I use 3D Matrix Metering most of the time and have my camera's Fn button set up to switch to the Spot meter temporarily, for special circumstances only. That way, I am using Nikon's incredible 3D Color Matrix Metering III the majority of the time—with its ability to consider brightness, color, distance, and composition. Matrix gives me the best metering I've had with any camera yet! The Center-weighted meter is still included in our modern cameras to make people who are used to using the older style meter more comfortable. Most of us will use Matrix metering these days.

Custom Setting b5: Fine-Tune Optimal Exposure

(User's Manual: Page 278, Menu Guide: Page 71)

Nikon has taken the stance that users should be allowed to fine-tune most major camera systems. The exposure system is no exception. Fine-tune optimal exposure allows you to fine-tune the Matrix, Center-weighted, and Spot metering systems by +1/−1 EV (+/− one stop) in 1/6 EV steps, independently (e.g., 6/6 = 1 EV step, 3/6 = 1/2 EV step).

In other words, you can force each of the three metering systems to add or deduct a little exposure from what it normally would use to expose your subject.

This stays in effect with no further notice until you set it back to zero. It is indeed fine-tuning because the maximum 1 EV step up or down is divided into six parts (1/6 EV). If you feel that your camera is too conservative with the highlights, mildly underexposing, and you want to force it to add 1/2 step exposure, you simply add 3/6 EV to the compensation system for that metering system.

This works like the normal compensation system except it allows you only 1 EV of compensation. As image 3 of figure 5.17A shows, an ominous-looking warning appears telling you that your camera will not show a compensation icon, as it does with the normal +/− Exposure compensation button, when you use the Fine-tune optimal exposure system. This simply means that while you have this fine-tuning system dialed in for your light meter, the camera will not remind you that it is fine-tuned by showing you a compensation icon. If it did turn on the compensation icon (+/− on the Control panel and in the Viewfinder), how could it show you the same icon when you are using normal compensation at the same time as meter fine-tuning?

Figure 5.17A – Fine-tune optimal exposure

Use the following steps to fine-tune any of the four metering systems:

1. Select b Metering/exposure from the Custom Setting Menu and scroll to the right (figure 5.17A, image 1).
2. Select b5 Fine-tune optimal exposure and scroll to the right (figure 5.17A, image 2).
3. Select Yes from the warning screen and scroll to the right (figure 5.17A, image 3).
4. Select the metering system you want to adjust. In figure 5.17A, image 4, you can see that I selected Matrix metering. Now, scroll to the right. All three meter fine-tuning operations work exactly the same way, and each meter can be adjusted independently of the other two. If you want to adjust a different meter besides Matrix metering, simply substitute one of the other three meter types in this step (Center-weighted metering or Spot metering). Scroll up or down in 1/6 EV steps until you reach the fine-tuning value you would like to use (figure 5.17A, image 5). I set +3/6, which is the equivalent of adding +1/2 EV of extra exposure to the Matrix metering system. You may also use a negative value for less exposure (e.g., −3/6).
5. Press the OK button to lock in the fine-tuning value for the metering system you selected in step 4 only. *You must fine-tune each metering system separately.* Notice the red arrow in figure 5.17A, image 6. It is pointing to an asterisk that shows, at a glance, that one of the metering systems in this menu has been fine-tuned.

Figure 5.17B – Fine-tune optimal exposure +/− direction symbols

Note: If you go into the menu system to see what is changed, it will show the fine-tuning fraction next to the meter that has been fine-tuned. It will also show the direction of exposure adjustment by using a plus or minus sign, as indicated by the red arrows in figure 5.17B. You can add or subtract exposure by setting the value to plus or minus.

Also, please be aware that Exposure fine-tuning is *not* affected by a two-button camera reset. Therefore, since the +/− symbol is not shown for Exposure fine-tuning, you must check for the asterisk above b5 (figure 5.17A, image 6) or examine the actual setting to see whether the D7200 is using Exposure fine-tuning. The camera will not remind you.

Finally, pay attention to your camera's histogram to make sure you're not regularly underexposing or overexposing images once you have the fine-tuning adjustment in place. If so, just go back in and adjust the fine-tuning up or down, or turn it off.

Settings Recommendation: Unless you have a good reason to adjust this, most of us will leave it alone. It certainly won't hurt anything to make a fine-tuning adjustment, if you feel confident that you really need it. I used to run +3/6 on my Nikon D300 a few years back, to force a brighter exposure. However, newer Nikon cameras have the most accurate light metering systems I have ever used; therefore, it may not be necessary to fine-tune any of the three meter types in your camera.

We have the ability to fine-tune our cameras to an amazing degree. Whether you need this now or not, you might later. Learn how it works and, as always, experiment with it to see if fine-tuning your light meter gives you better exposures.

Section Three: c Timers/AE Lock

Custom Settings c1 to c5

You'll find five settings within the *c Timers/AE lock* menu in the D7200:

- **c1:** Shutter-release button AE-L
- **c2:** Standby timer
- **c3:** Self-timer
- **c4:** Monitor off delay
- **c5:** Remote on duration (ML-L3)

Let's examine each of them and learn how to control various timers in the camera. We will also explore how to use auto-exposure lock (AE-L).

Custom Setting c1: Shutter-Release Button AE-L

(User's Manual: Page 279, Menu Guide: Page 72)

Shutter-release button AE-L is designed to allow you to lock your camera's exposure when you press the Shutter-release button halfway down. Normally that type of exposure lock happens only when you press and hold the AE-L/AF-L button. However, when you have

Shutter-release button AE-L set to On, your camera will perform the autoexposure lock (AE-L) function every time you start autofocus and take a picture.

This function allows you to meter from one area of the scene and then recompose to another area without losing the meter reading from the first area, as long as you hold the Shutter-release button halfway down.

Looking at this another way, when you have Shutter-release button AE-L set to Off, exposure will lock only when you hold down the AE-L/AF-L button.

Figure 5.18 – Shutter-release button AE-L

Here are the steps used to configure Shutter-release button AE-L:

1. Select c Timers/AE lock from the Custom Setting Menu and scroll to the right (figure 5.18, image 1).
2. Highlight c1 Shutter-release button AE-L and scroll to the right (figure 5.18, image 2).
3. Choose one of the two choices on the menu. In figure 5.18, image 3, Off has been selected.
4. Press the OK button to lock in the setting.

Settings Recommendation: I use this feature only when I really need it, then I turn it off. The rest of the time, I just use the AE-L/AF-L button to lock my exposure. I don't think I'd leave Shutter-release button AE-L turned on all the time because I might be holding the Shutter-release button halfway down to track a moving subject through light and dark areas.

For sunset shooters (or something similar) who like to include the sun in their image, this is a nice function. You can meter from an area of the sky that has the best color and then swing the camera around to include the sun in the shot. The camera will expose for the originally metered area as long as you hold the Shutter-release button halfway down. Normally, you'd just do this with the AE-L/AF-L lock button.

Custom Setting c2: Standby timer

(User's Manual: Page 279, Menu Guide: Page 72)

Standby timer controls the amount of time your camera's light meter stays on after you press the Shutter-release button halfway and then release it. The default value is 6 seconds.

When the light meter goes off, the various displays—like shutter speed and aperture—in the Control panel and Viewfinder do also.

If you would like your light meter to stay on longer for whatever reason, such as for multiple exposures, you can adjust it to the following settings:

- **4 s:** 4 seconds
- **6 s:** 6 seconds (default)
- **10 s:** 10 seconds
- **30 s:** 30 seconds
- **1 min:** 1 minute

- **5 min:** 5 minutes
- **10 min:** 10 minutes
- **30 min:** 30 minutes
- **No limit:** meter stays on continuously

Figure 5.19 – Selecting a Standby timer setting

Here are the steps to set the Standby timer:

1. Select c Timers/AE lock from the Custom Setting Menu and scroll to the right (figure 5.19, image 1).
2. Highlight c2 Standby timer and scroll to the right (figure 5.19, image 2).
3. Choose one of the nine choices on the menu. In figure 5.19, image 3, 6 s has been selected. You can't see all the available selections in image 3. Scroll down on your camera to find one more setting, No limit.
4. Press the OK button to lock in the setting.

Settings Recommendation: There are times when you want the light meter to stay on for a longer or shorter period of time than it normally does. When I'm shooting multiple exposures, I leave Standby timer set to No limit. However, when I'm shooting normally, it stays at either 6 s or 10 s. The longer the light meter stays on, the shorter the battery life, so extend the meter time only if you really need it. You can adjust it from 4 s to No limit. Easy enough!

Custom Setting c3: Self-Timer

(User's Manual: Page 279, Menu Guide: Page 72)

The *Self-timer* setting allows you to take pictures remotely or without touching the camera except to start the Self-timer operation. Hands-off shooting on a tripod can reduce vibrations so that you have sharper pictures. Additionally, it gives you time to place yourself in group shots so there will be some pictures of you to look at later. Put yourself in front of the camera from time to time, or no one will remember what you look like!

To set the Self-timer, hold down the Release mode dial lock button and turn the Release mode dial until the Self-timer symbol (figure 5.20A) is directly above the white indicator on the camera body. When you press the Shutter-release button, the Self-timer will start its timed countdown and will flash the little AF-assist illuminator light (figure 5.11A) until just before the shutter fires. Additionally, if you have Custom setting d1 Beep set to On, the camera will beep about twice per second while counting down and speed up to about four times per second just before it fires the shutter.

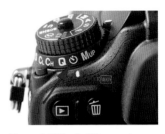

Figure 5.20A – Self-timer selection on Release mode dial

Here are the three choices you have when configuring the Self-timer:

- **Self-timer delay:** This setting allows you to specify a delay before the camera's shutter fires so you have time to position yourself for the shot or allow vibrations to settle down. The time delay ranges from 2 to 20 seconds. This setting can be used instead of a remote release, and you won't have cables to trip over.
- **Number of shots:** Use this setting to choose how many shots will be taken for each cycle of the Self-timer. You can choose from one to nine shots in a row.
- **Interval between shots:** If you are taking more than one shot during a Self-timer cycle, this setting allows you to choose a time interval between each shot ranging from 1/2 second to 3 seconds. This lets you select a time that allows vibrations from the previous shot to settle down.

Now let's look at the screens and steps used to adjust each of these settings. First, we'll look at the Self-timer delay. Here is a list of the four available Self-timer delay settings:

- **2 s:** 2 seconds
- **5 s:** 5 seconds
- **10 s:** 10 seconds (default)
- **20 s:** 20 seconds

Use the following steps to configure the Self-timer delay (figure 5.20B):

1. Select c Timers/AE lock from the Custom Setting Menu and scroll to the right (figure 5.20B, image 1).
2. Highlight c3 Self-timer and scroll to the right (figure 5.20B, image 2).
3. Select Self-timer delay from the menu and scroll to the right (figure 5.20B, image 3).
4. Choose one of the four delay options from the menu, from 2 seconds to 20 seconds (2 s to 20 s). Figure 5.20B, image 4, shows that I selected 10 s.
5. Press the OK button to lock in the setting.

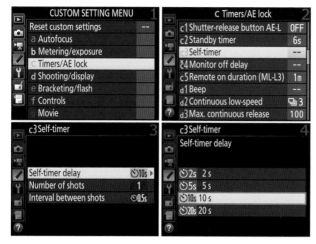

Figure 5.20B – Setting the Self-timer delay

Next, let's look at how to configure the Number of shots for each Self-timer cycle.

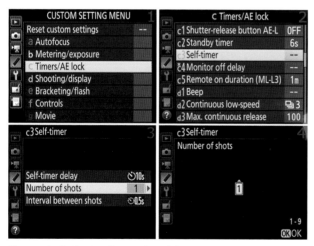

Figure 5.20C – Setting the Number of shots

Use the following steps to configure the Number of shots:

1. Select c Timers/AE lock from the Custom Setting Menu and scroll to the right (figure 5.20C, image 1).
2. Highlight c3 Self-timer and scroll to the right (figure 5.20C, image 2).
3. Select Number of shots from the menu and scroll to the right (figure 5.20C, image 3).
4. Choose the Number of shots, from 1 to 9, by scrolling up or down with the Multi selector. Figure 5.20C, image 4, shows that I selected 1 shot.
5. Press the OK button to choose the setting.

Finally, let's look at how to configure the Interval between shots for each Self-timer cycle. Here is a list of the four available Interval between shots settings:

- **0.5 s:** 1/2 second (default)
- **1 s:** 1 second
- **2 s:** 2 seconds
- **3 s:** 3 seconds

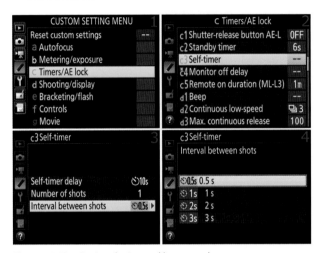

Figure 5.20D – Setting the Interval between shots

Use the following steps to configure the Interval between shots:

1. Select c Timers/AE lock from the Custom Setting Menu and scroll to the right (figure 5.20D, image 1).
2. Highlight c3 Self-timer and scroll to the right (figure 5.20D, image 2).
3. Select Interval between shots and scroll to the right (figure 5.20D, image 3).
4. Choose the Interval between shots, from 1/2 to 3 seconds (0.5 s to 3 s), by scrolling up or down with the Multi selector. Figure 5.20D, image 4, shows that I selected 0.5 s (1/2 second).
5. Press the OK button to choose the setting.

Settings Recommendation: Often, if I don't want to take the time to plug in a remote release cable, I just put my camera on a tripod and set the Self-timer delay to 2 or 5 seconds. This lets the D7200 make a hands-off exposure so I don't shake the camera or the tripod. If I must run to get into position for a group shot, I often increase the delay to at least 10 seconds to keep from looking like an idiot as I trip while running for position.

I can also control how many shots to take each time I use the Self-timer and how long to delay between those shots to allow vibrations to go away. I'm sure you'll agree that the Self-timer in your D7200 is one of the most flexible timers in a DSLR camera.

Custom Setting c4: Monitor Off Delay

(User's Manual: Page 279, Menu Guide: Page 73)

Monitor off delay lets you set a timeout for the Monitor on the back of the camera. You can select a variable timing for five individual functions that use the Monitor to display various screens. The Monitor will stay on until the time-out period expires.

Here is a list of the individual functions:

- **Playback:** This setting is used when you press the Playback button to review images you have taken (otherwise known as chimping images). Default timeout is 10 seconds (10 s).
- **Menus:** When you use the camera's various menus, this setting is used to control how long the menu stays open before the Monitor shuts down. Default timeout is 1 minute (1 min).
- **Information display** (includes the *i* button menu and info button screen): When you press the info button or the *i* button, the camera uses this setting to control the Monitor timeout. Default timeout is 10 seconds (10 s).
- **Image review:** When you take a picture and it appears on the Monitor, this setting controls the Monitor timeout. This is different from Playback, where you are reviewing a series of images you have already taken. Default timeout is 4 seconds (4 s).
- **Live view:** While you are taking still pictures or recording videos with the Live view screen (after pressing the LV button), this setting controls the Monitor timeout. Default timeout is 10 minutes (10 min).

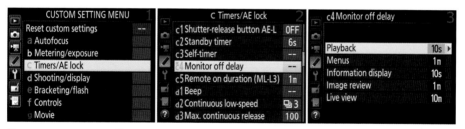

Figure 5.21A – Monitor off delay

Here are the steps to get to the screen for adjusting the timeouts. We'll consider each function individually.

1. Select c Timers/AE lock from the Custom Setting Menu and scroll to the right (figure 5.21A, image 1).
2. Highlight c4 Monitor off delay and scroll to the right (figure 5.21A, image 2).
3. Choose one of the five choices on the menu, as shown in figure 5.21A, image 3. You can set the Monitor off delay for each specific display type. Let's examine each one.

Playback

First, let's look at setting a timeout for *Playback*. This is used when you are "playing back" images you have taken previously. This is not the Image review timeout, which is used when the camera displays a picture on the Monitor immediately after taking it. Playback is for when you are looking at a series of images on the Monitor for your own enjoyment and quality verification or when you are showing images to another person. The available timeout is from 4 s to 10 min.

Figure 5.21B – Monitor off delay – Playback

Use the following steps to choose a Monitor off delay for viewing images on the Monitor after pressing the Playback button:

1. Figure 5.21B picks up where figure 5.21A leaves off. Select Playback from the c4 Monitor off delay screen (figure 5.21B, image 1).
2. Choose from 4 seconds (4 s) to 10 minutes (10 min) delay time. The factory default of 10 s is selected (figure 5.21B, image 2).
3. Press the OK button to lock in the setting.

Menus

Second, let's look at setting a timeout for using the *Menus* when you make adjustments to camera settings. How long do you want the timeout to be before the Monitor shuts off (4 s to 10 min)?

Figure 5.21C – Monitor off delay – Menus

Use the following steps to choose a Monitor off delay for viewing screens on the Monitor after pressing the Menu button:

1. Figure 5.21C picks up where figure 5.21A leaves off. Select Menus from the c4 Monitor off delay screen (figure 5.21C, image 1).
2. Choose from 4 seconds (4 s) to 10 minutes (10 min) delay time. The factory default of 1 min is selected (figure 5.21C, image 2).
3. Press the OK button to lock in the setting.

Information Display

Third, let's look at configuring a timeout for the *Information display* that shows up when you press the info button. This timeout also applies to the *i* button menu that is accessed by pressing the *i* button. You can select from 4 s to 10 min as a timeout for both screens.

Figure 5.21D – Monitor off delay – Information display and Quick Menu

Use the following steps to choose a Monitor off delay for viewing screens on the Monitor after pressing the info button or *i* button:

1. Figure 5.21D picks up where figure 5.21A leaves off. Select Information display from the c4 Monitor off delay screen (figure 5.21D, image 1).
2. Choose from 4 seconds (4 s) to 10 minutes (10 min) delay time. The factory default of 10 s is selected (figure 5.21D, image 2).
3. Press the OK button to lock in the setting.

Image Review

Fourth, let's look at setting a timeout for *Image review*. When you take a picture and have *Playback Menu > Image review* set to On, the camera will display a picture on the Monitor for a specific period of time, controlled by the Image review timeout (2 s to 10 min).

Please note that Image review is not the same as Playback, which is concerned with viewing a series of images, maybe even hours after they were taken. Image review sets the timeout for how long an image appears on the Monitor immediately after you take it.

Figure 5.21E – Monitor off delay – Image review

Use the following steps to choose a Monitor off delay for viewing images immediately after taking them:

1. Figure 5.21E picks up where figure 5.21A leaves off. Select Image review from the c4 Monitor off delay screen (figure 5.21E, image 1).
2. Choose from 2 seconds (2 s) to 10 minutes (10 min) delay time. The factory default is 4 seconds (4 s) but that seems a bit short, so I selected 1 minute (1 min) instead (figure 5.21E, image 2).
3. Press the OK button to lock in the setting.

Live View

Finally, let's look at setting a timeout for *Live view* (Lv). This timeout is used when you are taking still pictures or videos with the Monitor instead of the Viewfinder.

Figure 5.21F – Monitor off delay – Live view

Use the following steps to choose a Monitor off delay for viewing subjects on the Monitor after pressing the Lv button:

1. Figure 5.21F picks up where figure 5.21A leaves off. Select Live view from the c4 Monitor off delay screen (figure 5.21F, image 1).
2. Choose from 5 minutes (5 min) to No limit delay time. The factory default of 10 min is selected (figure 5.21F, image 2).
3. Press the OK button to lock in the setting.

Settings Recommendation: I set the c4 Monitor off delay to 1 min for Playback, Information display, and Image review on my D7200. I leave the other two settings, Menus and Live view, set to their factory defaults.

If you want to conserve battery power, leave the Monitor off delay set to a low value like 4 to 20 seconds. The longer the Monitor stays on, the shorter the battery life, so extend the Monitor time only if you really need it. Like a small notebook computer screen, that big, luxurious 3.2-inch VGA resolution Monitor pulls a lot of power. The Monitor and Control panel backlights are probably the biggest power drains in the entire camera. However, you don't need to be overly concerned about this. With as much image review (chimping) as I do, I can still shoot most of a day on one battery charge.

Live view uses the Monitor for much longer periods (10 min default), which, of course, drains the battery rather quickly. Therefore, it's not a good idea to have an extra-long Live view Monitor off delay. The 10 minute timeout seems reasonable to me, or even the 5 minute timeout if you use Live view mostly for taking still pictures. The timeout starts when you stop using the camera. Why leave it sitting there for a long time draining the battery?

Custom Setting c5: Remote on Duration (ML-L3)

(User's Manual: Page 279, Menu Guide: Page 73)

Interestingly, the c5 Remote on duration setting controls how long the camera will wait for you to press the shutter-release button on your Nikon ML-L3 infrared remote. It works in partnership with the Photo Shooting Menu > Remote control mode (ML-L3) we explored in a previous chapter (page 133). Recall that Remote control mode gives you four settings to choose from:

- *Delayed remote:* Two-second delay after you press the shutter-release button on the ML-L3 wireless remote.
- *Quick-response remote:* Instant release when you press the shutter-release button on the ML-L3 wireless remote.
- *Remote mirror-up:* The first press of the shutter-release button on the ML-L3 wireless remote raises the mirror, and the second press fires the shutter.
- *Off:* Remote control mode is disabled.

If you set Remote control mode to any of these three settings, the camera will stay in a ready state—looking for the remote signal from the ML-L3—for the time delay you set in Remote on duration. This means the camera stays ready to take a picture and leaves the exposure meter active until Remote on duration timeouts.

If you do not use the ML-L3 wireless remote during the specified delay period, remote shooting will cancel at the end of the timeout. The camera will then automatically set *Shooting Menu > Remote control mode (ML-L3)* to Off.

The following delay times are available for Remote on duration:

- 1 min: 1 minute (default)
- 5 min: 5 minutes
- 10 min: 10 minutes
- 15 min: 15 minutes

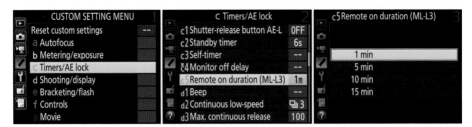

Figure 5.22 – Choosing a Remote on duration for Self-timer Remote control mode

Use the following steps to configure c5 Remote on duration:

1. Choose c Timers/AE lock from the Custom Setting Menu (figure 5.22, screen 1).
2. Select c5 Remote on duration (ML-L3) from the menu and scroll to the right (figure 5.22, screen 2).
3. Select a time-out delay period from 1 minute (1 min) to 15 minutes (15 min) (figure 5.22, screen 3).
4. Press the OK button to lock in your choice.

Note: On some previous Nikons, there was a setting for the ML-L3 on the Release mode dial. However, for the Nikon D7200, that unnecessary physical setting has been eliminated. Now you can use the menus. As soon as you set *Shooting Menu > Remote control mode (ML-L3)* to On, and take a Self-timer picture, the c5 Remote on duration (ML-L3) timeout begins. The camera will remain ready for starting the Self-timer with the ML-L3 wireless remote control until the timeout expires.

Settings Recommendation: I used to leave my Remote on duration time set to 1 min (factory default). However, I have recently been leaving it set to 5 min. I wish there were a two-minute setting because 1 min is not quite enough sometimes, especially for large group portraits, and 5 min is often too long and wastes the battery. If you need this function, you'll have to decide how long is long enough.

Section Four: d Shooting/Display

Custom Settings d1 to d12

Within the *d Shooting/display* menu, you'll find 12 settings in the D7200, as follows:

- **d1:** Beep
- **d2:** Continuous low-speed
- **d3:** Max. continuous release
- **d4:** Exposure delay mode
- **d5:** Flash warning
- **d6:** File number sequence
- **d7:** Viewfinder grid display
- **d8:** Easy ISO
- **d9:** Information display
- **d10:** LCD illumination
- **d11:** MB-D15 battery type
- **d12:** Battery order

Let's examine each of these settings and learn how to control them in the Custom Setting d functions.

Custom Setting d1: Beep

(User's Manual: Page 280, Menu Guide: Page 74)

The *Beep* setting allows your camera to make a beeping sound (if enabled) to alert you during the following events:

- Focus lock while using Single-servo AF (AF-S) mode
- Focus lock while using Live view photography mode
- Countdown during Self-timer and Delayed remote release mode operations
- When a picture is taken using Quick-response release mode
- When a picture is taken in Remote mirror-up mode
- At the end of a Time-lapse photography session
- When you try to take a picture with the memory card locked

You can set the camera to beep with a high- or low-pitched tone, and you can adjust the volume at which that tone sounds, or you can turn the beep sound off. When Beep is active, you'll see a little musical note displayed on the bottom-right side of the Information display on the Monitor, and, of course, you will hear the beep sound at appropriate times.

Volume

First let's examine how to set the Volume or disable Beep. Due to the advanced-enthusiast status of the D7200, Beep defaults to Off in the D7200. The Volume settings under Beep in the Custom Setting Menu are 3, 2, 1, and Off (figure 5.23A, image 4).

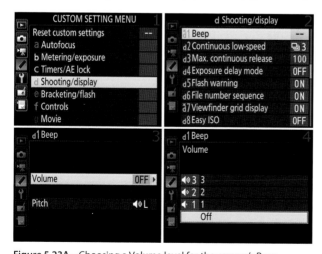

Figure 5.23A – Choosing a Volume level for the camera's Beep

Use the following steps to select one of the d1 Beep Volume choices:

1. Select d Shooting/display from the Custom Setting Menu and scroll to the right (figure 5.23A, image 1).
2. Highlight d1 Beep and scroll to the right (figure 5.23A, image 2).
3. Select Volume from the menu and scroll to the right (figure 5.23A, image 3).
4. Choose one of the four options from the list (1, 2, 3, or Off). In figure 5.23A, image 4, Off is selected (factory default). You will hear a sample beep in each volume level as you choose it. The level 1 beep is rather quiet, so you may not hear it unless you hold your ear closer to the camera, while the level 3 beep is almost obnoxiously loud.
5. Press the OK button to lock in the setting.

Pitch

Next let's consider how to change the pitch of the beep. You have two pitch levels available: High (H) and Low (L). Some people hear low tones better; some people hear high tones better. You should test both of them and see which sounds best to you. Here are the screens and steps to select a pitch for the beep.

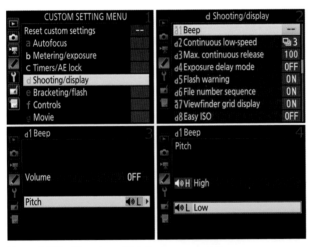

Figure 5.23B – Choosing a Pitch for the camera's Beep

Use the following steps to select a Beep Pitch:

1. Select d Shooting/display from the Custom Setting Menu and scroll to the right (figure 5.23B, image 1).
2. Highlight d1 Beep and scroll to the right (figure 5.23B, image 2).
3. Select Pitch from the menu and scroll to the right (figure 5.23B, image 3).
4. Choose one of the two options from the list (High or Low). In figure 5.23B, image 4, Low is selected. You will hear a sample beep in each pitch as you choose it.
5. Press the OK button to lock in the setting.

Settings Recommendation: I don't use Beep; it's turned Off on my D7200. If I were using my camera in a quiet area, why would I want it beeping and disturbing those around me? I can just imagine me zooming in on that big grizzly bear, pressing the Shutter-release button, and listening to the grizzly roar his displeasure at my camera's beep. I want to live, so I turn off Beep. This is another function that you either love or hate. You can have it either way, but be careful around big wild animals when Beep is enabled. They might think you're calling them to supper, and you may be the main course.

However, you might want the reassurance of hearing a beep when AF has been confirmed or when the Self-timer is counting down. If so, turn it on. The AF-assist illuminator flashes during Self-timer operations, so I generally use that instead of Beep.

By the way, Beep is automatically disabled when you're using the Q (Quiet) position on the Release mode dial, or when autofocusing during a video, regardless of how this function is configured.

Custom Setting d2: Continuous Low-Speed

(User's Manual: Page 280, Menu Guide: Page 75)

Continuous low-speed controls how many frames-per-second (fps) the camera can take when set to Continuous low speed (CL) on the Release mode dial (figure 5.24A).

CL mode is for those of us who would like to use a conservative frames-per-second (fps) rate. In Continuous high speed (CH) mode, the camera can record up to 6 fps. However, unless you are shooting race cars that are driving 200 m.p.h., and unless you have large memory cards, you may not want a large number of frames of the same subject a few hundredths of a second apart. Therefore,

Figure 5.24A – CL mode on Release mode dial

Nikon has given you CL mode to rein in the number of images you will capture in a burst—from 1 to 6 fps—while still giving you multiple-image capture capability.

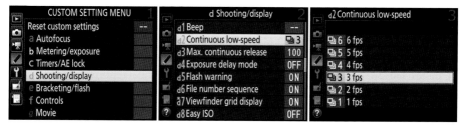

Figure 5.24B – CL mode shooting speed

Here are the steps used to configure CL mode shooting speed:

1. Select d Shooting/display from the Custom Setting Menu and scroll to the right (figure 5.24B, image 1).

2. Highlight d2 Continuous low-speed and scroll to the right (figure 5.24B, image 2).
3. Choose one of the six choices on the list. In figure 5.24B, image 3, 3 fps has been selected. You can choose from 1 to 6 frames per second.
4. Press the OK button to lock in the setting.

As the last screen in figure 5.24B, image 3, shows, you can adjust CL mode shooting speed so that your camera shoots at any frame rate from 1 to 6 fps. The default is 3 fps. Remember, you always have CH mode for when you want to blast off images like there's no end to your memory card(s), or when you want to impress bystanders with that extra-cool Nikon shutter-clicking sound.

Note: When you are shooting Interval timer photography, this setting also sets the frame advance rate for single-frame.

Settings Recommendation: Use your favorite CL mode shooting speed, and grab a few, or many, frames with each press and hold of the Shutter-release button. I leave mine set at the default of 3 fps because that is reasonably fast yet not wasteful of card space. If you'd like, you can slow it all the way down to 1 fps and take only one picture each second that you hold the Shutter-release button down. You'll need to play around with this setting and decide for yourself what speed you like.

Again, remember that you have both low (CL) and high (CH) speeds for the camera's shooting rate. This function is for the low speed setting (CL) found on the Release mode dial.

Custom Setting d3: Max. Continuous Release

(User's Manual: Page 280, Menu Guide: Page 75)

Max. continuous release sets the maximum number of images you can shoot in a single burst. It sounds like you can just start blasting away with your camera, shooting in a single burst until you have reached the number specified in figure 5.25, image 3, which is up to 100 images. While it is possible that you could reach 100 images in a single burst, it is improbable. Your camera is limited by the size of its internal memory buffer, the image format you are shooting, and certain camera settings.

There's a list in your camera User's Manual that specifies how large your camera's buffer is for each image type. In case you're interested in the raw buffer capacity data, the list is on pages 380–381. Here is a summary of what the User's Manual reports concerning the camera's two Image area modes:

- **NEF (RAW) files:** In DX (24×16) mode, the memory buffer holds from 18 to 35 RAW images. While using 1.3× (18×12) mode, the buffer holds from 29 to 67 RAW images. The numbers vary according to whether you are shooting with 12- or 14-bit color-depth and whether or not you are using RAW image compression.
- **JPEG files:** In DX (24×16) and 1.3× (18×12) modes the camera will hold up to 100 JPEG images in its internal buffer.

Note: All the preceding figures are approximate and will vary with the complexity of the subject matter in the image. The maximum number of images stored in the buffer may drop to a lower number with the following settings:

- JPEG Optimal quality compression is On
- ISO sensitivity is set to 12800 or higher
- Long exposure noise reduction is On
- Auto distortion control is On

Unless you are shooting JPEG images with JPEG Size priority compression, you may fill up your camera buffer before you reach the maximum of 100 shots specified by Max. continuous release. Using the fastest memory cards will help the camera hold the maximum number of images in its buffer because it can offload the buffer to the memory card(s) more quickly. If you are an action shooter, use the fastest cards you can afford!

Figure 5.25 – Max. continuous release

Here are the steps used to configure Max. continuous release:

1. Select d Shooting/display from the Custom Setting Menu and scroll to the right (figure 5.25, image 1).
2. Highlight d3 Max. continuous release and scroll to the right (figure 5.25, image 2).
3. Use the Multi selector to scroll up or down and set the number of images you want in each burst. You can select from 1–100. In figure 5.25, image 3, 100 has been selected (default).
4. Press the OK button to lock in the setting.

Settings Recommendation: If you have a need to limit your camera to a maximum number of images in each shooting burst, simply change this number from its default of 100 images to whatever number from 1 to 100 you feel works best for you. Personally, I want the buffer to hold as many images as it possibly can when I am blasting away in high-speed shooting modes, so I leave Max. continuous release set to 100.

However, you may want to artificially limit the camera to a maximum number of frames in one burst. This function allows you to maintain some control over your enthusiastic high-speed shooting. Do you really want dozens and dozens (and dozens) of pictures of those flying seagulls?

Custom Setting d4: Exposure Delay Mode

(User's Manual: Page 280, Menu Guide: Page 75)

Exposure delay mode introduces a delay of 1 to 3 seconds after the Shutter-release button is pressed—and the reflex mirror raised—before the shutter is actually released. Hopefully, during the delay, camera vibrations will die down and the image will be sharper.

The following settings are available in Exposure delay mode (figure 5.26).

- **1 s, 2 s,** or **3 s:** The camera first raises the reflex (viewing) mirror and then waits 1, 2, or 3 seconds before firing the shutter, depending on the selection you choose, as shown in figure 5.26, image 3. This allows the vibrations from the mirror movement to dissipate before the shutter fires. Of course, this won't be useful at all for shooting anything moving (e.g., action shots). But for slow shooters of static scenes, this is great and keeps you from having to use Mirror-up (MUP) Release mode, which requires you to press the Shutter-release button twice to take a picture. It has the same effect as MUP but requires only one Shutter-release button press and a 1- to 3-second delay.
- **Off:** The shutter has no delay when this setting is turned off.

Figure 5.26 – Exposure delay mode

Here are the steps used to configure Exposure delay mode:

1. Select d Shooting/display from the Custom Setting Menu and scroll to the right (figure 5.26, image 1).
2. Highlight d4 Exposure delay mode and scroll to the right (figure 5.26, image 2).
3. Choose one of the four choices on the list: 1 to 3 seconds (1 s, 2 s, or 3 s), or Off. In figure 5.26, image 3, Off has been selected.
4. Press the OK button to lock in the setting.

Settings Recommendation: Exposure delay mode is very important to me. As a nature shooter, I use it frequently for single shots. When I'm shooting handheld—or even on a tripod—and want a really sharp image, I use this mode to prevent the camera's internal reflex mirror movement from vibrating my camera and blurring my pictures.

If you handhold your camera, shoot mostly static subjects, and want sharper pictures, this will help. On a tripod, this is a time-saver compared to Mirror-up (MUP) mode, which requires two Shutter-release button presses, or a 30-second delay.

Custom Setting d5: Flash Warning

(User's Manual: Page 280, Menu Guide: Page 75)

Flash warning is a protection for you. If the camera senses that the image requires more exposure than ambient light provides, it will blink a small red lightning-bolt (flash) symbol on and off in the bottom-right corner of the Viewfinder (figure 5.27A).

This blinking flash symbol is simply a warning that your exposure may be dark if you do not either raise the flash and use it, or manually adjust the shutter speed, aperture, or ISO sensitivity.

Figure 5.27A – Flash warning location in Viewfinder

This blinking lightning-bolt flash symbol is the same one used to inform you that the flash is ready for use. If you raise the built-in flash, within a few seconds the flash symbol will stop blinking and shine solid red, informing you that the flash is ready to use.

Therefore, if you see the blinking flash symbol in the Viewfinder, please check your settings or use the flash. Otherwise, you may have an underexposed picture.

Let's examine how to use the Flash warning.

Figure 5.27B – Using the Flash warning

Use these steps to enable or disable the camera's flash warning system:

1. Select d Shooting/display from the Custom Setting Menu and scroll to the right (figure 5.27B, image 1).
2. Highlight d5 Flash warning and scroll to the right (figure 5.27B, image 2).
3. Choose one of the two choices on the list: On or Off. In figure 5.27B, image 3, On has been selected.
4. Press the OK button to lock in the setting.

Settings Recommendation: I like it when my camera warns me that I might be making an exposure error. I may legitimately have my camera set up for some special effect and really not need the flash, which would invalidate the warning. However, for everyday shooting, when I might not be paying as close attention to exposure as I should be, I welcome any little nudges the camera might give me.

Custom Setting d6: File Number Sequence

(User's Manual: Page 280, Menu Guide: Page 76)

File number sequence allows your camera to keep count of the image file numbers for each picture you take, in a running sequence from 0001 to 9999. After 9999 pictures, it rolls back over to 0001. Or, you can cause it to reset the image number to 0001 when you format or insert a new memory card.

Here are the three settings, and an explanation of how each works:

- **On** (default): Image file numbers start at 0001 and continue running in a sequence until you exceed 9999, at which point the image numbers roll over to 0001 again. The File number sequence continues even if a new folder is created, a new memory card is inserted, or the current memory card is formatted. If the file number exceeds 9999 during a shoot, the camera will create a brand-new folder on the same memory card and start writing the new images in numbered order from 0001 into the new folder. Similarly, if you accumulate 999 images in the current folder, the next image capture will result in the camera creating a new folder, but the file numbering will not be reset to 0001 unless that 999th image had a file number of 9999. In other words, the File number sequence will continue incrementing until 9999 images have been taken. File numbering continues from the last number used or the largest file number in the current folder, whichever is bigger, until 9999 images are reached, at which point the camera starts the numbering sequence over at 0001.
- **Off:** Whenever you format or insert a new a memory card, the number sequence starts over at 0001. If you exceed 999 images in a single folder, the camera creates a new folder and starts counting images at 0001 again.
- **Reset:** This is similar to the On setting. However, it is not a true running total to 9999 because the image number is dependent on the folder in use. The camera simply takes the last number it finds in the current folder and adds 1 to it, up to 999. If you switch to an empty folder, the numbering starts over at 0001. Since a folder cannot hold more than 999 pictures, you will not exceed 999 images in any one folder. Each folder has its own number series and causes a File number sequence Reset.

Figure 5.28 – File number sequence

Here are the steps used to configure File number sequence:

1. Select d Shooting/display from the Custom Setting Menu and scroll to the right (figure 5.28, image 1).
2. Highlight d6 File number sequence and scroll to the right (figure 5.28, image 2).
3. Choose one of the three choices on the list. In figure 5.28, image 3, On (default) has been selected. On is the best choice for most of us.
4. Press the OK button to lock in the setting.

Settings Recommendation: I heartily recommend that you set File number sequence to On, if it has been turned off. After much experience with Nikon DSLR cameras, and many years of storing hundreds of thousands of image files, I've found that the fewer number of files with similar image numbers, the better. Why take a chance on accidentally overwriting the last shooting session when copying files on your computer just because they have the same image numbers?

Custom Setting d7: Viewfinder Grid Display

(User's Manual: Page 280, Menu Guide: Page 77)

A few years ago, the 35mm film Nikon N80/F80 was released with a *Viewfinder grid display,* and I was hooked. Later, as I bought other professional cameras, I was chagrined to find that they did not have the on-demand gridlines that I had grown to love.

Figure 5.29A – Viewfinder without (left) and with the grid display (right)

With the Nikon D7200, you not only have a Viewfinder grid display (figure 5.29A), but you also have Live view (LV) gridlines (page 508). The best of both worlds! There are only two settings in Viewfinder grid display function:

- **On:** Gridlines are displayed in the Viewfinder
- **Off:** No gridlines are displayed in the Viewfinder

Figure 5.29B – Viewfinder grid display

Here are the steps used to enable/disable the Viewfinder grid display:

1. Select d Shooting/display from the Custom Setting Menu and scroll to the right (figure 5.29B, image 1).
2. Highlight d7 Viewfinder grid display and scroll to the right (figure 5.29B, image 2).
3. Choose On or Off from the list. In figure 5.29B, image 3, On has been selected.
4. Press the OK button to lock in the setting.

Settings Recommendation: I use these gridlines to line up things as I shoot so that I won't have weird tilted horizons and such. Many of us tend to tilt the camera one way or another, and gridlines help us see that we've tilted the frame.

I especially enjoy shooting with gridlines enabled when I'm down at the beach. Who needs tilted ocean views? When you're shooting architecture, the gridlines are invaluable for making sure buildings, walls, and doors are correctly oriented with the edge of the frame. There are lots of ways to use the Viewfinder grid display.

If you set Viewfinder grid display to On, I doubt you'll turn it back Off. The nice thing is that you can turn the gridlines On and Off at will. You don't have to buy an expensive viewfinder replacement screen for those times you need gridlines. Good stuff, Nikon!

Using a Grid Display on the Live View Screen

This section pertains only to the Viewfinder grid display in the Viewfinder. You can also turn on gridlines when the Live view screen is active by pressing the info button multiple times to scroll through the various display overlays. One of them is a grid display.

Custom Setting d8: Easy ISO

(User's Manual: Page 281, Guide Menu: Page 77)

Easy ISO allows you to use the camera's command dials to change the ISO sensitivity setting. Normally you would use *Photo Shooting Menu > ISO sensitivity settings* or press the ISO button and turn the Main command dial to change the ISO sensitivity. However, when you enable Easy ISO, the camera lets you adjust the ISO sensitivity with either the Main command dial or the Sub-command dial alone (according to exposure mode), without using the ISO button. This applies only when you use the P, S, or A modes on the Mode dial.

Typically, when you have the camera in P or S modes, you control the aperture (P mode) or shutter speed (S mode) with the Main command dial. The Sub-command dial does nothing. When you set the camera to Easy ISO, the normally unused Sub-command dial sets the ISO sensitivity when the P or S modes are set. Likewise, when the camera is set to A mode, you normally control the aperture with the Sub-command dial, and the Main command dial does nothing. When you enable Easy ISO in A mode, the camera lets you adjust the ISO sensitivity with the unused Main command dial, and you continue to control the aperture with the Sub-command dial.

For people who need to adjust the ISO sensitivity quickly while shooting, this can be very convenient. M mode on the Mode dial is not affected by this setting. You cannot change the ISO sensitivity with either command dial in M mode, because the command dials control the aperture and shutter speed.

Here are the two settings in the Easy ISO function:

- **On:** You can adjust the ISO sensitivity with the Sub-command dial when using P and S modes on the Mode dial. When using A mode, you will adjust ISO sensitivity with the Main command dial.
- **Off:** You will adjust the ISO sensitivity the normal way, by holding down the ISO button and rotating the Main command dial.

Now let's examine how to change the settings.

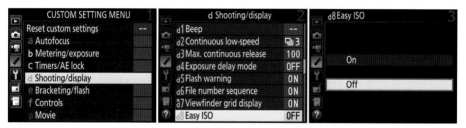

Figure 5.30 – Using Easy ISO to set ISO sensitivity

Use the following steps to enable or disable Easy ISO:

1. Select d Shooting/display from the Custom Setting Menu and scroll to the right (figure 5.30, image 1).
2. Highlight d8 Easy ISO and scroll to the right (figure 5.30, image 2).
3. Choose On or Off from the list. In figure 5.30, image 3, Off has been selected.
4. Press the OK button to lock in the setting.

Settings Recommendation: Having an ISO sensitivity adjustment on the opposite Command dial when using P, S, or A exposure modes can be convenient. Some other camera brands provide this as a default; therefore, for photographers switching to Nikon, this can be a much-welcome function. It feels a little strange at first for a longtime Nikon user, but it can be a fast way to dial in exposure compensation. Give it a try!

Custom Setting d9: Information Display

(User's Manual: Page 281, Menu Guide 78)

The *Information display* setting allows your camera to automatically sense how much ambient light there is in the area where you are shooting and adjust the color and brightness of the Information display screen accordingly. If the ambient light is bright, the color of the physical Information display screen will also be bright so it can overcome the ambient light.

To open the Information display screen, press the info button. The Information display screen shows the current shooting information.

Figure 5.31A – (1) Dark-on-light and (2) Light-on-dark display screens

Figure 5.31A shows the difference between the light and dark screens, which you can select by using one of the two Manual settings or by using Auto to allow the camera to select a screen automatically. In figure 5.31A, image 1 is the Dark-on-light screen and image 2 is the Light-on-dark screen.

Try this: With your lens cap off, your camera turned on, and nothing displayed on the rear Monitor, press the info button. If there's dim to bright ambient light, you'll see a white information screen with black characters. Now, go into a dark area or put your lens cap on and cover the Viewfinder eyepiece with your hand. You'll see that anytime there is very little ambient light, the camera changes the Information display screen to light gray characters on a dark background. This assures that you won't be blinded when you need to see the shooting information in a dark area.

In image 2 of figure 5.31A, I have brightened the screen's gray text so that it is clear in the printed book. In real life it is somewhat dimmer than displayed, to allow you to keep your night vision.

As shown in figure 5.31B, image 3, there are two available selections for the Information display setting:

- **Auto:** The D7200 determines through its lens (with no lens cap) or uncovered Viewfinder eyepiece how much ambient light there is and changes the color and contrast of the Information display screen accordingly.
- **Manual:** The Manual setting allows you to select the light or dark version of the Information display screen manually. If you choose Manual, you can see in figure 5.31C, image 4, that you have two options: B Dark on light (white screen) and W Light on dark (dark screen).

Auto

First let's see how to select the Information display Auto setting.

Figure 5.31B – Setting Information display to Auto

Use the following steps to configure the Information display setting for Auto:

1. Select d Shooting/display from the Custom Setting Menu and scroll to the right (figure 5.31B, image 1).
2. Highlight d9 Information display and scroll to the right (figure 5.31B, image 2).
3. In figure 5.31B, image 3, Auto is selected. In Auto mode the camera will choose the light or dark screen depending on the ambient light level.
4. Press the OK button to lock in the setting.

Manual

Next let's see how to configure the Information display Manual setting.

Figure 5.31C – Setting Information display to Manual

If you want to manually select the screen color for your camera's Information display screen, use the following steps:

1. Select d Shooting/display from the Custom Setting Menu and scroll to the right (figure 5.31C, image 1).
2. Highlight d9 Information display and scroll to the right (figure 5.31C, image 2).
3. Choose B Manual and scroll to the right (figure 5.31C, image 3).
4. The next screen shows the B Dark on light and W Light on dark choices. In figure 5.31C, image 4, B Dark on light is selected, so the light (white) background screen will be displayed when I press the info button. The camera will not adjust the screen color according to ambient light when you are using B Manual mode.
5. Press the OK button to lock in the setting.

Settings Recommendation: I leave Information display set to Auto because it seems to work very well at automatically selecting the proper screen for current light conditions. If you want to impress your friends and make your enemies envious, just show them how cool your camera is when it's smart enough to adjust its Information display screen color to the current light conditions.

Custom Setting d10: LCD Illumination

(User's Manual: Page 281, Menu Guide: Page 78)

The *LCD illumination* setting gives you a simple way to set how the illumination of the Control panel LCD backlight works. When it's on, the Control panel lights up in yellowish green. Here are the two choices and how they work:

Figure 5.32A – Backlight position of the Power and backlight switch

- **Off** (default): If you leave LCD illumination set to Off, the Control panel will not turn on its backlight when the exposure meter is active unless you tell it to by moving the Power switch to the backlight setting (figure 5.32A). If you move the Power switch all the way to the right, the Control panel will light up. The length of time the Control panel backlight stays on is controlled by the delay value selected in *Custom Setting Menu > c Timers/AE lock > c2 Standby timer,* which also controls how long the light meter stays on after activation.
- **On:** This setting makes the Control panel illumination come on anytime the exposure meter is active. If you shoot in the dark and need to refer to the Control panel often, then switch this setting to On. Just keep in mind that this setting will cause a greater battery drain when set to On.

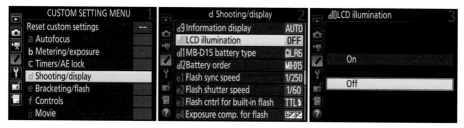

Figure 5.32B – LCD illumination

Use the following steps to configure the LCD illumination setting:

1. Select d Shooting/display from the Custom Setting Menu and scroll to the right (figure 5.32B, image 1).
2. Highlight d10 LCD illumination and scroll to the right (figure 5.32B, image 2).
3. Choose either On or Off from the menu. In figure 5.32B, image 3, Off is selected.
4. Press the OK button to lock in the setting.

Settings Recommendation: This setting will affect the camera's battery life because backlights pull a lot of power, so I don't suggest using the On setting unless you really need it. You have the Power switch (On/Off/Backlight)—surrounding the shutter-release button—to manually turn on the Control panel light when needed (figure 5.32A).

Custom Setting d11: MB-D15 Battery Type

(User's Manual: Page 281, Menu Guide: Page 79)

MB-D15 battery type applies only when you choose to use AA-sized batteries of various types in your optional MB-D15 battery pack. This function has no effect when you are using a normal Nikon EN-EL15 li-ion battery pack because the EN-EL15 is intelligent and communicates with the camera.

If you have an MB-D15 and plan on using low-cost AA batteries, then you'll need to tell the camera what type of AA batteries you're using for this session. It certainly is not a good idea to mix AA battery types due to voltage variations.

These are the battery types the camera will accept (figure 5.33, image 3):

- LR6 (AA alkaline)
- HR6 (AA Ni-MH)
- FR6 (AA lithium)

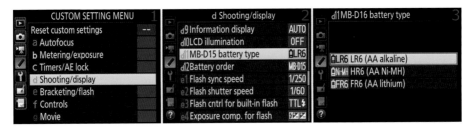

Figure 5.33 – MB-D15 battery type

Here are the steps used to configure the MB-D15 battery type:

1. Select d Shooting/display from the Custom Setting Menu and scroll to the right (figure 5.33, image 1).
2. Highlight d11 MB-D15 battery type and scroll to the right (figure 5.33, image 2).
3. Choose one of the three choices on the list. In figure 5.33, image 3, LR6 (AA alkaline) has been selected.
4. Press the OK button to lock in the setting.

Settings Recommendation: Nikon allows but does not recommend using certain AA batteries, such as alkaline (LR6). Its primary objection to this type is that they do not work well at lower temperatures. In fact, once the ambient temperature drops below 68°F (20°C), an alkaline battery starts losing its ability to deliver power and will die rather quickly. You may not get as many shots out of a set of AA batteries, so your cost of shooting may rise (see the upcoming **AA Battery Tips** sidebar).

However, AA batteries are readily available and relatively low cost, so some people like to use them, especially in an emergency. If you do choose to use AA batteries, I recommend sticking with lithium types (FR6). That is the same type of cell used in the normal Nikon EN-EL15 batteries and it is not affected as much by a low ambient temperature. You can also use the Ni-MH (HR6, nickel-metal hydride) batteries safely because they are not as temperature sensitive and provide consistent power.

AA Battery Tips

AA batteries are low cost, yet have reasonable capacity when used in the MB-D15 battery pack in warm ambient temperatures. There are some facts about AA batteries that you should know:

- The capacity of some AA batteries is sharply reduced once ambient temperatures have reached 68°F (20°C) and below.
- Alkaline AA batteries have less capacity than other AA types and should not be used in cool temperatures unless no other battery type is available.
- When shooting in cool temperatures, keeping spare batteries in your pocket to keep them warm and switching them out frequently may extend battery capacity.
- Your camera may have reduced performance when using AA batteries.

Custom Setting d12: Battery Order

(User's Manual: Page 281, Menu Guide: Page 80)

Battery order lets you choose the order in which you want the available batteries to be used—camera's battery first or those in the MB-D15 battery pack first.
Here are the two menu choices:

- Use MB-D15 batteries first
- Use camera battery first

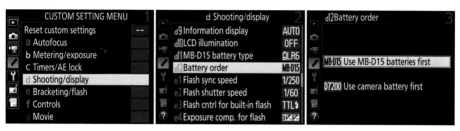

Figure 5.34 – Battery order

Here are the steps used to configure the Battery order:

1. Select d Shooting/display from the Custom Setting Menu and scroll to the right (figure 5.34, image 1).
2. Highlight d12 Battery order and scroll to the right (figure 5.34, image 2).
3. Choose one of the two settings on the list. In figure 5.34, image 3, Use MB-D15 batteries first has been selected.
4. Press the OK button to lock in the setting.

Settings Recommendation: Which battery do you want to draw down first? Personally, I like to use the MB-D15 batteries first and have my camera's internal battery available as a backup. That way, if I remove the MB-D15, my camera won't suddenly go dead due to a depleted battery. Nikon thinks the same way, evidently, because the camera defaults to Use MB-D15 batteries first.

Battery Charge Symbols

The following symbols will be shown by the camera when using any battery, including AA types or the normal EN-EL15 Li-ion battery pack.

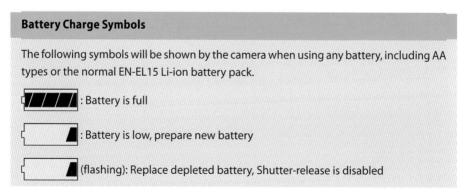

Section Five: e Bracketing/Flash

Custom Settings e1 to e7

Within the *e Bracketing/flash* menu, you'll find seven settings in the D7200:

- **e1:** Flash sync speed
- **e2:** Flash shutter speed
- **e3:** Flash cntrl for built-in flash
- **e4:** Exposure comp. for flash
- **e5:** Modeling flash
- **e6:** Auto bracketing set
- **e7:** Bracketing order

Let's examine how to use each of these settings in the following subsections.

Custom Setting e1: Flash Sync Speed

(User's Manual: Page 282, Menu Guide: 81)

Flash sync speed lets you select a basic flash synchronization speed from 1/60 s to 1/250 s for the built-in flash or an external Speedlight flash unit.

Additionally, there is a special flash mode available called Auto FP. This mode allows your camera to exceed the normal flash sync speed of 1/250 s, for those times when you need a higher shutter speed than 1/250 s. The two Auto FP modes are: 1/320 s (Auto FP) and 1/250 s (Auto FP). They are available only with certain external Speedlights and not with the built-in pop-up Speedlight.

At press time, seven Nikon Speedlights can be used with the D7200 in Auto FP high-speed sync mode:

- SB-910
- SB-900
- SB-800
- SB-700
- SB-600
- SB-500
- SB-R200

The two Auto FP high-speed sync modes—1/320 s (Auto FP) and 1/250 s (Auto FP)—enable the use of fill flash even in bright daylight with wide aperture settings when you are using Programmed Auto (P) or Aperture-priority auto (A) modes on the mode dial. Auto FP high-speed sync allows you to set your camera to use any shutter speed all the way up to the highest shutter speed available, 1/8000 s, and still use the external flash unit to fill in shadows.

See the upcoming section titled **Auto FP High-Speed Sync Review,** where we discuss how this works. Also, the upcoming subsection titled **Special Shutter Speed Setting X +**

Flash Sync Speed discusses synchronizing the flash in Shutter-priority auto (S) and Manual (M) modes.

Figure 5.35 – Flash sync speed

Here are the steps used to adjust your camera's Flash sync speed:

1. Select e Bracketing/flash from the Custom Setting Menu and scroll to the right (figure 5.35, image 1).
2. Highlight e1 Flash sync speed and scroll to the right (figure 5.35, image 2).
3. Choose one of the eight choices on the list—1/60 s to 1/320 s (Auto FP). In figure 5.35, image 3, 1/320 s (Auto FP) has been selected.
4. Press the OK button to lock in the setting.

When you're using Auto FP mode, the output of your flash is reduced but doesn't cut off the frame for exposures using a shutter speed higher than the normal flash sync speed (X Sync). Why? Let's review.

Auto FP High-Speed Sync Review

In a normal flash situation, with shutter speeds of 1/250 s and slower, the entire shutter is fully open and the flash can fire a single burst of light to expose the subject. It works like this: There are two shutter curtains in your camera. The first shutter curtain opens, exposing the sensor to your subject. The flash fires, providing correct exposure, and then the second shutter curtain closes. For a very brief period, the entire sensor is uncovered. The flash fires during the time when the sensor is fully uncovered.

However, when your camera's shutter speed goes above 1/250 s, the shutter curtains are never fully open for the flash to expose the entire subject in one burst of light. The reason is that at higher shutter speeds, the first shutter curtain starts opening and the second shutter curtain quickly starts following it. In effect, a slit of light is scanning across the surface of your sensor, exposing the subject. If the flash fired normally, a flash of light would expose the width of that slit between the shutter curtains, but the rest of the sensor would be blocked by the curtains. You would have a band of correctly exposed image, and everything else would be underexposed.

What happens to your external Nikon Speedlight to allow it to follow that slit of light moving across the sensor? It changes from a normal flash unit into a pulsing strobe unit. Have you ever danced under a strobe light? A strobe works by firing a series of light pulses.

Similarly, when your camera's shutter speed is so high that the Speedlight cannot fire a single burst of light for correct exposure, it can use its Auto FP high-speed sync mode and fire a series of light bursts over and over as the shutter curtain slit travels in front of the image sensor. The Speedlight can fire hundreds of bursts per second. To a photographer or subject, it still looks like one big flash of light, even though in reality it is hundreds of bursts of light, one right after the other.

When the camera is set to Auto FP mode, you'll see something like this on the Speedlight's LCD monitor:

- TTL FP
- TTL BL FP

The FP tells you that the camera and Speedlight are ready for you to use any shutter speed you'd like and still get a good exposure. Even with wide open apertures!

You can safely leave your camera set to 1/320 s (Auto FP) or 1/250 s (Auto FP) all the time because the high-speed sync mode does not kick in until you raise the shutter speed above the maximum setting of 1/250 s. Below that shutter speed, the flash works in normal mode and does not waste any power by pulsing the output.

This pulsing of light in Auto FP mode reduces the maximum output of your flash significantly but allows you to use any shutter speed you'd like while still firing your external Speedlight. The higher the shutter speed, the lower the flash output. In effect, your camera is depending on you to provide enough ambient light to offset the loss in flash power. I've found that even my powerful SB-910 Speedlight can provide only enough power to light a subject out to about 6–8 feet (1.8–2.4 m) when using a 1/8000 s shutter speed. With shutter speeds that high, there needs to be enough ambient light to help the flash light the subject, unless you are very close to the subject.

However, now you can use wide apertures to isolate your subject in direct sunlight—which requires high shutter speeds. The flash will adjust and provide great fill light if you're using Auto FP high-speed sync mode.

Note: If your flash fires at full power in normal or Auto FP sync modes, it will blink the flash indicator in the Viewfinder to let you know that all available flash power has been used and that you need to check to see if the image is underexposed. Check the camera's histogram often to validate your exposures, especially when using Auto FP.

Special Shutter Speed Setting X + Flash Sync Speed

When using Manual (M) or Shutter-priority auto (S) exposure modes, there is still one more numerical setting below 30 seconds, BULB, and −− (Time). It is called the X + Flash sync speed. This special setting allows you to set the camera to a known shutter speed and shoot away. You will see x 1/320 if *Custom Setting Menu > e1 Flash sync speed* is set to 1/320 s (Auto FP). Whatever Flash sync speed you select will show up after the x. If you select a Flash sync speed of 1/125 s, then x 1/125 will show up as the next setting below −−. Selecting a Flash sync speed of 1/60 s means that x 1/60 will show up below −−.

The shutter speed will not vary from your chosen setting. The camera will adjust the aperture and flash when in Shutter-priority auto (S) mode, or you can adjust the aperture while the flash controls exposure in Manual (M) mode.

This special X-Sync mode is not available in Aperture-priority auto (A) or Programmed auto (P) modes because the camera controls the shutter speed in those two settings. Primarily, you'll use this setting when you are shooting in Manual or in Shutter-priority auto and want to use a known X-Sync speed.

Settings Recommendation: I leave my camera set to 1/320 s (Auto FP) as shown in figure 5.35, image 3, all the time. The camera works just as it normally would until one of my settings takes it above the normal 1/250 s shutter speed, at which time it starts pulsing the Speedlight to match the shutter curtain travel. Once again, you won't be able to detect this high-frequency strobe effect because it happens so fast it seems like a single burst of light.

Be aware that the flash loses significant power (or reach) at higher shutter speeds because it is forced to work so hard. Please experiment with this to get the best results. You can use a big aperture like f/1.4 to have very shallow depth of field in sunlight because you can use very high shutter speeds. This will allow you to make images that many others simply cannot create. Learn to balance the flash and ambient light in Auto FP high-speed sync mode. All this technical talk will make sense when you see the results. Pretty cool stuff!

Which Flash Units for Auto FP High-Speed Sync Mode?

If you are using the camera's built-in pop-up Speedlight, or the small Nikon SB-300 or SB-400, your camera's maximum flash shutter speed is limited to 1/200 s. If you use the external Speedlights SB-910, SB-900, SB-800, SB-700, SB-600, SB-500, and SB-R200, you can use any shutter speed and the flash will adjust (pulse) to match lighting needs. With the larger Speedlights, you'll need to learn how to balance ambient light with light from the flash when using shutter speeds higher than 1/250 s. Just remember that your flash unit's range will be seriously reduced at higher shutter speeds.

Custom Setting e2: Flash Shutter Speed

(User's Manual: Page 283, Menu Guide: Page 82)

Flash shutter speed controls the minimum shutter speed your camera can use in various flash modes. You can select between 30 seconds (30 s) and 1/60 of a second (1/60 s). Whereas the previous function, Flash sync speed, controls the fastest shutter speed available, Flash shutter speed controls the slowest shutter speed available in specific modes.

Let's consider each mode and its minimum shutter speed:

• **Front-curtain sync, Rear-curtain sync,** or **Red-eye reduction:** In Programmed auto (P) mode or Aperture-priority auto (A) mode, the slowest shutter speed can be selected from the range of 1/60 second (1/60 s) to 30 seconds (30 s) (figure 5.36). Shutter-priority (S) mode and Manual (M) mode cause the camera to ignore Flash shutter speed, and the slowest shutter speed can be as slow as 30 seconds (30 s) if the photographer chooses a speed that slow.

- *Slow sync, Red-eye reduction with slow sync,* or *Slow rear-curtain sync:* These three modes ignore Flash shutter speed, and the slowest shutter speed can be as slow as 30 seconds (30 s) if the camera or photographer chooses a shutter speed that slow.

Figure 5.36 – Flash shutter speed

Here are the steps to set the Flash shutter speed minimum:

1. Select e Bracketing/flash from the Custom Setting Menu and scroll to the right (figure 5.36, image 1).
2. Highlight e2 Flash shutter speed and scroll to the right (figure 5.36, image 2).
3. Choose one of the settings on the list: 1/60 s to 30 s. In figure 5.36, image 3, 1/60 s has been selected. Remember that slower shutter speeds can cause subject ghosting when flash is used in high ambient light conditions.
4. Press the OK button to lock in the setting.

Custom setting e2 Flash shutter speed is only partially used by the flash modes because the default is preset to as slow as 30 seconds in Shutter-priority and Manual modes.

Settings Recommendation: I normally use 1/60 s. Shutter speeds lower than 1/60 s can cause ghosting if the ambient light is too high. The subject can move after the flash fires but with the shutter still open and with enough ambient light to record a blurred ghost effect. You'll have a well-exposed picture of the subject with a ghost of him also showing in the image. Use slower shutter speeds only when you are sure that you'll be in dark conditions and the flash will provide the only lighting—unless you're shooting special effects, like a blurred aftereffect following your subject to imply movement.

Custom Setting e3: Flash Cntrl for Built-in Flash

(User's Manual: Page 283, Menu Guide: Page 83)

Flash cntrl for built-in flash provides four distinct ways to control the pop-up Speedlight's flash output. This setting does not apply to flash units you attach via the Accessory shoe (hotshoe) on top of the camera. It is only for the pop-up flash.

Additionally, the built-in flash can be used to control multiple groups or banks of stand-alone Speedlight flash units. When you use the flash in this manner, you are using it in Commander mode, which we will also discuss.

Figure 5.37A – TTL mode

Here are the steps used to configure Flash cntrl for built-in flash:

1. Select e Bracketing/flash from the Custom Setting Menu and scroll to the right (figure 5.37A, image 1).
2. Highlight e3 Flash cntrl for built-in flash and scroll to the right (figure 5.37A, image 2).
3. Choose one of the four choices on the list. In figure 5.37A, image 3, TTL has been selected. The other choices will be detailed in figures 5.37B, 5.37C, and 5.37D. Those three figures start where figure 5.37A leaves off.
4. Press the OK button to lock in the setting.

Let's consider each of these modes.

Through The Lens (TTL)

Also known as i-TTL, this mode is the standard way to use the camera for flash pictures (figure 5.37A). TTL (through the lens) allows very accurate and balanced flash output using a preflash method to determine correct exposure before the main flash burst fires. This is a completely automatic mode and will adjust to distances along with the various shutter speeds and apertures your camera is using.

Manual (M)

This mode allows you to manually control the output of your flash (figure 5.37B). The range of settings can go from Full power to 1/128. At full power, the built-in Speedlight has a Guide Number of 39 feet (12 m) at ISO 100 and 68°F (20°C).

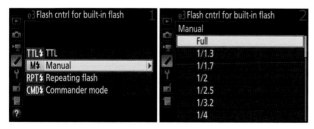

Figure 5.37B – Manual mode

Repeating Flash (RPT)

This setting turns your flash into a strobe unit that you can see pulsing (unlike Auto FP high-speed sync mode), allowing you to get creative with stroboscopic multiple flashes. Using screen 2 in figure 5.37C, you can use the Multi selector to scroll up and down to set the values or left and right to move between Output, Times, and Frequency. Press the OK button when you have it configured.

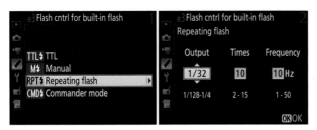

Figure 5.37C – Repeating flash mode

There are three settings, as shown in Figure 5.37C, image 2:

- **Output:** You can vary the power of the flash from 1/4 to 1/128 of the full power. The more power the flash uses, the fewer times it can fire. Here is a table of how many times the built-in pop-up flash can fire using the different Output levels:

 1/4: 2 times **1/32:** 2–10 or 15 times
 1/8: 2–5 times **1/64:** 2–10, 15, 20, 25 times
 1/16: 2–10 times **1/128:** 2–10, 15, 20, 25, 30, 35 times

- **Times:** This setting controls the number of times the flash will strobe per second, between 2 and 10 in one-step increments and then from 10 to 35 (at 1/128) in five-step increments. Refer to the preceding table to set the number of times the flash can fire. Increasing the flash power output (going toward 1/4) will lower the number of times, while decreasing the power (going toward 1/128) will increase the number of times the flash can fire. As you change the Output amount, you'll see the Times maximum change.

- **Frequency:** This lets the flash fire a series of pulses for each of the Times it fires, from 1 pulse to 50 pulses.

How Does Repeating Flash Work, Technically?

If you have Output set to 1/128, Times set to 5, and Frequency set to 50, that means the camera will fire its built-in pop-up Speedlight at 1/128 of the full power, 5 times, with each flash burst divided into 50 pulses. Therefore, the flash will pulse a total of 250 times at 1/128 power for a 1-second exposure, or 4 times for a 1/60-second exposure.

Commander Mode (CMD)

This mode allows your camera to become a commander, or controller, of up to two banks of an unlimited number of external CLS-compatible Speedlight flash units, with four available channels (figure 5.37D).

In figure 5.37D, image 2, you'll see Built-in flash, Group A and B, and a Channel setting. Following Built-in flash and Group A and B, you'll see Mode and Comp. settings. Use the Multi selector to move around and modify settings on this screen.

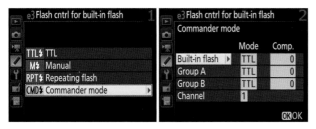

Figure 5.37D – Commander mode

Built-in flash: This lets you set the pop-up flash to one of three settings. The settings do not affect any of the flash units the Commander mode is controlling in Group A or B:

- ***TTL:*** Otherwise known as i-TTL mode, this is a completely automatic mode that performs monitor preflashes to determine correct exposure for the pop-up flash. You can set compensation (Comp.) from +3.0 to −3.0 EV in 1/3 EV steps.
- ***M:*** Manual mode allows you to choose a manual flash level from 1/1 (full power) to 1/128 (1/128 of the full power).
- ***−− :*** Flash-disable mode disables the pop-up flash from adding light to the image. The primary light burst from the pop-up flash will not fire. However, the pop-up flash still must fire the monitor preflashes to determine a correct exposure and to communicate with any flash units out there in Group A or Group B that it is "commanding."

Group A and B: These banks represent groups of an unlimited number of remote mode (slaved) Speedlights that your camera can control and fire under the wireless Nikon Creative Lighting System (CLS). Each group has four settings that apply to each flash unit in the bank:

- ***TTL:*** This works like Built-in flash except that it causes all flash units being controlled in each group to use TTL (i-TTL) for the group. You can also set compensation (Comp.) between +3.0 and −3.0 EV in 1/3 EV steps. Comp. will affect all flash units in the group, or bank.
- ***AA:*** This stands for Auto aperture and is only available when your D7200 is controlling a top-end Speedlight flash unit in slave mode on a bank. This is an older technology that does not use the newer i-TTL exposure technology. It is included for those who are used to using the older style of exposure. You can safely ignore this mode and use

TTL instead and you'll get better exposures. If you really want to use AA mode, that's fine. It works like TTL mode but with less accurate exposures. You can set compensation (Comp.) between +3.0 and −3.0 EV in 1/3 EV steps. Comp. will affect all flash units in that group or bank.

- *M:* Manual mode allows you to choose a manual flash level between 1/1 (full power) and 1/128 (1/128 of the full power) for each of the flash units being controlled by a particular group. If you like to shoot manually for ultimate control, the camera gives you a way to control multiple groups of flash units manually.
- *−−:* The flash units in the group do not fire. Flash-disable mode disables an entire group so that you can concentrate on configuring the other group. Then you can turn the disabled group back on and configure it, too. Or, you can just use one group of slaved Speedlights (A or B) and disable the other.

Channel: This one channel controls all slaved flash units. You must match the Channel number for the camera and each flash unit. This is the channel on which communications flow to all grouped, remote flashes. You have a choice of four Channel numbers, 1 to 4. This allows you to use your flash units near another photographer who is also controlling groups without firing the other person's flash units accidentally. You must each choose a different channel.

Commander Mode Notes

When you're using multiple flash units under the control of your camera in Commander mode, it is important that you understand the following points:

- The camera communicates with the remote slaved flash groups (A and B) during the monitor preflash cycle, so the pop-up flash must be raised in Commander mode in order to communicate with the remote flash units.
- Each remote flash unit has a little round photocell sensor on its side that picks up the monitor preflashes from your camera's pop-up flash. Make sure those little sensors are not blocked or exposed to direct, very bright light while in use or they may not be able to see the monitor preflashes from your camera.
- If you want to prevent the monitor preflashes from appearing in photographs, or causing people to squint, you need to purchase the optional SG-3IR infrared panel for the pop-up flash (Figure 5.37E). This infrared panel makes the monitor preflashes mostly invisible to humans and imaging sensors, yet the remote flash units can still see them and react properly. Nikon says this about using the built-in flash in Commander mode: *"To prevent timing flashes emitted by the built-in flash from appearing in photographs taken at short range, choose low ISO sensitivities or small apertures (high f-numbers) or use an optional SG-3IR infrared panel for the built-in flash. An SG-3IR is required for best results with*

Figure 5.37E – Optional SG-3IR infrared panel

rear-curtain sync, which produces brighter timing flashes. After positioning the remote flash units, take a test shot and view the results in the camera monitor." (Menu Guide: Page 88)

• Don't position any of the remote Speedlight flash units more than 33 feet (10 m) from the camera. That's the maximum distance Nikon supports for the D7200 pop-up flash in Commander mode. If you need more reach, the Nikon SU-800 Wireless Infrared Controller unit can replace the built-in flash/Commander mode combo. You will mount the Nikon SU-800 onto the Accessory shoe, just like a Speedlight flash unit and use it as a Commander instead of the built-in flash. If you use an SU-800, you will not use the camera's Commander mode to control the remote flash units. Instead, the SU-800 has its own settings similar to the D7200 Commander mode settings.

• There is no actual limit on the number of remote flash units you may use with the D7200's Commander Mode. However, Nikon warns that there is a practical limit of three Speedlights, after which "the light emitted by the remote flash units will interfere with performance." Since the Nikon CLS system is based on infrared and white light transmissions instead of radio waves, it may be possible to overpower the Commander unit's output with the powerful light from the Speedlight flash units. You may also have a similar situation when you are trying to shoot in bright sunlight because the sun may be too bright on the Speedlight light sensors for them to receive the transmission from the Commander unit. Therefore, if you are using a large number of remote flash units, you may need to work with better positioning and shading of the Speedlight sensors in order to get all of your remote flash units to fire.

Custom Setting e4: Exposure Comp. for Flash

(User's Manual: Page 283, Menu Guide: 89)

The Exposure comp. for flash function allows you to treat the subject and background differently when you use flash. You can separate the normal exposure compensation function (for the background) and the flash compensation function (for the subject). Exposure compensation can be applied to the background only, or to the background and subject (the entire frame) with flash. There are two available settings:

• **Entire frame:** Both the flash and the exposure compensation work normally, modifying the exposure over the entire frame.
• **Background only:** The nonflash exposure compensation (that you adjust with the Exposure compensation button) and the flash compensation (that you apply with the Flash compensation button) are separate. Flash compensation applies to the subject only, and nonflash exposure compensation applies to the background only.

Figure 5.38 – Exposure comp. for flash

Use the following steps to choose a flash and exposure compensation combination:

1. Select e Bracketing/flash from the Custom Setting Menu and scroll to the right (figure 5.38, image 1).
2. Highlight e4 Exposure comp. for flash and scroll to the right (figure 5.38, image 2).
3. Choose either Entire frame or Background only (figure 5.38, image 3). If you choose Background only, the nonflash and flash compensation functions are applied separately.
4. Press the OK button to lock in your choice.

Settings Recommendation: I leave my D7200 set to Entire frame for most shooting. If I need to change the light level relationship between the subject and the background, I set the camera to Background only and experiment until I find the best compensation for balance or to emphasize one or the other. Why not spend some time experimenting and learning how to use this excellent technology?

Custom Setting e5: Modeling Flash

(User's Manual: Page 284, Menu Guide: Page 89)

Modeling flash lets you fire a pulse of flashes to help you see how the light is wrapping around your subject. It works like modeling lights on studio flash units except it pulses instead of shines. You can press the Depth-of-field preview button to see the effect if you set Modeling flash to On.

This function works with Nikon's main Speedlight flash unit group: SB-910, SB-900, SB-800, SB-700, SB-600, SB-500, and SB-R200. It also works with the pop-up flash for limited periods. The SB-400 and SB-300 flash units do not work with Modeling flash. Here's what each of the settings for Modeling flash accomplishes:

- ***On:*** This setting allows you to see (somewhat) how your flash will light the subject. If you have this setting turned On, you can press the Depth-of-field preview button to strobe the pop-up flash, or any attached/controlled external Speedlight unit, in a series of rapid pulses. These pulses are continuous and simulate the lighting that the primary flash burst will give your subject. The Modeling flash can be used for only a few seconds at a time to keep from overheating the flash unit, so look quickly.

- **Off:** This means that no Modeling flash will pulse when you press the Depth-of-field preview button.

Figure 5.39 – Modeling flash

Here are the steps used to configure Modeling flash:

1. Select e Bracketing/flash from the Custom Setting Menu and scroll to the right (figure 5.39, image 1).
2. Highlight e5 Modeling flash and scroll to the right (figure 5.39, image 2).
3. Choose one of the two settings on the list. In figure 5.39, image 3, Off has been selected.
4. Press the OK button to lock in the setting.

Settings Recommendation: I used to forget that Modeling flash was turned on and when I checked my actual depth of field on a product shot by pressing the Depth-of-field preview button, I would get the modeling light instead of depth of field. I didn't find this feature to be particularly useful, and it often startled me. I now leave it set to Off. However, you might like it if you do a lot of studio-style flash photography that requires a modeling light. Give it a try, but be prepared—the pulsing of the flash sounds like an angry group of hornets about to attack your face.

Custom Setting e6: Auto Bracketing Set

(User's Manual: Pages 284, Menu Guide: Page 90)

Auto bracketing set lets you choose how bracketing works for each of the camera's bracketing methods. You can set up bracketing for the exposure system (AE), flash, White balance, and Active D-Lighting.

Let's start by reviewing the five types of bracketing on the D7200. I'll explain how to use bracketing in an upcoming section:

- **AE & flash:** When you set up a session for bracketing, the camera will cause any type of normal pictures you take to be bracketed, whether they are standard exposures or you are using flash. See how to bracket in the next section.
- **AE only:** Your bracketing settings will affect only the exposure system and not the flash.
- **Flash only:** Your bracketing settings will affect only the flash system and not the exposure.

- **WB bracketing:** White balance bracketing works the same as exposure and flash bracketing, except it is designed for bracketing color in mired values, instead of bracketing light in EV step values. WB bracketing is not available with image quality settings of NEF (RAW) or NEF (RAW) + JPEG.
- **ADL bracketing:** In this case, you are bracketing Active D-Lighting (ADL) in up to five separate exposures. The next higher level of ADL is used on each selected exposure.

External Camera Controls for Bracketing

First let's examine the controls used to set up your camera for all five bracketing methods.

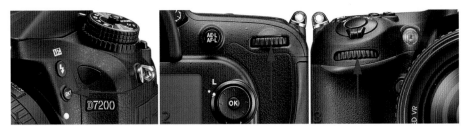

Figure 5.40A – Controls for Auto bracketing: (1) BKT button, (2) Main command dial, (3) Sub-command dial

Use figure 5.40A as an external control guide for the rest of the **Custom Setting e6: Auto Bracketing Set** section. You'll use the BKT button (1) and the Main command dial (2) or Sub-command dial (3) to change the bracketing values.

Now let's consider each of the bracketing methods that use the controls shown in figure 5.40A.

AE & Flash Bracketing (Includes AE Only and Flash Only)

Exposure bracketing *(AE & flash)* allows you to bracket a series of images using ambient light and/or a Speedlight flash unit. You can later combine these images into a high dynamic range (HDR) image with greater than normal dynamic range, as seen in figure 5.40B.

In figure 5.40B you will find a sample five-image bracket with 1.0 EV step between each exposure. I combined the five images using Photomatix Pro software **(http://www. hdrsoft.com)** and was pleased with the final result. The main image was created with a bracketed series of five shots—the pictures below the main image—using the same settings shown on the Control panel in figure 5.40D, image 1, as discussed in step 4 of the bracketing step-by-step method.

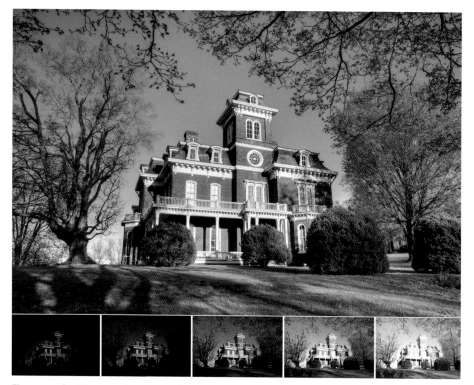

Figure 5.40B – Five-image bracket combined in Photomatix Pro to a single HDR image

AE & flash, AE only, and Flash only all use bracketing in exactly the same manner and are all considered in this one section.

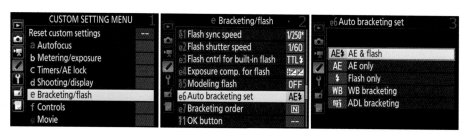

Figure 5.40C – AE and flash bracketing (top three types in image 3)

Here are the steps to configure AE and flash bracketing for results similar to what is seen in figure 5.40B:

1. Select e Bracketing/flash from the Custom Setting Menu and scroll to the right (figure 5.40C, image 1).
2. Highlight e6 Auto bracketing set and scroll to the right (figure 5.40C, image 2).
3. Choose AE & flash and press the OK button to lock in the setting (figure 5.40C, image 3).

4. Next, press and hold the BKT button (figure 5.40A, image 1). You can identify that bracketing is active by the BKT symbol on the Information display (Monitor) and Control panel. When you hold down the BKT button, you will see symbols on your camera's displays similar to the ones shown in figure 5.40D. The symbols will initially be 0F and 1.0 (if not previously changed) and there will be no lines below the –/+ scale. You will set both of those values as you create the bracket. The number of shots in the bracket appears on the top center of the camera displays, as shown in each screen in figure 5.40D as 5F, –2F, and +2F. You can shoot up to 9 frames (9F) in an AE & flash, AE only, or Flash only bracket. The number of small vertical lines hanging below the – 0 + scale equals the number of shots in the bracket. The position of those lines represents the EV spread of the shots in the bracket. In figure 5.40D, image 1, for instance, you can count five lines hanging below the –/+ scale, and there is one stop of exposure between each line, as signified by the number 1.0 (1.0 EV) seen in the top-right corner of the camera displays. Those five shots are represented by the 5F in image 1.

5. While holding the BKT button, turn the rear Main command dial (figure 5.40A, image 2) to select the number of shots in the bracket (up to 9). The number of shots can have a plus sign, minus sign, or no sign next to it (figure 5.40D). Select a number with a plus sign if you want the bracket to take only normal and overexposed shots. Select a number with a minus sign if you want the bracket to take only normal and underexposed shots. If you want the bracket to take exposures that are evenly distributed on both sides of the scale, select a number that has no plus or minus sign in front of it. The front Sub-command dial (figure 5.40A, number 3) controls the EV steps between each exposure in the bracket. This value appears on the top right of each screen in figure 5.40D as 1.0, 0.3, and 0.3. While holding the BKT button, rotate the front Sub-command dial to select the EV step value between each image in the bracket, in steps of 1/3, 1/2, or 1 EV. (The EV step value is set in *Custom Setting Menu > b Metering/exposure > b2 EV steps for exposure cntrl*. You can use *Custom Setting Menu > e Bracketing/flash > e7 Bracketing order* to set the order of the exposures. We'll discuss this in a later section titled **Custom Setting e7: Bracketing Order**. The default order is *normal > underexposed > overexposed*. You can change it to *underexposed > normal > overexposed* if you'd like.) Following are detailed explanations of the values on images 1, 2, and 3 of figure 5.40D:

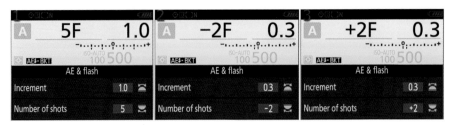

Figure 5.40D – Auto bracketing (AE & flash) on the Information display

- *Figure 5.40D, image 1,* shows a five-shot bracket on the camera's Information display with 1.0 EV step between each image. You can tell there are five shots by the 5F at the top left of the display, along with the number of lines below the −/+ scale. Additionally, you can see the Number of shots section at the bottom of the screen with the same numerical information as the larger number at the top. The 1.0, seen at the top right of the screen and in the Increment section, means that there is 1.0 EV step (1 stop) between each exposure in the bracket. The fact that the 5F has no plus or minus sign in front of it tells us that the bracket uses exposures that are normal, overexposed, and underexposed. The same symbols you see at the top of the screen on the Information display are duplicated on the Control panel on top of the camera. The Control panel does not show the Increment or Number of shots sections. Use whichever of these two displays is easier for you to work with.
- *Figure 5.40D, image 2,* shows a two-image bracket with 0.3 EV steps (1/3 stop) between each exposure. Notice the minus signs before the 2F symbol (−2F). This means that the bracket is configured to take only normal and underexposed shots—no overexposed ones. The two hanging-line bracketed images are shown on the minus side of the −/+ scale.
- *Figure 5.40D, image 3,* represents a three-image bracket with 0.3 EV steps between each exposure. The bracket is configured to take only normal and overexposed shots (+2F). Notice that the two hanging-line bracketed images are shown on the plus side of the −/+ scale.

6. Once you have configured your bracket, press the Shutter-release button to take each bracketed picture in the series. As you take each image, one of the lines that hang down below the −/+ scale will disappear. When they are all gone, your bracket is complete. If you have your camera set to one of the Continuous-release modes (CL or CH), you can shoot the number of frames in your bracket by holding down the Shutter-release button. Once the bracket is complete, the camera will stop firing.

Note about flash bracketing: If you are using a Speedlight flash unit to light the bracketed series, it may or may not be able to keep up with bracketed shots taken in Continuous-release mode. If you fully dump the flash power between shots, you'll have to wait for the next shot. Also, the pop-up flash simply does not recycle fast enough to be able to shoot continuously while flash bracketing, so you'll have to take each shot individually.

Here's a short review:

- BKT button plus rear Main command dial = number of shots
- BKT button plus front Sub-command dial = EV step value of bracketed exposures (1/3, 1/2, or 1 EV step)

Settings Recommendation: I normally bracket with a 1 EV step value (1 stop) so that I can get a good spread of light values in high dynamic range (HDR) images. In most cases, I will do a three- to five-image bracket, with one or two images overexposed and one or two images underexposed by 1 stop. This type of bracketing allows me to combine detail from

the highlight and dark areas in-computer for the HDR exposures everyone is experimenting with these days.

Using the Self-timer for Bracketing

If you select the Self-timer symbol from the Release mode dial, the camera will fire the entire bracket when you press the Shutter-release button—regardless of the number of frames in the bracket—by using the Self-timer. This little known feature of Nikon cameras allows you to take hands-off brackets. Be sure to allow enough time in *Custom Setting Menu > c Timers/ AE lock > c3 Self-timer > Self-timer delay* to let the vibrations from the initial Shutter-release press to die down. I use 5 or 10 seconds. You can also set a delay time between each Self-timer controlled frame by setting *Custom Setting Menu > c Timers/AE lock > c3 Self-timer > Interval between shots* to a value from 0.5 seconds to 3 seconds. Excellent mirror-slap vibration control! Why not let your camera do all the hard work?

WB Bracketing

The process for *WB bracketing* (white balance bracketing) is similar to the process for flash or exposure bracketing; you even use the same controls (figure 5.40A). No form of AE or flash bracketing will work during the time that Custom setting e6 is set to WB bracketing.

WB bracketing does not work when your camera is in NEF (RAW) and NEF (RAW) + JPEG modes. White balance information is stored with the RAW image but is not directly applied to the image. You can change the White balance after the fact when you are shooting RAW, so bracketing a RAW image does not make sense. If you press the BKT button with any form of RAW format enabled, the camera will not respond to the button press. You must be using a form of JPEG image to access WB bracketing.

Now let's examine how to select WB bracketing for JPEGs, and then bracket the White balance.

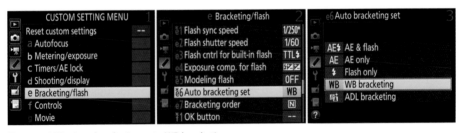

Figure 5.40E – Auto bracketing set – WB bracketing

Here are the steps to configure WB bracketing:

1. Select e Bracketing/flash from the Custom Setting Menu and scroll to the right (figure 5.40E, image 1).
2. Highlight e6 Auto bracketing set and scroll to the right (figure 5.40E, image 2).
3. Choose WB bracketing (figure 5.40E, image 3) and press the OK button. You will use the controls shown in figure 5.40A to choose the number of shots in the bracket,

which is shown at the top of the Information display (Monitor) and on the top Control panel (3F, A2F, or B2F in figure 5.40F). Press and hold the BKT button while turning the rear Main command dial left or right to select the number of shots, up to three shots total (3F). In figure 5.40F, the 3F symbol shows the number of images (3), as do the lines hanging below the −/+ scale. Notice in the Information display screens shown in figure 5.40F that there are Increment (in mired* steps) section and Number of shots (how many shots in the bracket) section. The Increment section describes the WB increment (1–3 where 1=5 mired, 2=10 mired, 3=15 mired) in amber (A) or blue (B). Figure 5.40F, image 1, shows a 5 mired difference (1), image 2 shows a 15 mired difference (3), and image 3 shows a 10 mired difference (2).

***Note:** 1 mired step represents a just-perceptible change in color. The camera can adjust the WB color toward amber (A) or blue (B), in 5, 10, or 15 mired steps, as described in step 4 and shown in the Bracketing Order column of Table 4.1. In the table, 0 means normal WB.

Camera Displays	No. of Shots	WB Increment	Bracketing Order in Mired
0F	0	1	0
b2F	2	1	0 > 1B
A2F	2	1	0 > 1A
3F	3	1	0 > 1A > 1B
b2F	2	2	0 > 2B
A2F	2	2	0 > 2A
3F	3	2	0 > 2A > 2B
b2F	2	3	0 > 3B
A2F	2	3	0 > 3A
3F	3	3	0 > 3A > 3B

Table 4.1 – Control panel symbols, no. of shots, Amber/Blue increments, and bracketing order

1. When you are using 3F, the camera brackets the White balance as: *normal > amber > blue*. When you are using A2F, the camera brackets: *normal > amber*. Finally, when you are using B2F, the camera brackets: *blue > normal*. The direction (order) of WB color bracketing is controlled by how you have *Custom Setting Menu > e Bracketing/flash > e7 Bracketing order* configured. We will consider that in our next main chapter section **(e7 Bracketing Order)** on page 261.

2. Now, let's examine the Increment section in a little more detail. As mentioned, each increment of color difference is called a *mired* and is controlled by the number at the top right of the Information display screens in figure 5.40F (same position on the top Control panel). Change the mired number by holding the BKT button while turning the front Sub-command dial left or right, up to three maximum. Each number represents multiple mired. Choose 1, 2, or 3, where 1=5 mired, 2=10 mired, and 3=15 mired. Following are detailed explanations of the values on screens 1, 2, and 3 of figure 5.40F:

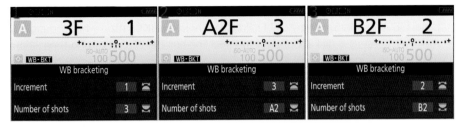

Figure 5.40F – WB bracketing (White balance)

- *Figure 5.40F, image 1,* shows a three-image bracket (Number of shots = 3, or 3F) on the camera's Information display, with a 5 mired difference (Increment = 1) in WB color between each image. As shown in Table 4.1, one image has normal WB, one has more amber, and one has more blue. Similar characters will appear on the camera's top Control panel.
- *Figure 5.40F, image 2,* shows a two-image bracket (Number of shots = A2, or A2F) with a 15 mired difference (Increment = 3) between each image, in the amber direction only.
- *Figure 5.40F, image 3,* shows a two-image bracket (Number of shots = B2, or B2F) with a 10 mired color difference (Increment = 2) in the blue direction only (B3F).

3. Press the Shutter-release button to take the bracketed picture series. Interestingly, you do this by taking *one* picture. The camera takes that picture, reapplies the color filtration for each image in the bracket, and then saves each image as a separate image file with a new consecutive file number and bracketed color value. This works very differently from AE or flash bracketing, where you have to fire off each individual frame of the bracket. WB bracketing is very easy because you only have to set the bracketing values and take one picture. The series of images in the bracket simply appears on your memory card.

What Is Mired?

A single mired represents a just-perceptible change in color. Changes to mired values simply modify the color of your image, in this case toward amber (reddish) or blue. In effect, changing mired toward amber or blue warms or cools the image. You don't have to worry about the details of mired values unless you are a color scientist. You can just visually determine whether you like the image the way it is or would prefer that it be warmer or cooler, and then bracket accordingly. WB bracketing toward the A direction warms the image, while the B direction cools it. Technically, a mired is calculated by multiplying the inverse of the color temperature by 106.

I'd rather let my camera figure out mired values and then judge them with my eye, wouldn't you?

Remember, if you shoot in RAW, you can modify color values later in your computer. Changes in color are applied permanently to JPEG files.

ADL Bracketing

ADL bracketing (ADL stands for Active D-Lighting) is designed to let you shoot a normal image and then a series of up to four additional images with Active D-Lighting applied to each at progressively higher levels.

If you will recall, ADL pulls out detail from the shadows (possibly increasing noise) and protects the highlights to help prevent loss of bright detail. This function allows you to bracket ADL at its various levels to see which will work best for your current shooting situation.

The progressive levels of ADL are Off, Low (L), Normal (N), High (H), Extra High (H+), and Auto. As you set ADL bracketing from two to five shots, you are setting the camera to switch to a higher ADL level for each consecutive shot.

Let's see how to select ADL bracketing, and then discuss how to use it.

Selecting ADL Bracketing

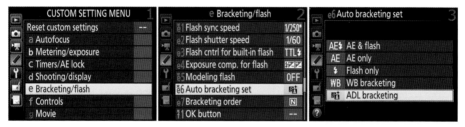

Figure 5.40G – Auto bracketing set – ADL bracketing

Here are the steps to select ADL bracketing:

1. Select e Bracketing/flash from the Custom Setting Menu and scroll to the right (figure 5.40G, image 1).
2. Highlight e6 Auto bracketing set and scroll to the right (figure 5.40G, image 2).
3. Choose ADL bracketing (figure 5.40G, image 3) and press the OK button. ADL bracketing is now enabled.

Using ADL Bracketing

Next let's examine how to select the various levels of ADL bracketing, using the same controls we examined in figure 5.40A. There are two distinct methods of using ADL bracketing. The first method is two-frame (2F) ADL.

This particular ADL bracketing method allows you to select 2F or two frames for ADL. The first frame will be taken with no ADL (Off) and the next with whichever ADL level you select with the front Sub-command dial (i.e., L, N, H, H+). It is controlled by the front Sub-command dial and uses the screens shown in figure 5.40H. Let's see how to choose a 2F ADL bracket.

Figure 5.40H – Using two-frame (2F) ADL bracketing

Two-frame ADL bracketing: Use these steps to choose an ADL bracketing level for the second frame of the bracket. The first frame will always be taken with ADL set to Off:

1. Press and hold the BKT button on the front of the camera (figure 5.40A, image 1) until the screen shown in figure 5.40H, image 1, appears. ADL 0F means ADL bracketing is set to Off (0F = zero frames). If any other screen settings appear instead (ADL 2F to ADL 5F), ADL bracketing is already active. With ADL 0F showing on the top of the Information display (Monitor) and top Control panel, and while continuing to hold the BKT button, turn the rear Main command dial one notch in a counterclockwise direction. If you turn it clockwise, nothing will happen. This initial counterclockwise turn of the rear Main command dial enables the ADL bracketing system.

2. The Main command dial counterclockwise turn will also cause the camera to enter the ADL 2F (two-frame) subsystem and one of the screens seen in figure 5.40H, images 1 through 6 will display. The camera remembers the last settings you used for ADL bracketing and returns to that setting. If you have not used ADL bracketing before, or have zeroed it out, the camera will display the ADL 2F screen seen in figure 5.40H, image 2 (red arrow), with the OFF AUTO setting selected in the Amount setting. When using 2F, the Number of shots setting will stay at 2. On the top Control Panel, the word Auto will appear instead, just below ADL 2F and the −/+ indicator scale. OFF AUTO simply means that when you shoot the next two frames, the camera will take the first picture with ADL set to OFF and the second picture with ADL set to AUTO. The AUTO setting lets the camera decide the appropriate level of ADL for the second image. (The Amount and Number of shots settings do not show on the top Control panel.)

3. Now, turn the *front* Sub-command dial (not the rear one) in a counterclockwise direction and you will see the camera step though the settings on the screens shown in figure 5.40H, images 3–6. By turning the front Sub-command dial you are keeping the camera within the 2F bracket type. You can select from High Plus (H+ or HP) down to

Low (L) ADL. HP shows on the Control panel for High Plus, instead of H+. This range se-
lection lets you choose from various levels of ADL for the second image in the bracket.
Notice how the first frame stays at OFF, with the second frame selectable from OFF L,
OFF N, OFF H, or OFF H+, meaning that the first frame of the 2F bracket will always be
taken with no ADL at all (OFF), and the second frame will be taken with whatever ADL
level you select with the front Sub-command dial.

4. Once you have selected the ADL level for the second frame (first frame always uses OFF),
 release the BKT button and take your two-frame bracket. When you are done bracket-
 ing, be sure to set the camera back to ADL 0F by holding the BKT button and turning
 the rear Main command dial, or the D7200 will continue to take ADL bracketed images
 perpetually.

Now let's examine how to use more than a two-frame (2F) ADL bracket. The camera can do
2F to 5F (five-frame) brackets for those times when you want several images with a range
of ADL values.

Figure 5.40I – Using two-frame (2F) to five-frame (5F) ADL bracketing

Two- to five-frame ADL bracketing: Use these steps to choose an ADL bracketing level
for the second and subsequent (up to 5 total) frame(s) of the bracket. The first frame will
always be taken with ADL set to OFF:

1. Press and hold the BKT button on the front of the camera (figure 5.40A, image 1) un-
 til the screen shown in figure 5.40I, image 1, appears. As discussed previously, ADL 0F
 means ADL bracketing is set to Off (0F = zero frames). With ADL 0F showing at the top of
 the Information display (Monitor) and top Control panel, and while continuing to hold
 the BKT button, turn the rear Main command dial one notch in a counterclockwise di-
 rection. If you turn it clockwise, nothing with happen. This initial counterclockwise turn
 of the rear Main command dial enables the ADL bracketing system.

2. With the first turn of the rear Main command dial, the camera is using ADL 2F bracketing (figure 5.40I, image 2); however, you can continue turning the *rear* Main command dial in a counterclockwise direction and select additional frames with a higher level of ADL for each consecutive frame. Turn the rear Main command dial to select the number of pictures you want in the bracket—from two to five frames—with ADL 2F, ADL 3F, ADL 4F, or ADL 5F showing.

3. While using ADL 2F (figure 5.40I, image 2), you can refer back to the previous information about using ADL 2F (figure 5.40H). However, if you need a broader range of ADL bracketing than 2F supplies, use 3F, 4F, or 5F to add extra frames with even higher levels of ADL.

4. Figure 5.40I, image 3, shows ADL 3F, which means there will be three pictures taken in the bracket. You can see the order of the bracket in the Amount setting, which is Off L N, or Off, Low, and Normal ADL. The first shot will be taken with ADL set to OFF, the second with ADL set to Low (L), and the third frame set to Normal (N). The Number of shots section will, of course, show 3 for ADL 3F brackets.

5. The same concept applies to figure 5.40I, images 4 and 5, which show the 4F and 5F ADL brackets. For the 4F setting, the Amount setting will show Off L N H, which means the bracket series will run: Off, Low, Normal, and High (figure 5.40I, image 4). For the 5F setting, the Amount setting will show Off L N H H+, which means the bracket series will run: Off, Low, Normal, High, and High+ (figure 5.40I, image 5). The Number of shots setting will reflect 4 for ADL 4F and 5 for ADL 5F.

6. In figure 5.40I, image 6, you'll see the top Control panel instead of the Information display on the Monitor while using ADL 5F. It represents the same settings as the Information display screen in figure 5.40I, image 5. Notice the AdL at the top center of the top Control panel and the number of frames in the bracket series at the top right (5F). There are no Amount or Number of shots settings on the Control panel, as are seen on the Monitor in figure 5.40I, images 1–5. Notice just under the −/+ scale that you can see lines hanging down. There are small red numbers below each line so that you can locate them more easily. Each hanging line represents a single frame in the bracket and will disappear as you take the shot. You'll be able to see hanging lines under the −/+ scale for only four of the shots—a small black arrowhead points to the right for the fifth (red arrow). Basically, the −/+ scale is too small to show all five shots in an ADL 5F bracket. Any ADL bracket less than five shots (2F, 3F, and 4F) will all display the full number of hanging lines.

7. Press the Shutter-release button to take each shot in the bracketed series. As each shot is taken, you'll see one of the vertical lines just under the −/+ scale disappear. If you have your camera set to one of the Continuous-release modes (CL or CH), you can shoot the number of frames in your bracket by holding down the Shutter-release button. You can also use the Self-timer to fire the bracket. Once the bracket is complete, the camera will stop firing.

ADL Bracketing order: *Custom Setting Menu > e Bracketing/flash > e7 Bracketing order* does not apply to ADL bracketing. The camera will bracket the image in the order shown in the Amount setting.

Settings Recommendation: This is a great way to capture very important shots and try to get extra shadow detail and highlight protection in some of them. You may not need ADL bracketing on all shots, but on very important images where you might need more dynamic range, ADL will help to open shadows and mildly protect the highlights.

Of course, if you shoot in RAW mode, you can apply ADL in-computer, after the fact. I don't bracket ADL very often, but I'm glad to know it's there when I need it.

One final note about bracketing of any type: Turn it off when you're done! I often forget and then wonder why my camera keeps under- and overexposing a series of images. Only after wasting several images do I realize that I left bracketing turned on. You'll see what I mean if you use AE & flash bracketing often, as I do.

Custom Setting e7: Bracketing Order

(User's Manual: Page 284, Menu Guide: Page 90)

Bracketing order allows you to choose the order of your exposure settings (normal, over-exposed, and underexposed) during a bracketing operation. There are two bracketing orders available in the D7200. They allow you to control which images are taken first, second, and third in the bracketing series. Bracketing order applies only to Exposure (AE), Flash, and WB bracketing.

Here are the three values in the bracket order and what they each mean:

- **MTR** = Metered value (normal exposure)
- **Under** = Underexposed
- **Over** = Overexposed

Next, let's see how these are used during bracketing:

- **MTR > under > over:** With this setting, the normal exposure (MTR) is taken first, followed by the underexposed image, and then the overexposed image. If you are taking a group of five images in your bracket (Custom setting e5), the camera will take the images like this: *normal exposure > most underexposed > least underexposed > least overexposed > most overexposed*. For WB bracketing, the pattern is *normal > amber > blue*. This does not apply to ADL bracketing.
- **Under > MTR > over:** Using this order for bracketing means that a five-image bracket will be exposed in the following manner: *most underexposed > least underexposed > normal exposure > least overexposed > most overexposed*. For WB bracketing, the pattern is *amber > normal > blue*. This does not apply to ADL bracketing.

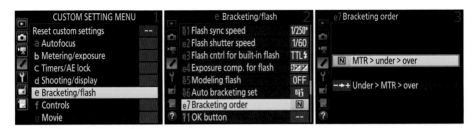

Figure 5.41 – Bracketing order

Finally, let's look at the steps to actually configure the Bracketing order:

1. Select e Bracketing/flash from the Custom Setting Menu and scroll to the right (figure 5.41, image 1).
2. Highlight e7 Bracketing order and scroll to the right (figure 5.41, image 2).
3. Choose one of the two bracketing orders on the list. In figure 5.41, image 3, MTR > under > over has been selected.
4. Press the OK button to lock in the setting.

Settings Recommendation: I leave Bracketing order set to *MTR > under > over*, so that when the images are displayed in series by the camera, I can see the normal exposure (MTR) first and then watch how it varies as I scroll through the bracketed images. It gets confusing to me if there are nine images in an exposure bracket and I am trying to figure out which one is the MTR image, as I would with the other bracketing order.

If that doesn't suit you, change it to the other direction, *Under > MTR > over*. The normal exposure will be in the middle of the bracket instead of at the beginning. Some prefer the more natural flow of that bracketing order (under to over).

Section Six: f Controls

Custom Settings f1 to f11

Within the *f Controls* menu you'll find 11 settings in the D7200:

- **f1:** OK button
- **f2:** Assign Fn button
- **f3:** Assign preview button
- **f4:** Assign AE-L/AF-L button
- **f5:** Customize command dials
- **f6:** Release button to use dial
- **f7:** Slot empty release lock
- **f8:** Reverse indicators
- **f9:** Assign movie record button
- **f10:** Assign MB-D15 AE-L/AF-L button
- **f11:** Assign remote (WR) Fn button

Let's examine how to use each of these settings in the following subsections.

Custom Setting f1: OK Button

(User's Manual: Page 284, Menu Guide: Page 91)

The OK button function determines how the OK button in the center of the Multi selector works in three different camera modes.

The three modes that affect how the OK button works are as follows:

- **Shooting mode** is in force when you are actually using the camera to take pictures through the Viewfinder.
- **Playback mode** is in use when you are examining pictures you've already taken on the rear Monitor.
- **Live view** is used when you are in Live view mode taking pictures with the Monitor instead of the Viewfinder.

Figure 5:42A – OK button at the center of the Multi selector

Figure 5.42A shows an arrow pointing to the OK button on the back of the camera. Let's examine each of the three modes in detail.

Shooting Mode

First let's see how pressing the OK button works in the Viewfinder-based Shooting mode. Following are the screens and steps used to configure what the OK button does (figure 5.42B).

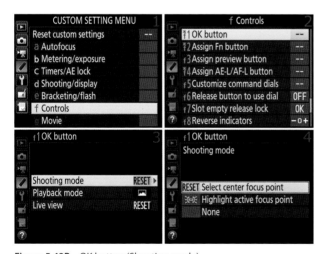

Figure 5.42B – OK button (Shooting mode)

Use these steps to begin configuration of the OK button:

1. Select f Controls from the Custom Setting Menu and scroll to the right (figure 5.42B, image 1).

2. Highlight f1 OK button and scroll to the right (figure 5.42B, image 2).
3. Select Shooting mode and scroll to the right (figure 5.42B, image 3).
4. Choose one of the three choices, according to the upcoming descriptions of each selection. In figure 5.42B, image 4, Select center focus point has been chosen.
5. Press the OK button to lock in the setting.

The three Shooting mode selections are as follows (figure 5.42B, image 4):

- **Select center focus point:** Often when shooting, you'll be using the Multi selector with your thumb to move the selected focus point (AF point) around the Viewfinder to focus on the most appropriate area of your subject. When you are done, you have to scroll the AF point back to the center. Not anymore! If Select center focus point is chosen, the focus point pops back to the center point of the Viewfinder when you press the OK button. This is the default action of the button.
- **Highlight active focus point:** Sometimes when the Viewfinder is showing a confusing subject, it may be a little hard to see the small black AF point bracket. When Highlight active focus point is selected and you press the OK button, the AF point lights up in red for easy viewing in its current location.
- **None:** This does what it says—nothing happens when you press the OK button in Shooting mode.

Playback Mode

Now let's examine how the OK button can be used in Playback mode. Playback mode is used when you are examining images on the camera's Monitor after you have taken them.

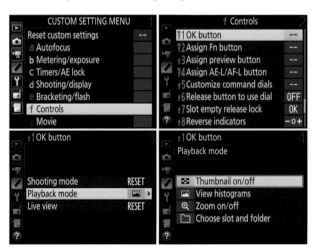

Figure 5.42C – OK button (Playback mode)

Use these steps to set up the OK button:

1. Select f Controls from the Custom Setting Menu and scroll to the right (figure 5.42C, image 1).
2. Highlight f1 OK button and scroll to the right (figure 5.42C, image 2).
3. Select Playback mode and scroll to the right (figure 5.42C, image 3).
4. Choose one of the four options on the list, according to the upcoming instructions. In figure 5.42C, image 4, Thumbnail on/off has been chosen. If you choose Zoom on/off, you'll need to scroll to the right and select one of the three subsettings (use figure 5.42F in the upcoming section called **Zoom on/off**). If you select Choose slot and folder, you'll also need to be aware of some additional screens your camera will present (use figure 5.42G in the upcoming section called **Choose slot and folder**).
5. Press the OK button to lock in the setting.

There are four selections in Playback mode, as follows (figure 5.42C, image 4):

Thumbnail on/off
This feature allows you to switch from viewing one image on your camera's Monitor to viewing multiple thumbnails instead. It's a toggle, so you can press the OK button to turn thumbnail view on and off. In figure 5.42D, image 1, Thumbnail on/off has been selected.

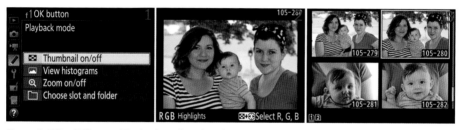

Figure 5.42D – OK button (Playback mode – Thumbnail on/off)

Use the following steps to configure and use Thumbnail on/off:

1. Figure 5.42D continues where figure 5.42C leaves off. Select Thumbnail on/off from the Playback mode menu (figure 5.42D, image 1) and press the OK button to select the setting.
2. Now when you press the Playback button and view a picture on the Monitor, like the family snapshot shown in figure 5.42D, image 2, you can then press the OK button to get a thumbnail view of that image along with three surrounding images (figure 5.42D, image 3). If you press the button repeatedly, the camera will toggle between normal view and thumbnail view.

View histograms

I discovered this really cool View histograms feature while I was writing another book, and now I immediately switch my Nikons to this setting when I get a new one.

When the OK button function is set to View histograms, I can have an image open on my Monitor, and then press and hold the OK button to view a luminance histogram. This saves a lot of scrolling around through the data, RGB histograms, and information screens. It's a quick histogram view that disappears when the OK button is released. Great feature! Let's see how to configure and use it.

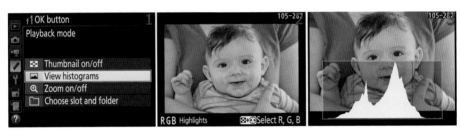

Figure 5.42E – OK button (Playback mode – View histograms)

Use the following steps to configure and use View histograms:

1. Figure 5.42E continues where figure 5.42C leaves off. Select View histograms from the Playback mode menu (figure 5.42E, image 1) and press the OK button to select the setting.
2. Now when you press the Playback button and view a picture on the Monitor, like the cute baby picture shown in figure 5.42E, image 2, you can then press the OK button to get a luminance histogram of that image (figure 5.42E, image 3). This is an extremely convenient setting for those who use the histogram regularly.

Zoom on/off

If you want to zoom into your image on the Monitor without using the normal zoom in and out buttons, this is a good feature for you. If you have an image showing on the Monitor and Zoom on/off is selected, you can press the OK button to jump immediately to one of three levels of zoom. It works like a toggle switch—pressing the OK button a second time takes you back to a normal full-screen view.

Here is a description of the three levels of zoom available under this setting (Low to High):

- **Low magnification:** This displays the image at 50 percent of actual size.
- **1:1:** This displays the image at 100 percent of actual size (pixel peeping).
- **High magnification:** This displays the image at 200 percent of actual size.

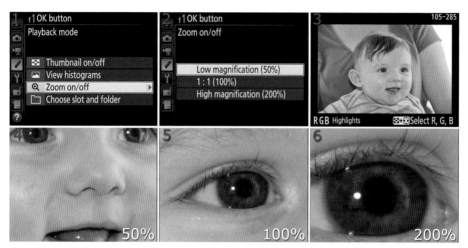

Figure 5.42F – OK button (Playback mode – Zoom on/off settings)

Use the following steps to configure and use Zoom on/off:

1. Figure 5.42F continues where figure 5.42C leaves off. Select Zoom on/off from the Playback mode menu (figure 5.42F, image 1).
2. Select Low magnification (50%), 1:1 (100%), or High magnification (200%) from the Zoom on/off list (figure 5.42F, image 2) and press the OK button to select the setting.
3. Press the Playback button to display a picture on the Monitor (as shown in figure 5.42F, image 3, where you see mister cute baby face again in RGB Highlights screen mode).
4. Now press the OK button and the camera will immediately zoom in to view the picture on the Monitor at whatever magnification level you chose in step 2. Screens 4, 5, and 6 in figure 5.42F match the zoom levels selectable in image 2: Low magnification (50%), 1:1 (100%), and High magnification (200%).

Note: The zoom display centers on the focus point used to take the image. If you are using Thumbnail view, you can select from a series of images on the Monitor. When you have one of the images selected, even though it is not full size, you can press the OK button and the image will be enlarged to whatever magnification level you previously selected. When you press the button again, the camera switches back to Thumbnail view.

Choose slot and folder

When you select Choose slot and folder, you will have a memory card slot selection screen available while you are examining an image in Playback mode. To open the slot selection screen, press the OK button.

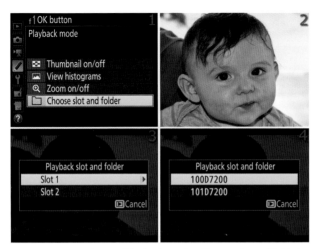

Figure 5.42G – OK button (Playback mode – Choose slot and folder)

Use the following steps to configure and use Choose slot and folder:

1. Figure 5.42G continues where figure 5.42C leaves off. Select Choose slot and folder from the Playback mode menu (figure 5.42G, image 1).
2. Press the OK button to select the setting.
3. Press the Playback button to display a picture on the Monitor.
4. When you press the OK button (figure 5.42G, image 2), you will be presented with the screen shown in figure 5.42G, image 3. Choose a card slot first, Slot 1 or Slot 2, and then scroll to the right.
5. You will now see a screen showing you the folders that can be found on the card in the slot you selected in the previous step (figure 5.42G, image 4). Select one of the folders, if there is more than one available, and press the OK button.
6. The camera will show images from the folder you have selected. If you have Playback Menu > Playback folder set to All or ND7200, the camera will switch folders, and even memory cards, when it gets to the end of the current folder. If Playback Menu > Playback folder is set to Current, the camera will show only the images in the current folder and will display no other images from any other folder or card.

Live View

When shooting still images in Live view mode, you can assign one of three different settings to the OK button.

Use the following steps to choose how the OK button functions in Live view mode:

1. Select f Controls from the Custom Setting Menu and scroll to the right (figure 5.42H, image 1).
2. Highlight f1 OK button and scroll to the right (figure 5.42H, image 2).
3. Select Live view and scroll to the right (figure 5.42H, image 3).

4. Choose one of the three settings, according to the upcoming descriptions. In figure 5.42H, image 4, Select center focus point has been chosen. Please refer to the list following these steps to decide which functionality you like best. If you select Zoom on/off, there will be another screen presented to you so that you can choose a magnification level for the Zoom on/off function. Figure 5.42I, image 2, shows the screen with magnification choices.

5. Press the OK button to lock in the setting.

Figure 5.42H – OK button (Live view mode)

Here are descriptions of each of the functions available:

- **Select center focus point:** When you are using Live view, you can scroll the little contrast-detection focus square to any point of the Monitor for excellent focusing. Unfortunately, moving the little focus square around the screen is time-consuming. If you want to return the focus square to the center of the screen at any time and have this Select center focus point mode selected, just press the OK button and the focus square pops to the middle of the Monitor.

- **Zoom on/off:** The Live view contrast-detection autofocus system allows you to zoom into your subject quite deeply so that you can focus very accurately. You could use the Playback zoom in button or Thumbnail/Playback zoom out button to zoom in and out, or you can configure this function and use the OK button to zoom in and out instead. With Zoom on/off, you can select one of three levels of magnification for focusing in Live view mode. When you want to zoom into the live image to focus on your subject in a very accurate way, simply press the OK button and the camera will immediately jump to a zoom position of 50 percent for Low magnification, 100 percent for 1:1 magnification, and 200 percent for High magnification. Use the screens found in figure 5.42I to select a magnification level. Figure 5.42I starts where figure 5.42H leaves off. This works similarly to functions found under *Playback mode > Zoom on/off* (figure 5.42F) except it is working with a live subject on the Monitor in Live view.

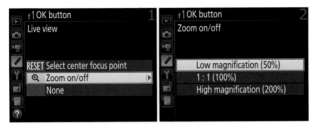

Figure 5.42I – OK button (Live view mode – Zoom on/off)

- **None:** If you press the OK button while in Live view, it has no effect.

Settings Recommendation: I have my camera set so that when I press the OK button in Shooting mode, it jumps to the center AF point. It saves time because I don't have to scroll back manually.

When I press the OK button in Playback mode, I have the camera show me a luminance histogram. I absolutely adore being able to see a histogram for an image I just took by pressing the OK button instead of scrolling to the histogram screen. This saves time by letting me see my camera's histogram when I need it most, right after taking the picture.

When using Live view mode, I leave my camera set to Select center focus point because it takes so long to scroll the little focus square around the Monitor. I find it quite nice to be able to pop the focus square to the center by pressing the OK button.

Custom Setting f2: Assign Fn Button
Custom Setting f3: Assign Preview Button
Custom Setting f4: Assign AE-L/AF-L Button

(User's Manual: Pages 284–285, Menu Guide: 92–97)

Assign Fn button, Assign preview button, and *Assign AE-L/AF-L button* are all discussed in this one section. All three work exactly the same way, so instead of repeating the same instructions three times, I chose to explain them once.

When I speak of the **Selected button,** I am talking about the camera button you want to configure—Fn, Preview, or AE-L/AF-L. When you see the words **Selected button** in bold italics, please mentally replace this with the button name you want to configure.

You can assign various camera functions to any of the three buttons mentioned. After we consider each of the screens used to assign the various functions, we'll look at each function in detail in the section **Assignable Function List**. There are a lot of different functions to select from.

The screens, steps, and settings we are about to review are designed to let you customize the usage of the Selected button alone or the Selected button + Command dials.

Here are the screens and steps used to configure Assign Fn button, Assign preview button, and Assign AE-L/AF-L button (figures 5.43A, 5.43B, and 5.43C):

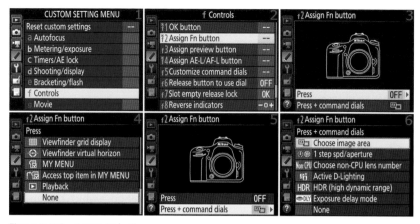

Figure 5.43A – Assign Fn button

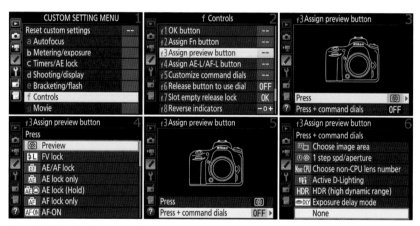

Figure 5.43B – Assign preview button

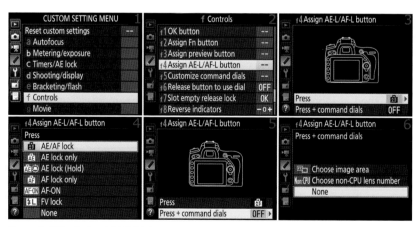

Figure 5.43C – Assign AE-L/AF-L button

Remember that the next nine steps are designed to explain any of the three buttons to which you can assign a function. **Selected button** represents the button you are currently assigning. For example, Preview button press is represented by **Selected button** press.

1. See figures 5.43A, 5.43B, and 5.43C for individual button assignment screens:
 figure 5.43A = Fn button
 figure 5.43B = Preview button (a.k.a., Depth-of-field preview button)
 figure 5.43C = AE-L/AF-L button
2. Select f Controls from the Custom Setting Menu and scroll to the right (figure 5.43A, 5.43B, or 5.43C, image 1).
3. Highlight (f2, f3, f4) Assign **Selected button** (Fn, Preview, or AE-L/AF-L) and scroll to the right (figure 5.43A, 5.43B, or 5.43C, image 2). This is where you choose which button you are working with and select it for function assignment.
4. Choose Press and scroll to the right (figure 5.43A, 5.43B, or 5.43C, image 3). The next step makes an assignment for when you simply press the button.
5. Select one of the functions from the list. This will assign the function you choose to a single press of the **Selected button** you are configuring (figure 5.43A, 5.43B, or 5.43C, image 4). See the upcoming section **Assignable Function List** for an explanation of each function.
6. Press the OK button to lock in the assignment for **Selected button** Press.
7. Now highlight Press + command dials and scroll to the right (figure 5.43A, 5.43B, or 5.43C, image 5). The next step makes an assignment for when you press and hold the button and then rotate one of the command dials.
8. Choose one of the functions to assign to Press + command dials (figure 5.43A, 5.43B, or 5.43C, image 6). The upcoming section **Assignable Function List** will explain what each one does.
9. Press the OK button to lock in the setting for **Selected button** Press + command dials.

Important note: The upcoming **Assignable Function List** is composed of two parts: The **Press** list of items, and the **Press + Command Dials** list of items.

Many items in the **Press** list cannot be used in combination with items in the **Press + Command dial** list. If you select one of these mutually exclusive Press functions, the camera will disable the Press + command dials function (if already selected) for that particular button. You'll see a warning on the screen that says, *"No function assigned to button + command dial."* Then, as soon as you select the Press function, the camera will set the Press + command dials function to None.

If you then go back and try to reset the value under Press + command dials, the camera will give you a warning that says, *"No function assigned to button press,"* and will set the Press function to None. The two functions cannot be used at the same time.

The only way to know which Press and Press + command dials functions cannot be used at the same time is to try and set them and see what happens. If they cannot be used at the same time, the camera will warn you, and you should select and use the one most important to you, ignoring the other.

Now let's look at the Assignable Function List to see what amazing powers we can give each of the assignable buttons on our cameras.

Assignable Function List
(Menu Guide: Pages 92–96)

Let's review each of the functions you can assign to the *Selected button* Press. Then we'll look at the ones you can assign to the *Selected button* Press + command dials.

Press

- *Preview:* Normally, the depth of field function is controlled by the Depth-of-field preview button. Some users may not like the location of the Depth-of-field preview button, and—since it is also configurable—decide to switch the Fn button (for instance) with the Depth-of-field preview button. Then, when Preview is selected in one of these Custom settings, the Fn button will activate Depth-of-field preview instead.
- *FV lock:* If you set *Selected button* to FV lock, the button will cause the built-in Speedlight or the external Speedlight to emit a monitor preflash and then lock the flash output to the level determined by the preflash until you press the *Selected button* a second time.
- *AE/AF lock:* Enabling this function causes AE (exposure) and AF (focus) to lock on the last meter and autofocus system reading while the Selected button is held down.
- *AE lock only:* This allows you to lock AE (exposure) on the last meter reading when you hold down the Selected button.
- *AE lock (Hold):* Enabling this function causes AE (exposure) to lock on the last meter reading when the *Selected button* is pressed once. It stays locked until you press the *Selected button* again. In other words, the *Selected button* toggles the AE lock. This is similar to AE lock (Reset on release) except that releasing the shutter does not reset the AE lock Hold. You must press the *Selected button* again to release AE lock.
- *AF lock only:* When set, this function locks the AF system (focus) on the last autofocus reading while you hold down the *Selected button*.
- *AF-ON:* If you set any of the three assignable buttons to AF-ON, that *Selected button* will initiate autofocus when you press it. Since the D7200 does not have an AF-ON button, most photographers who prefer back button focusing will assign this functionality to the AE-L/AF-L button press. Then the AE-L/AF-L button will duplicate the functionality of the AF-ON button, as found on more expensive Nikons, and the camera will initiate autofocus with a convenient thumb press.
- *Flash Off:* Press the *Selected button* as a temporary way to disable the flash when you want to leave your flash turned on and still be able to take a nonflash picture. While you hold down the *Selected button* the flash is disabled, and when the *Selected button* is released the flash works normally.
- *Bracketing burst:* Normally, during a bracketing sequence with the shutter's Release mode set to Single Frame Release Mode—the S next to CL and CH on the Release mode dial—you have to press the Shutter-release button once for each of the images in the

bracket. The only way to shoot all the images in the bracketed series without letting up on the Shutter-release button is to set the Release mode dial to CH, CL, or Qc. If you set Bracketing burst, you can hold down the **Selected button** while also holding down the Shutter-release button and the camera will take all the images in the bracket without letup and then stop. If the camera is already set to CH, CL, or Qc modes and you hold down the Shutter-release button and the **Selected button** at the same time, the camera will repeat the bracketing series over and over. This applies to AE, Flash, and ADL bracketing, which each take one image for each shutter release. Be careful, though, when using WB bracketing because it takes the entire bracket with only one shutter release. If you use this function for WB bracketing and hold down the Shutter-release button, you'll create multiple groups of bracketed images on your memory card, not just one bracketed series. In other words, multiple shutter releases will capture numerous multi-image WB brackets.

- **+NEF (RAW):** If you are a regular JPEG shooter and have JPEG fine, normal, or basic selected as your normal image capture format, you can use the **Selected button** to temporarily switch to NEF (RAW) mode for one image. Once you take the RAW format picture, the camera switches back to JPEG. If you decide not to take the NEF (RAW) picture after pressing the **Selected button,** just press the **Selected button** again to return to JPEG mode.

- **Matrix metering:** If you do not use Matrix metering as your primary metering system but want to use it occasionally, this setting allows you to turn on Matrix metering by holding down the **Selected button**. When you release the **Selected button,** the camera returns to your customary meter type, such as Spot or Center-weighted metering.

- **Center-weighted metering:** If you do not use Center-weighted metering as your primary metering system but want to use it occasionally, you can turn on Center-weighted metering by holding down the **Selected button**. When you release the button, the camera returns to your customary meter type, such as Spot or Matrix metering.

- **Spot metering:** If you do not use Spot metering as your primary metering system but want to use it occasionally, you can turn on Spot metering by holding down the **Selected button**. When you release the button, the camera returns to your customary meter type, such as Center-weighted or Matrix metering.

- **Viewfinder grid display:** When you press the **Selected button,** the camera will turn the framing grid display on or off in the Viewfinder.

- **Viewfinder virtual horizon:** You can press the **Selected button** to display a horizontal-only, Virtual horizon indicator on the bottom of the Viewfinder.

- **MY MENU:** Pressing the **Selected button** opens the MY MENU display on the Monitor. This is convenient for using your favorite settings from MY MENU without having to scroll through menus to activate the MY MENU display.

- **Access top item in MY MENU:** You can press the **Selected button** to jump directly to the top item in MY MENU. This allows you to quickly modify a frequently used menu item.

- **Playback:** This function causes the **Selected button** to act as if you had pressed the Playback button. Nikon included this so that you could play back images when using a big telephoto lens that requires two hands to use.

- **None:** When this setting is enabled, the **Selected button** does nothing.

Press + Command Dials

- **Choose image area:** You may press the **Selected button** and rotate either of the Command dials to choose from the camera's two image areas. Your choices are DX (24×16) and 1.3× (18×12). You can select the following formats as you hold down the **Selected button** and turn either one of the Command dials:
 24-16 equals DX (24×16)
 18-12 equals 1.3× (18×12)

Figure 5.43D shows the DX (24×16) image area on the Control panel, represented by the numbers 24–16.

Figure 5.43D – Choose image area

- **1 step spd/aperture** (not available for AE-L/AF-L + command dials): If you set *Custom Setting Menu > b Metering/exposure > b2 EV steps for exposure cntrl* to 1/3 step you can change your camera's shutter speed and/or aperture in 1/3 EV steps while in Aperture-priority (A), Shutter-priority (S), and Manual (M). However, you may want to use larger EV steps occasionally. By setting 1 step spd/aperture, you can hold down the **Selected button** and the camera will allow you to change the shutter speed or aperture in 1 step increments instead of the normal 1/3 step. Example shutter speeds in 1/3 EV steps are: 1/60, 1/80, 1/100, 1/125, 1/160. Example shutter speeds in 1 EV step are: 1/60, 1/125, 1/250, 1/500, 1/1000. You cannot make this assignment to the AE-L/AF-L button Press + command dials setting.

- **Choose non-CPU lens number:** If you have added non-CPU lenses under *Setup Menu > Non-CPU lens data* you'll be able to hold down the **Selected button** while rotating the front Sub-command dial to scroll through a list of up to nine non-CPU lenses (e.g., n-1). Figure 5.43E shows the Control panel icons you will see when you use Choose non-CPU lens number. The number 35 shown in figure 5.43E is the focal length of one of my registered non-CPU lenses—my AI Nikkor 35mm f/2—and the F2 represents the maximum aperture. The n-1 represents the lens numbers (n-1 through n-9) that are registered with the camera.

Figure 5.43E – Choose non-CPU lens number

- **(AdL) Active D-Lighting:** Press the **Selected button** and rotate either of the Command dials to adjust Active D-Lighting (AdL) to one of its six settings: Off (oFF), Low (L), Normal (n), High (H), Extra high (HP), and Auto (A). Figure 5.43F shows the Control panel icons you will see when you use Active D-Lighting as described here. You will see the symbols that represent the various settings, such as Auto, H, and HP, scroll by as you turn either of the Command dials. You cannot make this

Figure 5.43F – Active D-Lighting – Auto

assignment to the AE-L/AF-L button Press + command dials setting.

- **HDR (high dynamic range):** Press and hold the **Selected button** while rotating the rear Main command dial to choose an HDR mode for JPEG images (figure 5.43G). Your mode choices will be On (single photo), which is represented by a small 1 on the bottom of the Control panel; On (series), which uses a C character; and Off (oFF). Rotate the front Subcommand dial to choose the HDR strength. Your choices are Low (L), Normal (n), High (H), Extra High (HP), and Auto (A). Figure 5.43G shows the Control panel screen for HDR. You cannot make this assignment to the AE-L/AF-L button Press + command dials setting.

Figure 5.43G – HDR (high dynamic range)

- **Exposure delay mode:** Press the **Selected button** and rotate either of the Comand dials to choose an exposure delay of 1, 2, or 3 second(s). This is the same as setting an exposure delay with Custom setting d4 Exposure delay mode. Figure 5.43H shows the Control panel with Exposure delay mode selected. The dLY symbol stands for delay and the number 3 on the bottom is the delay time. In figure 5.43H, you can see that I selected 3 seconds of exposure delay. Therefore, when I press the Shutter-release button, my camera will raise the mirror and then wait three seconds to fire the shutter. This allows vibrations to die down, resulting in a sharper picture. You cannot make this assignment to the AE-L/AF-L button Press + command dials setting.

Figure 5.43H – Exposure delay mode – 3 seconds

- **None:** Nothing happens when you hold down the **Selected button** and rotate the Command dials.

Using the Quick Menu to Assign Buttons

Interestingly, you can also use the camera's *i* button menu to initiate assignments to the Fn button, Preview button, and AE-L/AF-L buttons. Use the following screens to do it, referring back to the **Assignable Function List** for selections.

Use the following steps to access the *i* button menu and initiate changes to the **Selected button** assignments:

1. Press the *i* button to open the *i* button menu.
2. You will see selectable settings as shown in figure 5.43I. Scroll up or down with the Multi selector and choose the button you want to assign.

3. When you have selected the correct button assignment screen, simply press the OK button or scroll to the right to open the actual assignment menus, which are identical to the menus covered in figures 5.43A, 5.43B, and 5.43C (starting with image 3 in each) and include all the functions listed in the **Assignable Function List**. Basically, the *i* button menu allows you to skip the first two menu items on the Custom Setting Menu and jump directly to the assignment screens (screens 3–6) in figures 5.43A, 5.43B, and 5.43C. This may save you a little time in the field.

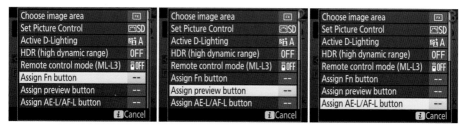

Figure 5.43I – Selected button assignment from the *i* button menu

Settings Recommendation: There are so many available functions here that I'm loathe to recommend anything definitively. However, I will tell you how I set mine, and you can experiment and see if that suits your style. If not, you've got a lot of choices!

Darrell's favorites:
* *Assign Fn button Press:* Spot metering (my normal meter is Matrix)
* *Assign Fn button Press + command dials:* Not used
* *Assign preview button Press:* Preview (Depth-of-field preview)
* *Assign preview button Press + command dials:* Not used
* *Assign AE-L/AF-L button Press:* AE lock only
* *Assign AE-L/AF-L button Press + command dials:* Exposure delay mode

Note: Those who would rather use back button focusing will want to assign AF-ON to the AE-L/AF-L button Press setting.

Custom Setting f5: Customize Command Dials

(User's Manual: Page 285, Menu Guide: Page 99)

Customize command dials does exactly what it sounds like—it lets you change how the Command dials operate. There are several operations you can modify:

* Reverse rotation
* Change main/sub
* Aperture setting
* Menus and playback
* Sub-dial frame advance

Let's examine each of these items and the screens and steps used to change them.

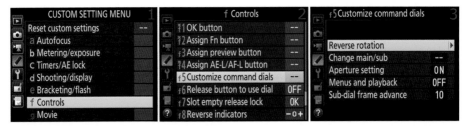

Figure 5.44A – Customize command dials

Use the following steps to change the functionality of the Command dials:

1. Select f Controls from the Custom Setting Menu and scroll to the right (figure 5.44A, image 1).
2. Highlight f5 Customize command dials and scroll to the right (figure 5.44A, image 2).
3. Choose one of the five selections from the list. In figure 5.44A, image 3, Reverse rotation has been selected.
4. Scroll to the right and use the screens and steps under each of the following sections to configure the various functions (figures 5.44B to 5.44G).

Reverse Rotation

Reverse rotation allows you to change what happens when you rotate the Command dials in a certain direction, including those on a mounted MB-D15 battery pack. You can reverse Command dial operations with this setting. There are two selections:

- **Exposure compensation:** When you press and hold the Exposure compensation button and turn the Sub-command dial clockwise, it decreases the amount of compensation. If you place a check mark in this box and select Done, the camera will increase the amount of compensation when you turn the Sub-command dial clockwise.
- **Shutter speed/aperture:** Normally, when the D7200 is set to Aperture-priority (A) or Manual (M) mode and you rotate the Sub-command dial clockwise, the aperture gets smaller. If you put a check mark next to Shutter speed/aperture and select Done, the aperture will instead get larger when you turn the Sub-command dial clockwise. The same goes for shutter speed in Shutter-priority (S) and Manual (M) modes. Normally, turning the rear Main command dial clockwise slows down the shutter speed. If you put a check mark next to Shutter speed/aperture and select Done, the shutter speed will instead get faster when you turn the Main command dial clockwise. Finally, when you override the aperture setting in Programmed auto (P) mode by turning the Main command dial clockwise, instead of decreasing the size of the aperture, it increases it.

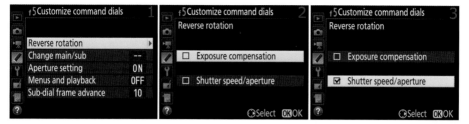

Figure 5.44B – Customize command dials (Reverse rotation)

Here are the steps to change the rotation direction of the Command dials:

1. Continuing from figure 5.44A, image 3, select Reverse rotation and scroll to the right (figure 5.44B, image 1).
2. Using the Multi selector, highlight Exposure compensation or Shutter speed/aperture and scroll to the right to set a check mark in the corresponding small check box (figure 5.44B, image 2). In figure 5.44B, image 3, I have placed a check mark in Shutter speed/aperture.
3. Press the OK button to lock in the setting.

Settings Recommendation: I leave the Command dials rotation set to factory default. I find life confusing enough without my camera working backward. Of course, if you come from a different camera brand than Nikon and are used to the dials working in the opposite direction, you may feel more comfortable reversing them on your D7200.

Change Main/Sub

Change main/sub allows you to swap the functionality of the two Command dials. The rear Main command dial will take on the functions of the front Sub-command dial and vice versa.

You can configure the camera so that this reversal of the Main and Sub command dials applies to both the Exposure setting (aperture and shutter speed) and the Autofocus setting (Autofocus modes and AF-area modes).

Exposure Setting

The Exposure setting subfunction allows you to switch the Main and Sub functionality of the Command dials for changing the aperture and shutter speed (figure 5.44C). Normally, the aperture is controlled by the front Sub-command dial, and the shutter speed is controlled by the rear Main command dial. However, when switched, that is reversed.

Let's consider the three settings you can choose under this subfunction and see how they each affect the actions of the Command dials. Here are the three setting variations:

- **On:** By selecting On, you reverse the functionality of the two Command dials so that the Sub-command dial controls shutter speed while the Main command dial controls aperture.

- **On (Mode A):** This special mode sets the camera so that the Main command dial controls the aperture when using Aperture-priority (A) mode only.
- **Off:** The functionality of the Command dials is set to the factory default. The Main command dial controls the shutter speed while the Sub-command dial controls the aperture.

Let's examine how to choose one of these settings.

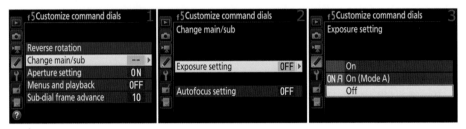

Figure 5.44C – Customize command dials (Change main/sub – Exposure setting)

Here are the steps to swap the functionality of the Command dials for the Exposure setting:

1. Continuing from figure 5.44A, image 3, select Change main/sub and scroll to the right (figure 5.44C, image 1).
2. Choose Exposure setting from the Change main/sub menu and scroll to the right (figure 5.44C, image 2).
3. Select one of the three settings: On, On (Mode A), or Off (figure 5.44C, image 3).
4. Press the OK button to lock in the setting.

Settings Recommendation: I leave the Command dials set to factory default (Off). I've been using Nikons for too many years to change Command dial functionality now. However, you may have valid reasons for swapping the Command dial functionality. If so, it's very easy.

Autofocus Setting

When adjusting the Autofocus setting you will hold in the AF-mode button (just under the Lens release button) and turn one of the Command dials while watching the modes change on the Control panel. Normally, the rear Main command dial controls the Autofocus mode (i.e., AF-S, AF-C) and the front Sub-command dial controls the AF-area mode (e.g., Single-point AF, Dynamic-area AF). However, you can reverse that with the *Change main/sub > Autofocus setting* subfunction.

Here is a list of the two settings within this subfunction and what each does:

- **On:** By selecting On, you reverse the functionality of the two Command dials so that the front Sub-command dial controls the Autofocus mode (i.e., AF-S, AF-C) and the rear Main command dial controls the AF-area mode (e.g., Single-point AF, Dynamic-area AF).
- **Off:** The functionality of the Command dials is set to the factory default. The front Sub-command dial controls the AF-area mode (e.g., Single-point AF, Dynamic-area AF) and the rear Main command dial controls the Autofocus mode (i.e., AF-S, AF-C).

Let's see how to choose one of these settings.

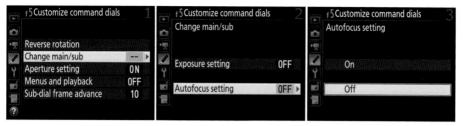

Figure 5.44D – Customize command dials (Change main/sub – Autofocus setting)

Here are the steps to swap the functionality of the Command dials for the Autofocus setting:

1. Continuing from figure 5.44A, image 3, select Change main/sub and scroll to the right (figure 5.44D, image 1).
2. Choose Autofocus setting from the Change main/sub menu and scroll to the right (figure 5.44D, image 2).
3. Select On or Off (figure 5.44D, image 3).
4. Press the OK button to lock in the setting.

Settings Recommendation: Again, I see no reason to reverse the functionality of the Command dials because I have trained my muscle memory over the last several years to work with the normal Main and Sub command dial functions. However, if you have recently come from a different camera brand over to the new Nikon D7200 and are used to the dials working in reverse, or you just prefer it that way, by all means reverse how the Command dials work.

Aperture Setting

There are two selections that allow you to modify how the camera treats CPU lenses that have aperture rings on them (non-G lenses):

- **Sub-command dial:** This is the factory default setting. The aperture is set using the Sub-command dial. If you select this setting and are using a non-G lens with an old-style aperture ring, you will need to set and lock it (if available) to the smallest aperture and then use the Sub-command dial to change apertures.
- **Aperture ring:** This setting allows those with older non-G type lenses with a CPU to use the lens's aperture ring to adjust the aperture instead of using the Sub-command dial. The EV increments will be displayed in only 1 EV steps when this is active. If you are using a G-type lens with no aperture ring, you clearly can't set the aperture with a non-existent aperture ring, so the camera ignores this setting.

Note: When a non-CPU lens is used, the aperture ring must always be used to set the aperture instead of the Sub-command dial.

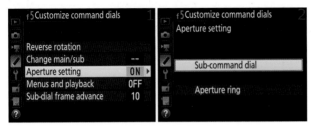

Figure 5.44E – Customize command dials (Aperture setting)

Here are the steps to change the style of Aperture setting:

1. Continuing from figure 5.44A, image 3, select Aperture setting and scroll to the right (figure 5.44E, image 1).
2. Select Sub-command dial or Aperture ring from the list (figure 5.44E, image 2).
3. Press the OK button to lock in the setting.

Settings Recommendation: I leave Aperture setting set to Sub-command dial. I have some older AF Nikkors that I still like using, so I keep them locked at their smallest aperture settings and use the Sub-command dial to change their apertures. I don't adjust apertures with the old aperture ring on the lens unless I'm using older non-CPU, manual focus AI or AI-S lenses.

Menus and Playback

Menus and playback is designed for those who do not like to use the Multi selector for viewing image Playback or Info screens. It also allows you to use the Command dials for scrolling though menus. There are two selections for how the menus and image playback work when you would rather not use the Multi selector:

- **On:** While viewing images during playback, turning the Main command dial to the left or right scrolls through the displayed images. Turning the Sub-command dial left or right scrolls through the data and histogram screens for each image. While viewing menus, turning the Main command dial left or right scrolls up or down in the screens. Turning the Sub-command dial left or right scrolls left or right in the menus. The Multi selector button works normally, even when this is set to On. This setting simply allows you two ways to view your images and menus instead of one. Also, when you are using thumbnail viewing of multiple images on the Monitor, turning the rear Main command dial moves left and right in the list of thumbnail images, while the front Sub-command dial moves up and down in the list of thumbnails.

- **On (image review excluded):** This works exactly the same as On, with one exception. When you use On alone (previous setting) and take a picture, the picture will show up on the Monitor and you can then use the Command dials to review images other than the one you just took. However, if you select On (image review excluded) instead of just On, you will not be able to examine other images with the Command dials when an image pops up for review after you take it. In other words, image review with the Command dials is excluded just after you take a picture. You can view only the picture you just took unless you use the Multi selector, not the Command dials, to scroll through the other images taken previously. You can still use the Command dials for Playback image review (after pressing the Playback button)—just not immediately after taking an image, when it first pops up on the Monitor.
- **Off:** This is the default action. The Multi selector is used to scroll through images and menus.

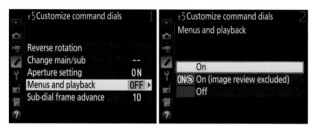

Figure 5.44F – Customize command dials (Menus and playback)

Here are the steps used to configure Menus and playback:

1. Continuing from figure 5.44A, image 3, select Menus and playback and scroll to the right (figure 5.44F, image 1).
2. Select one of the three settings (figure 5.44F, image 2). On is selected in image 2.
3. Press the OK button to lock in the setting.

Settings Recommendation: I have my camera set to On for Menus and playback. I like the fact that I can use the Multi selector or the Command dials to move around in my camera's menus and images. Try this one out; you may like it, too!

Sub-Dial Frame Advance

With the huge memory cards available today, you may find yourself having hundreds or even thousands of images on a single memory card. Have you ever had to scroll through a large number of images to find an image you want to look at more closely?

Nikon has come to our rescue with a function that lets you move around more efficiently within a large number of images, or even multiple folders, on a memory card.

This function is closely tied to the previous function, Menus and playback. Please review that function for details. If you have On or On (image review excluded) enabled under Menus and playback, you can use the following functionality:

- **10 frames:** When you rotate the front Sub-command dial during full-frame playback, the camera will jump forward or backward 10 frames at a time, skipping over the frames in between.
- **50 frames:** When you rotate the front Sub-command dial during full-frame playback, the camera will jump forward or backward 50 frames at a time, skipping the frames in between.
- **Folder:** When you rotate the front Sub-command dial during full-frame playback, the camera will move between folders. If there is only one folder on the memory card, the Sub-command dial does nothing.

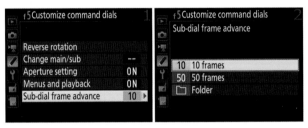

Figure 5.44G – Customize command dials (Sub-dial frame advance)

Use these steps to choose a Sub-dial frame advance setting:

1. Continuing from figure 5.44A, image 3, select Sub-dial frame advance and scroll to the right (figure 5.44G, image 1).
2. Select one of the three settings: 10 frames, 50 frames, or Folder (figure 5.44G, image 2).
3. Press the OK button to lock in the setting.

Note: If you do not have On or On (image review excluded) set in Menus and playback (previous subheading), the camera will not respond to any settings in the Sub-dial frame advance function. When you rotate the front Sub-command dial during full-frame playback, nothing will happen.

Settings Recommendation: I have my camera set to Folder because I often use different folders to separate the images on my camera's memory card. I currently shoot with 64GB Sandisk cards and they will hold hundreds of RAW images and thousands of JPEGs. As memory cards increase in size and the larger ones become more affordable, I can foresee a time when this function will become even more important.

Custom Setting f6: Release Button to Use Dial

(User's Manual: Page 285, Menu Guide: Page 101)

Release button to use dial allows those who don't like to or cannot hold down buttons and turn a Command dial at the same time to change to an easier method. This function may be very useful to people with limited hand strength, allowing them to operate the camera more easily.

The function works with the following buttons only:

- +/– Exposure compensation button
- +/– Flash compensation button
- BKT button
- ISO button
- QUAL button
- WB button
- Metering button
- AF-mode button

There are two settings under this function. Let's examine them and then look at the screens and steps to modify Release button to use dial:

- **Yes:** This setting changes a two-step operation into a three-step operation. Normally, you would press and hold down a button while rotating a Command dial. When you select Yes under Release button to use dial, the camera allows you to press and release a button, rotate the Command dial, then press and release the button again. The initial button press locks the button so that you do not have to hold your finger on it while turning the Command dial. Once you have changed whatever you are adjusting, you must press the button a second time to unlock it.
- **No:** This is the default setting. You must press and hold a button while rotating the Command dials in order to change camera functionality.

If the exposure meter turns off or you press the Shutter-release button halfway while the Yes operation is active, you must press the original button again to restart the action. You can set the exposure meter to No limit or a longer time-out in *Custom Setting Menu > c Timers/ AE lock > c2 Standby timer* to prevent the exposure meter from turning off after a few seconds. This may make the function more useful if you have weak hands or must move slowly.

Figure 5.45 – Release button to use dial

Here are the steps to configure Release button to use dial:

1. Select f Controls from the Custom Setting Menu and scroll to the right (figure 5.45, image 1).
2. Highlight f6 Release button to use dial and scroll to the right (figure 5.45, image 2).
3. Choose Yes or No. In figure 5.45, image 3, No has been selected.
4. Press the OK button to lock in the setting.

Settings Recommendation: A person with certain physical disabilities may find this to be a very useful function because it allows complex camera operation with only one hand.

Custom Setting f7: Slot Empty Release Lock

(User's Manual: Page 286, Menu Guide: Page 102)

Slot empty release lock defaults to locking the shutter when you try to take an image without a memory card inserted in the camera. By enabling it, you can take pictures without a memory card but cannot save them later.

This function exists so that when you have your camera tethered to your computer using Nikon Camera Control Pro 2 software (not included), you can send pictures directly to the computer, bypassing the memory card.

You can allow the camera to take pictures with no card inserted when you select the OK Enable release setting.

Here is a description of both settings:

- **LOCK Release locked:** When you choose this default setting, your camera will refuse to release the shutter when there is no memory card present.
- **OK Enable release:** Use this setting if you want to use the optional Camera Control Pro 2 software to send images from the camera directly to the computer.

Figure 5.46 – Slot empty release lock

Here are the steps used to configure Slot empty release lock:

1. Select f Controls from the Custom Setting Menu and scroll to the right (figure 5.46, image 1).
2. Highlight f7 Slot empty release lock and scroll to the right (figure 5.46, image 2).
3. Choose one of the two settings from the list. In figure 5.46, image 3, LOCK Release locked has been selected.
4. Press the OK button to lock in the setting.

Settings Recommendation: I tried using the OK Enable release setting as an experiment. I found that there is no real reason to use this setting other than when the camera is tethered to a computer. You cannot save the images in the memory buffer to a memory card later.

Custom Setting f8: Reverse Indicators

(User's Manual: Page 286, Menu Guide: Page 102)

Reverse indicators lets you change the direction of your camera's exposure displays. Normally, anytime you see the exposure indicators in your camera's Control panel, Viewfinder, or the Information display, the − is on the left and the + is on the right.

Figure 5.47A – Reversed indicators on the Information display (see red arrows)

See Figure 5.47A, where I show the Information display and the exposure indicator therein. The first image shows the normal direction. The second image shows the Information display with the exposure indicators reversed (see red arrows).

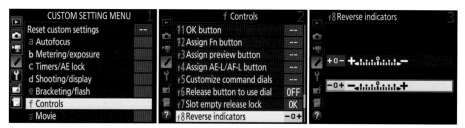

Figure 5.47B – Reverse indicators

Here are the steps to reverse the direction of all camera exposure indicators:

1. Select f Controls from the Custom Setting Menu and scroll to the right (figure 5.47B, image 1).
2. Highlight f8 Reverse indicators and scroll to the right (figure 5.47B, image 2).
3. Choose one of the two selections from the list. In figure 5.47B, image 3, the default exposure indicator direction has been selected.
4. Press the OK button to lock in the setting.

Settings Recommendation: If you have been using an older Nikon SLR or DSLR you may find the reversed exposure indicator scale on your D7200 somewhat jarring.

Having used Nikons since way back in 1980, I was quite used to my camera's exposure scale having the plus on the left and the minus on the right. When I first started using a Nikon that reversed this scale, it aggravated me to no end, and I changed it back to the "normal" +/− setting.

However, after thinking about it for a while, I realized that the histogram works in a –/+ direction, with dark on the left and bright on the right. I use the histogram frequently, so I changed the indicator direction back to the factory default of –/+. I have now used it this way for some time and it is beginning to make sense and feel more natural.

However, if you feel uncomfortable seeing the meter indicator working "backward," you may want to change the exposure indicator to the "correct" direction. If you do change it, you may also want to reverse the Exposure compensation direction with *Custom Setting Menu > f controls > f5 Customize command dials > Reverse rotation > Exposure compensation* (see the previous section **Custom Setting f5: Customize Command Dials**). Otherwise, you will notice that the Exposure compensation setting works backward from the reversed direction of the exposure indicator. It's a good thing we still have a choice about reversing things!

Custom Setting f9: Assign Movie Record Button

(User's Manual: Page 286, Menu Guide: Page 103)

Assign movie record button allows you to assign various functions to the Movie-record button for use during still-image shooting. When you are using your camera to take still pictures in Viewfinder or Live view photography mode, the Movie-record button has no functionality. It just sits there looking pretty with its exciting red dot. Normally, the only time the button has a function to perform is when you press it to start recording a video in Movie live view mode.

However, by assigning a function to the Movie-record button with this setting, you can use it to make adjustments when you are taking still images. This function becomes disabled when you set the Live view selector switch on the back of the camera to the Movie live view position. It is only active when taking stills.

There are four available subfunctions for the Movie-record button, as follows:

- **White balance:** Press the button and rotate a Command dial to choose a White balance setting (e.g., Flash, Cloudy, Shade).
- **ISO sensitivity:** Press the button and rotate a Command dial to choose an ISO sensitivity setting (e.g., 100, 125, 250).
- **Choose image area:** Press the button and rotate a Command dial to choose an Image area setting (e.g., DX, 1.3×).
- **None:** The Movie-record button does nothing when taking still pictures in Viewfinder or Live view photography mode.

The Movie-record button maintains normal functionality during video recordings, regardless of how this setting is configured. Let's examine how to choose one of the listed settings.

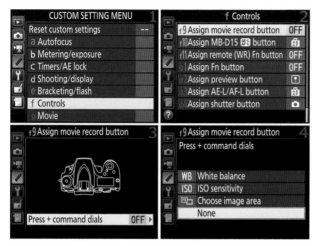

Figure 5.48 – Assign movie record button

Use these steps to choose a role for the Movie-record button when you are taking still pictures:

1. Select f Controls from the Custom Setting Menu and scroll to the right (figure 5.48, image 1).
2. Highlight f9 Assign movie record button and scroll to the right (figure 5.48, image 2).
3. Press + command dials will automatically be selected. Scroll to the right (figure 5.48, image 3).
4. In figure 5.48, image 4, choose one of the four selections from the list to select White balance (page 159), ISO sensitivity (page 173), Choose image area (page 158), or None.
5. Press the OK button to lock in the setting.

Settings Recommendation: I like to use the ISO sensitivity setting for this button assignment. The button falls naturally under my finger so I do not have to remove my eye from the Viewfinder to change ISO, which I would have to do if I used a menu or the ISO button on the rear of the camera. Of course, you may have other preferences, such as choosing an Image area or setting the White balance. Experiment until you find what works best for you.

Custom Setting f10: Assign MB-D15 AE-L/AF-L Button

(User's Manual: Page 286, Menu Guide: Page 104)

The *Assign MB-D15 AE-L/AF-L button* setting lets you assign a different function to the AE-L/AF-L button built into the optional MB-D15 battery pack than the button on the camera's body. There are seven distinct functions you can assign to the MB-D15's AE-L/AF-L button, as follows:

- **AE/AF lock:** Enabling this function causes AE (exposure) and AF (focus) to lock on the last meter and autofocus system reading while the AE-L/AF-L button on the MB-D15 is held down.
- **AE lock only:** This allows you to lock AE (exposure) on the last meter reading when you hold down the AE-L/AF-L button on the MB-D15.
- **AE lock (Hold):** Enabling this function causes AE (exposure) to lock on the last meter reading when the AE-L/AF-L button on the MB-D15 is pressed and released once. It stays locked until you press the AE-L/AF-L button again or the exposure meter goes off.
- **AF lock only:** This function locks the AF (focus) system on the last autofocus reading while you hold down the AE-L/AF-L button on the MB-D15.
- **AF-ON:** This causes the camera to initiate autofocus when you press the AE-L/AF-L button on the MB-D15. This is the normal setting for the AE-L/AF-L button.
- **FV lock:** If you set the AE-L/AF-L button on the MB-D15 to FV lock, the button will cause the built-in Speedlight or an external Speedlight to emit a monitor preflash. It will lock the flash output to the level determined by the preflash until you press the AE-L/AF-L button on the MB-D15 a second time.
- **Same as camera Fn button:** This setting allows you to set the AE-L/AF-L button on the MB-D15 so it executes whatever function you assigned to the camera's Fn button in *Custom Setting Menu > f controls > f2 Assign Fn button*.

Figure 5.49 – Assign the MB-D15 AE-L/AF-L button

Use the following steps to assign various functions to the Nikon MB-D15 battery pack's AE-L/AF-L button:

1. Select f Controls from the Custom Setting Menu and scroll to the right (figure 5.49, image 1).
2. Highlight f10 Assign MB-D15 AE-L/AF-L button and scroll to the right (figure 5.49, image 2).
3. Choose one of the seven selections from the list of functions (figure 5.49, image 3).
4. Press the OK button to lock in the setting.

Settings Recommendation: If you use an MB-D15 battery pack and don't use back button focus, you can choose one of the other six functions to assign to the AE-L/AF-L button on the MB-D15. As a nature photographer, I rarely use back button focus, and I often lock my exposure using AE lock, so I assigned AE lock only to my MB-D15's AE-L/AF-L button. Read over your choices carefully and choose the one that's best for you.

Custom Setting f11: Assign Remote (WR) Fn Button

(User's Manual: Page 287, Menu Guide: Page 105)

Assign remote (WR) Fn button allows you to assign various functions to the Fn button found on a Nikon WR-T10 Wireless Remote Controller. The WR-T10 controller is used to operate your camera through a Nikon WR-R10 Wireless Remote Transceiver.

You can assign one of 13 subfunctions to the Fn button on the WR-T10 controller, as follows:

• **Preview:** While you are using the Viewfinder, you can press the Fn button on the WR-R10 controller to preview depth of field. During Live view photography you can use the button as a toggle to open the aperture (maximum aperture) or stop it down (current aperture setting).
• **FV lock:** Press the Fn button on the WR-T10 controller to lock the flash value for the built-in flash and compatible accessory-shoe mounted Speedlights.
• **AE/AF lock:** Press and hold the Fn button on the WR-T10 controller to lock both the focus and exposure.
• **AE lock only:** Press and hold the Fn button on the WR-T10 controller to lock the exposure only.
• **AE lock (Hold):** Press and release the Fn button on the WR-T10 controller to lock the exposure. The exposure will remain locked until you press and release the Fn button again or the c2 Standby timer expires.
• **AF lock only:** Press and hold the Fn button on the WR-T10 controller to lock the focus only.
• **Flash off:** The flash will not fire when you press and hold the Fn button on the WR-T10 controller.
• **+ NEF (RAW):** If you are shooting in any of the JPEG modes (Fine, Normal, or Basic) and press the Fn button on the WR-T10 controller, the camera will immediately switch to NEF (RAW) mode for the next picture only. The original picture quality mode will be restored as soon as you release pressure on the Shutter-release button. If you decide not to take a RAW picture after pressing the WR-T10's Fn button, simply press the button again to cancel.
• **Live view:** Pressing the Fn button on the WR-T10 controller starts and ends Live view.
• **Same as camera Fn button:** Pressing the Fn button on the WR-T10 controller performs the same function as pressing the Fn button on the camera body.
• **Same as camera Pv button:** Pressing the Fn button on the WR-T10 controller does the same thing as pressing the Pv (preview) button on the camera body.
• **Same as camera AE-L/AF-L button:** Pressing the Fn button on the WR-T10 controller acts just like pressing the AE-L/AF-L button on the camera body.
• **None:** Pressing the Fn button on the WR-T10 controller has no effect.

Figure 5.50 – Assign remote (WR) Fn button

Use the following steps to assign a function to the Nikon WR-T10 controller's Fn button:

1. Select f Controls from the Custom Setting Menu and scroll to the right (figure 5.50, image 1).
2. Highlight f11 Assign remote (WR) Fn button and scroll to the right (figure 5.50, image 2).
3. Choose one of the 13 selections from the list (figure 5.50, image 3). The camera defaults to None.
4. Press the OK button to lock in the setting.

Settings Recommendation: Choose the function that best fits your current use of the camera. If you are standing near the camera and using the WR-T10 controller as a remote release, nearly all of the functions listed are beneficial.

Section Seven: g Movie

Custom Settings g1 to g4

Within the g Movie menu you'll find four Custom settings in the D7200:

- **g1:** Assign Fn button
- **g2:** Assign preview button
- **g3:** Assign AE-L/AF-L button
- **g4:** Assign shutter button

Let's examine how each of these functions work.

Custom Setting g1: Assign Fn Button

(User's Manual: Page 288, Menu Guide: Page 107)

Assign Fn button lets you choose how the Fn button works in Movie live view mode only. Following are the eight choices:

- **Index marking:** If you have Index marking enabled while you are recording a movie, you can set an index mark at the current frame position by pressing the Fn button. This index mark does not actually appear in the movie itself. It is, however, available when you are viewing and editing movies.
- **View photo shooting info:** This function allows you to view shooting information for still images when using Movie live view mode. The resulting still images have a slightly reduced image size and a different ratio, which we will discuss in a moment. Normally, when in Movie live view mode, the camera displays the shutter speed, aperture, and ISO sensitivity (recording information) for a potential movie at the bottom of the Monitor. When you press the Fn button, the camera displays the shutter speed, aperture, and ISO sensitivity (shooting information) for still image creation instead. The camera will happily take still images when you are using Movie live view mode. However, please note that there are some image size and ratio differences when taking a still image using Movie live view instead of Live view photography mode. When you are using Live view photography mode, a normal Large DX image is 6000 × 4000 (24 MP); however, while in Movie live view, a Large still image is 6000 × 3368 (20.2 MP). When using Movie live view, the camera switches its thinking and formats over to the HD world. Instead of the 3:2 aspect ratio used by Live view photography mode, the still image from Movie live view uses a 16:9 ratio. It is still a fully usable image at 20.2 MP. The ratio matches the look of an HDTV (16:9) instead of a normal picture format. You could use this mode for still images when you know the pictures will be displayed on an HDTV because it will match the HD ratio without the blank space on the sides you will find when displaying a normal 3:2 image on a modern monitor. Test this for yourself on a newer LCD or LED computer monitor and you will see how much more closely the 16:9 format matches the monitor's display size. See the section **Image Area** in the chapter titled **Shooting Menu** for more detail on image aspect ratios.
- **AE/AF lock:** While the Fn button is pressed and held in Movie live view, the camera locks both the focus and exposure values.
- **AE lock only:** While the Fn button is pressed and held in Movie live view, the camera locks only the exposure values.
- **AE lock (Hold):** When you press and release the Fn button, the camera locks the exposure value. When you press and release the Fn button a second time, the camera unlocks the exposure value.
- **AF lock only:** While the Fn button is pressed and held in Movie live view, the camera locks only the focus.
- **AF-ON:** Pressing the Fn button while in Movie live view initiates autofocus. While AF-ON is enabled, you cannot use the Shutter-release button to do autofocus.
- **None:** Pressing the Fn button when in Movie live view mode does nothing.

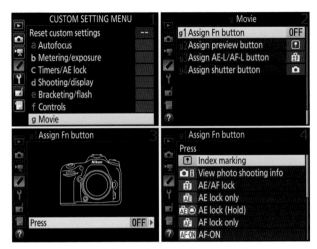

Figure 5.51 – Assign Fn button for Movie live view mode

Use these steps to assign the previously mentioned functions to the Fn button:

1. Select g Movie from the Custom Setting Menu and scroll to the right (figure 5.51, image 1).
2. Highlight g1 Assign Fn button and scroll to the right (figure 5.51, image 2).
3. Press will already be highlighted, so scroll to the right (figure 5.51, image 3).
4. Choose one of the eight selections from the list. Index marking is selected on my camera.
5. Press the OK button to lock in the setting.

Settings Recommendation: I set the Fn button to AF lock only for those times I am using autofocus during a video recording session and would like to temporarily turn AF off. The Index marking function is very useful for those who want to mark certain locations in a movie for future editing purposes. Nikon has added several new settings to the D7200 within this function, so you have a wider choice than you did with previous Nikons.

Custom Setting g2: Assign Preview Button

(User's Manual: Page 288, Menu Guide: Page 108)

Assign preview button lets you choose how the Preview (Pv) button works in Movie live view mode only. Following are the eight choices:

- **Index marking:** If you have Index marking enabled while you are recording a movie, you can set an index mark at the current frame position by pressing the Preview button. This index mark does not actually appear in the movie itself. It is, however, available when you are viewing and editing movies.

- **View photo shooting info:** This function allows you to view shooting information for still images when using Movie live view mode. Normally, the camera displays the shutter speed, aperture, and ISO sensitivity (recording information) for a potential movie at the bottom of the Monitor. When you press the Preview button, the camera displays the shutter speed, aperture, and ISO sensitivity (shooting information) for still image creation instead.
- **AE/AF lock:** While the Pv button is pressed and held in Movie live view, the camera locks both the focus and exposure values.
- **AE lock only:** While the Pv button is pressed and held in Movie live view, the camera locks only the exposure values.
- **AE lock (Hold):** When you press and release the Pv button, the camera locks the exposure value. When you press and release the Pv button a second time, the camera unlocks the exposure value.
- **AF lock only:** While the Pv button is pressed and held in Movie live view, the camera locks only the focus.
- **AF-ON:** Pressing the Fn button while in Movie live view initiates autofocus. While AF-ON is enabled you cannot use the Shutter-release button to do autofocus.
- **None:** Pressing the Fn button when in Movie live view mode does nothing.

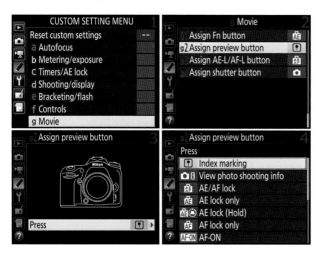

Figure 5.52 – Assign preview button for Movie live view mode

Use these steps to assign the previously mentioned functions to the Preview button:

1. Select g Movie from the Custom Setting Menu and scroll to the right (figure 5.52, image 1).
2. Highlight g2 Assign preview button and scroll to the right (figure 5.52, image 2).
3. Press will already be highlighted, so scroll to the right (figure 5.52, image 3).
4. Choose one of the selections from the list. In figure 5.52, image 3, Index marking is selected.
5. Press the OK button to lock in the setting.

Settings Recommendation: I set the Preview (Pv) button to AF lock to View photo shooting info so that I can take the 20.2 MP 16:9 ratio still images provided by Movie live view mode. I like to validate my exposure information by pressing Pv. Again, the Index marking function is very useful for those who want to mark certain locations in a movie for future editing purposes. Experiment with all eight of the available settings to choose which one works best for you.

Custom Setting g3: Assign AE-L/AF-L Button

(User's Manual: Page 288, Menu Guide: Page 108)

Assign AE-L/AF-L button lets you choose how the AE-L/AF-L button works in Movie live view mode only. Following are the eight choices:

- **Index marking:** If you have Index marking enabled while you are recording a movie, you can set an index mark at the current frame position by pressing the AE-L/AF-L button. This index mark does not actually appear in the movie itself. It is, however, available when you are viewing and editing movies.
- **View photo shooting info:** This function allows you to view shooting information for still images when using Movie live view mode. Normally, the camera displays the shutter speed, aperture, and ISO sensitivity (recording information) for a potential movie at the bottom of the Monitor. When you press the AE-L/AF-L button, the camera displays the shutter speed, aperture, and ISO sensitivity (shooting information) for still image creation instead.
- **AE/AF lock:** Enabling this function causes AE (exposure) and AF (focus) to lock on the last meter and autofocus system reading while the AE-L/AF-L button is held down.
- **AE lock only:** This allows you to lock AE (exposure) on the last meter reading when you hold down the AE-L/AF-L button.
- **AE lock (Hold):** This function causes AE (exposure) to lock on the last meter reading when the AE-L/AF-L button is pressed and released once. It stays locked until you press the AE-L/AF-L button again or the exposure meter goes off.
- **AF lock only:** This function locks the AF (focus) system on the last autofocus reading while you hold down the AE-L/AF-L button.
- **AF-ON:** Pressing the AE-L/AF-L button while in Movie live view initiates autofocus. While AF-ON is enabled, you cannot use the Shutter-release button to do autofocus.
- **None:** Pressing the AE-L/AF-L button when in Movie live view mode does nothing.

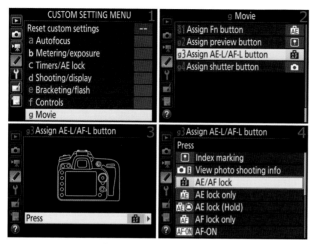

Figure 5.53 – Assign AE-L/AF-L button for Movie live view mode

Use these steps to assign the previously mentioned functions to the AE-L/AF-L button:

1. Select g Movie from the Custom Setting Menu and scroll to the right (figure 5.53, image 1).
2. Highlight g3 Assign AE-L/AF-L button and scroll to the right (figure 5.53, image 2).
3. Press will already be highlighted, so scroll to the right (figure 5.53, image 3).
4. Choose one of the eight selections from the list. In figure 5.53, image 3, AE/AF lock is selected.
5. Press the OK button to lock in the setting.

Settings Recommendation: Sometimes when you are making movies, the light will suddenly change levels drastically when the subject moves near a window or a bright lamp in the room. The surroundings will go dark, including the subject, while the camera adjusts to the much brighter light source. To prevent that from happening, it is a good idea to use AE lock (Hold). With a single touch of the AE-L/AF-L button, I can lock the camera at a correct exposure for the subject. If the subject walks in front of a bright window, the details outside the window will be blown out but the subject will still be properly exposed. The camera does not change exposure levels when a sudden bright light is temporarily introduced.

However, what if I need to walk from a dark room into a bright room, or even go outside with my subject? I simply press the AE-L/AF-L button again, allow the camera to adjust to the new light source, and then press it once more to lock the exposure again. Many videographers use a similar method. I find AE lock (Hold) to be the most useful function to assign to the AE-L/AF-L button.

Of course, since there are eight functions, you should read about each one and experiment with when and why you might use them. You will likely need all of them at one time or another.

Custom Setting g4: Assign Shutter Button

(User's Manual: Page 288, Menu Guide: Page 109)

Assign shutter button lets you choose how the Shutter-release button works in Movie live view mode only. Following are the two choices:

- **Take Photos:** If you are in the middle of recording a movie and you absolutely must have a still image of something going on in the frame, you can acquire a 16:9 aspect ratio image by pressing the Shutter-release button all the way down. The camera will stop recording the movie and take a still image with a pixel ratio of 6000 × 3368 (20.2 MP). This image will closely match the format of an HDTV and modern computer monitor, being shorter and wider than a normal 3:2 aspect ratio image.
- **Record movies:** If you are going to shoot movies for a while instead of taking still images, you can select this setting and the camera will enter Movie live view mode whenever you press the Shutter-release button halfway down. Once in Movie live view mode, you can focus by pressing the Shutter-release button halfway down again. Then press the Shutter-release button all the way down to start recording the movie. To stop recording the movie, simply press the Shutter-release button all the way down again. To stop Movie live view mode, press the Lv button. When you have this function selected, the camera behaves more like a true movie camera than a still camera. You cannot, of course, take still images when using this function because the Shutter-release button is set to enter, focus, start, and stop movie recording.

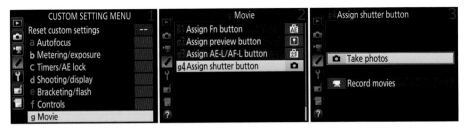

Figure 5.54 – Assign shutter button for Movie live view mode

Use these steps to assign the previously mentioned settings to the Shutter- release button:

1. Select g Movie from the Custom Setting Menu and scroll to the right (figure 5.54, image 1).
2. Choose g4 Assign shutter button and scroll to the right (figure 5.54, image 2).
3. Choose one of the two selections from the list. In figure 5.54, image 3, Take photos is selected.
4. Press the OK button to lock in the setting.

Settings Recommendation: If you use the Record movies function, the camera's brain becomes focused on recording video and turns off almost everything that has to do with still image creation. You can't take pictures, measure preset white balance, take dust off reference photos, do interval timer photography, or do most other things related to still imagery. If you think you might need to stop a movie and take a picture, don't use Record movies; use Take photos instead. You can still shoot a video, but you have the ability to stop the video and get a quick still image.

If you bought the Nikon D7200 to take advantage of its superior, clean, uncompressed, broadcast-quality video, you will most likely set the Record movies function and never look back. However, if you are like most of us and want the D7200 for both video and still images, Take photos is the best setting.

Author's Conclusion

Congratulations, you have gone through the most complex part of configuring your powerful Nikon D7200 camera. Be sure to review the information found in the section titled **The User Settings and the Custom Setting Menu,** at the beginning of this chapter. You have more than one User Setting under which you can save a completely different configuration of the Custom Menus.

Now, let's move into the next menu system—the Setup Menu—and configure the camera's basic setup. The Setup menu is very important for initial camera configuration, but only a few of its functions are used after initial setup.

06 Setup Menu

Water Running Before Lift Off © 2015 Phil Clavey (Philnblanks)

The Setup Menu contains a series of settings for basic camera configuration not directly related to taking pictures. It covers things like how bright you'd like the Monitor, battery information, firmware version, the default language, image sensor cleaning, and many other basic settings.

These menus are most likely the first you'll use when you prepare your new D7200. You'll have to set the Time zone and date, Language, and Copyright information (for embedding in images), among other things.

Following is a list of the 27 functions available in the Setup Menu:

- *Format memory card:* This function allows you to delete all images from your camera's memory card(s).
- *Save user settings:* You can configure the camera under the individual user settings U1 and U2 on the Mode dial and save the settings to internal memory. The D7200 will remember the settings and use them when you select U1 or U2.
- *Reset user settings:* If you decide to return one of your user settings (U1 or U2) back to the factory default, this function will do it for you.
- *Monitor brightness:* Choose the brightness level for the Monitor on the back of your camera.
- *Monitor color balance:* Use this function to adjust the color balance of the Monitor. You can use a reference shot taken by the camera, such as a picture of a color chart, to calibrate the Monitor's color balance.
- *Clean image sensor:* This function allows immediate cleaning of the imaging sensor to remove dust spots, or you can configure the camera to clean the sensor at startup and shutdown.
- *Lock mirror up for cleaning:* You can safely lock the mirror up and open the shutter so you can manually clean the sensor with a brush, blower, or chemicals and swabs.
- *Image Dust Off ref photo:* You can create a dust off reference photo to help remove a dust spot from images accidentally taken with some dust on the sensor. This requires the use of a program like Nikon Capture NX-D to actually remove the dust with the reference photo as a guide.
- *Flicker reduction:* If you often shoot under fluorescent or mercury-vapor lights while making a movie, this function allows you to choose a frequency that matches the local electrical power supply to reduce flickering.
- *Time zone and date:* Set the Time zone, Date and time, Date format, and Daylight saving time in your camera.
- *Language:* Choose the language you would like your camera to use from a list of 36 languages. Menus and screens will be displayed in the chosen language.
- *Auto image rotation:* This function adds camera orientation information to each image so it will display correctly on your camera's Monitor and later on your computer's monitor.
- *Battery info:* This function gives you information about the battery's current charge, the number of pictures taken with the battery on the current charge, and the useful life remaining in the battery (battery age) before you should dispose of it.

- *Image comment:* Add a comment (up to 36 characters) that embeds itself in the internal metadata of each image. This can help you protect yourself from image theft or simply add pertinent personal or location information to each image.
- *Copyright information:* You can add two items of information, including Artist (36 characters) and Copyright (54 characters). This function is designed for those who use their images commercially. It allows you to embed specific identity information into the picture's internal metadata.
- *Save/load settings:* This function allows you to save the current menu configuration of most internal camera settings to a memory card for transfer to a computer. You can back up complex configurations and restore them to the camera when needed.
- *Virtual horizon:* This function displays a horizontal virtual horizon on the camera's Monitor. This display shows tilt to the left or right. This is an excellent tool for leveling the horizon while shooting from a tripod.
- *Non-CPU lens data:* This function lets you select from a series of nine non-CPU lenses, such as AI and AI-S Nikkor lenses from the late 1970s to now. Each lens is registered within the camera with its own number so you can select it and use it later.
- *AF fine-tune:* You can fine-tune the autofocus for up to 12 of your AF-S lenses. The camera will detect which lens you have mounted and correct for front or back focus according to your settings.
- *HDMI:* You can select various HDMI sync rates for interfacing with an HDTV or monitor.
- *Location data:* If you own a GPS that can be connected to the camera—such as the Accessory-shoe mounted Nikon GP-1, GP-1A, or another GPS unit—this function allows you to record Latitude, Longitude, Altitude, Heading (with some GPS units), and UTC (Coordinated Universal Time) into the metadata of each image.
- *Wi-Fi:* Use the camera's built-in Wi-Fi and a free, downloadable smartphone or tablet app to wirelessly transfer selected images to your smart device.
- *NFC:* Allows you to start a wireless connection by touching the N-Mark logo on the handgrip of the camera to your smart device that uses NFC.
- *Network:* Allows photographers who own a Nikon UT-1 communication unit to set up a physical Ethernet network connection with the Nikon D7200 via the USB port.
- *Eye-Fi upload:* You can use an Eye-Fi Mobi SD card to transmit images from your camera to your smartphone or tablet. This item appears on the Setup menu *only* when an Eye-Fi card is inserted.
- *Conformity marking:* Allows you to view a screen displaying the worldwide standards with which the camera complies.
- *Firmware version:* Discover the current firmware version installed in your camera. Firmware is the camera's operating system software that is embedded on in-camera memory chips. It can be upgraded when Nikon releases new firmware specific to your camera.

Setup Menu Location

Figure 6.1 shows the location of the Setup Menu—the fifth menu down on the left. Its symbol is a wrench.

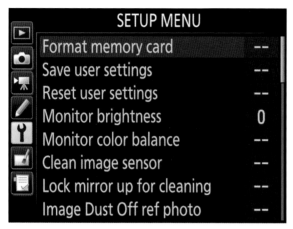

Figure 6.1 – The Setup Menu

Let's examine each of the settings on the Setup Menu in detail.

Format Memory Card

(User's Manual: Page 289, Menu Guide: 110)

Format memory card allows you to prepare your memory card(s) for use in your camera. This is the best way to prepare the memory card, and it should be done before using a new one.

Interestingly, formatting a memory card doesn't actually remove any images from the card. Instead, it removes their entries in the memory card's file allocation table (FAT) so they can no longer be seen or found by the camera. However, you could use card recovery software to rescue the images if you do not write anything new to the card after you format it. That's a good thing to remember in case you ever accidentally format a card with images you wanted to keep.

The D7200 has two memory card slots, both of which are SD/SDHC/SDXC card slots—hereafter referred to simply as SD card slots. You must format each of the SD card slots separately, using one of the two ways to format a memory card. First, you can use the *Setup Menu > Format memory card* function; second, you can use external camera controls. We'll look at both methods in this section.

Let's see how it is done with the Setup Menu by looking at the screens and steps for card formatting.

Format Memory Card Function

The first method allows you to use the Setup Menu to select a card slot for formatting. Let's see how it works.

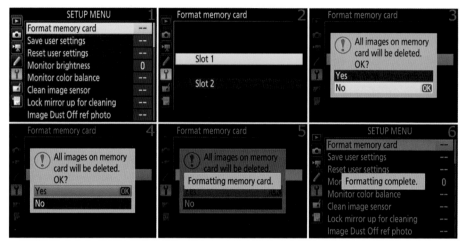

Figure 6.2A – Format memory card with Setup Menu screens

Use the following steps to format a memory card:

1. Select Format memory card from the Setup Menu and scroll to the right (figure 6.2A, image 1).
2. Next, you'll see a screen that asks you to select the card you want to format (figure 6.2A, image 2). You have a choice of Slot 1 or Slot 2. Choose the one you want to format, and scroll to the right. You'll need to repeat this action to format the second card.
3. The next screen makes it very clear with an ominous-sounding message that you are about to delete all the images on the card you have selected for formatting. The screen presents a big red exclamation point and the message *All images on memory card will be deleted. OK?* If you have decided not to format the card, just select No and press the OK button; otherwise, continue with step 4 (figure 6.2A, image 3).
4. Select Yes from the screen with the warning that all images will be deleted (figure 6.2A, image 4).
5. Press the OK button to start the format. When you press the OK button, you'll see two screens in quick succession (figure 6.2A, images 5 and 6). The first will say, *Formatting memory card.* A few seconds later—when the card has been successfully formatted— you'll briefly see a final screen that says, *Formatting complete.* Then the camera switches back to the Setup Menu's first screen. The card is now formatted and you can take lots of pictures.

Camera Button Format Method

This is the fastest method to format the memory card, and it is not very difficult. The camera defaults to formatting the primary card slot, not the secondary slot. You can select the secondary slot instead, as I'll describe in the upcoming step-by-step method. Figure 6.2B shows the buttons and Control panel screens used to format the card. Notice how the two buttons are marked with the red FORMAT symbol.

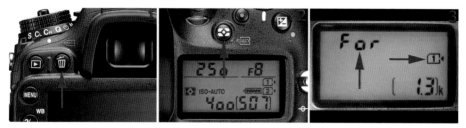

Figure 6.2B – Format memory card with camera controls

To complete the memory card formatting process, follow these steps:

1. Hold down the Delete/Format button and Metering/Format button at the same time for more than two seconds (figure 6.2B, images 1 and 2), until *For* starts flashing on the Control panel (figure 6.2B, image 3, red arrow on left).
2. While you're still holding down the two buttons and *For* is flashing, you can rotate the Main command dial with your thumb to select either Slot 1 or Slot 2 on the Control panel (screen 3, red arrow on right). It's a three-finger operation, but it's easier than it sounds. You can see in figure 6.2B, image 3, that I selected Slot 1.
3. Figure 6.2C represents the lower-right corner of the Control panel screen shown in figure 6.2B, image 3. I rotated the rear Main command dial and the Slot 2 symbol appeared below the location where the Slot 1 symbol was previously. When selected, Slot 2 is represented by a small empty rectangle. The tiny Slot 2 rectangle does not appear unless you have rotated the rear Main command dial while *For* is flashing. When you see the slot symbols exactly as shown in figure 6.2C, it means only Slot 2 is selected for formatting. Of course, if there is no SD card in Slot 2, you will

Figure 6.2C – Symbols for when Slot 2 is selected for formatting

be unable to select Slot 2 for formatting, and rotating the rear Main command dial will do nothing.
4. To actually format the selected card—once you have selected a card slot and while *For* is still flashing in the Control panel—release and instantly re-press the Delete/Format button and Metering/Format button together. You'll then see *For* showing on the Control panel where the image count normally appears (figure 6.2B, image 3 and

figure 6.2C, bottom-right corner where my camera says [1.3]k). The format operation is in process while *For* appears in the image count location, and it takes only a couple of seconds to complete. Do not turn your camera off during a card format. When *For* changes back to the image count number, the format operation is complete. You can repeat the operation for the other slot if needed.

Settings Recommendation: Both the *Setup Menu > Format memory card* and camera button format methods are easy to use. Most people learn to use the button press method because it's so fast. However, I sometimes use the *Setup Menu > Format memory card* method immediately after viewing images on the Monitor for verification of previous transfer to my computer. If it's safe to format the card, I quickly switch to the Setup Menu to format because I'm already looking at the Monitor. It's a good idea to learn how to use both methods.

Save User Settings

(User's Manual: Page 289, Menu Guide: Page 111)

Save user settings allows you to save up to two user settings. Later you can recall those settings by selecting U1 or U2 from the Mode dial. Each user setting can save certain configuration preferences, but they can't save others. The following lists include items that can and cannot be saved:

Items that can be saved
- Adjustments to one exposure mode (e.g., P, S, A, M, or SCENE) per user setting, including aperture (modes A and M), shutter speed (modes S and M), and flexible program mode (mode P*)
- Exposure and flash compensation (+/− EV settings)
- Flash mode (e.g., Fill flash, Rear-curtain sync, Slow sync, Red-eye reduction, no flash)
- Focus point (currently active AF point)
- Metering mode (e.g., Matrix meter, Spot meter)
- Autofocus modes (e.g., Single-servo autofocus, Continuous-servo autofocus, Auto-servo) in both Viewfinder and Live view photography modes
- AF-area modes (e.g., Single-point AF, Dynamic-area AF, Auto-area AF) in both Viewfinder and Live view photography modes
- Bracketing (e.g., Exposure, Flash, White balance, Active D-Lighting)
- Photo Shooting Menu (16 of 23 settings can be saved; seven settings cannot be saved [see next list])
- Movie Shooting Menu (11 of 15 settings can be saved; four settings cannot be saved [see next list])
- Custom Setting Menu (all 53 settings)
- Live view photography mode and Movie live view mode settings controlled by the Custom Setting Menu or the two Shooting Menus

Items that cannot be saved

- Release modes (S, CL, CH, Q, Qc, Self-timer, MUP)
- Reset photo shooting menu
- Reset movie shooting menu
- Storage folder (100D7200)
- Image area settings for still images or video (e.g., FX, DX)
- Manage Picture Control settings for still images or video
- Remote control mode (ML-L3) settings
- Multiple exposure settings
- Interval timer shooting settings
- Time-lapse photography settings
- Settings on other menus (i.e., Playback Menu, Setup Menu, Retouch Menu, My Menu, or Recent Settings menu)

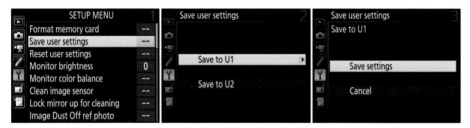

Figure 6.3 – Saving a user setting (U1 or U2)

Now, let's examine how to save a user setting. Use the following steps to save one of the two user settings (U1 and U2). This must be repeated for each of the settings:

1. Configure your camera's settings exactly how you want them to be saved for one user setting (U1 or U2). Be sure to configure all the items in the ***Items that can be saved*** list that you want to save. When you are finished, set the Mode dial to whatever shooting mode you want to use for the user setting (such as P, S, A, M, Auto, or SCENE), then save it. Do *not* select U1 or U2 on the Mode dial before you save the setting; instead, leave it set to one of the shooting modes.
2. Press the MENU button and select Save user settings from the Setup Menu, then scroll to the right (figure 6.3, image 1).
3. Choose either Save to U1 or Save to U2 from the menu and scroll to the right (figure 6.3, image 2).
4. Select Save settings from the menu (figure 6.3, image 3).
5. Press the OK button to save the selected setting.

Settings Recommendation: Anytime you make a modification to one of the two Shooting Menus or the Custom Setting Menu that you want to reuse, be sure to save it under one of the user settings. If you are making a temporary change, it isn't important to save it. The user settings will not change unless you resave them. However, if you want to save a

particular configuration for future reuse, just set the camera up the way you want to shoot and save the configuration under one of the user settings. Later, you can retrieve that configuration by simply selecting U1 or U2 on the Mode dial.

Reset User Settings

(User's Manual: Page 289, Menu Guide: Page 113)

Reset user settings allows you to reset one of the camera's user settings back to the factory defaults. The two user settings, U1 and U2, are independent of each other and must be reset individually. If you have a preowned D7200 it is a good idea to reset both of the user settings. That way, the user settings are fresh and ready to be configured for your styles of shooting. The two choices on the Reset user settings menu are Reset or Cancel.

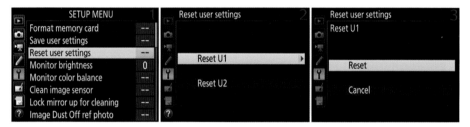

Figure 6.4 – Resetting a user setting (U1 or U2)

Here's how to reset one of your camera's user settings, either U1 or U2. Repeat these steps for each user setting:

1. Select Reset user settings from the Setup Menu and scroll to the right (figure 6.4, image 1).
2. Select either Reset U1 or Reset U2. Scroll to the right (figure 6.4, image 2).
3. Choose Reset or Cancel (figure 6.4, image 3).
4. Press the OK button to lock in your setting. If you chose Reset, the selected user setting will be reset immediately.

Settings Recommendation: If you bought a used Nikon D7200, why not reset the user settings? That way you can reconfigure the camera to your own styles of shooting. Anytime you want to start over with the Photo Shooting Menu, Movie Shooting Menu, or Custom Settings Menu, be sure to reset the user settings and resave after each reconfiguration.

Monitor Brightness

(User's Manual: Page 289, Menu Guide: Page 114)

Monitor brightness is more important than many people realize. If the Monitor is too dim, you'll have trouble seeing your images in bright light. If it is too bright, you might allow some images to be underexposed because they look fine on the Monitor. Even a seriously underexposed image may look okay on a screen that is too bright.

The D7200 allows you to adjust the brightness of the Monitor manually. You can select from 10 levels of brightness, varying from −5 to +5. If you want to adjust this frequently, just add this function to My Menu in your camera. We will discuss how to add items to My Menu in the chapter **My Menu and Recent Settings** on page 416.

Figure 6.5 – Monitor brightness level adjustment

Use the following steps to adjust the brightness of the camera Monitor:

1. Select Monitor brightness from the Setup Menu and scroll to the right (figure 6.5, image 1).
2. Use the Multi selector to scroll up or down through the values −5 to +5, scrolling to the minus side to dim the Monitor or to the plus side to brighten it (figure 6.5, image 2). Now, use the gray-level bars (dark to light) as a guide to adjust the brightness. Adjust until you can make a distinction between the last two dark bars on the left. That may be the best setting for your camera in the current ambient light. The brightness defaults to 0 (zero), which is right in the middle.
3. Press the OK button when you've found the value you like best.

Settings Recommendation: I generally leave Monitor brightness set to the zero setting unless I need the extra brightness on a sunny day. If you choose to set your camera to a level brighter than 0, be sure to check the histogram frequently to validate your exposures. Otherwise, you may find that you are mildly underexposing images because they look fine on the Monitor due to the extra brightness. That's one reason I examine the histogram often.

Some photographers run their monitor at −1 to keep the images from appearing artificially bright. This is a setting where experimentation is required. Letting the Monitor run too brightly might mask those times when the camera needs help. The bright screen can fool you. Use your histogram!

Monitor Color Balance

(User's Manual: Page 290, Menu Guide: Page 115)

Monitor color balance is a function that allows you to control the tint of the camera's Monitor. If you feel the Monitor has, let's say, a greenish tint, you can add a little bit of a complementary color to change the color to one that is more acceptable to you.

There are four color axes you can use for adjustment: green (G), amber (A), magenta (M), and blue (B). By moving the small black indicator toward a certain axis you will add a tint for that color. You can blend the colors to arrive at nearly any tint you prefer by moving the indicator between axes.

The effect is not extremely strong, so you will not make your monitor look garish with this function. However, the color tinting is strong enough that you can overcome any tint you perceive on the Monitor.

This effect does not change the color of the camera's images in any way. It only tints the color of the Monitor, allowing you to balance it against other known color sources.

In figure 6.6 there is a sample image from a normal Monitor coloration (screen 2) and four others with the tint shifted (screens 3–6).

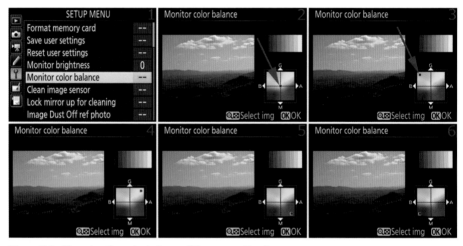

Figure 6.6 – Changing the color balance of the camera Monitor

Use the following steps to adjust the color balance of the camera's rear Monitor:

1. Select Monitor color balance from the Setup Menu and scroll to the right (figure 6.6, image 1).
2. Use the Thumbnail/Playback zoom out (ISO) button (Select img) and Multi selector to select a sample image from the SD card. At the point of the red arrow in figure 6.6, image 2, you will notice a small black square directly at the cross point of the color axes. You can move this small square directly along either of the color axis lines, or within the quadrants, as shown in screen 3 (red arrow). Notice how the small square has been moved into the corner of the quadrants in screens 3–6?

3. As you move the small black square around the color quadrants, you will see the tint of the small sample image change. Be sure you have a good sample showing on the screen so that you can choose the best balance. Maybe get an X-Rite color checker chart and take a picture of it under a neutral light source and use that picture for your sample. Remember that the ambient light will affect your perception of colors under that light, so make sure you balance the Monitor under the light source you use most often.

Note: Again, this adjustment does absolutely nothing to the picture the camera captures. It is merely for user comfort. If the memory card contains no images, a gray square will be displayed in place of the sample picture.

Settings Recommendation: Since I do not often adjust images in-camera, I will not be influenced by the way the Monitor looks. I mostly use the Monitor to make composition choices and to check the histogram. I think the Monitor on my D7200 is excellent the way it is and have no need for this Monitor color balance function.

However, if I were shooting in a studio, with carefully controlled lighting, and needed to do careful color matching for a product shot, I would be much more concerned about Monitor color balance.

Clean Image Sensor

(User's Manual: Page 290, Menu Guide: Page 116)

Clean image sensor is Nikon's helpful answer to dust spots on your images that are due to a dirty imaging sensor. Dust is everywhere and will eventually get on your camera's sensor. The D7200 cleans the sensor by vibrating the entire sensor unit. These high-frequency vibrations will hopefully dislodge dust and make it fall off the filter so you won't see it as spots on your pictures.

The vibration cleaning method seems to work pretty well. Of course, if sticky pollen, oil, or other moist dust gets onto the sensor, the vibration system won't be able to remove it. Then it will be time for wet cleaning using pads and sensor cleaning fluid.

Clean Now

Clean now allows you to clean the imaging sensor at any time. If you detect a dust spot, or just get nervous because you are in a dusty environment with your D7200, you can simply select Clean now and the camera will execute a sensor cleaning cycle.

Use the following steps to clean the camera's sensor immediately:

1. Select Clean image sensor from the Setup Menu and scroll to the right (figure 6.7A, image 1).
2. Select Clean now from the menu and press the OK button (figure 6.7A, image 2).

3. Step 2 starts the automatic cleaning process. At first the Monitor will go dark for a moment. Then a screen will appear that says, *Cleaning image sensor* (figure 6.7A, image 3). When the process is complete, another screen will appear that says, *Done* (figure 6.7A, image 4). Then the camera switches back to the Setup Menu.

Figure 6.7A – Clean now screens

Now, let's look at how to select an active method for regular sensor cleaning.

Clean at Startup/Shutdown

For preventive dust control, many people set their cameras to clean the sensor at startup, shutdown, or both. There are four selections for startup/shutdown cleaning:

- Clean at startup
- Clean at shutdown
- Clean at startup & shutdown
- Cleaning off

These settings are self-explanatory. I find it interesting that I don't detect any startup or shutdown delay when using the startup/shutdown cleaning modes. I can turn my camera on and immediately take a picture. The cleaning cycle seems to be very brief, or at least interruptible, in this mode.

Use the following steps to choose a Clean at startup/shutdown method:

1. Select Clean image sensor from the Setup Menu and then scroll to the right (figure 6.7B, image 1).
2. Choose Clean at startup/shutdown from the menu and scroll to the right (figure 6.7B, image 2).

3. Select one of the four methods shown in figure 6.7B, image 3. I chose Clean at startup & shutdown.

4. Press the OK button to lock in your choice.

Figure 6.7B – Clean at startup/shutdown screens

Nikon suggests that you hold the camera at the same angle as when you are taking pictures (bottom down) when you use these modes to clean the sensor.

Settings Recommendation: I leave my camera set to Clean at startup & shutdown. That way it will do a cleaning cycle every time I turn the camera on or off. It doesn't seem to slow down shooting; I can still turn on the camera and immediately begin taking photographs. A little sensor cleaning in this dusty world seems like a good idea to me.

Lock Mirror Up for Cleaning

(User's Manual: Page 290, Menu Guide: Page 116)

Lock mirror up for cleaning is for those times when the high-frequency vibration method of cleaning your D7200's sensor does not dislodge some stickier-than-normal dust. You may have to clean your sensor more aggressively.

In many cases, all that's needed is to remove the dust with a puff of air from a dust blower. The D7200 helps out by providing the Lock mirror up for cleaning mode so you can more safely blow a stubborn piece of dust off the sensor.

Using this function is much safer for blowing dust off the sensor because you can use both hands while battery power holds the reflex mirror up and the shutter open.

Figure 6.8A – Lock mirror up for cleaning

Use the following steps to select this mode for manual sensor cleaning (figure 6.7A):

1. Select Lock mirror up for cleaning from the Setup Menu and scroll to the right (figure 6.8A, image 1).
2. Press the OK button with Start highlighted (figure 6.8A, image 2).
3. You'll see a message screen telling you that as you press the Shutter-release button the camera will raise the mirror and open the shutter (figure 6.8A, image 3).
4. Remove the lens and press the Shutter-release button once. The sensor will now be exposed and ready for cleaning. Be careful not to let new dirt in while the sensor is open to air.
5. Clean the sensor with proper fluids and pads (e.g., Eclipse fluid and PEC*PADs).
6. Turn the camera off and put the lens back on.

Make sure you have a fresh battery in the camera because that's what holds the shutter open for cleaning. The battery must have a 60 percent or greater charge or the camera will refuse to allow you to start the process.

Settings Recommendation: You'll need a good professional sensor-cleaning blower, such as my favorite, the Giottos Rocket-air blower with a long tip for easy insertion (figure 6.8B). I bought my Rocket-air blower from the Nikonians Photo Pro Shop **(http://www.Photo-ProShop.com)**.

If an air blower fails to remove stubborn dust or pollen, you will have to either have your sensor professionally cleaned or do it yourself. Nikon states that you will void your warranty if you touch the sensor. However, many people still wet or brush clean their D7200's sensor.

If all of this makes you nervous, then send your camera off to Nikon for approved cleaning, or use a professional

Figure 6.8B – Giottos Rocket-air blower

service. Fortunately, a few puffs of air will often remove dust too stubborn for the high-frequency vibration methods. It helps to have the proper tools, such as the Giottos Rocket-air blower from the Nikonians Photo Pro Shop.

Image Dust Off Ref Photo

(User's Manual: Page 290, Menu Guide: Page 117)

You may go out and do an expensive shoot only to return and find that some dust spots have appeared in the worst possible places in your images. If you immediately create an *Image Dust Off ref photo,* you can use it to remove the dust spots from your images and then clean the camera's sensor for your next shooting session.

When you use the following instructions to create the Image Dust Off ref photo, you'll be shooting a blank, unfocused picture of a pure white or gray background. The dust spots in the image will then be readily apparent to Nikon Capture NX-D software. Yes, you must use Nikon's software to automatically batch-remove dust spots from a large number of images.

When you load the image to be cleaned into Capture NX-D, along with the Image Dust Off ref photo, the software will use the Image Dust Off ref photo to remove the spots in your production image.

The position and amount of dust on the sensor may change. You should take Image Dust Off ref photos regularly and use one that was taken within one day of the photographs you wish to clean up.

Finding a Subject for the Dust-Off Reference Photo

First, you'll need to select a featureless subject to make a photograph for the Image Dust Off ref photo. The key is to use a material that has no graininess, such as a bright, well-lit white card. I tried using plain white sheets of paper held up to a bright window, but the resulting reference photo was unsatisfactory to Capture NX-D. It gave me a message that my reference photo was too dusty when I tried to use it.

After some experimentation, I finally settled on three different subjects that seem to work well:

- A slide-viewing light table with the light turned on
- A computer monitor with a blank white word processor document
- A plain white card in the same bright light in which your subject resides

All of these were bright and featureless enough to satisfy both my camera and Capture NX-D. The key is to photograph something fairly bright, but not too bright. You may need to experiment with different subjects if you don't have a light table or computer.

Now, let's prepare the camera for the actual reference photo.

Figure 6.9A – Image Dust Off ref photo settings

Here are the steps you'll use to create an Image Dust Off ref photo:

1. Select Image Dust Off ref photo from the Setup Menu and scroll to the right (figure 6.9A, image 1).

2. Choose Start and press the OK button (figure 6.9A, image 2). Afterward, you'll see the characters *rEF* in the Viewfinder and on the Control panel. This simply means that the camera is ready to create the image. (**Note:** There is also a Clean sensor and then start selection. However, since I want to remove dust on current pictures, I won't use this setting. It might remove the dust bunny that is imprinted on the last 500 images I just shot! I'll clean my sensor after I get a good Image Dust Off ref photo. Choose Clean sensor and then start only if the Image Dust Off ref photo will not be used with existing images!)

3. When the camera is ready, hold the lens about 4 inches (10 cm) away from the blank subject and fire the shutter. The camera will not try to autofocus during the process, which is good because you want the lens at infinity. You are not trying to take a viewable picture; you're creating an image that shows where the dust is on the sensor. Focus is not important, and neither is minor camera shake.

4. If you try to take the picture and the subject is not bright enough, too bright, or too grainy (not featureless), you will see the screen shown in figure 6.9B. If you are having problems with too much brightness, use a gray surface instead of white. Most of the time this error is caused by insufficient light.

Figure 6.9B – Image Dust Off ref photo failure

5. If you don't see the screen in figure 6.9B and the shutter fires, you have successfully created an Image Dust Off ref photo. You will find the image shown in figure 6.9C on your camera's Monitor. A file that's approximately 12.6 MB is created on your camera's memory card with a filename extension of NDF instead of the normal NEF or JPG (an example filename is DSC_1234.NDF). This NDF file is basically a small database of the millions of clean pixels in your imaging sensor and a few dirty ones. You cannot display the Image Dust Off ref photo on your computer. It will not open in Nikon Capture NX-D or any other graphics program that I tried. It is used only as a reference by Capture NX-D when it's time to clean images.

Figure 6.9C – Successful Image Dust Off ref photo

White Card Tip

Remember, all your camera needs to create an Image Dust Off ref photo is a good look at its imaging sensor so it can map the dust spots into an NDF file (ref photo file). If you get the warning screen shown in figure 6.9B that says exposure settings are not appropriate, change the exposure settings and try again with a nice bright, clean, white surface. Put the lens very close to the surface, and make sure it is not in focus. Nikon recommends less than 4 inches (10 cm). You might even want to manually set the lens to infinity if you are having problems with this. When you've found your favorite white or gray surface for Image Dust Off ref photos, keep it safe and use it consistently.

Using Capture NX-D to Remove Dust Spots

Copy the NDF file (figure 6.9C) from your camera's memory card to the computer folder containing the images that have dust spots on them, the ones for which you created this Image Dust Off ref photo. You can use the Image Dust Off function (figure 6.9D) in Nikon Capture NX-D to remove the dust spots from all of the images represented by the Image Dust Off ref photo.

In figure 6.9D, the red-rimmed cutout in the middle is an enlargement of the Camera and Lens Corrections window in the control bar on the right side of Capture NX-D.

Here are the steps to use the Image Dust Off functions in Nikon Capture NX-D to remove dust from a group of images, using an Image Dust Off ref photo (figure 6.9D):

1. Copy your images into a folder on your computer, along with the Image Dust Off ref photo. It is best if they are in the same folder to make sure they represent the images you recently shot. You can browse to a different folder if you want to store the dust off photo elsewhere.
2. Now, open Capture NX-D and use the folder browser on the left side of the screen to browse to the folder that contains your images and the dust off photo.
3. Press the Camera and Lens Corrections button (figure 6.9D, arrow 1) on the left side of the screen.
4. Select the image you want to process from the picture(s) shown in the center section of Nikon Capture NX-D. Wait a moment. When the software detects a dust off ref photo in the folder, the Change… button (figure 6.9D, arrow 2) will become available.
5. Click the Change… button. If there is only one dust off ref photo in the folder with the images, a query window will open with the following question: *"Do you want to use a Dust off ref photo that is in the same folder as the active image?"* If there is more than one dust off photo in the folder, Capture NX-D will show you all the dust off photos available and ask the following question: *"More than one suitable Dust off ref photos have been found. Please select the one you wish to use based on its shooting date and time."* Choose the date-and-time-stamped dust off photo you want to use. Your choices will look like this:
 2016/04/30 13:45:05 DSC_1150.NDF
 2016/04/30 15:50:10 DSC_1185.NDF

Figure 6.9D – Nikon Capture NX-D's Image Dust Off function

6. Click the Yes button and Capture NX-D will process the images in the folder against the Image Dust Off ref photo, removing the dust spots from all the images in the folder. It will take some time to process the image—the computer will show a wait indicator until the picture is processed. Capture NX-D does not inform you that it is done, but when the hourglass or other wait indicator goes away the process is complete.
7. In the text field next to the Change button, you will see the date-and-time stamp of the Image Dust Off ref photo used to correct the image. It will look like this: "2016/04/30 15:50:10."

Settings Recommendation: Nikon Capture NX-D is free, and it's a good form of insurance, even if you use it for nothing more than removing dust from your images. Whenever you find yourself out in nature or shooting in an environment that might be dusty, why not create an Image Dust Off ref photo as the last photo of the day? That dust off photo may save you a lot of dust removal work. Let Capture NX-D do it for you! Download the free Nikon Capture NX-D at the following website:

http://imaging.nikon.com/lineup/microsite/capturenxd/

If for some reason the link does not work, just Google "Download Nikon Capture NX-D" and I'm sure you will find it.

Flicker Reduction

(User's Manual: Page 290, Menu Guide: Page 119)

Flicker reduction allows you to attempt to match the camera's recording frequency to that of the local AC power supply so that when you use Live view photography or Movie live view modes under fluorescent or mercury-vapor lighting, you can minimize flickering.

Start out by trying the Auto setting to see if the camera can determine the best setting. If not, there are two things you can do. First, try using the 50 Hz and 60 Hz settings individually to see if one helps. If the subject is especially bright, which makes flicker worse, Nikon recommends closing down the aperture.

Second, use a shutter speed that is close to the frequency of the local power supply. For a 60 Hz supply, use 1/30 s, 1/60 s, or 1/125 s. For a 50 Hz supply, use 1/25 s or 1/50 s.

In some cases, flicker can be impossible to remove completely; however, these methods may help you reduce it. Let's see how to choose a Flicker reduction frequency.

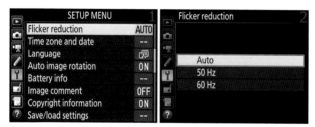

Figure 6.10 – Selecting a Flicker reduction frequency

Use the following steps to select a setting in hopes of reducing flicker:

1. Select Flicker reduction from the Setup Menu and scroll to the right (figure 6.10, image 1).
2. Choose Auto, 50 Hz, or 60 Hz from the menu (figure 6.10, image 2).
3. Press the OK button to lock in your setting.

Settings Recommendation: This function is somewhat limited because there are only two settings: 50 Hz or 60 Hz. However, it could help to control the flickering that looks like dark horizontal bands moving through the movie. Experiment to see if it helps to switch between the two settings when you detect flickering under fluorescent or mercury-vapor lighting. The best solution is to stay away from those types of lighting when shooting videos.

Time Zone and Date

(User's Manual: Page 290, Menu Guide: Page 120)

Time zone and date allows you to configure the Time zone, Date and time, Date format, and Daylight saving time for your camera.

If you haven't set the time and date, you'll see the "clock not set" icon (figure 6.11A) flashing on the Information display. In addition to the main li-ion battery pack, the camera has a built-in clock battery that is not user replaceable. The built-in battery charges itself from the main camera battery pack. If the "clock not set" icon is blinking on the Information display, it can also mean that the internal battery is exhausted and the clock has been reset.

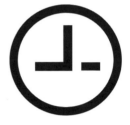

Figure 6.11A – Clock not set icon

It takes about two days of having a charged battery in the camera to fully charge the separate built-in clock battery. When the clock battery is fully charged, the clock will remain active without a main camera battery for up to three months.

Let's examine how to set the various parts of Time zone and date. You may have already done this when you first received your camera. We discussed this briefly in the first chapter.

Time Zone

The *Time zone* screen used to set the local time zone displays a familiar world map from which you will select the area of the world where you are using the camera. Figure 6.11B shows the Time zone configuration screens.

As an example, New York is in the Eastern Time zone (ET). You'll need to select your Time zone by choosing it from the map (figure 6.11B, image 3). I hope you remember your geography lessons! Fortunately, the camera displays some major city names below the Time zone map in case you don't recognize your location.

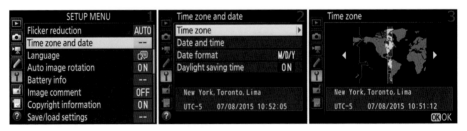

Figure 6.11B – Time zone settings

Use the following steps to set the Time zone:

1. Select Time zone and date from the Setup Menu and scroll to the right (figure 6.11B, image 1).

2. Choose Time zone from the menu and scroll to the right (figure 6.11B, image 2).
3. To set the Time zone, use the Multi Selector to scroll left or right until your location is under the vertical yellow bar or you see the nearest city marked with a small red dot (figure 6.11B, image 3).
4. Press the OK button to lock in the Time zone.

Date and Time

Figure 6.11C shows the three *Date and time* configuration screens. The final screen allows you to select the year, month, and day (Y, M, D) and the hour, minute, and second (H, M, S).

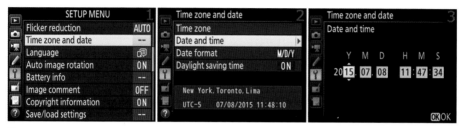

Figure 6.11C – Date and time settings

Use the following steps to set the Date and time:

1. Select Time zone and date from the Setup Menu and scroll to the right (figure 6.11C, image 1).
2. Choose Date and time from the menu and scroll to the right (figure 6.11C, image 2).
3. Using the Multi Selector, scroll left or right until you've selected the value you want to change. Then scroll up or down to change the value. The Y M D settings on the left in 6.11C, image 3, are for the year, month, and day. The H M S settings on the right are for the hour, minute, and second.
4. Press the OK button to lock in the Date and time.

Note: The international time format (ISO) is used for the time setting. To set the clock to 3 p.m., you would set the H and M settings to 15:00. Please refer to the following 12- to 24-Hour Time Conversion Chart.

12- to 24-Hour Time Conversion Chart	
A.M. Settings:	
12:00 a.m. = 00:00 (midnight)	06:00 a.m. = 06:00
01:00 a.m. = 01:00	07:00 a.m. = 07:00
02:00 a.m. = 02:00	08:00 a.m. = 08:00
03:00 a.m. = 03:00	09:00 a.m. = 09:00
04:00 a.m. = 04:00	10:00 a.m. = 10:00
05:00 a.m. = 05:00	11:00 a.m. = 11:00

P.M. Settings:

12:00 p.m. = 12:00 (noon)	06:00 p.m. = 18:00
01:00 p.m. = 13:00	07:00 p.m. = 19:00
02:00 p.m. = 14:00	08:00 p.m. = 20:00
03:00 p.m. = 15:00	09:00 p.m. = 21:00
04:00 p.m. = 16:00	10:00 p.m. = 22:00
05:00 p.m. = 17:00	11:00 p.m. = 23:00

Note: There is no 24:00 time (midnight). After 23:59 comes 00:00.

Date Format

Date format gives you three different ways to format the camera's date, as follows:
- **Y/M/D:** Year/Month/Day (2016/12/31)
- **M/D/Y:** Month/Day/Year (12/31/2016)
- **D/M/Y:** Day/Month/Year (31/12/2016)

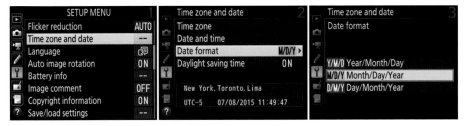

Figure 6.11D – Date format settings

Here are the steps to set the Date format:

1. Select Time zone and date from the Setup Menu and scroll to the right (figure 6.11D, image 1).
2. Choose Date format from the menu and scroll to the right (figure 6.11D, image 2).
3. Choose your favorite Date format from the menu (figure 6.11D, image 3). I selected M/D/Y Month/Day/Year.
4. Press the OK button to lock in the Date format.

Daylight Saving Time

Many areas of the world observe daylight saving time. On a specified day in spring of each year, many people set their clocks forward by one hour. Then in the fall they set them back, leading to the clever saying "spring forward, fall back."

If you set *Daylight saving time* to On, the camera will move the time forward by one hour. In the fall, you will need to remember to change this setting to Off so that the camera will move the time back by one hour. Otherwise the time stamp on your images will be off by one hour for half the year.

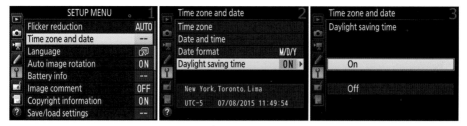

Figure 6.11E – Daylight saving time settings

Here are the steps to enable or disable Daylight saving time (figure 6.11E):

1. Select Time zone and date from the Setup Menu and scroll to the right (figure 6.11E, image 1).
2. Choose Daylight saving time from the menu and scroll to the right (figure 6.11E, image 2).
3. Figure 6.11E, image 3, shows you the two choices for Daylight saving time: On or Off. If you select On, your camera will move the time forward by one hour from its current setting. Select Off and the camera will move the time back by one hour. *This is not an automatic function!* You must remember to change the time if you are concerned with having a correct time stamp in your picture metadata. If you don't observe daylight saving time, just leave this setting set to Off and make sure the camera time matches your local time.
4. Press the OK button to lock in the setting.

Settings Recommendation: This series includes the first settings you'll modify when you get a brand-new D7200 camera. It is important that all these items are set correctly because this information is written into the metadata of each image you make. Daylight saving time is optional, but if you use it, you must remember to change it in the fall and spring of each year so your camera's time will match the local time. I have a reminder set up on my smartphone so that I won't forget. When you are setting all of your clocks and watches for the semiannual time change, just remember to set your camera's internal clock, too.

Language

(User's Manual: Page 290, Menu Guide: Page 120)

Language is a function that lets the camera know what language you prefer for the camera's menus, screens, and messages. Nikon is an international company that sells cameras and lenses around the world. For that reason, the D7200 can display its screens and menus in any one of 36 languages.

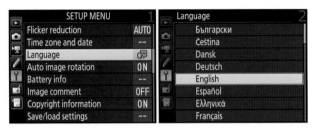

Figure 6.12 – Language selection

Use the following steps to select your preferred Language:

1. Select Language from the Setup Menu and scroll to the right (figure 6.12, image 1).
2. Choose your preferred Language (figure 6.12, image 2).
3. Press the OK button to lock in your choice.

Settings Recommendation: The camera should come preconfigured for the main language that is spoken where you live. If you prefer a different one, use this setting to select it.

Auto Image Rotation

(User's Manual: Page 290, Menu Guide: Page 121)

Auto image rotation is concerned with how vertical images are displayed on your camera's Monitor and later on your computer. Horizontal images are not affected by this setting. The camera has a direction-sensing device, so it knows how the camera was oriented when a picture was taken.

Depending on how you have Auto image rotation set, how the *Playback Menu > Rotate tall* setting is set, and the direction in which you hold your camera's hand grip, the camera will display a vertical image either as an upright portrait image, with the top of the image at the top of the Monitor, or lying on its side in a horizontal direction, with the top of the image to the left or right on the Monitor. The two selections in the menu are as follows:

• ***On:*** With Auto image rotation turned On, the camera stores orientation information within each image, primarily so the image will display correctly in computer software such as Nikon Capture NX-D, Lightroom, and Photoshop. In other words, the camera records, as part of the image metadata, whether you were holding your camera horizontally or vertically (hand grip down) or even upside-down vertically (hand grip up). The image will display in the correct orientation on your camera's Monitor only if you have *Playback Menu > Rotate tall* set to On. Auto image rotation lets the image speak for itself as to orientation, while Rotate tall lets the camera listen to the image and display it in the proper orientation.

- *Off:* If Auto image rotation is turned Off, the vertical image will be displayed as a horizontal image lying on its side in your computer software. The top of the image will be on the left or right according to how you held the hand grip—up or down—when you took the picture. The camera does not record orientation information in the image metadata. It will display images horizontally even if you have the *Playback Menu > Rotate tall* function set to On.

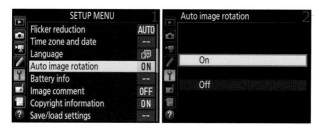

Figure 6.13 – Auto image rotation settings

Use the following steps to set the Auto image rotation function:

1. Select Auto image rotation from the Setup Menu and scroll to the right (figure 6.13, image 1).
2. Choose On or Off from the menu (figure 6.13, image 2).
3. Press the OK button to lock in your selection.

If you're shooting in one of the Continuous frame advance modes (CL or CH), the position in which you hold your camera for the first shot sets the direction in which images are displayed.

Settings Recommendation: If you want your images to be displayed correctly on your camera's Monitor and in your computer, you need to be sure that Auto image rotation is set to On. I always keep mine set that way.

Battery Info

(User's Manual: Page 291, Menu Guide: Page 122)

The *Battery info* screen (figure 6.14A, image 2) will let you know how much battery charge has been used (Charge), how many images have been taken with this battery since the last charge (No. of shots), and how much life the battery has before it will no longer hold a good charge (Battery age).

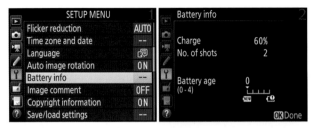

Figure 6.14A – Battery info screen

Here are the steps to examine the Battery info:

1. Select Battery info from the Setup Menu and scroll to the right (figure 6.14A, image 1).
2. The next screen is the Battery info screen. It is just for information, so there's nothing to set (figure 6.14A, image 2).
3. When you've finished examining your camera's Battery info, press the OK button to exit.

The D7200 goes a step further than some cameras. Not only does it inform you of the amount of charge left in your battery, it also lets you know how much life is left. After some time, all batteries weaken and won't hold a full charge. The Battery age meter will tell you when the battery needs to be completely replaced. It shows five stages of battery life, from 0 to 4, so you'll be prepared to replace the battery before it gets too old to take many shots.

Battery Info When Using an MB-D15 Battery Pack

If you are using a battery in your MB-D15 battery pack in addition to the one in the camera, the Battery info screen will display as a split screen.

The left side of the screen shows information for the battery in the camera, and the right side shows information for the battery in the MB-D15 battery pack (figure 6.14B).

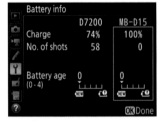

Figure 6.14B – Battery info screen with MB-D12 mounted

Settings Recommendation: It's important to use Nikon brand batteries in your D7200 so they will work properly with the camera. Aftermarket batteries may not charge correctly in the D7200 battery charger. In addition, they may not report correct Battery age information. There may be an aftermarket brand that works correctly, but I haven't found it. Instead, I use the batteries designed by Nikon to work with this camera. I am a bit afraid to trust a camera that costs this much to a cheap aftermarket battery of unknown origin.

Image Comment

(User's Manual: Page 291, Menu Guide: Page 123)

Image comment is a useful setting that allows you to attach a 36-character comment to each image you shoot. The comment is embedded in the picture's internal metadata and does not show up on the image itself. I attach the comment "Photo by Darrell Young" to my images.

You could include information containing your copyright here even though the camera has a place to put Copyright information (next section).

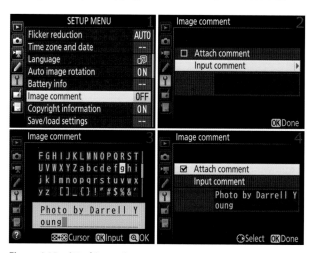

Figure 6.15 – Attaching an Image comment

Use the following steps to create an Image comment:

1. Select Image comment from the Setup Menu and scroll to the right (figure 6.15, image 1).
2. Select Input comment from the menu and scroll to the right (figure 6.15, image 2).
3. In figure 6.15, image 3, you'll see a series of letters, numbers, and symbols on top and a rectangle with tiny lines in the gray area at the bottom. Add your Image comment text there, up to 36 characters. The camera will attach the text in the comment field to the image. There is a blank spot just after the lowercase z, which represents a blank space that you can insert in the line of text. Notice that lowercase letters follow the uppercase letters. Use the Multi Selector to scroll through the numbers and letters to find the characters you want to use, and press the OK button to insert a character. If you make a mistake, hold down the checkered Thumbnail/Playback zoom out (ISO) button while using the Multi Selector to move to the position of the error. Push the Delete button and the character will disappear.
4. Press the Playback zoom in button when you are finished entering the comment.

5. The camera will switch back to the Image comment screen (figure 6.15, image 4). You need to put a check mark in the Attach comment check box so the comment will attach itself to each image. To check the box, highlight the Attach comment line and scroll to the right with the Multi selector to place a check mark in the box.

6. Press the OK button to save the new comment.

Settings Recommendation: You can use this comment field for any text you want to add to the internal metadata of the image (up to 36 characters). There is another Setup Menu selection called Copyright information (next section) that allows you to add your personal copyright. I added basic "who took it" information here because I am worried about image theft. You may want to add other text—since the camera provides a specific Copyright information screen—such as information to identify the shoot. Remember, you are limited to 36 characters in the comment.

Copyright Information

(User's Manual: Page 291, Menu Guide: Page 124)

Copyright information allows you to embed Artist and Copyright data into each image. Refer to figure 6.16 and use the following steps to add personal information to your camera. Your Artist name and Copyright information will then be written into the metadata of each of your images.

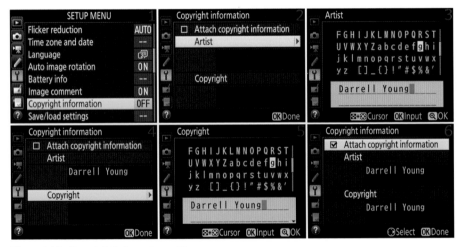

Figure 6.16 – Copyright information settings

Here are the steps to enter your Artist and Copyright information:

1. Select Copyright information from the Setup Menu and scroll to the right (figure 6.16, image 1).

2. Scroll down to Artist and scroll to the right (figure 6.16, image 2).

3. You'll now see the Artist data input screen with all the available characters to choose from (figure 6.16, image 3). Add your name here, with a maximum of 36 characters. Use the Multi Selector to scroll around within the characters. Lowercase characters follow the uppercase letters. Select a character by pressing the OK button. Correct errors within the text you've already entered by holding down the Thumbnail/Playback zoom out (ISO) button and scrolling left or right with the Multi Selector. Remove a character that's already in the name area by scrolling to it and pressing the garbage can Delete button. Press the Playback zoom in button when you have entered your name.

4. Now scroll down to the Copyright line on the Copyright information screen and scroll to the right (figure 6.16, image 4).

5. Add your name using the method and controls described in step 3 (figure 6.16, image 5).

6. Scroll up to the Attach copyright information line (figure 6.16, image 6). Initially there will be no check mark in the little box. You need to place one there. Scroll to the right with the Multi selector and you'll see a tiny check mark appear in the box.

7. Press the OK button to save your Artist and Copyright information.

Settings Recommendation: Be sure to add your name in both the Artist and Copyright sections of this function. With so much intellectual property theft going on these days, it's a good idea to identify each of your images as your own. Otherwise, you may post an image on Flickr or Facebook to share with friends and later find it on a billboard along the highway. With the Artist and Copyright information embedded in the image metadata, you will be able to prove that the image is yours and charge the infringer.

Embedding your personal information is not a foolproof way to identify your images because unscrupulous people may steal them and strip the metadata out of them. However, if you do find one of your images on the front page of a magazine or on someone's website, you can at least prove that you took the image and have some legal recourse under the Digital Millennium Copyright Act (DMCA). When you've taken a picture, you own the copyright to that image. You must be able to prove you took it. This is one convenient way.

You'll have even more power to protect yourself if you register your images with the U.S. Copyright office at the following web address: **http://copyright.gov/eco/**.

If you sell your camera, or loan it to someone, be sure to remove the Artist and Copyright information to prevent misuse of your name.

Save/Load Settings

(User's Manual: Page 291, Menu Guide: Page 125)

Do you have your D7200 set up exactly the way you like it? Have you spent hours and hours reading this book and the User's Manual, or simply exploring menus, and finally got all the settings in place? Are you worried that you might accidentally reset your camera or that it could lose its settings in one way or another? Well, worry no more! *Save/load settings* writes configuration settings to the memory card, allowing you to back up camera settings to your computer.

When you have your camera configured to your liking, or at any time during the process, simply use the Save/load settings function to save the camera configuration to your memory card. It creates a 17-KB file named NCSETUPG.BIN in the root directory of your memory card. You can then save that file to your computer's hard drive and have a backup of your camera settings.

Figure 6.17 – Save/load settings

Here are the steps to save or load the camera's settings:

1. Choose Save/load settings from the Setup Menu and scroll to the right (figure 6.17, image 1).
2. Select Save settings or Load settings from the Save/load settings menu, and then follow one of these two easy procedures (figure 6.17, image 2):
 a. **Save settings:** Select Save settings and press the OK button. Your most important camera settings will be saved to your memory card. Afterward, copy the settings file (NCSETUPG.BIN) to your computer for safekeeping. **Warning:** You may notice in the screen display in figure 6.17, image 2, that the Load settings selection is grayed out on your camera. If Load settings is not grayed out when you get ready to save the settings, be careful—you are about to overwrite previously saved settings that are currently on the memory card. The only time you'll see Load settings not grayed out is when an NCSETUPH.BIN file already exists on the memory card.
 b. **Load settings:** Insert a memory card with a previously saved NCSETUPH.BIN file in the card's root directory, select Load settings, and press the OK button. The settings you previously saved will be reloaded into the D7200 and will overwrite your current settings without prompting you for permission, so be sure that you are ready to have the settings overwritten. If you change the name of the NCSETUPH.BIN file, the D7200 will not be able to reload your settings.

Here is a list of settings that are saved or loaded when you make use of one of these functions. It doesn't save or load every setting in the D7200, only the ones listed here:

Playback Menu
- Playback display options
- Image review
- After delete
- Rotate tall

Photo Shooting Menu
- File naming
- Role played by card in Slot 2
- Image quality
- Image area
- JPEG compression
- NEF (RAW) recording
- White balance (includes fine-tuning adjustments and presets d-1 to d-6)
- Set Picture Control (Custom Picture Controls are saved as Standard)
- Color space
- Active D-Lighting
- Vignette control
- Auto distortion control
- Long exposure NR
- High ISO NR
- ISO sensitivity settings
- Remote control mode (ML-L3)

Movie Shooting Menu
- Destination
- Frame size/frame rate
- Movie quality
- Microphone sensitivity
- Frequency response
- Wind noise reduction
- Image area
- White balance (includes fine-tuning adjustments and presets d-1 to d-6)
- Set Picture Control (Custom Picture Controls are saved as Standard)
- High ISO NR
- Movie ISO sensitivity settings

Custom Settings
- All Custom Settings (except Reset custom settings)

Setup Menu
- Clean image sensor
- Flicker reduction
- Time zone and date (except Date and time)
- Language
- Auto image rotation
- Image comment
- Copyright information
- Non-CPU lens data

- HDMI
- Location data
- NFC
- Eye-Fi upload

My Menu and Recent Settings
- My Menu (includes all items you've entered)
- All Recent Settings
- Choose tab

Settings Recommendation: This function is a great idea. After using my camera for a few days and getting it set up just right, I save the settings file to my computer for safekeeping. Later, if I change things extensively for some reason and then want to reload my original settings, I just put the backed-up settings file on a memory card, pop it into the camera, select Load settings, and I'm back in business.

Virtual Horizon

(User's Manual: Page 291, Menu Guide: Page 128)

Virtual horizon is a function that allows you to level your camera when it's on a tripod. This particular Virtual horizon function is not for Live view photography or Movie live view still image or video use. All this function does is bring up a horizontal-only Virtual horizon indicator on the camera's Monitor so that you can use it to help level your camera to the horizon. Let's see how to use the convenient Virtual horizon to horizontally level your camera.

Figure 6.18A – Virtual horizon

Here are the steps to use the Virtual horizon:

1. Choose Virtual horizon from the Setup Menu and scroll to the right (figure 6.18A, image 1).
2. The next two screens (figure 6.18A, images 2 and 3) show the Virtual horizon indicator. You can use it to level the camera on your tripod or even handheld if you would like. The indicator shows left and right tilts. Figure 6.18A, image 2, indicates that the camera is tilted to the right. Image 3 shows that the camera is level.

Live View Virtual Horizon

The Live view photography and Movie live view modes have a similar, translucent version of this Virtual horizon that you can see through during live usage (figure 6.18B).

Once you enter either Live view photography or Movie live view mode, the Live view Virtual horizon is available by pressing the info button repeatedly until it shows up as one of several overlays available in either of those Live view modes.

Figure 6.18B – Live view Virtual horizon

Viewfinder Virtual Horizon

Although not directly related to the graphical Virtual horizon function for the camera's Monitor, there is another function called *Viewfinder virtual horizon* that is available to you. You can use it to see a somewhat different-looking Virtual horizon indicator in the camera's Viewfinder by assigning one of the assignable buttons to Viewfinder virtual horizon. Let's use the Fn button as an example. We covered how to assign different functionality to the Fn button in the chapter **Custom Setting Menu** in the section **Custom Setting f2: Assign Fn button**.

If you go to *Custom Setting Menu > f Controls > f2 Assign Fn button > Press* and choose Viewfinder virtual horizon, you will see another type of Virtual horizon on the bottom of your camera's Viewfinder when you press the button you've assigned it to (figure 6.18C, red arrows). If you prefer not to assign the Viewfinder virtual horizon to the Fn button, you can assign it to other buttons instead (e.g., Preview button).

Figure 6.18C – Viewfinder virtual horizon

The Viewfinder virtual horizon location is seen in figure 6.18C, with the camera held in both horizontal and vertical positions. Once it's assigned to a button, you can activate the Viewfinder virtual horizon with a press of that button. When it shows in the Viewfinder, it will register left and right tilt, by changing the look of the indicators at the red arrows' tips. The Viewfinder on the left is in the horizontal position, while the one on the right is in the vertical position. The Viewfinder virtual horizon moves to the correct orientation based on how the camera is held.

Settings Recommendation: This is a very convenient function because it allows me to level my camera when I am using a tripod without breaking out the old Accessory-shoe bubble level. I suggest adding this function to the My Menu section of your camera. That way, you will have it available whenever you want to use it, without digging through menus to find it. We will discuss how to add items to My Menu in the chapter titled **My Menu and Recent Settings**.

Non-CPU Lens Data

(User's Manual: Page 291, Menu Guide: Page 129)

Non-CPU lens data helps you use older non-CPU Nikkor lenses with your camera. Do you still have several older AI or AI-S Nikkor lenses? I do! The image quality from the older manual-focus (MF) lenses is excellent.

Since the D7200 is positioned as an advanced enthusiast's camera, it must have the necessary controls to use both auto focus (AF) and manual focus (MF) lenses. Many photographers on a budget use the older MF lenses to obtain professional-level image quality without having to break the bank on expensive lens purchases. You can buy excellent AI and AI-S Nikkor lenses on eBay for US$100–$300 and have image quality that only the most expensive zoom lenses can produce.

Lens manufacturers like Zeiss and Nikkor are still making MF lenses, and because some of them do not have a CPU (electronic chip) that communicates with the camera, it's important to have a way to let the D7200 know something about the lens in use.

This Non-CPU lens data function allows you to do exactly that. You can store information for up to nine separate non-CPU lenses within this section of the D7200.

Here is a detailed analysis of the Non-CPU lens data screen selections (figure 6.19A, image 2):

- **Lens number:** Using the Multi Selector, you can scroll left or right to select one of your lenses. There are nine lens records available. When you select a Lens number here, the focal length and maximum aperture of that lens will show up in the Focal length and Maximum aperture fields. If you haven't stored information for a particular Lens number, you'll see double dashes (– –) in the Focal length and Maximum aperture fields.
- **Focal length (mm):** This field contains the actual focal length in millimeters (mm) of the lens in use. You can select focal lengths from 6mm to 4000mm. Hmm, I didn't know they even made a 4000mm lens. I want one!
- **Maximum aperture:** This field is for the Maximum aperture of the lens. You can enter an f-stop number from F1.2 to F22. Remember, this is for the maximum aperture only (largest opening or f-stop). When you've entered a maximum aperture, the camera will be able to determine the other apertures by your use of the aperture ring on the lens. (Remember those?)

Figure 6.19A – Non-CPU lens data

Use the following steps to configure (save) each of your non-CPU lenses for use with your camera:

1. Select Non-CPU lens data from the Setup Menu and scroll to the right (figure 6.19A, image 1).
2. Choose Lens number and scroll left or right until you find the number (1–9) you want to use for this particular lens (figure 6.19A, image 2).
3. Scroll down to Focal length (mm) and scroll left or right to select the focal length of the lens. If you are configuring a non-CPU zoom lens, select the widest setting. This works because the meter will adjust for any light falloff that may occur as the lens is zoomed out.
4. Scroll down to Maximum aperture and scroll left or right to select the maximum aperture of the lens. If you are configuring a variable-aperture zoom lens, select the largest aperture the lens can use. This works because the meter will adjust for the variation in the aperture.
5. Press the OK button to store the setting.

The screen shown in figure 6.19A, image 2, allows you to either select a lens or save changes to any of your non-CPU lenses. In other words, you can use the set of screens in figure 6.19A to input information about the lens and/or select a lens.

When you have selected a lens for use, the *Setup Menu > Non-CPU lens data* selection will show the number of the lens you've selected. It will be in the format of No. 1 to No. 9. In figure 6.19A, image 1, you can see the lens selection (No. 1) at the end of the Non-CPU lens data line. That's my beloved AI Nikkor 35mm f/2 lens!

Selecting a Non-CPU Lens with External Camera Controls

The D7200 allows you to customize its buttons to do things the way you want them to be done. You may have only one or two non-CPU lenses, so it may be sufficient to use the Non-CPU lens data menu to select a lens. However, if you have a large selection of non-CPU lenses, you may wish Nikon had provided more than nine lens selections in the Non-CPU lens data menu.

Since I use several older manual-focus AI Nikkor lenses, I use the Custom Setting Menu's assign button functions to assign *Custom Setting Menu > f Controls > f2 Assign Fn button*

> *Press + command dials* to the Choose non-CPU lens number setting, for selecting Non-CPU lens data on the fly. Then I can simply hold down the Fn button and turn either of the Command dials to select one of the nine non-CPU lenses I have already registered with the camera.

Here are the steps to select a non-CPU lens using external camera controls, after making an assignment to one of the camera's buttons (e.g., Fn button):

1. On the bottom right of figure 6.19B, you will see n–1. That is where you choose the actual lens by its assigned number. You'll see n–1 to n–9 scroll by as you rotate whichever Command dial is most convenient to you.
2. In figure 6.19B, the number in the top center applies to the focal length of the currently selected lens, in this case, 35 (35mm).
3. The number on the top right of figure 6.19B shows the maximum aperture of the currently selected non-CPU lens (F2).

Figure 6.19B – Non-CPU lens data with external controls

4. Hold down the button you've assigned (I use Fn) and turn a Command dial until the number of your lens appears (n–1 to n–9), and then release the button. Now your camera knows which lens is mounted.

This is a really quick way to change the camera's Non-CPU lens data settings after you mount a different non-CPU lens.

Settings Recommendation: I like using the *f2 Assign Fn button > Press + command dial > Choose non-CPU lens number* setting to select my non-CPU lenses. This is very fast and easy in the field. Or, you can simply use the *Setup Menu > Non-CPU lens data* function to select a lens with menus. Play with both and learn how to use each. They'll both come in handy at different times.

AF Fine-Tune

(User's Manual: Page 292, Menu Guide: Page 130)

One thing that impresses me about the D7200 is its ability to be fine-tuned in critical areas like metering and autofocus (AF). With many older cameras, if an AF lens had a back focus problem, you just had to tolerate it or send it off to be fixed. Now, with *AF fine-tune,* you can adjust your camera so the lens focuses where you want it to focus.

Nikon has made provisions for keeping a table of up to 12 lenses you have fine-tuned for better focus. The idea behind fine-tuning is that you can push the focus forward or backward in small increments, with up to 20 increments in each direction.

When the little round, green AF indicator comes on in your camera's Viewfinder and AF fine-tune is enabled for a lens you've already configured, the actual focus is moved from its default position forward or backward by the amount you've specified. If your lens has a back focus problem and you move the focus a little forward, the problem is solved for that lens. Each of your AF lenses can be fine-tuned individually.

There are four selections on the AF fine-tune menu:

- AF fine-tune (On/Off)
- Saved value
- Default
- List saved values

Figure 6.20A – Fine-tuning the focus of a lens

Use the following steps to start the process of fine-tuning a lens (figure 6.20A):

1. Choose AF fine-tune from the Setup Menu and scroll to the right (figure 6.20A, image 1).
2. Select AF fine-tune (On/Off) from the menu and scroll to the right (figure 6.20A, image 2).
3. The next four subsections show the screens to configure AF fine-tune (figures 6.20B to 6.20E). Each of the following figures continues where figure 6.20A, image 2, left off.

AF Fine-Tune (On/Off)

Figure 6.20B shows the AF fine-tune (On/Off) screen and its selections. The two values you can select are as follows:

- **On:** This setting turns the AF fine-tune system on. Without this setting enabled (On), the D7200 focuses like a factory default D7200. Set AF fine-tune (On/Off) to On if you are planning to fine-tune a lens now. Press the OK button to save the value.
- **Off:** This default setting disables the AF fine-tune system.

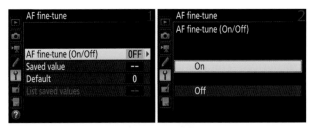

Figure 6.20B – Enabling or disabling AF fine-tune

Saved Value

With an autofocus lens mounted, *Saved value* allows you to control the amount of front or back focus fine-tuning you would like to input for the listed lens. At the top left of figure 6.20C, image 2, just under the words Saved value, you'll see the focal length of the lens that is mounted on your camera (mine is 50mm), the maximum aperture (mine is F1.4), and the number assigned to the lens (NO. – –).

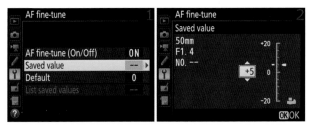

Figure 6.20C – Fine-tuning a lens with a Saved value

If you are configuring a lens for the first time, you'll see NO. – – at the location under the aperture number (figure 6.20C, image 2). You can fine-tune a maximum of 12 lenses. After you save a lens configuration, a number will appear in place of the dashes (No. 1 to No. 12).

To the right of the lens information in figure 6.20C, image 2, is a scale that runs from +20 on the top to –20 on the bottom. The yellow pointer on the right starts out at 0. You can move this yellow pointer up or down to change the amount of focus fine-tuning you need for this lens. Moving the pointer up on the scale pushes the focal point away from the camera, and moving it down pulls the focal point toward the camera. I set my 50mm F1.4 lens to +5 forward focus, as shown in figure 6.20C, image 2. When you set the fine-tuning amount you need, press the OK button to save the setting.

Default

The *Default* configuration screen looks a lot like the Saved value screen, except there is no lens information listed. This Default value will be applied to *all* AF lenses you mount on your camera. If you are convinced that your particular camera (not a lens) always has a back or front focus problem and you are not able or ready to ship it off to Nikon for repair, you can use the Default value to push the autofocus in one direction or the other until you are

satisfied that your camera is focusing the way you'd like. *Again, this will affect all autofocus lenses you mount on your camera.*

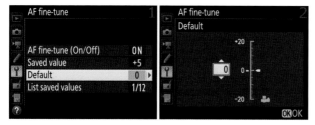

Figure 6.20D – Setting a Default fine-tune adjustment for all lenses

As shown in figure 6.20D, image 2, to set an *AF fine-tune > Default,* use the scale that runs from +20 on the top to −20 on the bottom. The yellow pointer starts at 0. You can move this yellow pointer up or down to change the amount of focus fine-tuning you need for whatever lens you currently have on the D7200 if no value already exists in the Saved value for the lens. Moving the pointer up on the scale pushes the focal point away from the camera (front focus), and moving it down pulls the focal point toward the camera (back focus). When you are done, press the OK button.

Note: You could use this Default value as a value for any of your AF lenses that do not have a Saved value. I tested this with a different lens (not shown) by setting a Saved value of +1 for my AF-S Nikkor 24–120mm lens. While the 24–120mm lens was still mounted, I set a value of −2 for the Default value. When I removed the 24–120mm lens and mounted an AF Nikkor 60mm micro lens, the +1 in the Saved value field disappeared, but the −2 in the Default field stayed put. Therefore, you can use the Default field either for all AF lenses that have no Saved value or for a currently mounted AF lens that you want to adjust but not save a value for.

List Saved Values

Notice in figure 6.20E that there are several screens used to configure the list of saved values. *List saved values* helps you remember which lenses you've fine-tuned. It also allows you to set an identification number (00–99) for a particular lens out of the 12 lenses you can register.

To the right of List saved values in figure 6.20E, image 1, you can see that I have assigned fine-tuning values to three of my 12 available lens values (3/12). In image 2, you'll see several of my lenses listed. Many people use the last two digits of the lens's serial number as the List saved values number for that lens. Alternatively, you can select a sequential number from 00–99. This screen will show a list of all lenses for which you have saved values.

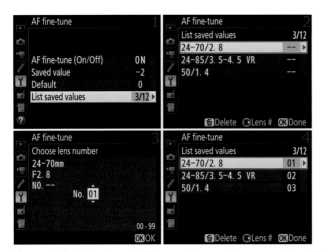

Figure 6.20E – Assigning an AF fine-tune lens number to one of your 20 lenses

However, in figure 6.20E, image 2, notice that I have not yet assigned any numerical value to any of the three lenses listed. You will see – – to the right of each list item when no identifying numerical value has been assigned to that lens.

In figure 6.20E, image 3, there is a little yellow box in the middle, after No., in which you can scroll up or down with the Multi Selector and select from 00–99. My camera has No. 01 selected. You can set whatever number you want to use from 00 to 99 for each particular lens. Press the OK button to save the numerical value for that lens and the camera will recognize the lens when you mount it, applying whatever fine-tuning value (+20 to −20) you previously set (see figure 6.20D).

In figure 6.20E, image 4, you can see that I have now assigned identifying numerical values to each of my fine-tuned lenses (01, 02, and 03).

Note: With AF fine-tune enabled, the lens may not be able to focus at the minimum focus distance or at infinity. Test this carefully!

Fine-tuning is not applied to any lenses when you're using Live view photography mode. If you use teleconverters, you will need to store a value for the lens itself and the lens with the teleconverter mounted.

Settings Recommendation: AF fine-tune is good to have. If I buy a new lens and it has focus problems, I don't keep it. Back it goes to the manufacturer for a replacement. However, if I buy a used lens or have had one long enough to go out of warranty and it later develops front or back focus problems, the camera allows me to fine-tune the autofocus for that lens. An advanced-enthusiast level camera has these little necessities to keep you out of trouble when shooting commercially.

HDMI

(User's Manual: Page 292, Menu Guide: Page 132)

HDMI (high-definition multimedia interface) allows you to display your images and video on a high-definition television (HDTV), external video monitor, or computer monitor with an HDMI connection. You can also use the HDMI port to stream clean, uncompressed, broadcast-quality video to an external video recording device, such as one of the recorders found on **www.Atomos.com** (my favorite is the Ninja Blade).

You'll need an *HDMI Type-A to HDMI Type-C cable,* which is not included with the camera but is available from many electronics stores. This cable is also known as a *mini-HDMI to HDMI A/V HD cable.*

Figure 6.21A gives you a close up look at both ends of the cable. The smaller end (mini-HDMI Type-C) goes into the HDMI port under the rubber flap on your camera, and the other end (HDMI Type-A) plugs into your HD device (e.g., external video recorder or HDTV). The HDMI setting has three options: Output resolution, Device control, and Advanced, which we'll discuss next.

Figure 6.21A – HDMI cable-end types

Output Resolution

You can select one of the following formats for output to your HDMI device:

- *Auto (default):* This allows the camera to select the most appropriate format for displaying your image on the currently connected device
- *1080p (progressive):* 1920 × 1080 progressive format
- *1080i (interlaced):* 1920 × 1080 interlaced format
- *720p (progressive):* 1280 × 720 progressive format
- *576p (progressive):* 720 × 576 progressive format
- *480p (progressive):* 640 × 480 progressive format

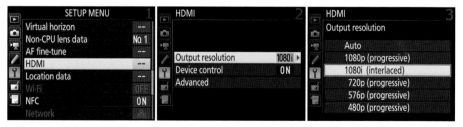

Figure 6.21B – Selecting an HDMI Output resolution

Use the following steps to select an Output resolution:

1. Select HDMI from the Setup Menu and scroll to the right (figure 6.21B, image 1).
2. Choose Output resolution from the menu and scroll to the right (figure 6.21B, image 2).

3. Select one of the five output resolutions (figure 6.21B, image 3) or Auto. I chose 1080i (interlaced) as an example. You might want to try Auto at first to see if the camera and display device will interface by themselves. If not, read the user's manual for the display device to find out what output resolution works best with it. Set the camera accordingly.
4. Press the OK button to lock in your selection.

Device Control

Select one of the two settings that affect how you will control your HDMI device:

- **On:** When you connect your camera to a television that supports HDMI-CEC, a simple display will appear on the screen of your HDMI device (e.g., play or slide show). When you see this display you can use your TV remote to control the camera's available operations for that HDMI connection.
- **Off:** You must use the Multi selector to control the image display on the TV.

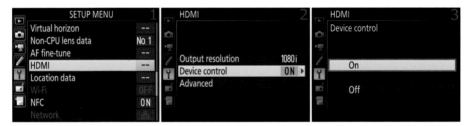

Figure 6.21C – Enable or disable Device control for HDMI-CEC

Use the following steps to enable or disable Device control:

1. Select HDMI from the Setup Menu and scroll to the right (figure 6.21C, image 1).
2. Choose Device control from the menu and scroll to the right (figure 6.21C, image 2).
3. Select On or Off from the menu (figure 6.21C, image 3).
4. Press the OK button to lock in your selection.

Advanced

With the large variety of display and recording devices available, your camera has to deal with all sorts of video standards. Here is a brief list of the controls available for modifying the HDMI video output:

- **Output range** controls how color is displayed on the receiving device. You can limit the RGB video output to a Limited range of 16 to 235, or a Full range of 0 to 255.

- *Output display size* sets frame coverage for horizontal and vertical output. Your choices are 95% or 100%. This allows you to fit the video display on monitors with a reduced display area, or a full display area.
- *Live view on-screen display* controls whether the camera outputs clean HDMI video or video with the shooting information overlaid on the video signal (e.g., aperture, shutter speed, ISO).
- *Dual Monitor* allows you to mirror the video stream from the HDMI port on the camera's Monitor, in addition to an external monitor. This uses more battery power but gives you dual monitors.

Let's examine each setting on the Advanced menu in more detail.

Figure 6.21D – Using Advanced HDMI settings

Use the following steps to open the Advanced menu:

1. Select HDMI from the Setup Menu and scroll to the right (figure 6.21D, image 1).
2. Choose Advanced from the menu and scroll to the right (figure 6.21D, image 2).
3. Select one of the four settings from the Advanced menu and scroll to the right (figure 6.21D, image 3).
4. Refer to figures 6.21E through 6.21H for details on the configuration of each item.

Output Range

Output range allows you to adjust the level of colors sent to a recording or display device. When you are outputting video to a device, such as an HDTV or recorder, the device may not accept normal *Full range* RGB with a color range of 0 to 255 correctly. Some devices accept only *Limited range* RGB input in the range of 16 to 235 color levels (YCbCr). If you try to send Full range RGB video output to a Limited range YCbCr device, you may end up with washed-out, grayish blacks and blown-out, featureless whites.

The solution is to match the correct output to the correct device type. If you see the problems just described when the camera is set to Full range (RGB), try the Limited range (YCbCr) setting instead. Or, you could try the Auto setting to see if the camera can detect what the display or recording device requires.

Again, we will discuss this in deeper detail in the upcoming chapter **Movie Live View**.

Figure 6.21E – Selecting an Output range

Use the following steps to select Full range or Limited range output (figure 6.21E continues from figure 6.21D):

1. Select Output range from the Advanced menu and scroll to the right (figure 6.21E, image 1).
2. Select Auto, Limited range, or Full range from the Output range menu. Auto (factory default) is selected in figure 6.21E, image 2.
3. Press the OK button to select the Output range.

Output Display Size

At times, the *Output display size* may not match the display device well. In that case, you can reduce the Output display size from 100% to 95%, to help the display fit better. I plugged my camera into a Vizio 32-inch HDTV and found that the output from the camera on the TV was a little bit too tall. I changed Output display size to 95% and it fit perfectly.

You can do this while viewing the live output on the HDTV by using the following steps. Let's see how to modify the Output display size.

Figure 6.21F – Changing the Output display size

Use the following steps to change the Output display size (figure 6.21F continues from figure 6.21E):

1. Select Output display size from the Advanced menu and scroll to the right (figure 6.21F, image 1).
2. Select 95% or 100% from the Output display size menu. 100% (factory default) is selected in figure 6.21F, image 2).
3. Press the OK button to select the Output display size.

Live View On-Screen Display

Live view on-screen display is the setting you'll use when you want the streaming video output from the camera to have no shooting information overlays. Here are your two choices:

- **Off:** When Live view on-screen display is set to Off, the camera outputs a clean, uncompressed, 4:2:2 video stream with no distracting overlays.
- **On:** If you choose On, the camera will stream video with the same information you see on the Monitor, which may include shooting information such as aperture, shutter speed, ISO sensitivity, metering mode, gridlines, sound input levels, focus mode, Picture Control type, image size, image quality, image area, and so forth.

If you want to output clean, overlay-free, uncompressed, broadcast-quality video, choose Off for this setting.

Figure 6.21G – Choosing a Live view on-screen display mode

Use the following steps to change the Live view on-screen display, enabling or disabling pure video output (figure 6.21G continues from figure 6.21D):

1. Select Live view on-screen display from the Advanced menu and scroll to the right (figure 6.21G, image 1).
2. Select On or Off from the Live view on-screen display menu. On is selected in figure 6.21G, image 2.
3. Press the OK button to lock in the setting.

We have examined only how to select and set the modes, with some basic reasons why we decided to use each mode. Shooting pro-level video is new to many photographers, so the chapter **Movie Live View** (page 519) will provide much-needed detail.

Dual Monitor

The Nikon D7200 can send an HDMI video output signal to two monitors simultaneously: an external monitor and the Monitor on the camera. You can use a basic external monitor merely to see the output more clearly, or you can use an external recorder, such as the Atomos Ninja Blade. Unlike its ancestors, the D7200 can also show the same signal you see on an external monitor on the camera's rear Monitor. Let's see how it works.

Figure 6.21H – Use an external monitor and the camera's Monitor

Use the following steps to enable or disable the Dual monitor capability built into the Nikon D7200 (figure 6.21H continues from figure 6.21D):

1. Select Dual Monitor from the Advanced menu, as seen in Figure 6.21H, image 1. The Dual monitor feature defaults to On. Therefore, if you want to use dual monitors, the camera is ready immediately. To change the setting, scroll to the right.
2. Select On or Off from the Dual monitor menu and then press the OK button to lock in the Dual monitor setting (figure 6.21H, image 2).

Settings Recommendation: Please spend some time familiarizing yourself with the features of this function. Later in this book, in the chapter titled Movie Live View (page 519), you will need to have an understanding of using HDMI output. The D7200 camera has enhanced video output compared to many of its predecessors. Therefore, if you have not been fond of video with an HD-SLR in the past, you may want to reconsider now that you are using the Nikon D7200. It is a portable home movie studio, with full broadcast-quality commercial capabilities!

Location Data

(User's Manual: Page 292, Manu Guide: Page 132)

Nikon has wisely included the ability to geotag your images with global positioning system (GPS) location data by providing an easy-to-use interface for various GPS devices.

Now when you shoot a spectacular travel image, you can rest assured that you'll be able to find that exact spot next year. With the Nikon GP-1 or GP-1A GPS units (or an aftermarket brand), the D7200 will record the following GPS information about your location into the metadata of each image:

- Latitude
- Longitude
- Altitude
- Heading (aftermarket only)
- UTC (time)

Using a GPS Unit with Your D7200

The GPS unit you choose must be compatible with the National Marine Electronics Association NMEA0183 data format version 2.01 or 3.0.

I use a Nikon GP-1 GPS unit on my D7200. It's small, easy to carry and store, and works very well. I have other Nikon DSLRs too, and this GPS unit works on all of them, with the proper cables. The Nikon GP-1A GPS unit is also fully compatible with the D7200.

In figure 6.22A, you can see a Nikon GP-1 attached to the camera's Accessory shoe. You can also see the GP1-CA90 cable plugged into the Accessory terminal on the side of the camera. I deliberately put the curl in the cable to keep it from sticking out awkwardly.

The Nikon GPS units come with two camera-to-GPS unit interface cables: the GP1-CA90 and the GP1-CA10 cable. The GP1-CA90 cable—seen on the right side of figure 6.22A—will interface with Nikon cameras such as the D3000, D3100, D3200, D3300, D5000, D5100, D5200, D5300, D5500, D90, D7000, D7100, D7200, D600, D610, D750, and Df, so it's a useful device for almost any of your newer consumer, prosumer, and advanced-enthusiast Nikon DSLRs.

Figure 6.22A – Nikon D7200 with a Nikon GP-1 GPS unit, GP1-CA90 cable, and MC-DC2 remote release cable

The GP1-CA10 cable (not shown) will interface with semi-pro and pro-level Nikon cameras that have a 10-pin port on the body. These cameras include the D200, D300, D300S, D700, D800, D800E, D810, D2X, D3, D3S, D3X, D4, and D4 S.

You can also get an optional Nikon MC-DC2 remote release cable that plugs directly into the GP-1 GPS unit for hands-off, vibration-free photography. You can see the MC-DC2 remote release cable on the left side of the camera in figure 6.22A. The MC-DC2 remote release cable can be used to fire the shutter on any Nikon DSLR that can interface with the Nikon GPS units. It is plugged into the GP-1 GPS unit on the opposite side of where the GP1-CA90 cable plugs in.

The mentioned cables are compatible with both the Nikon GP-1 and GP-1A GPS units. **Note:** The Nikon GP-1 and GP-1A GPS units do not have a built-in digital compass, so they will not report heading information to the camera. Other GPS units do have the built-in compass and will report the heading. If that is important to you, please investigate the *Geotagger Pro GPS Unit* at the Nikonians Photo Pro Shop. Here is a link: **https://www. photoproshop.com/**.

Preparing the Camera for GPS Usage

There are several screens used in setting up the D7200 for GPS use. First, you have to make a decision about the exposure meter when a GPS unit is plugged into the camera. While the GPS is plugged in, the camera's exposure meter must be active to record GPS data to the image. You should do one of two things:

• Set the exposure meter to stay on for the entire time that a GPS is plugged in. This, of course, will increase battery drain, but it keeps the GPS locked to the satellites (no seeking time).
• Press the Shutter-release button halfway down to activate the exposure meter before finishing the exposure. If you push the Shutter-release button down quickly and the GPS is not active and locked, it won't record GPS data to the image. The meter must be on before the GPS will seek satellites.

Standby Timer
Figure 6.22B shows the screens used to set the meter to either stay on the entire time the GPS is connected or shut down after Custom setting c2 Standby timer delay expires.
 Interestingly, the Location data function also has a setting named *Standby timer*. You can select either Enable or Disable for this Standby timer to control whether or not the GPS unit stays on continuously or shuts down when the timeout occurs for Custom setting c2 Standby timer.
 The Custom setting c2 Standby timer function is for all aspects of the camera. The Location data's Standby timer setting applies only to an attached GPS unit.
 Here's what each setting in Standby timer does:

• **Enable** (default): The meter turns off after the *Custom Setting Menu > c Timers/AE lock > c2 Standby timer* delay expires (default 6 seconds). GPS data will be recorded only when the exposure meter is active, so allow some time for the GPS unit to reacquire a satellite signal before taking a picture. This is hard to do when c2 Standby timer is set to Enable. You just about have to stand around with your finger on the Shutter-release button trying to keep the meter active. I suggest using Disable, as described next.
• **Disable:** The exposure meter stays on the entire time a GPS unit is connected. As long as you have a good GPS signal, you will be able to record GPS data at any time. This is the preferred setting for using the GPS for continuous shooting. It does use extra battery life, so you may want to carry more than one battery if you're going to shoot all day. Turn the camera off between locations.

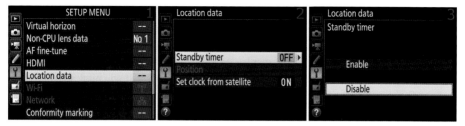

Figure 6.22B – Setting an Auto meter off delay for GPS usage

Here are the steps to configure the GPS settings:

1. Choose Location data from the Setup Menu and scroll to the right (figure 6.22B, image 1).
2. Select Standby timer and scroll to the right (figure 6.22B, image 2).
3. Select Enable or Disable (figure 6.22B, image 3). Use Disable for more reliable GPS usage, with somewhat greater battery drain. It is a good idea to carry multiple batteries if you are shooting all day with a Nikon GP-1, GP-1A, or an aftermarket GPS unit attached.
4. Press the OK button to lock in the setting.

Position

There is also a *Position* setting under Location data, as shown in figure 6.22C, image 2. If your GPS unit is not attached to the camera, the Position selection is grayed out. When a GPS is attached, the next screen after Position shows the actual GPS location data being detected by the D7200 (figure 6.22C, image 3).

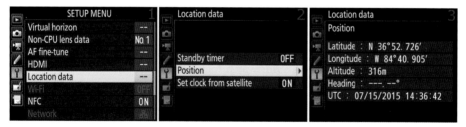

Figure 6.22C – GPS Position information screen

To validate that the GPS is picking up GPS location data, examine the Position screen by using the following steps (figure 6.22C):

1. Choose Location data from the Setup Menu and scroll to the right (figure 6.22C, image 1).
2. Select Position from the Location data menu and scroll to the right (figure 6.22C, image 2).
3. Examine the Position screen to see the five items provided from the GPS satellite data (figure 6.22C, image 3). Notice that my Nikon GP-1 GPS unit did not give me Heading information. Other GPS units will give you that information, as discussed previously.

When the camera establishes communication with your GPS unit, three things happen:

- Position information appears on the GPS Position screen (figure 6.22C, image 3).
- A small GPS satellite symbol will display on the upper-left corner of the Information display, just above the Exposure mode symbol (i.e., P, S, A, M). It will blink when acquiring a GPS signal lock and stop blinking when at least three global positioning satellites are acquired.
- An additional data information display screen will be displayed when you are using the Playback button to review images captured while the GPS was active. You can press up or down with the Multi Selector button to scroll through the image data screens on the Monitor. One of them will be similar to the screen shown in figure 6.22D, which is a picture of the GPS data screen from a picture I took of a tree.

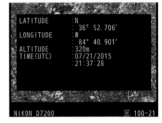

Figure 6.22D – GPS Information display screen (Playback)

Note: The Nikon GP-1 GPS unit will blink its rear LED light in red while acquiring satellites and shine solid green when locked onto three satellites. Allow a few seconds for the GPS to acquire satellites when the camera has been turned off. If you are a significant distance from where you last used the GP-1 GPS unit, it may require up to a minute or two to acquire a satellite lock. Once the GP-1 has a local satellite lock and you turn the camera off, the GPS unit will reacquire the signal in just a few seconds when the camera is turned back on.

Use GPS to Set Camera Clock

The D7200 has a cool feature designed to let the GPS satellite keep your camera's time accurate: the *Set clock from satellite* function. The camera can query the GPS satellite and set the camera's clock. If you use GPS a lot, you might want to leave this on. The clock in the Nikon D7200 is not as accurate as a wristwatch, for instance, and will tend to lose accuracy more quickly. It's a good idea to set the camera's clock from time to time. This is an easy way to accomplish that for GPS users.

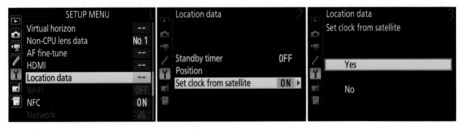

Figure 6.22E – Using GPS to set camera clock

Here are the steps to enable Set clock from satellite:

1. Choose Location data from the Setup Menu and scroll to the right (figure 6.22E, image 1).
2. Select Set clock from satellite and scroll to the right (figure 6.22E, image 2).
3. Select Yes to enable the setting or No if you want to check the clock yourself from time to time (figure 6.22E, image 3).
4. Press the OK button to save the setting.

Using the GPS

If the GPS icon is flashing on the Information display screen, it means that the GPS is searching for a signal. If you take a picture with the GPS icon flashing, no GPS data will be recorded. If the GPS icon is not flashing (solid), it means that the D7200 is receiving good GPS data and is ready to record data to a picture. If the D7200 loses communication with the GPS unit for more than two seconds, the GPS icon will disappear. Make sure the icon is displayed and isn't flashing before you take pictures!

If you want the GPS Heading information to be accurate, keep your GPS unit pointing in the same direction as the lens. Some aftermarket GPS units also contain a digital compass, unlike the Nikon GP-1. Point the GPS in the direction of your subject and give it enough time to stabilize before you take the picture or the Heading information will not be accurate. *This does not apply to the Nikon GP-1 or GP-1A GPS unit, which has no digital compass*. It records only Latitude, Longitude, Altitude, and UTC time, not the Heading.

The Nikon GPS units mount either onto the camera's Accessory shoe (figure 6.22A) or on the camera's strap, with the included GP1-CL1 strap adapter.

Settings Recommendation: Get the Nikon GP-1 or GP-1A GPS unit from one of many vendors, or get the Geotagger Pro GPS from the Nikonians Photo Pro Shop (www.PhotoPro-Shop.com). Either unit is easy to use, foolproof, and has all the cables you need for interfacing with your camera.

If you choose one of the Nikon GPS units, the only other cable you'll need to buy is the optional MC-DC2 shutter-release cable (coiled on the left in figure 6.22A). I use the tiny Nikon GP-1 GPS unit constantly when I'm shooting nature images so I can remember where to return in the future. After you start using a GPS unit, you'll find it hard to stop.

Wi-Fi

(User's Manual: Page 292, Menu Guide: Page 133)

The *Wi-Fi* function allows you to connect your camera directly to your smartphone or tablet (smart device) by using the D7200's built-in Wi-Fi. Nikon offers a free Wireless Mobile Utility (WMU) app on the Apple App Store for iOS smart devices and the Google Play Store for Android smart devices. Be sure to download the WMU to your smart device!

You can also download a PDF Wireless Mobile Utility user's manual for your respective smart device at one of the two following web addresses:

- *iOS (Apple) smart devices:* **http://nikonimglib.com/ManDL/WMAU-ios/**
- *Android smart devices:* **http://nikonimglib.com/ManDL/WMAU/**

Because there are multiple smart device types available, it is beyond the scope of this book to discuss how to use the WMU app for controlling the camera or retrieving images to your particular smart device. However, using the WMU is not difficult at all.

Once you have downloaded and installed the WMU app, you should read over the WMU user's manual for your smart device, start the camera's Wi-Fi, and connect your smart device to the D7200. You can then use your smart device to control the camera and take remote pictures. You can also use the WMU app to download pictures from the camera to the smart device for sharing on social media sites or for use on the smart device directly (images are copied to the camera roll).

Let's examine how to use start the Wi-Fi system on the Nikon D7200.

Using Wi-Fi on the Nikon D7200

Using the Wi-Fi system and the WMU app is fairly simple. However, the first time you use it you may need to refer to this material and the WMU user's manual for your smart device. Let's examine how the camera works when using the Wi-Fi feature. First, let's see how to enable Wi-Fi.

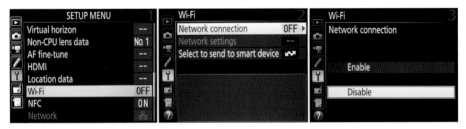

Figure 6.23A – Enabling or disabling the Wi-Fi system

Use these steps to enable or disable the Wi-Fi capability in your camera:

1. Select Wi-Fi from the Setup Menu and scroll to the right (figure 6.23A, image 1).
2. Choose Network connection and scroll to the right (figure 6.23A, image 2).
3. Highlight Enable or Disable and press the OK button to lock in your choice (figure 6.23A, image 3).

Note: You can bypass the Network connection setting just described if your smart device has NFC, by using near field communications to establish the initial wireless connection between your camera and your smart device. See the next chapter section titled **NFC** on page 358 for instructions.

Choosing a Network Type

Initially, the Network settings menu item will be grayed out and unavailable. Wait for a few seconds while the Wi-Fi system initializes and Network settings will become available for configuration.

Next you must select one of the Network settings, according to the type of smart device you are using (Android or iOS). There are four selections in the Network settings menu.

- **Push-button WPS:** Some Android devices support WPS, which allows you to select the WPS setting from its Wi-Fi menu. This is the equivalent of pushing a WPS button and using the automated WPS system to connect the camera to your Android device. This is an Android-only setting.
- **PIN-entry WPS:** On a WPS-enabled Android, you can enter a PIN displayed by the Android device to establish a connection with the camera. This is an Android-only setting.
- **View SSID:** This setting works for both Android and iOS smart devices and is the most common method used to connect a smart device to the camera's Wi-Fi system. You will select the camera from the list of available Wi-Fi devices shown by your Android or iOS smart device under its Wi-Fi settings. The camera Wi-Fi connection shown under this View SSID setting will appear in the smart device's Wi-Fi list, with an entry similar to this one: Nikon_WU2_0090B517AA32. Choose that entry to connect to the Android or iOS phone or tablet and then open the WMU app on your smart device. No password is required initially. Please see the **Special Network Security Information** subsection at the end of this main section.
- **Reset network settings:** This setting allows you to restore the camera to factory default Wi-Fi settings. Use this when you want to start fresh with Wi-Fi.

Next, let's examine the screens for each of the connection types. Each of the following screens continue where figure 6.23A, image 2, left off.

Push-Button WPS

If your Android smart device has a push-button WPS entry in its Wi-Fi menu, you can choose to use the automatic push-button WPS configuration. Here's how:

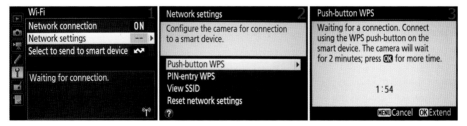

Figure 6.23B – Using Push-button WPS on an Android device

Use the following steps to connect using Push-button WPS:

1. Choose Network settings from the Wi-Fi menu and scroll to the right (figure 6.23B, image 1).
2. Select Push-button WPS from the Network settings menu and scroll to the right (figure 6.23B, image 2).
3. Touch the WPS push-button in the Wi-Fi settings of your smart device to initiate configuration. Your camera will wait for up to two minutes before it times out. You can press the OK button on the camera to extend that time by an additional two minutes (figure 6.23B, image 3).

PIN-Entry WPS

If your Android smart device offers pin-entry WPS, you can use the following screens to connect with PIN-entry WPS.

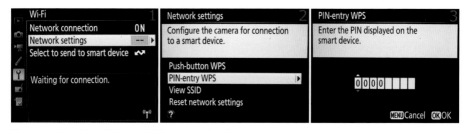

Figure 6.23C – Using PIN-entry WPS on an Android device

Use the following steps to connect using PIN-entry WPS:

1. Choose Network settings from the Wi-Fi menu and scroll to the right (figure 6.23C, image 1).
2. Select PIN-entry WPS from the Network settings menu and scroll to the right (figure 6.23C, image 2).
3. Open the smart device's Wi-Fi system and find the WPS PIN number. Enter the PIN number on the screen shown in figure 6.23C, image 3, by scrolling up or down on each of the character locations with the Multi selector.

View SSID

On an Android or iOS smart device you have a list of available Wi-Fi devices under the Wi-Fi settings area. You have used these Wi-Fi choices previously when you connected your smart device to Wi-Fi in your home or at a hotel or restaurant.

When you enable the Wi-Fi system in your camera, it will present its own SSID beginning with the word Nikon. You can connect to the Nikon Wi-Fi on your camera in the same manner that you connected to previous Wi-Fi systems. Initially, a password will not be required unless you have configured WPA2-PSK-AES encryption, as described later in this section (please do!).

Let's examine how to view the SSID your camera will offer under your smart device's Wi-Fi choices.

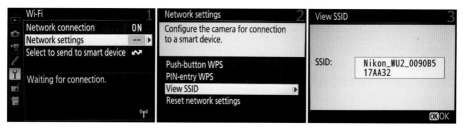

Figure 6.23D – Using View SSID on an Android or iOS device

Use the following steps to view the name of the currently enabled Nikon SSID:

1. Choose Network settings from the Wi-Fi menu and scroll to the right (figure 6.23D, image 1).
2. Select View SSID from the Network settings menu and scroll to the right (figure 6.23D, image 2).
3. The camera will present you with the current Nikon SSID name, as seen in figure 6.23D, image 3. You must choose this same name from your smart device's Wi-Fi selection menu in order to make the connection. See the upcoming **Special Network Security Information** section to protect your images from viewing or theft by third parties.

Reset Network Settings
If you would like to start fresh with the Wi-Fi settings in your camera, you can easily do so with the following setting.

Figure 6.23E – Restoring the camera's Wi-Fi settings to factory default

Use the following steps to reset the camera's Wi-Fi system back to factory defaults:

1. Choose Network settings from the Wi-Fi menu and scroll to the right (figure 6.23E, image 1).
2. Select Reset network settings from the Network settings menu and scroll to the right (figure 6.23E, image 2).
3. Select Yes from the screen shown in figure 6.23E, image 3, and press the OK button to reset the Wi-Fi settings. Select No and press the OK button to cancel.

Once you have enabled Wi-Fi, and selected one of the Network settings, you should open the WMU app on your smart device and look for the little antenna symbol in the top-left corner. If it shows an antenna symbol alone, the camera and smart device are communicating and ready for use. If you see the antenna symbol and it has a backslash through it, you have not successfully made a connection between the two devices.

Select to Send to Smart Device

The camera allows you to preselect images for immediate transfer to the smart device as soon as you open the WMU app and select View photos. You can mark individual images with a special symbol that signifies these images should be transferred immediately. Let's see how.

Figure 6.23F – Marking images for immediate transfer to the WMU app

Use the following steps to mark individual images for transfer to your smart device:

1. Choose Select to send to smart device from the Wi-Fi menu and scroll to the right (figure 6.23F, image 1).
2. Find the image(s) you want to mark for sending to the WMU app by pressing the Thumbnail/Playback zoom out (ISO) button to Set the images (figure 6.23F, image 2). You can zoom in to examine an image more closely before marking it by zooming in on the image with the Playback zoom in (QUAL) button.
3. Once you have marked all the images you want to transfer, press the OK button. The camera will display a screen saying *Selection complete* (figure 6.23F, image 3).
4. Open the WMU app and make sure it is connected to the camera.
5. Touch the View Photos selection in the app. The WMU app will display a window that says, *The camera contains pictures selected for transfer. Download will start immediately. OK/Cancel?* Touch the OK selection and you will see a numbered progress indicator on your smart device that shows the progress of the download. When the download is done, you will find your new images under the Latest Downloads selection of the WMU app.

Selecting Images with the *i* Button Menu

The camera allows you a shortcut method for sending a single image to the WMU app. There is a special selection on the *i* button menu for immediately sending a single image to a connected smart device. Let's see how it works.

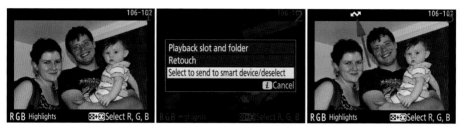

Figure 6.23G – Using the *i* button menu to send a single picture to the WMU app

Use the following steps to send a single image to a connected smart device's WMU app:

1. Press the Playback button, display an image on the Monitor, and find the one you want to send to the WMU app (figure 6.23G, image 1).
2. With that image displayed, press the *i* button on the back of the camera and open the *i* button menu (figure 6.23G, image 2). Highlight Select to send to smart device/deselect and press the OK button.
3. The selected image will be marked with the send symbol (figure 6.23G, image 3, red arrow).
4. Open the WMU app and make sure it is connected to the camera. Touch the View Photos selection in the WMU app. The app will display a window that says, *The camera contains pictures selected for transfer. Download will start immediately. OK/Cancel?* Touch the OK button and you will see a numbered progress indicator on your smart device while the download of images is taking place. When the download is done, you will find your new images under the Latest Downloads selection of the WMU app.

Exiting the Use of Wi-Fi

When you are finished using the WMU app you must shut down the camera's Wi-Fi system. Refer to figure 6.23A and the steps required to enable or disable the Wi-Fi system. Turning off the camera is not sufficient for exiting Wi-Fi. You must disable Wi-Fi manually using *Setup Menu > Wi-Fi > Network connection* (set it to Disable).

Special Network Security Information

At the time this book went to press, no password was required to make the Wi-Fi connection—but that could change in a future firmware update. Currently, that means anyone with a smart device with the WMU app installed can access your images without your knowledge when your camera's Wi-Fi is active. To prevent unauthorized access, you must

set up WPA2-PSK-AES authentication in your smart device's WMU app by using the following steps. Your camera will receive the password from the WMU app.

1. Enable Wi-Fi on the camera (figure 6.23A) and open the WMU app on your smart device. Make sure the camera and smart device are communicating (no slash through the antenna symbol on the top-left corner of the WMU app).
2. Touch the settings icon (gear cog) in the top-right corner of the WMU app. This opens the settings menu.
3. Touch the WMA settings selection.
4. Touch the Authentication setting. OPEN is currently selected. Choose WPA2-PSK-AES instead, by touching it. A check mark will appear next to WPA2-PSK-AES.
5. Touch > WMA settings in the top-left corner and a window will open with the following words: *No Password specified. Enter a Password. OK.* Touch the OK button on the window.
6. Touch the Password selection and the WMU app will switch to a password entry screen. Type a password from 8 to 63 characters long. Once you have entered the password, touch > WMA settings at the top left of the screen. You will see a series of dots appear next to the Password selection, showing that you have successfully entered a password. Now touch > Settings in the top-left corner.
7. A window will open on the WMU app that says: *Save changes and restart the Wireless Mobile Adaptor? Cancel/OK.* Touch OK. The previous Wi-Fi connection between the two devices will no longer be functional.
8. You must now go back into the smart device Wi-Fi settings and select the Nikon_ WU2_0090B517AA32 (or similar) SSID choice. The camera will challenge you for the password you entered in the WMU app. Enter the new password and make sure the connection was successful. You are now using an encrypted connection and no one can connect to your camera and steal your images without your password.

Settings Recommendation: I always use the normal selection of an SSID (View SSID) from the Wi-Fi menu of my smart device. It takes only a moment and most of us know how to connect to a Wi-Fi source. The camera is a Wi-Fi source when Wi-Fi is enabled on it. Please be sure to use encryption on your Wi-Fi connection as previously described, unless you are far away from other people. Your images are valuable!

NFC

(User's Manual: Page 292, Menu Guide: Page 134)

The *NFC* (near field communication) function allows you to start a wireless connection while using Viewfinder photography by touching your smart device's antenna to the N-Mark logo (figure 6.24A) on the side of the camera's handgrip—if your smart device supports NFC.

Figure 6.24A – the NFC N-Mark logo

Once the wireless connection is established through NFC, you can use the Nikon Wireless WMU app to control the camera or transfer images (see previous **Wi-Fi** chapter section on page 351). The NFC function is simply a convenient substitute for the *Setup Menu > Wi-Fi > Network connection* setting.

Instead of having to enable the Network connection, you simply touch your smart device to the camera's NFC N-Mark. This will enable a wireless connection between the smart device and your camera.

Note: The camera must have its light meter (c2 Standby timer) active during the connection process or the camera's NFC will not respond. Partially press the Shutter-release button to activate the Standby timer (defaults to a six second timeout).

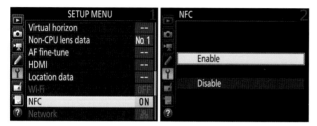

Figure 6.24B – Enabling or disabling

Use the following steps to enable or disable NFC for use with your smart device:

1. Select NFC from the Setup Menu and scroll to the right (figure 6.24B, image 1).
2. Choose Enable or Disable from the NFC menu (figure 6.24B, image 2).
3. Press the OK button to lock in your setting.

Settings Recommendation: Many Android smart devices support NFC these days and work great with the Nikon D7200; when the two devices connect through NFC, the WMU app opens automatically.

Newer Apple (iOS) devices have NFC, too, but at the time of writing, Apple's NFC is limited to Apple Pay only and will not work with Nikon cameras or any other NFC devices.

Network

(User's Manual: Page 293, Menu Guide: Page 134)

Network allows you to interface the Nikon D7200 with an Ethernet network cable for use on a local area network. You must own the Nikon UT-1 communication unit, which has an Ethernet port and a USB connector that plugs into the camera's USB port. When using the UT-1 communication unit to connect with a network, you can use the following functions:

- **FTP upload:** Transfer your images to an FTP server, or upload new images as they are taken.

- **Image transfer:** Transfer your images to a computer, or upload new images as they are taken.
- **Camera control:** Use the optional Camera Control Pro 2 software to save new images and videos directly to your computer.
- **HTTP server:** View and take pictures remotely, using a computer web browser or iPhone.

Professional studio and sports shooters may be using the UT-1 communication unit on an Ethernet network or attached to a WT-5 wireless transmitter. The majority of Nikon shooters transfer images via USB cable or a card reader.

Using this UT-1 communication unit is beyond the scope of this book. Please refer to the Nikon UT-1 User's Manual for more information.

Eye-Fi Upload

(User's Manual: Page 293, Menu Guide: Page 135)

Eye-Fi upload allows you to use an Eyefi card to send images you take from your camera to your computer, either through a local Wi-Fi Internet connection or directly to the computer with an Ad hoc Wi-Fi connection.

Eye-Fi upload appears on the Setup Menu of your D7200 *only* when you have an Eyefi card inserted. Otherwise, the camera does not even show the Eye-Fi Upload menu selection between Network and Conformity marking on the Shooting Menu.

The Eye-Fi company makes several of these SD cards with built-in Wi-Fi transmitters. Figure 6.25A shows two of my Eyefi cards: the Pro X2 8 GB high-speed Class 6 SDHC card (no longer fully supported by Eyefi) and the mobi 8GB Class 10 SDHC card (mobi is current and comes in varying capacities).

Figure 6.25A – Eye-Fi Pro X2 8 GB and mobi 8GB Wi-Fi cards

The current Eyefi card for the majority of users is called mobi. It uses the latest technology for those who want to connect their Nikon to a tablet or smartphone through the Eyefi Mobile App. The app is available as a free download from the iTunes store (Apple), Google Play store (Android), and Kindle store (Amazon).

Older Eyefi cards that may still be available (but not fully supported by Eyefi) include Connect, Explore, Mobile, Geo X2, and Pro X2. For more information on Eyefi cards, see the following website: **http://www.eyefi.com**.

Enabling Eye-Fi Uploads on the D7200

An Eyefi card does not use any more battery life than a normal SD card until you enable Wi-Fi. Unless you are currently shooting images for transfer, I wouldn't leave the Eye-Fi upload feature (Wi-Fi) enabled. Why waste battery life out in the woods?

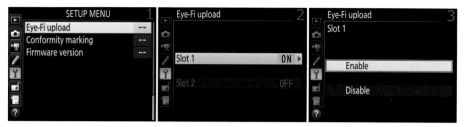

Figure 6.25B – Enabling Eye-Fi (Wi-Fi)

Here are the steps to Enable or Disable Eye-Fi upload:

1. Choose Eye-Fi upload from the Setup Menu and scroll to the right (figure 6.25B, image 1).
2. Choose the slot that contains your Eyefi card (figure 6.25B, image 2). Most of the time there will be only one Eyefi card used in the camera. However, you could use two if you like.
3. Select Enable or Disable from the Eye-Fi upload screen (figure 6.25B, image 3).
4. Press the OK button to lock in the setting.

Settings Recommendation: I no longer use an Eye-Fi card in my Nikon D7200 camera. The Wi-Fi system built into the D7200 seems to be very efficient so why use an external card? However, some may prefer to continue using the Eyefi cards because they are used to the Eyefi system and have built a workflow surrounding Eyefi. Maybe that's why Nikon left Eye-Fi Upload as a current choice. I consider Eyefi card use to be replaced by the new built-in camera Wi-Fi system.

Conformity Marking

(User's Manual: Page 293, Menu Guide: Page 137)

Conformity marking is a simple function that lets you see the symbols for the various industry standards with which your camera conforms. These standards have symbols you can research if you so desire.

Figure 6.26 – Viewing the symbols for Nikon

Use the following steps to view the camera's conformity standards:

1. Choose Conformity marking from the Setup Menu (figure 6.26, image 1).
2. Figure 6.26, image 2, shows the Conformity marking screen with the symbols of conformity.
3. Press the OK button when you are done viewing the symbols.

Firmware Version

(User's Manual: Page 293, Menu Guide: Page 137)

Firmware version is a simple informational screen, like the Battery info screen. It shows you which version of the camera's operating system (firmware) you are running. My camera is currently running version C 1.00 and L 2.005.

Figure 6.27 – Viewing the camera's Firmware version

Here are the steps to see the Firmware version of your camera:

1. Choose Firmware version from the Setup Menu and scroll to the right (figure 6.27, image 1).
2. Examine the Firmware version (figure 6.27, image 2).
3. Select Done and press the OK button.

When it's time to do a Firmware update, you will use this same Firmware version menu to update the camera. An extra menu item will appear below the Done selection, allowing you to update the Firmware. Follow the instructions provided on Nikon's website for each Firmware update.

Author's Conclusion

Whew! The D7200 may seem like a complicated little beast, but that's what you get when you fold pro-level functionality into a relatively small DSLR body. For as complex as it is, I'm certainly delighted with it.

Next, we'll consider how to use the camera's Retouch Menu to adjust images without using a computer. If you are in the field shooting RAW files and you need a quick JPEG, black-and-white version of a file, or red-eye reduction, the Retouch Menu has you covered.

You can even do things like image distortion and perspective control, color balance changes, filtration, cropping, and image resizing—all without touching a computer. Let's see how!

07 Retouch Menu

Silent Wings © 2015 Jim Buch (jimray)

Retouching allows you to modify your images in-camera. If you like to do digital photography and want to postprocess your images for maximum quality, but you don't particularly like to adjust images on a computer, these functions are for you. Obviously, the camera Monitor is not large enough to allow you to make extensive creative changes to an image, as you can with Nikon Capture NX-D, Lightroom, or Photoshop on a computer. However, it is surprising what you can accomplish with the Retouch Menu.

The D7200 has 19 Retouch Menu selections. The following is a list of each function and what it does:

- **D-Lighting:** This feature opens up detail in the shadows and tends to protect highlight details from blowing out. This is similar to the *Photo Shooting Menu > Active D-Lighting* function, but it's applied after the image is taken.
- **Red-eye correction:** This removes the unwanted red-eye effect caused by light from a flash reflecting back from the eyes of human subjects.
- **Trim:** This feature creates a trimmed (cropped) copy of a selected photograph. You can crop the image to several aspect ratios, including 1:1, 3:2, 4:3, 5:4, and 16:9.
- **Monochrome:** You can convert your color images to monochrome. There are three tints available, including Black-and-white (grays), Sepia (reddish), and Cyanotype (bluish).
- **Filter effects:** Seven filter effects are available that can be applied to the image to change its appearance. The seven filters are Skylight, Warm filter, Red intensifier, Green intensifier, Blue intensifier, Cross screen, and Soft.
- **Image overlay:** This creates a new image by overlaying two existing NEF (RAW) files. Basically, you can combine two RAW images to create special effects—like adding an image of the moon into a separate landscape picture.
- **NEF (RAW) processing:** You can create highly specialized JPEG images from your NEF (RAW) files without using your computer.
- **Resize:** You can take a full-size image and convert it to several smaller sizes. This is useful if you would like to send an image via email or if you need a smaller image for other reasons.
- **Quick retouch:** The camera automatically tweaks the image with enhancements to saturation and contrast. In addition, when a subject is dark or backlit, the camera applies D-Lighting to open up shadow detail.
- **Straighten:** You can straighten an image with a crooked horizon by rotating it in-camera until it looks good. The camera will trim (crop) the edges of the image to create a normal perspective without the tilt.
- **Distortion control:** You can remove barrel and pincushion distortion that affects the edges of the image. You can set the camera to make automatic adjustments, or you can do it manually. The camera automatically trims (crops) the edges of the image after adjustment.
- **Fisheye:** This feature allows you to incrementally bulge images from their centers in a hilarious way to get that strange fisheye effect you can often see while looking through a door peephole. It provides a very distorted image that will make your friends either laugh or chase you. Warning: This effect can be dangerous to use on wives, sisters, and girlfriends! (Don't ask me how I know!)

- *Color outline:* This creates an outline effect, as if you had traced an underlying image on paper with a pencil. The effect is monochrome, contrary to the name of the function. Nikon provides this effect to "create an outline of a photograph to use as a base for painting." If you are a painter, this may be useful to you.
- *Color sketch:* This effect is very similar to Color outline; the main difference is that the result is in pastel color. The edges of the subjects in your image are sketched and colorized, similar to using colored pencils or crayons. You can control the vividness of the color and the contrast of the line edges.
- *Perspective control:* This is a useful control that helps adjust perspective distortion out of an image. It's useful for pictures of things like buildings, which can have a falling-over-backward effect when shot with a wide-angle lens. You can adjust the building so it looks more natural. The camera automatically crops the edges of the image to allow the distortion to be removed.
- *Miniature effect:* This effect allows you to create a reverse diorama (an image with a very limited band of sharpness that is taken from a high vantage point) to make the image look fake. The image may be of a real subject, like a city shot from the top of a tall building; however, the Miniature effect causes the scene to look artificial, as if small models of reality were used.
- *Selective color:* You can use this function to create photographs with certain elements in color and the rest in black-and-white. Imagine a bright red rose with no color in the image except the rose petals. You can selectively choose a color with an eyedropper icon, and only that color will appear in the image.
- *Edit movie:* You can shorten a movie by cropping out a small section from a large movie file.
- *Side-by-side comparison:* You can compare a retouched image—created via the Retouch Menu—with the original image. The images are presented side by side so you can see the before and after versions. This function is available from the *i* Button menu only.

Figure 7.1 – Retouch Menu

The Retouch Menu of the D7200 is shown in figure 7.1. It is the sixth menu down the menu selection bar, just below the Setup Menu. Its icon resembles a palette and paintbrush.

Retouched File Numbering

When you use Retouch Menu items, the D7200 does not overwrite your original file. It always creates a JPEG file with the next available image number. The retouched image will be numbered as the last image on the memory card. If you have 100 images on your card and you are retouching image number DSC-0049, the new JPEG image will be number DSC-0101 (it will be the 101st image).

Accessing the Retouch Functions: Two Methods

There are two methods for accessing the Retouch Menu. You can use the main Retouch Menu—under the MENU button—to choose an image to work with, or you can display an image in Playback mode and press the *i* button to open a menu with most of the Retouch functions available. They work basically the same way, except the Playback Retouch Menu leaves out the step of choosing the image for retouching because there is already an image selected on the screen.

Since both the Playback Retouch Menu and Retouch Menu methods have the same functions, we'll discuss them as if you were using the Retouch Menu. However, in case you decide to use the Playback method, let's discuss it briefly.

Playback Retouching

Use the following steps if you want to work with an image that you are viewing on the Monitor—what I call Playback retouching.

Figure 7.2 – Playback Retouch Menu

To use the Retouch Menu options, follow four basic steps, as shown by the sample screen flow of the D-Lighting selection:

1. Press the Playback button and choose a picture by displaying it on the Monitor (figure 7.2, images 1 and 2). You now have a picture ready for retouching.
2. Press the *i* button to open a small menu that has a Retouch selection (figure 7.2, images 3 and 4). Scroll to the right after highlighting Retouch (image 4).
3. Select one of the Playback Retouch Menu items (figure 7.2, image 5) and then scroll to the right to work with that particular setting (figure 7.2, image 6). In this case D-Lighting is selected, but you have virtually all the Retouch Menu items on this special Playback retouching menu.

Note: Remember that Playback retouching is available by simply pressing the *i* button and selecting Retouch from the menu when the image you want to retouch is displayed on the Monitor.

Limitations on Previously Retouched Images

Sometimes there are limitations imposed when you are working on an image that has already been retouched. You may not be able to retouch a previously retouched image with another retouch function. When you use the Playback retouch method, the items will be grayed out on the menu. If you use the Retouch Menu directly, any images that are overlaid with a box containing a yellow X cannot be retouched again with the current retouch function.

Using Retouch Menu Items Directly

The following functions work backward from the Playback Retouch Menu just described. Instead of selecting an image first, you must select a Retouch Menu function first and then select an image to which you want to apply the effect. Let's consider each Retouch Menu function.

D-Lighting

(User's Manual: Page 294, Menu Guide: Page 141)

D-Lighting allows you to reduce the shadows in an image and maybe even rein in the highlights a bit. It lowers the overall image contrast, so it should be used sparingly. The D7200 is not aggressive with its D-Lighting, so you can use it quickly if needed. Also, remember that Retouch Menu effects are applied to a copy of the image, so that your original is safe. Use the following steps to apply D-Lighting to an image:

1. Select D-Lighting from the Retouch Menu and scroll to the right (figure 7.3, image 1).
2. You'll see the currently selected image surrounded by a yellow box. Select the image you want to modify and press the OK button (figure 7.3, image 2).
3. Choose the amount of D-Lighting you want for the chosen image by using the Multi selector to scroll right or left (Lo to Hi). When the image on the right of the side-by-side comparison looks the way you want it to, press the OK button to save the new file. My camera has Hi selected.
4. The D7200 will display a brief *Image saved* notice and then display the new file on the Monitor. The retouched image will have a small palette-and-paintbrush icon to show that it has been retouched (figure 7.3, image 4, red arrow). The original image is still available for future retouching.

Figure 7.3 – D-Lighting Retouch Menu

Settings Recommendation: There is no one setting that is correct for all images. I often use the medium selection between Lo and Hi to see if an image needs more or less D-Lighting, then I change it to Hi or Lo if needed. Remember that any amount of D-Lighting has the potential to introduce noise in the darker areas of the image, so the less D-Lighting you use, the better.

Red-Eye Correction

(User's Manual: Page 294, Menu Guide: Page 141)

Red-eye correction attempts to change bright red pupils—caused by reflected light from the flash—back to their normal color. Red eye makes a person look like one of those aliens with glowing eyes from a science fiction show. If you've used flash to create a picture, the Red-eye correction function will work on the image if it can detect any red eye. If it can't detect red eye in the image, it will not open the red-eye system and will briefly display a screen that says *Unable to detect red-eye in selected image.*

If you try to select Red-eye correction for an image in which flash was not used, the camera will display a screen that says *Cannot select this file.*

Figure 7.4 – Red-eye correction

Use the following steps to execute the Red-eye correction function:

1. Select Red-eye correction from the Retouch Menu and scroll to the right (figure 7.4, image 1).
2. You can zoom in on an image to see if it has red eye by highlighting the image and pressing the Playback Zoom in (QUAL) button. Select the image you want to correct and press the OK button (figure 7.4, image 2).
3. You'll see an hourglass on the Monitor for several seconds (figure 7.4, image 3) while the Red-eye correction process takes place.
4. Zoom in to check the red-eye reduction with the Playback zoom in (QUAL) button or press the Playback button to cancel. Press the OK button to save the file with a new file name (figure 7.4, image 4).
5. You'll see an *Image saved* message screen (figure 7.4, image 5) and then the saved image will appear on the Monitor (figure 7.4, image 6). Again, you can tell it is a retouched image because of the palette-and-paintbrush symbol above the top-left corner of the image. This newly retouched image will have its own new file number.

Settings Recommendation: I've found that the Red-eye correction function works pretty well as long as the subject is fairly large in the frame. The image of the lovely young lady in figure 7.4, image 4, had only minor red eye. That gives you an idea of how large in the frame the subject has to be for this function to work well. With small subjects, I've had it correct one eye that was closer to the camera (and therefore larger in the image) and not the other. I have also tried Red-eye correction for larger groups of people. Sometimes it works and other times it doesn't.

I would rate this function as quite helpful but not always effective. However, it's a good function for quick Red-eye correction on critical images you need to use immediately.

Trim

(User's Manual: Page 294, Menu Guide: Page 142)

The *Trim* function allows you to crop an image in-camera, change its aspect ratio, and save the file as a new image. Your original image is not modified.

This is a useful function if you need to cut out, or trim, the most useful area of an image to remove distracting elements from the background.

Figure 7.5 – Trim function

Use the following steps to Trim an image in-camera:

1. Select the Trim function from the Retouch Menu and scroll to the right (figure 7.5, image 1).
2. Select the image you want to modify (figure 7.5, image 2). Press the OK button when you have selected your target image.
3. You'll see a screen that has a crop outlined in yellow (figure 7.5, image 3). Use the Play-back zoom out/thumbnails (ISO) button to crop or trim more of the image or the Play-back zoom in (QUAL) button to crop less. Use the Multi selector to move the yellow se-lection rectangle in any direction within the frame until you find the best trim.
4. Select the Aspect ratio of the crop by rotating the Main command dial. Your choices are 3:2, 4:3, 5:4, 1:1 (square), or 16:9. Figure 7.5, image 3, shows that the 1:1 Aspect ratio is selected.
5. When you have the crop correctly sized and the Aspect ratio set, press the OK button to save the image with a new file name, the results of which are seen in figure 7.5, image 4. Before the retouched image is displayed you will see an *Image saved* message screen appear briefly.

Settings Recommendation: This is a very useful function for cropping images without a computer. The fact that you have multiple Aspect ratios available is just icing on the cake. The camera has some useful Aspect ratios, including a square (1:1) and an HD format (16:9).

Monochrome

(User's Manual: Page 294, Menu Guide: Page 143)

The *Monochrome* function is fun to play with and can make some nice images. Converting the images to one of the three monochrome tones is a good starting point for creative manipulation. The three different types of Monochrome are as follows: Black-and-white (grays), Sepia (golden tone), and Cyanotype (blue tone).

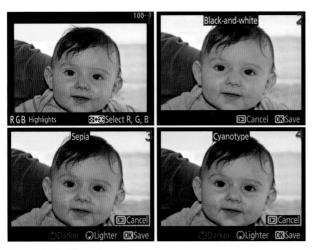

Figure 7.6A – Monochrome images

Figure 7.6A shows a sample of a normal color image and the three monochrome tones you can use. I chose the Darker setting on the Sepia and Cyanotype versions to show their maximum effects. Notice that the Black-and-white version has no darkness or lightness setting because the D7200 provides only one level. However, for Sepia and Cyanotype, you can fine-tune the tint from light to very saturated in three levels.

Use the following steps to create a Monochrome image from a color image:

1. Select Monochrome from the Retouch Menu and scroll to the right (figure 7.6B, image 1).
2. Select a Monochrome tone—Black-and-white, Sepia, or Cyanotype. I selected Sepia.
3. Select the image you want to modify and press the OK button to select (figure 7.6B, image 3).

Figure 7.6B – Monochrome (Sepia) image creation

4. For a Black-and-white image, you cannot adjust the level of lightness or darkness. For Sepia and Cyanotype, you can use the Multi selector to saturate or desaturate the tone (figure 7.6B, image 4). Scroll up or down and watch the screen until the tint is as dark or light as you want it to be. You can cancel the operation by pressing the Playback button.
5. Press the OK button to save the image with a new file name (figure 7.6B, image 4, red arrow).
6. A screen that says *Image saved* will briefly appear, then the final image will be displayed with a retouch icon in the top left of the Monitor (figure 7.6B, screens 5 and 6).

Settings Recommendation: I normally use the Black-and-white conversion when I need an immediate Monochrome image. However, it's a lot of fun to make a new image look old-fashioned with either Sepia or Cyanotype.

Filter Effects

(User's Manual: Page 294, Menu Guide: Page 144)

The D7200 allows you to add one of four *Filter effects* to an image. You can intensify the image colors in various ways, add starburst effects to points of light, and add a softening effect for a dreamy look.

Here is a list of the effects:
- Skylight
- Warm filter
- Cross screen (starburst filter)
- Soft

Skylight Filter Effect

This effect is rather mild and removes the blue effect caused by atmospheric diffraction in distant scenes. This effect makes an image slightly less blue.

Figure 7.7A – Skylight filter effect

Use the following steps to choose the Skylight filter effect:

1. Select Filter effects from the Retouch Menu and scroll to the right (figure 7.7A, image 1).
2. Select Skylight and scroll to the right (figure 7.7A, image 2).
3. Choose an image and press the OK button (figure 7.7A, image 3). You can zoom in by pressing the Playback zoom in (QUAL) button if you want to examine the image first.
4. You will see the image with the Skylight effect added (figure 7.7A, image 4). Press the OK button to save the image with a new file name, or press the Playback button to cancel.

Warm Filter Effect

The Warm filter effect adds a mild red cast to the image to make it appear a little warmer. Use these steps to set the Warm filter effect:

1. Select Filter effects from the Retouch Menu and scroll to the right (figure 7.7B, image 1).
2. Select Warm filter and scroll to the right (figure 7.7B, image 2).
3. Choose an image and press the OK button (figure 7.7B, image 3). You can zoom in by pressing the Playback zoom in (QUAL) button if you want to examine the image first.
4. You will see the image with the Warm filter effect added (figure 7.7B, image 4). Press the OK button to save the image with a new file name, or press the Playback button to cancel.

Figure 7.7B – Warm filter effect

Cross Screen Filter Effect

The Cross screen filter effect adds a starburst to any points of light. There are four adjustments for this effect, along with Confirm and Save commands. My subject for this test is a tiny LED flashlight held at a distance.

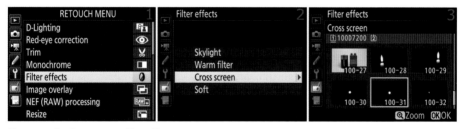

Figure 7.7C – Cross screen filter effect

To create the Cross screen filter effect, use the following steps:

1. Select Filter effects from the Retouch Menu and scroll to the right (figure 7.7C, image 1).
2. Select Cross screen and scroll to the right (figure 7.7C, image 2).
3. Choose an image with the Multi selector and press the OK button (figure 7.7C, image 3). You can zoom in by pressing the Playback zoom in (QUAL) button if you want to examine the image first.
4. Now follow steps 5 through 10. Step 5 and figure 7.7D start where figure 7.7C, image 3, left off.

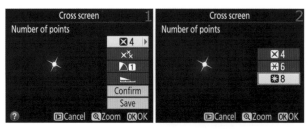

Figure 7.7D – Cross screen filter effect – Number of points

5. The first adjustment is the Number of points (4, 6, or 8) in the starburst. Scroll to the right to select the Number of points (figure 7.7D, image 1). In figure 7.7D, image 2, you can see that an icon with the number of rays in the starburst is provided along with a numeral. I selected 8 points. Press the OK button to lock in your selection. You can zoom in by pressing the Playback zoom in (QUAL) button if you want to examine the image first. You will follow the same procedure for the next three adjustments, which are Filter amount, Filter angle, and Length of points on the starburst.

Figure 7.7E – Cross screen filter effect – Filter amount

6. The second adjustment is the Filter amount (figure 7.7E, image 1). This adjustment affects the brightness of the light source(s). The more Xs, the brighter the light source. I selected the maximum level in figure 7.7E, image 2.

Figure 7.7F – Cross screen filter effect – Filter angle

7. Select the angle of the starburst rays with the Filter angle adjustment. You can rotate the rays in a clockwise direction until the starburst is at the angle you prefer (figure 7.7F, image 1). Notice that the rays are rotated clockwise by a few degrees in figure 7.7F, image 2. This is not a strong effect, but you can rotate the rays a few degrees in either the clockwise (3) or counterclockwise (1) direction.

Figure 7.7G – Cross screen filter effect – Length of points

8. Select the length of the starburst rays with the Length of points adjustment (figure 7.7G, image 1). I wanted the longest rays, so I selected the bottom setting in figure 7.7G, image 2. If you look closely, you can see that the rays are slightly longer in figure 7.7G, image 2.

Figure 7.7H – Cross screen filter effect – Confirm

9. Select Confirm to see the cumulative effects applied to your image (figure 7.7H). This is like an update button. You can change the adjustments in steps 5 through 8 multiple times and Confirm them each time to see the updated image until the effect is the way you want it. You must do the Confirm step after each change or you will not see a difference. Figure 7.7H, image 1, shows the Cross screen effect before the Confirm selection was executed and image 2 shows the Cross screen starburst after Confirm was selected with the cumulative settings applied.

Figure 7.7I – Cross screen filter effect – Save

10. Select Save and press the OK button (figure 7.7I, image 1). After a moment you'll see a screen that says *Image saved* (figure 7.7I, image 2). Then you'll see the full-size image in normal Playback mode (figure 7.7I, image 3).

Settings Recommendation: If you are testing this effect and can't get the rays to appear, you may need to make the points of light smaller, but not too small. Try shooting a candle or keychain LED flashlight in a darkened area as an experiment. You will soon learn how small the point of light must be. Small, round points of light work best with this effect.

Soft Filter Effect

The Soft filter effect is designed to give your subject that dreamy look popularized by old movies, where the beautiful woman looks soft and sweet. You can select from three levels of softness: Low, Normal, and High.

Figure 7.7J, images 1–4, show small versions of the original image and the three softness settings: image 1 = no effect, image 2 = Low, image 3 = Normal, image 4 = High.

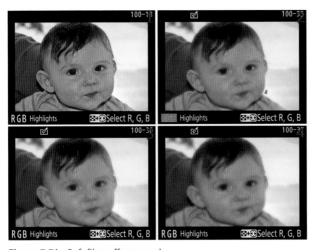

Figure 7.7J – Soft filter effect samples

This is an interesting effect. Even though the overall image has a softness to it after the effect has been applied, the subject is still somewhat sharp. It doesn't look like the image is soft because of poor focus or camera movement. It's like a softness has been overlaid on the image, and the original image is still sharp. You would have to see this misty look in a full-size image to understand what I mean.

Here are the steps to select one of the Soft filter levels:

1. Select Filter effects from the Retouch Menu and scroll to the right (figure 7.8, image 1).
2. Choose Soft from the menu and scroll to the right (figure 7.8, image 2).
3. Select the image to receive the Soft filter effect and press the OK button (figure 7.8, image 3). You can zoom in if you want to examine the image first by pressing the Playback zoom in (QUAL) button.

4. You'll see a sliding scale from Lo to Hi (figure 7.8, image 4, red arrow). Use the Multi selector to scroll left or right and select one of the softness levels. The small image on the left is the original image, and the one on the right is the adjusted image. You can easily see the softness vary as you select different levels. Choose the level you want to use.
5. Press the OK button to save the new image and display it on the Monitor, as shown in figure 7.7J.

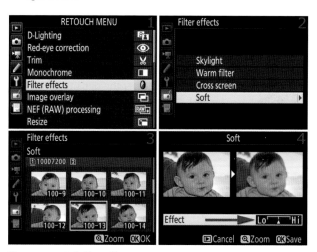

Figure 7.8 – Soft filter effect settings

Settings Recommendation: In comparing the levels of softness, I tend to like the middle setting, between Lo and Hi, best. The Low setting looks like I made a mistake, and the High setting seems too soft to me. Compare the three levels and see which one works best for you.

Image Overlay

(User's Manual: Page 294, Menu Guide: Page 145)

The *Image overlay* function is a nice way to combine two RAW images as if they were taken as a multiple exposure. You can select two NEF (RAW) shots and combine them into a single new overlaid image.

The results can be a lot like what you get when you use *Photo Shooting Menu > Multiple exposure,* but Image overlay gives you a visual way to overlay two separate images instead of shooting multiple exposures in one frame. The results can be high quality because the overlay is done using RAW image data.

Image Overlay Ideas

You can set up all sorts of special effects with Image overlay, from duplicating a person in a picture to making another person look transparent. Here's how:

- *Overlay idea #1:* Shoot two separate pictures of the same person against a solid colored background. Have the person stand on the right side in one picture and on the left side in the other picture. Have the person extend a hand, as if to shake hands. Overlay the two images and adjust the density to match. See if you can make people believe that long-lost twins just met.
- *Overlay idea #2:* With your camera on a tripod, take a picture of someone sitting on the left side of a couch. Without moving the camera, shoot another person sitting on the right side of the same couch. Overlay the two images and lower the density of the second image so it is partially transparent, or ghosted.

Figure 7.9 – Image overlay (combining two images into one)

Use the following steps to do an Image overlay:

1. Select Image overlay from the Retouch Menu and scroll to the right (figure 7.9, image 1).
2. Highlight RAW under the Image 1 heading with the yellow box (figure 7.9, image 2). This is for the first NEF (RAW) image in the overlay process. Press the OK button to open the image selection screen.

3. NEF (RAW) images will be the only pictures that appear in the selection screen. Choose the first NEF (RAW) image by highlighting an image in the list of pictures (figure 7.9, image 3). Press the OK button to select a picture and return to the combination screen.

4. The image you just selected will appear under the Image 1 position (figure 7.9, image 4). At this point, you can vary the gain (density) of the first image by using the Multi selector to scroll up or down in the X1.0 field. The X1.0 setting is variable from X0.1 to X2.0. It lets you control how bright (transparent) or dark (dense) an image is so it can more closely match the density of the other image in the overlay. X1.0 is normal image density.

5. Use the Multi selector to move the yellow box to the Image 2 position (figure 7.9, image 5). Press the OK button to open the selection screen to choose the second NEF (RAW) image for the overlay.

6. Highlight the second RAW picture (figure 7.9, image 6), then press the OK button again to select it.

7. The second RAW image will now appear in the Image 2 position of the overlay combination screen (figure 7.9, image 7). Use the X1.0 field to vary the density of the second image. Try to match the density as much as possible to provide a realistic overlay, unless you are trying to create a special effect, such as ghosting.

8. Use the Multi selector to move the yellow box to the Preview area. You'll see two selections below it: Overlay and Save. Choose one of them and press the OK button (figure 7.9, image 8).

9. If you select Overlay, the camera will temporarily combine the images, and you'll see a preview screen (not shown) that displays a larger view of the new image. You can press the OK button to save the image with a new file name, or you can press the Playback zoom out/thumbnails (ISO) button to return to the previous screen.

10. If you choose Save instead of Overlay and press the OK button, the D7200 immediately combines the two images and saves the new image with a new file name without letting you preview the image first. It will be displayed on the Monitor in final combined form (figure 7.9, image 9). Basically, the Save selection saves immediately, and Overlay gives you a preview of the combination so you can modify or save it.

Settings Recommendation: This is an easy way to overlay images without a computer. There are some drawbacks, though. One image may have a strong background that is impossible to remove, no matter how much you fiddle with the image density (X0.1 to X2.0). This is a situation in which a computer excels, since you can use software tools, like masking in Photoshop, to remove parts of the background and make a more realistic overlay. However, if you must combine two simple images in the field, you have a way to do it in-camera.

NEF (RAW) Processing

(User's Manual: Page 295, Menu Guide: Page 148)

NEF (RAW) processing is a function that allows you to convert a RAW image to a JPEG inside the camera. If you normally shoot in RAW but need a JPEG quickly, this is a great function. It works only on images taken with the D7200, so you can't insert a card from a different Nikon camera and expect to process those images.

There are a lot of things you can do to an image during NEF (RAW) processing. A RAW file is not yet an image, so the camera settings you used when you took the picture are not permanently applied. In effect, when you use NEF (RAW) processing you are applying the camera settings to the JPEG image after the fact, and you can change the settings you used when you originally took the picture.

You can apply settings when you take a picture through the Photo Shooting Menu or by using external camera controls. However, with NEF (RAW) processing, the settings are applied to the image after the fact, instead of while shooting. See the chapter titled **Photo Shooting Menu** (page 56) for a thorough explanation of each setting.

Let's see how to convert a RAW image to JPEG—in the camera. If you don't like working with computers but like to shoot RAW images, this is an important function!

Here's a list of post-shooting adjustments you can make with in-camera NEF (RAW) processing, with basic explanations of each function:

- *Image quality:* With NEF (RAW) processing, you are converting a RAW file to a JPEG file, so the camera gives you a choice of FINE, NORM, or BASIC. These are equivalent to the *Photo Shooting Menu > Image quality* settings called JPEG fine, JPEG normal, or JPEG basic.
- *Image size:* This lets you select how large the JPEG file will be. Your choices are L, M, or S, which are equivalent to the Large (24.2 MP), Medium (13.6 MP), and Small (6.0 MP) settings in *Photo Shooting Menu > Image size.*
- *White balance:* This lets you change the White balance of the image after you've already taken the picture. You can select from a series of symbols that represent various types of White balance color temperatures. As you scroll up or down in the list of symbols, notice that the name of the corresponding White balance type appears just above the small picture. You can see the effect of each setting as it is applied.
- *Exposure compensation:* This function allows you to brighten or darken the image by applying +/– Exposure compensation to it. You can apply exposure compensation up to 2 EV in either direction (−2.0 EV to +2.0 EV).
- *Set Picture Control:* With this setting you can apply a different Picture Control than the one with which you took the image. It shows abbreviations—such as SD, NL, VI, MC, PT, LS, or FL—for each Picture Control, plus any Custom Picture Controls you might have created with the designation of C-1, C-2, C-3, and so forth.

- **High ISO NR:** You can change the amount of High ISO NR applied to the image. The camera has H, N, L, or Off settings, which are equivalent to the *Photo Shooting Menu > High ISO NR* settings called High, Normal, Low, and Off.
- **Color space:** You can choose from the camera's two Color space settings: sRGB or Adobe RGB. Adobe RGB is abbreviated as AdobeRGB in this setting. This is equivalent to the *Photo Shooting Menu > Color space setting*.
- **Vignette control:** This setting allows you to control how much automatic vignette (dark corner) removal you want to use. If a particular lens regularly causes light falloff in the corners of your pictures, this function can be useful. You can select from H, N, L, or Off.
- **D-Lighting:** This lets you manage the level of contrast in the image by brightening the shadows and protecting the highlights. You have four choices: Low (L), Normal (N), High (H), and Off.
- **EXE:** This simply means execute. When you select EXE and press the OK button, all your new settings will be applied to a new JPEG image, and it will be saved to the memory card with a separate file name.

Figure 7.10A – NEF (RAW) processing

Now, let's look at the steps you can use to convert a file from NEF (RAW) to JPEG in-camera:

1. Select NEF (RAW) processing from the Retouch Menu and scroll to the right (figure 7.10A, image 1).
2. Only NEF (RAW) images will be displayed in the selection screen that opens. Select a RAW image with the Multi selector and then press the OK button (figure 7.10A, image 2). Now we'll look at each setting shown in figure 7.10A, image 3. The following steps, and figures 7.10B through 7.10N, begin where figure 7.10A, image 3, left off.

Figure 7.10B – NEF (RAW) processing – Image quality

3. Select one of the Image quality settings—FINE, NORM, or BASIC—from the Image quality menu (figure 7.10B). FINE gives you the best possible quality in a JPEG image. After you select the setting you want to use, press the OK button to return to the main NEF (RAW) processing configuration screen. You can cancel the operation with the Playback button. You can zoom in to check the image quality with the Playback zoom in (QUAL) button.

Figure 7.10C – NEF (RAW) processing – Image size

4. Select one of the Image size settings from the Image size menu (figure 7.10C). Your choices are L (24.0 MP), M (13.5 MP), and S (6.0 MP). Select the setting you want to use then press the OK button to return to the main NEF (RAW) processing configuration screen. You can cancel the operation with the Playback button.

Figure 7.10D – NEF (RAW) processing – White balance

5. Select one of the White balance settings for your new JPEG (figures 7.10D to 7.10G). You can choose from AUTO, Incandescent, Fluorescent, Direct sunlight, Flash, Cloudy, Shade, K-Choose color temp., or PRE–Preset manual (figure 7.10D, image 2). A1 and A2 (figure 7.10D, image 3) refer to normal (A1) and slightly warmer (A2) White balance settings. The tint of the White balance can be fine-tuned in figure 7.10D, image 4. Please review the chapter titled **White Balance** on page 449 for information on each of these

items. The Fluorescent, K, and PRE settings have additional screens with choices that you must select. Let's examine the extra screens in those three settings.

Figure 7.10E – NEF (RAW) processing – White balance – Fluorescent

- **Fluorescent:** You must choose a type of fluorescent light. There are seven choices, with names like Sodium-vapor, Warm-white, Cool-white, and so forth. Each choice has a number assigned to it. Figure 7.10E, image 3, shows Cool-white fluorescent, which is number 4 on the list. Scroll to the right to move to the fine-tuning screen, where you can adjust the color tint of the image by moving the black dot in the color box with the Multi selector (figure 7.10E, image 4). You can immediately press the OK button for no changes, or you can make fine-tuning changes and press the OK Button to save the setting, or you can press the Playback button to cancel.

Figure 7.10F – NEF (RAW) processing – White balance – K-Choose color temp.

- **K-Choose color temp.:** You can choose a color temperature from the list shown in figure 7.10F, image 3. Remember that color temperatures change how the image color looks. The list ranges from 2500K (cool) to 10000K (warm). You can also use the fine-tuning screen to modify the color's base (figure 7.10F, image 4). Press the OK button to save the setting, or press the Playback button to cancel.

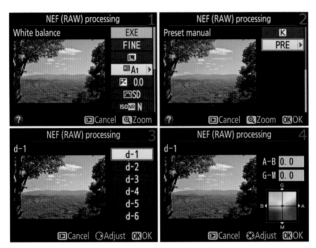

Figure 7.10G – NEF (RAW) processing – White balance – PRE-Preset manual

- **PRE–Preset manual:** With this setting you can choose a saved White balance while letting the camera measure the ambient light reflected from a gray or white card (the PRE method). See the chapter titled **White Balance** on page 459 for information on doing ambient light (PRE) readings. You can choose from up to six previous PRE readings that are stored in memory locations d-1 to d-6 (figure 7.10G, image 3). As you scroll through the list of settings, you'll see the color temperature of the image change. My current d-1 setting contains an ambient light reading White balance (WB) from a gray card. The WB reading was around 5K color temperature; therefore, the color of the foliage looks about right for a sunny summer day, which is about 5500K. Select the setting you want to use and press the OK button to return to the main NEF (RAW) processing configuration screen, or you can scroll to the right and fine-tune the colors of the individual WB setting (figure 7.10G, image 4). You can see your fine-tuning adjustment change the color temperature of the image on the Monitor. If you decide you don't want to fine-tune the WB, simply press the OK button when you get to the fine-tuning screen. The camera will return to the main NEF (RAW) processing configuration screen. You can cancel the operation by pressing the Playback button.

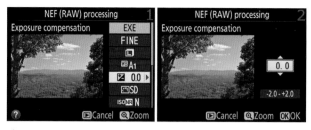

Figure 7.10H – NEF (RAW) processing – Exposure comp.

6. Now you can lighten or darken the image by selecting an Exposure compensation value from −2.0 EV to +2.0 EV steps (figure 7.10H, image 2). When the image looks right, press the OK button to return to the main NEF (RAW) processing configuration screen. You can preview the image with the Playback zoom in (QUAL) button or cancel the operation by pressing the Playback button.

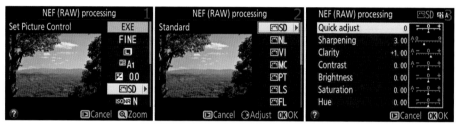

Figure 7.10I – NEF (RAW) processing – Set Picture Control

7. Next you can apply a Nikon Picture Control or one of your own Custom Picture Controls, if you've created any (figure 7.10I, image 2). These controls change how the image looks. You can make it sharper and give it more contrast, give it more or less color saturation, or change it to monochrome. In fact, you can even modify the settings of the current Picture Control by using the fine-tuning screen (figure 7.10I, image 2). Choose from SD (Standard), NL (Neutral), VI (Vivid), MC (Monochrome), PT (Portrait), LS (Landscape), FL (Flat), or C-1 to C-9 (Custom Picture Controls), which appear farther down the list than shown in figure 7.10I, image 2. You can scroll to the right with the Multi selector if you want to fine-tune the image (figure 7.10I, image 3). Scroll up or down to select one of the settings (e.g., Sharpening, Contrast, Saturation) and scroll left or right to modify the selected setting. If you make a mistake and want to start over, press the Delete button. The camera will display a screen that says *Selected Picture Control will be reset to default settings. OK?* Choose Yes or No and press the OK button. If a Picture Control is configured differently than the factory default, an asterisk will appear next to its name in all menus (e.g., SD*). The Monochrome (MC) Picture Control lets you adjust not only settings such as Sharpening, Contrast, and Brightness in the fine-tuning screen, but it also gives you toning (tint) controls like the *Photo Shooting Menu > Set Picture Control* function. When the image looks right, press the OK button to return to the main NEF (RAW) processing configuration screen. You can cancel the operation by pressing the Playback button.

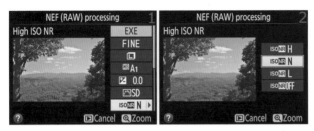

Figure 7.10J – NEF (RAW) processing – High ISO NR

8. If the image needs high ISO noise reduction, you can apply it now (figure 7.10J, image 1). You have a choice of four settings: High (H), Normal (N), Low (L), or Off (figure 7.10J, image 2). Choose one and press the OK button to return to the main NEF (RAW) processing configuration screen. You can cancel the operation by pressing the Playback button. You can zoom in and check the image by pressing the Playback zoom in (QUAL) button.

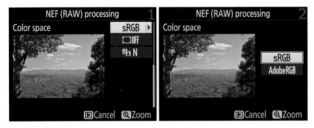

Figure 7.10K – NEF (RAW) processing – Color space

9. Color space lets you choose one of the camera's two color space settings: sRGB or Adobe RGB (figure 7.10K, image 2). Choose one and press the OK button to return to the main NEF (RAW) processing configuration screen. You can cancel the operation with the Playback button. You can zoom in and check the image first by pressing the Playback zoom in (QUAL) button.

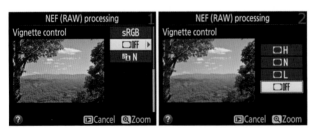

Figure 7.10L – NEF (RAW) processing – Vignette control

10. Vignette control (figure 7.10L) allows you to lighten the corners of your images automatically. One minor problem with a full-frame sensor is that the extra bending of light that reaches to the corners of the frame can cause a small amount of light falloff, or darkening of the corners and edges. This is called vignetting. The camera has four settings to control vignetting: high (H), normal (N), low (L), or Off. Normal (N) is generally the setting I use.

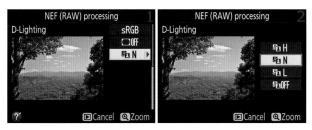

Figure 7.10M – NEF (RAW) processing – D-Lighting

11. D-lighting (figure 7.10M) is very similar to *Photo Shooting Menu > Active D-Lighting* in that it restores shadow detail and protects highlights in your images. However, D-Lighting is applied after the fact, and Active D-Lighting is applied at the time the image is taken. Otherwise they are basically the same thing. You can select from high (H), normal (N), low (L), or Off (figure 7.10M, image 2). Press the OK button to set the D-Lighting level, or press the Playback button to cancel.

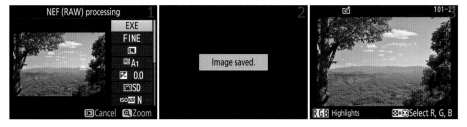

Figure 7.10N – NEF (RAW) processing – EXE (execute)

12. When you are finished with NEF (RAW) processing, scroll up to the EXE (execute) selection and press the OK button (figure 7.10N, image 1). An hourglass will display for a few seconds while the new JPEG is being saved with your carefully crafted settings. A screen that says *Image saved* will appear briefly (figure 7.10N, image 2), and then the new JPEG will be displayed in a normal Playback screen (figure 7.10N, image 3) and will be saved on the memory card with a new file name. You can cancel the operation with the Playback button.

With this NEF (RAW) processing function you can actually go out and shoot RAW files and turn them into nicely crafted JPEGs without using a computer. Postprocessing is built into the camera!

Settings Recommendation: NEF (RAW) processing is a complex, multistep process because you're doing a major conversion from NEF (RAW) to JPEG in-camera. You're in complete control of each level of the conversion and can even replace the camera settings you originally used when you took the picture. If you want to simply convert the image without going through all these steps, just choose the EXE selection and press the OK button. That will convert the image with the camera settings you used to do the previous conversion, or it will use the factory default settings if you have not previously converted an image on this camera.

Resize

(User's Manual: Page 295, Menu Guide: Page 150)

The *Resize* function allows you to convert an image from a full-size 24.2 MP picture (6000 × 4000) to a smaller one, with four extra-small sizes. This function lets you create images that can easily be emailed or used on a website or blog.

There are three selections:
- ***Select image:*** This selection allows you to choose one or more images for resizing
- ***Choose destination:*** This selection allows you to choose a destination for the resized pictures
- ***Choose size:*** You can choose from four image sizes:
 a. 1920 × 1280 – 2.5 M
 b. 1280 × 856 – 1.1 M
 c. 960 × 640 – 0.6 M
 d. 640 × 424 – 0.3 M

Let's examine the steps for resizing images:

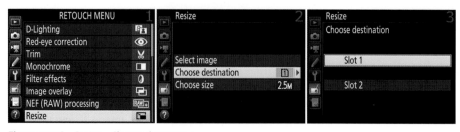

Figure 7.11A – Resize – Choose destination

1. Select Resize from the Retouch Menu and scroll to the right (figure 7.11A, image 1). Although it seems out of order, select Choose destination and scroll to the right (figure 7.11A, image 2). Select one of the card slots to be the destination for the resized images and press the OK button (figure 7.11A, image 3). This selection will be grayed out if one of the memory card slots is empty. In that case the destination will be the card slot that contains a card. Skip this step if you are using only one memory card.

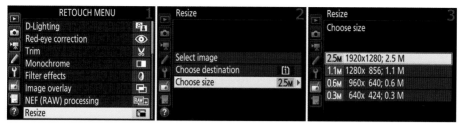

Figure 7.11B – Resize – Choose size

2. Next, select Choose size and scroll to the right (figure 7.11B, image 2). You'll see four sizes, from 2.5 M to 0.3 M (figure 7.11B, image 3). These are the actual megapixel sizes available for images after you save them. Select a size and press the OK button.

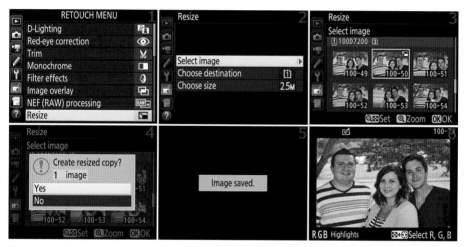

Figure 7.11C – Resize – Select image

3. Next, choose Select image and scroll to the right (figure 7.11C, image 2). You'll see six image thumbnails. Use the Multi selector to scroll around in this group of thumbnails. When you see an image you want to resize, press the Playback zoom out/thumbnails (ISO) button to Set the image as the one to be resized. You can select and Set as many images as you'd like, and each of them will be resized. A tiny resize symbol will appear in the top-right corner of each thumbnail you Set (figure 7.11C, image 3). When you are done selecting images, press the OK button. A message will ask, *Create resized copy?* (figure 7.11C, image 4). Select Yes and press the OK button to create the resized image(s). A screen that says *Image saved* will briefly appear (figure 7.11C, image 5). The last image in the group of resized images will display (figure 7.11C, image 6). The resized images will look just like the originals, except for the palette-and-paintbrush retouch icon in the top-left corner (figure 7.11C, image 6) and the reduced size.

Settings Recommendation: I use this function when I'm in the field and want to make a small image to send via email. The full-size JPEG file is often too large to send through some email systems. It's nice to have a way to reduce the image size without having to find a computer. Please notice that this function does not reduce the image size by cropping, like the Trim function we studied earlier. Instead, it simply reduces the image in the same aspect ratio as the original, and it has a smaller megapixel size.

Quick Retouch

(User's Manual: Page 295, Menu Guide: Page 153)

If you want to simply adjust an image so that all parameters are within viewable range, use the *Quick retouch* function. It creates a new copy of an existing image with "enhanced saturation and contrast," according to the User's Manual. D-Lighting is automatically applied to your old image, and the new image is supposed to look better. You can scroll up and down in the preview screen to see the range of enhancements that can be applied when the new image is created.

Figure 7.12 – Quick retouch of the image

Here are the steps to Quick retouch an image:

1. Select Quick retouch from the Retouch Menu and scroll to the right (figure 7.12, image 1).
2. You'll see the images that are eligible for Quick retouch. Use the Multi selector to scroll to an image you want to retouch, and press the OK button to select it (figure 7.12, image 2).

3. Use the Multi selector to scroll left or right, and select from a range of Lo to Hi (figure 7.12, image 3). I chose the medium setting in between the two. You can preview the effect of your changes by looking at the before (left) and after images (right).
4. Press the OK button when you're satisfied. The new image will be created and displayed on the Monitor (figure 7.12, image 4).

Settings Recommendation: This function can help some images have a little more snap. I use Quick retouch only if I am going to give someone a JPEG image directly out of the camera, using the Wi-Fi system, and want to enhance it a little first.

Straighten

(User's Manual: Page 295, Menu Guide: Page 153)

Straighten is another really cool function. Often, when I shoot a landscape or ocean view handheld, I forget to level the horizon. With Straighten I can level the image before anyone else sees it.

You can rotate an image up to 5 degrees clockwise or counterclockwise. You use the Multi selector to scroll right or left through a graduated scale. Each increment is equal to about 0.25 degrees. As you rotate the image, the camera will automatically trim the edges so the picture looks normal. Of course, this means you are throwing away some of the image and making it smaller. However, it's better for the image to be a little smaller and have a nice level horizon, don't you think?

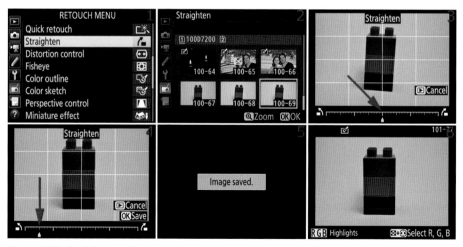

Figure 7.13 – Straighten an image

Here are the steps to Straighten or level an image:

1. Select Straighten from the Retouch Menu and scroll to the right (figure 7.13, image 1).
2. With the Multi selector, scroll to the image you want to straighten and press the OK button to select it (figure 7.13, image 2).
3. Rotate the image to the right (clockwise) or the left (counterclockwise) in 0.25 degree increments with the Multi selector (figure 7.13, image 3). Notice that there is a yellow pointer in the middle of the scale below the image in figure 7.13, image 3. This image needs to be rotated to the left, so in figure 7.13, image 4, you can see that I pushed the yellow pointer toward the left, which rotated the image counterclockwise. When you are happy with the new image, press the OK button to save it, or press the Playback button to cancel.
4. A screen that says *Image saved* will briefly appear (figure 7.13, image 5).
5. You'll see the newly straightened and saved image on the Monitor (figure 7.13, image 6).

Settings Recommendation: This is a handy function to level an image—as long as it is not tilted more than 5 degrees—without using a computer.

Distortion Control

(User's Manual: Page 295, Menu Guide: Page 154)

The *Distortion* control function is a companion to the Straighten function. The Straighten function levels the image from left to right, and the Distortion control function addresses barrel and pincushion distortion.

Figure 7.14A – Extreme barrel (left) distortion and pincushion (right) distortion

As seen in figure 7.14A, barrel distortion causes the edges of a subject to bow outward, like a barrel (left image). Pincushion distortion is the opposite; the edges bow inward, like an hourglass (right image).

In many cases, wide-angle lenses tend to have some barrel distortion at their widest settings, while many telephoto lenses evidence a degree of pincushion distortion at their longest settings. You will rarely see distortion as bad as that shown in figure 7.14A; however, most lenses have a little distortion and could use minor corrections for straight lines in the image. The Distortion control allows you to do just that before the image leaves the camera.

Using this control will remove some of the image edges as distortion compensation takes place. There are two settings in the Distortion control function: Auto and Manual.

Auto Distortion Control

You can use this setting only if you have a D or G lens on your D7200. Select Auto when you want the camera to automatically make rough distortion adjustments, and then you can fine-tune the adjustments yourself if you think the new image needs it.

Figure 7.14B – Auto Distortion control

Here are the steps to let the camera make an Auto distortion adjustment:

1. Select Distortion control from the Retouch Menu and scroll to the right (figure 7.14B, image 1).
2. Choose Auto from the menu and scroll to the right (figure 7.14B, image 2).
3. With the Multi selector, select the image you want to fix and press the OK button (figure 7.14B, image 3). You can zoom in to check the image first by pressing the Playback zoom in (QUAL) button.

4. The camera will automatically make its best adjustment and then display the adjusted image (figure 7.14B, image 4, red arrow). The yellow adjustment pointer will be centered along the scale at the bottom of the screen. You can move the pointer between barrel and pincushion distortion adjustments, as represented by the small icons on either end of the scale (the barrel is on the left, and the pincushion is on the right).

5. If you are not satisfied with the camera's Auto adjustment, use the Multi selector to move the yellow pointer to the left to remove pincushion distortion (add barrel) or to the right to remove barrel distortion (add pincushion). I chose full pincushion distortion correction by adding barrel (figure 7.14B, image 5, red arrow).

6. When you are happy with the appearance of the image, press the OK button to save it, or press the Playback button to cancel. You'll see the new adjusted image on the Monitor (figure 7.14B, image 6).

The effect is not easy to see in these small images or on the Monitor of the camera. However, if you look closely at figure 7.14B, image 4, and compare it to image 5, you can see a slight difference. Images that need greater adjustments should be corrected on a computer with full-sized images.

Manual distortion adjustments work the same way, except the camera does not make an Auto adjustment before displaying an image that you can manually adjust.

Note: This function will not work with any images that were taken with the *Photo Shooting Menu > Auto distortion control* set to On. You will see a yellow square surrounding an X overlaying the image if it is not acceptable to the Distortion Control function (figure 7.14B, image 3). There is no need to use Distortion control on an image that has already had distortion removed with the Auto distortion control.

Manual Distortion Control

You are in control of this operation. You can adjust the distortion in the image until you think it looks good, without interference from the camera.

Here are the steps to manually correct distortion:

1. Select Distortion control from the Retouch Menu and scroll to the right (figure 7.14C, image 1).

2. Choose Manual from the menu and scroll to the right (figure 7.14C, image 2).

3. Use the Multi selector to scroll to the image you want to fix, and press the OK button to select it (figure 7.14C, image 3). You can zoom in to check the image first by pressing the Playback zoom in (QUAL) button.

4. The image will be displayed with the yellow pointer centered under the scale on the bottom of the screen (figure 7.14C, image 4). No adjustment has been made yet.

5. Move the yellow pointer along the scale to the left to remove pincushion distortion (add barrel) or to the right to remove barrel distortion (add pincushion). I chose full pincushion distortion correction by adding barrel (figure 7.14C, image 5, red arrow).

6. When you are happy with the appearance of the image, press the OK button to save it, or press the Playback button to cancel.

7. You'll see the new adjusted image on the Monitor.

Figure 7.14C – Manual Distortion control

As with the Auto distortion adjustment, the Manual distortion adjustment is rather minor. If you look closely at figure 7.14C, image 4, and compare it to image 5, you'll see that the golden D7200 box appears slightly less distorted.

Settings Recommendation: These functions are not overly useful because they do not allow for larger corrections. However, they do allow minor distortion correction. Use a program on your computer, such as Photoshop or Lightroom, for greater distortion corrections.

Fisheye

(User's Manual: Page 295, Menu Guide: Page 155)

The *Fisheye* function is quite fun! You can distort your friends and make hilarious pictures that will make everyone laugh (well, maybe not everyone). Although the results are not true circular fisheye images, they do have a similar distorted appearance.

Figure 7.15A shows three samples of the Fisheye setting. Notice the small yellow pointer at the bottom under the scale. The farther toward the right you move it, the more distorted the image. The first image is normal, the second and third images are more distorted, and the fourth image is fully fisheyed! (Can you detect trouble brewing with wives and girl-friends? I used a picture of me to stay out of trouble!)

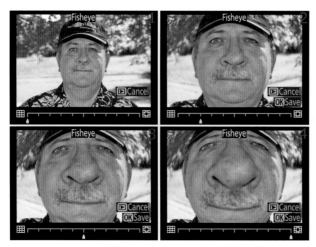

Figure 7.15A – Fisheye distortion samples

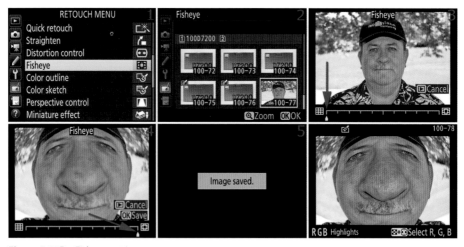

Figure 7.15B – Fisheye settings

Here are the steps to use Fisheye to distort one of your images:

1. Select Fisheye from the Retouch Menu and scroll to the right (figure 7.15B, image 1).
2. Scroll to the image you want to distort and press the OK button to select it (figure 7.15B, image 2).
3. Now press the Multi selector to the right and watch the yellow pointer move and the distortion grow (figure 7.15B, images 3 and 4).
4. When you've found the perfect distortion amount (to the max, right?), simply press the OK button to save the image, or press the Playback button to cancel. An *Image saved* screen will appear briefly, and the finished product will appear on the Monitor (figure 7.15B, images 5 and 6).

Settings Recommendation: Be careful with this one! If you publish many pictures of your friends with this effect, I'm afraid they'll start running when they see you with your camera.

Color Outline

(User's Manual: Page 295, Menu Guide: Page 155)

Have you ever wanted to convert one of your images to a cartoon or a line drawing? *Color outline* will do it for you! This retouch setting creates an interesting outline effect on the distinct lines or color changes in your image.

Figure 7.16A – Color outline sample

Figure 7.16A shows an original image and the image after Color outline was applied. The final image is not actually in color.

You can convert an image to a color outline by opening it in Photoshop and using the fill functions to add cartoon colors between the lines (like the Color sketch function, coming up next). Or you can post-process the image into a fine-art line tracing. This is an unusual functionality and shows the direction that our highly computerized cameras are going. They have computer power built in, so why not make use of it in new and fun ways?

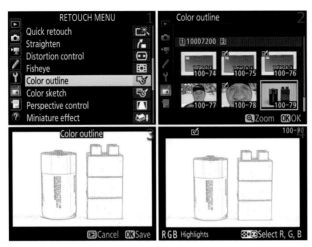

Figure 7.16B – Color outline settings

Here are the steps to create a Color outline:

1. Choose Color outline from the Retouch Menu (figure 7.16B, image 1).
2. Select an image from the list of thumbnails. You can either press the OK button to start the conversion to outline form, or press the Playback zoom in (QUAL) button to check the image first (figure 7.16B, image 2). After conversion, press the OK button to save the new image, or press the Playback button to cancel.
3. The converted image will display a save option (figure 7.16B, image 3). Press the OK button to save the image, or the Playback button to cancel. If you selected Save, the new image will appear on the Monitor (figure 7.16B, image 4).

Settings Recommendation: The Color outline setting gives you the opportunity to be creative and have some fun with your images. It makes a very sparse image that resembles a line drawing. You could use this as a basis for a painting, hand coloring, or just to have a cool-looking image that most cameras won't make.

Color Sketch

(User's Manual: Page 295, Menu Guide: Page 156)

With the *Color sketch* setting you can create a copy of your image that looks like a sketch made with colored pencils or crayons. This function is similar to Color outline, except it uses pastel colors instead of edge-only grayscale. Figure 7.17A shows an image before and after Color sketch was applied.

Figure 7.17A – Color sketch sample

You can convert an image to a Color sketch and change the Vividness (pastel color saturation) and Outlines (line and color contrast) until it meets your needs. I maxed out both settings in figure 7.17A, image 2).

Figure 7.17B – Color sketch settings

Use the following steps to create a Color sketch:

1. Choose Color sketch from the Retouch Menu (figure 7.17B, image 1).
2. Select an image and press the OK button (figure 7.17B, image 2).
3. You can now set the Vividness, or color saturation, of the pastel colors. Change the Vividness until you like the look (figure 7.17B, image 3).
4. Next, you'll choose an Outlines setting, which will change the contrast of the lines and colors (figure 7.17B, image 4).
5. I set Vividness to the maximum (+) (figure 7.17B, image 5, red arrow) and left Outlines on a medium setting. Press the OK button to make the new image, or press the Playback button to cancel. You can zoom in with the Playback zoom in (QUAL) button to check the image before you save it.
6. The new image will display on the Monitor (figure 7.17B, image 6).

Settings Recommendation: Like Color outline, the Color sketch function lets you play around with the post-processing computer built into your camera. Occasionally I like to play with these functions. Are they really useful? Well, I guess it depends on how often you need a Color outline or Color sketch. Maybe you have a great use for them in mind.

Perspective Control

(User's Manual: Page 296, Menu Guide: Page 157)

Perspective control gives you control over some forms of perspective distortion in your images. When you take a picture from the base of a tall object, like a building, with a wide-angle lens, the building looks like it's falling over backward. With large-format view cameras, you can correct the problem by using their rise, fall, shift, tilt, and swing controls.

Nikon makes perspective-control lenses that perform some of the functions of a view camera, namely tilt and shift. However, good view cameras and perspective-controls lenses cost significantly more than the D7200 camera.

Nikon has given D7200 users some image correction capability with the Straighten, Distortion control, and Perspective control functions. We discussed the first two functions earlier in this chapter. Now let's see how to use Perspective control.

Perspective control allows you to stretch the left, right, top, or bottom of an image to tilt leaning objects so they appear straighter in the corrected image. Figure 7.18A, image 3, shows the yellow pointers (red arrows) you can move to change the perspective of an image by tilting the top toward you or away from you or rotating the image to the left or right. This is a powerful control because it can help give certain images a much better perspective.

Figure 7.18A – Adjusting an image with Perspective control

Use the following steps to configure Perspective control:

1. Select Perspective control from the Retouch Menu and scroll to the right (figure 7.18A, image 1).
2. Choose an image from the list of thumbnails and press the OK button (figure 7.18A, image 2).
3. You'll see gridlines for edge comparison and two slider controls that are operated by the Multi selector (figure 7.18A, image 3, red arrows). You can move the yellow pointer on

the vertical scale up or down to tilt the top of the image toward you or away from you. Or you can slide the yellow pointer on the horizontal scale to the left or right to turn the edges toward you or away from you.

4. When the image looks the way you want it, press the OK button to save the image, or press the Playback button to cancel.

Figure 7.18B – Tilting the top of the image

The images in figure 7.18B show what happens to the subject when you use the vertical slider (red arrows). Notice how the top of the subject leans either toward you or away from you (forward-to-backward tilt) depending on how the slider is positioned.

Figure 7.18C – Rotating the sides of the image

Figure 7.18C shows how the image swings to the left or right as you move the yellow sliders along the horizontal scale (red arrows). Can you see how powerful this function is for controlling perspective? The camera automatically crops off the top and bottom of the stretched ends to keep the image looking like a normal rectangle, so the final image will be somewhat smaller.

Settings Recommendation: Learn to use this powerful function! You now have excellent Perspective control, with no additional lens purchases! Add Straighten for leveling horizons (rotating the image), then Distortion control for removing barrel and pincushion distortion. You have the basics of a graphics program built right into your camera.

Miniature Effect

(User's Manual: Page 296, Menu Guide: Page 158)

Miniature effect is unusual because it allows you to create a reverse diorama. A diorama is a small 3-D model that looks like the real thing. You may have seen a city diorama, where there are tiny detailed houses and cars and even figures of people. A diorama is often used to make a movie when the cost would be too high to use real scenes.

I call the Miniature effect a reverse diorama because the camera takes an image that you have shot and uses a very narrow band of sharpness with a very shallow depth of field to make it look like a diorama, but it is actually real.

Figure 7.19A – Miniature effect reverse diorama

Figure 7.19A is a sample Miniature effect image I took while overlooking a mountain scene. It's best to shoot this type of image from a high vantage point so it looks like a real miniature.

The camera added extra saturation to the image to make the subject look unreal. Notice that there is a band of sharpness running horizontally across the middle of the image. That very shallow depth of field in a full-sized image makes it look fake. The depth of field is usually that narrow only in closeup and macro shots.

Figure 7.19B – Miniature effect settings

Here are the steps to create your own Miniature effect reverse diorama:

1. Select Miniature effect from the Retouch menu and scroll to the right (figure 7.19B, image 1).
2. Choose an image from your camera's memory card that was shot from a high vantage point that would make a good reverse diorama and press the OK button (figure 7.19B, image 2).
3. Notice the narrow yellow rectangle in figure 7.19B, image 3. This band represents a horizontal, movable band of sharpness. You can move it up or down on the screen by scrolling up or down with the Multi selector, until you find the optimum place to put the sharpness. Everything above and below the band is blurry. If you are working with a vertical image, the band will be vertical instead of horizontal. You can change the width of the band of sharp focus by scrolling left or right with the Multi selector for a horizontal orientation (figure 7.19B, image 4, red arrow). In image 3, you see the default-width band of sharpness. In image 4, I narrowed the band of sharpness. You can also widen it.
4. To change the band's orientation, press the Playback zoom out/thumbnails (ISO) button (figure 7.19B, image 5, red arrow). Once the orientation is changed you can move the band of sharp focus to where it looks best, and modify the width of the band, with the Multi selector. After you position the band where you want it, press the OK button (Save).
5. You will see an *Image saved* screen briefly appear, then the new Miniature effect image will be displayed on the Monitor (figure 7.19B, image 6). It is saved with a new file name on your memory card.

Settings Recommendation: You can get good effects when you are looking down on your subject, such as from a bridge, the top of a building, or an airplane. It's a lot of fun to make these images. Next time you are high above a real scene with lots of detail, try shooting a Miniature effect image for fun.

Selective Color

(User's Manual: Page 296, Menu Guide 159)

Selective color allows you to create black-and-white still images with selective colors left in. We have all seen pictures of a lovely red rose with only the petals in color while the rest of the image is black-and-white. Well, the Nikon D7200 goes a step further and allows you to create black-and-white images with up to three selective colors. Let's see how to do it.

Figure 7.20A – Using Selective color

Use these steps to create black-and-white images with up to three selective colors:

1. Select Selective color from the Retouch Menu and scroll to the right (figure 7.20A, image 1).
2. Choose an image to use as a base and press the OK button (figure 7.20A, image 2).
3. Turn the Main command dial to select one of the color boxes (figure 7.20A, image 3, top red arrow) where you will store the colors you want to retain in your image. Turn the Main command dial multiple times in either direction to make it skip over a color box and move to the next box.
4. Use the Multi selector to scroll the yellow selection box to the location in the image from which you want to choose a color, then press the AE-L/AF-L button to select it (figure 7.20A, image 3, bottom red arrow). You can zoom in with the Playback zoom in (QUAL) button to select a color more precisely from a small section of the subject, and you can zoom back out with the Playback zoom out/thumbnails (ISO) button. You can see that I chose the color of the red Lego block for one of the color choices. In figure 7.20A, image 4, you can see that I chose the color of the green Lego block as the second color to keep. I pressed the AE-L/AF-L button to capture the color and store it in the second color box (red arrows). Figure 7.20A, image 5, shows that I chose the color of the blue Lego block and stored it in the third color box (red arrows).

5. You can adjust the range of colors that will be retained by highlighting the up/down selector next to a color box by turning the Main command dial to select the up/down control and then using the Multi selector to raise or lower the number from 1 to 7 (figure 7.20A, image 6, red arrow). I lowered the sensitivity value for the red color all the way down to 1 because the gold of the Nikon box was close enough to red that the gold color would not quite disappear without the lowest red setting, and even with the lowest red setting there is still a tinge of gold left over in the box color. Evidently, the copper color on the top of the Coppertop battery was close enough to red that even a lower red sensitivity would not remove the color. The higher the number, the more colors similar to the selected color in the color box will be retained (wider color sensitivity), and vice versa (lower up/down control values equal a narrower color range sensitivity).

6. After you have finished configuring the Selective color system, you can press the OK button to save the image. An hourglass will stay on the screen for a few seconds while the camera removes the colors you have disallowed, and an *Image saved* screen will appear briefly. The final image will then appear on the Monitor and will be saved under a new file name. Figure 7.20B shows before and after images.

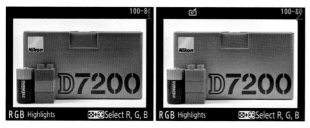

Figure 7.20B – Before (1) and after Selective color (2)

Settings Recommendation: In figure 7.20B, image 2, I selected only the green color and removed all other colors. As you can clearly see in image 2, only the color green is still left in the image, while all other colors are now rendered in monochrome.

Selective color images are a lot of fun. You can shoot images and later remove most of the colors for fine art black-and-white images. Other than the clunky interface surrounding the color boxes, this function is a useful one. You may want to spend a few minutes learning to use it and then see if you can make some art.

Edit Movie

(User's Manual: Page 296, Menu Guide: Page 161)

Edit movie gives you a two-step process to cut a section out of the middle of a movie created with your camera, or you can remove a beginning or ending segment. In addition, you can save an individual frame as a still image from anywhere in the movie.

There are two individual parts to the process of editing a movie—Choose start point and Choose end point—and you use them one at a time. When you complete one of the

start point or end point choices, the camera saves the file as a new movie with a new file name. This creates a bunch of smaller movies on your memory card that you'll need to delete—take care that you don't delete the wrong ones!

There are three parts to Edit movie:

- **Choose start point:** This allows you to delete frames from the beginning of your movie and choose a new starting point
- **Choose end point:** This allows you to delete frames from the end of your movie and choose a new ending point
- **Save selected frame:** You can take a low-resolution snapshot of any frame in the movie

Since Choose start point and Choose end point use exactly the same screens and steps, the two functions are combined in the next section. Do one function, then, if needed, do the other by repeating the steps.

Choose Start Point and Choose End Point

Let's examine the steps to remove a movie segment:

1. Press the Playback button to display movies and pictures on your Monitor. Scroll back and forth with the Multi selector and find the movie you would like to trim.

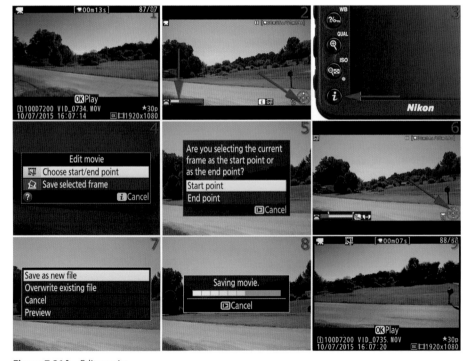

Figure 7.21A – Edit movie

2. Press the OK button to start playing the movie (figure 7.21A, image 1). Watch the progress bar in the bottom left corner of the movie until it gets close to the point where you want to trim it (figure 7.21A, image 2, left red arrow), then press down on the Multi selector to pause the movie (figure 7.21A, image 2, right red arrow). While the movie is playing, you can jump back or ahead by 10 seconds at a time by turning the Main command dial. You can also scroll left or right to examine individual frames. If you use the Main command dial while the movie is playing, it will automatically pause the movie when it jumps 10 seconds. You can start the movie again by pressing the OK button. You can make the movie display faster or slower (2x, 4x, 8x, and 16x) by tapping left or right on the Multi selector while the movie is playing. This can save time when you are dealing with a long movie. Basically, you want to get to the point in the movie where you plan to make the change, then move to the next step.

3. With the movie paused, press the *i* button (figure 7.21A, image 3), and the information shown in figure 7.21A, image 4, will appear. Highlight Choose start/end point and press the OK button.

4. Another message will appear, as shown in figure 7.21A, image 5, which gives you the choice of choosing the Start point or End point. Decide whether you are cutting off the beginning of the movie (Start point) or the end of the movie (End point), and press the OK button to execute the command.

5. Press up on the Multi selector (figure 7.21A, image 6, red arrow, which indicates a scissors symbol) and a new window will open and allow you to save the trimmed movie (figure 7.21A, image 7). From this screen you can choose Save as new file, Overwrite existing file (be careful, this destroys the original file), Cancel, or Preview. Cancel is self-explanatory. Preview plays the shortened movie without actually trimming it, and then it jumps back to the screen shown in figure 7.21A, image 7.

6. Press the OK button when you have highlighted your choice. If you selected Save as new file, the camera will save the new trimmed movie under a new file name and display it on the Monitor, ready for playing (figure 7.21A, screens 8 and 9).

7. Repeat these steps for trimming the other end of the movie, if you would like to, and select the opposite choice in step 4.

This editing process could leave several trimmed versions of the movie on your memory card—the final of which is the fully trimmed version—unless you choose Overwrite existing file. If you decide to use the overwrite method, back up the movie first in case you make a mistake.

Note: If a video has been previously edited, an editing symbol that resembles a frame of film overlaid with a pair of scissors will appear in the upper-left area of the video thumbnail when you see it on the Monitor (figure 7.21A, image 9). You *can* re-edit a movie that has been previously edited.

Your movie must be at least two seconds long when you're done or the camera will refuse to cut any more frames; it will give you the terse message *Cannot edit movie*.

Save Selected Frame

You can save an individual low-resolution frame from anywhere in the movie. The frame size is based on the *Movie Shooting Menu > Frame size/frame rate* setting:

- A 1920 × 1080 movie contains single still images of just over 2 MP
- A 1280 × 720 movie contains single still images of just under 1 MP

Figure 7.21B – Save selected frame from movie

Let's examine how it's done using the Retouch Menu:

1. Choose Edit movie from the Retouch Menu and scroll to the right (figure 7.21B, image 1).
2. Select Save selected frame and scroll to the right (figure 7.21B, image 2).
3. Choose one of the available movies and press the OK button (figure 7.21B, image 3).
4. Press the OK button to start playing the movie, and when it gets to the point where you want to cut out a frame, press down on the Multi selector to pause the movie (figure 7.21B, image 4). While the movie is playing, you can press left or right on the Multi selector to move through it a frame at a time until you find your favorite frame. You can jump 10 seconds forward or backward in the movie by rotating the Main command dial. Notice that the icon above the movie in image 4 looks like a frame being removed from a piece of film (red arrow).
5. Press up on the Multi selector when you have located the frame you want, and a small box will appear that says *Proceed? Yes/No* (figure 7.21B, image 5). Choose Yes from the menu, and the camera will make a copy of the frame as a separate image. While the selected frame is being saved you will see an hourglass then a screen that says *Done*.

6. The new image will be displayed on the Monitor (figure 7.21B, image 6). It is in the format of the movie, with a 16:9 ratio, even though it is now a still image. The icon at the top of the screen, which looks like a pair of scissors over a film frame, indicates that the image has been edited out of a movie (figure 7.21B, image 6, red arrow).

Settings Recommendation: This series of steps becomes easier when you do it a few times. Practice it once or twice, and you'll remember it later.

Side-by-Side Comparison

(User's Manual: Page 296, Menu Guide: Page 162)

Side-by-side comparison allows you to compare an image you've retouched with the original source image. Interestingly, this function is not available from the Retouch Menu. You'll find it on the Playback Retouch Menu, which you access by pressing the *i* button when a picture is displayed on the Monitor.

Figure 7.22 – Side-by-side comparison

Here are the steps to compare the original and retouched images side by side on the Monitor:

1. Press the Playback button to bring an image up on the Monitor. Find an original image that you know has been retouched (figure 7.22, image 1) or any image marked with the retouched symbol. If you try to use an image that has not been retouched, Side-by-side comparison will be grayed out and unavailable on the menu (figure 7.22, image 3).
2. Press the *i* button to access an abbreviated *i* button menu. Choose Retouch and scroll to the right (figure 7.22, image 2).

3. Scroll all the way to the bottom of the Playback Retouch Menu, select Side-by-side comparison, and press the OK button (figure 7.22, image 3).
4. The original image will appear on the left, and one of the retouched versions will appear on the right (figure 7.22, image 3). If you retouched an original image more than once, a yellow arrow will appear above or below the retouched image. This means you can scroll up or down to see the other retouched versions. The retouched picture of my face in figure 7.22, image 3, shows the Fisheye filter effect. There is at least one more retouched image, which can be accessed with the Multi selector, as indicated by the yellow arrow on the bottom of the retouched image.

Settings Recommendation: I often use this function when I want to compare images to which I've added a color cast so I can see how they compare to the original. It's very convenient since you can choose the original image or one of the retouched images and the camera is smart enough to place them in the proper position in the Side-by-side comparison. You can tell an image is retouched by looking for the retouch icon in the upper-left corner of the image when it's displayed on the Monitor.

Author's Conclusions

Nikon has given camera users who dislike computers a way to work with their images in-camera. Although the Retouch Menu is not as fully featured as a computer graphics program, it does allow you to do quick and convenient conversions.

At first I didn't think this group of Retouch Menu functions would be all that useful to me. However, I find myself using them more in the field than I expected. Whether you use them often or not, it's good to know they are there for emergencies.

Next we'll move into the final menu system in the camera. It's called My Menu, and it may become very valuable to you as you learn how it works. It's a place to put your often-used, favorite settings so you can get to them very quickly. In the next chapter, we'll see how My Menu and its cousin, Recent Settings, work.

08 My Menu and Recent Settings

The Ultimate Green Stalker © 2015 Pete Kyryluk, PNK PhotoWorks (Pete K)

As you have read through this book and experimented with your camera, you've surely noticed that the D7200 has a large number of menus, screens, functions, and settings. When I took pictures of the camera's menus and screens for this book, I ended up with hundreds of images. That many screens can be complex to navigate. We need a shortcut menu for our most-used settings—a place to keep the functions we're constantly changing.

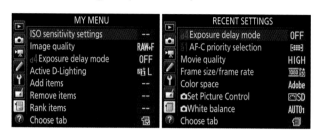

Figure 8.1 – My Menu and Recent Settings

Nikon has given us two specialty menus in the D7200: My Menu and Recent Settings (figure 8.1). These are both designed to give us exactly what we need—a menu that can be customized with only the most-used functions, and a menu of recent changes to functions.

For instance, I often turn Exposure delay mode on and off. Instead of having to search through all the Custom settings, trying to remember exactly where Exposure delay mode lives, I simply added that Custom setting to My Menu. Now, whenever I want to add a 1-second to 3-second exposure delay after pressing the Shutter-release button so that mirror vibrations can settle down, I can just go to My Menu and enable Exposure delay mode. I can do it quickly and without searching.

I rarely use Recent Settings. I prefer the control I get with my own personally customizable menu—My Menu. The Recent Settings menu has very little flexibility because it's an automatically updated camera-controlled menu system. You really can't do much in the way of configuring it. You'll just select and use it. On the other hand, My Menu is a personal collection of links to my most-used settings. It is completely configurable.

We'll consider both menus in this chapter, with an emphasis on configuring My Menu.

What's the Difference between My Menu and Recent Settings?

You can add up to 20 settings from the Playback Menu, Shooting Menu, Custom Setting Menu, Setup Menu, and Retouch Menu to My Menu. Recent Settings will automatically show the last 20 settings you've modified in the other menus, but it's not configurable. The most important difference between the two menus is the level of control you have over what appears on them. My Menu is completely customizable and does not change unless you change it, and, as mentioned previously, Recent Settings simply shows the last 20 changes you've made to your camera's settings. Recent Settings will change every time you change a setting in your camera. However, because it shows the last 20 changes, you ought to be able to find the ones you change most often somewhere in the list. The two menus are mutually exclusive and cannot appear on the D7200 at the same time. One takes the place of the other when you select the Choose tab setting at the end of each menu.

My Menu

(User's Manual: Page 297, Menu Guide: Page 164)

My Menu is *my* menu! I can add or remove virtually any camera setting found on one of the primary menus. When I use My Menu, I don't have to spend time looking for the function buried in the main menu system. Because I often use each function on My Menu, I'm glad to have it immediately available.

My Menu is the last selection on the D7200's menu system (figure 8.1). Its icon looks like a file folder tab turned sideways, with a check mark on it.

When you first look at My Menu, you'll see nothing but the following menu options:

- Add items
- Remove items
- Rank items
- Choose tab

Let's examine each of these menu choices in detail.

Add Items

To add an item to My Menu, you'll need to locate the item first. Search through the menus until you find the setting you want to add, and then make note of where it's located. You could do this from within the Add items menu, but I find that it's harder to locate what I'm looking for if I haven't already confirmed where it lives. Is it under the Custom Setting Menu or one of the Shooting Menus or maybe the Setup Menu? Make a note of where items you want to add to My Menu are located before you start adding them, or it may take longer than necessary.

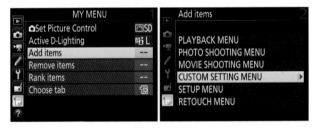

Figure 8.2 – Adding items to My Menu

After you've found the item you want to add and made note of its location, use the following steps:

1. Select Add items from My Menu. Notice that I already have Set Picture Control and Active D-Lighting added to My Menu (figure 8.2, image 1). I want to add something else.
2. Use the Multi selector to scroll right, and you'll find a list of menus to choose from. The Add items screen shows all the menus available in the D7200 except My Menu and Recent Settings (figure 8.2, image 2). Let's add one of my favorites, Exposure delay mode (figure 8.3).

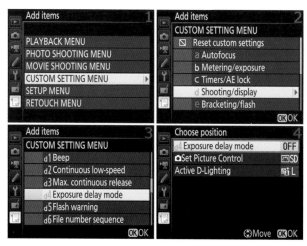

Figure 8.3 – Adding Exposure delay mode to My Menu

3. Figure 8.3 picks up where figure 8.2 left off. We already know that Exposure delay mode is under the Custom setting menu, so let's scroll down to it and scroll to the right (figure 8.3, image 1).

4. We now see the Custom setting menu and Custom settings a–e (figure 8.3, image 2). Scroll down to d Shooting/display and then scroll to the right. **Note:** There are more Custom settings than appear on image 2. If you scroll down, you will also find Custom settings f and g.

5. Figure 8.3, image 3, shows the d4 Exposure delay mode function that we want to add. All we have to do is highlight it and press the OK button. Once that is done, the D7200 switches to the Choose position screen (figure 8.3, image 4).

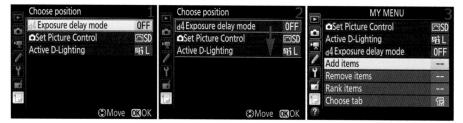

Figure 8.4 – Choosing a position for Custom setting d4 Exposure delay mode on My Menu

6. Figure 8.4 begins where figure 8.3 left off. Since I've already added a couple of other items to My Menu, I now have to decide the order in which I want them to be presented. The new d4 Exposure delay mode setting is on top because it is the newest entry (figure 8.4, image 1). I think I'll move it down two rows and put Set Picture Control in the top position.

7. To move the position of the selected item, simply scroll down. The d4 Exposure delay mode setting has a yellow box around it (figure 8.4, image 2). As you scroll down, a yellow underline moves down the list (figure 8.4, image 2, red arrow). This yellow underline

represents the place to which I want to move d4 Exposure delay mode. When I've de-
cided on the position and have the yellow underline in place, I just press the OK button.
The screen pops back to the first My Menu screen, with everything arranged the way I
want it (figure 8.4, image 3). Notice that d4 Exposure delay mode is now at the bottom
of the list.

Remove Items

Now that I've shown you how to Add items, let's examine how to Remove items. I rarely
change Picture Controls because I shoot mostly in RAW mode, so I'll remove the Set Picture
Control line item from My Menu and save one of the 20 slots for something else.

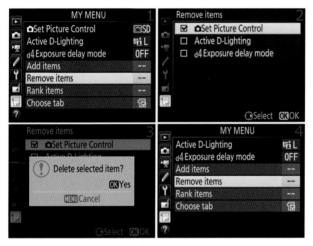

Figure 8.5 – Removing an item from My Menu

Use the following steps to Remove items from My Menu:

1. Select Remove items from My Menu and scroll to the right (figure 8.5, image 1).
2. The Remove items screen presents a series of selections with check boxes. Whichever
 boxes you check will be deleted when you press the OK button (figure 8.5, image 2). You
 can check the boxes by highlighting the line item you want to delete and then scrolling
 right with the Multi selector. Pressing right on the Multi selector acts like a toggle and
 will check or uncheck a line item.
3. When you've checked the settings you want to remove, simply press the OK button. A
 small white box pops up and asks, *Delete selected item?* (Figure 8.5, image 3.)
4. Pressing the OK button signifies Yes and removes the Set Picture Control setting from
 My Menu. A screen displaying *Done* shows briefly, and then the D7200 switches back to
 the My Menu screen. You can press the MENU button to cancel if you decide you don't
 want to remove an item. You will notice, in image 4, that the Set Picture Control setting
 is now gone.

Rank Items

Ranking items is similar to positioning new additions in My Menu. All the Rank items selection does is move an item up or down in My Menu. You can switch your most-used My Menu items to the top of the list.

Figure 8.6 – Ranking items in My Menu

Use the following steps to Rank items:

1. Select Rank items from My Menu and scroll to the right (figure 8.6, image 1).
2. Now you'll see the Rank items screen and all the current My Menu items (figure 8.6, image 2). I've decided that I use d4 Exposure delay mode more than Active D-Lighting, so I'll move it to the top.

Figure 8.7 – Ranking items in My Menu (continued)

3. Highlight d4 Exposure delay mode and press the OK button. A yellow box will appear around that item. Move appears at the bottom of the screen (figure 8.7, image 1).
4. Next, scroll up with the Multi selector (figure 8.7, image 2). This action moves the yellow positioning underline to the top of the list (figure 8.7, image 2, red arrow).
5. Press the OK button to select the new position and d4 Exposure delay mode will move to the top of the list (figure 8.7, image 3).

Choose Tab

Choose tab allows you to switch between My Menu and Recent Settings. Both menus have the Choose tab selection as their last menu choice.

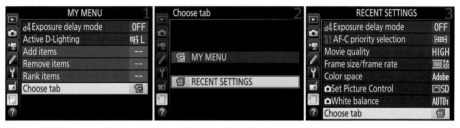

Figure 8.8 – Selecting My Menu or Recent Settings (Choose tab)

Use the following steps to switch between My Menu and Recent Settings:

1. At the bottom of My Menu, select Choose tab and scroll to the right (figure 8.8, image 1).
2. You'll now have a choice between My Menu and Recent Settings. Choose Recent Settings and press the OK button (figure 8.8, image 2).
3. The Recent Settings screen will now appear, completely replacing My Menu on the main menu screen (figure 8.8, image 3). Notice that it has a Choose tab selection at the bottom, just as My Menu does. The items you see on the Recent Settings menu are items I have recently adjusted. Your camera will display a different list of items. The last 20 items adjusted will be displayed when you scroll up or down on the Recent Settings menu. If you have never used the Recent Settings menu, all that will appear on the screen initially is the Choose tab selection. As you make adjustments to other menu items, they will appear on the Recent Settings menu.
4. Select Choose tab and press the OK button to return to My Menu (figure 8.8, image 3).

Clearly, this is a circular reference. You can use the Choose tab selection as a toggle between the two menus. When you do, one menu replaces the other as the last selection on the camera's main menu screen.

Settings Recommendation: You can see how My Menu gives you nice control over a customized menu that is entirely yours. Configure it however you want by choosing from selections in the primary menus. My Menu will save you significant time when you look for your 20 most-used selections.

If you're inclined to use Recent Settings, just remember that after you pass 20 camera setting adjustments, the next setting you use will jump to the top of the list, moving everything down by one position. The last item on the list will simply disappear.

Now, let's take a look at Recent Settings in a little more detail.

Recent Settings

(User's Manual: Page 297, Menu Guide: 168)

Recent Settings is very simple. This menu remembers the last 20 changes you've made to your D7200 camera. Each menu selection that was modified is stored in a temporary place called Recent Settings.

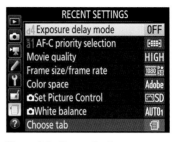

Figure 8.9 – Recent Settings

If you change something in your camera that's not already on the Recent Settings menu (figure 8.9), it will be added to the menu, replacing the oldest change with your new one—at the top of the list—if there is no room left at the bottom (i.e., you've exceeded 20 items).

This can be a convenient way to find something you've changed recently but whose location you have trouble remembering on the main menu systems.

Removing Items

To remove an item from Recent Settings you can highlight the item you no longer need and press the Delete button. Here are the steps:

Figure 8.10 – Removing an item from Recent Settings

Use these steps to remove one item from Recent Settings:

1. Highlight the item you want to remove (figure 8.10, image 1) in Recent Settings and press the Delete button (figure 8.10, image 2).

2. A popup window will appear with the question: *Delete selected item?* (Figure 8.10, image 3). Signify Yes by pressing the Delete button again, which will immediately remove the item from Recent Settings. To cancel the operation instead, press the Menu button.
3. A small popup screen will inform you that the camera is *Done* and Recent Settings will display with the item removed (Figure 8.10, image 4).

Settings Recommendation: If you want a more permanent menu for your favorite changes to the D7200, you'll need to enable the My Menu system instead of the Recent Settings Menu. The Recent Settings Menu is fine, but I want to directly control what settings I have quick access to without searching. My Menu is my choice!

Author's Conclusion

This is the last of the text-based menus we'll cover in the D7200. We've been through all the menu screens in the last several chapters!

Now it's time to see how to use the controls we've carefully configured. Our next chapter takes up the subjects of exposure metering, exposure modes, and the histogram. Please pay extra attention to the section on the histogram if you want excellent exposures every time.

The Blue Beauty (Verditer Flycatcher) © 2015 Srijan Roy Choudhury (Lighter)

I've been using Nikon cameras since 1980. It seems that with each new camera, there have been improvements in metering and exposure modes. The Nikon D7200 is no exception. Within this camera, Nikon has designed metering and exposure to work not only with still images, but also with broadcast-quality video (D-Movies).

Additionally, the D7200 has one of the most sensitive autofocus systems made for an HD-DLSR camera, with the ability to autofocus successfully at −3 EV. That's the equivalent of focusing by moonlight.

In this chapter, you'll learn how the exposure metering system and modes work. We'll look at how each of four different light meter types is best used. We'll examine the various modes you can use when taking pictures, and finally, we'll study how the histogram works on the Nikon D7200. The histogram readout gives you great control over metering and will help you make the most accurate exposures you've ever made. It is very important that you understand the histogram.

This chapter is divided into three parts:

- **Section 1 – Metering:** The Nikon D7200 provides four major light metering systems: 3D Color Matrix Metering III, Center-weighted, Highlight-weighted, and Spot.
- **Section 2 – Exposure Modes:** The camera's Mode dial allows access to various shooting or exposure modes, such as Programmed auto (P), Shutter-priority auto (S), Aperture-priority auto (A), and Manual (M).
- **Section 3 – Histogram:** The histogram is a digital bell-curve readout that shows how well an image is exposed. It's an important tool for advanced photographers. This chapter discusses how to read the histogram and better control your exposures. Let's get started by looking more deeply into the four exposure metering systems.

Section 1: Metering

(User's Manual: Page 105, Menu Guide: Page 69)

The basis for the Nikon D7200's exposure meter is a 2016-pixel RGB sensor that meters a wide area of the frame. When used with a Nikkor G, E, or D lens that contains a CPU, the camera can set the exposure based on the distribution of brightness, color, distance, and composition. Most people leave their light meter set to Matrix metering and enjoy excellent results.

The Nikon D7200 uses a newly developed Advanced Scene Recognition System including the 2016-pixel RGB sensor that measures each scene's light properties, color spectrum, and brightness levels. It then compares your subject against the camera's built-in image database to provide even more accurate autoexposure. With a metering sensor this sensitive, the D7200 can do things with ease that other cameras struggle to accomplish.

Figure 9.1A – Metering button (1) and Metering symbol on the Control panel (2)

Figure 9.1A shows the Metering button (image 1) used to select one of the metering modes and the location of the metering mode symbol on the top Control panel (image 2).

To switch among the four exposure meter types, simply hold down the Metering button and rotate the rear Main command dial. You will see a series of three metering symbols on the Information display, as shown in figure 9.1B, images 1–3. You will also see the metering mode symbol change on the Control panel (figure 9.1A, image 2), if you prefer to use it.

Figure 9.1B – Three meter types (in order): Matrix, Spot, and Center-weighted Metering mode symbols on the Information display

Figure 9.1B shows the Information display screen with the three metering symbols and all the other icons you'll normally see. These same symbols, shown at the point of the red arrows, can be seen at the bottom-left of the bar when you look through the Viewfinder. Learn to recognize what each Metering symbol means.

Figure 9.1B displays the three meter types you will find them when you hold down the Metering button and rotate the rear Main command dial counterclockwise. Match the screen number and metering symbols to these metering types:

1. Matrix metering
2. Spot metering
3. Center-weighted metering

Now, let's examine the three meter types to determine which you will use most often.

3D Color Matrix III Metering

The Nikon D7200 contains the 3D Color Matrix III metering system, one of the most power-ful and accurate automatic exposure meters in any camera today.

In figure 9.1C, you can see the Matrix metering sym-bol. This is the factory default meter.

How does Matrix metering work? There are character-istics for many thousands of images stored in the cam-era. These characteristics are used along with proprietary Nikon software and complex evaluative computations to analyze the image that appears in your Viewfinder or in Live view. The meter is then set to provide accurate expo-sures for the greatest majority of your images.

Figure 9.1C – Matrix metering mode symbol

Whether you are taking a scenic picture with the bright sky above and the darker earth below, or a group shot with one or several human faces, the metering system evaluates the image and com-pares it to hundreds of similar images in the camera's database; then it automatically se-lects and inputs a meter setting for you.

The meter examines four critical areas of each picture. It compares the levels of *bright-ness* in various parts of the scene to determine the total range of EV values. It then notices the *color* of the subject and surroundings. If you are using a G, E, or D lens with a CPU chip, it also determines how far away your lens is focused so it can determine the *distance* to your subject. Finally, it looks at the *compositional* elements of the subject.

When it has all that information, it compares your image to tens of thousands of image characteristics in its image database, makes complex evaluations, and comes up with an exposure value that is usually right on target, even in complex lighting situations.

Spot Metering

Often only a spot meter will do. In situations where you must get an accurate exposure for a very small section of the frame, or if you must get several meter readings from various small areas, the D7200 can be adjusted to fit your needs. The Spot meter evaluates only 2.5 percent of the frame, so it is indeed a *spot* meter.

In figure 9.1D, image 1, you can see the Spot metering symbol. The D7200's Spot meter consists of a 3.5mm cir-cle (0.16 inch) surrounding the currently active AF point in both Single and Continuous AF modes (AF-S and AF-C).

Figure 9.1D – Spot metering mode symbol

How big is the 3.5mm spot? The Spot meter barely surrounds the AF point square in your viewfinder (figure 9.1D). It is a little larger than the brackets that ap-pear around the active AF sensor when you slightly press

the Shutter-release button. In fact, the Spot meter follows the currently active AF point, within the 51 AF points in the Viewfinder, as you move the AF point around the frame with the Multi selector.

When your D7200 is in Spot meter mode and you move the AF point to some small section of your subject, you can rest assured that you're getting a true spot reading. In fact, you can use your Spot meter to determine an approximate EV range of light values in the entire image by taking multiple manual spot readings from different parts of the subject and comparing the values. If the values exceed 9 EV or 10 EV steps, you have to decide which part of your subject is most important and meter for it.

On an overcast day, you can usually get by with no worries since the range of light is often within the recording capability of the sensor. On a bright, sunny day, the range of light can be more than a single image can record, and you might have to use a graduated neutral-density filter or HDR imaging to rein in the excessive light range.

Just remember that spot metering is often a trade-off. Either you have the highly specific ability to ensure that a certain portion of an image is exposed with spot-on accuracy (Spot meter) or you can use the camera's multiple averaging skills (Matrix meter) to generally get the correct exposure throughout the frame. The choice is yours, depending on the shooting situation.

If you spot meter the face of someone who is standing in the sun, the shadows around the person will usually be underexposed and have little or no data. If you spot meter the areas in the shadows instead, the person's face is likely to be blown out and lose detail. We'll discuss this more in section 3 of this chapter, which explores the histogram (on page 442).

Center-Weighted Metering

If you are a bit old-fashioned, were raised on a classic center-weighted meter, and still prefer that type, the D7200's exposure meter can be transformed into a flexible center-weighted meter with variable-sized weighting that you can control.

In figure 9.1E, you can see the Center-weighted metering symbol. The Center-weighted meter in the D7200 meters the entire frame but concentrates 75 percent of the metering into an adjustable circle in the middle. The 25 percent of the frame outside the circle provides the rest of the metering. If you'd like, you can make the circle as small as 6mm or as large as 13mm. You can even completely eliminate the circle and use the entire Viewfinder frame as a basic averaging meter.

Figure 9.1E – Center-weighted metering mode symbol

Let's examine the Center-weighted meter more closely. Using *Custom Setting Menu > b Metering/exposure > b4 Center-weighted area,* you can change the size of the circle where the camera concentrates the meter reading. (See **Custom Setting b4 – Center-weighted Area** in the chapter **Custom Setting Menu** on page 205).

The default circle is 8mm in the center of your camera's Viewfinder (figure 9.1F). However, by changing Custom setting b4 Center-weighted area, you can adjust this size to one of the following:

- 6mm (0.23 inch)
- 8mm (0.31 inch) (default)
- 10mm (0.39 inch)
- 13mm (0.51 inch)
- Average (entire frame)

Figure 9.1F – Center-weighted metering

Again, the Center-weighted meter is a pretty simple concept. The part of your subject that's in the center of your D7200's Viewfinder influences the meter more than the edges of the frame, on a 75/25 basis. The circle gets 75 percent importance. The red circles shown in figure 9.1F are just rough approximations. Simply meter the subject with the center of the Viewfinder, and you should have good results.

Note: If you are using a non-CPU lens, the Center-weighted meter defaults to 8mm and cannot be changed. Adjustments to Custom setting b4 Center-weighted area have no effect.

Where's the Circle?

You can't actually see any indication of circles in the Viewfinder, so you'll have to imagine them, as I did in figure 9.1F.

Locate your current autofocus (AF) sensor in the middle of your Viewfinder. Now imagine the smallest circle, 6mm, which is about one-quarter of an inch. The largest circle is 13mm, which is a little bigger than half an inch. This unseen circle in the center area of the Viewfinder provides the most important 75 percent metering area.

Settings Recommendation: If I used the Center-weighted meter often, I would stay with the 8mm setting. That's a pretty small circle—almost a spot meter—so it should give you good readings. I would point the circle at the most important part of my subject, get a meter reading, use the AE-L/AF-L button to lock the exposure, recompose the picture, and then release the shutter.

The most sensitive area is large enough at 8mm to see more than a pure spot meter, though, so you have the best of both worlds. There isn't much difference between 8mm and 13mm, so it probably won't matter which one you use. If you are concerned, then experiment with the settings and see which one works best for you.

Using the Average Setting

If you set your meter to Average (Avg) in Custom setting b4 Center-weighted area, the light values of the entire Viewfinder are averaged to arrive at an exposure value. No particular area of the frame is assigned any greater importance (figure 9.1F).

This is a little bit like Matrix metering but without the extra smarts. In fact, on several test subjects, I got similar meter readings from the Average and Matrix meters. However, Matrix metering should do better in difficult lighting situations because it has a database of image characteristics to compare with your current image—including color, distance, and where your subject is located in the frame.

Settings Recommendation: Use your Spot meter to get specific meter readings of small areas on and around your subject; then make some exposure decisions yourself and your subject should be well exposed. Just remember that the Spot meter evaluates only for the small area that it sees, so it cannot adjust the camera for anything except that one tiny area. Spot metering requires some practice, but it is a very precise way to obtain exposure readings.

Section 2: Exposure Modes

(User's Manual: Page 51)

My first Nikon, back in 1980, was a Nikon FM. I remember it with fondness because that was when I first got serious about photography. It's hard for me to imagine that it has already been 35 years since I bought my FM! Things were simpler back then. When I say simpler, I mean that the FM had a basic center-weighted light meter, a manual exposure dial, and manual aperture settings. I had to decide how to create the image in all aspects. It was a camera with only one mode: M, or manual.

Later I bought a Nikon FE and was amazed to use its A mode, or Aperture-priority auto. I could set the aperture manually and the camera would adjust the shutter speed for me. Luxury! The FE had two modes, Manual (M) and Aperture priority (A).

A few more years went by, and I bought a Nikon F4 that was loaded with features and was much more complex. It had four modes, including the two I was used to, M and A, and two new modes, Shutter-priority auto (S) and Programmed auto (P). I had to learn even more stuff! The F4 was my first P, S, A, M camera.

Does this sound anything like your progression? If you're over 50, maybe so; if not, you may just be getting into the digital photography realm with your D7200, and I ought to stop reminiscing and get to the point.

Today's cameras are amazingly complex compared to cameras only a few years ago. Let's examine how we can use that flexibility for our benefit. The D7200 is also a P, S, A, M camera. That's the abbreviated progression of primary shooting modes that allow you to control the shutter speed and aperture. In addition, the D7200 has 16 SCENE modes, seven

EFFECTS modes, and a fully AUTO mode for when you just want to take good pictures without thinking about exposure. Let's examine each in detail.

There is just one control on the D7200 to set the following modes: AUTO; No Flash; SCENE; U1 and U2; EFFECTS; and M, A, S, P. It is a convenient control called the Mode dial (figure 9.2A). Let's discuss each exposure mode in detail.

Programmed Auto (P) Mode

Programmed auto (P) mode is designed for those times when you just want to shoot pictures and not think much about camera settings but still want emergency control when needed. The camera takes care of the shutter speed and aperture for you and uses your selected exposure meter to create the best pictures it can without human intervention. You can override the aperture by turning the rear Main command dial.

Figure 9.2A shows the Mode dial set to Programmed auto (P) mode. This mode is called Programmed auto because it uses an internal software program. It tries its best to create optimal images in most situations.

P mode first appeared as a rudimentary AUTO mode on Nikon SLR film cameras and is still on the Mode dial to benefit those who learned to use it in the good old days of film cameras. However, even the User's Manual calls this a "snapshot" mode.

Figure 9.2A – Mode dial set to Programmed auto (P) Mode

P mode can handle a wide variety of situations well, but I wouldn't depend on it for my important shooting. It can be great at a party, for example, where I want some nice snapshots. I don't have to think about the camera and I can just enjoy the party. To me, P mode is *P* for Party.

It's a good mode to use when you want to let the camera control the aperture and shutter while you control the flash. In a sense, it's like AUTO mode except that you, instead of the camera, decide when to use the popup Speedlight. It also lets you override the aperture in an emergency. You may need more depth of field and decide to use a smaller aperture, so you can take control by turning the Main command dial. When you do, the aperture is under your control, while the camera controls the shutter.

P mode comes in two parts: Programmed auto and Flexible program. Flexible program works similarly to Aperture-priority auto (A) mode. Why do I say that? Let me explain by giving an example.

Unexpected Group Shot!

You're shooting at a family party, taking a natural-light snapshot of cousin Jane. The camera, which is in P mode, has selected f/3.5 for the aperture. Suddenly cousin Bill, aunt Millie, and five more people run to get in the picture. Where you were shooting an individual portrait—using a shallow depth of field to emphasize your subject—now you have

a group with more than one row. You (being a well-trained photographer) glance down at your camera and realize that the f/3.5 aperture won't give you enough depth of field to focus on the front row and still have a sharp image of the back row. You pop open the flash (for extra light) and turn your Main command dial clockwise to reduce the aperture size for more depth of field.

Figure 9.2B – Standard (P) mode (image 1), and Flexible program (P*) mode (image 2) on the Information display

When the camera senses the Main command dial being turned, it realizes that it's being called upon to leave snapshot (standard P) mode (figure 9.2B, image 1) and give you some control. It displays a small P* on the Information display screen (figure 9.2B, image 2) to let you know it realizes you are taking over control of the aperture. Since you are turning the dial clockwise, it obligingly starts cranking down the aperture. After a few rotational clicks to the left, your aperture is now at f/8. You put the camera to your eye, yell, "say cheeeeese!" and press the Shutter-release button. You've got the shot! A family memory, captured.

What you did in my imaginary scenario was invoke the Flexible program (P*) mode in your D7200. How? As soon as you turned the Main command dial, the D7200 left normal P mode and switched to P* (Flexible program). Before you turned the Main command dial, the D7200 was happily controlling both the shutter speed and the aperture for you. When you turned the dial, the D7200 immediately switched to Flexible program mode and let you have control of the aperture. It then controlled only the shutter speed. In effect, the D7200 allowed you to exercise your knowledge of photography very quickly and assisted you only from that point.

If you turn the Main command dial clockwise, the aperture gets smaller. If you turn it counterclockwise, the aperture gets larger. Nothing happens if you turn the Sub-command dial. You can take control of the aperture only in Flexible program mode. Can you see why I say Flexible program mode acts like Aperture-priority (A) mode?

Understanding the Extra Clicks
When using P* mode, if you turn the Main command dial counterclockwise until the aperture reaches its maximum size (usually f/3.5 on a kit lens), the camera starts counting clicks but does nothing else. To start making the aperture move again, you have to turn back the same number of clicks (up to 15). I have no idea why Nikon does it this way, but it's been like this for many years.

It's confusing to have the camera stop letting you control the aperture just because you turned the Main command dial past wide open by several clicks—until you turn it back the same number of clicks. It's no big deal, really. Just be aware that this will happen so you won't think the camera is not working correctly.

Shutter-Priority Auto (S) Mode

Shutter-priority auto (S) is for those who need to control the shutter speed while allowing the camera to maintain the correct aperture for the available light. You'll turn the Main command dial to adjust the shutter speed, while the camera controls the aperture.

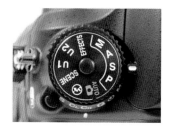

Figure 9.2C shows the Mode dial set to S for Shutter-priority auto mode. If you find yourself shooting action, you'll want to keep the shutter speed high enough to capture an image without excessive blurring. Shooting sports, air shows, auto races, or any quickly moving sub-

Figure 9.2C – Mode dial set to Shutter-priority auto (S)

ject requires careful control of the shutter. If you shoot a bird in flight, you'll want to use a fast shutter speed that allows for just a tiny bit of motion blur in its wings while stopping the body of the bird.

Sometimes you'll want to set your shutter speed to slow settings for special effects or time exposures, such as a small waterfall in a beautiful autumn stream. See figure 9.2D for both effects.

Figure 9.2D – Fast shutter speed to stop bird and slow shutter speed to blur water

If the light changes drastically and the camera cannot maintain a correct exposure with your current shutter speed setting, it will inform you by blinking the aperture setting and displaying an exposure indicator showing the amount of under- or overexposure (−/+) in the Viewfinder, Control panel, and Information display (press the info button).

Figure 9.2E shows the Information display as an example. The aperture indicator (upper-red arrow) blinks and the exposure indicator (lower-red arrow) appears when the exposure is incorrect.

To change the shutter speed, simply rotate the Main command dial to any value between 30 seconds and 1/8000 second. Turn the wheel counterclockwise for faster shutter speeds and clockwise for slower speeds. The camera will try to adjust the aperture to maintain a correct exposure; if it can't, it will warn you by blinking.

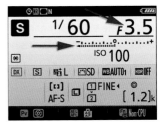

Figure 9.2E – Significant underexposure, aperture setting at point of upper arrow will blink

Watch Out for Camera Shake!

Be careful when the shutter speed is set below 1/125 second. Camera shake becomes a problem for many people at 1/60 second and slower. If you are careful to stand still, brace your arms against your chest, and spread your feet apart with one in front of the other, you'll probably be able to make sharp images at 1/60 to 1/30 second.

Surprisingly, your heartbeat and breathing is reflected in your hands during slow shutter speed photography. If you are going to shoot at slow shutter speeds, buy yourself a nice solid tripod. You'll make much nicer pictures.

Figure 9.2F – Woman holding camera for steady shooting, and pro photographer using a tripod

Figure 9.2F shows the two main ways to steady a camera. Notice in the first picture how the young lady has her elbow tucked into her chest, her feet apart, and one foot in front of the other. She is squeezing the shutter release very slowly to prevent adding shake, and she is breathing out very slowly as she is firing the camera. This handholding technique provides maximum sharpness. In the other picture a professional photographer is using a tripod for maximum sharpness.

The picture of the small waterfall in Great Smoky Mountains National Park (figure 9.2D) was taken at a shutter speed of several seconds. It is virtually impossible for a person to hold a camera perfectly still for several seconds, so a shot like this is not possible without a tripod.

Aperture-Priority Auto (A) Mode

Nature and macro shooters, and anyone concerned with carefully controlling depth of field, often leave their cameras set to Aperture-priority auto (A) mode. Figure 9.2G shows the Mode dial set to Aperture-priority auto mode.

Figure 9.2G – Mode dial set to Aperture-priority auto (A)

Aperture-priority auto mode, or A mode, allows you to control the aperture while the camera takes care of the shutter speed for optimal exposures. To select an aperture, you use the Sub-command dial. Turn the wheel clockwise for smaller apertures (stopping down) and counterclockwise for larger apertures (opening up).

The minimum and maximum aperture settings are limited by the minimum and maximum aperture openings on the lens you're using. Most consumer lenses run from f/3.5 to f/22. More expensive pro-style lenses may have apertures as large as f/1.2, but they generally start at f/2.8 and end at f/22–f/32.

Figure 9.2H – Large aperture to blur background and small aperture for deep focus

The aperture directly controls the amount of depth of field—or zone of sharpness—in an image. Depth of field is an extremely important concept for photographers to understand. Simply put, it allows you to control the range or depth of sharp focus in your images. In the bird image in figure 9.2H, the depth of field is very shallow, and in the scenic shot it is very deep.

Suggested Reading for Depth of Field, Aperture, and Shutter Speed Basics

Many people who use the D7200 are advanced photographers, reflecting the purpose of this feature-laden camera, and they fully understand things like depth of field, shutter speed, and aperture.

However, many novice photographers have decided to go for the D7200 as their first entry into serious HD-SLR photography. The relationship between aperture, shutter speed, and ISO sensitivity are so important for new photographers that I wrote a book titled *Beyond Point-and-Shoot*, published by Rocky Nook, to clearly explain it (figure 9.2I).

The book gives new DSLR users a way to fully understand how to use the more advanced features of their cameras and not depend so much on automatic modes. If that describes you, get the book. It will open your eyes to the best ways to control your new D7200—for the best images you've ever taken.

Figure 9.2I – Beyond Point-and-Shoot (http://www.pictureandpen.com/BeyondPS.asp)

Manual (M) Mode

Manual mode takes a big step backward to the days of old. It gives you complete control of your shutter and aperture so you can make all the exposure decisions, with suggestions from the light meter. Figure 9.2J, image 1, shows the Mode dial set to Manual (M).

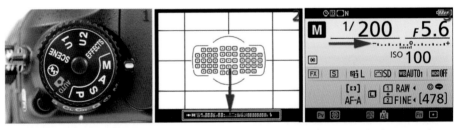

Figure 9.2J – Mode dial set to Manual (M); analog exposure display in Viewfinder and Information display screen

In figure 9.2J, images 2 and 3, notice the electronic analog exposure display at the red arrows. This display, which is visible when you look in the Viewfinder or press the Info button, has a minus sign (–) on the left and a plus sign (+) on the right. Each dot on the scale shown in image 3 represents 1/3 EV step, and each line represents 1 EV step. My manual exposure in image 3 shows one stop of underexposure (–1 EV). There is a miniature version of the same scale at the bottom of the Viewfinder. It's hard to see in figure 9.2J, image 2, but it is easy to see at the bottom of the Viewfinder.

You can control how sensitive this scale is by changing *Custom Setting Menu > b Metering/exposure > b2 EV steps for exposure cntrl*. You can set Custom setting b2 to 1/3 EV step or 1/2 EV step. The camera defaults to 1/3 step.

When you are metering your subject, a dashed bar will show up underneath the analog exposure display and extend from the zero in the center toward the plus side to indicate overexposure, or toward the minus side to indicate underexposure. You can gauge the amount of over- or underexposure by the number of dots and lines the bar passes as it heads toward one side or the other. The goal in Manual mode is to make the bar disappear. As mentioned previously, in figure 9.2J, image 3, the bar is indicating underexposure of 1 EV step (or 1 stop).

You can adjust the aperture with the Sub-command dial and adjust the shutter speed with the Main command dial. In Manual mode you have control over the aperture (for depth of field) and the shutter speed (for motion control). If your subject needs a little more depth of field, just make the aperture smaller, but be sure to slow down the shutter speed as well (or your image may be underexposed). If you suddenly need a faster shutter speed, then set it faster, but be sure to open the aperture to compensate for it. The camera will make suggestions with the meter, but you make the final decision about how the exposure will look.

Manual mode is for taking your time and enjoying your photography. It gives you the most control of how the image looks, but you need more knowledge to get correct exposures.

Settings Recommendation: As a nature photographer, I am mostly concerned with getting a nice sharp image with a deep depth of field. About 90 percent of the time my camera is set to Aperture-priority auto (A) and f/8. I started using this mode back in about 1986 when I bought my Nikon FE, and I have stayed with it since. In A mode, you control the aperture and the camera controls the shutter speed.

However, if I were shooting sports or action, I would have my camera set to Shutter-priority auto (S) most often, which would allow me to control the speed of the shutter and capture those fast-moving subjects without a lot of blur. The camera will control the aperture so I have to concentrate only on which shutter speed best fits my subject's movement.

I use the other two modes, Programmed auto (P) and Manual (M), only for special occasions. When I want to control the camera absolutely, I use Manual.

I probably use Programmed auto (P) mode least of all. I might use it when I am at a party and just want to take nice pictures for my own use. I let the camera make most of the

decisions in P mode, and I still have the ability to quickly jump into Flexible program (P*) mode when events call for a little more aperture control.

Why shouldn't you just use AUTO mode instead? (We'll explore this in the next section.) Well, AUTO mode controls everything, including when to use flash and which ISO sensitivity setting is best; therefore, it may not work well for maximum quality images in lower light levels. With P mode, the camera controls only the shutter speed and aperture, and you control the rest.

As mentioned, some people have recently switched from using a point-and-shoot camera to the more powerful Nikon D7200. Most point-and-shoot cameras have a completely automatic mode and some SCENE modes that represent common photographic opportunities. If you have come over from the point-and-shoot world, you might enjoy using the AUTO or SCENE modes at first while learning the more advanced P, S, A, and M modes. Let's look into how these extra modes work.

Auto Exposure (AUTO) Mode

The AUTO exposure mode (figure 9.2K) is for those times when you want to get the picture with no thought as to how the camera works. All you need to be concerned about in AUTO mode is whether the battery is fully charged and how well the image is composed.

Figure 9.2K – Mode dial set to AUTO exposure mode

The D7200 becomes a big point-and-shoot camera, like a heavy Nikon COOLPIX. Many of its internal modes become automatic, which means you can't change them because the camera decides what is best for each setting. Here is a list of some of the most important functions that become disabled when using AUTO mode:

- White balance
- Picture control
- Active D-Lighting
- HDR (high dynamic range)
- Multiple exposure
- Built-in speedlight flash
- Movie ISO sensitivity settings
- Time-lapse photography
- Exposure compensation
- Metering mode
- Most flash functions
- Bracketing
- Save/load settings

In effect, you relinquish control of many of the camera's functions for a "guarantee" that some sort of picture will be provided. In most cases, the D7200 will provide its normal excellent images when you select AUTO. However, in difficult circumstances, the camera is free to turn up the ISO sensitivity and extend the Active D-Lighting range to get a picture, even at the expense of image quality.

If you want to loan your camera to your grandmother and she has no interest in how cameras work, the D7200 will happily make nice images for her in AUTO mode. While you are learning to use the more advanced functions of the camera, you, too, might benefit from using this mode for a while. You'll usually get better pictures when you control the camera, but the D7200 has some very efficient software that will help you if you're not ready to take control.

Settings Recommendation: I don't like to admit it, but I do use AUTO mode sometimes. The D7200 is such a good camera that it will make some nice images without my help. If I have reasonably good light and am not shooting for commercial work, I will switch to AUTO mode just to enjoy taking pictures. Sometimes we need to take ourselves less seriously. AUTO mode lets me do that. Try it!

Bad Exposure Warning

If the light changes drastically and the camera cannot maintain a correct exposure due to your current settings, the offending setting will blink in the Viewfinder, Control panel, and Information display. The camera will also display the −/+ Exposure indicator (as you use in Manual mode) with an approximate number of EV steps of over- or underexposure.

If you see the aperture or shutter-speed setting blinking in any of the displays along with the −/+ Exposure indicator displaying a −/+ EV value, please validate your exposure before taking the picture.

SCENE and EFFECTS Modes

SCENE and EFFECTS modes are considered "Creative Photography" modes by Nikon. They allow beginning photographers to emulate the camera settings they would be inclined to use if they had more experience. These modes allow them to make consistently good images, and later, as their experience grows, they can use the P, S, A, and M modes to get more creative control over their images.

Because the Nikon D7200 has thousands of images stored in its Matrix metering system, I wouldn't be surprised if each of these creative modes uses a subset of stored image types that more closely match the selected subject matter. This might hold true in Matrix metering mode. I have no way to prove this, so don't quote me!

If you choose to use SCENE or EFFECTS modes, do so with the understanding that you can eventually learn to control the image to a finer degree with the P, S, A, and M modes.

Don't be afraid to experiment with the more advanced features of the D7200. You can always fall back on the Creative Photography modes if you feel uncomfortable.

With the P, S, A, M, AUTO, SCENE, and EFFECTS modes on the Mode dial, Nikon has given us the best of all worlds in one camera. Full or partial automation, or complete manual control. What flexibility!

The Nikon D7200 provides no less than 16 SCENE modes (figure 9.2L, images 1–3) and seven EFFECTS modes (figure 9.2L, images 4–6) designed to give inexperienced users control over certain styles of photography.

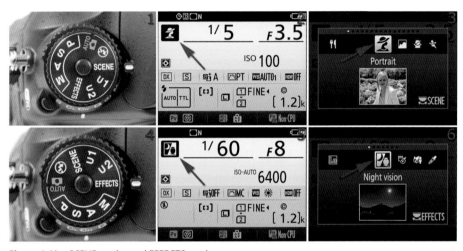

Figure 9.2L – SCENE modes and EFFECTS modes

Here is a list of the various SCENE and EFFECTS modes:

SCENE modes
- Portrait
- Landscape
- Child
- Sports
- Close up
- Night portrait
- Night landscape
- Party/indoor
- Beach/snow
- Sunset
- Dusk/dawn
- Pet portrait
- Candlelight
- Blossom
- Autumn colors
- Food

EFFECTS modes
- Night vision
- Color sketch
- Miniature effect
- Selective color
- Silhouette
- High key
- Low key

Now, let's examine how to select a mode:

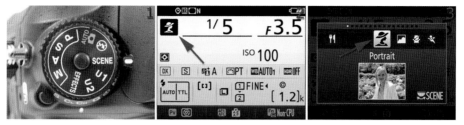

Figure 9.2M – Selecting a SCENE mode

Here are the steps to select a SCENE or EFFECTS mode:

1. Set the Mode dial to SCENE or EFFECTS (figure 9.2M, image 1). All steps work exactly the same for either of these two modes, so we will simply use the SCENE modes setting as our example.
2. Press the info button, which will open the Information display screen with the current SCENE or EFFECTS mode symbol showing (figure 9.2M, image 2, red arrow).
3. Turn the Main command dial, which opens the SCENE (or EFFECTS) selection screen, as seen in figure 9.2M, image 3. The scene mode display appears for only about two or three seconds before the Monitor changes back to the Information display screen again, with the corresponding scene mode symbol displayed above the sample picture (red arrow). Quickly turn the dial again to show more creative modes and select the one you want to use.

Each SCENE and EFFECTS mode is basically self-explanatory. However, just in case you want more information, each mode has a help screen available, which will describe how that mode works.

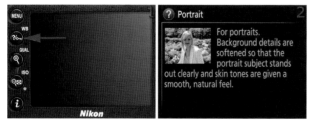

Figure 9.2N – The help screen for the Portrait SCENE mode

To access the help screen, press the Help/protect/WB button (figure 9.2N, image 1) while one of the modes is being displayed on the Monitor (figure 9.2N, image 2).

Section 3: Histogram

Back in the good old film days, we didn't have a histogram, so we had to depend on our experience and light meter to get a good exposure. Because we couldn't see the exposure until after we had left the scene, we measured our success by the number of correctly exposed images we were able to create. With the exposure meter/histogram combination found in the D7200, and the ability to zoom in to our images with the high-resolution Monitor on the back, our success rate is much higher than ever before.

The histogram can be as important as the exposure meter, or even more so. The meter sets up the camera for the exposure, and the histogram verifies that the exposure is a good one.

If your exposure meter stopped working, you could still get perfect exposures using only the histogram. In fact, I gauge my efforts more by how the histogram looks than anything else. The exposure meter and histogram work together to make sure you get excellent results from your photographic efforts.

Figure 9.3A shows the D7200's three histogram screens.

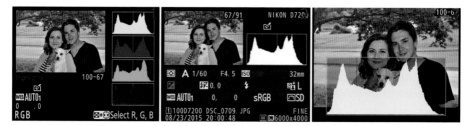

Figure 9.3A – The D7200's three histogram screens

RGB Histogram, Screen 1: Figure 9.3A, image 1, is the RGB histogram screen. It shows an individual histogram for each color channel. On the top is a luminance histogram followed by the red, green, and blue (RGB) channels.

If your camera does not display the RGB histogram screen shown in figure 9.3A, image 1, you'll need to select the check box found at *Playback Menu > Playback display options > RGB histogram*. This setting enables or disables the RGB histogram screen, which you can then find by displaying an image on the Monitor and then scrolling up or down with the Multi selector.

One important reason to examine the RGB histogram is to see if any one color channel has lost all detail in the dark or light areas. Later in this chapter, we will examine how you can determine when detail has been lost.

Luminance Histogram, Screen 2: Figure 9.3A, image 2, shows a slightly larger luminance histogram along with image information.

If your camera does not display the Luminance histogram screen shown in figure 9.3A, image 2, you'll need to select the check box found at *Playback Menu > Playback display options > Overview*. This setting enables or disables the Overview screen, which you can

then find by displaying an image on the Monitor and then scrolling up or down with the Multi selector.

This is a basic luminance histogram, which is a weighted view of the brightness and color in a scene based on how the human eye perceives light. How does the luminance histogram differ from the RGB histograms? The luminance histogram is a representation of the perceived brightness (luminosity) from a combination of the red, green, and blue channels.

In other words, the luminance histogram tries to accurately reflect the light you see by weighting its color values in a particular way. Since the human eye sees green most easily, the luminance histogram is heavily weighted toward green. Notice in figure 9.3A, image 1, how the luminance histogram at the top (the white one) looks very similar to the green channel histogram below it.

Red and blue are also represented in the luminance histogram but in lesser quantities (59 percent green + 30 percent red + 11 percent blue = luminance). The luminance histogram measures the perceived brightness in 256 levels (0–255).

The luminance histogram is an accurate way of looking at the combined color levels in real images. Because it more accurately reflects the way our eyes actually see color brightness, it may be the best histogram for you to use, most of the time.

Luminance Histogram, Screen 3: The white histogram shown in figure 9.3A, image 3, is exactly the same as the white luminance histogram seen in screen 2 and the top white histogram in screen 1.

This particular histogram (figure 9.3A, image 3) is available only by assigning one of the camera's buttons to open it. In *Custom Setting Menu > f Controls > f1 OK button > Playback mode,* I assigned View histograms to the OK button.

Now whenever I am viewing an image on the camera's Monitor, I can press the OK button and the camera will display the histogram seen in figure 9.3A, image 3, as long as I hold down the button. This works only when you're using Playback mode (viewing images). It is a fast and convenient way to get a histogram open without scrolling through a bunch of image data screens.

Now that we have discussed how to open the various histogram screens in the D7200, let's discuss how a histogram works.

Understanding the Histogram

Using your D7200's histogram screens will guarantee you a much higher percentage of well-exposed images. It is well worth spending time to understand the histogram. It's not as complicated as it looks.

I'll cover this feature with enough detail to give you a working knowledge of how to use the histogram to make better pictures. If you are deeply interested in the histogram, there is a lot of research material available on the Internet. Although this overview is brief, it will present enough knowledge to improve your technique immediately.

Excellent Dynamic Range

The D7200's sensor can record a certain range of light values—according to DxO Labs, 14.5 EV steps, which is an amazing amount of dynamic range.

Unfortunately, even with the massive potential dynamic range the D7200 has, many of the higher-contrast subjects we shoot contain more light range than the camera can capture in one exposure.

It is important to understand how your camera records light so you can better control how the image is captured. Even though the dynamic range of the D7200 is superior to other cameras, it still can't handle the range of light captured by the human eye.

Let's look into the histogram so you can determine how well you have captured the light in the scene before your lens. The gray rectangular area in figure 9.3B represents an in-camera histogram. Examine it carefully! Think about it for a minute before reading on.

The histogram is basically a graph of 256 steps that represents the maximum range of light values your camera can capture (0 = pure black and 255 = pure white). In the middle of the histogram are the midrange values that represent middle colors like grays, light browns, and greens. The values from just above zero and just below 255 contain detail.

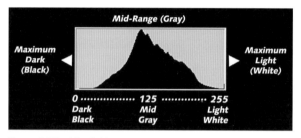

Figure 9.3B – A basic histogram

The actual histogram looks like a mountain peak, or a series of peaks, and the more there is of a particular color, the taller the peak that represents that color. In some cases the graph will be rounder on top, and in other cases it will be flattened or have several peaks.

The left side of the histogram represents the maximum dark values that your camera can record. The right side represents the maximum light values your camera can capture. On either end of the histogram (0 or 255), the light values contain no detail. They are either completely black (0) or completely white (255).

The height of the histogram (top of mountain peaks) represents the amount of individual colors. You cannot easily control this value in-camera, other than changing to a Picture Control with more or less saturated color, so it is for your information only.

We are mostly concerned with the left- and right-side values of the histogram because we do have much greater control over those (dark versus light). In figure 9.3C, we see a basic histogram tutorial with three separate histograms that have different exposures. Refer to figure 9.3C as we discuss the histogram further.

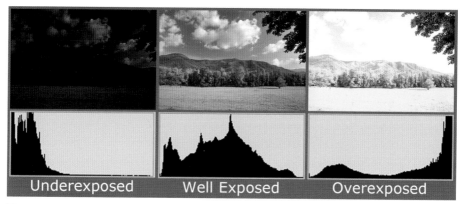

Figure 9.3C – Three histograms: Underexposed, Well Exposed, and Overexposed

Simply put, the histogram's horizontal scale is related to the darkness and lightness of the image, and the vertical scale of the histogram (valleys and peaks of the mountains) have to do with the amount of color information.

The left (dark) and right (light) directions of the horizontal scale are very important for your picture taking. If the image is too dark, the light values will be clipped off on the left side; if it's too light, the light values will be clipped off on the right side.

When you see the three histograms next to each other (figure 9.3C), does it make more sense? See how the underexposed histogram is all the way to the left of the histogram window and is clipped midpeak? Note how both edges of the well-exposed histogram just touch the horizontal edges of the histogram window. Finally, notice how the overexposed histogram is crammed toward the right and clipped.

Highlights Blink Mode

There are also other Monitor viewing modes that you can use along with the histogram, such as the Highlights (blink) mode for blown-out highlights (see the *Playback Menu > Playback display options* and select Highlights, as shown in figure 9.3D).

This mode will cause your image to blink from light to dark in the blown-out highlight areas, as seen in the overexposed candle flame in figure 9.3D, images 3 and 4.

This white-to-black blinking is a rough representation of a histogram in which the highlight value is clipped, and it is quite useful for quick shooting. Using your camera's light meter, histogram, and Highlights (blink) mode together is a very powerful way to control your exposures.

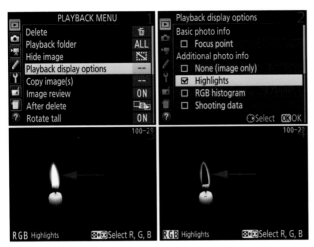

Figure 9.3D – Selecting the Highlights blink mode

Why Master the Histogram?

If you master using the histogram, you will have a fine degree of control over where you place the light range of your images. This is sort of like using the famous Ansel Adams black-and-white Zone System, but it is represented visually on the Monitor of your D7200.

The manipulation of histogram levels in-computer is a detailed study in and of itself. It's part of having a digital darkroom. Learn to use your computer to tweak your images, and you'll be able to produce superior results most of the time. Even more important, learn to use your histogram to capture a nice image in the first place!

Your histogram is simply a graph that lets you see at a glance how well your image is contained by your camera. If it's too far left, the image is too dark; if it's too far right, the image is too light. If clipped on both ends, there is too much light for one image to contain. Learn to use the histogram well and your images are bound to improve!

Settings Recommendation: The camera's light meter should be used to get the initial exposure only. Then you can look at the histogram to see if the image's light range is contained within the limited range of the sensor. If the histogram is clipped to the right or the left, you may want to add or subtract light with the +/− Exposure compensation button or use Manual mode. Let your light meter get you close, then fine-tune with the histogram.

Author's Conclusions

This camera certainly gives you a lot of choices for light meters and exposure modes. You can start using this camera at whatever level of photographic knowledge you have. If you are a beginner, use the P or AUTO mode. If you want to progress into partial automation, use the S or A mode. And if you are a dyed-in-the-wool imaging fanatic, use the M mode for full manual control of the camera. You have a choice with the D7200!

The next chapter is about a subject of great importance to digital photographers—white balance (WB). Understanding WB gives you an edge over other photographers. Learning about the histogram and white balance will place you in a spot occupied by relatively few people. When you have mastered those two subjects and learned about color spaces, you will indeed be an advanced digital photographer. Let's proceed!

10 White Balance

My Cold-Blooded Friend © 2015 William Gaston Jr (BillGastonJr)

Back in the good old days, photographers bought special rolls of film or filters to meet the challenges of color casts that come from indoor lighting, overcast days, or special situations.

The D7200 balances the camera to the available light with the White balance (WB) controls. Fortunately, the D7200's improved Auto White balance setting does a great job for general shooting. However, discerning photographers should learn how to use the White balance controls so they can achieve color consistency in special situations.

If you are using modes other than P, S, A, or M on the Mode dial (e.g., SCENE, EFFECTS, AUTO), the camera automatically sets the white balance for you. However, since you are an enthusiast photographer, surely you will be using the semiautomatic modes (P, S, or A), or even the manual mode (M)—if not now, at least soon. In each of these modes, you are responsible for telling the camera which white balance to use. Let's learn how!

How Does White Balance Work?

(User's Manual: Page 111, Menu Guide: Page 39)

Normally, White balance is used to adjust the camera so that whites are truly white and other colors are accurate under whatever light source you are shooting. You can also use the White balance controls to deliberately introduce color casts into your image for interesting special effects.

Camera WB color temperatures are exactly the opposite of the Kelvin scale we learned in school for star temperatures. Remember that a red giant star is cool, and a blue/white star is hot. The WB color temperatures are opposite because the WB system adds color to make up for a deficit of color in the original light of the subject.

For instance, under a fluorescent light, there is a deficit of blue, which makes the subject appear greenish yellow. When blue is added, the image is balanced to a more normal appearance, with a WB in the 4200K range.

Another example is when you are shooting on a cloudy, overcast day. The cool ambient light could cause the image to look bluish if it's left unadjusted. The White balance control in your camera sees the cool color temperature and adds some red to warm the colors a bit. The normal camera White balance on a cloudy, overcast day might be about 6000K.

Just remember that we use the real Kelvin temperature range in reverse and that red colors are considered warm and blue colors are cool. Even though this is the opposite of what we were taught in school, it fits our situation better. To photographers, blue seems cool and red seems warm! Just don't let your astronomer friends convince you otherwise.

White Balance Fundamentals

Understanding WB in a fundamental way is simply realizing that light has a range of colors that go from cool to warm. We can adjust our cameras to use the available light in an accurate and neutral, balanced way that compensates for the actual light source. Or we can allow a color cast to enter the image by unbalancing the settings. In this chapter, we will discuss this from the standpoint of the D7200's controls and how they deal with WB.

Color Temperature

The D7200 WB range can vary from a very cool 2500K to a very warm 10000K. Figure 10.1 shows a picture adjusted in Photoshop, with the use of software filters, to three WB settings. Notice how the image in the center is about right; the image on the left is cooler (bluish cast), and the image on the right is warmer (reddish cast).

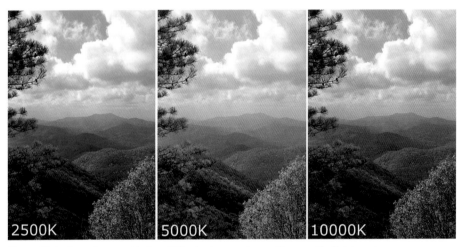

Figure 10.1 – Same image with three WB color temperature settings on the Kelvin scale

The same adjustments we made with film types and lens filters can now be achieved with the White balance settings built into the D7200. To achieve the same effect as daylight film and a warming filter, simply select the Cloudy White balance setting while shooting in normal daylight. This sets the D7200 to balance at about 6000K, which makes nice warm-looking images. If you want to really warm the image up, choose the White balance setting called Shade, which sets the camera to 8000K. Or you could set the White balance to AUTO2, which warms up the colors and automatically adjusts for current light sources.

On the other hand, if you want to make the image appear cool or bluish, try using the Fluorescent (4200K) or Incandescent (3000K) setting in normal daylight.

Remember, the color temperature shifts from cool values to warm values. The D7200 can record your images with any color temperature from 2500K (very cool or bluish) to

10000K (very warm or reddish) and any major value in between. There is no need to carry different films or lens filters to deal with light color ranges. The D7200 has very easy-to-use color temperature controls and a full range of color temperatures available.

There are two methods for setting the White balance on the D7200:

- Manual WB using the WB button and selecting options
- Manual WB using the Shooting Menus (Photo and Movie) and selecting options

You may prefer to use different methods according to the amount of time you have to shoot and the color accuracy you want.

Camera Control Locations for WB Adjustment

In this chapter we will often use the WB button, Main and Sub-command dials, and Information display when adjusting the White balance.

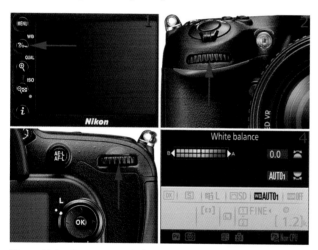

Figure 10.2 – Camera controls for White balance adjustment

Figure 10.2 provides a numbered illustration of the following controls:

1. WB button
2. Sub-command dial
3. Main command dial
4. Information display

Remember these control names and locations for use in this chapter and later in the field.

Note: Nikon recently seems to be downplaying the use of the top Control panel for more than just basic information. For instance, the Control panel no longer identifies which white balance you are currently using, although it does show internal adjustments for the white balance. That seems confusing. The Information display on the rear monitor now

automatically turns on when you press the WB button. Therefore, this book will be using the Information display as the primary way to set the camera's white balance, with only some references to the Control panel as an alternate source to see settings once a particular white balance has been selected with the Information display.

Technical Information on Mired

Often in this chapter I will talk about adjusting White balance in mired increments. *Mired* stands for *micro reciprocal degree*, which is a unit of measure used to express differences in color temperature values. It is based on a just-noticeable difference—1 mired—between two light sources. It is founded on the difference of the reciprocal of Kelvin color temperatures (not the temperatures themselves). The use of mired values dates back to 1932 when Irwin G. Priest invented the method. The values are based on a mathematical formula, as follows: **M = 1,000,000/T,** where M is the desired mired value and T is the color temperature in Kelvins. Most of us don't need to be concerned about understanding the term. Just realize that it means a visual difference between color values.

Manual White Balance Using the WB Button

Sometimes you might want to control the WB manually. The methods in this section and the next one accomplish the same thing, except the first method configures the WB using a button and dial and the next method uses the camera's menu system.

Each of these methods will allow you to set a particular WB temperature. If you want your image to appear cool, medium, or warm, you can set the appropriate color temperature, take the picture, and then look at the image on the Monitor.

Here is how to manually choose a WB type using the WB button, Main command dial, and Information display:

1. Press and hold the WB button (figure 10.2, image 1).
2. Rotate the Main command dial (figure 10.2, image 3).
3. Select one of the symbols that you see in the following list. The symbols will appear one at a time on the Information display as you rotate the rear Main command dial. You will see them where AUTO1 currently appears (figure 10.3, lower red arrow). Each click of the dial will change the display to the next WB setting. The symbols, options, and their Kelvin values are as follows (see a comprehensive list on page 111 of the User's Manual):
 - **AUTO1 or AUTO2:** Auto White balance: 3500K to 8000K

 - Incandescent: 3000K

 - Fluorescent: 2700K to 7200K

 - Direct sunlight: 5200K

- ⚡ Flash: 5400K

- ☁ Cloudy: 6000K

- ⌂ Shade: 8000K

- **K** **K:** Choose a color temperature (2500K–10000K)

- **PRE** **PRE** (Preset manual): White balance measured from actual ambient light

4. Rotate the front Sub-command dial to fine-tune the tint of the White balance setting (figure 10.3, upper red double arrow). You can adjust toward blue (B) or amber (A) in 2.5 mired increments. Each increment will be represented by the letter A or B followed by a decimal number ranging from 0.5 to 6.0. Again, the letter A stands for amber (red) and the letter B stands for blue. One full increment (e.g., A1.0 to A2.0) equals 5 mired for that color; one half increment (e.g., B0.5 to B1.0) equals 2.5 mired for that color. You can adjust from 2.5 mired (0.5) to 30 mired (6.0) in either the A or B direction. As you fine-tune the White balance color tint settings, you will see a little black square move left or right in the color indicator bar on the top left of figure 10.3.

Figure 10.3 – White balance selection on the Information display

Manual White Balance Using the Photo Shooting Menu

White balance (WB) is designed to let you capture accurate colors in each of your camera's RGB color channels. Your images can reflect realistic colors if you understand how to use the White balance settings. This is an important thing to learn about digital photography. If you don't understand how White balance (WB) works, you'll have a hard time when you want consistent color across a number of images.

Many people leave their cameras set to Auto White balance. This works fine most of the time because the camera is quite capable of rendering accurate color. However, it's hard to get exactly the same White balance in each consecutive picture when you are using Auto mode. The camera has to make a new White balance decision for each picture in Auto. This can cause the White balance to vary from picture to picture.

For many of us this isn't a problem. However, if you are shooting in a studio for a product shot, I'm sure your client will want the pictures to be the same color as the product and not vary among frames. White balance lets you control that carefully, when needed.

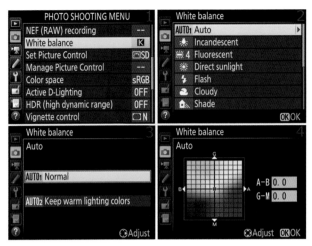

Figure 10.4A – Setting White balance to Auto1 – Normal

The steps to select a White balance setting are as follows:

1. Select White balance from the Photo Shooting Menu and scroll to the right (figure 10.4A, image 1).
2. Choose a White balance type, such as Auto or Flash, from the menu and scroll to the right (figure 10.4A, image 2).
3. If you choose Auto, Fluorescent, Choose color temp., or Preset manual you will need to select from an intermediate screen, similar to the one shown in figure 10.4A, image 3. Auto presents two settings: Auto1 – Normal and Auto2 – Keep warm lighting colors. Fluorescent presents seven different types of fluorescent lighting. Choose color temp. lets you select a color temperature manually from a range of 2500K (cool) to 10000K (warm). Preset manual (PRE) shows the stored White balance memory locations d-1 through d-6 and allows you to choose one of them. If this seems a bit overwhelming, just choose Auto1 – Normal for now.
4. As shown in figure 10.4A, image 4, you'll now arrive at the White balance fine-tuning screen. You can make an adjustment to how you want this White balance to record color by introducing a color bias toward green (G), magenta (M), blue (B), or amber (A). You do this by moving the little black square in the middle of the color box toward the edges of the box in any direction. If you make a mistake, simply move the black square to the middle of the color box. Most people do not change this setting.
5. After you have finished adjusting (or not adjusting) the colors, press the OK button to save your setting. Most people press the OK button as soon as they see the fine-tuning screen so they don't change the default settings for that particular White balance.

You'll also find it convenient to change the White balance settings by using external camera controls.

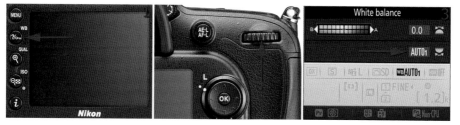

Figure 10.4B – Setting White balance with external controls

Use these steps to set the WB with external camera controls and the Monitor:

1. Hold down the WB button, which shares functionality with the Help/protect button (figure 10.4B, image 1).
2. Turn the rear Main command dial (figure 10.4B, image 2) as you watch the WB icons change on the Monitor (figure 10.4B, image 3). Select the WB value you want to use. My camera has Auto1 selected. If you want to fine-tune the WB, you can do so on this screen (image 3) along the blue (B) and amber (A) axes only. Simply turn the front Sub-command dial and you will see characters appear where 0.0 is currently displayed on the Information display (and Control panel on top). You will also see a small black square indicator move toward the B or A in the B/A color scale in the top left of the Information display screen (image 3). For instance, to add blue, turn the Sub-command dial clockwise and numbers such as B0.5 or B1.0 will appear instead of 0.0. The larger the number after the B, the more blue tint is added. To add amber (reddish) to the WB, turn the Sub-command dial counterclockwise. The indicator will move toward the A in the B/A scale and you will see characters such as A0.5 or A1.0 appear in place of 0.0. The adjustment range for B is from B0.5 to B6.0; the adjustment range for A is A0.5 to A6.0.
3. Release the WB button to lock in your choice.

Settings Recommendation: Understanding White balance is especially important if you plan to shoot JPEGs regularly because it is very difficult to change a JPEG image after the fact, without seriously damaging the quality of the image. When shooting RAW images, you can easily change the White balance after the image is taken with no damaging effects to the picture.

Manual White Balance Using the Movie Shooting Menu

The White balance settings for video recording works basically the same way they do for making still images. You can select a specific WB type, such as Direct sunlight, Fluorescent, or Cloudy, or you can let the camera decide which WB to use with the Auto WB mode.

If you prefer to be extremely accurate, you can choose a specific Kelvin color temperature from 2500K to 10000K, or you can do an ambient light reading from a white or gray card for best color temperature matching.

Now, let's examine how to select a particular WB value for your video.

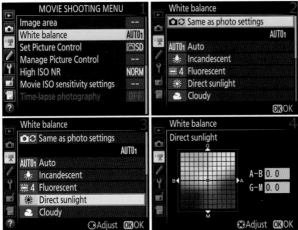

Figure 10.5A – Choosing a WB value for video recording

The steps to select a White balance setting for video recording are as follows:

1. Select White balance from the Movie Shooting Menu and scroll to the right (figure 10.5A, image 1).
2. If you prefer to use a carefully prepared WB value currently in use in the Photo Shoot-ing Menu for still images, you can highlight the Same as photo settings selection and press the OK button to use the same settings you were using previously for your still images (figure 10.5A, image 2). This is a factory default setting for video recordings. If this setting is satisfactory, you can press the OK button to select it and skip the follow-ing steps. To use a different WB for video recordings than you use for still images, pro-ceed with step 3.
3. Choose a White balance type, such as Auto or Cloudy, from the menu and scroll to the right (figure 10.5A, image 3).
4. If you choose Auto, Fluorescent, Choose color temp., or Preset manual you will need to select from an inter-mediate screen with additional choices, similar to the one shown for the Fluorescent WB in figure 10.5B. The Auto WB screen presents two settings: Auto1 – Normal and Auto2 – Keep warm lighting colors. Fluorescent presents seven different types of fluorescent light-ing (as seen in figure 10.5B). Choose color temp. al-lows you to select a color temperature manually from a range of 2500K (cool or bluish looking) to 10000K (warm or reddish looking). Preset manual (PRE) provides stored White balance memory locations d-1 through d-6 and allows you to choose one of them to store or reuse a

Figure 10.5B – Sample intermedi-ate screen for Fluorescent

certain WB setting. If this seems a bit overwhelming, just choose Auto1 – Normal; we will consider how to use the PRE setting later in this chapter. Once you have selected the WB value you want to use, either press the OK button to lock the WB value in and skip step 5, or scroll to the right to fine-tune the value.

5. If you want to fine-tune the WB value, you will use the screen shown in figure 10.5A, image 4. You can make an adjustment to how you want this White balance to record color by introducing a color bias toward green (G), magenta (M), blue (B), or amber (A). You do this by moving the little black square in the middle of the color box toward the edges of the box in any direction. If you make a mistake, simply move the black square to the middle of the color box. Most people do not change this setting. After you have finished adjusting (or not adjusting) the colors, press the OK button to save your setting. Most people press the OK button as soon as they see the fine-tuning screen so they don't change the default settings for that particular White balance.

Settings Recommendation: I generally leave my camera set to the *Same as photo settings* selection when I am shooting video (figure 10.5A, image 2). A nature photographer, such as myself, generally can shoot both still images and video with similar WB values. However, your style of video may require a WB setting completely different from the setting you use to shoot still images. The camera offers you the ability to have separate WB values for both photos and video.

Manual Color Temperature (K) with the WB Button

The K selection on the Information display allows you to manually select a WB value between 2500K and 10000K. This setting gives you the ability to use a very specific WB setting for those times when you need absolute consistency.

Here are the steps to select a specific Kelvin (K) White balance value using external camera controls:

1. Select the K symbol on the Control panel by holding down the WB button and rotating the rear Main command dial (figure 10.6, red arrow).
2. While still holding down the WB button, rotate the front Sub-command dial to select the WB Kelvin temperature you desire, from 2500K to 10000K. In figure 10.6, I selected 5560K. This K value appears on the Information display and the top Control panel for your convenience.

Figure 10.6 – Manual Color temperature (K) with external camera controls

Manual Color Temperature (K) with the Shooting Menus

You can also manually select a color temperature and fine-tune it by using the Photo or Movie Shooting Menus.

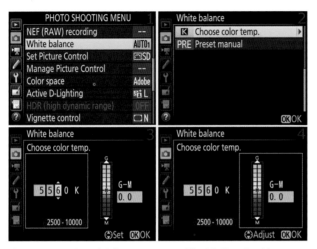

Figure 10.7 – Manual Color temperature (K) with Shooting Menu screens

Here are the steps to select a specific Kelvin (K) White balance value using the Photo Shooting Menu as an example. It works the same way for both the Photo and Movie Shooting menus:

1. Choose White balance from one of the two Shooting Menus and scroll to the right (figure 10.7, image 1).
2. Scroll down and select Choose color temp. from near the end of the White balance menu and scroll to the right (figure 10.7, image 2).
3. Use the Multi selector to scroll up or down in the Choose color temp. box and choose a number from 2500K to 10000K (figure 10.7, image 3, inside the yellow rectangle). My camera has 5560K selected. Press the OK button to skip step 4 (fine-tuning), or move the yellow box to the right to use the fine-tuning area (color scale).
4. As shown in figure 10.7, image 4 (inside the yellow rectangle), you can fine-tune the color temperature to include more green or magenta (G–M), in 0.25 increments (1.25 mired each), from G0.25 to G6.0, or M0.25 to M6.0. One full increment (e.g., M2.25 to M3.25) equals 5 mired. You simply press up or down with the Multi selector. Up adds green (G) and down adds magenta (M). As you can move the little black square up or down in the color scale, you are fine-tuning the tint of the color temperature you selected in screen 3 (5560K). To cancel the fine-tuning operation, simply return the little square to the center of the color scale and press the OK button. After you have fine-tuned the color temperature to your liking, press the OK button to lock in the setting.

See the upcoming section called **Fine-Tuning White Balance** for more detailed information on fine-tuning.

When you have selected an exact White balance, or fine-tuned one of them, all the images you shoot from that point forward—until you change to another WB—will have that setting. You can have very consistent White balance from image to image by using this method. For in-studio product shoots, or in any circumstance when you need a constant White balance, this is a desirable function.

Measuring Ambient Light by Using PRE

This method allows you to measure ambient light values and set the WB. It's not hard to learn and is very accurate because it's an actual through-the-lens measurement of the source light's Kelvin temperature.

Figure 10.8A – WhiBal cards

You'll need a white or gray card to accomplish this measurement. Figure 10.8A shows the popular WhiBal white balance reference card, which is available at the following website: **http://michaeltapesdesign.com/whibal.html**

The WhiBal card set is very convenient because it includes cards that will easily fit in your pocket or camera bag. I highly recommend these cards because of their durability, portability, and sizes for all occasions.

Doing a PRE WB Reading for Viewfinder Photography

Here's how to select the PRE White balance measurement method:

1. Press and hold the WB button.
2. Rotate the rear Main command dial and select PRE (White balance preset) from the Information display (figure 10.8B, lower arrow).
3. Choose one of the White balance memory locations (d-1 to d-6) to store the WB reading you are about to

Figure 10.8B – Selecting the PRE (PrE) White balance ambient light measurement method

make. You can use this same reading over and over by simply selecting this memory location again, with this screen or in the Shooting Menus.

4. Once you have selected PRE, continue holding the WB button until the letters PrE start flashing on the Control panel (figure 10.8C). You'll also see the selected WB memory location (d-1 to d-6) showing to the right of PrE.

Figure 10.8C – The PrE setting blinking on the Control panel

5. While PrE is still flashing, point the camera at a white or neutral gray card in the light source under which you will be taking pictures. The camera does not have to focus on the card, but the card should fill the frame, so try to get close without making a shadow. Press the Shutter-release button fully, as if you were photographing the card. The shutter will fire, but nothing will appear on the Monitor.

6. Check the Control panel to see if Good is flashing and PrE appears on the lower-right portion of the Control panel. If Good is flashing, you have successfully measured for a correct White balance under the light in which you are shooting. If you see no Gd flashing (instead of Good), the operation was not successful. Your available light may not be bright enough to take an accurate reading.

Doing a PRE WB Reading in Live View Mode

You can use the PRE method while the camera is in Live view. The camera is configured in basically the same way as the Viewfinder mode just discussed, with a few minor differences. Let's see how it works.

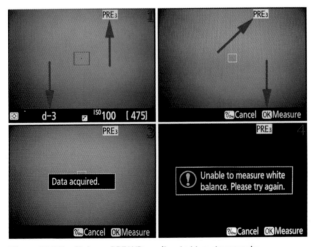

Figure 10.8D – Doing a PRE WB reading in Live view mode

Here are the steps used to do a PRE WB reading in Live view mode:

1. Press the Lv button and enter Live view. It does not matter whether you are using Movie live view mode or Live view Photography mode, they both work the same way.
2. As seen in figure 10.8D, image 1 (red arrows), once in Live view, press the WB button and quickly turn the front Sub-command dial to select one of the PRE memory locations (PRE1 to PRE6, representing PRE memory locations d-1 to d-6). If you wait too long to turn the front Sub-command dial and make a selection, the camera will enter PRE reading mode for whatever PRE number is currently selected. Make your memory location selection quickly. We will use PRE3 (d-3) for our example.
3. Quickly release and then press and hold down the WB button again. In a couple of seconds PRE3 (for example) will start flashing in the top-right area of the Monitor (figure 10.8D, image 2, top red arrow) to let you know the camera is ready for the ambient-light reading process. Also, PrE will flash on the Control panel (figure 10.8C). When PRE3 and PrE are flashing, you can store the Live view PRE ambient-light reading from the gray card into your selected PRE memory location by pressing the OK button (figure 10.8D, image 2, lower red arrow). You can also use the Shutter-release button to make the reading, if you prefer. Hold the gray card in front of the lens and press the OK button or Shutter-release button.
4. After a successful reading is made, a small box opens with the message *Data acquired* (figure 10.8D, image 3). The Control Panel will also flash Good, just like in the steps previously discussed for non-Live view readings.

If the reading was not successful, the camera will report *Unable to measure white balance. Please try again* (figure 10.8D, image 4). In the meantime, the Control panel will flash No Gd, as previously discussed.

Settings Recommendation: After PrE starts blinking on the Control panel—or PRE3 (for example) on the Live view Monitor—you must take the new White balance measurement within about six seconds or you will have to repeat the PRE reading steps. If you have *Custom Setting Menu > c Timers/AE lock > c2 Standby timer* set to longer than six seconds, the PRE measurement timeout (how long PrE flashes) will match it. The PRE measurement timeout is tied directly to the length of time the light meter is active, which is controlled by *c2 Standby timer*.

The PRE measurement is very sensitive because it uses the light coming through the lens to set the WB. Unless you are measuring in extremely low light, it will virtually always be successful. If the lens aperture is set too small during the PRE reading, you may have trouble getting a good reading. If so, open the aperture.

Fine-Tuning White Balance

As briefly discussed earlier in this chapter, you can use the Shooting Menu to fine-tune any of the White balance settings in the camera.

You can even fine-tune a PRE White balance value that you created previously with an ambient light reading (d-1 to d-6). The color balance can be moved toward G (green), A (amber), M (magenta), or B (blue), or it can be moved toward intermediate combinations of those colors. Let's see how.

Fine-Tuning a Camera White Balance Setting

The D7200 includes nine White balance settings (e.g., Auto1, Flash, Shade). Each of them can be fine-tuned with either a color box or a color scale. Let's examine how it works by using the Flash WB value as an example.

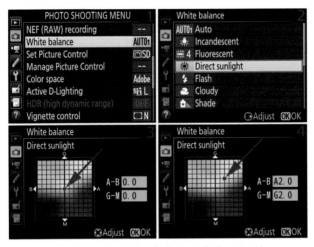

Figure 10.9A – Fine-tuning White balance with Shooting Menu screens

Here are the steps to fine-tune a White balance setting using the Photo Shooting Menu as an example:

1. Select White balance from the Photo Shooting Menu (or Movie Shooting Menu) and scroll to the right (figure 10.9A, image 1).
2. Choose one of the White balance types and scroll to the right (figure 10.9A, image 2). I chose Direct sunlight because both the Photo and Movie Shooting Menus have that setting.
3. You will now see the fine-tuning screen with its color box. In the middle of the color box is a small black square (figure 10.9A, image 3, red arrow). When this square is in the middle, as shown in image 3, nothing has been changed. Each press of the Multi selector in a given direction is equal to one 1.25-mired step (0.25 increment) in the G/M

axis (vertical movement) and a 2.5-mired step (0.5 increment) in the A/B axis (horizontal movement). Up is green (G), down is magenta (M), left is blue (B), and right is amber (A). Each full step (containing multiple increments) is equal to 5 mired (e.g., A1.0–A2.0). You can see in figure 10.9A, image 4, that I have added both G and A by moving the square to a position in between those two values (red arrow). The A2.0 and G2.0 that appear next to A–B and G–M means that I have added 10 mired to both amber (A) and green (G).

4. Press the OK button to save your changes. An asterisk will appear after the name of the fine-tuned White balance selection on the Photo Shooting Menu screen and any other WB displays (figure 10.9B, red arrow). To remove the fine-tuning adjustment, simply return to the screen with the color box and center the square, as in figure 10.9A, image 3.

PHOTO SHOOTING MENU	
NEF (RAW) recording	--
White balance	☀
Set Picture Control	⊡
Manage Picture Control	--
Color space	Adobe
Active D-Lighting	䐉 L
HDR (high dynamic range)	OFF
Vignette control	☐N

Figure 10.9B – An asterisk appears after a fine-tuned WB setting

Settings Recommendation: If you aren't familiar with adjusting the default color temperature, or if you don't want to change it (most people don't), then simply press the OK button without moving the square from the center (figure 10.9A, image 3).

Fine-Tuning a PRE Measured White Balance

Previously we examined how to take a PRE measurement from a white or gray card to balance the camera to the available light. What if you want to fine-tune one of the already existing d-1 to d-6 Preset values? Let's do it!

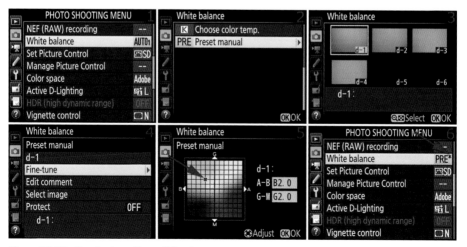

Figure 10.9C – Fine-tuning a Preset WB value

Use these steps to fine-tune a Preset White balance value:

1. Select White balance from the Shooting Menu and scroll to the right (figure 10.9C, image 1).
2. Choose Preset manual from the menu and scroll to the right (figure 10.9C, image 2).
3. Use the Multi selector to scroll to the memory location you want to fine-tune, from d-1 to d-6 (figure 10.9C, image 3). Press the Playback zoom out/thumbnails (ISO) button to select it.
4. Choose Fine-tune from the Preset manual menu and scroll to the right (figure 10.9C, image 4).
5. Use the Multi selector to adjust the color balance (figure 10.9C, image 5). Scroll around in the color box toward whatever color you want to add to the currently stored White balance (red arrow). You'll see the color-mired values change on the right side of the screen in the fields next to A–B and G–M. Each press of the Multi selector in a given direction is equal to one 1.25-mired step (0.25 increment) in the G/M axis (vertical movement) and 2.5-mired steps (0.5 increment) on the A/B axis (horizontal movement). Up is green (G), down is magenta (M), left is blue (B), and right is amber (A). Each full increment is equal to 5 mired (e.g., A1.0–A2.0).
6. Press the OK button to save your adjustments to the stored White balance. The camera will return to the main Shooting Menu screen, and PRE* will appear next to White balance (figure 10.9C, image 6, red arrow). The asterisk indicates that this particular Preset White balance has been fine-tuned.

Editing the PRE White Balance Comment Field

You can add up to 36 characters of text to the comment field of a memory location (d-1 to d-6) for a stored PRE White balance setting. Change the comment to something that will remind you of this measured WB setting's purpose.

Here are the steps to edit a comment field for a WB setting:

1. Select White balance from the Photo Shooting Menu and scroll to the right (figure 10.10, image 1).
2. Choose Preset manual from the menu and scroll to the right (figure 10.10, image 2).
3. Select the memory location for which you want to edit the comment (d-1 to d-6) and press the Playback zoom out/thumbnails (ISO) button (figure 10.10, image 3). This will open the Preset manual menu.
4. Choose Edit comment from the Preset manual menu and scroll to the right (figure 10.10, image 4).
5. The character selection panel will now appear (figure 10.10, image 5). Use the Multi selector to navigate among the letters and numbers. Press the OK button to add a character to the comment line at the bottom of the screen. To scroll through the characters

you've already added, hold down the Playback zoom out/thumbnails (ISO) button while navigating to the left or right with the Multi selector. Press the Delete button to delete the current character. Press the Playback zoom in (QUAL) button to save the memory location comment.

6. The White balance memory location screen will now appear with the new memory location comment displayed (figure 10.10, image 6, red arrow). I filled in the comment field for memory location d-1 with the reminder Overcast day.

Settings Recommendation: It's a good idea to name each of your important saved PRE WB settings so that you can remember what each one represents.

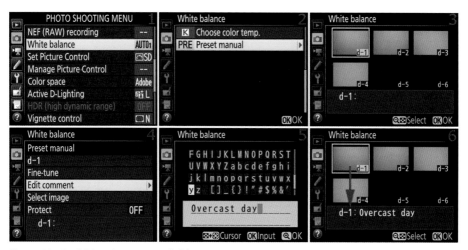

Figure 10.10 – Editing the comment field

Using the White Balance from a Previously Captured Image

You can select a White balance setting from an image you have already taken. This WB value can then be applied to pictures you are about to take. If you are shooting pictures under a light source that you previously used for other photographs, this can be a timesaver.

Here are the steps to use the White balance setting from an image stored on your camera's memory card:

1. Select White balance from the Photo Shooting Menu and scroll to the right (figure 10.11, image 1).
2. Choose Preset manual from the menu and scroll to the right (figure 10.11, image 2).
3. Choose a memory location to which you want to save the White balance setting from an existing picture. I chose the blank memory location d-5 (figure 10.11, image 3). Press the Playback zoom out/thumbnails (ISO) button to select the memory location. This opens the Preset manual menu.

4. Choose Select image from the Preset manual menu and scroll to the right (figure 10.11, image 4). Select image will be grayed out if there are no images on your current memory card.

5. You will now see the Select image screen (figure 10.11, image 5). Navigate through the available images until you find the one you want to use for WB information. You can zoom in to look at a larger version of the image by pressing the Playback zoom in (QUAL) button. Press the OK button to select the image.

6. A small picture of the image will appear in your selected White balance memory location and is saved there for future use (figure 10.11, image 6). The White balance setting from that picture is now the White balance setting for the camera, until you change it.

Figure 10.11 – Using the White balance from a previously taken image

Protecting a PRE White Balance Reading

You may have gone to great efforts to create a particular White balance Preset value that you will use frequently. Maybe you have a studio with a certain type of lighting that does not vary and you want to have a dependable PRE value available for it. Let's see how to protect a PRE (d-1 to d-6) value.

Figure 10.12 – Protecting a PRE White balance from deletion or change

Here are the steps to protect a PRE White balance value:

1. Select White balance from the Photo Shooting Menu and scroll to the right (figure 10.12, image 1).
2. Choose Preset manual from the menu and scroll to the right (figure 10.12, image 2).
3. Choose the memory location you want to protect (d-1 to d-6). I chose d-3, which is where I stored my PRE reading called "My monolight strobes" (figure 10.12, image 3). Press the Playback zoom out/thumbnails (ISO) button to select the PRE memory location. This opens the Preset manual menu.
4. Choose Protect from the Preset manual menu and scroll to the right (figure 10.12, image 4).
5. Choose On to protect or Off to remove protection from a PRE White balance memory location. I am protecting d-3, so I chose On (figure 10.12, image 5).
6. The camera will now display the White balance screen with a protection symbol displayed on the memory location you protected. The key symbol at the point of the red arrow in figure 10.12, image 6, indicates that memory location d-3 is locked from deletion or change. You cannot modify the protected value in any way, including fine-tuning or editing the comment field, until you remove the protection.

Note: If you try to write a new value to a PRE memory location you have protected, the camera will refuse to overwrite the protected memory location. Instead, it will display the characters PrT on the Information display and Control panel and will flash PrT if you persist in trying to overwrite the location. PrT simply means that the camera recognizes this as a protected PRE value and refuses to replace it until you go into the menu and unprotect it.

Auto White Balance

Auto White balance works pretty well in the D7200. As the camera's RGB meter senses colors, it does its best to balance to any white or midrange grays it can find in the image. However, the color may vary a little on each shot. If you shoot only in Auto WB mode, your camera considers each image a new WB problem and solves it without reference to the last image taken.

The Auto WB setting also has the White balance fine-tuning screen, as discussed in the section called **Fine-Tuning White Balance** earlier in this chapter. I don't see how this is particularly useful because each image is likely to have a slightly different color temperature to deal with. That means the fine-tuning will have little value for more than an image or two. If you were shooting in the exact same light for a period of time, I suppose the fine-tuning would be useful; however, wouldn't it make more sense to do a PRE reading of the light for an exact WB? This choice will depend on your shooting style and personal preferences.

Using Auto WB (AUTO1 and AUTO2)

Auto White balance comes in two flavors: AUTO1 and AUTO2. The difference is that AUTO2 uses warmer colors than AUTO1. For general shooting, AUTO1—or AUTO2, if you prefer warm colors—is all that's needed.

Figure 10.13 – Auto White balance choices

Here are the steps to select one of the Auto White balance options:

1. Choose White balance from the Photo Shooting Menu and scroll to the right (figure 10.13, image 1).
2. Select Auto from the menu and scroll to the right (figure 10.13, image 2).

3. Choose AUTO1 Normal or AUTO2 Keep warm lighting colors (according to your color warmth preference) and scroll to the right (figure 10.13, image 3).
4. Press the OK button to lock in the WB setting, or scroll to the right to fine-tune it if you'd like (figure 10.13, image 4). See the section called **Fine-Tuning White Balance** earlier in this chapter.

Settings Recommendation: I often use AUTO1 White balance on my D7200. The only time I use anything but AUTO1 is when I am shooting special types of images. For instance, if I am shooting an event with flash and I want consistent color, I often choose the Flash White balance setting. Or, if I am shooting landscapes under direct sunlight, I often shoot with the Direct sunlight White balance setting. Other than special occasions, Auto White balance works very well for me. Give it a try, along with each of the others in their intended environments. This is all part of improving your digital photography. A few years back we carried different film emulsions and colored filters to get these same effects. Now it's all built-in!

Should I Worry about White Balance If I Shoot in RAW Mode?

The quick answer is no, but that may not be the best answer. When you take a picture using NEF (RAW) mode, the sensor image data has no White balance, sharpening, or color saturation information applied. Instead, the information about your camera settings is stored as markers along with the RAW black-and-white sensor data. Color information, including White balance, is applied permanently to the image only when you post-process and save the image in another format, like JPEG, TIFF, or EPS.

When you open the image in Nikon Capture NX-D, or another RAW conversion program, the camera settings are applied to the sensor data in a temporary way so you can view the image on your computer screen. If you don't like the White balance, or almost any other setting you used in-camera, you can simply change it in the conversion software and the image looks as if you used the new setting when you took the picture.

Does that mean I am not concerned about my WB settings because I shoot RAW most of the time? No. The human brain can quickly adjust to the colors in an image and perceive them as normal, even when they are not. This is one of the dangers of not using the correct WB. Because an unbalanced image on your computer screen is not compared to another correctly balanced image side by side, there is some danger that your brain may accept the slightly incorrect WB as normal, and your image will be saved with a color cast.

As a rule of thumb, if you use your WB correctly at all times, you'll consistently produce better images. You'll do less post-processing if the WB is correct in the first place. As RAW shooters, we already have a lot of post-processing work to do. Why add WB corrections to the workflow? It's just more work, if you ask me!

Additionally, you might decide to switch to JPEG mode in the middle of a shoot, and if you are not accustomed to using your WB controls, you'll be in trouble. When you shoot JPEGs, your camera will apply the WB information directly to the image and save it on your memory card—*permanently*. Be safe: always use good WB technique!

White Balance Tips and Tricks

When measuring WB with a gray or white card, keep in mind that your camera does not need to focus on the card. In PRE mode, it will not focus anyway because it is only trying to read light values, not take a picture. The important thing is to put your lens close enough to the card to prevent it from seeing anything other than the card. Three or four inches (about 75mm to 100mm) away from the card is about right for most lenses.

Be careful that your lens does not cast a shadow onto the card in a way that lets your camera see some of the shadow. This will make the measurement less accurate. Also, be sure that your source light does not produce glare on the card. This problem is not common because most cards have a matte surface, but it can happen. You may want to hold the card at a slight angle to the source light if the light is particularly bright and might cause glare.

Finally, when the light is dim, use the white side of the card because it is more reflective. This may prevent a *no Gd* reading in low light. The gray card may be more accurate for color balancing, but it might be a little dark for a good measurement in dim light. If you are shooting in normal light, the gray card is best for balancing. You might want to experiment in normal light with your camera to see which you prefer.

Author's Conclusions

With these simple tips and some practice, you can become a D7200 WB expert. Starting on page 111 of your D7200 User's Manual you'll find extensive WB information, if you want another perspective.

Learn to use the color temperature features of your camera to make superior images. You'll be able to capture very accurate colors or make pictures with color casts to reflect how you feel about them. Practice a bit, and you'll find it easy to remember how to set your WB in the field.

Now, let's turn our attention to the autofocus (AF) system in the D7200. Many people find the various modes hard to remember and even a bit confusing. In the upcoming chapter, we'll examine how the AF modes work and how they relate to other important camera functions, such as the AF-area and Release modes.

11 Autofocus, AF-Area, and Release Modes

Battle in the Air © 2015 Paul R Sorrells (Rickman)

Autofocus (AF) and Release modes are active settings that you'll deal with each time you use your camera. Unlike adjusting settings in the menus, which you'll do from time to time, you'll use Autofocus and Release modes every time you make an image or movie. You will adjust AF-area modes less often; however, these critical functions affect how and where the camera focuses on your subject.

To take pictures and make movies, you need to be very familiar with these settings, so this is a very important chapter for your mastery of the Nikon D7200. Grab your camera and let's get started!

This chapter is divided into three sections:
- Section 1: Autofocus in Viewfinder Photography
- Section 2: Autofocus in Live View Photography
- Section 3: Release Modes

Section 1: Autofocus in Viewfinder Photography

The Nikon D7200 has two types of autofocus built in, with different parts of the camera controlling AF in different shooting modes (figure 11.1). When you take pictures through the Viewfinder, one type of autofocus is used, and when you shoot a picture or movie using Live view, a different type is used. They are as follows:

- **TTL phase detection autofocus:** The Multi-CAM 3500 II autofocus module provides through-the-lens (TTL) phase detection autofocus, with 51 AF points in a gridlike array in the central area of the Viewfinder (figure 11.1, image 1). This type of AF is known simply as *phase-detection AF*. It is a very fast type of autofocus and is used by the camera only when you are taking pictures through the Viewfinder.
- **Focal plane contrast AF:** The camera's imaging sensor provides focal plane contrast AF, which uses pixel-level contrast detection (figure 11.1, image 2). A simple name for this is *contrast-detection AF*. The entire surface of the imaging sensor can be used to detect contrast between light and dark boundaries to provide autofocus. This is a relatively slow form of autofocus, but it is extremely accurate because it is done at the pixel level. This form of autofocus is used only while you are shooting in Live view mode.

What Is the Multi-CAM 3500 II Autofocus Module?

The Multi-CAM 3500 II AF module is a very accurate autofocus system that controls where and how your camera's AF and AF-S lenses achieve the sharpest focus on your subject.

The Nikon D7200 offers a significant boost in the number of Viewfinder AF points over older cameras, with a total of 51. What do we gain from all these extra AF points and more powerful modes? As we progress through this chapter, we will discuss these things in detail, along with how your photography will benefit most from using all the features of the Multi-CAM 3500 II AF system.

Figure 11.1 – (1) Multi-CAM 3500 II AF module and (2) a CMOS DX format imaging sensor

Three Mode Groups

There are three specific mode groups that you should fully understand: Autofocus modes, AF-area modes, and Release modes. Many people get these modes confused and incorrectly apply functions from one mode to a completely different mode. It *is* a bit confusing at times, but if you read this carefully and try to wrap your brain around the different functionalities provided, you'll have much greater control of your camera later.

Note: The Nikon User's Manual page numbers are provided in case you want to see what the manual has to say. Using the manual is entirely optional because this book covers the information in more explicit detail.

First, let's consider how autofocus works when using the Viewfinder. The three mode groups for Viewfinder shooting are as follows:

Autofocus modes (User's Manual: Page 83):
- Auto-servo AF (AF-A)
- Single-servo (AF-S)
- Continuous-servo (AF-C)

AF-area modes (User's Manual: Page 86, Menu Guide: Page 64):
- Single-point AF
- Dynamic-area AF (9, 21, and 51 AF points)
- 3D-tracking AF
- Auto-area AF

Release modes (User's Manual: Page 66):
- Single frame (S)
- Continuous low speed (CL)
- Continuous high speed (CH)
- Quiet shutter-release (Q)
- Self-timer
- Mirror up (MUP)

What is the difference between these modes? Think of them like this: The Autofocus modes control *how* the AF module focuses, the AF-area modes control *where* it focuses, and the Release modes control *when* focus happens and how often a picture is taken.

While the Release modes are not directly Focus modes, it is a good idea to consider them at the same time because they control when Autofocus executes.

In upcoming sections, we'll look into all of these mode types and see how they work together to make the D7200's autofocus and subject tracking system one of the world's best.

With the controls built into the D7200 body, you'll be able to select whether the AF module uses one or many of its 51 AF points to find your subject. You'll also select whether the camera simply locks focus on a static subject or whether it continuously seeks a new focus if your subject is moving, and how fast (in frames per second) it captures the images.

Settings Recommendation: If you are having trouble remembering what all these modes do—join the club! I've written multiple books about Nikon cameras and I still get confused at times about what each mode does. I often refer back to my own books to remember all the details. I have both the print and e-book versions of my books so they are always nearby (I love having the digital versions available on my iPad and iPhone).

You'll become familiar with the modes you use most often, and that is usually sufficient. Try to associate the type of mode with its name, and that will make it easier. Learn the difference between an Autofocus mode (focus *how*), AF-area mode (focus *where*), and a Release mode (focus *when*).

Custom Settings for Viewfinder AF and Live view/Movie AF

The AF module has eight configurable Custom settings, a1–a8. We've examined each of those Custom settings in the chapter titled **Custom Setting Menu** (page 184). You may want to review each of them.

Using Autofocus and AF-Area Modes for Viewfinder Photography

(User's Manual: Pages 83, 86, Menu Guide: 62)

The D7200 has distinct modes for how and where to focus. We'll examine each of those modes as a starting point in our understanding of autofocus with the Multi-CAM 3500 II AF module. We'll tie together information about the Autofocus modes, AF-area modes, and Release modes since they work together to acquire and maintain good focus on your subject. Release modes are covered in the last section of this chapter because both Viewfinder and Live view photography use the same Release modes.

Figure 11.2A shows the controls we'll use in combination to change how the camera focuses and captures images. The caption helps you identify each control.

Notice in figure 11.2A, image 4, that the Multi selector has a lock switch below it. You can see a white dot and an L to the left-top side of the switch. Move the switch to the dot setting (as shown), which unlocks the internal AF point movement capability. Otherwise, you won't be able to move the AF point around the Viewfinder within the 51 available points.

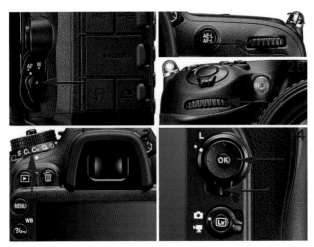

Figure 11.2A – AF-mode button (1), Front Sub-command dial (2A), Rear Main command dial (2B), Release mode dial (3), and Multi selector, with AF-lock switch below (4)

Settings Recommendation: I leave my D7200's AF-lock switch unlocked all the time, but I check as the camera is focusing to make sure I am using the AF point I want to use. I can use the Multi selector to move a single AF point around the array of 51 available points when using Single-point AF, or a group of points when using Dynamic-area AF. We'll discuss this in more detail later.

Cross-Type AF Points at Various Apertures

Cross-type AF points will initiate autofocus in either a horizontal or a vertical direction, unlike standard AF points, which work only in a horizontal direction. The ability of the AF system to function properly is dependent on the maximum aperture of the lens in use (or of the lens and teleconverter combination). Lenses normally autofocus at maximum aperture and only stop down to the aperture you have selected when you take a picture. Most cameras are designed to autofocus with lenses having a maximum aperture of f/5.6 or larger (e.g., f/1.4, f/2.8, f/4).

The Nikon D7200 is in a special class of camera since its autofocus can work with lenses that have a maximum aperture smaller than f/5.6. The camera can autofocus using lenses or teleconverter/lens combos that have maximum apertures from f/5.6 to f/8.

Figure 11.2B shows the various arrangements of cross-type and extra-sensitive AF points the camera can use when you are working with small maximum apertures. The maximum aperture of the lens determines which AF points act as cross-type and which do not.

You must be sure to select one of the AF points shown in figure 11.2B if you are using a lens or teleconverter/lens combo that has a maximum aperture smaller than f/5.6. The camera will not prevent or warn you if you try to use an AF sensor inappropriate to the small maximum aperture.

You cannot select one of the overall patterns shown in figure 11.2B. You simply move your active AF sensor into one of the locations in the patterns, according to how small the maximum aperture happens to be. Study this carefully if you regularly use teleconverters on telephoto lenses with autofocus.

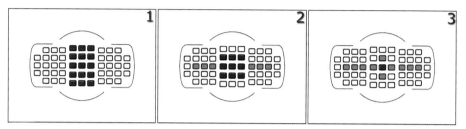

Figure 11.2B – 15 Cross-type AF points at f/5.6 or larger aperture in red (1); 9 Cross-type AF points in red and 6 AF points that work between f/5.6 and f/8 in blue (2); 1 Cross-type AF sensor in red and 10 AF points that work at f/8 in blue (3).

- *Figure 11.2B, image 1,* shows the 15 AF points (in red) that are cross-type AF points. The center three columns of AF points are cross-type, while the uncolored AF points are standard line sensors (not cross-type) and work with lenses that have a maximum aperture of f/5.6 or larger.
- *Figure 11.2B, image 2,* shows the arrangement of nine cross-type AF points (in red), along with 6 extra-sensitive AF points (in blue) that are not cross-type, all of which work with lenses that have a maximum aperture between f/5.6 and f/8.
- *Figure 11.2B, image 3,* shows the arrangement of one cross-type AF point (in red), along with 10 extra-sensitive AF points (in blue) that are not cross-type—for a total of 11 AF points—all of which work with lenses that have a maximum aperture of f/8.

Any AF points not marked in red or blue in figure 11.2B are standard AF points that work only with lenses having maximum apertures of f/5.6 and larger. You may be able to get the standard-sensitivity AF points to respond with lenses having smaller maximum apertures, but you shouldn't depend on consistency of autofocus when a standard AF point is in use at maximum apertures smaller than f/5.6.

Autofocus Basics – Clarifying a Point of Potential Confusion
Older Nikons (not the D7200) may not autofocus reliably with a lens having a maximum aperture smaller than f/5.6. That may sound bad, if you assume that it means the camera will not autofocus reliably when the aperture is stopped down to f/5.6. That's not the case!

Instead, autofocus may not work reliably on older Nikons with a lens having a *maximum* aperture of f/5.6, with emphasis on the word maximum.

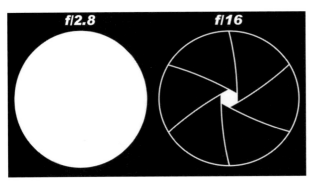

Figure 11.2C – Sample *maximum* aperture (f/2.8) and *minimum* aperture (f/16). Actual maximum and minimum aperture varies according to the lens.

Maximum aperture (figure 11.2C) means the largest aperture (biggest hole) the lens can possibly have when it is wide open. A lens autofocuses with the aperture wide open and then stops the lens down (closes the aperture to a smaller hole) only at the very moment of exposure. If you are using a lens with a *maximum* aperture of f/5.6, the widest the lens can ever open is f/5.6, which does not provide enough light internally for many older Nikons to autofocus reliably.

It is critical you understand that we are not talking about autofocusing with a standard Nikkor lens at f/5.6, f/8, f/11, f/16, or a smaller aperture opening. All AF Nikons will autofocus with an AF lens at any aperture the lens supports. Again, they can do that because autofocus happens at maximum aperture, which on even low-cost Nikon lenses, is usually about f/3.5. The maximum aperture on many prime lenses is f/1.4 or f/1.8. And on pro zooms, the maximum aperture is usually f/2.8 or f/4.

Therefore, your older Nikon will autofocus on normal AF lenses all the way down to the smallest aperture because the actual autofocus happens at maximum aperture (largest hole), which on most lenses is bigger than f/5.6.

When you add a teleconverter to a slow telephoto lens, the maximum aperture can sometimes drop below the f/5.6 barrier, making autofocus difficult or impossible on older Nikons.

Fortunately, the Nikon D7200 is not limited like the older Nikons! As you saw in figure 11.2B, the camera has special arrangements of AF points that can autofocus on lenses with a maximum aperture all the way down to f/8. That makes the Nikon D7200 a special and valuable camera for those who want to use telephoto lenses with teleconverters.

Autofocus Modes in Detail

(User's Manual: Page 83)

The Autofocus modes allow you to control how the autofocus works with static and moving subjects. They allow your camera to lock focus on a subject that is not moving or is moving very slowly. They also allow your camera to follow focus on an actively moving subject. Let's consider the three servo-based Autofocus modes to see when and how you might use them best.

Figure 11.3 – Selecting an Autofocus mode with the Control panel or Information display

Here are the steps to select an Autofocus mode (figure 11.3):

1. Hold in the AF-mode button (figure 11.3, image 1).
2. Turn the rear Main command dial (figure 11.3, image 2A).
3. The Control panel will show any of the three modes (AF-A, AF-S, and AF-C) as you turn the rear dial (figure 11.3, image 3). In this instance, Single-servo Autofocus mode (AF-S) is selected.
4. **Optional:** Alternatively, the camera offers the Information display, which you can access by pressing the info button before pressing the AF-Mode button (figure 11.3, image 2B). If the Information display is *already active* when you press the AF-mode button (image 1), the Focus mode/AF-area mode screen shown in figure 11.3, image 4, will be displayed. If it is not already active, the adjustment screen will not appear. If active, you can adjust the Autofocus mode at the point of the red arrow (figure 11.3, image 4) by turning the rear Main command dial.
5. Release the AF-mode button when the mode you want to use is displayed on the Control panel or Information display.

Let's consider what each of the three modes do.

Auto-Servo AF (AF-A) Mode

Auto-servo AF (AF-A) is an automatic mode that pays attention to your subject's movement. It is rather simple to use because it senses whether your subject is static or moving.

- **Subject is not moving:** If the subject is not moving, the camera automatically uses AF-S mode. In this mode the focus locks on the subject and does not update as long as the subject remains still. However, the focus can unlock if the camera detects subject movement, and it will automatically switch to AF-C mode, not locking again unless the subject stops moving.
- **Subject is moving:** If the subject is moving, the camera automatically sets itself to AF-C mode. It detects the movement across the AF points and automatically keeps focus up to date as long as you keep some AF points on the subject. Focus does not lock, unless the subject stops moving.

Single-Servo AF Mode (AF-S)

Single-servo AF (AF-S) works best when your subject is stationary—like a house or landscape. You can use AF-S on slowly moving subjects if you'd like, but you must be careful to keep autofocus adjusted as the subject moves. The two scenarios listed next may help you decide:

- **Subject is not moving:** When you press the Shutter-release button halfway down, the AF module quickly locks focus on your subject and waits for you to fire the shutter. If your subject starts moving and you don't release and reapply pressure on the Shutter-release button to refocus, the focus will be obsolete and useless. When you have focus lock, take the picture quickly. This mode is perfect for stationary subjects or, in some cases, very slowly moving subjects.
- **Subject is regularly moving:** This will require a little more work on your part. Since the AF system locks focus on your subject, if the subject moves even slightly, the focus may no longer be good. You'll have to lift your finger off the Shutter-release button and reapply pressure halfway down to refocus. If the subject continues moving, you'll need to continue releasing and pressing the Shutter-release button halfway down to keep the focus accurate. If your subject never stops moving, is moving erratically, or stops only briefly, AF-S is probably not the best mode to use. In this case, AF-C is better because it never locks focus and the camera is able to track your subject's movement, keeping it in constant focus.

Continuous-Servo AF Mode (AF-C)

Using Continuous-servo AF (AF-C) is slightly more complex because it is a focus-tracking function. The camera looks carefully at whether the subject is moving, and it even reacts differently if the subject is moving from left to right, up and down, or toward and away from you. Read these three scenarios carefully:

- **Subject is not moving:** When the subject is standing still, Continuous-servo AF acts a lot like Single-servo AF with the exception that the focus never locks. If your camera moves, you may hear your lens chattering a little as the autofocus motor makes small adjustments in the focus position. Because focus never locks in this mode, you'll need to be careful that you don't accidentally move the AF point off the subject because it may focus on something in the background instead.
- **Subject is moving across the Viewfinder:** If your subject moves from left to right, right to left, or up and down in the Viewfinder, you'll need to keep your AF point on the subject when you are using Single-point AF area mode. If you are using Dynamic-area AF or Auto-area AF mode, your camera can more easily follow the subject across a few or all of the 51 AF points. We'll cover this in more detail in the upcoming section called **AF-Area Modes in Detail**.
- **Subject is moving toward or away from the camera:** If your subject is coming toward you, another automatic function of the camera kicks in. It is called *predictive focus tracking,* and it figures out how far the subject will move before the shutter fires. After you've pressed the Shutter-release button all the way down, predictive focus tracking moves the lens elements slightly to correspond to where the subject should be when the shutter fires a few milliseconds later. In other words, if the subject is moving toward you, the lens focuses slightly in front of your subject so that the camera has time to move the mirror up and get the shutter blades out of the way. It takes several milliseconds for the camera to respond to a press of the Shutter-release button.

Note: Sometimes, in addition to "Autofocus modes," the AF modes are called "Focus modes" in Nikon literature, including the User's Manual. In this book, I use Autofocus mode or AF mode. I use *Autofocus mode* most frequently to prevent the reader from confusing this mode with the AF-area modes.

Predictive Focus Tracking

Let's talk about a practical use of an Autofocus mode. For instance, if you are shooting an air show, a fast-moving airplane flying toward you can move enough to slightly change the focus area by the time the shutter opens. If you press the Shutter-release button all the way down until the shutter releases, autofocus occurs first, and then the mirror moves up and the shutter starts opening. That takes a few milliseconds in the D7200. In the time it takes for the camera to respond to your press of the Shutter-release button, the airplane has moved slightly, which just barely throws the autofocus off. With predictive focus tracking, the camera predicts where the airplane will be when the image is actually exposed, and it adjusts the focus accordingly.

Let's say you're playing a ball game and you throw the ball to a running player. You would have to throw the ball slightly in front of the receiving player so that the player and the ball arrive in the same place at the same time. Predictive focus tracking does something similar for you. It saves you from trying to focus your camera in front of your subject and waiting several milliseconds for it to arrive. The timing would be a bit difficult!

Effect of Lens Movement

Lens movement (especially with long lenses) can be misinterpreted by the camera as subject movement. In that case, predictive focus tracking follows your camera movement while simultaneously trying to track your subject.

Attempting to handhold a long lens will drive your camera crazy. Use a vibration reduction (VR) lens or a tripod for best results. Nikon says that there are special algorithms in predictive focus tracking that allow it to notice sideways or up-and-down movement, and the camera shuts down the predictive focus tracking. That is, predictive focus tracking is not activated by the D7200 for sideways or up-and-down subject movement or panning.

Basically, predictive focus tracking works only when the subject is moving toward or away from you.

Settings Recommendation: I leave my camera's Autofocus mode set to AF-S most of the time because I shoot a lot of static nature images and portraits. If I am shooting sports, though, I switch to AF-C mode so that the camera will keep updating its autofocus as the subject moves very quickly. Wildlife photography is another type of imaging that begs for AF-C and its continuously updating autofocus.

If you are not yet sure which mode will work best for you, maybe you should set your camera to AF-A mode because it is adaptive and will help you keep focus on your subject.

AF-Area Modes in Detail

(User's Manual: Page 86, Menu Guide: Page 193)

The four AF-area modes are designed to let you control how many Viewfinder AF points or sensors are in use at any one time. Three of the four modes will help you track subject movement. Basically, the AF-area modes control the number and pattern of AF points you can use to focus on your subject.

Here, again, is a list of the four AF-area modes:

- Single-point AF
- Dynamic-area AF (9, 21, and 51 AF points)
- 3D-tracking AF
- Auto-area AF

You can use one AF point in Single-point AF mode and 9, 21, or 51 AF points in Dynamic-area AF mode. You can even select 3D-tracking mode (51 AF points), which uses the color of the subject to help track it, keeping it in focus while it moves around. If you don't want to think about the autofocus area, you can let the camera automatically control the AF-area mode by selecting the Auto-area mode setting.

There are a total of six AF-point pattern selections within the four AF-area modes, as follows:

- **S:** Single-point AF (1 AF point)
- **d9:** Dynamic-area AF (9 AF points)
- **d21:** Dynamic-area AF (21 AF points)
- **d51:** Dynamic-area AF (51 AF points)
- **3d:** 3D-tracking (51 AF points)
- **Auto:** Auto-area AF (51 AF points)

First we'll see how to select one of the AF-area modes and then we will examine each mode individually.

Figure 11.4A – Controls to set AF-area mode d21

Here are the steps to choose an AF-area mode. We will use the 21-point Dynamic-area AF mode as an example:

1. Hold in the AF-mode button (figure 11.4A, image 1).
2. Turn the front Sub-command dial (figure 11.4A, image 2) as you watch the six available AF-area mode pattern names scroll by on the Control panel (see previous list). Figure 11.4A, image 3, shows the camera set to 21-point Dynamic-area AF mode (red arrow).
3. **Optional:** If you prefer to use the Information display instead of the Control panel, you must press the info button first (figure 11.4A, image 2B), followed by the AF-mode button. Then you will choose an AF-area mode with the front Sub-command dial (figure 11.4A, image 4).
4. Release the AF-mode button when the AF-area mode you want to use is displayed on the Control panel or Information display.

Some AF-Area Modes Are Not Always Available

Some of the AF-area modes will not show up if you have your camera set to AF-S Single-servo Autofocus mode (see previous Autofocus modes main section). Be sure to remember that *Autofocus modes* and *AF-area modes* are two different things, or this section may be confusing. Read carefully and notice when the text says Autofocus mode and when it says AF-area mode.

The word "servo" is a clue that we are discussing an Autofocus mode—not an AF-area mode. All three Autofocus modes have the word servo in the name.

The Autofocus mode *Single-servo AF* (AF-S) allows only these two AF-area modes:
- Single-point AF
- Auto-area AF

The Autofocus modes *Auto-servo AF* (AF-A) and *Continuous-servo AF* (AF-C) allow all four of the AF-area modes:
- Single-point AF
- Dynamic-area AF
- 3D-tracking
- Auto-area AF

You will adjust the Autofocus mode with the rear Main command dial and the AF-area mode with the front Sub-command dial, while holding in the AF-mode button. Now let's discuss each AF-area mode in detail.

Single-Point AF

Single-point AF uses one AF point out of the array of 51 points to acquire good focus. In figure 11.4B, image 2, notice that the center AF point is the one that provides focus information currently. Any of the 51 AF points can be selected with the Multi selector, and will provide autofocus information instead.

Figure 11.4B – Single-point AF mode, images 1 and 2

If two people are standing next to each other, with a gap in the middle, the single center AF point will examine the space between the two subjects. You can do one of two things to overcome this problem:

- You can get the focus first by pointing the center AF point at the face of one of the subjects, pressing the Shutter-release button halfway to focus, and then holding it down while recomposing the image. When you have recomposed the shot—without releasing the button—press the Shutter-release button the rest of the way down and take the picture.
- You can compose the picture first by centering it however you'd like, then use the Multi selector to move the single AF point until it rests on the face of one of the subjects. With the AF point repositioned, press the Shutter-release button halfway down to get good focus and the rest of the way down to take the picture.

Either of these methods will solve the age-old autofocus problem of having a perfectly focused background with out-of-focus subjects, caused by the center AF point concentrating on the background between the subjects.

Single-Point AF Example

If a subject is not moving—like a tree or a standing person—then Single-point AF and Single frame (S) Release mode will allow you to acquire focus. When focus is acquired, the AF module will lock focus on the subject and the focus will not change. If the subject moves, your focus may no longer be perfect and you'll need to recompose while releasing and then pressing the Shutter-release button halfway down to refocus.

Often, if the subject is moving very slowly or sporadically, I don't use Continuous low speed (CL) Release mode[1]. Instead I leave the camera in Single frame (S) Release mode. I tap the Shutter-release button halfway to acquire focus when the subject moves and tap it again as needed. When I'm ready, I simply press the Shutter-release button the rest of the way down, and I've got the shot!

Dynamic-Area AF

This mode is best used when your subject is moving. Instead of using a single AF point for autofocus, several sensors surrounding the one you have selected are also active.

Again, this mode is available only if you have the AF-C (Continuous-servo AF) or AF-A (Auto-servo AF) autofocus modes selected. It won't even appear on the Control panel or Information display if you have AF-S (Single-servo AF) autofocus mode selected.

The top row of figure 11.4C shows the Control panel with Dynamic-area AF selected in 9, 21, and 51 point modes. You may select one of the three AF-point patterns using the controls shown in figure 11.4A. In figure 11.4A, image 3, 21-point Dynamic-area AF has been selected.

1 For more information on the Release modes, see **Section 3: Release Modes** on page 496)

Figure 11.4C – Dynamic-area AF mode

The bottom row of figure 11.4C shows the three AF point patterns (9, 21, and 51) in the Viewfinder. While taking pictures, you will not actually see all these extra AF points light up, only when you first select a pattern (see the upcoming subsection, **Viewing Autofocus Patterns** on page 487). Instead you will see only the AF point in the center of the pattern. You will have to imagine the other points surrounding the single point you can see. You can move the 9- and 21-point patterns around the Viewfinder with the Multi selector.

The AF point you can see in the Viewfinder provides the primary autofocus; however, the surrounding points in the pattern you've selected are also active. If the subject moves and the primary AF point loses its focus, one of the surrounding points will quickly grab the focus.

If the subject is moving slowly or predictably, you can use a smaller pattern, such as the 9-point selection. If the subject's movement is more erratic or unpredictable, you might want to increase the number of AF points involved. If 9 won't do it, try 21, or even 51, for subjects that are very unpredictable and move quickly.

One caution is that the more AF points you use, the slower the initial autofocus may be, especially in low light. However, when the initial focus is acquired, the camera can track the subject quite well with all three patterns.

Can you see how flexible Dynamic-area AF could be for you, especially when you adjust the patterns? If your subject will move only a short distance—or is moving slowly—you can simply select a pattern of 9 points. Maybe you're doing some macro shots of a bee on a flower and the bee is moving around the blossom. Or you might be photographing a tennis game, in which case you could use 21 or 51 points to allow for more rapid side-to-side movement without losing focus. You'll have to decide which pattern best fits your needs for the current shooting situation.

Using Dynamic-area AF, you can more accurately track and photograph all sorts, sizes, and speeds of moving subjects. The initial focus reaction speed of the AF system is somewhat slower when you use 51 points because the camera needs to process a lot more

information. Take that into consideration when you are shooting events. However, I have used 51-point Dynamic-area AF at both weddings and graduation ceremonies with great success. The D7200 is faster than my previous enthusiast Nikons at acquiring the initial focus.

Viewing Autofocus Patterns

You can actually see the autofocus patterns if you use the camera's Viewfinder while choosing the setting. In the Viewfinder, the 9-, 21-, and 51-point patterns are shown accurately. However, when seen in the Viewfinder, the patterns for Auto-area AF and 3D-tracking do not actually reflect the pattern the camera uses. Instead, the camera shows an outline surrounding all 51 AF points when displaying the Auto-area AF mode in the Viewfinder. In reality, when using Auto-area, the camera chooses any combination of the 51 AF points it deems necessary to use.

When you select 3D-tracking, the camera spells out "3d" in the viewfinder using AF points. Similar to how Auto-area AF and 3D-tracking use whatever AF point they need to track the moving subject.

When using Auto-area AF or the three Dynamic-area AF modes, you can see an outline in dots surrounding the active AF point in the Viewfinder. This outline shows the AF points within the outline that can potentially track your subject if the initial focus point loses the subject.

3D-Tracking AF

The mode called *3D-tracking* (shown as 3d on the Control panel, Information display, and in the Viewfinder) adds color-detection capability to the tracking system (figure 11.4D, image 1). The camera not only tracks by subject area, but also remembers the color of the subject and uses it to track even more accurately.

Figure 11.4D – 3D-tracking AF mode, images 1 and 2

3D-tracking works like the 51-point pattern except that it is more intelligent. Often your subject will be a different color from the background, and the D7200's color-based system will provide more accuracy in difficult conditions. Be careful if the subject is a similar color to the background because this may reduce the autofocus tracking accuracy.

3D-tracking is a good mode for things like action sports, air shows, races, and so on. It allows the camera to become a color-sensitive, subject-tracking machine.

Note: As mentioned in an earlier section, you will see "3d" in the Viewfinder only when you first select 3D-tracking AF. After that, you will just see the tracking AF point—with a tiny dot in the middle—move around the Viewfinder as it tracks your subject.

Auto-Area AF

Auto-area AF turns the D7200 into an expensive point-and-shoot camera. Use this mode when you simply have no time to think about autofocus and would still like to get great images. The AF module decides what the subject is and selects the AF points it thinks will work best (figure 11.4E).

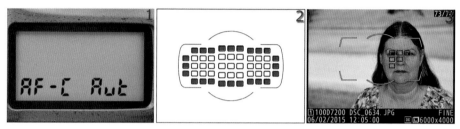

Figure 11.4E – Auto-area AF mode

If you are using a D, E, or G lens, there is "human recognition technology" built into this mode. Using Auto-area AF with the Viewfinder, your D7200 can usually detect a human face and help you avoid shots with perfectly focused backgrounds and blurry human subjects (figure 11.4E, image 3). This is great for when you are using flash with people against dark backgrounds. The camera tries its best to keep the exposure accurate for the faces.

In the past, I rarely used Auto-area AF for anything except snapshots. However, I have been trying it when shooting quickly at events such as weddings and graduations, and the camera is quite accurate at finding and exposing for people. This is a great people mode. Give it a try!

Now, let's talk about how the camera uses the mode groups in unison. See the sidebar **Capturing a Bird in Flight** for an example of how the camera uses the three mode groups—Autofocus, AF-area, and Release modes—to track a flying bird.

Settings Recommendation: Many people use Single-point AF-area mode quite often. It works particularly well for static or slowly moving subjects. When I'm out shooting beautiful nature images, I use Single-point AF-area mode along with Single frame (S) Release mode almost exclusively.

If I'm shooting a wedding where the bride and groom are walking slowly up the aisle, Single-servo Autofocus mode (AF-S), Single-point AF-area mode, and Continuous low speed (CL) Release mode seem to work well for me, although recently, I have been successfully experimenting with Continuous-servo Autofocus mode (AF-C), Dynamic-area AF (9 points) mode, and Continuous-high (CH) Release mode. The D7200 is uncannily accurate at finding and tracking human faces in Auto-area AF mode. You must use AF-C along with Auto-area to let the camera track a face. If you use AF-S and Auto-area, the camera will

quickly find the face but not track it. That's okay when you're taking a group shot, but it's not so good when you're tracking a moving face, such as a bride walking down the aisle.

I suggest experimentation with all these modes. You will need to use them all for different types of photography, so take the time necessary to learn how each mode functions for your styles of shooting.

Now, let's examine how the camera uses autofocus in Live view photography mode (non-Viewfinder).

Capturing a Bird in Flight

Let's imagine that you are photographing a colorful bird perched in a tree but you want some shots of it in flight. You are patiently waiting for it to take flight. Your camera is set to 3D-tracking (51-point) AF-area mode and Continuous high speed (CH) Release mode. You are using Continuous-servo (AF-C) Autofocus mode so that autofocus never locks and will track the bird instantly when it starts flying. You've already established focus with the AF point you selected with the Multi selector, and you are holding the Shutter-release button halfway down to maintain focus. Since you've set the Release mode to CH (Continuous high), you can fire off rapid bursts of images (up to four per second). Suddenly, and faster than you can react, the bird takes flight. By the time you can get the camera moving, the bird has moved to the left in the Viewfinder, and the focus tracking system has adjusted by instantly switching away from the primary AF point you used to establish focus. It is now using other AF points in the pattern of 51 points to maintain focus on the bird. You press the Shutter-release button all the way down, and the images start pouring into your memory card. You are panning with the bird, firing bursts until it moves out of range. You've got the shot!

Section 2: Autofocus in Live View Photography

(User's Manual: Page 84)

Live view (Lv) mode is one of the new features that many old-timers love to hate. New DSLR users generally like to use it because they are accustomed to composing on the LCD screen of a point-and-shoot camera.

Both types of users should reconsider Live view. An old-timer who is used to using only the Viewfinder to compose images might find that some types of shooting are easier with Live view. Point-and-shoot graduates may want to see if they can improve image sharpness by using the Viewfinder.

I've been using SLR, DSLR, rangefinder, and point-and-shoot cameras for more than 47 years, and with the D7200 I'm now using a powerful HD-SLR. When Live view mode first came out, my initial thought was "gimmick." However, since I've been shooting macro shots with Lv mode, the ease of use has changed my thinking. When I need extreme, up-close focusing accuracy, Lv mode can be superior to the Viewfinder. If you're an experienced DSLR photographer, try shooting some macros with Lv mode. I think you'll find that your work improves, and your back feels much better, too.

If you've come over from the point-and-shoot world to your new D7200, then use Lv mode if it makes you comfortable—at first. However, please realize that it is difficult to make sharp images when you are waving a heavy DSLR around at arm's length while composing a picture on the Monitor. Also, the extra weight of the DSLR will tire your arms needlessly. Learn to use the Viewfinder for most work and Lv mode for specialized pictures. Both image composition tools are useful.

Using Autofocus and AF-Area Modes for Live View Photography

Live view mode is a little different than the Viewfinder when it comes to autofocus. In some ways it is simpler, and in other ways it is more complex. The Autofocus modes have only two settings, and the AF-area modes have four.

The Release modes that we will discuss in **Section 3: Release Modes** (page 496) are the same whether you're using Live view photography mode or the Viewfinder.

The three mode groups available in Live view mode are as follows:

Autofocus modes (User's Manual: Page 84)
- Single-servo (AF-S)
- Full-time-servo AF (AF-F)

AF-area modes (User's Manual: Page 88)
- Face-priority AF
- Wide-area AF
- Normal-area AF
- Subject-tracking AF

Release modes (User's Manual: Page 66)
- Single frame (S)
- Continuous low speed (CL)
- Continuous high speed (CH)
- Quiet shutter-release (Q)
- Self-timer
- Mirror up (MUP)

Autofocus in Live View Mode

In some instances, a live view through the Monitor is quite useful. For instance, what if you want to take an image of a small flower growing very close to the ground? You can lie down on the ground and get your clothes dirty, or you can use Lv mode instead. Live view photography mode allows you to see what your camera's lens sees without using the Viewfinder. Anytime you need to take pictures up high or down low, or even on a tripod, the D7200 will happily give you that power with Lv mode.

To set your camera to Live view photography mode, simply flip the little Live view selector switch on the back of the camera to the top position so that the white dot lines up with the small camera icon, as shown in figure 11.5A.

Most of the Autofocus mode, AF-area mode, and Release mode information discussed in this chapter for Live view photography mode also applies to Movie live view mode (bottom movie-camera-on-tripod position in figure 11.5A). We will discuss Movie live view mode in a later chapter.

Figure 11.5A – Choosing Live view photography mode

Once you have chosen Live view photography mode, press the Lv button, and you are ready to start taking well-focused still pictures.

A Difference in Live View Mode Compared to Older Nikons

The Nikon D7200 differs from older Nikons when using Live view mode. Whereas previous semipro Nikons had Handheld and Tripod modes, the D7200 combines the two modes, sort of. In previous Nikons, the reflex mirror would drop during an autofocus operation in Handheld mode so the camera could use standard phase-detection autofocus. The mirror stayed up in Tripod mode only with contrast-detection autofocus.

The D7200 is different in that it raises the reflex mirror at the beginning of Live view mode and does not lower it for autofocus operations. Therefore, the Nikon D7200 always uses mirror-up shooting when in Live view. That means the camera cannot use the fast phase-detection autofocus provided for shooting with the Viewfinder. The primary problem is that contrast-detection AF is usually slower than phase-detection AF. However, the contrast-detection AF in the Nikon D7200 is improved over older Nikons.

Many photographers were initially confused by the sounds coming from the D7200 when taking a picture in Live view. It sounds like the mirror is dropping when you take a picture, but it isn't. The Monitor blacks out briefly, as on previous Nikons, while the camera fires the physical shutter. However, the Monitor blackout happens only while the shutter is firing. It has nothing to do with movement of the reflex mirror.

Now, let's examine the two Autofocus modes. Remember, the Autofocus modes tell the camera *how* to focus.

Figure 11.5B – Choosing an Autofocus mode under Live view

Use the following steps to change the Autofocus mode:

1. Press and hold the AF-mode button (figure 11.5B, image 1).
2. Rotate the rear Main command dial (figure 11.5B, image 2).
3. AF-S and AF-F will appear on the Monitor as you turn the dial. Release the AF-Mode button when your chosen mode appears. Singe-servo AF (AF-S) is selected in figure 11.5B, image 3.

The two Autofocus mode selections are covered next. I photographed the screen with the lens cap on so you can clearly see the selections on a black background.

Single-Servo AF

Figure 11.5C has a red arrow pointing to the Single-servo AF (AF-S) mode symbol on the Live view screen. You control the focus by pressing the Shutter-release button halfway down. When focus is acquired, it locks and does not update unless you deliberately update it. You will have to refocus if you or your subject moves by releasing pressure on the button and then reapplying pressure to refocus.

Figure 11.5C – Single-servo AF (AF-S) mode

A single red or green AF point square (with a dot) will appear in the middle of the Monitor. It will blink in red when the scene is not in focus and turn green when the scene is in good focus. You can move the square around the screen to select the area of your subject on which the camera will focus. If your subject doesn't move or moves very slowly, use this Autofocus mode.

Full-Time Servo AF

Figure 11.5D has a red arrow pointing to the Full-time servo AF (AF-F) mode symbol on the Live view screen. The red or green AF point square appears in the middle of the Monitor, as in Single-servo Autofocus mode. It blinks on and off in red as the camera focuses, then turns green and stops blinking when good focus is acquired. As focus changes and is reacquired, you will see it blink green a few times. You can move the focus square around the Monitor to select a focus area.

Figure 11.5D – Full-time-servo AF (AF-F) mode

This mode provides constantly updating autofocus that is tempered by the AF-area mode (discussed next) you have selected. The size and shape of the focus square changes with the AF-area mode you have selected.

The focus doesn't lock on the subject initially, which simply means it updates continuously (like AF-C) until you press the Shutter-release button halfway down, at which time the camera locks focus. If you release pressure from the Shutter-release button, the camera

unlocks the focus and resumes continuous autofocus. The camera acts as if it is in AF-S mode when you have pressure on the Shutter-release button and AF-C mode when you remove pressure.

In Movie live view mode, you won't press the Shutter-release button at all, except to force a refocus. The camera will maintain focus on your subject automatically.

Settings Recommendation: Unless I am going to do some very specialized macro shooting, I leave Live view mode's Autofocus mode set to AF-F, or Full-time servo AF. That way, the camera will automatically attempt to keep a good focus on my subject. If I am shooting a macro shot, I want to control exactly where the focus falls for depth of field control, so I use AF-S, or Single-servo AF.

Professional video shooters will invariably focus manually to prevent the frequent and sometimes noisy (according to lens used) refocus operations of the camera when it detects changes in subject distance or contrast.

AF-Area Modes

The AF-area mode lets you choose *where* the camera senses your subject. Autofocus works differently for each of the four AF-area modes. You can make the camera to look for people's faces, track a moving subject, widen out for landscapes, or pinpoint the focus on a small area of the frame.

Let's look at how to select the four AF-area modes, then examine what each one does.

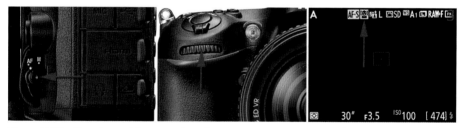

Figure 11.5E – Choosing an AF-area mode under Live view

Use the following steps to change the AF-area mode (figure 11.5E):

1. Press and hold the AF-mode button (figure 11.5E, image 1).
2. Rotate the front Sub-command dial (figure 11.5E, image 2).
3. Various symbols will appear on the Monitor as you turn the dial. They represent four choices: Face-priority AF, Wide-area AF, Normal-area AF, and Subject-tracking AF. Release the AF-Mode button when your chosen mode appears. Face-priority AF is selected in figure 11.5E, image 3.

Face-Priority AF

The red arrow in figure 11.5F points to the *Face-priority AF* symbol. When you are taking portraits in Live view mode or shooting movies with people in Movie mode, you may want to consider using Face-priority AF. The camera has the ability to track focus on the faces of several people at the same time. It is quite fun to watch as the little green and yellow AF point squares find faces and stay with them as they move—green squares are for focused faces and yellow squares are for unfocused faces.

Figure 11.5F – Face-priority AF

Nikon claims the camera can detect up to 35 faces at the same time. That's a lot of people! According to Nikon, "When multiple faces are detected, the camera will focus on the subject recognized to be the closest. Alternatively, you can also choose a different subject with the Multi selector."

Wide-Area AF

The red arrow in figure 11.5G points to the *Wide-area AF* symbol. If you are a landscape shooter who likes to use Live view mode or shoot movies of beautiful scenic areas, this is your mode.

The camera will display the AF point square on the Monitor, and it will be red when out of focus, green when in focus. You can move this AF point around until it rests exactly where you want the best focus to be. The camera will sense a wide area and determine the best focus, with priority on the area under the focus square. Nikon says, "Suitable for hand-held shooting such as landscape."

Figure 11.5G – Wide-area AF

Normal-Area AF

The red arrow in figure 11.5H points to the *Normal-area AF* symbol. This mode is primarily for shooters who need to get very accurate focus on a small area of the frame.

If you are shooting a butterfly up close and want to focus on one of the antennae, use Normal-area AF. This is a great mode to use with a macro lens because it gives you a much smaller AF point square that you can move around the frame. Compare it to the AF point in Wide-area AF mode and you'll see that it is about 25 percent of

Figure 11.5H – Normal-area AF

the size. You can pinpoint the exact area of the subject that you want to have the sharpest focus. Nikon says, "Suitable for tripod shooting with pinpoint focus such as close up."

Subject-Tracking AF

The red arrow in figure 11.5I points to the *Subject-tracking AF* symbol. When autofocus is locked in—either by using the Shutter-release button in AF-S mode or automatically in AF-F mode (discussed previously)—this mode lets you start subject tracking with the OK button. When the subject is selected (after you press the OK button), the camera locks its attention on the subject and tracks it whether the subject or the camera moves.

Figure 11.5I – Subject-tracking AF

If you are making a movie of a black bear in the Great Smoky Mountains, you just move the focus point to the bear, focus, and press the Multi selector center button, and focus will stay with the bear. It is amazing to watch the camera do this.

I suggest that you try AF-F, or Full-time servo AF, with this mode. Full-time autofocus allows your camera to fully track the subject without you worrying about keeping it in focus yourself. Nikon says, "Suitable for a moving subject."

Settings Recommendation: Why not leave the AF-area mode set to Face-priority AF if you photograph people a lot? If you are using Live view for macro shooting, Normal-area AF gives you the smallest, most accurate mode for detailed, up-close focusing. Landscape shooters should use Wide-area AF, and wildlife or sports shooters should use Subject-tracking AF.

Now, let's carefully examine the Release modes, which affect the camera for Viewfinder and Live view shooting.

Using Focus Lock

Focus lock is a tool for those times when you need to lock the focus on a certain area of the subject and recompose for a different composition. If the AE-L/AF-L button is configured correctly, you can lock the focus on your subject whenever you want to. The Custom setting that controls the AE-L/AF-L button is Custom setting f6: *Custom Setting Menu > f Controls > f4 Assign AE-L/AF-L button > Press*. It defaults from the factory to AE/AF lock. You can leave the setting at the default, which locks both the exposure and autofocus, or choose AF lock only so you can lock just the autofocus at any time. This is convenient when you are using the AF-C Autofocus mode, which never locks focus on the subject but keeps updating. For a picture or two, you may want to lock the focus and recompose without the focus changing. Assign AE/AF lock or AF lock only to the AE-L/AF-L button so that whenever you press the button, the focus is locked until you release it.

Section 3: Release Modes

(User's Manual: Page 66)

The D7200 has several *Release modes,* which apply to both Viewfinder and Live view photography.

Release modes involve *when* images will be taken and how fast you can take them. In figure 11.6A, we see the Release mode dial (right red arrow) with its lock release button (left red arrow). Press the lock release button and turn the Release mode dial to select a mode. Single frame (S) is selected in figure 11.6A.

Figure 11.6A – Release mode dial and lock button

Now, let's look at each of the six release modes in more detail.

- S: Single frame
- CL: Continuous low speed
- CH: Continuous high speed
- Q: Quiet shutter-release
- Self-timer
- MUP: Mirror up

In the good-old film days, the first three release modes would have been called motor-drive settings because they are concerned with how fast the camera is allowed to take pictures.

We've already talked about these modes to some degree in the sections on the AF-area modes.

Single Frame (S) Release Mode

Single-frame Release mode is the simplest frame rate because it takes a single picture each time you press the Shutter-release button fully. There is no speed here. This is for photographers shooting a few frames at a time.

Nature shooters often use this mode because they are more concerned with correct depth of field and excellent composition than high-speed burst shooting.

Figure 11.6B – Single frame (S) Release mode

Release Priority Settings

When you switch your D7200 out of Single frame (S) Release mode, you must be aware of how Custom settings a1 and a2 are configured. These two Custom settings allow you to choose Focus or Release priority when shooting in AF-S and AF-C Autofocus modes. It's important that you understand these two priorities before you start using your camera on critical shoots, or some of your images may not be in focus at all. I won't cover that information in this chapter, but we've looked at Custom settings a1 and a2 in detail in the chapter titled **Custom Setting Menu** (page 184). Please be very sure that you understand what they do! (Hint: Most of us should use Focus priority.)

Continuous Low Speed (CL) Release Mode

Continuous low speed Release mode allows you to select a frame rate between one and six frames per second (fps). When you hold down the Shutter-release button, the camera will fire at the chosen frame rate continuously until you let up on the button or the internal memory buffer gets full. Choose CL on the Release mode dial to select this mode (figure 11.6C).

Figure 11.6C – Continuous low speed (CL) Release mode

The default CL frame rate from the factory is 3 fps. If you want more or less speed, simply open *Custom Setting Menu > d Shooting/display > d2 Continuous low-speed* and select your favorite frame rate (figure 11.6D).

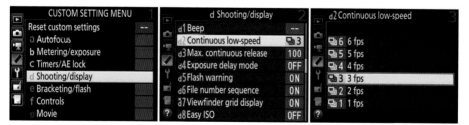

Figure 11.6D – Choosing a Continuous low speed Release mode frame rate

Use these steps to select a Continuous low-speed setting:

1. Choose d Shooting/display from the Custom Setting Menu, then scroll to the right (figure 11.6D, image 1).
2. Select d2 Continuous low-speed from the d Shooting/display menu and scroll to the right (figure 11.6D, image 2).
3. Highlight the frame rate—from 1 fps to 6 fps—that you want to use for CL mode and press the OK button to lock in the rate. The default is 3 fps, as seen in figure 11.6D, image 3.

Continuous High Speed (CH) Release Mode

Continuous high speed Release mode is designed for when you want to shoot at the highest frame rate the camera can manage (figure 11.6E).

The normal frame rate for the Nikon D7200 in CH mode is 6 fps in DX mode and up to 7 fps in 1.3× mode, which is quite fast for a camera in this price range. With a burst speed that high, and the camera's fast autofocus, you can capture sports events and fast-action situations with excellent success.

Figure 11.6E – Continuous high speed (CH) Release mode

Internal Memory Buffer

The camera's internal memory buffer limits how many frames you can take. When shooting in JPEG fine mode, you will be able to shoot up to 100 frames in both DX and 1.3× modes, without stopping. You can control this maximum by adjusting *Custom Setting Menu > d Shooting/Display > d3 Max. continuous release*.

In Lossless compressed NEF (RAW) mode, you can shoot up to 18 images at 14 bits or up to 27 pictures at 12 bits in DX mode before the memory buffer is full. In 1.3× mode you can shoot up to 29 images at 14 bits or up to 44 pictures at 12 bits.

Afterward, the frame rate will slow down to maybe 1 fps while the camera is offloading buffered images to the memory card. See the "Buffer capacity" column in the chart on pages 380–381 of your Nikon User's Manual for a list of Image quality/Image size modes and buffer capacity.

Requirements for Fast Frame Rates

All of the settings for fast frame rates (high fps) are based on the assumption that you are shooting with at least a 1/250s shutter speed, have a fully charged battery, and have some buffer space left in your camera's internal memory.

Quiet Shutter-release (Q) Release Mode

When not using Live view mode, *Quiet shutter release* (Q) Release mode is designed to help the camera make as little noise as possible when you fire the shutter (figure 11.6F). Instead of raising the reflex mirror, taking the picture, then lowering the mirror in one smooth step, the D7200 ties the raising and lowering of the mirror to the position of the Shutter-release button.

Figure 11.6F – Quiet shutter-release (Q) Release mode

When you press the Shutter-release button down and take a picture in Q mode, the mirror raises and the shutter fires. However, the mirror does not lower until you fully release the Shutter-release button.

If you want to reduce noise, you can hold the Shutter-release button down longer than normal and separate the raising and lowering of the mirror into two steps. This tends to draw out the length of the mirror/shutter action and reduces the perception of noise volume. In reality, the noise is not much quieter, but since it is broken into two parts, it sounds quieter.

In Live view mode the mirror is always raised; therefore, Q mode does nothing special for the mirror when using Live view. However, in Live view mode, the camera's focal-plane shutter is always open for viewing (obviously) and closes only long enough to time the image exposure. When you press the Shutter-release button in Q mode, the camera's shutter closes, reopens for the exact length of the selected shutter speed, then closes again. It does not reopen for viewing until you release pressure from the Shutter-release button. That breaks the shutter action into four parts when you fully press the Shutter-release button: *shutter closes > shutter opens for shutter speed time length > shutter closes at the end of shutter speed time > shutter reopens for Live view*. The final step, shutter reopens for Live view, happens only after finger pressure is released from the Shutter-release button. This quiets the shutter a tiny bit.

What makes this a little confusing is that the camera seems to act in a similar manner even when you are not using Q mode. In non-Q mode, the Monitor does not come back on when you are taking a Live view picture until you release pressure from the Shutter-release button, even though the shutter has already reopened. The only real difference between Q and non-Q mode is the fact that the final click of the shutter reopening is delayed until you let go of the Shutter-release button. You'll have to take a few pictures in Q and non-Q modes while counting the clicks to see what I mean.

Self-Timer Release Mode

Use the *Self-timer* Release mode to make your camera take pictures a few seconds after you press the Shutter-release button (figure 11.6G). The camera will autofocus when you press the Shutter-release button halfway down and start the Self-timer when you press it all the way down.

The factory default timeout for the Self-timer is 10 seconds. You can use *Custom Setting Menu > d Shooting/ display > c3 Self-timer > Self-timer delay* to set the timeout to 2, 5, 10, or 20 seconds. You can also use c3 Self-timer to control the number of shots taken for each self-timer cycle (up to 9), and the amount of time between each shot (up to 3 seconds).

Figure 11.6G – Self-timer Release mode

If you like to hear that little *beep beep beep* when the Self-timer is counting down the seconds before firing the shutter, you can turn that sound on with *Custom Setting Menu > d Shooting/display > d1 Beep*.

After you press the Shutter-release button in Self-timer mode, the AF-assist illuminator will blink about twice per second and the beeping will start. When the last two seconds arrive, the AF-assist illuminator will shine continuously and the beeping will double in speed. You are out of time when the beeping speeds up! The image is taken at about the time the beeping stops.

If you want to stop the self-timer, all you have to do is press the MENU or Playback button.

Mirror Up (MUP) Release Mode

Use *Mirror up* Release mode to raise the camera's mirror, allowing vibrations to die down before releasing the shutter (figure 11.6H). The camera will first autofocus when you press the Shutter-release button halfway down and then raise the mirror when you press it all the way down.

You can then use a remote release to fire the shutter, or even press the Shutter-release button again (not recommended because it cancels out the benefit of using MUP mode by introducing new vibrations). If you do

Figure 11.6H – Mirror up (MUP) Release mode

nothing after raising the mirror, the camera will fire by itself after about 30 seconds.

In Live view mode, the mirror is already raised. Therefore, the primary benefit from MUP mode is the fact that the camera delays firing the shutter until you press the Shutter-release button a second time. That means you can allow camera vibrations to die down before the final shutter release happens, even when shooting in Live view mode.

The MUP mode is very simple and very effective. I use this constantly when I am doing nature photography.

Don't Touch That Shutter Release!
Please buy an electronic shutter release (MC-DC2) so you don't have to use your finger to press the Shutter-release button when the camera is on a tripod and in MUP mode. Touching the camera seems a bit silly after going to all that trouble to stabilize the camera and raise the mirror. A finger press could shake the entire tripod! If you do not have a wireless or cabled shutter release, simply wait 30 seconds after pressing the Shutter-release button in MUP mode, and the camera will fire on its own. This could be used as a slow but high-quality self-timer.

Custom Settings for Autofocus (a1–a8)

For a complete discussion of the autofocus-related Custom settings a1 through a8, please see the chapter titled **Custom Setting Menu** on page 184. When considering autofocus issues, it is very important that you read the information in that chapter concerning Custom settings a1 and a2. If you don't read and understand that section, you may get quite a few out-of-focus images as a result.

Also, please consider using Focus tracking with lock-on when you are using any mode that does focus tracking (9 point, 21 point, 51 point, or 3D-tracking). This will prevent your camera from losing focus on the subject if something comes between the camera and the subject while the subject is moving. Otherwise, the camera may switch the focus to the intruding object and lose the tracked subject. To enable Focus tracking with lock-on, go to *Custom Setting Menu > a Autofocus > a3 Focus tracking with lock-on* and choose a tracking delay timeout. I suggest using 3 (Normal) as a starting point.

With lock-on enabled, the camera remembers the subject you are tracking for up to a couple of seconds after it loses contact with it. If the subject reappears, the camera will continue tracking it.

Author's Conclusion

I've followed the development of Nikon autofocus systems since the late 1980s. Autofocus with the Nikon D7200 is a real pleasure. It has a more powerful AF system than many cameras before it, and yet it is somewhat simplified in its operation by comparison. The system can still seem complex, but if you spend some time with this chapter, you should come away with a much greater understanding of the D7200's AF module. You'll better understand how you can adapt your camera to work best for your style of photography. Enjoy your D7200's excellent Multi-CAM 3500 II autofocus system!

12 Live View Photography

Red Crown in the Sunshine © 2015 Carl Mohr (Nikonlad62)

Live view photography mode in the Nikon D7200 is a mature still-imaging system that's easy to use and full featured. It allows you to take your eye away from the camera and use the Monitor on the back as your viewfinder.

If you need to shoot with your camera at arm's length, such as in a crowd while taking pictures over the top of people's heads, the big 3.2-inch (8.13-cm) Monitor makes it easy to see your subject. If you need to take pictures that require you to bend over, such as when shooting closeups (macros) of plants or insects, the Live view mode will save your back a lot of pain.

The contrast-detection autofocus used by Live view photography mode detects contrast at the pixel level, providing literally microscopic focus accuracy. Additionally, you can move the focus square to any point on the Monitor that will give you the most accurate autofocus.

Live view is divided into two parts in the Nikon D7200, Live view photography mode and Movie Live view mode. In this chapter, we will examine Live view photography mode, which is used exclusively for shooting still images. You cannot shoot video in Live view photography mode; the Movie-record button will not respond.

In the next chapter (page 519), we'll investigate Movie live view mode for special format (16:9) still images and broadcast-quality HD movies.

Live View Mode

(User's Manual: Page 46, Menu Guide: Page 92)

To enter *Live view photography* mode you will flip the Live view selector lever to its top position (figure 12.1A, image 1) and press the Lv button. To exit Live view photography mode, simply press the Lv button again. Figure 12.1A, image 2, shows the Live view screen you'll see first. Normally, this screen would show the subject you are about to photograph, but I left the lens cap on to provide maximum contrast for all the controls we will discuss.

Figure 12.1A – Entering and exiting Live view mode

Opening Notes on Using Live View Photography Mode

As discussed in the previous chapter, Live view photography mode uses contrast-detection autofocus, which is activated by the Shutter-release button if you are using Single-servo AF (AF-S) Autofocus mode, or automatically if you selected Full-time servo AF (AF-F) Autofocus mode.

You can move the small red focus square (figure 12.1A, image 2) to any location on the screen to select off-center subjects. When you have good focus, the red square turns green. You are not limited to the central 51-point AF area as you are when you're looking through the Viewfinder.

Screen Blackout During Exposure

The screen doesn't black out while autofocus is active because the camera focuses by detecting contrast changes on the imaging sensor. When you fire the shutter, the Monitor will black out briefly while the picture is taken. The blackout is necessary to allow the camera to fire the shutter, which blocks light to the imaging sensor briefly. The reflex mirror does not drop when you are taking a picture in Live view photography mode, therefore the blackout period is brief.

Extreme Focusing Accuracy

Use Live view photography mode when you need extreme autofocus accuracy. Contrast-detection AF is slower than phase-detection AF but very accurate. You can zoom in to pixel-peeping levels with the Playback zoom in (QUAL) button before starting autofocus. This is great for macro shooting because you can select very specific sections of the subject for focusing (figure 12.1B).

Figure 12.1B – Pipevine Swallowtail (*Battus philenor*) captured in Great Smoky Mountains National Park with a mid-70s AI Nikkor 200mm f/4 on a bellows for macro, from about six feet (two meters) away

Taking Pictures in Live View Photography Mode

Hold the Shutter-release button down all the way and wait a moment for the camera to take the picture. It's usually slower than taking a picture with the Viewfinder because auto-focus takes more time. When you take a picture in Live view photography mode, it appears on the Monitor. To return to Live view photography to take more pictures, just press the Shutter-release button halfway down.

According to Nikon, one important consideration in Live view photography mode is to cover the eyepiece when using Live view. Very bright external light coming in the eyepiece of the Viewfinder may influence the exposure detrimentally.

However, I experimented with this by shining an *extremely* bright LED flashlight directly into the Viewfinder eyepiece while I was metering the subject with Live view and saw absolutely no change in exposure. I then switched to standard Viewfinder-based photography mode and found that shining the flashlight in the Viewfinder eyepiece had an immediate and large effect on exposure.

You may want to test this for yourself and see if your D7200 reacts to light through the Viewfinder during Live view photography. Or, you can play it safe and close the eyepiece shutter.

Settings Recommendation: You can use Live view photography mode on or off your tripod. I normally use Live view for macro images (figure 12.1B), for which I especially need the extra accuracy and focus positioning capability. With older Nikons, I was not all that interested in Live view photography because it didn't feel mature or complete. However, the Nikon D7200 has a very refined Live view photography mode. It can be used in almost any situation where standard Viewfinder-based photography will work.

One exception is action shooting. Live view photography is not as good for many types of action shots because the autofocus method is slower and the shutter lag seems longer. If the camera is prefocused in Live view, maybe you could capture some action, but I wouldn't try it for action shots that require rapid autofocus.

Live view photography mode is for when you have the time and inclination to stand back from your camera and take excellent photos in a more contemplative manner. To my way of thinking, it is like using a small view camera instead of an HD-SLR. If you've not been in the habit of using Live view, I would suggest you give it a try. The D7200 makes it a lot easier and more effective to use.

Live View Photography Mode Screens

(User's Manual: Pages 64)

There are five screens available in Live view photography mode. You will move between these screens by pressing the info button repeatedly.

Live View Photography: Screen 1

Figure 12.2A shows numerous symbols that allow you to see how various features are configured. To help examine the small symbols shown, I have numbered them and provided an explanation.

Figure 12.2A – Live view photography, image 1

1. **Shooting mode:** Selected by rotating the Mode dial on top of the camera. The available selections you will see on the dial are Programmed auto (P), Shutter-priority auto (S), Aperture-priority auto (A), Manual (M), EFFECTS, U1 and U2, SCENE, No flash, and AUTO.
2. **Autofocus mode:** Set with AF-mode button and rear Main command dial. Available settings are AF-S and AF-F.
3. **AF-area mode:** Set with AF-mode button and front Sub-command dial. Available settings are Face-priority AF, Wide-area AF, Normal-area AF, and Subject-tracking AF (uses graphical symbols).
4. **Active D-Lighting:** Controlled by *Photo Shooting Menu > Active D-Lighting,* with settings Low to Extra High and Auto or Off (L = Low, N = Normal, H = High, H* = Extra high, A = Auto, Off). You can also use the *i* button menu to select a value for this item.
5. **Picture Control:** Controlled by *Photo Shooting Menu > Set Picture Control.* You can also use the *i* button menu to select a value for this item. See the upcoming subsection **Selecting a Picture Control in Live View** for more detail.
6. **White balance:** Set the camera's White balance by holding down the WB button and rotating the rear Main command dial. Select from nine White balance settings, including Auto (A1), Incandescent, Fluorescent, Direct sunlight, Flash, Cloudy, Shade, Choose color temp., and Preset manual (uses graphical symbols).

7. *Image size:* Controlled by *Photo Shooting Menu > Image size* with settings Large (L), Medium (M), and Small (S). You can also use the *i* button menu to select a value for this item.

8. *Image quality:* Controlled by *Photo Shooting Menu > Image quality,* with settings NEF (RAW) + JPEG, NEF (RAW), JPEG, and TIFF. The abbreviations you'll see on the Monitor for these settings are FINE, NORM, BASIC, RAW+F, RAW+N, RAW+B, RAW, and TIFF. You can also use the *i* button menu to select a value for this item.

9. *Image area:* Controlled by the *Photo Shooting Menu > Image area* setting. You can select any of the available image areas, including: FX, 1.2×, and DX. The Monitor will display an image cropped to the various sizes selected in Image area.

10. *AF point (focus):* Can be moved around the screen with the Multi selector to select the subject for autofocus. This focus rectangle will vary in size and color according to the AF-area mode selected (#3) and whether the subject is in focus.

11. *Frame count (remaining pictures):* Approximately how many more pictures can be taken and stored on the currently selected memory card.

12. *ISO sensitivity:* Controlled by *Photo Shooting Menu > ISO sensitivity settings,* with choices of ISO values from ISO 100 to Hi 2 (ISO 102400 in black-and-white only). You can also control this value by holding down the ISO button and turning the rear Main command dial. The ISO values will change on the Monitor.

13. *ISO mode:* Controlled by *Photo Shooting Menu > ISO sensitivity settings > Auto ISO sensitivity control,* with the choice of On or Off. You can also control this value by holding down the ISO button and turning the front Sub-command dial to select from ISO or ISO AUTO on the Monitor.

14. *Exposure compensation:* This symbol will appear only when +/− exposure compensation has been dialed into the camera. Adjust this value with the +/− Exposure compensation button near the Shutter-release button.

15. *Aperture:* Set by turning the front Sub command dial, with aperture minimum and maximums that vary according to the mounted lens. Manual change is available only in Aperture-priority auto (A) and Manual (M) modes. The Camera controls this value in Shutter-priority auto (S) and Programmed auto (P) modes, although in P mode, the camera will allow you to override the aperture manually by turning the rear Main command dial and entering into Flexible program (P*) mode.

16. *Shutter speed:* Set with the rear Main command dial, with settings from 30 seconds to 1/8000 second (8000). Manual change is available only in Shutter-priority auto (S) and Manual (M) modes. The Camera controls this value in Aperture-priority auto (A) and Programmed auto (P) modes.

17. *Metering mode:* Set by holding down the Metering button and turning the rear Main command dial, with the following choices: Matrix, Center-weighted, and Spot.

18. *Center of Frame Dot:* This small dot appears when the AF point rectangle is directly in the middle of the frame. It will be red when out of focus and green when in focus, following the color of the surrounding AF point (#10).

Live View Photography: Screen 2

Figure 12.2B shows a much cleaner screen with an almost blank area at the top and a single line of information along the bottom, which matches the descriptions #10 through #18 for figure 12.2A. This is for users who prefer an uncluttered screen while shooting still pictures.

Figure 12.2B – Live view photography, image 2

Live View Photography: Screen 3

Figure 12.2C shows a screen that is similar to the previous screen except that gridlines are added. Use these gridlines to level your subject in the Viewfinder, as is necessary when photographing things like a horizon in scenic photography or buildings, doors, and walls in architectural photography.

Figure 12.2C – Live view photography, image 3

Live View Photography: Screen 4

The final screen, shown in figure 12.2D, displays a Virtual horizon that allows you to level the camera in a horizontal direction only.

The key to using the display is to understand the colors and the lines. Yellow means the camera is not level. Green means it is level. The horizontal line is currently yellow, which means the camera is off level. Rotate the back of the camera clockwise or counterclockwise until the yellow line turns green, which indicates the camera is level horizontally.

Figure 12.2D – Live view photography, image 4

Using the *i* Button Menu in Live View Photography Mode

Pressing the *i* button while in Live view photography mode gives you access to convenient control functions, including:

- Image area
- Image quality
- Image size
- Set Picture Control

- Active D-Lighting
- Remote control mode (ML-L3)
- Monitor brightness

Let's discuss each of these functions in detail. Normally, since these are Live view screens, you would see the subject on the screen. However, to maximize the contrast, so that you can see the settings, I created these screenshots with the lens cap on.

Use the Correct *i* Button Menu
As you begin to work with each of these Live view photography mode *i* button functions, please keep in mind that the camera must be in Live view photography mode to access and change the Live view photography mode setting configurations.

Therefore, select Live view photography mode with the Live view selector switch first and then press the Lv button to enter Live view photography mode (figure 12.1A).

If the screens you see on your camera do not match the ones shown in the rest of this chapter, you are using the *i* button menu for the Photo Shooting Menu instead of the one for Live view photography.

Image Area
This convenient function allows you to choose one of the two Image area selections found in the *Photo Shooting Menu > Image area* function. You can select from the following values:

- DX (24×16)
- 1.3× (18×12)

Figure 12.3A – Setting the Image area

Use the following steps to choose one of the Image area settings:

1. Make sure your camera is in Live view photography mode (figure 12.1A).
2. Press the *i* button and the Image area menu will open (figure 12.3A, image 1).
3. Select the first item on the menu and Image area will be displayed on the top right of the screen (figure 12.3A, image 1). Scroll to the right with the Multi selector or press the OK button.
4. The menu on the right side of the screen will allow you to select the Image area you want to use for this Live view session (figure 12.3A, image 2). Scroll up or down with the Multi selector and choose one of the two Image area values (DX or 1.3×).
5. Press the OK button to lock in the Image area setting. Press the *i* button to close the menu.

Note: When you choose an image area value, you will see the rear Monitor adjust to the new image area. It will immediately reflect the new image size and shape.

Also, the image area you select while in Live view will remain the same when you exit Live view and go back to shooting with the Viewfinder.

For additional information on the Choose Image area function, see the **Photo Shooting Menu** chapter under the **Image Area** subheading, on page 75.

Image Quality

Image quality mode allows you to adjust the image quality of your pictures using the same settings as the *Photo Shooting Menu > Image quality* function. Your choices are:

- **RAW+F:** NEF (RAW) + JPEG fine
- **RAW+N:** NEF (RAW) + JPEG normal
- **RAW+B:** NEF (RAW) + JPEG basic
- **RAW:** NEF (RAW)
- **FINE:** JPEG fine
- **NORM:** JPEG normal
- **BASIC:** JPEG basic

Figure 12.3B – Image quality selections

Use the following steps to choose one of the Image quality settings:

1. Make sure your camera is in Live view photography mode (figure 12.1A).
2. Press the *i* button and the Image quality menu will open (figure 12.3B, image 1).
3. Highlight the second item on the menu and Image quality will be displayed on the top right of the screen (figure 12.3B, image 1). Scroll to the right with the Multi selector or press the OK button.
4. The menu on the right side of the screen will allow you to select the Image quality you want to use for this Live view photography session (figure 12.3B, image 2). Scroll up or down with the Multi selector and choose one of the seven Image quality values (see previous list).
5. Press the OK button to lock in the Image quality setting. Press the *i* button to close the menu.

Note: For additional information on the Image quality function, see the **Photo Shooting Menu** chapter under the **Image quality** subheading on page 65.

Image Size

Image size mode allows you to adjust the image size of your pictures using the same settings as the *Photo Shooting Menu > Image size* function. Your choices are:

- **L:** Large – 6000 × 4000 – 24.0 M
- **M:** Medium – 4496 × 3000 – 13.5 M
- **S:** Small – 2992 × 2000 – 6.0 M

Figure 12.3C – Image size selections

Use the following steps to choose one of the Image size settings:

1. Make sure your camera is in Live view photography mode (figure 12.1A).
2. Press the *i* button and the Image size menu will open (figure 12.3C, image 1).
3. Highlight the third item on the menu and Image size will be displayed on the top right of the screen (figure 12.3C, image 1). Scroll to the right with the Multi selector or press the OK button.
4. The menu on the right side of the screen will allow you to select the Image size you want to use for this Live view session (figure 12.3C, image 2). Scroll up or down with the Multi selector and choose one of the three Image size values (L, M, or S).
5. Press the OK button to lock in the Image size setting. Press the *i* button to close the menu.

Note: For additional information on the Image size function, see the **Photo Shooting Menu** chapter under the **Image Size** subheading on page 73.

Set Picture Control

The Set Picture Control function allows Live view photography shooters to quickly choose and fine-tune various Picture Controls for different image looks. There are seven Picture Controls available, and as you select each one, the Live view will update with the look provided by that control. Here are your choices:

- **SD:** Standard
- **NL:** Neutral
- **VI:** Vivid
- **MC:** Monochrome

- **PT:** Portrait
- **LS:** Landscape
- **FL:** Flat

The information needed to work with these Picture Controls is quite extensive, especially for the Monochrome (MC) Picture Control. Since that information is already covered in detail in a previous chapter, it will not be repeated here. Instead, to do more than select a Picture Control and some minor fine-tuning, please refer to the **Photo Shooting Menu** chapter under the subheading **Set Picture Control** on page 87.

Figure 12.3D – Set Picture Control selections

Use the following steps to choose one of the Set Picture Control settings:

1. Make sure your camera is in Live view photography mode (figure 12.1A).
2. Press the *i* button and the Set Picture Control menu will open (figure 12.3D, image 1).
3. Highlight the fourth item on the menu and Set Picture Control will be displayed on the top right of the screen (figure 12.3D, image 1). Scroll to the right with the Multi selector or press the OK button.
4. The menu on the right side of the screen will allow you to select the Picture Control you want to use for this Live view session (figure 12.3D, image 2). Scroll up or down with the Multi selector and choose one of the seven Picture Controls (see previous list).
5. Scroll to the right with the Multi selector or press the OK button and the fine-tuning screen will appear. Use it to adjust Sharpening, Clarity, Contrast, Brightness, Saturation, and Hue. Not all the fine-tuning settings are available on all seven Picture Controls. See Picture Control fine-tuning information on page 89 of this book for more details.

Figure 12.3E – Extra Monochrome settings

6. The Monochrome (MC) Picture Control (figure 12.3E, image 1) has a couple of extra settings not found on the other controls, including Filter effects (image 2) and Toning (image 3). Information on these settings is quite extensive and has been covered well

in previous chapters of this book. Therefore, it will not be repeated here. For more details, see the MC Picture Control **Filter Effects** and **Toning** information on page 93 of this book.

7. Press the OK button to lock in the Set Picture Control setting. Press the *i* button to close the menu.

Active D-Lighting

This function provides an easy way to change the Active D-Lighting (ADL) value. ADL extends the dynamic range of your images for excellent shadow and highlight detail enhancement while using Live view photography mode. This is the same as the *Photo Shooting Menu > Active D-Lighting* function. Your Active D-Lighting choices are as follows:

- **A:** Auto
- **H*:** Extra high
- **H:** High
- **N:** Normal
- **L:** Low
- **Off**

Figure 12.3F – Configuring Active D-Lighting

Use the following steps to select one of the Active D-Lighting settings:

1. Make sure your camera is in Live view photography mode (figure 12.1A).
2. Press the *i* button to open the Active D-Lighting menu (figure 12.3F, image 1).
3. Highlight the fifth item on the menu and Active D-Lighting will be displayed on the top right of the screen (figure 12.3F, image 1). Scroll to the right with the Multi selector or press the OK button.
4. Select one of the five Active D-Lighting values or Off (figure 12.3F, image 2). Low (L) is selected in screen 2.
5. Press the OK button to lock in the value. Press the *i* button to close the menu.

Note: Whatever Active D-Lighting value you select while in Live view photography mode will still be active for Viewfinder shooting when you close Live view.

For additional information on the Active D-Lighting function, see the **Photo Shooting Menu** chapter under the **Active D-Lighting** subheading on page 108.

Remote Control Mode (ML-L3)

The Remote control mode ML-L3 function allows you to select how your camera works with the Nikon ML-L3 infrared remote. You can select a specific timeout, or cause the camera to fire immediately upon pressing the ML-L3 release button. Your setting choices are:

- **Off:** The camera does not respond to the ML-L3 remote control.
- **Remote mirror-up:** The first press on the ML-L3's release button causes the mirror to raise to allow time for camera vibrations to settle. The second press of the release button fires the camera's shutter.
- **Quick-response remote:** The camera's shutter is released as soon as you press the ML-L3 release button.
- **Delayed remote:** The camera's shutter is released two seconds after you press the ML-L3 release button.

Figure 12.3G – Remote control mode (ML-L3) selections

Use the following steps to choose one of the Remote control mode settings:

1. Make sure your camera is in Live view photography mode (figure 12.1A).
2. Press the *i* button and the Remote control mode menu will open (figure 12.3G, image 1).
3. Highlight the sixth item on the menu and Remote control mode (ML-L3) will be displayed on the top right of the screen (figure 12.3G, image 1). Scroll to the right with the Multi selector or press the OK button.
4. The menu on the right side of the screen will allow you to select the ML-L3 release button setting you want to use for this Live view session (figure 12.3G, image 2). Scroll up or down with the Multi selector and choose one of the four Remote control mode (ML-L3) values (see previous list).
5. Press the OK button to lock in the setting. Press the *i* button to close the menu.

Note: For additional information on the Remote control mode (ML-L3) function, see the **Photo Shooting Menu** chapter under the **Remote Control Mode (ML-L3)** subheading on page 133.

Monitor Brightness

With the Monitor brightness function, you can change the brightness of the Monitor. When using Live view, there are times when bright ambient light may interfere with your ability to see details on the Monitor. At other times, when shooting in dark areas, the brightness of the Monitor could be blinding.

You may want to use this function to change the backlight intensity of the Monitor from quite bright to very dim. These brightness changes do *nothing* to the pictures you are taking. This function is merely for your comfort while shooting in varying light levels.

Figure 12.3H – Monitor brightness selections

Use the following steps to choose one of the Monitor brightness settings:

1. Make sure your camera is in Live view photography mode (figure 12.1A).
2. Press the *i* button and the Monitor brightness menu will open (figure 12.3H, image 1).
3. Highlight the seventh item on the menu and Monitor brightness will be displayed on the top right of the screen (figure 12.3H, image 1). Scroll to the right with the Multi selector or press the OK button.
4. The menu on the right side of the screen will allow you to select the Monitor brightness you want to use for this Live view session (figure 12.3H, image 2). Scroll up or down with the Multi selector and choose from a range of 10 levels of brightness (+5.0 to −5.0). The default is zero (0), which is a medium setting.
5. Press the OK button to lock in the Monitor brightness setting. Press the *i* button to close the menu.

Note: Changing the Monitor's brightness in Live view photography mode does not affect the Monitor brightness after leaving Live view, such as when viewing pictures on the Monitor, adjusting menu items, and viewing the Information display. However, this setting does affect how bright the Monitor appears when you are using Movie live view mode to record videos (see next chapter). Live view photography mode and Movie live view mode are both affected by this setting, but not Viewfinder mode. Movie live view mode also allows you to adjust Monitor brightness in a similar way.

For more information on the Monitor brightness function see the **Setup Menu** chapter under the **Monitor Brightness** subheading on page 309.

Closing Notes on Live View Photography Mode

Movie Live View Still Images
An important fact to note is that when you first set your camera to Movie live view mode, before you press the Movie-record button, it can take 20.2-megapixel still pictures in a 16:9 format (6000×3368 pixels). The Movie live view still image size matches most HD devices, so if you are shooting stills for display on HD devices closely matching the 16:9 format, use Movie live view to take some pictures.

Nearly all the information we have considered in this chapter applies to Movie live view still images, too. Just flip the Live view selector switch to the bottom position (figure 12.1A), press the Lv button, and start taking excellent 20.2-MP still images for HD devices (e.g., tablets, HDTVs, and newer computer monitors). We will consider more about Movie live view in the next chapter.

Using Autofocus in Live View
Nikon strongly recommends using an AF-S lens when you are shooting in Live view modes. According to Nikon, "The desired results may not be achieved with other lenses or teleconverters."

You may see darkening or brightening in the Monitor as autofocus takes place, and autofocus will be slower than it is with Viewfinder-based photography. From time to time, the focus indicator square may remain green (instead of red) when the camera is not actually in focus. Simply refocus when that occurs.

There are several issues that may cause the camera to have difficulty focusing in Live view, as follows (according to Nikon):

- The subject contains lines parallel to the long edge of the frame
- The subject lacks contrast
- The subject under the focus point contains areas of sharply contrasting brightness or includes spotlights, a neon sign, or another light source that changes in brightness
- There is flickering or banding under fluorescent, mercury-vapor, sodium-vapor, or similar lighting
- A cross-screen (star) filter or other special filter is used
- The subject appears smaller than the focus point
- The subject is dominated by regular geometric patterns (e.g., window blinds or a row of windows in a skyscraper)
- The subject is moving

Additionally, there are several issues that may cause focus tracking to fail in Live view mode:

- The subject is moving too fast
- Another object gets between the camera and the subject, obscuring it

- The subject changes visibly in size
- The subject's color changes
- The subject gets brighter or dimmer
- The subject gets too small, too close, or too light or dark
- The subject is the same color as the background

Live View Camera Protection System

If conditions could harm the camera when using Live view, such as using Live view for extended periods on a hot day, causing the camera to overheat, the D7200 will protect itself by automatically shutting down Live view. A countdown will show on the Monitor 30 seconds before the Live view system shuts down. If conditions warrant, the countdown timer may appear immediately upon entering or reentering Live view. This countdown allows your expensive camera to protect its internal circuits from overheating and causing damage.

Author's Conclusions

Live view photography mode in the D7200 is a mature and very usable way to shoot still images. Using the Monitor is not just for point-and-shoot photographers any more. There are several good reasons for using the Live view system, such as extreme focusing accuracy when shooting macro images and when composing the image on the Monitor gives you a better feel for the subject than the Viewfinder.

The next step in learning about the Nikon D7200 is to examine Movie live view mode. This mode can be used for special HD-format still images, but it's primarily designed for shooting excellent, broadcast-quality HD movies. Let's examine the powerful video subsystem in your D7200 and see how it works.

13 Movie Live View

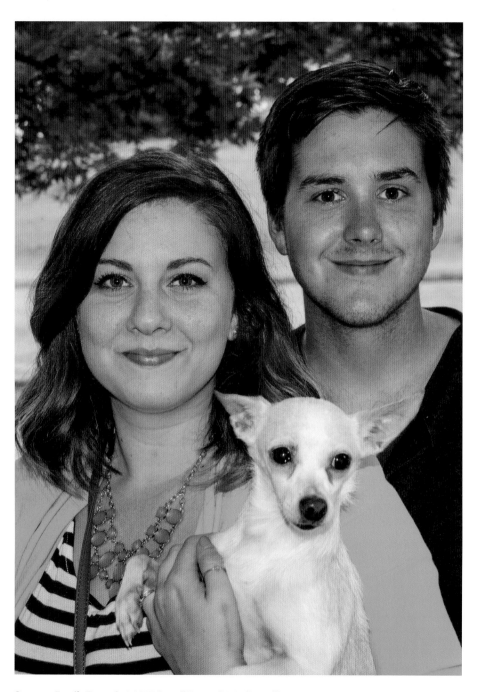

Summer Family Portrait © 2015 Darrell Young (DigitalDarrell)

With each new DSLR camera released, Nikon has advanced the capability of the video re-cording system. The Nikon D7200 is no exception. In fact, this camera has achieved a level of video capability that few other cameras can claim, even outside the 35mm form factor. Due to the power and flexibility of its Movie live view video mode, it has led the way in establishing a new type of camera, the *hybrid digital single-lens reflex* camera, or HD-SLR. Where older Nikon DSLR cameras were primarily still-image producers that happened to have video recording capability, the new HD-SLR D7200 was constructed with a video sys-tem just as capable as the still-image system.

When you use the still-imaging side of the Nikon D7200, you are taking extreme-resolution images that few other 35mm DX form-factor DSLRs can match. When you create videos with the D7200, again you can create videos that few cameras can match. The Nikon D7200 has the ability to stream broadcast-quality, uncompressed, HD (720p) or Full HD (1080p) video with no camera control overlays—called clean video—from its HDMI port.

In a sense, the Nikon D7200 has two video subsystems. One is for recording high-quality, compressed home videos in MOV format, up to 29 minutes and 59 seconds long each, to the camera's SD memory cards. The second is for outputting a clean, uncompressed, 1080p video stream from the HDMI port with no time constraints. The second video type allows true commercial use of the Nikon D7200 for shooting Full HD video.

This camera is so appealing and powerful in both its still-image and video modes that it is causing an influx of other-brand users to come over to Nikon. And why not? The Nikon D7200 has one of the best image quality ratings of any production DX digital camera and a video system that is more capable than most cameras in its class. And the nice thing is—you own a Nikon D7200!

High Definition vs. Hybrid Digital

You will find quite a bit of discussion on the Internet about what HD-SLR truly stands for. Some claim it stands for *High Definition Single-Lens Reflex* and others claim *Hybrid Digital Single-Lens Reflex*. In fact, the *HD* in HD-SLR stands for hybrid digital. The camera is a hybrid that shoots both stills and video.

Honestly, though, where do the abbreviations stop? What new abbreviations will the next generation of cameras bring? If you want to go all out on using abbreviations, the Nikon D7200 is a high-definition, video-enabled, hybrid, digital single-lens reflex camera (HDVEHDSLR?). Now that's a satisfying abbreviation! ☺

Selecting Movie Live View Mode

(User's Manual: Page 161)

Just in case you are a new HD-SLR user and have never used Nikon's Live view modes, let's see how to switch the camera into Movie live view mode. In figure 13.1, the camera is set to Movie live view mode, which is just below the setting for Live view photography mode (previous chapter) on the Live view selector switch.

Once you have entered Movie live view mode, you can take HD-ratio (16:9) still images and HD videos in the 16:9 aspect ratio only. No matter how you have the camera set in *Movie Shooting Menu > Image area,* the still images and video are still in 16:9 ratio.

If you are shooting video or still images in DX mode or with a DX lens attached, the images and movies are still in the 16:9 aspect ratio; however, the camera creates a cropped, DX-sized 16:9 ratio image or video that gives the appearance of pulling the subject in closer. It isn't re-

Figure 13.1 – Selecting Movie live view mode

ally magnifying the image, just using less of the imaging sensor to capture the subject, so it appears larger in the image or video when displayed.

Movie Live View Still Images

As mentioned at the end of chapter 12, the Nikon D7200 provides a still-image capability in Movie live view mode that is very similar to that of Live view photography mode. In fact, most of what is written in the chapter **Live View Photography** applies equally to Movie live view mode's 16:9 ratio still images.

For that reason, we will not discuss all the capability of the Movie live view still-imaging function because that would merely be a repeat of the previous chapter. When you decide to take a picture (instead of a movie) using Movie live view mode, let the information in chapter 12 govern how you shoot, tempered by the differences discussed in this chapter. Let's consider the available still-image options and sizes, as listed in table 13.1.

Image Area	Pixel Size	Print Size (in/cm)
DX (24×16)	6000×3368	20.00×11.23 in/50.80×28.52 cm
1.3× (18×12)	4800×2696	16.00×8.98 in/40.64×22.81 cm

Table 13.1 – Movie live view mode 16:9 still Image area and Image size with pixel and print dimensions. See expanded table on page 169 of the User's Manual.

Image Area in table 13.1 represents the values found in Movie *Shooting Menu > Image area > Choose image area* but includes only values from FX and DX because those are the only formats supported for the 16:9 aspect ratio of Movie live view mode.

Figuring Print Sizes in Inches and Centimeters

The print sizes listed in table 13.1 are based on printing the image at 300 dpi. The print size will be different at different dots per inch (dpi) settings. The formula to figure print sizes at various dpi settings is as follows (1 inch = approximately 2.54 cm):

Print size (in) = Pixel size (one dimension) / dpi

Therefore, a pixel size of 6000 pixels/300 dpi = 20.00 inches (50.80 cm), as shown in table 13.1. That means the same pixels at 240 dpi would provide a larger image, as the formula shows: 6000 pixels/240 dpi = 25.00 inches (63.50 cm). For metric system users, the formula would have one more step, conversion from inches to centimeters:

Print size (cm) = (Pixel size / dpi) × 2.54

So, a pixel size of (6000 pixels / 300 dpi) × 2.54 = 50.80 cm. Remember this useful formula, whether in inches or centimeters, if you use dots per inch as the standard for printing. This formula works for any pixel-to-print size conversion (in dots per inch), not just in Movie live view mode. Use the pixel size for each dimension (height and width) of the image to determine an overall print size.

Movie Live View Screens

Let's start out by examining each of the five screen overlays you can use while taking stills or shooting movies in Movie live view mode. You can scroll through each of the five screens by pressing the info button repeatedly.

Movie Live View: Screen 1

The Nikon D7200 has two screens for each overlay in Movie live view. The first screen is available when you are shooting still images and the second when you are recording video. I am using the first screen as a guide initially so that we can examine each of the controls on the screen. Once you start recording movies, some of the controls in the overlay disappear. Figure 13.2A shows the first screen you should see when you enter Movie live view. Let's examine each of the controls displayed in the overlay.

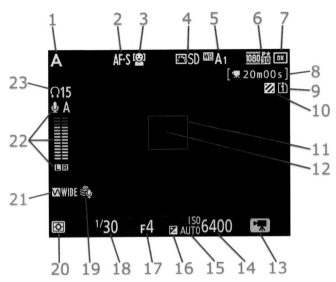

Figure 13.2A – Movie live view screen

Here is a list of controls shown on the first screen. Each number in figure 13.2A has a corresponding entry in the list that follows:

1. **Exposure mode:** Select this by turning the Mode dial on top of the camera. The available selections are Programmed auto (P), Shutter-priority auto (S), Aperture-priority auto (A), Manual (M), EFFECTS, U1 and U2, SCENE, No-flash, and AUTO. The No-flash mode only has an effect when you are using Movie live view for taking still photos. Otherwise, when shooting a video in No-flash mode, the camera uses the equivalent of AUTO mode.

2. **Autofocus mode:** Set with the AF-mode button and rear Main command dial. Available settings are AF-S and AF-F. AF-S uses single autofocus that locks on your subject; AF-F provides continuous autofocus.

3. **AF-area mode:** Set with the AF-mode button and front Sub-command dial. Available settings are Face-priority AF, Wide-area AF, Normal-area AF, and Subject-tracking AF (uses graphical symbols). You can find details about how each of these AF-area modes work in the chapter titled **Autofocus, AF-Area, and Release Modes,** under the subheading **AF-Area Modes in Detail** (page 482).

4. **Picture Control:** This is controlled with the Set Picture Control selection on the i Button Menu. You can use any of the camera-supplied Picture Controls (e.g., SD, VI, FL), or you can use any Custom Picture Controls you may have created (e.g., C-1, C-2). You can also change Picture Controls with the Movie Shooting Menu > Set Picture Control function.

5. **White balance:** Set the camera's White balance by holding down the WB button and rotating the rear Main command dial. Select from the White balance settings, including Auto (A1), Incandescent, Fluorescent, Direct sunlight, Cloudy, Shade, Choose color temp., and Preset manual (uses graphical symbols).

6. **Frame size/frame rate:** This is controlled with *Movie Shooting Menu > Frame size/frame rate*. It shows the frame size and frame rate to which your Movie mode is currently set. The choices are 1080p at 60, 50, 30, 25, or 24 fps, or 720p at 60 or 50 fps. You can also adjust this setting before you start shooting a video with the Frame size/frame rate setting in the *i* Button Menu, as described in the upcoming **Preparing to Make Movies** section.

7. **Image area:** You can choose between DX (24×16) and 1.3× (18×12) modes for varying the size of the video. 1.3× has a narrower field of view than DX; therefore, you might want to experiment with that mode for more distant subjects in your videos. You can choose one of these two values in the *i* Button Menu.

8. **Time remaining:** When you are recording a movie, this feature shows you how much time is left before the camera automatically stops recording. Here is a list of the recording times:
 - 1080p60 and 1080p50 both have a maximum recording time of 10 minutes with the High quality bit rate (42 Mbps) and 20 minutes with the Normal quality bit rate (24 Mbps).
 - 1080p30, 1080p25, 1080p24, 720p60, and 720p50 all have maximum recording times of 20 minutes with the High quality bit rate (24 Mbps) and 29 minutes 59 seconds with the Normal quality bit rate (12 Mbps).
 - When you use the HDMI port to send uncompressed video to an external video recording device, there is no limit on the recording time.

9. **Movie destination:** This setting reflects the configuration stored in *Movie Shooting Menu > Destination*. You can also adjust this setting before you start shooting a video with the Destination setting in the *i* Button Menu, as described in the upcoming **Preparing to Make Movies** section. You have a choice of SD card Slot 1 or Slot 2. Movies will be recorded only to the selected destination card unless it has been removed from the camera, at which time the D7200 will record video to the only available card.

10. **Highlight display:** Also known as Zebra mode, the Highlight display places alternating black-and-white stripes, like a zebra, on areas that are blown out to pure white and have lost all highlight detail. You must enable or disable this setting before you start shooting a video with the Highlight display setting in the *i* Button Menu, as described in the upcoming **Preparing to Make Movies** section.

11. **AF point (focus):** This AF point rectangle can be moved around the screen with the Multi selector to select the subject for autofocus. This focus rectangle will vary in size and color according to the AF-area mode selected (#3) and whether or not the subject is in focus.

12. **Center of Frame Dot:** This small dot appears when the AF point rectangle is directly in the middle of the frame. This dot, as well as the surrounding AF point rectangle (#11), will be red when the subject is out of focus and green when it is in focus.

13. **Movie live view symbol:** This symbol is merely a label to let you know you have the camera set to Movie live view mode.

14. **ISO sensitivity:** Controlled by *Movie Shooting Menu > Movie ISO sensitivity settings > ISO sensitivity (mode M)*, with ISO values choices from ISO 100 to 25600. You must choose

an ISO sensitivity setting before you start shooting the movie. If this value needs to vary, you will need to use ISO Auto mode as discussed in #15. Also, see the chapter titled **Movie Shooting Menu** under the subheading **ISO Sensitivity** (page 173) for more information on this setting.

15. *ISO Auto mode:* Controlled by *Movie Shooting Menu > Movie ISO sensitivity settings > Auto ISO control (mode M),* with the choice of On or Off. You must choose and adjust this setting before you start recording a video. See the chapter titled **Movie Shooting Menu** under the subheading **Auto ISO Control (Mode M)** on page 174 for more information on this setting.

16. *Exposure compensation:* This symbol will appear only when +/– exposure compensation has been dialed into the camera. Adjust this value with the +/– Exposure compensation button near the Shutter-release button.

17. *Aperture:* Set by turning the front Sub-command dial, with aperture minimums and maximums that vary according to the mounted lens. Adjustment is available in A and M mode only. You must set the aperture for a video *before* you press the LV button to enter Movie live view mode. Manual aperture change is not available once Movie live view is active (not just unavailable during actual video recording).

18. *Shutter speed:* Set shutter speed with the rear Main command dial. Settings range from 1/30 second to 1/8000 second (8000) when using Manual mode (M) on the Mode dial only. The camera controls this value in Aperture-priority auto (A), Shutter-priority auto (S), and Programmed auto (P) modes. Even in Shutter-priority auto (S) mode, the camera forces you to use the ISO Auto setting (#15). Only in Manual mode (M) do you have limited control over the shutter speed (1/30 to 1/4000 sec). (*Note:* You can enable or disable ISO Auto in Manual (M) exposure mode by setting Auto ISO control (mode M) to On or Off with *Movie Shooting Menu > Movie ISO sensitivity settings > Auto ISO control (mode M).* That's right, you can use ISO Auto in Manual (M) mode in case the light changes too quickly for you to manage it with manual controls. This is a powerful feature and safety factor for the Nikon D7200 camera.

19. *Wind noise reduction:* This symbol will appear when Wind noise reduction is enabled. Wind noise reduction attempts to remove the worst of the rumbling sound you hear when wind strikes an unprotected microphone. This function is controlled by the *Movie Shooting Menu > Wind noise reduction* setting, or by the Wind noise reduction setting in the *i* Button Menu, as described in the upcoming **Preparing to Make Movies** section.

20. *Metering mode:* Movie live view allows you to use two of the camera's metering modes: Matrix metering and Center-weighted metering. Hold down the Metering button and rotate the rear Main command dial to change the metering mode. This must be set before you start recording video.

21. *Frequency response:* This symbol will appear to let you know whether you have the microphone's frequency response set to Wide or Voice. Wide will capture a much broader range of sound for when you want to record all sounds in a scene. The Voice setting limits the sound recording sensitivity to ranges encompassing human voice frequencies, making it best for recording speech, such as during a public discourse or

lecture. This function is controlled by the *Movie Shooting Menu > Frequency response* setting, or by the Frequency response setting in the *i* Button Menu, as described in the upcoming **Preparing to Make Movies** section.

22. ***Microphone sensitivity:*** This setting allows you to adjust the current Microphone sensitivity setting. As shown in figure 13.2A, #21, there are three symbols associated with this setting. The top symbols of a mic and the letter A means that I have the mic set to Auto. The two side-by-side lines of bars show a live view of the left and right sound channels in action, and the L (left) and R (right) symbols indicate which channel is which. For the side-by-side sound level bars, white means normal sound, yellow means loud sound, and red means too-loud sound that may be distorted. The mic sensitivity is controlled by *Movie Shooting Menu > Microphone sensitivity,* with the choice of Auto sensitivity, Manual sensitivity (in 20 steps), and Microphone off. You can also adjust this setting with the Microphone sensitivity setting in the *i* Button Menu, as described in the upcoming **Preparing to Make Movies** section.

23. ***Headphone volume:*** This setting lets you adjust the volume output by the camera to a set of headphones. You can also adjust this setting between off (0) and 30 before you start shooting a video with the *i* Button Menu, as described in the upcoming **Preparing to Make Movies** section. Also, while listening to a video play back on the camera, you can adjust the volume level by pressing up with the Playback zoom in (QUAL) button or down with the Playback zoom out/thumbnails (ISO) button until you have selected a comfortable volume level. You must adjust the Headphone volume before starting a movie recording session.

When you press the Movie-record button, the screen removes several of the controls in the overlay along the top, as shown in figure 13.2B. You can tell this is a screen from a video being recorded by the REC symbol in the top-left corner, next to the red dot. REC will be displayed the entire time you are recording.

Figure 13.2B – Movie live view screen overlay 1, during a video recording

Why do some of the controls disappear during a video recording? Basically, to clean up the screen a bit so the overlay is less distracting while you are concentrating on your subject. During the video recording, you can still change some of the control functions shown in figure 13.2A, with the exception of the following functions (see numbers in previous list):

* Picture Control
* Frame size/frame rate
* Movie destination
* Headphone volume
* Metering mode
* Exposure mode

The MENU button has no effect during a video recording, so you are locked out of even attempting to make any serious camera adjustments that have no button/dial combinations on the camera. However, many button and dial functions still respond.

For instance, if you press the AF-mode button while recording a video, the Autofocus and AF-area mode symbols will reappear, allowing you to turn the rear Main command dial to change the Autofocus mode or the front Sub-command dial to change the AF-area mode. Try it. Likewise, if you press the WB button during a recording, you can change White balance on the fly. Finally, you can always add or subtract Exposure compensation with the +/– Exposure compensation button.

Also, you can adjust several of the control functions by pressing the *i* button and selecting one of the following functions from the menu:

- Microphone sensitivity
- Frequency response
- Wind noise reduction
- Highlight display

Shooting in Manual (M) mode gives you the greatest control over the camera during a video recording. In Manual, you can adjust the following functions:

- Autofocus mode
- AF-area mode
- White balance
- AF point (focus)
- Shutter speed
- Aperture
- Exposure compensation
- ISO sensitivity

Basically, Manual mode (M) gives you full control of the camera while recording a video. Aperture-priority auto (A) allows you to control the aperture, while the camera controls the rest. Shutter-priority auto (S) and Programmed auto (P) give you much less control and could almost be considered point-and-shoot modes when recording video.

Now, let's consider the other available screen overlays and their purposes. Press the info button when you see screen 1 (figure 13.2A or 13.2B) and the camera will switch to screen 2 (figure 13.2C, image 1 [still images] and image 2 [video recording]).

Movie Live View: Screen 2

Screen 2 in the overlay series is a very bare screen for those times when you want very little distraction while making a still image or recording a video (figure 13.2C, images 1 and 2). You can still see the most important controls at the bottom of the screen (aperture, shutter speed, and ISO sensitivity), but everything else is stripped out of the overlay.

Nikon calls the screen in figure 13.2A the *Information on* screen, while figure 13.2C shows the *Information off* screen.

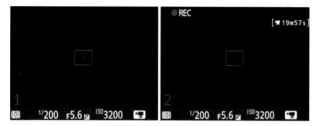

Figure 13.2C – Movie live view screen overlay 2, for still images (1) and video recording (2)

Movie Live View: Screen 3

Most photographers have a tendency to tilt their cameras to the left or right slightly. The *Framing guides* screen is designed to help keep things level in the Viewfinder (figure 13.2D). The grid lines are very useful for keeping horizons level and architecture straight.

Figure 13.2D – Movie live view screen overlay 3, for still images (1) and video recording (2)

I leave these grid lines turned on in my Viewfinder-based photography all the time and use them in Live view mode when I need to level things in comparison to a feature in my subject, such as the horizon.

Movie Live View: Screen 4

The *Histogram* screen gives you a live histogram to help you judge exposure during video recording (figure 13.2E). In Manual (M) mode, you can adjust the aperture, shutter speed, or ISO sensitivity to correct for under- or overexposure. In other Exposure modes, you can

use the +/– Exposure compensation button to push the exposure toward the dark or light sides, making the exposure better.

Figure 13.2E – Movie live view screen overlay 4, for still images (1) and video recording (2)

If you are a video perfectionist who wants to control all aspects of the video production, you will certainly enjoy having a live histogram to keep you informed immediately when light levels change in a way that will damage your video's quality. This is a truly professional tool and one all serious videographers should use regularly, especially in Manual (M) mode!

Movie Live View: Screen 5

The *Virtual horizon* screen displays camera rotation (roll) with the camera's built-in tilt sensor (figure 13.2F). If the lines are green, it means the camera is level. The tilt sensor senses left and right rotational tilts. When the camera is not level in one direction or the other, the line for that direction turns yellow and signifies the approximate degree of tilt.

Figure 13.2F – Movie live view screen overlay 5, for still images (1) and video recording (2)

In figure 13.2F, image 1, the camera is level, as signified by the green line. However, the camera is tilted or rotated to the right in image 2, as shown by the yellow line.

This is very useful when setting up a camera on a tripod to shoot a video. You can start the video with the knowledge that the camera is level left to right. While you're shooting a video handheld, this screen may be invaluable to prevent introducing tilt into an otherwise excellent video.

Preparing to Make Movies

(User's Manual: Page 161)

The Movie mode in the D7200 is one of the best video recording systems Nikon has put in a DX-based DSLR. It has automatic or manual focus, 1080p HD recording, stereo sound, 10-minute, 20-minute, or 29-minute 59-second recording segments according to frame size and rate, a 4 GB size-per-movie maximum, and excellent rolling shutter correction.

If you want to buy all the cool attachments, like stabilization frames, bigger external video monitors, external streaming video recorders (**Atomos.com**), a headphone set, and an external stereo mic, this camera has the ports and controls to support them.

Let's examine how to prepare for and record videos and then how to display them on various devices. Keep in mind that the D7200 offers two levels of video recording; first, to the camera's memory card as a compressed (b-frame H.264/MPEG-4 AVC) QuickTime MOV file; and second, as an uncompressed 4:2:2, clean (overlay-free), broadcast-quality HDMI video stream through the HDMI port to an external recording device, both with Linear PCM sound recording.

Basic HD Video Information

Before shooting your first movie, you'll need to configure the camera for your favorite video frame size and rate. We'll look into the actual configuration in a later section. For now, let's briefly discuss some basics:

A video frame is much smaller, in terms of pixels, than a normal still-image frame. Although your D7200 can create beautiful 24-megapixel still images, its best HD video image is just above 2 megapixels (2,073,600 pixels).

Whoa! How can 2 megapixels be considered high definition (HD)? Simply because it matches one of the high-definition television (HDTV) broadcast resolutions. In the good old days of standard-definition television (SDTV), there was even less resolution. Would you believe that the old CRT-tube TV you have stored in the garage displays only 345,600 pixels, or 0.3 megapixels?

I've been talking about the number of megapixels, but that's not normally how HD devices are rated. Instead of the number of pixels, most HD information talks about the number of lines of resolution. There are several HD standards for lines of resolution. The most common standards are 720p, 1080i, and 1080p. The p and i after the numbers refer to *progressive* and *interlaced*. We'll talk about what that means in the next section.

The D7200's best Movie mode captures video at 1080p, which is a display-quality HDTV standard. At the time of this writing, much over-the-air broadcast-quality HD is 720p, but 1080p is quickly becoming the standard. The 1080p designation simply means that your camera captures and displays HD images with 1,080 lines of vertical resolution. Each of those lines is 1,920 pixels long, which allows the D7200 to match the 16:9 aspect ratio expected in HDTV. An older SDTV usually has an aspect ratio of 4:3, which is taller and narrower than the HDTV 16:9 aspect ratio.

Progressive versus Interlaced

What's the difference between progressive and interlaced? Technically speaking, progressive video output displays the video frame starting with the top line and then draws the other lines until the entire frame is shown. The D7200 displays 1,080 lines progressively from the top of what the imaging sensor captured to the bottom (lines 1, 2, 3, 4 … 1,080).

Interlaced video output displays every even line from top to bottom, then comes back to the top and displays every odd line (lines 2, 4, 6, 8 … 1,080, then 1, 3, 5, 7 … 1,079).

Progressive output provides a higher-quality image with less flicker and a more cinematic look. I'm sure that's why Nikon chose to make the D7200 shoot progressive video. Now, let's set up our cameras and make some movies!

Camera Setup for Making Quick Movies

The D7200 is capable of creating movies at any time, and with little thought, by simply using the following settings and actions:

- Flip the Live view selector lever to Movie live view
- Press the Lv button to enter Live view
- Set the Autofocus mode to AF-F (Full-time-servo AF) with the AF-mode button and rear Main command dial
- Set the AF-area mode with the AF-mode button (face detection is preferred) and the front Sub-command dial
- Set the Mode dial to AUTO (green camera icon)
- Press the Movie-record button

Setting up the camera in this way makes it act like a standard video camera, where you give little consideration to camera settings and simply shoot the video.

However, you have purchased an advanced-level camera, and you may want to do more than just take automatic movies. The D7200 can do it either way. Let's discuss how to set up the camera for more professional movie creation. First, we will consider the 10 primary settings found on the *i* Button Menu and then we will consider a few more settings that are critical for proper video capture.

Using the *i* Button Menu in Movie Live View

Press the *i* button while in Movie live view mode to access up to 11 convenient control functions—according to what mode the camera is using—including the following:

Before starting video recording

- Image area
- Frame size/frame rate
- Movie quality
- Microphone sensitivity
- Frequency response
- Wind noise reduction
- Set Picture Control
- Destination
- Monitor brightness
- Highlight display
- Headphone volume

During video recording

- Microphone sensitivity
- Frequency response
- Wind noise reduction
- Highlight display

Let's examine each of these 11 settings individually and prepare for recording premium-quality videos. Some of the settings are fully covered in previous chapters of this book, so we won't go into extreme detail about how to select the settings; only the screens are necessary.

Image Area

The camera has two Image area settings available for still images and video: DX (24×16) and 1.3× (18×12).

The DX choice takes data from the camera's 16:9 ratio, 6000 × 3368 pixel array and subsamples a 1920 × 1080 subset of the DX image data for the video. DX also gives you shallow depth of field for pulling focus—changing focus to a different subject while recording—which is a technique that makes HD-SLR video very interesting. DX also matches the aspect ratio and depth of field found in many other digital video cameras, so many videographers prefer using the DX mode when recording video.

The 1.3× choice uses data from the 16:9 ratio, 4800 × 2696 pixel rectangle in the center of the D7200's sensor, subsampling a 1920 × 1080 subset of the 1.3× image data for the video.

Figure 13.3A – Choosing an Image area

Use these steps to choose a video Image area (DX or 1.3×):

1. Make sure the Live view selector lever is set to Movie live view mode and that you have pressed the Lv button to enter Movie live view.
2. Press the *i* button to open the *i* button menu. Select Image area from the list (figure 13.3A, image 1). Scroll to the right.
3. Choose DX or 1.3× from the Image area menu (figure 13.3A, image 2).
4. Press the OK button to lock in the setting. Press the *i* button to return to the Live view screen.

Note: The Image area setting for Movie live view is a separate setting from the Image area setting for Viewfinder mode or Live view photography mode. In other words, Viewfinder mode and Live view photography mode share Image area settings. Movie live view mode is completely separate and has its own Image area configuration. Therefore, you can run the Image area at DX for Viewfinder still image shooting and Live view Photography still image creation, and run 1.3× mode in Movie live view mode at the same time.

Settings Recommendation: I like to use the DX setting because I enjoy pulling focus, and the shallower depth of field of the DX mode makes that easy. Of course, when I need more depth of field than DX can easily provide, I use the 1.3× mode. You should shoot video in both modes and see which look you prefer.

Frame Size/Frame Rate

There are two *Frame size* settings available in *Movie Shooting Menu > Frame size/frame rate,* and five *frame rate* settings. The frame sizes are both HD standards at 1920 × 1080 and 1280 × 720. The frame rates are 60, 50, 30, 25, and 24 fps.

The camera records video using the progressive (p) scanning method (sequential lines) and can output both progressive (p) and interlaced (i) standards through its HDMI port to external devices. Choose your favorite frame rate and size using the menu screens shown in figure 13.3B.

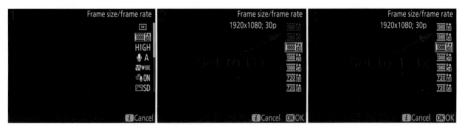

Figure 13.3B – Choosing a Frame size/frame rate

Use these steps to choose a video frame rate and frame size:

1. Make sure the Live view selector lever is set to Movie live view mode and that you have pressed the Lv button to enter Movie live view.
2. Press the *i* button to open the *i* Button Menu. Select Frame size/frame rate from the list (figure 13.3B, image 1). Scroll to the right.
3. Choose one of the seven choices from the menu (figure 13.3B, image 2). My camera has 1920 × 1080; 30p selected. (***Note:*** In figure 13.3B, image 2, you can see that 1080/60p and 1080/50p are grayed out and unavailable. Those two modes are not available when the camera is set to an Image area of DX (24×16) mode [image 2]. You will, however, note that both 1080/60p and 1080/50p are available when the camera is set to 1.3× (18×12) mode [image 3].)
4. Press the OK button to lock in the setting. Press the *i* button to return to the Live view screen.

Obviously, you must set the Frame size/frame rate before you actually start recording video. The Frame size/frame rate setting changes how large the resulting movie will be when it's stored on your memory card and computer hard drive. The maximum the camera will allow is 4 GB in any single movie segment. All frame sizes and rates are limited in recording time length to 10 minutes, 20 minutes, or 29 minutes 59 seconds, per the Movie quality bit rate in table 13.2:

Frame Size/ Frame Rate	Bit Rate High Quality	Bit Rate Normal Quality	Maximum Length High Quality/Normal
1920 × 1080; 60p	42 Mbps	24 Mbps	10 min/20 min
1920 × 1080; 50p	42 Mbps	24 Mbps	10 min/20 min
1920 × 1080; 30p	24 Mbps	12 Mbps	20 min/29 min 59 sec
1920 × 1080; 25p	24 Mbps	12 Mbps	20 min/29 min 59 sec
1920 × 1080; 24p	24 Mbps	12 Mbps	20 min/29 min 59 sec
1280 × 720; 60p	24 Mbps	12 Mbps	20 min/29 min 59 sec
1280 × 720; 50p	24 Mbps	12 Mbps	20 min/29 min 59 sec

Table 13.2 – Frame size/frame rate, Movie quality bit rates, and Maximum movie length

We will discuss how to choose the bit rate, or Movie quality, in the next subsection, **Movie Quality,** on page 535. The Movie quality affects how much data is collected by the camera, and directly affects the resulting video's file size along with the maximum length of time you can record in one video clip.

Video File Format

The file format used by the D7200 is the popular Apple QuickTime MOV format. This format is handled well by virtually all computer movie players. The video compression used inside the MOV file is H.264/MPEG-4 Advanced Video Coding.

A computer should display any of the Movie quality modes. Using a mini-HDMI (type C) to HDMI standard (type A) cable, you can play Full HD videos on an HDTV. An HDMI cable is not included with the camera. They are easily available online and in many electronics stores. We'll talk more about how to display video in a later section, which includes pictures of the cables.

Settings Recommendation: There are three considerations when selecting a Movie quality setting: First, how much storage capacity do you have on your camera's memory cards? Second, what type of display device will you show the movies on? Third, are you a video fanatic?

If you are fanatical about video, you'll shoot only at the fastest rates and highest quality. Others may want to shoot a lot of family videos and hate storing the huge files that result from high frame sizes and rates. In that case, the normal quality setting and lower resolutions may be sufficient.

If you can't stand watching a non-HD video on YouTube, maybe you should stick to maximum quality. If standard YouTube videos are sufficient for your needs, nearly any quality setting from the D7200 will look great on your computer.

This is a personal decision, and you'll need to experiment with video modes to find a balance between quality and file size.

Why Different Frame Rates?

The NTSC encoding format, established in the 1940s, originally used two frame rates: 30 fps and 60 fps. In the 1960s a new German standard was created called PAL, which used 25 fps and 50 fps. Today, frame rates of 24, 25, 30, 50, and 60 are common in DSLR cameras. These rates can also be expressed as a hertz (Hz) rate on progressive scan monitors. The primary frame rate used in the movie industry is 24p.

A video is many still pictures joined together and moved past your eye at a very fast rate. The human eye maintains an image at about 10 fps to 16 fps (1/10 to 1/16 second), so frame rates faster than that do not flicker for many people. However, some people's eyes are more sensitive and can see flicker in somewhat faster frame rates, especially using peripheral vision (not looking directly at the screen).

Many people prefer 24 fps because that is normal for cinema movies. This rate is called a cinematic rate. Other people like the faster frame rate of 30 fps due to its lack of flicker. I suggest that you try all the frame rates and see which you like best. You might even want to shoot some video at 60 fps and play it back at 30 fps for cool slow-motion effects.

Movie Quality

The Movie quality setting has to do with the Maximum bit rate (Mbps) that the camera can flow while making the movie. The higher the bit rate, the higher the quality of the movie. The bit rate can go as low as 12 Mbps in Normal quality mode and as high as 42 Mbps in High quality mode. Here is a table that shows the Mbps flow in High (HIGH) and Normal (NORM) quality modes (table 13.3):

Frame Size/ Frame Rate	Bit Rate HIGH Quality	Bit Rate NORM Quality
1920 × 1080; 60p	42 Mbps	24 Mbps
1920 × 1080; 50p	42 Mbps	24 Mbps
1920 × 1080; 30p	24 Mbps	12 Mbps
1920 × 1080; 25p	24 Mbps	12 Mbps
1920 × 1080; 24p	24 Mbps	12 Mbps
1280 × 720; 60p	24 Mbps	12 Mbps
1280 × 720; 50p	24 Mbps	12 Mbps

Table 13.3: Bit rates per Movie quality setting

Let's examine how to choose one of the two bit rates.

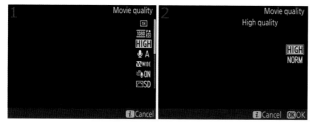

Figure 13.3C – Choosing a Movie quality (bit rate)

Use these steps to choose a Movie quality (bit rate) for your video:

1. Make sure the Live view selector lever is set to Movie live view mode and that you have pressed the Lv button to enter Movie live view.
2. Press the *i* button to open the *i* Button Menu. Select Movie quality from the list (figure 13.3C, image 1). Scroll to the right.
3. Choose HIGH or NORM from the Movie quality menu (figure 13.3C, image 2).
4. Press the OK button to lock in the setting. Press the *i* button to return to the Live view screen.

Changing the bit rate is one way to control the amount of data the video contains. The higher the bit rate, the better the movie quality—but the larger the movie file size (up to 4GB). You will need to decide which is more important, quality or size.

Note: You can also set the Movie quality by using the *Movie Shooting Menu > Movie quality* menu.

Settings Recommendation: Unless I am just shooting a video for the Internet only (Facebook or YouTube) and of a subject with no commercial value, I shoot with the camera set to Maximum frame rate, frame size, bit rate, and whatever other maximums I can find and max out. If a video has potential to make me some money or is of an interesting subject that others will enjoy watching, I want the best quality I can wring out of those little 2MP frames. However, that comes with a trade-off of much larger file sizes, so I have committed to buying larger and larger hard drives each year or two.

Microphone Sensitivity

The Microphone sensitivity setting is designed to give you the ability to set how sensitive the Microphone is to surrounding sound. This setting affects the Built-in microphone until you plug in an external Microphone in the camera's Microphone (MIC) jack under the rubber Connector cover (figure 13.3D).

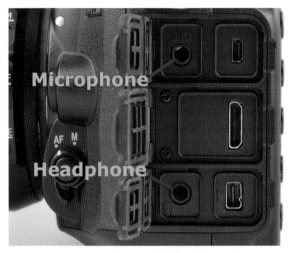

Figure 13.3D – Headphone and Microphone plugs

Let's look at the best way to set the Microphone level just before recording a video.

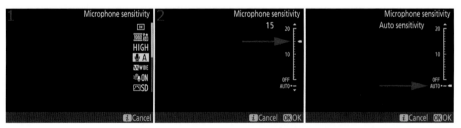

Figure 13.3E – Manually setting the Microphone sensitivity with camera controls

Use these steps to choose a Microphone sensitivity:

1. Make sure the Live view selector lever is set to Movie live view mode and that you have pressed the Lv button to enter Movie live view.
2. Press the *i* button to open the *i* Button Menu. Select Microphone sensitivity from the list (figure 13.3E, image 1). Scroll to the right.
3. Choose from as low as Off to as high as level 20 from the Microphone sensitivity slider on the right side of the screen (figure 13.3E, image 2). I have selected Microphone sensitivity level 15.
4. If you would rather have the camera decide which Microphone sensitivity to use, the D7200 offers an Auto sensitivity setting at the bottom of the sensitivity slider (figure 13.3E, image 3).
5. Make a selection and press the OK button to lock in your chosen mic sensitivity level. Press the *i* button to return to the Live view screen.

The Microphone can be adjusted during a video with the *i* button menu. Keep the indicator in the mid to upper white zone for normal sound (figure 13.3F, red arrow).

As the sound increases, the indicator hits the yellow zone and finally the red zone, where clipping may occur.

The D7200 offers the ability to plug in an optional stereo microphone (figure 13.3G). It disables the built-in stereo mic and overcomes some of its limitations. There are several microphones available for the D7200, including a few that mount onto the camera's Accessory shoe like a flash unit does. I like Nikon's ME-1 microphone, shown in figure 13.3G.

Figure 13.3F – Monitoring the sound level

Figure 13.3G – Nikon D7200, AF-S Nikkor 24–85mm f/3.5–4.5G ED VR lens, with Nikon ME-1 microphone in Accessory shoe

In figure 13.3D you can see where an external Microphone plugs into the camera. The top plug is for a headphone and the bottom plug is for a microphone.

Figure 13.3H – Nikon D7200 Built-in stereo microphone (red arrows are left (L) and right (R) channels)

If you decide to simply use the Built-in microphone, just be sure you don't accidentally cover it with your finger while recording a video. The Built-in stereo microphone is a series of holes on top of the prism housing in front of the flash accessory shoe (figure 13.3H, red arrows).

Note: You can also set the Microphone sensitivity from the *Movie Shooting Menu > Microphone sensitivity* setting.

Settings Recommendation: First of all, I strongly suggest that you acquire the Nikon ME-1 external microphone. I have really enjoyed using it. It vastly improves the quality of sound flowing into the camera during a video and isolates the camera's clicking and whirring noises more effectively. The ME-1 is relatively inexpensive—well, compared to a lens, anyway.

I leave the sound level set to Auto (A) most of the time. However, if I am in an especially loud environment, I will set the sound manually to about 15. When there are sudden loud sounds in Auto mode, the camera seems to struggle and often clips the sound as it overwhelms the camera's sound circuitry.

I suggest experimenting with this because normally it's not a problem. Where the problem occurs is somewhere like a ball game. You will be recording the game and someone scores, to the crowd's great yelling and stomping happiness. Auto may not be the best setting under those circumstances.

Frequency Response

Sound is a very important part of video recording. Maybe you want to record a video while visiting a national park and would like to pick up the sound of every birdsong, leaf rustle, and gurgling stream. Using the wide frequency option will allow this type of sound recording. On the other hand, using the voice frequency option while recording a video of a wedding ceremony is a good choice because it won't pick up the sounds of a bird singing outside the window and rumbling road traffic outside.

With a combination of the Microphone sensitivity and Frequency response functions, you can capture some very high-quality sound. Microphone sensitivity affects how sensitive the microphone is to sound, and Frequency response affects which sound frequencies the mic is most sensitive to. We've already considered Microphone sensitivity, so now let's see how to make the mic sensitive to a wide frequency range (national park) or a human voice frequency range (wedding ceremony).

Figure 13.3I – Choosing a Frequency response for the mic

Use these steps to choose a Frequency response range for the microphone in use:

1. Make sure the Live view selector lever is set to Movie live view mode (figure 13.1) and that you have pressed the Lv button to enter Movie live view.
2. Press the *i* button to open the *i* Button Menu. Select Frequency response from the list (figure 13.3I, image 1). Scroll to the right.
3. Choose WIDE (Wide range) or VOICE (Vocal range) from the Frequency response menu (figure 13.3I, image 2).
4. Press the OK button to lock in the setting. Press the *i* button to return to the Live view screen.

Settings Recommendation: If you are recording a human speaker, use VOICE, and for about anything else use WIDE. I leave my camera set to WIDE most of the time because I am a nature photographer and enjoy hearing natural sounds.

Wind Noise Reduction

Have you ever recorded a video on a beautiful, breezy summer afternoon, only to later find that you have recorded that distinctive rumbling sound of wind blowing across a microphone instead of the clear sound you desired?

While that sound may not be completely eliminated without using special microphones designed to deal with it—such as the Nikon ME-1—it can be significantly reduced with the Wind noise reduction function, which removes or cuts low frequency noises like wind rumbles.

Let's see how to enable and disable the Wind noise reduction low-cut filter.

Figure 13.3J – Enabling or disabling Wind noise reduction

Use these steps to enable or disable Wind noise reduction:

1. Make sure the Live view selector lever is set to Movie live view mode (figure 13.1) and that you have pressed the Lv button to enter Movie live view.
2. Press the *i* button to open the *i* Button Menu. Select Wind noise reduction from the list (figure 13.3J, image 1). Scroll to the right.
3. Choose ON or OFF from the Wind noise reduction menu (figure 13.3J, image 2).
4. Press the OK button to lock in the setting. Press the *i* button to return to the Live view screen.

Settings Recommendation: I use this wind noise filter selectively. Most of the time I am using an external Nikon ME-1 hotshoe microphone, which has a foam screen around the mic to reduce or eliminate any wind noise and does *not* allow the camera to use Wind noise reduction (the menu selection grays out). I do use Wind noise reduction when I am using the built-in stereo mic to record family events outside.

Set Picture Control

This function provides a means to change Picture Control before you start recording a video. It has the same functionality as the *Movie Shooting Menu > Set Picture Control* function. Let's determine how to use this function to change Picture Controls for your different types of video sessions.

Figure 13.3K – Choosing a Picture Control for video recording

Use the following steps to set a Picture Control for your video:

1. Make sure the Live view selector lever is set to Movie live view mode (figure 13.1) and that you have pressed the Lv button to enter Movie live view.
2. Press the *i* button to open the *i* Button Menu. Select Set Picture Control from the list (figure 13.3K, image 1). Scroll to the right.
3. Choose one of the seven Picture Controls, which include Standard (SD), Neutral (NL), Vivid (VI), Monochrome (MC), Portrait (PT), Landscape (LS), and Flat (FL), as seen in figure 13.3K, image 2. If you have previously created any Custom Picture Controls (e.g., C-1, C-2), they will appear on the next page of the menu. Review the information in the section titled **Set Picture Control** on page 540 for more detailed information about the individual controls. Also, if you want to know more about creating your own Custom Picture Controls, see the section titled **Manage Picture Control** on page 164. You can press the OK button to lock in the chosen Picture Control, or you can fine-tune the control with step 4 by scrolling to the right.
4. Use the fine-tuning screen (figure 13.3K, image 3) to adjust the Sharpening, Clarity, Contrast, Brightness, Saturation, and Hue for each control. Or you can use the Quick Adjust setting to do an overall adjustment. Not all individual adjustments are available for all Picture Controls.
5. Press the OK button to lock in the setting change and the Picture Control, or press the Delete button (garbage can) to reset the control back to factory specs. Press the *i* button to return to the Live view screen.

Settings Recommendation: When I am shooting fun family videos, I leave the camera set to the Standard (SD) picture control because it is unlikely I will do anything to the video except watch it.

However, when I am shooting video for commercial reasons, I use the Flat (FL) picture control. This setting has a much lower color saturation and contrast, and provides a significantly higher dynamic range. This allows commercial grading (video post-processing) of the movie.

Destination

The D7200 allows you to choose which of your camera's two card slots will receive the video. It also gives you an estimate of available video recording time for each card, based on the current Frame size/frame rate and Movie quality settings.

Figure 13.3L – Choosing a Destination for your video (Slot 1 or Slot 2)

Use these steps to choose which memory card the camera will use to save your new video:

1. Make sure the Live view selector lever is set to Movie live view mode (figure 13.1) and that you have pressed the Lv button to enter Movie live view.
2. Press the *i* button to open the *i* Button Menu. Select Destination from the list (figure 13.3L, image 1). Scroll to the right.
3. Choose Slot 1 or Slot 2 from the Destination menu (figure 13.3L, image 2). You can see the amount of recording time your camera has with the current video settings. My Slot 1 card has space for 2 hours, 32 minutes, and 10 seconds (02h 32m 10s) as shown just below the selected card slot name (Slot 1).
4. Press the OK button to lock in the setting. Press the *i* button to return to the Live view screen.

Settings Recommendation: This boils down to personal preference. All I can advise is to have either big (32 GB or 64 GB, minimum) cards or a bunch of smaller ones because the Nikon D7200 can quickly fill up a memory card with its video files. I generally relegate video to Slot 2, and still images to Slot 1.

Monitor Brightness

The Monitor brightness function is for your convenience when shooting in very light or dark environments. You can quickly turn the brightness up or down with camera controls. The brightness setting in no way affects the video recording itself. It is just for your Monitor viewing comfort while recording video.

Figure 13.3M – Setting the Monitor brightness to a comfortable level for viewing

Use these steps to choose a Monitor brightness level for video recording:

1. Make sure the Live view selector lever is set to Movie live view mode (figure 13.1) and that you have pressed the Lv button to enter Movie live view.
2. Press the *i* button to open the *i* Button Menu. Select Monitor brightness from the list (figure 13.3M, image 1). Scroll to the right.
3. Use the Multi selector to scroll up or down and set the brightness to a comfortable level (figure 13.3M, image 2). You can scroll up or down over a range of 10 steps (−5 to +5). The yellow indicator in image 2 is set to 0 (factory default), a medium setting.
4. Press the OK button to lock in the setting. Press the *i* button to return to the Live view screen.

Note: You can also adjust the Monitor brightness with *Setup Menu > Monitor brightness*.

Settings Recommendation: I generally leave my camera set to the middle setting (0) unless I am out in bright sunshine, when I may crank it all the way up to the + sign on top of the indicator (maximum). At night, when I am out shooting star trails, I will crank it all the way down to −5, to save my night vision. The 0 setting is about right for normal use.

Highlight Display

The Highlight display or Zebra stripe mode is a welcome addition to the Nikon D7200's features. This display allows you to determine when an area of your video has lost all highlight detail (it is blown out to pure white).

Figure 13.3N – High display (zebra stripe mode) reveals blown out to white areas

In figure 13.3N, you can see the zebra stripes in the white background of my deliberately overexposed image. See how the small zebra stripes show exactly the area that has no highlight detail left? If there is any detail left, even a small amount, the zebra stripes will not show in that area, as can be seen by the very faint shadow areas to the left of the subjects and a triangular shaped region on the top right of the frame.

This can be a useful function to guard against overexposure when shooting video in high-contrast lighting conditions. Let's see how to select it.

Figure 13.3O – Using the Highlight display (Zebra stripe mode)

Use these steps to enable or disable the Highlight display (zebra stripes) for video recording:

1. Make sure the Live view selector lever is set to Movie live view mode (figure 13.1) and that you have pressed the Lv button to enter Movie live view.
2. Press the *i* button to open the *i* Button Menu. Select Highlight display from the list (figure 13.3O, image 1). Scroll to the right.
3. Select ON or OFF from the list (figure 13.3O, image 2) and press the OK button to lock in the setting.
4. Image 3 shows the same image as image 1, except the Highlight display's alternating black-and-white zebra stripes are enabled and show the blown-out (pure white) areas with no detail. Figure 13.3N shows an enlarged version for easy reference.

Settings Recommendation: I generally leave Highlight display enabled because I want to know when the highlights are blown out in certain areas of my videos. I can then reduce the exposure quietly and save the video from looking bad.

Headphone Volume

The Headphone port under the bottom rubber Connector cover is an excellent addition to the Nikon D7200 (figure 13.3P). It allows you to plug in a headphone set to isolate yourself from surrounding sounds and focus on hearing what the camera is actually recording. This is important for those who are concerned about maximum sound quality. Let's examine how to change the Headphone volume.

Figure 13.3P – Headphone port (bottom) under rubber Connector cover

Figure 13.3Q – Choosing a Headphone volume output level

Use these steps to select a Headphone volume to use while recording your video:

1. Make sure the Live view selector lever is set to Movie live view mode (figure 13.1) and that you have pressed the Lv button to enter Movie live view.
2. Press the *i* button to open the *i* Button Menu. Select Headphone volume from the list (figure 13.3Q, image 1). Scroll to the right.
3. Choose a level from Off to 30 for the Headphone volume (figure 13.3Q, image 2). Be careful not to have it turned up high when you use the headset or earbuds or you could damage your hearing. The camera is set to level 15 on the volume range in screen 2, which is a medium setting.
4. Press the OK button to lock in the setting. Press the *i* button to return to the Live view screen.

Settings Recommendation: The headphone you use doesn't have to be an expensive outfit to be effective. I often simply use a set of normal isolation earbuds, like the ones you would plug into your smartphone or iPod. Earbud headsets can be stored in a small pocket in your camera bag, so they will always be with you. I like the type that have good bass response and can be inserted in your ears, instead of the type that kind of hang off of your ears (like the ones that come with an iPhone).

I have found that output level 15 is about right for my ears while recording and for playback. However, I hear less well than I did when I was young due to listening to my Walkman (remember those) at high volume as a kid. Be careful not to go too loud because sudden sound increases might damage your hearing. You may be more comfortable with the volume around 10 or 12.

The really cool thing is how people react when you have a set of earbuds connected to your camera. Invariably someone with a cheap point-and-shoot camera will ask me why, and I tell them, of course, that my camera has a built-in iPod so I can listen to music as I take pictures. They are amazed and don't even realize I am videoing their face as we talk!

Camera Speaker Location for Video Playback

In addition to headphone audio output, the camera has a built-in speaker on the back. This tiny speaker, while not useful during video recording to monitor the sound, can be used to review the audio during video playback.

You'll see five small holes just to the right of the info button (figure 13.3R). This little speaker can put out an amazing amount of volume.

You can control the volume output of the speaker during video playback by pressing the Thumbnail/playback zoom out (ISO) button (volume down) and Playback zoom in (QUAL) button (volume up). The setting range is 1 through 30, and Off. I find that level 20 is about right to hear well in a normal environment.

If you prefer, you can use headphones to listen to the playback sound from the video.

Figure 13.3R – Nikon D7200 Speaker

Additional Settings to Consider Before Shooting a Video

In addition to the 11 controls found in the *i* Button Menu, there are a few more settings that you should consider before shooting a video:

Choosing a White Balance

White balance sets the color tint of the video. It is very important to use a White balance (WB) that matches the light source where you will be shooting the video. Auto WB works most of the time but can sometimes have problems with mixed lighting.

You should be aware of the White balance and even experiment with it for your videos. Maybe you should switch to Shade White balance when in the shade or Direct sunlight when in the sunlight. If you pay careful attention to your camera's White balance, your videos will have superior quality.

Figure 13.3S – Choosing and fine-tuning a White balance

Use the following steps to set the White balance before or during a video recording:

1. Use figure 13.3S as a guide. While in Movie live view mode, press and hold the WB button (figure 13.3S, image 1).
2. Notice that the Movie live view screen shows a White balance (WB) setting with a yellow background (figure 13.3S, image 2). Auto1 (A1) is currently selected.
3. Choose a White balance by rotating the rear Main command dial (figure 13.3S, image 3).
4. In figure 13.3S, image 4, you will see that the WB value is no longer set to A1. Instead, the Direct sunlight symbol is selected. Choose the WB you want to use and release the WB button. If you want to fine-tune the WB before using it, follow steps 5–7. Otherwise skip them and make your video without fine-tuning.
5. You can fine-tune the WB value by rotating the front Sub-command dial (figure 13.3S, image 5).
6. Fine-tuning allows you to add amber (warm) or blue (cool) fine-tuning to the standard for that WB setting. You can fine-tune the colors in a range of from 0.5 to 6.0 steps of am- ber (A) or blue (B). Notice in figure 13.3S, image 6, that B0.5 is selected (left red arrow), which means a ½ step of blue is added to the normal Direct sunlight value, cooling it down a little. Also, notice that an asterisk has appeared after the WB symbol (right red arrow). This shows that you have fine-tuned the WB value. The asterisk will stay until you reset the WB value back to 0.0 (where B0.5 is currently set). Figure 13.3S, image 2, shows the fine-tuning value still set to 0.0, while image 6 shows it set to B0.5.
7. Release the WB button to select the White balance.

Watch the Monitor carefully as you select different White balance settings. You will see any color tint changes as you adjust the White balance. You can change the White balance dur- ing the actual video recording, as well as fine-tune the color tint. This shows how serious it is to use a correct White balance. Fortunately, the Nikon D7200 makes it easy.

Note: You can also use the *Movie Shooting Menu > White balance* setting to manage the WB value for your movie. Refer to the **White Balance** chapter (page 159) for more information.

Settings Recommendation: I often use Auto WB (A1) unless I am in tricky lighting situ- ations, such as inside under fluorescent lighting with some outside lighting coming in through the windows. In situations like that, I try to match the camera to the most preva- lent light source.

The camera does well outside in natural light, although I have at times seen a little blue- ness in the shade. If the look seems a little blue in the shade, I might use Shade WB. The critical thing is whether the color tint in the video you are seeing on the Monitor looks like the scene you see with your own eyes. If not, try to make the camera match what you see.

Selecting an Autofocus Mode

Autofocus modes let you choose *how* the camera will focus on your subject. The Autofocus modes available in Movie live view are AF-S and AF-F. AF-S is single-point AF and you control it with the Multi selector. AF-F is camera-controlled Autofocus. There are no other Autofocus modes available for Movie live view.

You can move the focus square to any point on the Monitor to focus on the best area of your subject in either Autofocus mode. If you are using AF-S, you can initiate focus by pressing the Shutter-release button down halfway. In AF-F mode, the camera decides on the best focus.

You can even change Autofocus modes while recording a video. Here's how to select the AF mode with external camera controls.

Figure 13.3T – Choosing an Autofocus mode

Use the following steps to set an Autofocus mode before or during a video recording:

1. While in Movie live view mode, press and hold the AF-mode button (figure 13.3T, image 1).
2. Choose an Autofocus mode by rotating the rear Main command dial (figure 13.3T, image 2).
3. In figure 13.3T, image 3, you will see that the AF-S mode is selected. As you rotate the rear Main command dial this value will change between AF-S and AF-F.
4. Release the AF-mode button to select the White balance.

Settings Recommendation: Many people use Full-time-servo AF (AF-F mode) for fun video shooting. However, for commercial purposes, AF-F mode may be lacking. The camera can struggle to remain in focus in low light, or focus on the wrong object, which is distracting to viewers. That's why many serious videographers use manual focus lenses, so they can control the focus with great smoothness—after much practice, of course.

I like videoing with my manual and autofocus prime lenses, such as my AI Nikkor 35mm f/2 or AF-S Nikkor 50mm f/1.4G in MF mode. I'm sure you already have, or will soon have, several favorite lenses that work well for video. Just be sure to try them in Manual mode for best focus results.

See the chapter titled **Autofocus, AF-Area, and Release Modes** on page 473 for more detailed information on the Autofocus modes.

Choosing an AF-Area Mode

The AF-area mode lets you choose *where* the camera will autofocus on your subject. The setting modifies the basic way autofocus decides what part of the subject is important. Let's examine each screen and AF-point style and then see how to select one of the four AF-area modes.

The following list explains the four available AF-area modes (figure 13.3U):

- **Face-priority AF** (figure 13.3U, image 3): The camera has the ability to track focus on the faces of several people at the same time. It is quite fun to watch as the little green and yellow AF point squares find faces and stay with them as they move. Nikon claims it can detect up to 35 faces at the same time.
- **Wide-area AF** (figure 13.3U, image 4): For the landscape shooters among us who like to use Live view mode or shoot movies of beautiful scenic areas, this is the mode to use. The camera will display a big red (out of focus) or green (in focus) AF point square on the Monitor. You can move this big AF point square around until it rests exactly where you want the best focus to be. The camera will sense a wide area and determine the best focus, with priority on the area under the green square.
- **Normal-area AF** (figure 13.3U, image 5): This is a mode primarily for shooters who need to get very accurate focus on a small area of the frame. This is a great mode to use with a macro lens because it gives you a much smaller AF point square that you can move around the frame with the Multi selector.
- **Subject-tracking AF** (figure 13.3U, image 6): In this mode you have to autofocus first with the Shutter-release button (AF-F mode does this automatically). Then you start subject tracking by pressing the OK button once. To stop subject tracking, press it again.

Figure 13.3U – The four AF-area modes

Use the following steps to set an AF-area mode before or during a video recording:

1. While in Movie live view mode, press and hold the AF-mode button (figure 13.3U, image 1).
2. Choose an AF-area mode by rotating the front Sub-command dial (figure 13.3U, image 2).
3. In figure 13.3U, images 3 to 6, you will see the four AF-area modes. Use the list in the previous section (Choosing an AF-Area Mode) to choose the best mode for your video making.
4. Release the AF-mode button to select the AF-area mode.

Settings Recommendation: Why not leave the AF-area mode set to Face-priority AF if you video people a lot? If you are using Movie live view for macro shooting, Normal-area AF gives you the smallest, most accurate area mode for detailed, up-close focusing. Landscape shooters should use Wide-area AF, and wildlife or sports shooters should use Subject-tracking AF.

See the chapter titled **Autofocus, AF-Area, and Release Modes** on page 482 for more detailed information on the AF-area modes.

Selecting an Exposure Mode

The Exposure modes on the Mode dial—Programmed auto (P), Shutter-priority auto (S), Aperture-priority auto (A), and Manual (M)—give you various levels of control over the D7200. It is best to use Manual (M) mode when possible if you want better control over the camera. All modes have control limitations, but M mode has less than the others.

You can also use the EFFECTS and SCENE modes if you want to impart a certain look to your video. And, if you want to shoot video with no extra thinking, you can select AUTO mode. Review the material found in the chapter titled **Metering, Exposure Modes, and Histogram** (page 430) for more detailed information on using all of the Exposure modes.

The following list provides information about using the aperture, shutter speed, and ISO sensitivity settings during a movie:

- **Aperture:** When using Aperture-priority mode (A) or Manual mode (M), you must adjust the aperture to a setting you want to use *before* you switch the camera into Movie live view mode by pressing the Lv button. Once the camera has entered Movie live view mode, the aperture will not respond to adjustment. When you control the aperture in M or A mode, by choosing an f/stop (e.g., f/4, f/8), you can control depth of field for cinematic blurred backgrounds in videos containing people and deep focus in landscapes.
- **Shutter speed:** Manual mode (M) is the only mode where you have complete control of the shutter speed during the video recording session. This allows you to control the level of motion blur by simply rotating the rear Main command dial, thereby changing the shutter speed to any value between 1/30 and 1/8000 second. You cannot reduce the shutter speed to below 1/30 second when in Movie live view mode. Shutter-priority

mode (S) does *not* allow you to change the shutter speed when in Movie live view mode. When you adjust the shutter speed during the video (in M mode only) you can use a slower shutter speed to capture a beautiful blur effect for a waterfall and quickly switch to a faster shutter speed to help prevent blur in a deer leaping over a fence. Normally the shutter speed is best left at double the frames per second rate, e.g., you would use 1/60 second for 1080/30p or 1/50 second for 1080/24p.

- *ISO sensitivity:* You have full control over the ISO sensitivity of the camera only when using Manual mode (M). You control the ISO sensitivity by holding in the ISO button while rotating the rear Main command dial. You can adjust ISO sensitivity to anything between ISO 100 and 25600. The D7200 allows you to use ISO AUTO in Manual (M) mode! This prevents the video from going too dark or light when ambient light changes, even though you are shooting everything else manually. ISO AUTO is selectable by holding in the ISO button and rotating the front command dial. (Have you ever walked from outside to inside while shooting a video and saw what happened? ISO AUTO allows the camera to quickly adjust to light level changes while you keep controlling everything else. Quite powerful!)

Note: If you prefer, you can relinquish all control to the camera during video capture by using AUTO mode. The Nikon D7200 lets you decide. Just select AUTO from the Mode dial on top.

While using any mode except Manual (M), the camera acts like a consumer video camera and leaves you little control over any of the exposure controls, with the exception of using the +/− Exposure compensation button to add or subtract exposure.

As mentioned previously, remember that the D7200 allows you to use Auto ISO control (mode M) in Manual (M) mode, in which the camera adjusts the ISO sensitivity to maintain a correct exposure. You can also select Auto ISO control (mode M) in the Movie *Shooting Menu > Movie ISO sensitivity settings* function while in Movie live view mode (but before beginning video capture).

Let's examine how to select an Exposure mode.

Figure 13.3V – Selecting an Exposure mode (P, S, A, or M)

Here are the steps to select an Exposure mode:

1. While in Movie live view, select the mode from the Mode dial (figure 13.3V, image 1).
2. You can use any of the modes on the Mode dial when shooting a video (figure 13.3V, image 2). As you rotate the rear Mode dial, the selected mode will appear in the position indicated by the red arrow in figure 13.3V, image 2 Manual (M) mode is selected in this image). Some screen overlay modes will not display the selected mode. If you can't see the mode on your camera's Movie live view screen, press the info button until one of the overlay screens shows the mode.

Note: If you use semiautomated Exposure modes (P, S, and A), or the fully automated modes (EFFECTS and SCENE), the camera alone will manage the ISO sensitivity to maintain a good exposure. The Nikon D7200 uses the ISO sensitivity as a failsafe to make sure the video is usable. It will raise the ISO up to noisy levels pretty quickly when light starts falling, so be aware of that and use artificial light (e.g., LED) to prevent having noisy videos.

If you are shooting in Manual mode and do not use ISO AUTO, the camera cannot adjust the ISO to compensate. Your video will get darker or brighter until you change the ISO. I suggest using ISO AUTO, even when shooting in Manual (M) mode, to keep consistent lighting in your videos. Video is a little harder to shoot compared to still images because it is live and everything you do to affect exposure is immediately apparent to all viewers. Practice, practice, practice!

Settings Recommendation: The Nikon D7200 is an excellent video camera. It can do things that even expensive pro video cameras cannot do because the large sensor makes such shallow depth of field and the lens selection is so great. However, that puts a burden on you when you use the camera manually. You now have the control you need for expert usage, so go practice and make the camera's controls second nature so that you can react well to changes.

I recommend shooting most videos in AUTO mode until you are fully comfortable with operating the camera manually and understand what will happen. As a videographer, you now have the control you need to make masterpiece video or really bad video. Get some books on the subject and learn your new skills well. We are no longer just still photographers!

A couple of books I highly recommend are *How to Shoot Videos That Don't Suck: Advice to Make Any Amateur Look Like a Pro* by Steve Stockman (Workman Publishing Company, 2011) and *Mastering HD Video with Your DSLR* by Helmut Kraus and Uwe Steinmueller (Rocky Nook, 2010). These books set me on the path to much better videos by not only discussing the formats and cameras involved but also offering great advice on video technique.

Recording a Video with Your D7200

(User's Manual: Page 66)

Now let's look at the process of recording a video to the camera's memory card. There are several easy steps, as shown in the upcoming description. This is assuming you've gone through the configuration process discussed in the first part of this chapter that readies your camera to record video in the modes you prefer to use. Let's record a video!

Figure 13.4 – Recording a video

Here are the steps to start recording a movie:

1. Flip the Live view selector on the back of the camera to the Movie live view position (figure 13.4, image 1).
2. Press the Live view (Lv) button to enter Movie live view (figure 13.4, image 2).
3. Press the Movie-record button to start recording (figure 13.4, image 3).
4. The video will now start recording with the REC icon in the upper-left corner, the time-left counter counting down in the upper-right corner, the Microphone sensitivity indicator moving as the camera records sound, and your new video recording being written to the camera's selected memory card (figure 13.4, image 4).
5. To end the movie recording, simply press the Movie-record button once again.

Amazingly, that's all there is to it. You have a powerful, professional video camera built into your still camera. It is available with the flip of a switch and the press of a button.

Settings Recommendation: In most cases, unless you really want to try to control the camera manually, just shoot your video in AUTO mode and enjoy what you have captured. The camera will make a great video in most circumstances. When you are ready to move into high-end video production, the Nikon D7200 is ready to help you move up.

Recording Video from the HDMI Port

The Nikon D7200 has an ability that only a few DSLRs in the 35mm camera genre have: streaming uncompressed, broadcast-quality video out of its HDMI port to an external re-cording device. Doing so is a fairly complex process, requiring knowledge of wrappers, containers, formats, and interfacing with expensive recording equipment. The process of creating commercial video is beyond the scope of this book.

For those of you who are interested in learning about the much more complex process of streaming uncompressed HDMI video, I have prepared a document that should get you started. It is called **Streaming Uncompressed HDMI Video from Your Nikon D7200** and is available at the following websites:

http://www.nikonians.org/NikonD7200
http://rockynook.com/NikonD7200

Please download this document and consider it. I give you the basics on working with the HDMI port along with format information to make your learning process easier. I also list several websites and forums where you can gain very deep knowledge on using your D7200 for high-end video creation.

Displaying Movies

(User's Manual: Page 177)

Now the fun begins! You have created a video on one of your memory cards. What next? You can always simply transfer the video to your computer and view it there or upload it to Facebook or YouTube directly, both of which know how to convert the QuickTime MOV file to display on their respective sites.

Let's also discuss how to enjoy one of your movies directly from the camera, either on the camera's LCD Monitor or on an HDTV.

Displaying a Movie on the Camera LCD Monitor

Viewing a movie on the D7200 Monitor is simplicity itself, just like video capture. Videos are stored on the camera's memory card just like still pictures. All you have to do is select the video you want and press the OK button to play it.

Figure 13.5A – Playing a movie on the Monitor

Use the following steps to play a movie on the Monitor:

1. Press the Playback button to display images on the Monitor (figure 13.5A, image 1).
2. Locate the video you want to play by scrolling through your images and videos with the Multi selector. When the video appears on the camera Monitor, you'll be able to identify it by three signs: a small movie camera icon in the top-left corner, a minutes and seconds (total time) counter at the top center of the screen, and the words OK Play at the bottom of the screen. The image you see is the first frame of the video (figure 13.5A, image 2).
3. Press the Multi selector center button to start playing the video (figure 13.5A, image 3).

Settings Recommendation: The Monitor on the D7200 is big enough for several people to enjoy one of your videos. Don't be afraid to show off a bit because your camera creates excellent high-resolution videos. Set it up on the kitchen table, put a jar next to it for tips, and start a video. You'll find viewers!

Displaying a Movie on an HDTV
To display a video from your camera on an HDTV, you'll need an HDMI cable with a mini-HDMI (type C) end to insert into your D7200; the other end will have to match your HDTV's HDMI port, which is usually HDMI standard (type A). We'll talk more about the cable specs in a moment, but first let's discuss your camera's HDMI output frequencies.

Before you attempt to connect your Nikon D7200 to your HDTV, be sure that you've correctly configured your HDMI output to match what your HDTV needs or you won't get a picture. Use the *Setup Menu > HDMI* setting to select a specific Output resolution, or just select Auto so the camera and HDTV can figure it out for you. Here is a list of formats supported by your camera for video playback:

- ***Auto:*** Allows the camera to select the most appropriate format for displaying on the currently connected device
- ***1080p:*** 1920 × 1080 progressive format
- ***1080i:*** 1920 × 1080 interlaced format
- ***720p:*** 1280 × 720 progressive format
- ***576p:*** 720 × 576 progressive format
- ***480p:*** 640 × 480 progressive format

Figure 13.5B – Selecting an HDMI Output resolution

Here are the steps to select an Output resolution:

1. Select HDMI from the Setup Menu and scroll to the right (figure 13.5B, image 1).
2. Choose Output resolution from the menu and scroll to the right (figure 13.5B, image 2).
3. Select one of the six output resolutions (figure 13.5B, image 3). I suggest using Auto initially because it works well in most cases.
4. Press the OK button to lock in your selection.

Settings Recommendation: If you have any difficulty getting your camera to interface with your HDTV, please refer to the section **HDMI** in the chapter titled **Setup Menu** (page 341). In my experience with the camera, most of the time it just works when you plug it into the HDTV and video flows immediately. However, sometimes there are some configuration issues that involve using the Advanced setting on the HDMI menu. I won't go back over those here because most of the time the camera interfaces well, and you can always refer back to the chapter on the Setup Menu if you have any problems.

Make sure you have the correct HDMI port selected if your HDTV has more than one HDMI port. Often there is a control on the HDTV's remote that lets you select a particular HDMI port. Until that port is active, you will see nothing from the camera.

Adjusting Video Output Size, Range, and Information Overlays
If the video appears too big to fit on the HDTV screen, you can reduce the size of the D7200's video output by five percent (from 100% to 95%) with *Setup Menu > HDMI > Advanced > Output display size.*

If the colors appear washed out in your video, you may have to try a different Output range (Full or Limited) with *Setup Menu > HDMI > Advanced > Output range.*

Finally, if you don't want the camera to display its control overlays on the recording, you can turn off the overlays for the HDTV display with *Setup Menu > HDMI > Advanced > Live view on-screen display* (set to Off).

HDMI Cable Types
Now your camera is ready to output video on a compatible HDTV. Figure 13.5C shows what compatible HDMI cable ends look like. You'll have to purchase an HDMI cable because you don't receive one with your D7200.

You'll need to use a mini-HDMI (type C) to HDMI standard (type A) cable. And, of course, you'll need to plug your HDMI cable into the correct port on the D7200.

In figure 13.5D, you can see the port you'll need to use with your mini-HDMI (type C) connector. Before it is plugged in, here's how to display a video on your HDTV:

Figure 13.5C – HDMI connectors, types A and C

1. Turn your camera off. Why take a chance on blowing up your camera from a static spark?
2. Open the rubber flap on the left side of your D7200 and insert the mini-HDMI (type C) cable end into the HDMI port (figure 13.5D, red arrow).

3. Insert the HDMI standard (type A) cable into one of your HDTV's HDMI ports. (Both video and sound are carried on this one cable.)

4. Your HDTV may have multiple HDMI ports, and you may have other devices connected, like a cable box or satellite receiver. When you plug the D7200's HDMI cable into your HDTV, be sure to select that HDMI input port on your HDTV or you won't see the D7200's video output. You may have to select the input from your HDTV remote or use another method. If in doubt, check your HDTV manual. (If your HDTV only has one HDMI port, please ignore this step.)

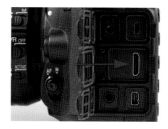

Figure 13.5D – HDMI connector, type C (mini-HDMI)

5. Turn on the camera and press the Playback button; then locate the video you want to show off.

6. Press the OK button to play the video on your HDTV. The Nikon D7200 can display movies on both progressive and interlaced devices.

Settings Recommendation: Unless you are heavily into HDMI and understand the various formats, just leave the camera set to Auto. That allows the D7200 to determine the proper format as soon as it's plugged into the display device and the HDMI input port is selected.

Author's Conclusions

The video capability in the Nikon D7200 is simply amazing. You will create some of the best videos of your life with this camera. When you are out shooting still images, why not grab some videos, too? Years from now, actually hearing and seeing friends and family who are no longer with us will mean a lot.

Pictures are important, but so is video. Your camera does both, and either is available at a moment's notice. Carry your camera with you and record your life. Hard drives are cheap compared to the memories you will lose if you don't record them. Make good backups and give away family videos to your family. Share the good qualities of your powerful camera with others, and the goodwill will come back to you later.

Be sure to download the extra material titled **Speedlight Flash** from the downloadable resources websites. The additional material covers how to use the built-in Speedlight on your D7200, or an external Nikon Speedlight, to directly control multiple banks of remote Speedlights with Nikon's Creative Lighting System (CLS).

Thank You!

I'd like to express my personal appreciation to you for buying this book and for sticking with me all the way to the end of it. I sincerely hope that it has been useful to you and that you'll recommend my books to your Nikon-using friends.

Keep on capturing time...

Credits for Chapter Opening Images

Chapter 1: Everyone Loves a Baby © 2015 **Brenda Young** (*DigitalBrenda*)
Shooting info: AF-S Nikkor 16–85mm f/3.5–4.5 ED VR lens at 58mm, 1/100s at f/8, ISO 1600
Photographer comment: Two of my children dropped by to visit, and one brought my new grandson, Maverick. Mama Emily and Aunt Hannah each gave little Maverick a kiss on his cute little cheeks. I used fill flash in Auto exposure mode and the camera performed flawlessly, balancing the foreground and background light.

Chapter 2: This is my best side © 2015 **Ray Heslewood** (*Hessy*)
Shooting info: Nikon 500mm f4 VR lens and TC14E III (700mm), 1/800 at f6.3, ISO250
Photographer comment: I took this picture of a Crimson Chat in a fairly arid location just north of Carnarvon in Western Australia while I was on holiday in 2015.

Chapter 3: Wallaroo and Joey © 2015 **Deborah Albert** (*debalbe*)
Shooting info: AF-S Nikkor VR 16–85 f/3.5–5.6G VR lens at 26mm, 1/500s at f/11, ISO 100
Photographer comment: I got up at dawn to watch the sunrise and was returning to my tent at Sal Salis Ningaloo Reef on the west coast of Australia, only to find this wallaroo right in front of the tent. We startled each other and she hopped off, but not too far for my long lens. It was magical to have the joey pop his head out. The early morning light was perfect.

Chapter 4: North Face of the Eiger © 2015 **Dave Irwin** (*Delta5*)
Shooting info: Tamron 150–600mm, 1/1250s at f/6, ISO 450
Photographer comment: This image was captured in May 2015 at about 2100 m near Kliene Scheidegg in the Swiss Alps. There were fast-moving clouds and the peaks were mostly hidden, but the turbulence intermittently revealed brilliant sunshine, blue sky, and ominous high rock-faces. I set up the camera and sat back to watch the movements of the weather. A rather chilly hour later, patience finally paid off; this atmospheric exposure captured the immense scale and dark mood of the infamous Ogre.

Chapter 5: Detroit Tigers Miguel Cabrera © 2015 **Steven King** (*steve-king*)
Shooting info: Nikkor 200–400mm f/4, 1/5000s at f/4, ISO 800
Photographer comment: This image of Detroit Tigers first baseman, Miguel Cabrera, was taken from the photo-well behind first base in Comerica Park during Opening Day, April 6, 2015. This is a very popular place to shoot for all professional photographers because of the vantage point that it allows for images all over the field.

Chapter 6: Water Running Before Lift Off © 2015 **Phil Clavey** (*Philnblanks*)
Shooting info: AF-S Nikkor 70–200mm f/2.8 VRII/TC14E II (280mm), 1/1000s at f/5.6, ISO 1250
Photographer comment: My brother-in-law, a fellow photographer, took me to a county nature preserve near Fort Meyers Beach, Florida, in late spring. While I took many shots of birds at rest, I kept my shutter at speed high and used Continuous Dynamic 9-point autofocus on the chance I would get some flight shots. I stopped down a full stop to maximize image quality. I was able to pan with the bird and fired a short burst.

Chapter 7: Silent Wings © 2015 **Jim Buch** (*jimray*)
Shooting info: AF-S Nikkor 300mm f/4D/TC-14E II (420mm), 1/2000s at f5.6, ISO 1800
Photographer comment: I captured this adult bald eagle in late April as it left its nest in a city park near downtown Eugene, Oregon. This vertical crop of a horizontal image is one of many I took last spring as I returned several times to monitor the growth of two chicks that hatched in March and fledged in July.

Chapter 8: The Ultimate Green Stalker © 2015 Pete Kyryluk (*Pete K*)
Shooting info: Nikon 105 2.8g VR Macro lens, 1/160s at f/18, ISO 800
Photographer comment: I was excited to open the package with my new Nikon D7200 camera body and anxiously waited for the arrival of the Nikon 105 2.8g VR Macro lens. When the lens arrived, I immediately attached it to the new body and ran outside to try out the new combination. This photo was the beginning of my venture into macro photography. I was impressed with the super fast and accurate autofocus. The colors and resolution of this camera and lens combination impressed me very much.

Chapter 9: The Blue Beauty (Verditer Flycatcher) © 2015 Srijan Roy Choudhury (*Lighter*)
Shooting info: Nikkor AF-S 300mm f/4 IF ED lens, 1/500 at f/4.5, ISO 720
Photographer comment: I took this picture around 06:00 AM in the morning, at a place called Tinchuley in West Bengal. My son, Annoy, and I were out exploring the region for birds. Annoy spotted the bird and alerted me. To avoid any camera shake I kept my camera on Auto ISO and made sure that the shutter speed did not drop below 1/500. Excellent high ISO performance of Nikon D7200 made sure that the photo came out perfect with almost no ugly noise. The bird was very agile and was very near its nesting place, so for few moments it waited to perceive if there was any threat and gave loud calls of alert. Once it felt safe, it resumed feeding activity and flew away.

Chapter 10: My Cold Blooded Friend © 2015 William Gaston Jr (*BillGastonJr*)
Shooting info: Nikkor 80–400mm f/4.5–5.6G ED VR lens at 400mm, 1/200s at F5.6, ISO 100
Photographer comment: I saw this little guy running along some rocks at the Dallas Zoo. He only paused like this for a couple of seconds before running off. The focus speed of this camera over my D80 has already allowed me to capture many more pictures.

Chapter 11: Battle in the Air © 2015 Paul R Sorrells (*Rickman*)
Shooting info: Tamron SP 150–600mm f/5–6.3 Di VC USD at 600mm, 1/2000 sec at f/8, ISO 280
Photographer comment: I took this photograph below the Conowingo Dam on the Susquehanna River in MD, at the top of the Chesapeake Bay. The "Dam" is well known worldwide, not only for the resident Bald Eagles, but also for the fall/winter influx of the many migratory birds from New Jersey, New York, Maine, and Massachusetts. The lead eagle has a large shad and the trailing eagle was attempting to steal it rather than catch his own. The D7200 maintained focus tracking while using CH mode and drastically improved my success rate.

Chapter 12: Red crown in the sunshine © 2015 Carl Mohr (*Nikonlad62*)
Shooting info: Tamron 150–600mm AF OS lens at 600mm, 1/1000s at f/8, ISO 2500
Photographer comment: My sister-in-law told me of a Pileated Woodpecker in her yard, so I dashed off to her house. This is the first Pileated Woodpecker I have ever photographed. I cropped the photo to vertical. I somewhat overexposed the white on her face, but was able to salvage it in Photoshop after converting from RAW to TIFF. If I could do it over, I would lower the ISO and check for highlight blinking.

Chapter 13: Summer Family Portrait © 2015 Darrell Young (*DigitalDarrell*)
Shooting info: AF-S Nikkor 16–85mm f/3.5–4.5G ED VR lens at 35mm, 1/60s at f/4.5, ISO 560
Photographer comment: After my wife Brenda photographed my daughter and grandson (chapter 1 opening image), I grabbed the D7200 to take a few family portraits using fill flash and Auto exposure mode. The D7200 uses its Matrix metering in a very intelligent way to balance ambient light and the built-in Speedlight output in a very appealing manner. What a great little camera!

Index

nikonians®

nikonians.org

— Worldwide home for Nikon user

With over 500,000 members from 170 nations, Nikonians.org is the largest Internet communi for Nikon photographers worldwide.

Enter the following Code to Obtain a 50% discount for a Nikonians Gold Membership:

NikD7TdYEBXm

50% rebate
gold